GEORGE CRUIKSHANK'S
LIFE, TIMES, and ART

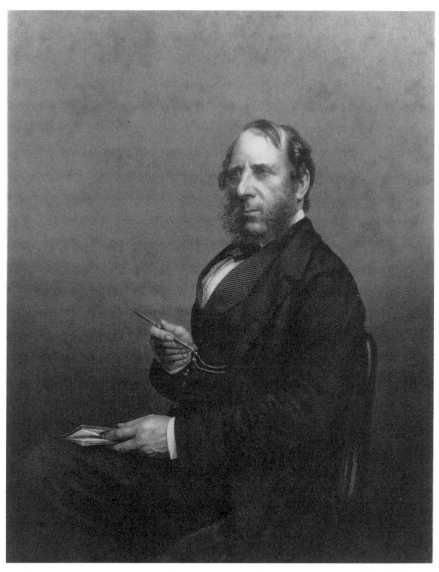

George Cruikshank, photograph by J. and C. Watkins, engraved by D. J. Pound, c. 1855

GEORGE CRUIKSHANK'S LIFE, TIMES, and ART

Robert L. Patten

Volume 2: 1835–1878

THE LUTTERWORTH PRESS

CAMBRIDGE

Publication of this book has been supported, in part, by a grant from the John Simon Guggenheim Memorial Foundation.

The Lutterworth Press
P.O. Box 60
Cambridge
CB1 2NT

British Library Cataloguing in Publication Data
A catalogue record is available from the British Library.

ISBN 0 7188 2874 7

Manufactured in the United States of America

Contents

Illustrations

Acknowledgments

In addition to those persons and institutions cited in volume one, I am for this volume also grateful to Draper Hill, John H. Snaith, and Elizabeth Miller for information, to John Wardroper for advice and favors, to Elizabeth Burke for rigorous copy-editing, to Terry Munisteri for impeccable proofing, and to Jane M. Dieckmann for her comprehensive indexing of both volumes.

The following owners have graciously given permission to quote from materials in their collections: the Trustees of the British Library; the Trustees of the British Museum; the William Andrews Clark Memorial Library, the Richard Vogler George Cruikshank Collection at the Grunwald Center for the Graphic Arts, and the Department of Special Collections, University Research Library, all part of the University of California at Los Angeles; Special Collections, Tutt Library, The Colorado College; the Directors of Coutts and Co., London; the Houghton Library, Harvard University; the Huntington Library; the Rare Book and Special Collections Library, University of Illinois at Urbana-Champaign; the Lilly Library, Indiana University; the W. Hugh Peal Collection (63M22), Division of Special Collections and Archives, University of Kentucky Libraries; the London Borough of Camden Local Studies and Archives Centre; the Corporation of London—Greater London Record Office; Special Collections, Merkle Collection, University of Maryland Baltimore County; the Special Collections Library, University of Michigan; Special Collections, University of Missouri-Columbia Libraries; the Pierpont Morgan Library; the Henry W. and Albert A. Berg Collection, The New York Public Library, Astor, Lenox, and Tilden Foundations; the Whitaker Papers #3433 in the Southern Historical Collection and the Cruikshank Papers #11,005 in the General and Literary Manuscripts Group, Wilson Library, University of North Carolina at Chapel Hill; the John Johnson Collection of Printed Ephemera, Bodleian Library, University of Oxford; the Pennsylvania State University Libraries; the Rare Book Department, Free Library of Philadelphia; the Department of Rare Books and Special Collections, Princeton University Libraries; George Bell archive, Reading University Library; the

Department of Rare Books and Special Collections, University of Rochester Library; the Royal Archives, Windsor Castle, by gracious permission of Her Majesty Queen Elizabeth II; the Director and University Librarian, the John Rylands University Library of Manchester; the Trustees of the National Library of Scotland; Department of Special Collections, Stanford University Libraries; Harry Ransom Humanities Research Center, University of Texas at Austin; the H. Gregory Thomas Collection of The University Club Library, New York, NY; the Board of Trustees of the Victoria and Albert Museum; and the Special Collections Department, University of Virginia Library.

The following owners have kindly allowed us to reproduce materials from their collections: the Trustees of the British Museum; the Board of Trustees, National Gallery of Art, Washington, D.C.; the Royal Collection by gracious permission of Her Majesty Queen Elizabeth II; Hazel Snaith; and the Board of Trustees of the Victoria and Albert Museum.

Chronology

Date	Life	Times	Art
1835	William Harrison Ainsworth (WHA) entertains at Kensal Lodge, later at Kensal Manor House (to mid-1840s)		*The Comic Almanack* (to 1853)
			1 Aug.: *Cruikshankiana*
			Fisher and Son's illustrated Scott (to 1838)
	17 Nov.: GCk meets Charles Dickens (CD)		
1836		Wheatstone invents telegraph	8 Feb.: *Sketches by Boz*, First Series
			May: *Rookwood*, 4th ed.
	4 Nov.: CD becomes editor of *Bentley's Miscellany*	H. K. Browne begins illustrating CD's fiction	
			17 Dec.: *Sketches by Boz*, Second Series
1837			GCk illustrates *Bentley's Miscellany* (to Oct. 1843)
			Oliver Twist (to Nov. 1838)
		20 June: Accession of Queen Victoria	
	9 Sept.: John Macrone dies		
1838		Chartist agitation (to 1848)	*Memoirs of Grimaldi*
	GCk hires Thackeray to write for *Comic Almanack*		
1839	Feb.: WHA succeeds CD as editor of *Bentley's Miscellany* (to Dec. 1841)		*Jack Sheppard* (to Oct.)
			Loving Ballad of Lord Bateman
1840		10 Feb.: Queen Victoria marries Prince Albert	*Tower of London*

Date	Life	Times	Art
1840			*Guy Fawkes*
		Free Trade agitation (to 1846)	
		June: Thackerary's essay on GCk in *Westminster Review*	
	12 Dec.: Dinner to celebrate *Tower of London*		
1841		*Punch* founded	
			May: *George Cruikshank's Omnibus* (to Jan. 1842)
	24 Aug.: Theodore Hook dies		
			Dec.: *The Drunkard*
1842	8 Jan.: Percy Cruikshank marries		GCk illustrates *Ainsworth's Magazine*
			The Miser's Daughter
	July: GCk attends dinner welcoming CD back from America		
	21 Aug.: William Maginn dies		
	6 Nov.: William Hone dies		
1843			
	Oct.: GCk breaks with Richard Bentley		
1844			*The Bachelor's Own Book*
	19 June: GCk attends farewell dinner before CD departs for Italy		
1845	3 May: Thomas Hood dies		*George Cruikshank's Table-Book*
	June: WHA resigns as editor of *Ainsworth's Magazine*		*History of the Irish Rebellion in 1798*
1846	GCk participates in CD's amateur theatricals (to 1848)	June: Corn Laws repealed	reissue of *Oliver Twist* in parts
1847	GCk becomes total abstainer, devotes himself to Temperance		July: *The Bottle* *Greatest Plague of Life*
1848		Gold found in California	
		Feb.: Fall of Louis Philippe	
		Chartism collapses	

Date	Life	Times	Art
1848		Revolutions throughout Europe	July: *The Drunkard's Children*
	9 Aug.: Frederick Marryat dies		
1849	GCk abstains from tobacco		GCk takes up oil painting
	28 May: Mary Ann Cruikshank dies		*Frank Fairlegh* (Jan. to Mar. 1850)
	Summer: GCk has breakdown		*Clement Lorimer*
1850			*The Disturbed Congregation* exhibited at Royal Academy
	7 Mar.: GCk marries Eliza Widdison, moves to 263 Hampstead Road		
	Adelaide Attree joins household as maid		
1851			*1851; or, The Adventures of Mr. and Mrs. Sandboys* (8 parts, Feb.–Sept.)
	GCk attends festivities celebrating opening of Great Exhibition (May–June)	1 May: Great Exhibition opens	
		Louis Napoleon voted President of France	
1852			*Talpa*
			Uncle Tom's Cabin
			GCk publishes illustrated pamphlets on various subjects periodically to 1870
		14 Sept.: Wellington dies	
		Dec.: Second Empire declared in France	
1853	GCk applies to study at Royal Academy	Crimean War (to 1856)	*Hop o' My Thumb*
		July: John B. Gough arrives in England	
	10 Aug.: Mary Cruikshank dies		
		1 Oct.: CD publishes "Frauds on the Fairies"	
1854			Jan.: *George Cruikshank's Magazine* (to Feb.)
	Feb.: GCk replies to CD's attacks		*Jack and the Beanstalk*

Date	Life	Times	Art
1854	May: GCk chairs Temperance meeting at Sadler's Wells		*Cinderella*
	20 Nov.: George Robert Archibold born		
1855			*Runaway Knock* exhibited at British Institution
1856	GCk becomes involved with J. W. Howell		Ruskin praises GCk's work in *Modern Painters*, vol. 4
	13 Mar.: Isaac Robert Cruikshank dies		
	19 Nov.: David Bogue dies		
1857		Indian Mutiny; General Havelock relieves Lucknow	*Life of Falstaff* (Apr. to Jan. 1858)
		Banking crisis	
1858			
1859		War for Italian independence	
		Darwin publishes *Origin of Species*	
1860	26 June: Robert Brough dies		*Worship of Bacchus*, oil painting, watercolor, and engraving (to 1864)
	Autumn: GCk helps to organize Volunteer regiments		
		U.S. Civil War begins	
1861	Mar.: GCk tacitly in command of Volunteer regiment		
		15 Dec.: Prince Albert dies	
1862		Cotton famine in Midlands	
			4 Aug.: *Worship of Bacchus* exhibited
			Nov.: larger exhibit at Exeter Hall
1863	GCk and Richard Bentley shake hands		*All the World's a Stage*, watercolor and oil painting (to 1865)
	24 Dec.: Thackeray dies		
1864	29 Oct.: John Leech dies		

Date	Life	Times	Art
1865	fund-raising efforts on GCk's behalf begin, continue into 1870s		
1866	GCk receives Civil List pension and annual stipend from Turner Fund of Royal Academy		etchings of Grimms's Fairy Tales for Ruskin
1867		suffrage extended	
			Mar.: *The British Bee-Hive*
1868		Doré establishes his London Gallery	Hotten reprint of *German Popular Stories*
	30 Sept.: GCk resigns from Volunteers		
1869			
1870			GCk designs statue of Robert the Bruce
	25 Apr.: Maclise dies	Franco-Prussian war	
	9 June: CD dies	Paris Commune	
			Aunt Judy's Christmas Volume
1871			G. W. Reid catalogue published
	Dec.: Forster's *Life of Dickens* vol. 1 published		
	30 Dec.: GCk's letter to *The Times*		
1872	GCk etches on glass for his autobiography		*The Artist and the Author*
1873	GCk proposed, unsuccessfully, for a knighthood		
	Testimonial concluded		
1874			
1875			last etchings
	8 Mar.: silver wedding anniversary		
1876	28 Feb.: GCk signs final will		
	GCk sells collection to Westminster Aquarium		
1877			*The Rose and the Lily*
1878	1 Feb.: GCk dies	Whistler sues Ruskin for libelous review	
	9 Feb.: GCk buried at Kensal Green Cemetery		
	29 Nov.: GCk interred in crypt of St. Paul's		

Phase
3

"Immortal George"
1835–1851

25

MIDDLE-CLASS CHARACTERS

Boz is the CRUIKSHANK of writers.

Spectator[1]

EIGHTEEN THIRTY-FIVE was George Cruikshank's watershed year. Republication of the satiric and humorous prints he had done over more than thirty years summarized those aspects of his Georgian art transmitted to proto-Victorians. The *Comic Almanack* commenced, to be repeated annually until 1854, Cruikshank's most sustained bid to superintend a publication entirely of his own devising and management. And the career in book illustration that had been limping along with commissions for second-rate fiction and new editions of the classics leaped forward with his introduction to Harrison Ainsworth and Charles Dickens. At the age of forty-three, Cruikshank was about to experience more acclaim than ever before. But the associations with Ainsworth and Dickens that led to his stunning succession of triumphs soured in the decades that followed, until at the end of Cruikshank's life he was forced to defend his reputation, his veracity, almost his sanity, against charges that he lied or was deluded in his claims to have collaborated with the great writers in the production of some of their most famous books. What from the perspective of 1835–1840 looks like another meteoric rise in Cruikshank's fortunes appears in retrospect to be the beginning of that long decline in his reputation which culminated, a few years after his death, in eclipse.

When William IV died in the summer of 1837 and was succeeded by an eighteen-year-old queen, the authors and artists linked to the opening decades of her reign were beginning to find their voices and art: Ainsworth, R. H. Barham, Edward Bulwer Lytton, Dickens, the Fraserians, Leech, Maclise, Clarkson Stanfield, Thackeray. Of those associated with the heyday of Romanticism, only a few survived: Leigh Hunt, Landseer, Turner, and Wordsworth. William Powell Frith, who was to become a friend of Cruikshank, an intimate friend of Dickens, and painter of anecdotal panoramas

about midcentury life, arrived in London in March 1835 to study drawing in the studio of Henry Sass alongside Maclise and Thackeray, just returned from Paris.[2] From abroad and the country, by various routes, unknown to one another at first, the great early Victorian authors and artists were assembling in London, exchanging ideas and boiling up the heady brew of fun and drama that was to intoxicate the subjects of the young Victoria.

One way or another many of them bumped into a hirsute survivor of the Georgian age, a man a generation their senior, who knew not only the emerging London of new police acts and poor laws but also the old London of sweeps and swells. Cruikshank was a survivor who had to adapt to survive, and in adapting his knowledge and his art to nascent Victorianism, he provided continuity, a sense of history, and a peculiar sense of social structure and social character that at first strengthened, and then slowly diverged from, Victorian sensibility. The culture he helped shape grew up and repudiated him.

In order to help shape that culture, Cruikshank himself repudiated parts of his past. Gone were the days and nights of his boisterous carousing and the disheveled early morning arrivals at the Hones. Gone too were the mass meetings in the streets addressed by Radical orators and whipped into action by inflammatory prints. Now, married to a frail but sociable woman, comfortably housed in a semi-rural north-London suburb, and established as an illustrator of classic European fiction, Cruikshank distanced himself from the behavior and politics of an earlier, more outspoken era. "I regret exceedingly that I cannot undertake the illustrations," he wrote to the publisher Blackwood at this time. "The fact is that for many years past I have eschewed political works altogether . . . & were I to break . . . my rule in this instance it would lay me open to numberless annoying & pestering applications from various parties."[3] Although he still collaborated with new as well as established authors, Cruikshank now rarely accepted suggestions from strangers and friendly amateurs; he sought reputable publishers and publications and strove for control over as many aspects of the work as he could manage. Like Hogarth and Blake, Cruikshank wanted to be artist, author, printer, bookseller, and publisher all at once; he also aspired to lead a respectable, middle-class, professional life. Neither his temperament nor the demands of his vocation, however, were altogether suited to this petit bourgeois ideal.

It was, nonetheless, an ideal that in some ways Cruikshank shared with his new friends, chief among whom were William Harrison Ainsworth and Charles Dickens. "Petit bourgeois" is too modest a description of the aspirations of Ainsworth (fig. 1), who, according to his biographer Samuel Marsh Ellis, was by the mid-1830s "the Lion of the day—courted and feted by all the most distinguished members of literary, artistic, and social circles in the

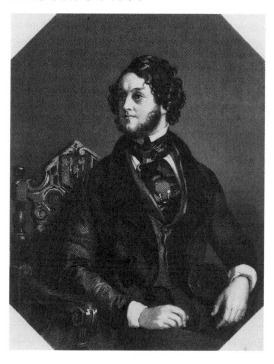

1. Daniel Maclise, "William Harrison Ainsworth," Ainsworth's Magazine, *engraving by E. Finden from oil painting,* Jan. 1844

greatest city of the world."[4] Born in 1805, Ainsworth was the son of a successful Manchester solicitor who loved telling his receptive child tales about famous highwaymen and criminals. When his father died in 1824, Ainsworth moved to London to study law and to further literary and theatrical ventures that had brought him into correspondence with Wordsworth, and within a few months of his arrival had promoted him into the circle of Charles Lamb, Henry Crabb Robinson, Mary Shelley, and Bryan W. Proctor, a lawyer who wrote verse, a tragedy, and a biography of Edmund Kean under the pseudonym Barry Cornwall.[5] During the next two years, Ainsworth was admitted to the bar, married Anne Frances Ebers, and published a historical novel that, through the mediation of Lockhart, came to Scott's attention and started a friendship between the established historical novelist and the aspirant. Then Ainsworth quit the law and sold his father's practice in order to join his father-in-law John Ebers in publishing, bookselling, and running a lending library connected to the King's Theatre. As a publisher and bookseller, the young Ainsworth met all of literary London. He initiated a fancy annual, *The Keepsake,* and was successful in obtaining a contribution from Scott; he also launched the literary careers of Samuel Laman Blanchard, the genial editor and essayist who became good friends with Ainsworth, Dickens, and Cruikshank, and of Caroline Norton, whose

involvement in an adultery suit Dickens was to parody in *Bardell v. Pick-wick*.[6] In 1829 Ainsworth quit publishing, and the following year he re-turned to the law; but he was still interested in writing plays or novels. "Have you been able to invent or find any plot, or other incident, adaptable to my projected Domestic Tragedy?" he asked his best friend James Cross-ley, a Manchester solicitor and antiquarian who frequently supplied Ains-worth with subjects and plots.[7] Evidently the answer was no, for Ainsworth then took off on an extensive trip to the Continent.

On his return, he was invited to the first banquet attended by the con-tributors to the leading new half-crown monthly, *Fraser's*, edited by Maginn, "the greatest magazinist of the nineteenth century," who was im-mortalized by Thackeray as Captain Shandon in *Pendennis*.[8] The writers and artists included the witty and popular humorist Theodore Hook, Lock-hart, Thomas Carlyle (who published *Sartor Resartus* in *Fraser's* in 1833–1834), the accomplished polyglot rhymester and polemicist "Father Prout" (Francis Mahony), Thackeray, Maclise and his brother-in-law Percival Weldon Banks, hack novelists and historians such as D. M. Moir, the Rev. G. R. Gleig, and John Galt, and the tyrannical editor of the *Literary Ga-zette*, William Jerdan, already well known to Cruikshank. The *Fraser's* crowd was irrepressible, quarrelsome, inventive; they were based in London rather than Edinburgh like the contributors to the heavyweight quarterlies; they tended to be Tory rather than Whig in politics (being guided by "the counsel of Coleridge and the countenance of Scott"), and to favor new writers, extravagant puns, literary gossip, and slashing controversy over the magisterial polemics of their established rivals. *Fraser's* was, in Carlyle's colorful term, a "dog's meat-tart of a periodical," and it was marked "by the dash and 'riotous mirth' of the Regency."[9] Not only did it take up Ains-worth; it tried, as we have seen, to appropriate Cruikshank as an artist of its own persuasion.

In April 1834 Richard Bentley, starting on his own as a publisher after quarreling with his partner Henry Colburn, issued the first edition of *Rook-wood*, Ainsworth's fanciful tale about the disputed inheritance of an Eliza-bethan estate. The novel features a disguised Dick Turpin and his famous (though apocryphal) ride on Black Bess from London to York—the same ride that the servant of Cruikshank's great-uncle Archibald allegedly wit-nessed. Although no author's name appeared on the title page, Ainsworth was too well known among the literati, and too eager to be recognized, for his responsibility to be long kept a secret; even before his name appeared in the second edition, published in August, he was famous. Rarely has a novel by a comparatively unknown writer so seized the public's imagina-tion. Dick Turpin became the progenitor of countless gentlemanly robbers in lace and gold trim who swagger through historical romances, criminal

fiction (known as "Newgate novels"), swashbuckling theatrical pieces (down to and including Douglas Fairbanks's and Errol Flynn's early films), holiday entertainments, "penny dreadfuls," chapbooks, woodcuts, and popular prints. The novel was immediately staged at the Adelphi and other theaters, and at Astley's Amphitheatre Cruikshank's friend Andrew Ducrow produced a famous equestrian drama, *Turpin's Ride to York.*

At this time Ainsworth was introduced by the novelist and dandy Edward Bulwer Lytton to Lady Blessington.[10] Through her the fledgling author met the Holland House set: Lord Holland, nephew of the radical politician C. J. Fox whom Gillray and Cruikshank had caricatured; politicians such as Lord Brougham, Earl Grey, Lord John Russell, and Talleyrand; and famous authors such as Tom Moore, Samuel Rogers, Sydney Smith, Thomas Macaulay, and Washington Irving.[11] In July 1834, one year after Maclise's sketch of Cruikshank was printed, *Fraser's* "Gallery" exhibited Maclise's portrait of Ainsworth. He was at this time "a buck of the first degree" with a "barber's block type of beauty." His wavy hair glistening and reeking from Macassar oil, and his pink and white complexion offset by luxuriantly curled whiskers, he sported the garments of a dandy of William IV's reign: a high-collared, tight-waisted coat, a black satin stock fixed by two jeweled pins and a chain, an ultra-gorgeous waistcoat, a profusion of rings, and a carefully brushed beaver top hat.[12] Though rivaling Count D'Orsay and Benjamin Disraeli as a leader of fashion, Ainsworth was neither conceited nor vulgar; his manners were said to be refined, pleasant, and hospitable.[13]

Early in 1835 Ainsworth separated from his wife and went to live with his cousin's widow, Mrs. James Touchet, and her sister, Miss Buckley, at Kensal Lodge in the Harrow Road. For six years here, and for a time thereafter at the adjoining Kensal Manor House, Ainsworth and Eliza Touchet, "a clever, sarcastic, fascinating talker," according to Edgar Johnson, entertained the brightest wits, artists, and authors of early Victorian England.[14] The Lodge was modest: it stood close to the road and comprised only three entertaining rooms and four or five bedrooms, but because of the elevated site the garden side looked out over the countryside of North Kensington, the Porto Bello farm, Notting Hill, famous for nuts and nightingales, and beyond the Thames to the hazy blue of the Surrey Hills.[15]

To this pleasant prospect and this ebullient host came many of Ainsworth's social and literary friends, including Thackeray, Dickens, John Forster, and Cruikshank: "Truly an immortal company," Ellis records, "the majority in the glow of youth, overflowing with high spirits, gifted with genius, and full of ambition for the years to come."[16] Forster and Dickens would ride out from town, and then the three equestrians would explore the country north and west, to Ruislip, Stanmore, Harrow, Acton, Chiswick, Shepherd's Bush, and Wormwood Scrubs. Or they would walk, past

Willesden Church and lock where Jack Sheppard had his memorable adventures, or to Esher, near which the author Mary Howitt encountered the perambulating authors one afternoon in the late 1830s.[17] Dinner took place at five o'clock; afterward the guests engaged in spirited conversation and drinking, or if the night was fine or the entertainment promising, returned to town to attend the theater or a soiree.

Amidst this company Cruikshank was remembered fondly for his conviviality, his renditions of *The Ballad of Lord Bateman* accompanied by the composer Frank Romer, and his dancing of the hornpipe in the manner of the great impersonator of jolly British tars, T. P. Cooke. "Cruikshank keeps his ground I see," wrote Laman Blanchard to Ainsworth some time during this period. "May his tankard never be less, and his whiskers flourish a thousand years. Pray Heaven he hath not lost his voice singing of anthems! When you see him give the least of his admirers—yet no little one either—a lift in his jolly remembrance."[18]

No one was closer to Ainsworth in the mid-1830s than Charles Dickens (fig. 2), who was seven years younger and thousands of pounds poorer, but who shared the sparkling wit, the interest in criminals' lives, and the ambition to write his way into fame and fortune. In 1835 Dickens was living in chambers at 13 Furnival's Inn, working for the *Morning Chronicle* as a reporter, writing and selling additional "Sketches of London" to the *Evening Chronicle*, and courting Catherine, eldest daughter of a fellow journalist George Hogarth. Dickens was a young man of extraordinary vivacity, with a lively, mobile face that seemed, according to Leigh Hunt, to have "the life and soul in it of fifty human beings," and yet, as Jane Welsh Carlyle observed, to be "made of steel."[19] Like Ainsworth, Dickens aspired to be a dandy, and so he appears in a description by an unnamed friend:

> A slight, trimly-built figure; an oval face eminently handsome; long silken hair, and slight downy whiskers; a swallow-tail coat with a very high velvet collar; a voluminous satin stock with a double breast-pin; a crimson velvet waistcoat, over which meandered a lengthy gold chain; beneath the crimson vest one and sometimes two under-waistcoats; "Cossack" trowsers for morning dress; for evening wear, tightly-fitting black pantaloons with small buttons at the ankles, the pedal extremities being endued with speckled black silk hose and "pumps"; while the high mounting stock was replaced by a white cravat, with a bow about eight inches wide, and a protruding jabot or shirt-frill.[20]

Dickens's hold on fashion was a good deal more tenuous than Ainsworth's. He had very little money, and while prospects of earning more through his writing encouraged his prodigal productivity, he had no fine clothes or fine friends to spare. The aspiring publisher John Macrone and the American journalist Nat Willis visited Dickens a few days after he moved into Furnival's Inn; Willis described the young writer as

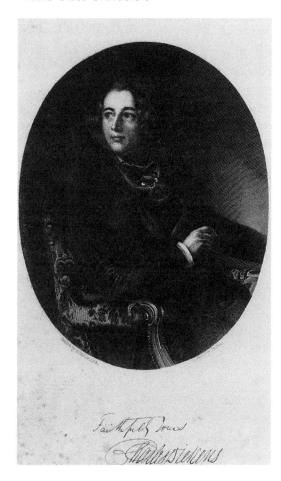

2. Daniel Maclise, "Charles Dickens," frontispiece to Nicholas Nickleby, engraving by E. Finden from oil painting, Oct. 1839

dressed very much as he has since described Dick Swiveller, *minus* the swell look. His hair was cropped close to his head, his clothes scant, though jauntily cut, and after changing a ragged office-coat for a shabby blue, he stood by the door, collarless and buttoned up, the very personification, I thought, of a close sailer to the wind.[21]

Dickens was at the time lonely: he had been rejected by his first love partly because his prospects and background were unsuitable; he was living in poorly furnished lodgings; and his modest reputation and circumstances hardly qualified him for the salons of Lady Blessington and Lady Holland. So for Dickens the friendship with Ainsworth provided access to scenes and persons hitherto above his social station; and Ainsworth's meteoric rise through the success of a single Newgate novel encouraged Dickens's own

ambitions and oriented his planning as much as it altered his taste in velvet waistcoats and satin stocks.

While Ainsworth was capitalizing on his new fame, and Dickens was anticipating his, Cruikshank remained hard at work trying to sustain his reputation and income. In the autumn of 1834 he had been asked by the periodical writer James Henry Vizetelly and the publisher Charles Tilt to supply illustrations for a comic almanac which they wanted to inaugurate in imitation of Thomas Hood's *Comic Annual*.[22] The idea may have been the publisher's, or it may have originated with Vizetelly, as his son later asserted.[23] The almanac was set up to parody Francis Moore's, published by the Stationers' Company, and to participate in the "March of Intellect" which delighted in poking fun at superstition.[24] Vizetelly took the name Rigdum Funnidos and claimed in a "Preludium" conceived as rhymed theatrical dialogue *à la Fraser's* to be the successor prophet to Moore.[25] Each month's prediction, interspersed with meteorological signs, was accompanied by a Cruikshank steel-etching illustrating a principal event or scene in or near London and characteristic of that month. Thus "March" winds are depicted collapsing the umbrellas, whipping the coattails and skirts, and tumbling the hats of pedestrians passing by Tilt's Fleet Street shop, while Cruikshank and Tilt converse in the doorway (fig. 3). "April" rhymes

M A R C H .

3. George Cruikshank, "March," etching for 1835 Comic Almanack

are accompanied by a picture of April showers, and May is characterized by a spirited procession of chimney sweeps. July takes place in Vauxhall, August in Billingsgate, September at St. Bartholomew's Fair where a runaway bull causes the disturbance, and October witnesses a bedraggled "Return to Town" after a holiday at Hastings. Vizetelly says he gave Cruikshank the subjects for the year: they were all chosen to bring out the artist's skill in depicting urban scenes, entertainments, and mishaps, and to avoid the kind of political satire he had eschewed. When Vizetelly suggested that Cruikshank design a woodcut showing Lord Brougham falling between the two stools of "peers" and "people," the artist refused, and the design, though calling on Cruikshank's iconography, was executed by another.

When the small octavo in blue stiff paper wrappers was published just before Christmas, sales were so encouraging that the partners decided to continue the venture. The writing was only fitfully clever, and the first plates, though carefully and in places heavily worked, were more competent than inspired; but Thackeray recalled in 1840 that the first number showed "a great deal of comic power, and Cruikshank's designs were so admirable, that the 'Almanac' at once became a vast favourite with the public, and has so remained ever since."[26] Circulation approached twenty thousand copies, and, from 1835 to 1853, the *Comic Almanack* was the primary source of regular income for the artist.

Throughout the winter of 1834–1835, Cruikshank toiled on minor commissions. For *Angelo's Pic-Nic; or Table Talk*, a continuation of the famous fencing master's reminiscences, Cruikshank executed a delightful colored frontispiece showing Henry Angelo at a table spread with the picnic dishes—plates on which miniatures of the various authors whose contributions fill the book act out their scenes.[27] Angelo was pleased with the design for this and a vignette title, but tardy with payment; on 9 October 1834 he begged a month's extension, holding out the prospect of a future commission as partial compensation.[28] Obscure though this octavo was, it has associations with Cruikshank's future collaborators. The publisher was Ainsworth's father-in-law, John Ebers, and its name was echoed by Dickens six years later when he punned on it and on his celebrated *Pickwick Papers* in the title to the three volumes which he edited, and which Cruikshank among others illustrated, to benefit John Macrone's widow: *The Pic-Nic Papers*.

Minor commissions for other publishers yielded the odd shilling. Cruikshank reetched a title-page vignette and a series of three pictures of a traveler outfighting a highwayman, first published in the *Stadium*, for issue in Baron de Berenger's *Helps and Hints to Protect Life and Property*.[29] Samuel T. Davenport engraved a frontispiece, and John Thompson executed a vignette wood-engraving from Cruikshank's designs, for Edward A. Kendall's

Burford Cottage and its Robin Redbreast, published by Tegg.[30] Tegg also issued *Beauties of Washington Irving* embellished with twenty woodcut vignettes engraved by John Thompson from Cruikshank's sketches.[31] (A thrifty and a canny man, Tegg later used seven of the blocks in an 1839 edition of Irving's *Salmagundi*, reissued them in 1866, and combined them with other cuts Cruikshank had done for Tegg in an undated collection of *Eighty-two Illustrations*.[32] It is doubtful that either artist or engraver received anything for these reprints.) Cruikshank also contributed four copperplate etchings to the printed version of Sheridan Knowles's *The Wife; or Women as They Are*.[33]

In August of 1835, having finished most of the pending work and feeling out of sorts, Cruikshank took Mary Ann for a holiday to Dover. His mother, at home in Pentonville, replied to one of his seaside messages with domestic news.[34] From the tone and contents of Mary's letter it seems evident that harmony had long since been restored between the "deposed dowager" and her younger son's wife.

It may have been after the Cruikshanks returned from the seaside that the introductions and proposals for new projects began. There is no evidence of how or when Ainsworth and Cruikshank met. Laman Blanchard, who knew both, might have introduced them; Cruikshank was writing to Blanchard in terms of close familiarity in June 1835.[35] Or perhaps the connection was made through John Macrone, known to Ainsworth by 1834, and to Cruikshank before November 1835.[36] Macrone, born on the Isle of Man in 1809, had come to London in his early twenties and entered into a partnership with James Cochrane. Together they published the *Monthly Magazine* from January to August 1834; in it first appeared five of the pieces Dickens would later include in the First Series of *Sketches by Boz*. Macrone then went into business for himself and was on the *qui vive* for promising authors, illustrators, and materials. Or Ainsworth might have sought out Cruikshank on his own, for he admired the artist's pictures, and had paid tribute to him in the first, unillustrated, edition of *Rookwood*, where the sexton Peter Bradley is described as "one of those odd, grotesque, bizarre, caricatures of humanity, which it occasionally delighteth our inimitable George Cruikshank to limn."[37]

Nor is it certain how and when Ainsworth and Dickens met.[38] If, as Edgar Johnson posits, Ainsworth first introduced Dickens to Macrone, then since Macrone and Nat Willis called on Dickens in December 1834, Dickens must have met Ainsworth some months previously.[39] Certainly by the summer of 1835, Ainsworth, Macrone, and Dickens were acquainted with each other. Macrone had obtained from Richard Bentley republication rights for *Rookwood* and was bringing out a third edition. Macrone may already have been exploring with Ainsworth and Cruikshank the possi-

bility of a fourth edition, illustrated for the first time, with plates by the artist whose caricatures the text already mentioned. According to Edgar Johnson, it was on an afterdinner walk from Kensal Lodge back to Holborn that Macrone proposed to Dickens bringing out a collection of his sketches with illustrations by Cruikshank. Johnson offers no evidence for this story, and somewhat clouds its plausibility by identifying Cruikshank as a "famous cartoonist," and by recapitulating his career among the "radical caricaturists" as the designer of "brilliant savage portrayals of George IV."[40] It would not have been Cruikshank's political satires that Macrone had in mind. For Ainsworth's novel he was thinking of Cruikshank's illustrations to historical fiction, and for Dickens's journalism, the artist's London plates from *Tom and Jerry* to the just-published *Comic Almanack*.

When Cruikshank was approached about these commissions, did he hesitate before accepting? Had he already settled with Vizetelly on the subjects for the 1836 *Comic Almanack*, for which the steels had to be finished around the end of November? Were the two frontispieces and two vignette titles for Matthew Barker's *Land and Sea Tales* being rushed to completion? "I am much pleased with your illustrations," Barker told Cruikshank, "though the scene on the mountain ["The Farmer's Daughter," frontispiece to volume 1] does not exactly tally with the text. I wish I had seen them in proof."[41] The surviving evidence supplies no answer. What we do know is that Cruikshank had a lean budget of work through the summer of 1835, and that after he returned to Pentonville from his August holiday the commissions for important work came tumbling through the letter slot.

Around the beginning of October John Macrone approached George with the proposal to illustrate Dickens's sketches. He may have suggested trying to bring the volume out in time for the Christmas trade—perfectly possible, as it would not take Macrone's printer long to reset previously published work nor for Cruikshank to provide some vignettes. As soon as the *Comic Almanack* plates were out of the way, Cruikshank could see his way clear, so he assented, and Macrone took the news to Dickens.

At this point, the artist was much less pressed for time than the writer: Dickens "had been for months previously," as he told the mother of his friend Henry Austin, "up all night and asleep all day," reporting the proceedings in Parliament until the House recessed on 10 September.[42] Then he came down with an illness that lingered through October; on the 11th, Mrs. Hogarth and Catherine caught scarlet fever, and Dickens, having just moved back into Furnival's Inn after spending the summer in lodgings near the Hogarths, had to travel to Chelsea to be "by the bed-side of [Catherine] every day."[43] Moreover, Dickens had contracted to furnish Vincent George Dowling with a new sketch for the magazine *Bell's Life* each week and was constantly behind schedule.[44]

Late in October after he completed "Love and Oysters," Dickens got together with Macrone about the book. Macrone would not have been ready to talk business much sooner than the twenty-third; his first child, Frederick Joseph Bordwine, was born on 20 October. For some reason, publisher and author thought the title of the collected sketches should parody Sir Francis Bond Head's *Bubbles from the Brunnens of Nassau, by an Old Man* (1834), sketches of a visit to drink mineral waters that might vaguely recall the Bath scenes in *Humphry Clinker*. But "Bubbles from the Bwain of Box and the Graver of Cruikshank" didn't quite work.[45] "Precisely the idea you suggest about the metallic bubbles, entered my brain after I left you the other day—," Dickens wrote to Macrone on 27 October; "bubbles from a spring impregnated with steel, I *have* heard of: but bubbles coming direct from a steel instrument would, I am inclined to think, be a natural curiosity."[46] What Dickens didn't know, being ignorant about etching techniques, is that bubbles do rise when the metal plate is immersed in acid for the biting in; and since he didn't understand that part of the joke, it seems likely that the title originated with Cruikshank, who planned to use steel plates for *Boz*.[47] (Steel was cheaper than copper, an advantage that Macrone, hard pressed for cash, would appreciate.) Dickens, uncertain how the plates were to be made, proposed two alternative titles: "Sketches by Boz and Cuts by Cruikshank" or "Etchings by Boz and Wood Cuts by Cruikshank." By assigning the word "etchings" rather than the customary "sketches" to his own contribution, Dickens was left with "wood cuts" for Cruikshank, though wood-engraving would have been an expensive and time-consuming addition to the project. Uncertainties about medium aside, Dickens's alternative titles stress the parallel contributions of author and artist: "I think perhaps some such title would look more modest," he explained; "—whether modesty *ought* to have anything to do with such an affair, I must leave to your experience as a Publisher to decide."[48]

Dickens's letter also reveals that he had been thinking about which of his periodical sketches might be included in the collection. He planned to assemble copy from the *Morning Chronicle* and *Monthly Magazine* texts. Moreover, publisher and author had agreed on two volumes, and Dickens promised Macrone that if, when the existing sketches were set in type, the quantity fell short, he would make up the difference with "two or three new Sketches" plus "The Great Winglebury Duel," then being set for the December issue of the *Monthly*.[49] So at the end of October the contents of the *Sketches* were not yet determined, nor even fully written. Though Cruikshank had joined the project, he had not yet been given any letterpress.

On 29 October Dickens called on Macrone to talk further about the *Sketches*.[50] They also discussed Ainsworth's *Rookwood* ("we talked about the very book"), which Dickens later that day wrote to borrow from Macrone

for the Hogarths.[51] That Cruikshank was engaged to illustrate both works
for Macrone doubtless informed their deliberations, as they turned over
ideas about which sketches, in which order, and what kind and number of
pictures, ought to be included. Dickens intended to pursue the Newgate
line, though in his own way. He applied to Alderman Wood for admission
to that prison on the same day; actually went, with Macrone and Nat
Willis, to Newgate and to Coldbath Fields on 5 November; and composed
"A Visit to Newgate" toward the end of the month.[52]

Two months after receiving the commission, Cruikshank still hadn't met
his newest collaborator. Far behind schedule, Dickens determined if neces-
sary to resign his connection to *Bell's Life*, then was ordered to cover Lord
John Russell's speech to the Bristol Reformers scheduled for 10 November.
Cruikshank expected Dickens and Macrone to call on Saturday evening,
the 7th, but at five o'clock Saturday morning, "writing by candle-light
shivering with cold, and choaked with smoke," Dickens asked Macrone

> to tell Mr. Cruikshank how very much I regret the impossibility of seeing him
> this evening, and thereby gratifying my long cherished wish to obtain an intro-
> duction to a gentleman whose much appreciated talents (I don't say it ego-
> tistically) no one appreciates so highly as myself?—Secondly, will you add that
> I shall be most happy to accompany you to Myddleton Terrace on either Thurs-
> day, Friday, or Saturday Evening next?[53]

While the awkwardness of Dickens's syntax and the formality of his ref-
erences to Cruikshank betray an insecurity not evident in his correspond-
ence with Macrone, they should not be taken as evidence that Dickens did
not appreciate Cruikshank's talents. Author and artist shared many inter-
ests, including eighteenth-century fiction, the works of Washington Irving,
popular drama, nursery tales, and London street life. Although Dickens
probably read classic English novels in Cooke's Pocket Library unillustrated
editions rather than in Roscoe's, some of his early reading might have been
illustrated by Cruikshank: *Mother Bunch's Entertaining Fairy Tales*, *Valentine
and Orson*, some of *Fairburn's Songsters*, and innumerable ballad sheets with
crude woodcut heads. Certainly he knew the artist's plates for *Life in Lon-
don*, *Mornings* and *More Mornings at Bow Street*, and Scott's *Letters on
Demonology and Witchcraft*.[54] And as the artist's woodcuts for Hone's
pamphlets and some of his other designs were so often reproduced, Dickens
was likely to be familiar with a lot of miscellaneous Cruikshank imagery,
including his picture of the cat fighting her own reflection in a polished
boot, which George had knocked off as an advertisement for Warren's
Blacking.[55]

Dickens was out of town during the intervening week, but returned on
Friday, 13 November. The next morning he asked Macrone, "Do you go to

Cruikshank's with me?—And if so (which I think would be better as it is partially a business affair) will it suit you to go to-night, or shall we fix Monday Evening?"[56] If Macrone had, according to Dickens's previous instructions, fixed a meeting for Saturday, it had to be canceled; and on the succeeding Monday he was unable to accompany Dickens, as his infant son died that day. Finally, on Tuesday morning, 17 November, Dickens, alone, paid his long-deferred call on George Cruikshank.

For Cruikshank, after nearly a score of years collaborating with aspiring authors, the arrival of a young newspaper reporter who wished to republish occasional pieces was hardly an important event; and the cancellation of two previous meetings scarcely conveyed a sense of urgency to a project mooted six weeks earlier. Still, he was courteous, asked to look over the published sketches, promised to speak further with Macrone as soon as the publisher had recovered from his bereavement, and pledged that as far as he was concerned the book could be out by Christmas.[57] That was a rash pledge, since Cruikshank had not yet studied the material he was to illustrate, had evidently not finalized arrangements with Macrone about kind, size, number, and medium of the plates, had never worked with Dickens before, and had other commitments. Moreover, though it may not have been clear at this interview, Dickens was substantially revising his texts before they went to the printer, Charles Whiting.

Reading the *Monthly Magazine*, *Chronicle*, and *Bell's Life* versions of these sketches, therefore, would not have provided Cruikshank with the copy he had been asked to illustrate. And there were five other pieces not yet written or printed which were eventually swept up into the collection.[58] This preliminary read-through might give the artist ideas about possible subjects, which, along with number, style, and placement, could then be settled with author and publisher prior to his starting to draw and etch. Cruikshank received three volumes of the *Monthly* from Dickens on Monday, 23 November; accompanying one of them was a formal note ("Mr. Dickens presents his compts. to Mr. Cruikshank and begs to forward a volume").[59] In the same note Dickens appointed a further meeting, at Cruikshank's, with himself and Macrone, for that evening, in order "to conclude the arrangement." Exactly what was to be concluded remains obscure, since Cruikshank hadn't seen the printed material yet. At the last minute, Dickens was commanded by John Black, editor of the *Morning Chronicle*, to review John Baldwin Buckstone's new burletta. "As Cruikshank remains at home for us the second time," Dickens wrote hastily to Macrone, "he must not be disappointed. Will you do me the favor of proceeding there . . . on my undertaking to join you at his house by 9?"[60] Once again an appointment at Cruikshank's to settle the business of the *Sketches*

was altered at the last minute by the press of Dickens's other obligations, and once again, apparently, Cruikshank accommodated the busy writer.

One result of that meeting was that Macrone urged Dickens to complete his Newgate sketch for inclusion in the volumes. Dickens worked on it Wednesday and Thursday; Thursday night George Hogarth read it and said "it would 'make' any book"—"an opinion," Dickens reported to Macrone, "which Black more than confirms."[61] Dickens intended to show corrected proof to his publisher—but not to his illustrator. For in spite of the fact that "A Visit to Newgate" was the first tale written after the "arrangement" with Cruikshank was supposedly "concluded," it was not the kind of story that requires, or can be enhanced by, illustration: the climax comes when the sympathetic narrator, viewing one of the temporarily vacant condemned cells, imaginatively projects what an inmate might be feeling on the night before his execution. Although Cruikshank knew Newgate at least as well as Dickens, he did not have an opportunity to collaborate with Dickens on portraying a condemned man until *Oliver Twist*, three years later.

While Dickens was completing another tale about condemned men, "The Black Veil," which concerns a mother who tries to revive her hanged son, Cruikshank read through the previously printed sketches. On Monday, 30 November, Dickens stopped by Amwell Street hoping that Cruikshank could furnish him with a list of intended illustrations and frontispieces. Macrone was eager to get the volumes out quickly; Christmas was only four weeks away. And Dickens felt he couldn't arrange the contents until he knew which pieces Cruikshank planned to illustrate.[62] But as Cruikshank was not at home, Dickens visited with Mary Ann for a few minutes, asking her about the neighborhood and how much it cost to rent a house.[63] He then "strolled about Pentonville thinking the air did my head good," he told his fiancée, "and looked at one or two houses in the new streets." But alas, they were much too dear, so he decided to stick with his plan to vacate 13 Furnival's Inn and before his marriage move into larger quarters at number 15.[64]

Progress on the *Sketches* was further impeded when Dickens was sent the next day to Hatfield to report on a fire. Before he left London he may have received Cruikshank's list of illustrations for volume 1, but he had no time to arrange the contents of either volume and he knew that his "presence in town [was] so essential to the appearance of my book," as he told Catherine.[65] Cruikshank, who saw Dickens immediately after his return, extolled his writings and asked that proof of the revised sketches be forwarded to Amwell Street every evening. Clearly Cruikshank wanted the drawings he was then making to agree in every respect with the altered texts Dickens was submitting to the printers.

By 8 December relations between author and artist were more informal. Dickens thought of including another "Prison Paper" in *Sketches* and applied to Cruikshank for an introduction to George Laval Chesterton, Governor of Coldbath Fields Prison, so that he might revisit that model institution.[66] But the next day he changed his mind. "The Tread-Mill will not take the hold on men's feelings that the Gallows does," he explained to Macrone, "and [George] Hogarth—whose judgment in these matters from long experience is not to be despised—says that he thinks the insertion of another Prison Paper would decidedly detract from the 'hit' of the first."[67]

In the same communication Dickens frets that neither he nor Cruikshank has received the specimen page or proof from the printer. "I hope there is not going to be any more delay, but that both Cruikshank and I are to be supplied at once." Only about ten days remained if the volumes were to be offered to the Christmas trade and as yet the contents were still fluctuating. Dickens wasn't the only one frustrated by delays. Cruikshank complained to Macrone that he felt unduly pressed for the illustrations to volume 2 when he hadn't even seen the whole text from which to pick subjects.[68] He regretted this "unpleasant turn in the state of affairs," and while finishing the etchings for Barker's *Land and Sea Tales*, he went on penciling ideas for the subjects already selected.

It had been determined in one of the conferences that Cruikshank's illustrations would be small vignettes, about 3¼ by 3 inches. There were practical advantages to this choice: the individual illustrations would require less work than full-page bordered prints, and two vignettes could be etched on the same plate, saving time, the cost of additional plates, and printing charges, since the two images could be pressed simultaneously and subsequently divided.[69] In respect to the mode of illustration, therefore, Cruikshank was doing his best to fulfill his pledge. Moreover, he exerted himself to find the best way of rendering each subject: some twenty drawings have survived for the eight plates in volume 1, and another nine exist for volume 2.[70] He made at least four trial drawings concerning the first chapter of "The Boarding House," including one of Mrs. Maplesone with her daughter and a suitor. He finally selected the scene where Calton and Hicks ask Tibbs to serve as "father" and give away Mrs. Maplesone at her wedding the next day, but Cruikshank picks a moment in the interview well before the climax, when Simpson's impending marriage to Julia Maplesone is disclosed. "It would require the pencil of Hogarth to illustrate—our feeble pen is inadequate to describe—the expression which the countenances of Mr. Calton and Mr. Septimus Hicks respectively assumed at this unexpected announcement," the text continues. Evidently there was not enough coordination between writer and artist to adjust this interjection to the actual artist and the actual illustration; or else the nonexistent illustration

of the climactic disclosure pays tribute to Hogarth while the existent plate of an earlier moment in the scene displays Cruikshank's skill at setting the stage for the denouement. Lack of coordination seems the more likely explanation.[71]

For both collaborators on the *Sketches*, the pace continued hectic. On the evening of 12 December Cruikshank received Dickens yet again; they probably looked over drawings and settled on subjects for the second volume. The next day Dickens rushed down to Kettering to report a by-election. In his absence, George Hogarth was reading proofs that Whiting dispatched daily. Macrone sent a specimen page on to Kettering, and Dickens in reply expressed satisfaction with both the printing and the revised schedule, whereby the book might be issued during the first week of the new year.[72] Publication prior to the holidays was no longer an option.

While Dickens and Macrone were out of town, Cruikshank continued working on the plates, but took the time to see Chesterton and obtain an invitation for Dickens to revisit Coldbath Fields. On Monday, 21 December, Cruikshank received a note saying that Dickens was home and that he would have called on the artist "to see how you had been getting on, but I was fearful of disturbing you, and thought the better way would be to write and make the enquiry. I hope to hear you have made considerable progress."[73] Dickens offered to come round if Cruikshank wished to consult about the plates, and declared that he had decided not to write up a second prison piece for *Sketches*.

It was at this juncture, when Dickens and Macrone were both coping with professional and familial difficulties, that a note of irritation creeps into the dialogue. Cruikshank probably only settled on the subjects and treatment for the eight plates of volume 2 on 12 December. Yet Dickens, having decided that he would not write any more material for *Sketches*, and evidently *before* he had heard from Cruikshank about the artist's progress, left a message at Macrone's office asking him, as soon as he came back into town, to "be kind enough to write to Cruikshank impressing the necessity of dispatch upon him." "I think he requires the spur," Dickens added.[74]

The next morning, 22 December, Dickens went to the printers, who were just starting to set type on the second volume and who thought they could be finished in a week. However, if they had to wait on Cruikshank's plates, Whiting told Dickens, he would like to have the extra week for composition, proofing, and printing. Dickens, impatient with the long accouchement, again asked Macrone to determine from Cruikshank "by what day he would undertake to finish," and to "apply the spur" to the artist.[75] When Cruikshank met Dickens and Macrone on Christmas Eve writer and publisher waxed indignant at the news that the artist would finish "a" plate the following week, and two the week thereafter. It seemed as if Cruik-

shank's "negligence" threatened a long delay in publication, just at a time when Dickens was readying copy for the advertising. But two days later, Dickens recalled that Cruikshank had said each plate would contain four subjects—actually *two*, another example of the writer's unfamiliarity with graphic production; "the sixteen will therefore be accomplished much sooner than we expected," he told Macrone, "and perhaps at as good a season after all."[76]

Thus between 12 and 24 December, Cruikshank had finally settled on the design for each of the sixteen plates, had worked up finished drawings, and was etching—all of this going on in his studio while his mother and wife made festive preparations around him. Moreover, Cruikshank wasn't the only one behindhand. Macrone had evidently not read, and had certainly not yet commented on, Dickens's latest composition, "The Black Veil," although it had been completed for about a month. Even Dickens was a bit laggard; it wasn't until the 30th that he noticed "one or two errors" in the first volume, in proof since the 22nd.[77]

Dickens hoped to see proof of the etchings on Saturday, 2 January, but was disappointed. Cruikshank came by Furnival's Inn two days later to say that he would invite Dickens up to the studio toward the end of the week to see the plates.[78] Buoyed by this sign of progress, Dickens forwarded to Cruikshank a copy of his Preface: "As I have mentioned your name in the accompanying little preface to my book," Cruikshank was informed, "I think it better to inclose it for your perusal, although I hope you will find nothing in it to object to."[79] In this preface Dickens calls the *Sketches* a pilot balloon with a car containing not only the author, but also "all his hopes of future fame, and all his chances of future success." Cruikshank had often drawn the figure of the balloon as an emblem of speculation, so perhaps Dickens's metaphor was implicitly an acknowledgment of a shared imagery. Desiring "the assistance and companionship of some well-known individual, who had frequently contributed to the success, though his well-earned reputation rendered it impossible for him ever to have shared the hazard, of similar undertakings," the author continued, he (no mention of Macrone's role) invited George Cruikshank as one "possessing this requisite in an eminent degree." The preface adds that though "this is their first voyage in company, . . . it may not be the last."

While Cruikshank was perusing this tribute, Dickens told Macrone that he could see no way to change the title of the forthcoming *Sketches*, since it was printed on the verso of every leaf. If Macrone had an alternative in mind, Dickens would be happy to consider it; "the only reason that induces me to favor the present title at all, is that it is both unaffected and unassuming—two requisites which it is very desirable for a young author ["not" revealingly left out] to lose sight of."[80] The prospect of changing the

running title at all suggests that though proof had been pulled and corrected, the sheets had not yet been printed nor the formes cast into stereotype. The point is worth making, because once again the imminence of the book's publication was doubtful. Dickens was still pestering Macrone about the start of the publicity campaign; the first advertisement appeared in the *Morning Chronicle* for 9 January 1836 announcing that *Sketches* was "nearly ready" and that there would be "numerous Etchings by George Cruikshank."[81] Neither the exact publication date, nor the exact number of etchings, could be specified, and indeed the preface, when printed, was dated "*February, 1836*." But the issue of the title seems to have been resolved. Finally, in advance of the publication date Dickens and Macrone were testing selected pieces on others—George Hogarth and George Cruikshank, of course, but also John Black and Harrison Ainsworth, whose opinion Dickens was "highly gratified" to receive in early January.[82]

After all the pressure and the irritation with delays, suddenly there was a two-week hiatus in activity, with no complaints. On 22 January, since Dickens was indisposed, Cruikshank took pulls of the first four illustrations to Furnival's Inn and arranged for Fred Dickens, younger brother and general factotum, to fetch four more from Amwell Street that evening. Cruikshank planned to finish up the remaining images within a week, so Dickens grew sanguine that before the first of February the two volumes would be at the binder's.[83] There is no hint of anger from any quarter at this further postponement of the publication date; perhaps, since they had missed Christmas, any date in midwinter was equally acceptable. Moreover, Dickens was too preoccupied with illness and other projects to fret over a relatively trivial delay, so long as everyone involved in *Sketches* seemed to be working conscientiously.

By 1 February Cruikshank had finished proofing the plates. He sent a portfolio to Dickens, at the same time requesting a copy of *Rookwood*, since Macrone was evidently eager to get that venture started too. In reply, Dickens recorded that he was "most delighted with the Plates you have done," and that he "rejoiced to find that we have so nearly approached the termination of our labours in Boz's cause."[84]

Dickens also responded to a suggestion Cruikshank had made to him as Dickens was concluding *The Village Coquettes* that he write up "a little Satire on the class of pieces usually presented, at the Theatres in these times." Both were ardent theatergoes who got pleasure and amusement from the often tawdry, amateurish, and vulgar presentations in the non-patent houses. A series of Cruikshank lampoons, visually interacting with Dickens's satiric prose, might have made a moderately successful book, although with two or three plays in the offing, Dickens was in a rather vulnerable position to be castigating his fellow playwrights. Nonetheless,

Dickens thought he "could turn it to the account you desire—a good one." Nothing came of this, the first surviving instance of Cruikshank's suggesting a subject and treatment for Dickens to write up to. Neither of the proposed collaborators had any time to spare.

On 2 February the *Morning Chronicle* carried Dickens's puff announcing that the *Sketches* would appear at the end of the week. At the same time Dickens asked Macrone when he expected to have the first copies and wrote personal letters "to the Authorities" to be inserted in the review copies, soliciting a favorable notice.[85] On Saturday morning he still didn't know when advance bound copies would be ready; they arrived Saturday afternoon, so Monday, 8 February, one day after Dickens's twenty-fourth birthday, became the effective publication day.[86]

In spite of Dickens's impatience and worry that Macrone was missing deadlines for reviews, notices appeared quickly and were generally quite appreciative.[87] Since nearly all the papers had been previously published, reviewers tended to dwell on the new pieces and on Cruikshank's illustrations, which most thought in his "very best style," entering "fully into the spirit as well as the feeling of the writer."[88] The first, appearing on 11 February, was George Hogarth's "beautiful notice" (Dickens's phrase),[89] which devoted a paragraph to the illustrations of "the modern Hogarth,"

> who has evidently laboured *con amore*, and has equalled—indeed we may say surpassed—any of his previous efforts. The illustrations (of which there are a considerable number in each volume) are beautiful and highly finished etchings, admirable as pieces of art, and full of the truth, nature, grotesque humour, and irres[is]tible drollery, which distinguish this unrivalled artist. Nothing can excel the ability with which he has embodied the conceptions of his coadjutor, and placed before the very eyes of the reader, the scenes and characters which "Boz" has presented to his imagination.

"Coadjutor" was a term that provoked no reaction from Dickens on this occasion.

The *Literary Gazette*'s review appeared on the 13th; the *Sun*'s on the 15th; and on Saturday the 20th, just after subscription day for bulk orders from libraries and book dealers, the *Athenaeum*, the *Spectator*, and the *Court Journal* all weighed in. The latter singled out Cruikshank's illustrations for special praise: "We half suspect that they are, taken all together, his very best. They may not be so extravagently [*sic*] droll as some, but they are more even and true to middle-life characters; there is more of slyness and quaintness of humour in them; and they are far more carefully executed. Even Cruikshank improves upon himself when he takes pains." If the time taken to bring the plates to perfection had ever needed justification, such a notice provided it. The review concluded that "these volumes are the merriest of the season," and that there was in Boz's style, as in his

name, a likeness to a Boswell who reported on "the middle ranks" of society.

The middle classness of the subjects of these sketches was in fact a feature of which several critics approved. That thereafter Cruikshank in particular was to be identified with, and to find his material in, middle-class foibles rather than Radical politics, significantly altered his subjects, treatment, and tone—initially for the better, providing him with a new audience and a new, gentler, more benevolent style, but ultimately for the worse, diluting the acid of his satire and imprisoning him within middle-class conventions that enfeebled his art and cramped his life. But those developments were more than a decade away when the first *Boz* reviews hailed the new limners of the middle ranks of society.

John Forster, not yet introduced to Dickens or Cruikshank, gave the *Sketches* a tepid notice in the *Examiner* ("the fault of the book is the caricature of Cockneyism"), but others were more unreservedly enthusiastic: the *Sunday Times* (Cruikshank's "genius, like the purse of Fortunatus, is inexhaustible"), the *Sunday Herald*, the *Atlas*, the *Weekly Despatch* (which had a gratifyingly large circulation), the *Morning Post*, and the *Metropolitan Magazine*.

By the middle of February 1836, Cruikshank could look back on the preceding half year and congratulate himself on a turn of fortune. The 1836 *Comic Almanack* had been produced with the help of Vizetelly, a second version of Moore's prophetical nonsense, mock meteorology, comic verses, and superbly detailed, visually and verbally punning plates capturing the essence of each month. For instance, December's "Boxing Day" features fisticuffs, a box office, carters, and a box and trunkmaker. The Old Sailor's latest stories had been adequately launched; the eighth part of *My Sketch Book* had been issued by Charles Tilt in November 1835; Cruikshank's vignettes for the First Series of *Sketches* were collecting good notices; and there was the prospect of further work for Macrone illustrating *Rookwood* and possibly a new project with Dickens. Perhaps the artist sensed that Dickens's balloon was rising, while his own vehicle, albeit secure, was stationary; but he was a thorough professional with regard to his art, and produced the best that was in him for each commission.

It is worthwhile pausing to survey this detailed history of Cruikshank's and Dickens's collaboration, since so much was written subsequently, from hindsight and sometimes bitter partisanship, to reconstruct the events. Because of Dickens's unique achievement, and because for him fame came so early, the story of these hectic months has generally been told from his point of view, authenticated by his letters which were saved and transmitted to posterity while most of Ainsworth's, and nearly all of Cruikshank's during this period, were destroyed. Consequently, it is commonplace to

allege that the *Sketches* were delayed by the artist's dilatoriness, and even to depict Dickens as constantly anxious, irritated, or irate at Cruikshank's pace.[90] Moreover, there is a tendency to think of this association with Dickens as marking the high point of Cruikshank's career, and to ask why he didn't illustrate more of the succeeding novels, as if there were something wrong with the artist that caused Dickens to abandon him. There were legitimate professional and personal differences between author and artist, and these got temporarily magnified under pressure of time. Each was accustomed, when distressed, to strike out with exaggerated ferocity: Dickens in violent language ("I have long believed Cruikshank to be mad," he was to explode a few months later) and Cruikshank in such images as his pulling the nose of a publisher. But the so-called delays were not Cruikshank's fault. He designed, etched, and proofed sixteen illustrations in about eight weeks. Indecision about the scope and contents of the volumes on the part of author and publisher, their personal disruptions, and Dickens's extensive revisions, new contributions, and overcommitment to other projects, postponed the appearance of the First Series of *Sketches* beyond the unrealistic December target. Both author and artist may have chafed from time to time at the hold-ups, but each worked as fast as he could.

At this time in their lives, their relationship had progressed from Dickens's wary formality and Cruikshank's forbearing courtesy, through a mutual testing of each other's temperament and art, to a comfortable though not yet intimate collaboration. For Cruikshank, Dickens seemed to promise good texts to illustrate, ones at least as congenial as those he received from Barker and Ainsworth; and for Dickens, Cruikshank had a name that was marketable, a genius that was congenial, and a feeling for London that at many places jibed with his own. Neither author nor artist, however, thought that in this initial partnership lay the potential for the greatest collaboration either would enjoy. Only in hindsight does it look as if a marriage made in heaven was consummated, as it were, by the printer's devil.

26

A PICTURE OF EVERY-DAY LONDON

*It might be said that—at the beginning, anyhow—the work of
the writer Dickens ranks below that of the illustrator Cruik-
shank, so satisfactory a formula has the latter already found for
what Dickens is still struggling to say.*

Mario Praz[1]

CRUIKSHANK had little time to savor the plaudits greeting
Sketches. Immediately he turned to the other Macrone commis-
sion, the *Rookwood* illustrations. Since Macrone intended to issue a one-
volume edition, all the type would have to be reset; Ainsworth took the
opportunity to revise his text and incorporate nine additional "sepulchral"
lyrics. One of these he had originally sung to the Fraserians just after the
novel's initial publication. "Capital" the company exclaimed; "as superb as
anything in *Rookwood*." And so it got included in the revision.[2]

Ainsworth was thus also able to respond to Cruikshank's designs and to
alter details of the text or the artist's trial drawings so as to achieve the
right effect. Cruikshank and Ainsworth discussed ideas on 1 March 1836,
and then walked out from Amwell Street, thus missing an unscheduled
visit from Macrone and Dickens. When Cruikshank returned home and
learned what had happened, he penned a note to his publisher suggesting
that Macrone join Ainsworth on the afternoon of the fourth, so "that we
may finally decide upon the number—of subjects &c &c."[3]

After that Friday consultation, Cruikshank prepared a few sketches to
show Ainsworth.[4] Alarmed by their slightness, the author alerted his pub-
lisher to a potential problem, and on receipt of Macrone's reply, dispatched
another letter:

I *have* seen some of George Cruikshank's designs, and it was because I thought
them so sketchy that I wrote to you. They are anything but full subjects and
appear to be chosen as much as possible for light work. He shirked the inaugura-
tion scene, for instance, because it was too crowded. I quite agree with you that
a few good designs are better than many meagre sketches, and all I want is that

you should make George understand this. He has evidently two styles, and one can scarcely recognize in some of his 'Bozzes' the hand of the designer of the *Comic Almanack*. . . . I pray of you to see G.C., and don't let him put us off so badly—there's a good fellow![5]

Obviously Ainsworth did not understand the function of preliminary sketches any more than Dickens did. Cruikshank was trying to get the characters depicted accurately—physiognomy, stature, gesture, clothing, psychology, relationships. Macrone wrote back reassuring Ainsworth that everything would work out. He also urged his author to speak directly to Cruikshank. Ainsworth, mollified, replied, "I shall write to G.C. to-day myself. But do not omit the necessary *clincher* on your part. . . . I am very sanguine respecting *Rookwood*."[6]

Limiting his evidence to these letters about Cruikshank's illustrations to *Rookwood*, Ellis reinforces the impression that Ainsworth was unhappy with the artist's contributions: "It is evident that neither Ainsworth nor his publisher were [sic] satisfied with the illustrations."[7] To the contrary, two other letters tipped into Robert Lee Wolff's copy of *Rookwood* show that Ainsworth's dissatisfaction was confined to the preliminary sketches, and that as the work progressed, the author waxed enthusiastic about the art-ist's contribution.[8] The first, on 30 March, manifests how closely author, publisher, and artist were working together. "Cruikshank's etchings . . . are exquisite," Ainsworth told Macrone.

> He has succeeded to a miracle! Nothing can be more charming than the fron-tispiece unless it be the vault [the first illustration, of the Cruikshankian sexton in the vaulted crypt of the Rookwood family] and nothing can surpass the vault unless it be the gipsy scene ["The Inauguration," when Dick Turpin is initiated into the gipsy band].—In short, as you will easily conjecture, I am abundantly satisfied with his designs—and at a *glance* can see nothing to alter or amend.

Having said as much, Ainsworth then went on to give detailed critiques of each submission for Macrone to transmit to Cruikshank. Ainsworth judged the title page, for which Cruikshank had etched both the vignette of Rook-wood Hall and the lettering, "particularly clever"; "do not let George efface one of the chimneys or gables, or that delicious dovecot spire. I do not see *how* it can be improved—and repeat that it quite comes up to my own notions." Ainsworth was also concerned that "light and shade," pictorial-izations of the text's Gothic mystery and doom, be "skilfully managed." He hoped the heroine's features would be rendered more comely, corrected the representation of a shoe buckle by reference to the pictures of John Freder-ick Lewis, and detected a slight flaw in the metal plate, but otherwise he lavished encomia: "All the rest is admirable," "What a glorious dramatic scene he has made," "No fears of him now."

At this point Cruikshank had evidently completed drawings or trial proofs for the illustrated title page and the first four plates. The illustrations are all large borderless vignettes, about as wide as those for *Boz*, but an inch or more taller. Most are atmospheric and relatively static; even the rescue of Lady Rookwood is depicted as a frozen moment. All save "The Inauguration" are melodramatic, portentously brooding, as stagy as Ainsworth's affected prose. But Ainsworth was ecstatic: "I really cannot express how much pleased I am with George's sketches," he concluded to Macrone; "they beat his 'Boz' hollow. Let him go on and prosper. They will *ensure* success to the book."

Ainsworth had other things to say to Macrone as well. He was annoyed at the slowness of Hansard, the printer: "He ought to let me have a sheet a day instead of which I receive one per week.—It is nonsense to talk of corrections. They are such as any clever printer would accomplish without difficulty—and I am really disappointed at his dilatoriness." Now, instead of Dickens asking Macrone to give Cruikshank the spur, Ainsworth asks Macrone to give Hansard a nudge: "When I write again to him I shall give him as D'Orsay says a *grand blow up*—and I think a little acceleration on your part would be as well." Clearly letters of complaint couched in vigorous terms were a commonplace event in publishing. Ainsworth concludes by reporting that his "bilious" health has been righted by "George's exquisite designs," and his ladies (Mrs. Touchet and Miss Buckley) "are charmed with George's performance."

Less than a fortnight later Hansard had completed composition through page 144 and Ainsworth had corrected proofs. Cruikshank had also finished several more plates. "My dear Macrone," Ainsworth penned on 11 April, "I am in raptures with George's handiwork—he improves—perceptibly." The author finds one flaw in the "Inauguration" plate: the Knight of Malta should be left-handed. He suggests better defining the statue in "The Bridal," and making the sexton even more "*Satanic.*" "The arbour ["The Arbour at Kilburn"] is delicious and cannot be improved." But "The Hornsey Gate" must be reetched in order to introduce a turnstile. "As it is, there is an open gate which Turpin would unquestionably have taken in lieu of the high gate." For some reason—possibly lack of time—Cruikshank did not make the alteration. Ainsworth concludes his commentary on the plates with more praise: "As I said at the first so I now repeat—they delight me vastly—and I am quite sure that the Public will be equally delighted."

In the meantime, Cruikshank worked up more Scott illustrations and the ninth part of *My Sketch Book*, while Dickens and Ainsworth entangled themselves in agreements that were later to cause all three considerable anguish. In March 1836 George Hogarth, at Richard Bentley's request, introduced the publisher to Dickens; by August Boz and Bentley were nego-

tiating the first of an eventual nine contracts for books. On 31 March 1836 Dickens published "The Tuggs's at Ramsgate" in Chapman and Hall's *Library of Fiction* and the first number of *Pickwick* appeared. On 2 April Dickens married Catherine Hogarth; they traveled to Chalk for their honeymoon. A fortnight later, on 17 April Dickens met his *Pickwick* illustrator, Robert Seymour, for the first and only time: Seymour committed suicide three days thereafter.

Thackeray, living in Paris and staying in London for only a couple of weeks, may have heard about the unexpected opening for an illustrator for Dickens's book from Cruikshank and approached the author.[9] "I recollect walking up to [Dickens's] chambers in Furnival's Inn with two or three drawings in my hand," Thackeray told the Fellows of the Royal Academy at a dinner in May 1858, but "strange to say, he did not find [them] suitable."[10] Nonetheless, for a few hours he thought himself chosen, and to celebrate he dined on sausage and mashed potatoes with Hablot Browne, a fellow artist commissioned by Chapman and Hall to provide the plates for the *Library of Fiction*.[11] A pen sketch by Thackeray records one other April 1836 visit with Dickens, this time in the company of Maclise and Father Prout, smoking and drinking around a table in Macrone's shop.[12]

The first applicant chosen to succeed Seymour was Robert Buss, who supplied plates for the June number. He lacked the technical expertise to etch them competently, so they were spoiled in the printing. "I am quite willing to admit that my alleged illustrations were not good," Buss told John Forster in 1871.[13] A call went out through the Grub Street grapevine for help; in July Cruikshank recommended John Leech, a young artist who had taken a few lessons from him.[14] But by then Dickens had engaged Thackeray's former dinner partner, Browne, to be his regular *Pickwick* man.[15]

Why wasn't Cruikshank asked? Edgar Johnson, convinced that Dickens "chafed at Cruikshank's slowness" during the production of *Boz*, thinks "Dickens may not have felt that Cruikshank sufficiently appreciated the importance of promptitude."[16] On the other hand, he also conjectures that Cruikshank "was booked up with as much work as he could handle." In fact, by June Cruikshank was already committed to Dickens for a Second Series of *Sketches*; Dickens needed another artist for his new publishers and his new serial, and he needed someone who worked quickly and took direction readily. Furthermore, Dickens was not about to share in the creation of *Pickwick*, having wrested control from Robert Seymour, who first brought the idea of publishing illustrated Cockney sporting sketches to Chapman and Hall. Besides, before August the fortunes of the shilling monthly numbers of *Pickwick* were too doubtful for Chapman and Hall to risk the expense of hiring Cruikshank. So the fact that Dickens did not turn to his *Boz* illustrator does not mean that he disliked Cruikshank or his designs.

Quite the contrary. Merle detected in *Pickwick* "a decided robbery" of Cruikshank's figures and style.[17] And at this time Dickens was, as Percy recollects, a "general guest at Amwell Street, adding to the circle of wits, who assembled round George's Table."[18]

In May Macrone issued the fourth edition of *Rookwood*.[19] Ainsworth's revised text and Cruikshank's plates ensured a brisk sale and further notices, especially from friends. Maginn reviewed it prematurely in the April *Fraser's* ("Another Caw from the Rookwood.—Turpin out again"), and within a year Barham had dubbed the novel "the most spirited and original Romance of the day."[20] Contrary to Ellis's later opinion that Cruikshank "had not reached the height of his powers," Maginn declared that "George is in the full zenith of his ascendant star." The twelve illustrations were also sold separately in a wrapper for 6s., and Cruikshank prepared a few large india proofs for particular friends, a sure sign that he felt satisfied with his work.

But Macrone, undercapitalized, had continual cash flow problems; he still could not repay any part of the £500 he had borrowed from Sala's Aunt Sophia when he was courting her in the autumn of 1834. Consequently at the end of the year his share in the copyright of *Rookwood* was transferred back to Bentley, who then issued a fifth edition (1837) with two illustrations by J. Cawse, for one of which Ainsworth posed as Luke Bradley (eventually discovered to be the legitimate heir to Rookwood).[21] Since in 1837 Cruikshank was principal illustrator for *Bentley's Miscellany*, the choice of Cawse as illustrator for this fifth edition cannot instance a dispute between Bentley and Cruikshank, but only another of the many stratagems for working the *Rookwood* copyright. The novel was also translated into French and Dutch, and printed in Philadelphia by Carey and Lea, who were shortly to become Dickens's first American publishers as well. As Ainsworth considered its long and ardent reception, he decided to make it "part of a more extensive edifice, which, in time, I may be able to construct." He contemplated writing a full series of portraits of the robber, on the road, in the theaters, and in prison. "In [Jack] Sheppard [the reader] shall discover [the robber] in Newgate; shall witness his midnight labours; admire his ingenuity and unconquerable perseverance; and marvel at his extraordinary escapes."[22]

But first, Macrone had to be helped out of financial difficulties. Ainsworth spent much of the summer devising projects. As he told Macrone, "I feel confident that I can not only make you a successful but what in my opinion is of as much consequence a *récherché* and gentlemanlike publisher."[23] Ainsworth had just met John Forster, who was already exercising his power on the novelist. "I cannot explain the secret of his influence over people," Ainsworth later reported. "He had a knack of making people do as

he liked, whether they liked it or not."[24] At present the project was to get Macrone to publish Robert Browning's long poem *Sordello*. Ainsworth urged accepting the manuscript for its literary value, even though it was uncertain whether the obscure work would pay. He met the twenty-four-year-old poet—Browning, like Dickens, was born in 1812—on 28 July, and the next day reported to Macrone his "very high opinion" of one who looked as if he might be the son of Paganini, blessed with superabundant black locks and a "lion-like ruff" of whiskers. Moreover, Ainsworth advised the hard-pressed publisher to get on with a Second Series of *Sketches by Boz*; his mother had been reading the First Series "with great delight," and that seemed the highest compliment he could pay the book.[25]

Another as yet unrealized asset in Macrone's accounts was *Crichton*, a novel Ainsworth had been working on for over a year and which was to be illustrated by Thackeray. Father Prout had taken a great interest in the subject, and made valuable suggestions; in early March Ainsworth's head was spinning over *Crichton*; and by 23 April he had devised enough matter to declare the novel completed. But he wanted to revise extensively, and thus arranged to send Hansard the manuscript in mid-May. By June Ainsworth still wasn't satisfied with the text, while Macrone grew increasingly despondent. Subscriptions on two recent publications had fallen well below his expectations, and he had nothing in sight before October. Ainsworth urged him to prepare *Boz* for the start of the fall season. Meanwhile he had parceled up the first two volumes of *Crichton* and posted them to Father Prout with a request that he write a "startling" review for the July *Fraser's*.

But *Crichton* continued to go wrong. Thackeray was distracted by the complications of his engagement to Isabella Shawe and the arrangements for starting a new journal, the *Constitutional and Public Ledger*, for which he would be Paris correspondent. So on 12 July Ainsworth engaged Maclise at £50 for three copper etchings—a rate that slightly exceeded the terms Macrone had been prepared to offer. And the Second Series of *Sketches* wasn't going anywhere either. Dickens was swamped with projects: *Pickwick* monthly, *The Strange Gentleman* and *The Village Coquettes* preparing for production, *Sunday Under Three Heads* to appear under the auspices of Chapman and Hall at the end of June, and a three-decker entitled *Gabriel Vardon, the Locksmith of London* promised to Macrone by the end of November. Reporting duties sent Dickens in May to Ipswich and in June to the trial of the Prime Minister, Lord Melbourne, for adultery. "I have written to Cruikshank," Dickens informed Macrone on 17 June, presumably to initiate work on the Second Series. "As yet no answer."[26]

Cruikshank was at home, so occupied with finishing up *My Sketch Book* that he had no leisure to answer correspondence.[27] By the twenty-third, Dickens concluded from the lack of reply that Cruikshank must be out of

town. Having composed "A Madman's Manuscript" for the July *Pickwick*, Dickens proposed that he and Macrone visit the lunatic asylum at Lambeth prior to writing another "mad" piece for *Sketches*, possibly one Cruikshank could illustrate. But nothing came of this idea.[28]

It was not until the last week in July therefore that Cruikshank finally met with Dickens, who agreed to furnish the whole text of the Second Series in time for George to work up accurate and telling pictures. Immediately Cruikshank received two stories; then he heard nothing more, as Dickens was once again revising the text of the First Series for a second edition issued 10 August. This edition removed Cruikshank's name from the title page and inserted a second preface thanking the public for its reception; but the artist's name was retained on the spine and in the first preface, and relations between author and artist stayed cordial.

Pickwick and *Boz* and *Coquettes* and reporting were not enough for Dickens, exultant in his strength. Percival Banks, one of Maginn's closest collaborators on *Fraser's*, had taken over editing the *Carlton Chronicle* and wanted material. Dickens promised a series of "Leaves From an Unpublished Volume By Boz (which will be torn out, once a fortnight)."[29] These would subsequently be raked into Macrone's second collection of *Sketches*. At this point none were written; one new sketch appeared three days later, and on 1 November the *Carlton Chronicle* published a revised version of a previously printed sketch about an omnibus cad. So clearly in August and September the contents of the Second Series of *Sketches* had not yet been determined. Moreover, Dickens also entered into an agreement with Thomas Tegg to supply before Christmas the text of a child's book, *Solomon Bell the Raree Showman*.[30] And on 22 August, after considerable discussion, Dickens and Bentley entered into an agreement for two three-deckers to be completed prior to any "other literary production."[31] As soon as Parliament recessed, Dickens and Kate left for Elm Cottage, Petersham, where they stayed on holiday for five weeks. The quantity of work facing Boz on his return was indeed formidable.

Meanwhile, Macrone and Cruikshank waited. During August Macrone journeyed to Paris to sign up Victor Hugo and Paul de Kock; and he continued negotiations, prodded by Ainsworth, for Thomas Moore.[32] But his situation was becoming more desperate. He could expect no substantial increase in earnings before the autumn, October at the earliest; bookselling died during the long vacation. And signs were not wanting that neither *Crichton* nor *Gabriel Vardon* nor *Sketches* would be ready for the holiday season. Fortunately for his fragile peace of mind, Macrone did not yet know about Dickens's agreement with Bentley; that news was confirmed in early November. But his peace was temporarily disrupted by the birth of a second son, William John Bordwine, on 30 September. George and Mary Ann

went to Edinburgh to visit friends during the month, and returned around
the time of Mrs. Macrone's confinement.[33] Possibly it was then that Cruik-
shank dashed off his *Comic Alphabet*, published at Myddleton Terrace, and
contemplated issuing a "Comic Memorandum Book."[34]

In early October 1836 Cruikshank may have been pressured by Macrone
to finish up the Second Series. An undated draft of a letter from artist to
publisher implies that George too felt frustrated by the long hiatus since its
inception:

> The arrangement with Mr. Dickens was that I was to have the choise of a
> quantity of "Sketches" to select subjects from—*& not to be compeled to illustrate*
> *those only which might be sent as a matter of course—&* in order that the work
> might be got out in good time I was to have been supplied with the copy some
> months back. Now I have only recd. *those* said two Sketches—& the moment I
> got them—they were read & my memoranda made—& duly deposited under a
> cover marke[d] Illuts. by Boz Vol. 2—since which I have been in daily expecta-
> tion of seeing others—& indeed expecting the whole & have felt puzzled &
> surprised at their non appearance—indeed I have been waiting for them untill I
> could wait no longer & with submission to you I do not.[35]

After all, it was the beginning of October, and Cruikshank had the *Alma-*
nack to prepare. He was finishing two drawings for the fables of La Fon-
taine, which he planned to send to Baron Feuillet de Conches in Paris
along with a letter of introduction for the engraver Goodyear.[36] With other
projects pending, he could ill afford simply to sit still until Dickens got free.
One thing he could do was prepare a frontispiece based on the prefaces to
the First Series, showing the "aeronauts" (likenesses of himself and
Dickens) waving to the "Public" from the car of a rising balloon (fig. 4).[37]

As soon as Dickens returned from holiday, he was caught up in final
rehearsals for *The Strange Gentleman*, premiering 29 September. Once
again he was "so over head and ears in work" that he had to dash off
apologetic notes declining meetings, postponing articles, promising addi-
tional work shortly.[38] He managed to send to Cruikshank some copy at the
start of October; but then Macrone wanted the manuscript back, and
Cruikshank wanted an appointment, which Dickens had to delay for two
days.[39]

At that 5 October meeting artist and author settled on the subjects of
eight plates for the first of what Macrone still expected to be two additional
volumes of *Sketches*. (Dickens already had doubts.) Cruikshank asked to
keep the manuscript for a further two days, "being anxious," Dickens re-
ported to Macrone the next afternoon, "to be quite exact in following my
descriptions." Macrone had forwarded to Dickens more bad news: yet an-
other trade sale had been a fiasco for him, although it had answered the
purpose for Charles Tilt, who had advised Chapman and Hall when

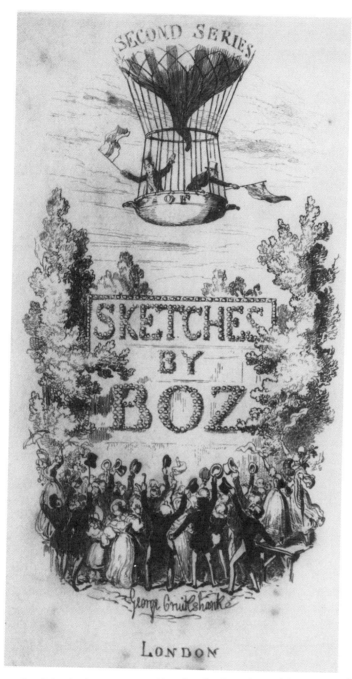

4. George Cruikshank, *frontispiece to* Sketches by Boz, Second Series, *tinted etching, Dec. 1836*

Pickwick seemed a failure and was now trying to assist Macrone.[40] The next day Cruikshank dropped by Furnival's Inn with the roll of manuscript which Dickens then sent off to Macrone with a promise to produce additional copy shortly. "But as to the second Volume, I must again say that I am *quite certain* I cannot get it out before Christmas. There really is not time, unless Hansard's people, have greatly under-calculated the quantity sent."[41] On 10 October, Dickens promised to send his publisher "all the Copy I have, in the course of the day"; that included the two sketches published by Banks, and two for the *Morning Chronicle*, the second of which appeared the next day.[42]

This then was the state of affairs when Macrone wrote again urging Cruikshank to hasten. After waiting for more than two months for the text, not yet complete, Cruikshank was irritated by Macrone's continued prodding:

> As it would not answer my purpose to stand Idle I have commenced another work which *must* be finished before I can take up the Secd. Vol [that is, the Second Series] of "Boz." I shall be truly sorry should this affect any of yr. Publishing arrangements but it is clearly no fault of mine—I did expect to see the MS. from time to time in order that I might have the privilege of suggesting any little alterations to suit the Pencil—but if you are printing the book all that sort of thing is out of the question—only thus much I must say that unless I can get good subjects to work upon, I will not work at all.[43]

Rather unwisely, Macrone communicated this letter to Dickens, perhaps to explain why Cruikshank was not getting on faster. The artist did not think he was making extraordinary demands when he asked to see the manuscript so that he might suggest "any little alterations to suit the Pencil": it was the sort of exchange with authors he had been accustomed to for many years, and in keeping the copy for a few extra days in order "to be quite exact in following" Dickens's descriptions, he rhymed with Boz's desire for harmony between picture and story. But Dickens, under enormous pressure just then, exploded. "I have long believed Cruikshank to be mad," he declared to Macrone,

> and his letter therefore, surprises me, not a jot. If you have any further communication with him, you will greatly oblige me by saying *from me* that I am very much amused at the notion of his altering my Manuscript, and that had it fallen into his hands, I should have preserved his emendations as "curiosities of Literature". Most decidedly am I of opinion that he may just go to the Devil; and so far as I have any interest in the book, I positively object to his touching it.
>
> I think it a great question whether it requires any illustrations at all, but if so, I think my Pickwick man had better do them, as he is already favorably known to the public, by his connection with that immortal gentleman. This will be matter for reflection, and you are the best judge about it.[44]

In July Dickens had been thinking about Bedlam and Cruikshank simultaneously, but he was being rhetorical in claiming he thought the artist mad. There is no evidence that at this time he doubted the artist's sanity or professional competence. His touchiness about suggested emendations may have been occasioned by all the modifications to his dramatic scripts that the production phase was forcing. And his references to the "immortal" Pickwick and to "my Pickwick man" betray a shift not only in interest but also in allegiance. The serial publication Chapman and Hall was issuing now preoccupied Dickens far more than the republication of additional *Sketches*; in fact he wanted to extricate himself from several prior engagements, including the *Morning Chronicle*. However irritating Cruikshank's remarks were, they were also useful to Dickens, almost at a subconscious level, in emotionally distancing himself from Macrone and *Boz*.

Although Dickens's letter has been cited as an instance of Cruikshank's presumption, the threatened blowup blew over much more quickly than is generally acknowledged. Macrone probably never passed on Dickens's outburst, while Cruikshank, having let off steam, rearranged his schedule so that he could "proceed at once with—'Boz'—." He told Macrone on the 15th that he hoped to be finished with preliminary drawings in ten days and to "hold a conversation" about them with Dickens then.[45] That meeting must have gone well, because Dickens offered to procure Mary Ann tickets for *The Strange Gentleman* on the 28th, an engagement Dickens was forced to postpone as "one of the principal Actresses" fell ill.[46]

Suddenly, at the beginning of November, the long-threatening storm broke. Ainsworth had told Macrone months before that Dickens had contracted with Bentley for two novels, but Macrone had refused to believe him or to investigate. The harassed publisher could not face any more bad news; he owed over £5,000 and, prompted by Kensal Lodge, had contracted for more expensive and gentlemanly authors. "Let me congratulate you about Moore," Ainsworth wrote early in the month. "You have indeed added a princely name to your list, and have done what few other publishers could do. I feel convinced you will have a good season."[47] *Crichton* will be reviewed favorably by Jerdan, Forster, Banks, and Laman Blanchard, Ainsworth assured him, so "keep up your spirits. 'Boz' will do, and I shall do— and though we shall not make up your £5,000 by next Xmas, WE will put a few cool hundreds into your pocket to help to carry on the war, and to establish your credit."[48] Ainsworth was working himself into illness churning out copy, correcting Hansard's wretched compositors, and importuning friends for favorable publicity about *Crichton*.

At the same time, Dickens concluded negotiations that freed him from reporting forever. First he persuaded Chapman and Hall to raise his monthly stipend for the *Pickwick* installments; in return he promised to

provide copy more punctually. That guaranteed him £25 a month. Next he told Richard Bentley that editing a new magazine for him would not interfere with *Pickwick*, and that he would engage not only to edit but also "to furnish an original article of his own writing, every monthly Number, to consist of about a sheet of 16 pages," if Bentley would contract for a minimum of a year.[49] That guaranteed £20 a month for editing and twenty guineas a month for writing—the difference in scale of payment being a subtle indicator of the status of each activity. As soon as the agreement was signed on 4 November, Dickens resigned from the *Morning Chronicle* and turned his hand to the first advertisements for *Bentley's Miscellany*. He also obtained from Macrone Father Prout's real name and address, and wrote not only to Mahony, but to most of the other Fraserians, hoping to enlist them as authors for the new journal.

Unmistakably Dickens wanted not just to rival, but to outdo, Maginn; and Grub Street, scenting competition, raised its fees. "Unless the remuneration be a degree better than Fraser's," Dickens told Bentley, Mahony "should be unwilling to leave his old Publisher."[50] Others from the *Fraser's* circle who wrote for Bentley in the first year were Maginn himself, who dashed off a prologue and later contributed some papers on Shakespeare, Ainsworth, Barham, Jerdan, and Hook. Dickens added Matthew Barker, George Hogarth, and Charles Whitehead to the stable. Meanwhile Richard Bentley rushed off on the day he obtained Dickens's participation to secure Cruikshank as principal illustrator; their agreement was signed on 29 November.[51]

With these arrangements concluded, Dickens asked for confirmation of what he believed to be an earlier understanding, that he would not write *Gabriel Vardon* for Macrone by the end of the month or ever. Macrone was furious. He wrote indignantly to Dickens complaining about everything, including Bentley, and turned to Ainsworth for comfort. But Ainsworth's counsel hardly consoled: the £200 Macrone had offered for the novel was "preposterously small," and even Bentley's £500 fell several hundred pounds shy of Boz's worth. Moreover, Macrone was wrong to have mentioned Bentley at all in his reply to Dickens; he was wrong to have "betrayed irritability and weakness" (Ainsworth's idea of the gentlemanly publisher surfaces here), wrong to have written a hasty letter, wrong to have done anything but tell Dickens, "I shall hold you to your agreement," and then put the matter in the hands of a solicitor.[52]

The loss of Dickens's next novel made it even more imperative that Macrone realize his investment on *Crichton* and the Second Series of *Sketches*. Though Ainsworth had hoped to be through in time for reviewers to tout his novel in the December magazines, the writing dragged on and on. He and Macrone sent copies of the two completed volumes to influential

friends. *Fraser's* and the *Literary Gazette* loyally published puffs that remained discreetly silent about the absence of a third volume. But Ainsworth could not complete his story.[53]

As a distraction, and to keep his publisher's spirits up, Ainsworth in early November proposed that following *Crichton* he write a serial, like Dickens's *Pickwick*, entitled *The Lions of London: or Country Cousins in Town*. This one-shilling monthly periodical would consist of various stories about old and new London, alternating between comedy and tragedy, with lots of comic songs thrown in, evidently told to a company of listeners by an old gentleman in his chambers. For illustrators, Ainsworth urged Macrone to approach Cruikshank, if he was not already tied up by Bentley, and "to engage Leech as a subaltern assistant to fight under the 'greater Ajax.' . . . Let Leech undertake the old—the romantic—the picturesque; George—the modern comedy and manners." Ainsworth gave Macrone specific instructions for Leech's first plate, to depict the execution of Catherine Howard or another gloomy scene from the reign of Henry VIII. George, on the other hand, should practice representing Tom Hill, an eccentric book collector who was the butt of many a Fraserian joke, and who, under the name Tom Vale, was to be introduced into the old gentleman's chambers, "as I mean to carry him out triumphantly, and to make him play the part of 'Mr. Weller' in my story." In concluding one sally of this new campaign, Ainsworth tried to cheer up his desperate friend: "Rely upon it, if each No. has a story of this sort in it—and is properly illustrated—we make such a hit as has not been made even by *Pickwick*."[54]

In December Macrone prepared advertisements for *The Lions of London* mentioning Cruikshank as the only illustrator.[55] Certainly Cruikshank took the commission seriously. He prepared a monthly wrapper design for wood-engraving that depicts Christopher Wren's masterpiece, St. Paul's. And to illustrate the first number of *Lions*, Cruikshank etched a group portrait of "Sir Lionel Flamstead and his Friends," using the features of Ainsworth, Dickens, Tom Hill, George Daniel, and Gilbert Winter ("one of the best specimens of the Manchester men of the last generation," Ainsworth called him in 1881) as models for the characters.[56] But Ainsworth, unable to complete *Crichton*, told Macrone in mid-December to cancel the ads for the new work. It was never revived, though Cruikshank's wrapper design was adapted for Ainsworth's *Old St. Paul's*, brought out in parts and as a three-volume novel in 1841 by Macrone's successor Hugh Cunningham. He saved money by printing Cruikshank's image of Wren's church although the novel deals with the preceding Gothic structure. Once again, what for Cruikshank had been a promising project came to a poor end. More and more he was becoming subject to the contractual negotiations, promises, and projects of Ainsworth and Dickens, who included him or

dispensed with his services according to their own resources and priorities. The narrative of Cruikshank's professional life was, unbeknownst to him, in danger of being taken over by writers more powerful than himself.

November and December were exceptionally busy months for the artist. He and Mary Ann finally went as Dickens's guests to *The Strange Gentleman* on 3 November. Even when all the original cast was present, Cruikshank thought the acting wretched and characteristically told his host so in a letter written nearly a fortnight later. Dickens did not welcome such frankness from many people—Cruikshank and Forster are notable exceptions—and certainly not from people with whom he was quarreling. But in this instance his reply is remarkable for conciliation: he told Cruikshank he was "glad that you thought the piece was badly acted (that being very like my own impression)," and concluded by inviting George and Mary Ann to accompany him and Catherine to the opening night of *The Village Coquettes*: "I am sanguine about that."[57] Whatever animosity toward Cruikshank Dickens felt in mid-October had long since died.

On Saturday evening, 19 November, Cruikshank received Dickens in Amwell Street for a long talk about the new magazine *Bentley's Miscellany*. Samuel Lover would illustrate his own novel, *Handy Andy*, and Cruikshank was at least initially to illustrate Dickens's monthly contribution. Dickens hoped to have the text to Cruikshank by the 5th of the month, to give the artist time to make careful preliminary drawings and a finished etching, but at that moment he had nothing much in mind as a subject for the January number.

There was a tradition in the Cruikshank family, Blanchard Jerrold records, "that Dickens, calling one day in Amwell Street, saw a series of illustrations which Cruikshank had prepared for a story he had in his mind of the life of a thief. Dickens was so struck with them, and with the artist's account of his plan, that he determined to make London the scene of Oliver Twist's adventures."[58] Those drawings about the life of a thief had been lying about the studio for seventeen years; initially sketched in 1819, they had been shown to Egan in the midtwenties and then thrust aside. With *Pickwick* reviving the novel about life in London, and *Rookwood* popularizing fictions about criminals, the time seemed right to both Cruikshank and Dickens for a contemporary novel about London thieves. Whether Dickens actually saw Cruikshank's sketches on this, or any other, occasion, or whether they simply talked more generally about Cruikshank's idea, it seems likely that some discussion of this matter did take place. Maybe the decision to set *Oliver* in London came later; Dickens in fact started *Bentley's* with a story about the provincial mayor of Mudfog who grows pompous, statistical, and philosophical in office (just as Oliver's Workhouse Boards do), but ends up rejoining his cronies in a jolly public

house. It is clear that Dickens and Cruikshank were on good terms at this time, that Dickens was overwhelmed with work, that he respected Cruikshank's judgment about art and the theater, and that the families got on well together. A week after the November meeting, Dickens had not written a word about Mudfog, "so if anything should occur to you as a good illustration," he told Cruikshank, "I shall be happy to adopt it."[59]

Adding to Dickens's distractions were final rehearsals for the opera and a severe attack of facial rheumatism: "For the last fortnight I have been very unwell," he reported to Cruikshank two days later, "unable for many days to put pen to paper, and the unlooked-for extent of the preparations for the opera, occupies my whole day. I cannot do more than one pair of hands and a solitary head can execute, and really am so hard pressed just now that I must have breathing time."[60] Dickens's pleading evidently responds to a note from Cruikshank, acting on behalf of Macrone, proposing that *Sketches* be limited to the single volume already printed. Dickens thought it "an excellent notion," and promised to cooperate "in any way [Macrone] can desire." The artist, who had at least twelve different preliminary subjects worked up, went back to the studio to complete the first ten. Two others, "The Last Cabdriver" and "May-day, in the Evening," would eventually be finished and added to the second edition of the Second Series.

On the last day of November Cruikshank called on Dickens in Furnival's Inn to settle on a "capital" subject for the first *Bentley's* illustration, "Ned Twigger in the Kitchen of Mudfog house."[61] Characteristically, the scene the illustrator chose deals with a minor incident involving minor characters, but it precipitates the disasters of the mayor's inauguration day and thus leads indirectly to his reformation and resignation. Cruikshank received Dickens's manuscript on 5 December with a covering note asking his opinion of it; the artist immediately read it and took notes, so that it could be sent on to the printer.[62]

While Cruikshank was completing his etching, Dickens was negotiating with Hansard about Macrone's copyright in both series of *Sketches* and the unwritten novel, *Gabriel Vardon*; they eventually settled, 5 January 1837, on a payment of £100, in exchange for which Macrone purchased copyright in all the *Sketches* and relinquished the letter of 9 May 1836 in which Dickens had agreed to write a novel for him.[63] With that dispute well on the way to settlement by 2 December, Dickens turned back to the *Miscellany*, and then to composing a last story for *Sketches*, "The Drunkard's Death." "It, and the Preface, shall be in Paternoster Row, at 7 in the morning, *precisely*," he promised Hansard on the 7th.[64] He may also have received a letter from Macrone at this time, justifying the publisher's conduct and rather disingenuously blaming Cruikshank for any delays: "The book is printed throughout and ready.—I have done every thing I had to do, or

could do that I have told you and *what Gentlemen* usually tell [is] *the Truth*, it is delayed solely by the pressure of Mr. Cruikshank's engagements."[65]

There was a further hitch on 10 December when Dickens saw Macrone's advertising copy for insertion in the January *Pickwick* and *Miscellany*; it still promised that *Gabriel Vardon* was forthcoming. But Dickens scotched that irritant by ordering Chapman and Hall and Bentley not to accept such copy.[66] Finally, one week later, Macrone issued the much-delayed and contested Second Series of *Sketches by Boz*.

This one-volume addition did not receive so much attention as the First Series either at the time of its publication or subsequently. It came out at a busy season for booksellers and reviewers, who were swamped by florid *Annuals* and *Almanacks* and other holiday items. *Sketches by Boz* was old news in December, and if Boz continued to be of interest it was because of his theater pieces and *Pickwick*. For later commentators, the combined *Sketches* issued in serial format in 1837–1839 provides a more convenient edition for discussing Dickens's achievement in his first hard-cover publication.[67] Thus Cruikshank's contribution to the Second Series has rarely been distinguished either from that in the First Series or from the larger copies for the monthly issue.

And yet the illustrations to this collection of Bozzes rank among Cruikshank's finest. The frontispiece of the author and artist in a balloon, "Seven Dials," "The Streets—Morning," "Monmouth Street," "Scotland Yard," "Mr. John Dounce," and "Vauxhall Gardens by Day" have elicited considerable appreciation, both in their own right and in conjunction with Dickens's text. Cruikshank had had more time during the preparation of the Second Series to study Dickens's perspective, to register the kaleidoscope of tones the text invokes, to seek out ways of situating images within pictorial and literary traditions that complement Dickens's situating the letterpress within the same traditions. Cruikshank's vignettes even revise his own earlier depictions of London, which "pre-create," to use Geoffrey Tillotson's term, Dickens's comic world.[68] George also had had more time to make independent judgments about the paradigms shaping Boz's prose, and in subtle ways to record his dissent. The tug-of-war between the author's sensibility and the artist's can be detected in a number of instances, and is sufficiently present throughout *Sketches* to indicate that the plates are not *representations* of the text, but *responses* to it, to the conventions shaping verbal and visual *mimesis*, and to the phenomena of London by which Dickens and Cruikshank were differently affected.

For example, take "Meditations in Monmouth Street," one of the most important of the sketches (as opposed to "tales") in *Boz*, initially written for publication in the 24 September 1836 *Morning Chronicle*. It opens with the voice of the "speculative pedestrian" who identifies Monmouth Street

as "the only true and real emporium for second-hand wearing apparel." After briefly recapitulating the street's history in a severely curtailed version of Pierce Egan's conventional guide-book narration, Boz imagines the persons who once inhabited the clothing, goes on to discern in a sequence of outfits the progress—actually a declension—of an indulged town boy into a pauper, husband, father, and felon, and concludes by speculating on a great many boots and shoes that spring up into a festive dance. This illusion is broken by the shrill voice of a bulky woman superintending her wares, who resents the narrator's staring. The barrel-organ grinder whose music harmonized with the narrator's reverie retreats, and the speculative pedestrian takes flight just as his vision does.

This piece incorporates many of the central features of the *Sketches*. The narrator, characterized as a bystander knowledgeable and discriminating about the city and its past, possesses a power to enter imaginatively into the life of the scenes about him, to discern their hidden significance, and to appropriate, through scopic concentration, identities and secrets the possessors would rather conceal. The speculative pedestrian is both outsider and insider, both empathetic and prying, both understanding and decidedly prejudiced: "Holywell Street we despise; the red-headed and red-whiskered Jews who forcibly haul you into their squalid houses, and thrust you into a suit of clothes, whether you will or not, we detest."

Indeed, in devising the persona of "Boz" as speculative pedestrian, Dickens jumped in near the beginning of what became a long tradition of bachelor narrators, ranging from the "I" of Lamb and Hazlitt (briefly married twice, but essentially a bachelor) through the great Continental realists—Honoré de Balzac, Stendhal, Anton Chekhov—and down to twentieth-century novelists and essayists such as Marcel Proust and Henry James, Cesare Pavese, Walter Benjamin, and Roland Barthes. These solitary urban observers, as Phillip Lopate anatomizes them, use irony as both a sign of and corrective to their self-conscious idiosyncrasy; they openly display their prejudices and testiness; they are anecdotal and digressive in their narratives; and they are *flâneurs* of books, boulevards, and bistros, spokesmen—Walter Benjamin posits—for the petty bourgeoisie who try through their perspicacity and detached sympathy to reconcile the powerful and the poor. They are also elegists, commemorating the passing moment from a perspective both detached from and complicit in that evanescence. Finally, they tend to be melancholic, defensive, desirous of being self-sufficient but needing company or at least the human spectacle to observe. Unengaged to life or wife, death is their ultimate partner—a marriage displaced by Dickens onto the iterated Newgate sketches.[69]

Moreover, for all the customary visual acuity of these ocular pedestrians, Boz here, and in such set pieces as the climax of "A Visit to Newgate," sees

mainly with his mind's and heart's eyes—imagines, often in great detail, a vital past only indicated by the traces remaining in the present. Whereas the midcentury painters of modern life such as Constantin Guys sketch the momentary configurations of street scenes, Dickens's "sketcher" writes with his imagination. This power of bringing objects to life, this habit of metonymically moving from inanimate thing to animate person who wore or possessed thing, becomes closely associated in *Sketches* with the narrator's prevailing awareness that people act histrionically, and that clothes are therefore indices to their wearers' sense of identity. Clothing in *Boz*, Virgil Grillo explains, is "a sure index to the lies people tell themselves and the world; moreover, it is a sure record of the injustices that the world perpetrates on the meek. Finally, clothing itself becomes an embodiment of the basic patterns of existence in . . . 'Monmouth Street,' literally an 'historical fabric' from which Dickens' imagination can reconstruct the sad stories of the wearers."[70]

In his brilliant lecture on "The Fiction of Realism," Hillis Miller implicitly calls several of these assumptions into question. For him, nothing is a "sure" index or record: the roles indicated by clothing are merely what is available from the cultural repertory for self-expression, available both to the wearer and to the artist—writer or etcher—who necessarily also expresses himself through this sartorial convention. People thus speak themselves through appropriating previous images, and are therefore limited by the conventions of their time: "The imprisonment of the human spirit in its conferring of meaning is a fundamental theme of the *Sketches*," Miller maintains.[71]

Furthermore, Boz's imagination does not "reconstruct the sad stories of the wearers": it invents them, in an act that simultaneously discloses the fictiveness of the invention. First the narrator "speculates" on the propensity of the waistcoats, trousers, and shoes to burst into activity on their own accord and take off down the street on the bodies of their conjured wearers. This reverses the customary metonymic transfer of person to thing. Instead, thing becomes person. After the atomistic instances of unspecified garments, the narrator then moves to a sequence of particularized outfits which range themselves in the order of a Hogarthian progress: they furnish for the discerning observer a history of the idle apprentice. So the very clothing itself is ordered by, and orders, a narrative based on a graphic convention with which Dickens, Cruikshank, Ainsworth, and many other early Victorians were thoroughly familiar. This story is a version of an earlier story told in a different medium a century ago, when Monmouth Street, as the narrator remarks at the beginning, was filled with ponderous laced coats and embroidered waistcoats: "But it is the times that have changed, not Monmouth Street." As Miller observes, "A movement from

things to people to stories is the habitual structural principle of the *Sketches*."[72]

Finally, there is at several places in Dickens's text, as more generally in bachelor narratives, a sense that time wears things and people down: the town boy's father dies, his mother turns into "an old and feeble woman," and he is transformed into a "cold and ghastly form that lay rotting in the pauper's grave." Youth is either sickly, like his infant, or cheeky, or fleeting, like all the able-bodied who stump or dance off down the street, leaving the speculator alone with his thoughts. A Byronic melancholy and a partially sympathetic, partially dismissive attitude toward age play about the text, giving it at moments a histrionic pathos and at other moments what Chesterton has called "the peculiar hardness of youth . . . reach[ing] even to impudence . . . that almost offensive smartness."[73] The narrator notices that the "young fellow in the pumps managed so artfully that every time the old gentleman advanced to salute the lady in the cloth boots, he trod with his whole weight on the old fellow's toes, which made him roar with anguish, and rendered all the others like to die of laughing. We were in the full enjoyment of these festivities."[74]

None of these implications seems present in the illustration (fig. 5). It works, almost defiantly, *against* the text. Whereas Boz's street is animated by his imagination, Cruikshank's neighborhood teems with its own life: several middle-aged women with babies, three men of assorted ages, five children playing amidst the cobblestones, and a dog. There are jolly and undespised Jews: Moses Levy is the name inscribed on the lintel of one shop. And there are punning names having nothing to do with Dickens's script, but familiar from the caricaturist's fount of puns: "Clipp Tailor" and "P. Patch." There is no barrel-organ grinder, and no "bulky lady of elderly appearance" glaring at the "imperence" of the spectator. These folk are happy in their playing, smoking, and flirting; they are utterly at home conducting their lives in the theater of the street. Youth is not deformed or sickly or blackguardly, and age is content with a pipe. Idleness is not the road to ruin.

There are not even many clothes in this image. Although in 1845 Cruikshank would range shoes into a taxonomy of wearers and infer from them the characteristics and habits of their owners, he here refuses the hints of Dickens's text and declines to provide any indication of that sequence of outfits which triggered the narrator's speculation about the fate of an idle town boy. Cruikshank's "Monmouth Street" has little to do with a pessimistic view of life, nor does it endorse a Hogarthian connection between idleness and dissipation. The amusements of the people here, and in other plates of this period, tend to be revitalizing, comparatively innocent, and harmless. And the artist is engaged with the inhabitants—not as a self-

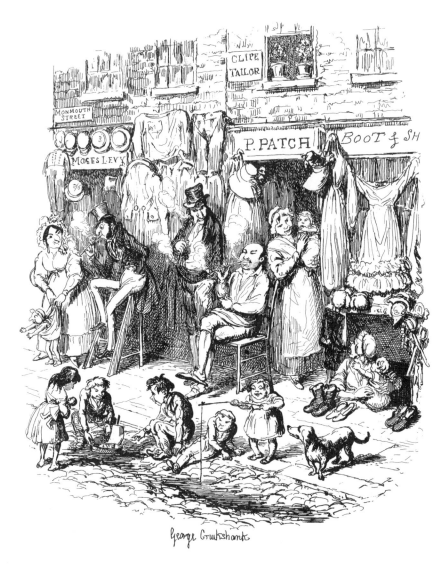

5. *George Cruikshank, "Monmouth Street,"* Sketches by Boz, *Second Series, etching, Dec. 1836*

contained bystander but as a member of the community who can (and has) participated through life and art in the activities and feelings so lovingly depicted.

Cruikshank's resistance to aspects of Dickens's paradigms can be detected in earlier plates. In the First Series of *Sketches*, the illustration to

"The Pawnbroker's Shop" has been interpreted as tracking a decline and fall from respectability to vagrancy and prostitution. But the juxtaposition of social, occupational, and class types; their commingling; the contrast between those who are open about their poverty and those who still attempt to conceal their transactions; and the difference between the two clerks and between their matter-of-factness and the range of attitudes (inebriated insouciance, dismay, surliness, genteel embarrassment, and brazenness) expressed by their clients seem more pointed themes. Variety more than inevitable deterioration organizes the illustration.[75]

"Private Theatricals," also from the First Series, depicts amateurs getting into costume for *Macbeth*; but even more than Dickens's text Cruikshank's illustration, drawing as it does on Hogarth's *Strolling Actresses Dressing in a Barn*, emphasizes the disparity between the roles to be played in the tragedy and the domestic comedy of everyday life. The young lady dressed for Fleance paints Banquo's face with a hare's foot, while a tall stout woman who, because of her slight resemblance to Mrs. Siddons, is always picked for Lady Macbeth studies the stage directions. Two new players, a milksop Malcolm and a black-eyed female impersonating a gentlewoman for the first time, flirt. Duncan is a fourteen-year-old boy with soaped and whitened hair, and the armies are represented by two dirty men with corked countenances. Cruikshank's performers are clearly not going to be good in their roles; they are only having fun at play-acting. In this instance, at least, the costumes neither imprison nor express self.

Of course, Cruikshank could hardly illustrate the center of "Meditations in Monmouth Street." It would be nearly impossible for him to represent the "speculative pedestrian," as opposed to the "Boz" of the preface imaged in the balloon frontispiece, although ever since Cruikshank began etching independent satirical plates he had known how to incorporate within the picture the observer from whose perspective the recorded incident is comic. But how could he draw a figure whose private musings elicit a shrill outburst from one of those inspected? Either the inhabitants of Monmouth Street would seem hostile, or the observer would seem to be actively provoking them. In other plates, as Miller discusses, an observer does appear: Dickens himself, a small boy, a neutral passer-by, or a portrait hanging on the wall which by its presence complexly comments on mimesis, life, and time.[76] But when the narrator is most involved in *creating* the fiction, Cruikshank is less likely to include a surrogate within the illustration. It is not always the case, as Miller implies, that "Cruikshank's etchings are divided within themselves."[77] But the artist does find ingenious ways of imaging both the momentary vitality of furious and evanescent action, and the distanced perspective afforded by time's passage, precisely the double perspective Baudelaire was to formulate as the vision of modern art. The lifeless inven-

tory of Monmouth Street in Cruikshank's plate clearly contrasts to the
energy of the living; but the contrast reverses the polarities of Dickens's
text.

That the *Sketches* are faithful accounts of lower-middle-class urban life
has been the principal reaction of readers since John Forster: "a picture of
every-day London at its best and worst, in its humours and enjoyments as
well as its sufferings and sins, pervaded everywhere . . . with the absolute
reality of the things depicted."[78] If Cruikshank differed from Dickens about
the interpretation of that life, what did they have in common that made
each think the other's vision compatible? To begin with, they shared the
conviction that contemporary popular culture was worth chronicling.
Others might treat the city as romance, domestic drama, archaeology, or
setting for metaphysical speculations. Dickens and Cruikshank preferred to
encounter and record the city more directly; they found all the material
they needed in the noisy, bricky, jumbled scenes on the banks of the lower
Thames.

Second, they shared a vocabulary for conceptualizing and expressing
that culture. The graphic components derived from Hogarth, Netherland-
ish genre painting, Bosch, Breughel, Hans Holbein's *Dance of Death*,
eighteenth-century English book illustration, and caricature. The literary
conventions derived from *Don Quixote* and the classic English novel and
from virtually the whole range of theater, Astley's and pantomine to
Shakespeare and Jonson. The representational vocabulary comprised physi-
ological psychology from Lavater to Gall and Spurzheim; a conviction that
character is histrionic and indicated by types of clothing, speech, and ges-
ture codified by artists, actors, playwrights, authors, and critics; and a habit
of classifying that was equally a part of the caricaturist's and the writer's
training.

Third, both artist and author responded vigorously and inventively to
the energy of the city: it sparked their imagination, modified the conven-
tions they had inherited from Augustan and Georgian art, impelled them
to reformulate their vocabularies, and replenished their vitality because
rapid and incessant change forced them constantly to alter their visions.

But Cruikshank says different things about London than Dickens.
Middle-aged, married, childless, struggling to maintain a moderate in-
come, and watching the ambitions as well as the excesses of his youth
wane, Cruikshank believes in the virtues of work and play and in the com-
pensations to be found in every byway of the city. He eschews the melodra-
matic and the sentimental, sees more comedy than tragedy in love, and
reserves his satire for folly, in the conviction that if mankind will go right
things will go right. Hillis Miller detects in the *Boz* illustrations a "sense of
enclosure, even of suffocation," deriving from their concentric organi-

zation, their darkness, and the ponderous architectural features that over-
hang and threaten the tiny figures who explode, as Baudelaire first ob-
served, with the furious gestures of the pantomine in their minuscule
world.[79] But in fact Cruikshank avoids picturing such dark subjects as "The
Black Veil" and "The Drunkard's Death," and when he chooses a moment
in "The Hospital Patient" to illustrate, he picks not the climactic scene of
the beaten woman confronting her assailant, but the very subsidiary, pre-
liminary, and comic scene of a pickpocket being conveyed to the police
office in a wheelbarrow.

It is true that buildings figure prominently in the plates. Often Cruik-
shank frames his vignette with an architectural element, but usually the
crowd spills out from, or fills almost to the point of bursting out from, the
enclosure: "The Election for Beadle" (especially in the 1836 version),
"'Coach!'" (as the first illustration of "Hackney Coach Stands" was eventu-
ally titled), and "Greenwich Fair" from the First Series, and "Vauxhall Gar-
dens by Day" from the Second Series, supply representative instances. A
"crowd in a little room," so characteristic of Jane Austen's settings, also
characterizes Cruikshank's, but in the Second Series the claustrophobia
that will become so powerful in *Oliver Twist* is less present. Indeed, here
Cruikshank relishes exterior ornamentation, oversized gas lamps, leaded
windows, exuberant fan lights above pretentious doorways, gabled roofs,
smoking chimneys, and spiked towers. He shows how settings reflect and
react to their inhabitants, but, unlike Dickens, emphasizes animation (of
structure as well as occupant) over attrition.

In "The Streets—Morning" (fig. 6) Cruikshank captures a poetics of
space, atmosphere, and light that both corresponds to Dickens's somewhat
labored evocation of chilly absence ("an air of cold, solitary desolation
about the noiseless streets"; "the stillness of death is over the streets") and
adds instances of early-morning waking that presage the renewal of all the
furious activity that constitutes the comedy of life. Cruikshank, says Mario
Praz somewhat unfairly,

> needs nothing more than a background of deserted streets with a solitary police-
> man, a stall with hot drinks in the foreground, a chilly-looking man drinking,
> and a little boy who seems wholly engaged in rubbing his hands together and
> stretching himself, to suggest completely the raw atmosphere of early morning.
> Dickens, on the other hand, launches out into a long essay that has all the
> appearance of a composition by a diligent schoolboy trying to remember all the
> things he saw one day when he happened to leave the house early.[80]

Who can be certain what makes the magic of this plate, one of Cruik-
shank's most celebrated?[81] Is it the long recession of the crooked cobbled
thoroughfare, the way the illumination of the gas lamps is paling in the
thin morning light, the humor of the pub sign ("The Rising Sun") and the

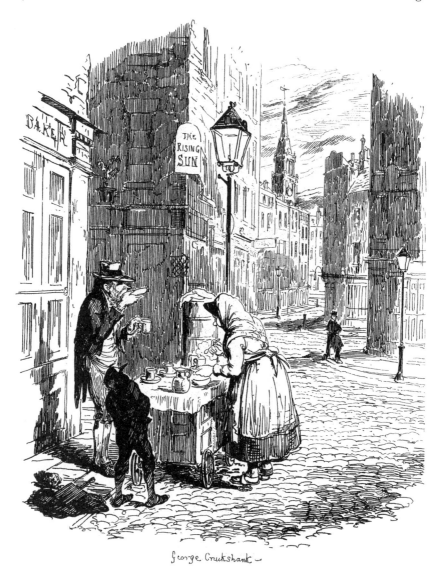

6. *George Cruikshank, "The Streets—Morning," Sketches by Boz, Second Series, etching, Dec. 1836*

shuttered "Baker," the perfect gesture of the chimney sweep fishing in his pockets for a coin, the excessive diminution of the policeman which at once gives perspectival depth and psychologically modifies the loneliness of the streets without implying authoritarianism? Or is it the spire of the

church at the vanishing point of the recession, where the street and the buildings meet the dawn with a promise about which Dickens's prose is far less confident?

Cruikshank's plate here picks up not only from the few hints contained in the description of "The Streets—Morning,"[82] but also from a description of a "street-breakfast" in a byway near Temple Bar that Percy Noakes passes at five in the morning on his way to "The Steam Excursion": "The coffee was boiling over a charcoal fire, and large slices of bread and butter were piled one upon the other, like deals in a timber-yard . . . A little sweep was standing at a short distance, casting a longing eye at the tempting delicacies; and a policeman was watching the group from the opposite side of the street." In conflating a passage from a tale republished in the First Series with one from a sketch republished in the Second Series, Cruikshank in yet another way demonstrates both his dependence on Dickens's text and his independence. He animates and softens Boz's "cold, solitary desolation," and appears to gift the sweep with a penny to purchase a cup of coffee.

There is another element of urban life that Cruikshank evokes repeatedly: noise. For both artist and author the morning streets are hushed, before the discordant compound of "men . . . shouting, carts backing, horses neighing, boys fighting, basket-women talking, piemen expatiating on the excellence of their pastry, and donkeys braying" assaults the ears of Londoner and countryman alike. But other plates—"Seven Dials," "Vauxhall Gardens by Day," "A Pickpocket in Custody," and "Monmouth Street" from the Second Series—reverberate with laughter, cursing, crying, talking, screaming, and singing. In "Scotland Yard" (fig. 7), the lusty coalheavers send forth their voices on a winter's night to the banks of the river, dwelling on the last words of a popular song "with a strength and length of emphasis which made the very roof tremble above them." One might imagine that sound was a property reproducible by words, not by pictures, but Cruikshank's illustration vibrates to the lungs of the singers, the chimes of the clock striking the hour, and the crackle and roar of the fire. The dog so prominently placed at the center of the composition might almost be an emblem of another type of noisemaker, silenced and deafened by the uproar around him. Perhaps he is the comic observer of this scene, thoroughly cowed.

Boz, an anxious and ambitious twenty-four, is less sure than Cruikshank about the benevolence of the universe. He sees folly, pretense, and hypocrisy in the genteelisms of the middle classes and has only limited sympathy with the pleasures of those in the class from which he has risen. He is more aware of competition between ages and classes and sexes. His sense of the variety of life in London extends to the miserable, the pathetic, and the

7. *George Cruikshank, "Scotland Yard," Sketches by Boz, Second Series, etching, Dec. 1836*

tragic as he knows them from melodrama. In setting forth his taxonomy of types—and nearly everyone he describes is a "type"—he acts like an anthropologist classifying, anatomizing, and somehow defamiliarizing the world around him. Above all, he exults in the power to say whatever he wishes to say and make that saying replace experience by its superior understanding, sympathy, judgment, and vividness.

Cruikshank knew and loved London before Dickens was even born. He inherited, modified, and established a graphic vocabulary for uttering that affection before Dickens mastered the alphabet. He explored the haunts of thieves and coalheavers and prostitutes while Dickens was exploring the

precincts of Rochester cathedral and the country paths of Chatham. What therefore Cruikshank brought to *Boz* was not only a different sensibility about the city but also an established mode of representing it. If Dickens's prose, alternating between clever and sympathetic, humorous and turgid, struggles to establish a new sensibility and way of saying, Cruikshank's pictures refamiliarize for his contemporaries these *Sketches* of an emerging culture. He knew what he wanted to say, whereas Dickens was just forming his art. Cruikshank knew which stories he could illustrate, and which ones he could not. He knew what would "tell" in a plate, whereas Dickens was uncertain, inconsistent, and sometimes missed his effects. In short, Cruikshank possessed a certainty about his vision that makes his work for the early Dickens wonderfully complete, while Dickens's prose falters. But Cruikshank's certainty was within a decade to turn rigid and reactionary, while Dickens's experimentations with urban sketches and speculative pedestrians led to unprecedented growth.

OLIVER TWIST AND THE "APPLES OF DISCORD"

Suppose Cruikshank suggested to Dickens that his subject should be a poor boy thrown upon the skirts of London. It is but the motive, the theme. In all the range of Dickens's work, there is nothing more essentially his own than "Oliver Twist," from the name of the hero to the last line of the final chapter.

Blanchard Jerrold[1]

The constant presence of . . . pictorial illustrations has unconsciously influenced [Dickens's] own fancy while at work in drawing his ideal characters; which are insensibly moulded by, and accommodated to, the grotesque, quaint, and exaggerated figures and attitudes of the caricaturist's pencil. . . . Thus the writer follows the caricaturist, instead of the caricaturist following the writer; and principal and accessory change places.

Samuel Warren[2]

[Oliver Twist] perhaps even seemed to me more Cruikshank's than Dickens's; it was a thing of such vividly terrible images, and all marked with that peculiarity of Cruikshank that the offered flowers or goodnesses, the scenes and figures intended to comfort and cheer, present themselves under his hand as but more subtly sinister, or more suggestively queer, than the frank badnesses and horrors. The nice people and the happy moments, in the plates, frightened me almost as much as the low and the awkward.

Henry James[3]

ON TUESDAY, 6 December 1836, the Cruikshanks joined Richard and Charlotte Bentley as guests of the Dickenses for the opening night of *The Village Coquettes*. Dickens's operetta received poor notices— Forster thought the orchestra "inefficient" and the costumes "absolutely

disfiguring." Nevertheless, the first-nighters dutifully called for the author at the end, and, according to Forster's review, were disconcerted to discover that he did not resemble any of his characters.[4] (Forster himself met Dickens for the first time later that winter at Ainsworth's.[5]) However much the reviewers subsequently blew "their little trumpets against unhappy me, most lustily," Dickens later reported, the premiere party had much to celebrate: a new periodical forthcoming in less than a month that teamed the outstanding graphic artist of the age with a rapidly rising literary star.

Cruikshank had undertaken to lend his name to *Bentley's Miscellany* (fig. 8) for a flat fee of £50, and in addition to furnish for twelve guineas each month one plate, the copyright of which Bentley would then own.[6] George further agreed not to supply prints for Colburn, Bentley's former partner, under penalty of £100. On that early December evening, none of the principals anticipated that the *Miscellany* would be the vehicle by which Boz's new fiction would be conveyed to the public. Nor did they anticipate that Cruikshank's illustrations would become so important a part of the novel's reception and subsequent reputation. Likewise, the social satire ("my glance at the new poor Law Bill," Dickens called it), the squalid low life, and the violence of *Oliver Twist* were unpredicted then.[7] Indeed, the initial emphasis in the journal's founding, as Dickens's "Prospectus" declares, was on "a feast of the richest comic humour."[8] When R. H. Barham learned that the original title, *The Wit's Miscellany*, was to be changed to *Bentley's Miscellany*, he asked, "Why go to the other extreme?", and Theodore Hook said "the title was ominous—'Miss-sell-any'."[9] Subsequently William Maginn composed a doggerel, "Song of the Cover," celebrating Cruikshank's wrapper design and the magazine's success:

Bentley, Boz, and Cruikshank, stand,
 Like expectant reelers—
"Music!"—"Play up!"—pipe in hand,
 Beside the *fluted* pillars!
Boz and Cruikshank want to dance,
 None for frolic riper,
But Bentley makes the first advance,
 Because he "pays the piper."[10]

It could be misleading to say that "none of the principals" thought the periodical would be the place for Boz's next novel, since, if Cruikshank's reconstruction of the events long afterward holds any credibility, he and Dickens may by December have talked over "what the subject should be for the first serial." Cruikshank's idea, as he explained in a letter published in *The Times* on 30 December 1871, "was to raise a boy from a most humble position up to a high and respectable one—in fact, to illustrate one of those cases of common occurrence, where men of humble origin by natural

8. George Cruikshank, wrapper design for Bentley's Miscellany, *wood-engraving, 1837*

ability, industry, honest and honourable conduct, raise themselves to first-class positions in society."[11] Here again the artist's moral optimism, which counterpointed Boz's pessimism in *Sketches*, governs his conception of a nineteenth-century version of Francis Goodchild's "progress" in *Industry and Idleness*.[12] To signify the inherent nobility of his hero, the artist thought of naming him "Frank Foundling or Frank Steadfast," but Dickens overheard an omnibus conductor calling someone Oliver Twist, and chose that name instead. "I think the word Twist," Cruikshank noted, "proves to a certain extent that the boy [Dickens] was going to employ for his purpose was a very different sort of boy" from the one the artist envisaged.

As Cruikshank also wanted to "bring the habits and manners" of London criminals before the public, just as he had when he proposed the "Life of Don Cove" to Egan in the 1820s, he "suggested that the poor boy should fall among thieves, but that his honesty and natural good disposition should enable him to pass through this ordeal without contamination." According to his *Times* letter, Cruikshank described to Dickens the adult thieves, their female companions, and the young accomplices. "A long time previously" Cruikshank had directed Dickens's attention to Field Lane, Holborn Hill, where many receivers of stolen goods resided.[13] "It was suggested," Cruikshank continues, "that one of these receivers, a Jew, should be introduced into the story; and upon one occasion Mr. Dickens and Mr. Harrison Ainsworth called upon me at my house in Myddleton-terrace, Pentonville, and in course of conversation I then and there described and performed the character of one of these Jew receivers, who I had long had my eye upon; and this was the origin of 'Fagan' [sic]." Cruikshank, who had already visited Newgate and sketched the cell in which condemned felons were held, says he had a hard time persuading Dickens to put either a Jew or a Christian into that cell, although he eventually got his way with Fagin.[14] Cruikshank reports in this same letter that Ainsworth was "so much struck" with the artist's description and personification of the Jew that he said the two of them "could do something together," as afterwards they did.

The fierce controversy surrounding the 1871 claim that Cruikshank originated *Oliver Twist* belongs of course to the last phase of the artist's career. Not all the statements he made thirty-five years after the fact are precisely accurate, and some—especially about the origin of Fagin and his last hours in the condemned cell—must be modified in the light of other stories Cruikshank told and comments Dickens made while composing the novel. But the general outline is not simply a lie, as Forster charged, nor a "delusion" of Cruikshank's old age, as it was labeled at the time by his friends and later by most commentators on the novel. The sketches for the life of a thief were still in Cruikshank's studio. He had tried to induce at least one other author to collaborate on such a book. He had been interested for

seventeen years in producing a modern version of Hogarth's *Industry and Idleness* beyond what had gone into *Life in London*. He was accustomed to making suggestions to authors, just as he was accustomed to receiving and acting on suggestions from authors. And, as we shall see, there is evidence that at the time of *Oliver*'s composition Cruikshank spoke openly of his role in originating the novel.

Over three decades later, Ainsworth told Blanchard Jerrold that Dickens once "declared to me" that Cruikshank "was excessively troublesome and obtrusive in his suggestions"; since Dickens "could not stand it," he determined to send the artist only "printed matter in future."[15] If Ainsworth's report is reliable, Dickens's complaint would seem to be about the artist's wanting to alter details of a scene that Dickens either was about to compose, or had written out but not yet sent to the printer; it does not seem to apply to preliminary discussions about a story, nor to the start of *Bentley's*, when as we have seen Dickens solicited the artist's advice.

With authors, artists, and publishers shuttlecocking ideas for new works daily, it was entirely in character for the age and for the persons involved in the origin of *Oliver Twist* to discuss their notions of what kind of story might make a hit and win customers for the new journal.[16] Cruikshank certainly had a stake in realizing his long-deferred dream for a novel about people and places he knew intimately and had portrayed dozens of times in the preceding years.[17] What in his elderly anxiety to reaffirm his reputation he fails to acknowledge is that Dickens too had much at stake in *Oliver* and had already written extensively about the characters and scenes the novel incorporated.[18] In 1836, an exchange of views between the two friends about the content of Dickens's next serial would have seemed exhilaratingly congruent; at the start, the *Miscellany* collaboration promised a complementarity of imagination far closer than that achieved in the *Sketches*. Dickens may have heard Cruikshank out and then taken his own way; but that way was so like the one his artist proposed that each could feel proprietary about the result.

Between 5 December, when Cruikshank received copy of "Public Life of Mr. Tulrumble" for the January number of *Bentley's*, and the beginning of the new year, he heard little more about his February assignment. Dickens, as usual, was overcommitted: he did not finish his *Pickwick* installment until 23 December and then worked furiously on editorial correspondence over the holidays. On Friday, 6 January 1837, at 6:15 p.m., "after a day and night of watching and anxiety," Charles Culliford Boz Dickens was born.[19] The Cruikshanks heard the news the following Monday when Dickens apologized for the tardiness of his notice: "I thought I might just as well defer the communication until I had something else to say; knowing that the importance of such intelligence diminishes very materially outside

one's own house." That "something else" was a further postponement of the text which Cruikshank was to illustrate for the February number: "The bustle *et cetera* has rather put me out this month," Dickens confesses, so "I want you to give me as long a time to prepare the subject in, as you can, on my promise to behave better next time. Say until what day you can conveniently give me; and I will call on you at your own time, and settle our illustration."[20]

They met in Amwell Street around 18 January, for on that day Dickens told Bentley that he had "hit on a capital notion for myself, and one which will bring Cruikshank out."[21] The birth, orphaning, badging, and ticketing of Oliver, a Parish foundling, promised both humor and pathos; and though the setting was the workhouse in the same provincial town of Mudfog of which Nicholas Tulrumble had been mayor, such figures as the beadle and other parish authorities would give Cruikshank the opportunity to replicate previous characters of that type and physiognomy, even though they were not explicitly Londoners.

Cruikshank's initial depiction of the hero, "Oliver asking for more," contains further evidence of early collaboration with Dickens.[22] Oliver and his fellow workhouse inmates have closely cropped hair, although Dickens's text makes no mention of such disfigurement. However, Cruikshank probably knew through his friend Pettigrew that the orphans' heads were often shaved because of scalp infections. The connection to Pettigrew may be an even more important factor in the early stages of *Oliver*'s composition. In his 1871 *Times* letter Cruikshank explains that

> it so happened, just about this time, that an inquiry was being made in the parish of St. James's, Westminster, as to the cause of the death of some of the workhouse children who had been "farmed out," and in which inquiry my late friend Joseph Pettigrew (surgeon to the Dukes of Kent and Sussex) came forward on the part of the poor children, and by his interference was mainly the cause of saving the lives of many of these poor little creatures. I called the attention of Mr. Dickens to this inquiry, and said if he took up this matter his doing so might help to save many a poor child from injury and death.[23]

Richard Vogler has demonstrated that there was a spring 1836 controversy, reported in *The Times*, about the treatment of St. James's Parish pauper children, and that some of the details may be ironically echoed in Dickens's description of the Mudfog Parish administration.[24] There is also a book dealer's catalogue entry of a 6 February 1872 letter from the rector of St. Martin's, the Reverend Mr. J. B. Deane, to Cruikshank, confirming the assertion that Pettigrew had been engaged in an 1836 controversy with parish authorities over their treatment of children and recalling that Pettigrew told him "how you [Cruikshank] had suggested a popular tale by Mr. Dickens, founded upon the sufferings of a parish child."[25]

Moreover, in his *Times* letter, Cruikshank instances an alteration in the appearance of Oliver as further indication that he caused Dickens to change direction:

> I earnestly begged of him to let me make Oliver a nice pretty little boy, and if we so represented him, the public—and particularly the ladies—would be sure to take a greater interest in him and the work would then be a certain success. Mr. Dickens agreed to that request, and I need not add here that my prophecy was fulfilled; and if any one will take the trouble to look at my representations of "Oliver" they will see that the appearance of the boy is altered after the two first illustrations.

There is no question that in the third plate, "Oliver plucks up a spirit," he appears as a curly-haired, well-formed boy with what Mario Praz has described as "the fair, long, sad face of a neo-classic angel."[26] The meager but comparatively more generous rations provided by the Sowerberrys—Bumble thinks that Oliver's pugnacious spirit comes from eating meat—may partly account for a more robust physique, and the curly hair may simply have grown out since the days of workhouse shaving, but the contrast between the timid parish orphan unlucky enough to draw the lot that compels him to ask for more and the apprentice who strikes Noah Claypole for insulting his mother does point, in both the text and the illustration, to a development of character toward greater nobility and courage.[27] Dickens may all along have intended this development, so that Cruikshank's recommendations merely confirmed rather than initiated his own plans. But once again, it is not impossible that the artist's influence materially affected the course of the novel.

Thackeray believed that it did. In 1840 he published his conviction that "the artist wanted the attractive subject of a boy growing up from the meagre poverty of workhouse childhood to the graceful beauty of happy youth, and the letterpress was written 'to match, as per order'."[28] Thackeray, who knew both Dickens and Cruikshank intimately at this time, and was in and out of the Amwell Street studio frequently as he collaborated with Cruikshank on the 1839 and 1840 *Comic Almanacks*, obviously had heard Cruikshank's version of the novel's origin and credited it. The artist made the same points to Bentley's office manager, Edward S. Morgan, who recalled that Cruikshank

> stated to me emphatically in the course of many conversations I had with him on the subject, in the course of business, that it was to him, Mr. Dickens had been indebted for his introduction to many of the characters that served as prototypes of prominent personages in Oliver Twist: Fagin, the Artful Dodger, &c &c; as well as for many suggestions as to the incidents that figure conspicuously in that work.[29]

And the very text of the novel in *Bentley's* indicates a number of changes of direction on Dickens's part, as he shifts from conceiving of his story as part of the Mudfog papers to thinking of it as a novel in volumes. The openness of Oliver's fate, the confused motivations given Fagin for trying to blacken the boy's soul, the late development of Monks's plot, and the transfer of interest from Oliver to Nancy during the latter stages of the narrative may all be signs that Dickens reconceived his story in the course of publication, as he wrestled with Bentley over contracts and as he discussed with Cruikshank the illustrations.[30]

While Bentley paid the piper and Dickens and Cruikshank frolicked, John Macrone drooped. He sold Ainsworth's new work *Crichton* to Bentley for £1,000, with a further payment of £150 going directly from Bentley to Ainsworth to prompt the novel's long delayed completion.[31] Since *The Lions of London* would never roar, and *Gabriel Vardon* would never tap his anvil for Macrone, he could count on none of the principals associated with him the previous year: not Ainsworth, not Dickens, not Cruikshank. He struggled on through the summer publishing the *London and Westminster Review* and trying to make something from his dearly purchased rights to "gentlemanly" authors both native and Continental, but the inventive optimism of 1835–1836 could not be rekindled.

Ainsworth, having at last finished *Crichton*, busied himself about its sale. The novel was issued in three volumes on 27 February, and as Ainsworth told Crossley, "The whole of the first edition was sold out the first day—1250 copies."[32] A second edition was printed and distributed while Ainsworth continued to press for more puffing. After the first spurt, however, sales died; no third edition was required until 1849. So Ainsworth sat back down at his desk and began a second installment of his "full series of portraits of the robber." At first he focused, as in *Crichton,* on the exemplary protagonist, Thames Darrell, using the name as his provisional title; but his own interests, and the evident sensation *Oliver Twist* was generating by midsummer, encouraged him to shift the focus and eventually the title to the rogue, Jack Sheppard.

Cruikshank was shortly to become connected both to Macrone's plight and to Ainsworth's novel, but meanwhile his principal work each month was the plate for *Bentley's.* Despite the promise Dickens made in November 1836 to have copy ready by the fifth of each month, he was chronically late, enmeshed in editorial duties and *Pickwick.* After Charley's birth, Catherine remained in a "very low and alarming state," so although Dickens had completed the equivalent of nearly eleven printed pages for the March installment, he was compelled to put off writing the rest, and, suffering himself from violent headache, to retreat to Mrs. Nash's cottage at Chalk,

where he had spent his honeymoon, for a month of country air and recuperation.[33]

Cruikshank was thus unable to discuss with Dickens the March plate, "Oliver escapes being bound apprentice to the Sweep." Dickens came up for the day on Wednesday, 8 February, but did not drop by Amwell Street, as he was "so driven for time, that I know not where to turn." Instead, he sent the chapter already composed, explaining that there would be another not yet written:

> The place which I think will make a good Illustration is at p 17 [of the manuscript], but to understand it thoroughly, I fear you will have to read the whole. We had better not give Oliver's real master [the parochial undertaker] and mistress this number, because we shall want them in the next plate; and for this reason I have substituted a preliminary negociation with Mr. Gamfield the Sweep.[34]

If Dickens had not yet written chapter four, in which the Sowerberrys make their first appearance, then he must have talked the story over with Cruikshank at some point before leaving town, since otherwise the reference to Oliver's "real master and mistress" would have been incomprehensible. Perhaps to forestall the artist's suggestions for improvements, Dickens describes the scene at the magistrate's office in great detail, and Cruikshank, seizing on the moment when Oliver falls to his knees and implores the old gentleman to starve or beat or kill him rather than apprentice him to Gamfield, follows the text exactly, representing everything from the sweep's "very repulsive countenance" to Bumble's incredulity. In the contrasted expressions of the six principal characters, Cruikshank sums up the text's narrative line, and by encircling Oliver with the half-blind magistrate, Gamfield, Mr. Limbkins of the poor law board, and the beadle, he imprisons the boy and prevents visual or physical access to the one sympathetic onlooker, the second magistrate—surrogate for the reader—who looks up from his newspaper and orders Bumble to hold his tongue.[35] The notion that Oliver is, in Mario Praz's colorful phrase, "in the midst of the saraband of demons from the London underworld" is here anticipated by the "philosophers," who by administering utilitarian philanthropy threaten the orphan's body as much as Fagin will threaten his soul.[36] To anticipate the theme of imprisonment so early in the novel, after only three chapters had been written, Cruikshank must have had some inkling of Dickens's future course. And by devising a variant on Francis Goodchild's presiding over the impeachment of Tom Idle, he subtly reinscribes his favorite Hogarth topos.[37] "If you have anything to write or say to me," Dickens concluded in sending his instructions, "my brother will forward it. I shall be in town again, *tomorrow week* for the whole day." Perhaps on that day

Cruikshank was able to show his preliminary drawings; in any event he had time to execute a carefully finished etching, perfectly in sympathy not only with the text to date but with implications not yet articulated.

At the end of the month Cruikshank accepted a minor commission, to illustrate the Reverend Thomas Streatfeild's ballad "The Old Oak Chair." Streatfeild was a wealthy curate, artist, and topographer living at "Chart's Edge," Westerham, who collected fifty-two volumes of notes and drawings for a history of Kent. But he died in 1848 without issuing anything beyond a prospectus. Cruikshank was supposed to have met Streatfeild once in 1836 at St. Paul's Coffee Shop, but the letter of an intermediary setting up the engagement arrived after the hour appointed. Henry George, Streatfeild's agent and publisher, enclosed the ballad with a note to the artist asking for his terms and advice. Cruikshank recommended four designs for wood-engraving. When they were completed at the beginning of May he charged considerably less than his usual two guineas apiece, having heard privately that the commissioning parties were strapped for funds—surely not the case. The wood-engraver Stephen Sly billed more than double (£10 7s.) what the artist earned.[38] In early 1838, Henry George copublished with Charles Tilt and Simpkin, Marshall, the last work of Streatfeild, *Lympsfield and its Environs . . . and The Old Oak Chair.*[39] The paltriness of the commission and the contrast between his earnings and the wood-engraver's, not to mention Dickens's or Ainsworth's or Bentley's, reinforced Cruikshank's awareness that his financial situation was precarious, and that only unremitting work kept him and Mary Ann in middle-class comforts.

When the great clown Joey Grimaldi died on 31 May, Bentley treated with Grimaldi's executors for the *Memoirs* he had dictated and his friend Thomas Egerton Wilks had arranged for publication. That eventually became another commission for Dickens and Cruikshank. Meanwhile George completed his plate for the April installment of *Bentley's*, "Oliver plucks up a spirit," a brilliantly rumbustious and noisy image in which the fair Mrs. Sowerberry makes her only appearance (her husband's portrait is never offered), and Oliver for the first time is depicted as a "nice pretty little boy."[40]

By the end of March Thackeray's time in Paris as foreign correspondent for the *Constitutional* was over. Moving his family into temporary quarters with his mother and step-father in Albion Street, he engaged in free-lance journalism for the next decade, "writing for his life," as Carlyle said. He depended on friends for early commissions: Maginn offered him the columns of *Fraser's*, where he published under the *noms de plume* of Charles James Yellowplush and Michael Angelo Titmarsh, and his wife's relations introduced him to *The Times*. But he pestered Cruikshank among others for more work, and he began to develop under the acute pressure of neces-

sity lifetime habits of rapid composition succeeded by idleness and dissipa-
tion.

By contrast, Dickens felt prosperous enough to give up Grub Street and
to lease a house at 48 Doughty Street from the beginning of April. The
attendant disruptions put him fearfully behind with his month's periodical
writing, "and as if these causes of delay were not enough," he complained
to Bentley in midmonth, "I do verily believe that I have had to read as
many papers for the Miscellany, as all the Editors and Sub Editors of all the
other Magazines put together."[41]

Cruikshank, calling in Doughty Street around the twelfth, made several
sketches of Boz's portrait, contrary to his usual practice of not drawing from
life.[42] ("I was sitting for my portrait to George Cruikshank . . . to-day,"
Dickens told his friend Thomas Beard, "and George being a ticklish subject
[I] could not leave him."[43]) While drawing, Cruikshank may have talked
over the important plate for the May *Miscellany*, "Oliver introduced to the
respectable Old Gentleman," the first portrait of Fagin and his gang.[44] But
evidently he didn't see copy—either manuscript or proof—until around
the twenty-first.[45] He was expecting to illustrate a contribution by Ains-
worth as well, since Bentley had contracted for a second monthly plate
from May onward. But as Ainsworth's piece hadn't arrived by the twen-
tieth, Dickens asked him if he would "object to illustrating Barker's paper"
("Nights at Sea") instead.[46] Cruikshank received Barker's text on 24 April,
and returned proof of the *Oliver* installment that same day; working rapidly,
he etched both steels before the end of the month.[47]

On 29 April the artist joined Bentley and George Hogarth at Dickens's
for a quiet dinner, "with a little Music in the Evening."[48] "It was a right
merry entertainment," Bentley recalled a score of years later. "Dickens was
in force, and on joining the ladies [including Dickens's sister Fanny, a pia-
nist and vocalist] in [the] drawing room, Dickens sang two or three songs,
one the patter song 'The Dog's Meat Man', & gave several successful imita-
tions of the most distinguished actors of the day."[49] Bentley did not recall
Cruikshank's presence, though it is easy to imagine George entering enthu-
siastically into the festivities.

One week later, after returning to Doughty Street from the theater,
Dickens's young sister-in-law Mary Hogarth collapsed; on Sunday 7 May
she died in Dickens's arms. Catherine was so shaken she suffered a miscar-
riage. Dickens, unnerved more by Mary's death than by Catherine's condi-
tion, told Ainsworth that he was "compelled for once to give up all idea of
my monthly work, and to try a fortnight's rest and quiet" in Hampstead.[50]

Cruikshank heard this news right away, but by midmonth still knew
nothing about what he was to etch instead of *Oliver*. "Here we are on the
16th of the month," he complained to Bentley, "and I have not yet received

any thing in the shape of a subject for the 'Miscellany'."[51] Cruikshank explains that he had not bothered Dickens, but that he should have received proof of the stories to be illustrated four days previously. Bentley, standing in for his absent editor, promptly dispatched two articles, "Romance of a Day" and "Darby the Swift." Cruikshank endeavored "to make something" out of the former, which, as he pointed out to Bentley, contained an incomprehensible passage, but since he could "make nothing" of the latter, he prayed for "more matter for a May morning."[52] He got it in the shape of a further installment of Barker's "Nights at Sea," and in short order produced the delightfully fanciful image of "Jack outwitting Davy Jones."

On 25 May, Cruikshank wrote a long letter to Merle in Switzerland, accounting for the delay in finding a publisher for *Melton de Mowbray*, an autobiographical novel which Merle had forwarded to him over a year before. The manuscript had been mislaid by the proprietors of the *Metropolitan Magazine*, Saunders and Otley, who kept it interminably and did not reply to his letters. So Cruikshank wrote a "rather peppery epistle" directly to the editor, Captain Marryat, saying that "as agent in the matter in the absence of the author I insisted upon its being returned to me immediately provided they [the publishers] did not use it—and failing this that I should make a demand & enforce the payment!" This fusillade was answered by an apology from Edward Howard, Marryat's subeditor, who at last returned the manuscript. During a dinner at Bentley's shortly thereafter, Cruikshank met Howard, and finding him a pleasant fellow "gave up the idea that I had *almost* entertained of calling him out!" Howard admitted he had not read the story closely and offered to give it a more careful inspection. Should he send it back to Howard, Cruikshank asked, or "as Bentleys Miscellany is now within my reach," should he submit it to that periodical? Cruikshank closed by reporting on his poor health—the doctors advised getting out of town instantly—and by proposing to meet Merle in Calais "or somewhere on the *borders* of the Continent" in late June or early July. "I cannot spare time to penetrate to the *interiors* altho' I have a pressing invitation to Paris," he postscripted.[53]

He was however too busy in June and July to travel abroad. As soon as he returned from resting in Dover, Cruikshank buckled down to new work for Macrone, who, from lack of any other expedient, planned to issue the *Sketches* one more time. Both series would be gathered together and published in monthly parts similar to those of *Pickwick*. Cruikshank had twenty-seven plates to make over again in a slightly larger format and thirteen new ones plus a wrapper to design and etch, so that each of the twenty numbers would contain two illustrations. On 6 June Macrone expressed great anxiety about George's progress on the wrapper design; he hoped that the image could be kept simple enough to avoid the expense of a

professional block cutter, and asked that the artist keep him informed of progress.[54] Nine days later, presumably having completed his wrapper design, Cruikshank replied.[55] At the same time, having made preliminary drawings of "Oliver amazed at the Dodger's mode of 'going to work' " for the July *Miscellany*, Cruikshank asked Dickens for the subject of the second plate, which turned out to be "A Marine's Courtship," another illustration for Barker's tales.[56] "By the way," George concluded, "would you like to see the Drawing [for *Oliver*]?—I can spare it for an hour or two if you will send for it."[57]

At this moment Dickens was so distracted he may never have bothered looking at Cruikshank's drawing. He had heard on 9 June from the binder of *Pickwick* that Macrone planned to issue the *Sketches* in monthly numbers. Immediately he dashed off a letter to Forster, asking him to wait upon Macrone and to tell him

> that I have a very natural and most decided objection to being supposed to presume upon the success of the Pickwick, and thus foist this old work upon the public in its new dress for the mere purpose of putting money in my own pocket. Neither need I say that the fact of my name being before the town, attached to three publications at the same time, must prove seriously prejudicial to my reputation.[58]

Macrone turned obstinate, however, and after calculating with Hansard the probable costs and profits from the project, demanded £2,000 for the entire copyright of both series. At this point, Bentley jumped in to "bid for these apples of discord."[59] Dickens had told his publisher that he had an ulterior object in seeking to prevent the republication of the *Sketches*: "It is quite time that I should seek to derive some permanent advantage from works from which booksellers derive so much present gain. If I could purchase these copyrights for myself, I would do so (indeed I am prepared to do so) at almost any temporary sacrifice."[60] Bentley found offensive Dickens's reference to greedy "booksellers" (a term of reproach as Dickens used it), whereas Dickens believed that Bentley's inquiries about purchasing the copyright on his own behalf prompted Macrone to ask for even more money.

On 17 June Chapman and Hall, with Dickens's concurrence, agreed to pay Macrone's original price for the copyright, and a further £250 for the remaining stock, of both series of *Sketches*. Cruikshank's twenty-eight copper plates were thrown in gratis.[61] Dickens, in turn, consented to Chapman and Hall's issuing the *Sketches* in monthly parts. Cruikshank's wrapper and work on reetching the illustrations would now be done for Dickens's *Pickwick* publishers, while at the same time he continued for Bentley and Dickens on *Oliver*.[62]

Cruikshank's meeting with Forster at Dickens's on 19 June to celebrate the conclusion of these negotiations had to be canceled, however, because Dickens had not yet written one word for the July *Pickwick*, those scenes in the Fleet which he predicted to Forster the next day would "bang all the others," and which Forster called "his masterpiece" in the 2 July *Examiner*.[63] The darker tone characterizing *Oliver* from the start was now beginning to invade Dickens's comic serial, as his art rapidly matured and deepened in sympathy and understanding. "Read Oliver," Dickens counseled Bentley toward the end of the month. "I think he flourisheth."[64] He may have been flourishing as a story, but as a character, poor Oliver is chased by a rabid crowd roaring "Stop thief!" and committed to the tender mercies of the brutal police magistrate Mr. Fang.

July was deceptively calm, although thunderclouds were massing. Dickens traveled to France and Belgium with Catherine and with H. K. Browne until the 9th; on his return he was "terribly behindhand."[65] Immediately he entered into negotiations with Bentley for a new agreement that would establish a price (£700) and date (October 1838) for the delivery of the manuscript of *Barnaby Rudge*, and that would make *Oliver Twist* the second novel called for in his earlier agreement. Bentley objected that Dickens wanted to be paid twice, once when *Oliver* fulfilled the clause requiring an original article of sixteen pages per month for the *Miscellany*, and a second time when *Oliver* was published as a book. But Dickens threatened "that if you hold me to the strict letter of my agreement respecting the Novels, I shall abide by the strict letter of my agreement respecting the Miscellany, and arrange my future plans with reference to it, accordingly."[66] Exactly what that threat meant is unclear, since Dickens had already agreed to serve as editor for a term of five years, renewable.[67] Negotiations dragged on. In Dickens's opinion, Bentley's recalcitrance contrasted markedly to Chapman and Hall's "honorable and generous treatment" in presenting to him a set of six Pickwickian punch ladles. "It is indeed a pleasure to be connected with such men (I was going to say booksellers) as you," he wrote to the latter firm.[68]

Since Dickens's correspondence with Bentley was temporarily curtailed, Cruikshank told the publisher directly on 21 July that the *Oliver* plate ("Oliver recovering from the fever") was finished and would be sent to the lettering engraver, Francis P. Becker, in an hour or two. He promised to forward a proof of it and of the second subject, "Midnight Mishaps," in the morning.[69] One instance of the extraordinary artistic sympathy then existing between Dickens and Cruikshank is observable in this plate. From the beginning, Dickens had structured his narrative on an inversion of the parable of the Good Samaritan. The parish seal, stamped on the large brass buttons of Bumble's coat, depicts "the Good Samaritan healing the sick

and bruised man."[70] But Oliver, most unfortunate of wayfarers, falls by the side of the road trying to escape from the parish Samaritans, and is rescued, in the first instance, by thieves. When he falls a second time outside Mr. Fang's court, he is picked up by Mr. Brownlow, and, in the words of the chapter title, "is taken better care of, than he ever was before." Accordingly, Cruikshank includes two pictures on the wall of Oliver's chamber: one, important for the future of the story and evidently discussed with Dickens, is a portrait of his mother; the other, over the mantel, portrays the Good Samaritan. This detail does not appear in the surviving preliminary sketches and thus may have been added independently by Cruikshank during etching.[71]

The artist still had time for sociability. The poet and essayist Theodore Martin recalled one evening in 1837 when at Kensal Lodge Ainsworth entertained Dickens, Forster, Alexander Dyce, Banks, and Cruikshank.

> The conversation was very brilliant, and interesting to me, young man [he was twenty-one] as I then was. . . . Forster seemed to me a very dictatorial person— Shakespeare owed much of any popularity he had to the influence of *his* patronage of the poet. . . . Ainsworth . . . was at work on his *Jack Sheppard*, for I remember his taking me to his working room upstairs, and showing me the rare mezzotint of Sheppard, and a number of engravings, hanging about the walls, of people and places that were to be dealt with in the novel.[72]

Eighteen months thereafter, when *Jack Sheppard* displaced *Oliver Twist* at the start of each issue of the *Miscellany*, Ainsworth urged Cruikshank to consult these prints for likenesses of the characters and for historical details.[73] During his research, Ainsworth may also have made suggestions to Dickens about his criminals. Ellis asserts that Dickens got the name for Bill Sikes, first introduced in the August number, from Ainsworth; James Sykes, so violent he was nicknamed "Hell and Fury," was one of Sheppard's friends and fellow conspirators who later turned and impeached him.[74] R. H. Gooch, a friend of Cruikshank, wrote the following otherwise unsubstantiated and somewhat improbable account of Sikes's origin:

> I have often sat in Cruikshank's parlour which numbered among its visitors the burglar Sikes. His first name, it seems, was Bill, though his surname has not come down to us. "Jaw away, Bill," Dickens would say, and Dickens took shorthand notes while Cruikshank did the sketching. Both Nancy and Oliver were also veritable characters and used to make their way to this room.[75]

Thackeray, "as poor as a rat" and casting about for any kind of employment during this summer, drifted into Cruikshank's studio one day for conversation and encouragement.[76] Seizing upon the designs for the forthcoming serialized *Sketches*, he penciled an alternative wrapper and plate.[77]

He also drafted an article, "The Professor," which was published in the September *Miscellany* under the pseudonym Goliah Gahagan.

In August, Dickens's relationship with Bentley ruptured. By the 5th, Dickens had heard nothing from the "infernal, rich, plundering, thundering old Jew," applying, for Forster's sake, his description of Fagin to his publisher, who had never replied to the proposals of the preceding month.[78] On the 12th, Bentley called in Doughty Street. The conversation did not go well; Bentley was afterwards convinced that Dickens wanted to provoke him, and when that failed, to submit the dispute to arbitration.[79] Some patching up must have taken place subsequently, for on the 15th Dickens wrote to Bentley about editorial matters: "Some message has just been delivered here, relative to the second plate [for the September number]. As I waited on Cruikshank yesterday and begged him to furnish a second one, it is quite impossible that I can now countermand it."[80] The *Oliver* plate may already have been completed. Like many others, the preliminary drawings for "Oliver claimed by his affectionate friends" contain an alternative caption, "Bill Sykes and Nancy seizing Oliver, and assuring the bystanders he has run away from his friends." Such provisional titles were probably Cruikshank's suggestions; they record his understanding of the thrust of the scene, and were offered to Dickens as he settled on the wording for the copperplate engraver.[81]

A second attempt at negotiation collapsed when Dickens sent Thomas Beard to New Burlington Street the next day to meet with "the disinterested, unprejudiced, private friend" named by Bentley to speak on his behalf. The "friend" proved to be Bentley's solicitor, John Swarbreck Gregory. Dickens, infuriated by what he thought of as this act of bad faith, requested that future correspondence about the *Miscellany* be conducted through a third party, since "any direct communication between us, would henceforth be most unpleasant to me, and most repugnant to my feelings."[82] For a time, that party was W. Wilson, office manager to Richard's brother Samuel, the printer.

On 30 August Dickens sent Wilson the names of the papers for the October number along with instructions to forward to Cruikshank proofs of four of them *"as soon as you can conveniently get them worked,* as he is very anxious to select his subjects for illustration." Although Dickens was still interested, personally and financially, in "the Miscellany progressing," he determined not to provide any copy for *Oliver* until the dispute was resolved in his favor.[83] Therefore, before going to Broadstairs on holiday, he informed Cruikshank that there would be no *Oliver* to illustrate, and that he had directed the printer to send proofs of four other tales. If they did not furnish two subjects, Dickens would forward another of Barker's stories, and if Cruikshank still could not find material, "I will assist you with more

matter."[84] Conciliatory and considerate, Dickens was relying on Cruikshank in some measure to take up the slack. The confidence he placed was shortly to be extended, when Cruikshank became the "third party" who tried to mediate the quarrel with Bentley.

While Dickens was away, Cruikshank consulted with the publisher and agreed to communicate Bentley's new terms. The house in Doughty Street was robbed, so the Dickenses returned to town early. Cruikshank immediately paid a call; he returned a second time on Friday, September 15. He reported to Bentley afterwards that Dickens insisted on Oliver's counting as the second novel. Minimizing the importance of this concession in an effort to wrest Bentley's consent, Cruikshank argued that "the public will be heartily tired of 'Oliver Twist' long before he reache[s] to three volumes—and I should say more likely to injure the Miscellany than otherwise—People like novelty."[85] He received further instructions from Bentley that evening and prepared to meet Dickens again the following morning. Meanwhile, the printers dispatched proofs of the October Miscellany to Dickens. Bentley had set up articles Dickens had never seen, and had altered the arrangements Dickens had made. Infuriated, Dickens informed his publisher and Cruikshank on Saturday morning that he was resigning from the magazine at the end of the month.[86]

Although some allowance must be made for Bentley, who may not have been sure how much editorial work Dickens was performing during this period, he had been undermining Dickens's authority all along. For instance, Barham, Bentley's old St. Paul's school chum who had been acting for some time as the publisher's unofficial adviser, told Thomas Hughes's grandmother in the spring of 1837 that all his Ingoldsby contributions went directly from him to the printer and that proofs were returned to him "without any intermediate channel." Barham remonstrated with Bentley about inferior articles Dickens had printed, and urged his friend to moderate Dickens's satire, for he disapproved of the "Radicalish tone" of Oliver Twist: "I think it will not be long before it is remedied, for Bentley is loyal to the backbone himself."[87] In the past Bentley had sometimes urged acceptance of pieces addressed to him rather than to Dickens, but never before had he meddled to this extent. When Cruikshank arrived on Saturday morning, Dickens "made a stand upon his Editorial right." At noon, Cruikshank begged Bentley to come to some decision by Monday so that if a friendly arrangement could be concluded "there would then be time to get out the 'Oliver Twist' in the next number."[88] (Whatever he had said to Bentley about the public's tiring of the novel, Cruikshank was eager enough to have it continue.) By the evening, George had received Dickens's letter releasing him "from any further trouble" in the negotiation because Dickens had resigned as editor.[89]

Bentley wrote back a starchy note to Dickens declaring that he was putting the matter in the hands of his legal advisers; Dickens replied by sending the name of his solicitor, Charles Molloy. Cruikshank shuttled back and forth a few more times—in an undated letter Dickens informs Forster that "Cruikshank has been here—deputed by Bentley to say nothing." However, George had made some headway. "He is going to call again tomorrow Morning, and it may be necessary for me to see Talfourd [one of Dickens's legal counselors] afterwards."[90]

In the end Bentley conceded on the novel and the contents of the October *Miscellany*, and Dickens relinquished some of his editorial prerogatives. *Bentley's* was too profitable to be scuttled, and there was some justice to Dickens's complaint that his value had risen well beyond that named in earlier agreements. The principles of a new agreement were jointly ratified on the 28th. They gave Bentley the right to originate three articles in every issue, bound Dickens for three years as editor, assigned him half copyright in any of his *Miscellany* papers after three years, accepted *Oliver* as one of the novels, to be completed by 1 May 1838, and *Barnaby Rudge* as the other, to be completed by the end of October in the same year, and stipulated that Bentley would pay £500 for the former and £700 for the latter for a three-year undivided lease on copyright and half the copyright and profits thereafter.[91]

Several features of this contract impinged on Cruikshank. For one thing, he might now be assigned articles introduced by Bentley, rather than by Dickens; with regard to his illustrations editorial responsibility had been formally divided. As a consequence, Dickens lost interest: "Order the Miscellany just as you please," he told Bentley in December. "I have no wish or care about the matter."[92] For a second, after the middle of October, when Dickens completed the final double number of *Pickwick*, he could devote more of his time to thinking about Oliver's progress, and to structuring it for three volumes. For a third, now that *Twist* was scheduled to be published as a book in mid-1838, Cruikshank's plates would do double duty and might be reviewed as a sequence when they appeared all together.[93] And for a fourth, by his exertions Cruikshank had been partly instrumental in securing the continuation of the novel and Dickens's service as editor of the *Miscellany*. He had conducted energetic negotiations in such a way that he retained the confidence and trust of both parties, something the other "unprejudiced private friends" were unable to do. The hot-tempered egotistical eccentric of legend was nowhere in evidence during this turbulent month.

Lingering resentments and new matters of dispute honed the edge of exchanges between Dickens and Bentley. The publisher, having purchased unconditionally from Wilks his manuscript of Grimaldi's *Memoirs*, may

have planned to serialize them in the *Miscellany*, but Dickens refused to "consent to any one article of Mr. Wilks's agreement."[94] Bentley could insert the material on his own, but he thought better of it, and at the end of November wrung from Dickens reluctant agreement to edit the papers for £300 and half-profits after the advance had been earned back from sales. Dickens said many years later that he undertook the task "chiefly to please Cruikshank."[95] The bad feeling still existing pervades the agreement, which sets forth in very specific ways how Bentley must submit his ledgers to Dickens's audit and how arbitration of disputes was to be effected.[96]

Cruikshank heard from Bentley early in October that one of the November plates would illustrate *Oliver*. Dickens confirmed that decision around the ninth when he told the artist he would be receiving proofs of all the other papers from which to pick a second subject.[97] Friday evening the 13th Cruikshank received from Dickens the first eleven slips of *Oliver* chapter sixteen so that he could study them over the weekend. "I think you will find a very good subject at page 10," Dickens told him, "which we will call 'Oliver's reception by Fagin and the boys'."[98] While Dickens consulted the office copy of *Bentley's* to refresh his memory about Oliver's birth in preparation for writing Bumble's narrative to Mr. Brownlow in chapter seventeen, Cruikshank made his usual notes and drawings preparatory to etching.[99] Once again the plate follows the text precisely, illustrating the moment when Charley Bates inspects Oliver's new togs by the light of a tallow candle stuck into a cleft stick, Fagin makes low bows with mock humility, and the Dodger rifles Oliver's pockets. (An alternate caption on one sketch reads "The grinning Jew makes an obeisance to Oliver, Jack Dawkins and followers.") Not featured in Dickens's text, the looming shadow of Bill Sikes splayed on the wall of the "low earthy-smelling room" counterpoints the gang's feigned hilarity.[100]

Ainsworth, readying yet another edition of *Rookwood* for Bentley's Standard Novels, penned on the 18th of the month a footnote to the preface praising his fellow novelist's "wonderful knowledge of London life and character, and unequalled powers of delineation," for which Dickens returned thanks on the 30th. In the same letter he promised to discuss with Ainsworth when he dined at Kensal Lodge on 8 November what could be done for poor Mrs. Macrone.[101] Disheartened and worn out, Dickens's first publisher had died suddenly on 9 September; after the debts were paid, his widow and children were destitute, a fact that Ainsworth must recently have communicated to his friend. Dickens's efforts on her behalf culminated in the three-volume collection *The Pic-Nic Papers*, published after many delays in the summer of 1841 by Colburn, with illustrations volunteered by Cruikshank, Browne, and P. G. Hamerton.

The rest of the year passed in comparative peace. The dinner to cele-

brate *Pickwick* was held at the Prince of Wales in Leicester Place on Satur-day, 18 November. Those attending were Ainsworth, Browne, Chapman, Dickens and his father, Forster, Hall, Jerdan, Samuel Lover, William Charles Macready, Thomas Noon Talfourd, and probably Cruikshank, to whom Dickens had written the preceding Thursday asking, "Have you made up your mind about Saturday? . . . Let me know."[102] Dickens sent George the sixth installment of Barker's "Nights at Sea" for one December subject and visited him at least twice to settle the second subject, "Master Bates explains a professional technicality."[103] "Shall you be at home at Two oClock to-day?" Dickens queried in the middle of November. "I have been prevented from writing Oliver, so perhaps had better settle the Illustration with you at that time if convenient."[104] And later that month: "I am de-lighted with the drawing, which is most admirable. I shall be at home tomorrow morning 'till a quarter to 12, and if you don't call on *me*, I will call on *you* about 1/2 past one."[105] Charley Bates's demonstration to Oliver of what it means to be "scragged" reinforces the prediction made by the gentleman in the white waistcoat at the close of the first installment that Oliver "will come to be hung." In Dickens's upside-down parable, Fagin's industrious apprentices may be booked for the rope.

During the autumn Cruikshank had much to do. By October he had executed six etchings, and Ebenezer Landells had carved a title-page vi-gnette and tail piece from George's designs for *Rambles in the Footsteps of Don Quixote*, the last production of Henry David Inglis, Scots traveler and miscellaneous writer.[106] Cruikshank's wrapper design for Bentley's forth-coming parts issue of Louis-Adolphe Thiers's *History of the French Revolu-tion* was reproduced in the October *Pickwick* Advertiser.[107] The serial publication of *Sketches* commenced at the beginning of November and ran until June 1839, so every month Cruikshank had to ready two plates for Chapman and Hall. *The Comic Almanack* for 1838 had to be finished for Tilt in time for the expected twenty thousand Christmas sale. And for Thomas Tegg, who was bringing out what the original Peter Parley, the American Samuel Taylor Goodrich, calls a "counterfeit" issue of Peter Par-ley's *Tales about Christmas*, Cruikshank designed twenty-one new wood-engravings to which Tegg added five engraved for previous publications.[108]

Another project involved D. M. Moir, a Scots physician. He contributed to *Blackwood's* and *Fraser's* under the pseudonym "Delta" and was now re-writing and enlarging his 1826–1827 chef-d'oeuvre, *The Life of Mansie Wauch*. Cruikshank had agreed to make eight full-page etchings providing Moir sent him the manuscript as soon as it was revised, since they would have to hurry if Robert Blackwood and his copublisher Robert Cadell were to issue it for the holiday trade. On 6 November Moir pressed his artist for results, asked him to send the manuscript chapters to Cadell for printing,

and requested word about when the illustrations might be expected. In a postscript, he praised the *Oliver* plates, saying that every character down to Sikes's dog was completely individualized.[109] Unfortunately for the publishers, Cruikshank had no time to finish this commission, which consequently dragged on for another year.

He did try to speed a decision from Bentley on Merle's manuscript, which he had submitted on receipt of the author's instructions. "Another Letter from my friend respecting his MS.!" he wrote Bentley on 7 December, "and as he now begins to use strong & pressing language I feel compelled to give him some sort of answer—May I therefore beg as a great favor that you will let me have your Decision in the course of this Ev[enin]g or by tomorrow M[ornin]g?—I had hoped indeed were it only to oblige *me* that you would have decided earlier in this matter—but pray do not let there be any further delay."[110] Bentley returned a favorable answer, but this project too languished until the following summer, while Merle peppered his friend with stinging remarks about the lack of progress.[111]

Throughout December Dickens wrestled with Wilks's "dreary twaddle" about Grimaldi, dictating revisions to his father, John Dickens.[112] He also wrote three more chapters about Oliver before the fifth, but waited until the printer had calculated the number of pages in type before sending copy to Cruikshank, since if he had overwritten, the last incident ("The Burglary") must be held over to the February issue.[113] Fortunately, the printers were able to fit it all in. The January installment, which concludes the "First Book" of the novel, terminates in the best cliff-hanger fashion: "The noises grew confused in the distance; and a cold deadly feeling crept over the boy's heart; and he saw or heard no more." In addition to preliminary drawings, Cruikshank executed two states of the plate as he strove for just the right effect of terror and suspense.[114] "The result," as the artist Brian Robb testifies, "is that Cruikshank so closely involves the spectator in his interior world that you have almost the illusion that if you keep your eye on the page the characters will go on to enact the scene which must follow this momentary episode."[115] Theatrical adapters were within five months to exploit the dramatic potential of this plate.

Celebrations and dinners wound up the season. Charley Dickens was christened at St. Pancras New Church on 9 December. Afterwards a few friends assembled in Doughty Street for music and cards; whether they included the Cruikshanks the records do not disclose. Three days later Dickens dined in Amwell Street where for the first time he met Lockhart.[116] In subsequent days Dickens rode out with Talfourd, Forster, and Ainsworth, dined at Macready's, and met Clarkson Stanfield, a painter of theatrical backdrops and marine subjects who had served in the navy with Douglas

Jerrold and was a close friend of Captain Marryat's brother Joseph. George and Mary Ann apparently spent a quiet time at home. No trace of their Christmas activities remains.

The tempo picked up considerably in 1838. Cruikshank completed the *Grimaldi* plates in early February, may have collaborated with Dickens and possibly with Thackeray on *More Hints on Etiquette* published in March, hired Thackeray to write copy for the 1839 *Almanack*, illustrated nautical works by Barker and Captain Glascock, etched some individual plates of distinction for republications of Bunyan and Defoe and Milton, finished the *Mansie Wauch* project, furnished Bentley with more steels depicting *Ingoldsby* legends, rushed out the final *Oliver* images—executing a new one when the last plate did not suit Forster and Dickens—collaborated with Ainsworth in revising *Jack Sheppard* for serial release, continued his monthly labors on *Sketches*, got out another *Comic Almanack* by December, and partied over the holidays with Ainsworth and Dickens. He seemed to have found, if not Fortunatus's purse, then at least Peter Schlemihl's seven-league boots, and to be scaling alp after alp of achievement.

On 2 January Dickens and Ainsworth spent the day at Macrone's office looking for literary properties to salvage for the estate. One possibility was to serialize the unwritten *Lions of London*, in which Dickens would describe the present metropolis and Ainsworth would "endeavour to revive its departed glories," while Leech and Cruikshank furnished the designs.[117] Impressed by Ainsworth's concern, Dickens recorded in his diary for the day, "Ainsworth has a fine heart."[118] By 5 January, Dickens had finished *Grimaldi* except for his introduction and conclusion, so Cruikshank could have the manuscript and, calling on his vivid recollections of the clown's glorious performances as well as his many spirited and sympathetic portraits, begin designing the plates. Carried away by his enthusiasm, the artist also painted a watercolor (unpublished) of Grimaldi memorializing his "apparently bottomless capacity for strong spirits."[119]

After working hard for several days on *Sketches of Young Gentlemen*, Dickens returned to Oliver. He deliberately postponed for two months giving any clue as to whether his protagonist survived and, instead, filled the intervening five chapters with the comic relief of Mr. Bumble's courtship, intercalated with Fagin's alarmed response to the news that the burglary had been foiled and Oliver shot. By the sixteenth, Dickens was "badly off": "I have not done the young gentleman, nor written the preface to Grimaldi, nor thought of Oliver Twist, or even suggested a subject for the plate," he told Forster.[120] He then started the first chapter of *Oliver*, book two, but chose to keep it by him for reference. Having evidently already talked the scene over with his artist, he penned a memo to George: "I have

described a *small* kettle for one on the fire—a *small* black teapot on the table with a little tray & so forth—and a two ounce tin tea cannister. Also a shawl hanging up—and the cat & kittens before the fire."[121] At some point Cruikshank must have seen the manuscript, since the plate follows Dickens's text right down to the small round table, the sugar basin, and the two port-wine bottles. Actually, no mention is made in Dickens's manuscript of the shawl hanging on the wall behind the matron, though she does muffle herself "in a thick shawl which she hastily caught up" upon being summoned to old Sally's death bed. Perhaps Dickens wrote to Cruikshank before he finished composing the chapter, and at that point only *thought* he would describe the location of Mrs. Corney's wrap.[122] Independently of the text, Cruikshank adds a small ceramic figure of Paul Pry on the mantelpiece: the inquisitive meddlesome character provides a Hogarthian analogue to Bumble's inventory of the widow's portable property.[123] Thackeray thought Cruikshank's version of this scene "even better" than "Boz's exquisite account."[124]

On 21 January Cruikshank received another pleading letter from Moir, who acknowledged that the artist was busy but pointed out that all the sheets had been printed by November and that he and Blackwood were in an awkward position waiting on the illustrations.[125] This backlog did not prevent the Cruikshanks from attending a party at Doughty Street on Saturday evening 27 January. Chapman and Hall would be there, so though *Lions* could not be discussed in front of the ladies, "it would do it no harm if we met together," Dickens wrote inviting Ainsworth to join the company. "The illustrious George and *his* stout lady are coming, so that the Anti-Bores will be triumphant and keep the Bores in due subjection."[126]

Since Dickens went away to Yorkshire with Browne on 30 January, Cruikshank sent the title for a *Grimaldi* plate to Becker on the first of February.[127] As soon as he returned, Dickens asked Bentley to accept *Barnaby*, first as a serial following *Oliver* in the magazine, and then as his second novel. That proposal succeeded, although it took another six months to hammer out the exact terms. Cruikshank was thus slated to become the illustrator for Dickens's next novel, running in tandem with Browne who had become the regular artist for the Chapman and Hall serials. Had the *Lions* come to anything, he would have been very busy indeed. But Bentley was frustrated by Ainsworth's delays—*Jack Sheppard* should have been finished the previous December, and of two other works for which he had paid a £300 advance there was no sign.[128] Perhaps Ainsworth admitted his overcommitment and bowed out of yet a further novel, for by mid-February Dickens was soliciting material for a one-volume miscellany to benefit Mrs. Macrone. He explained to prospective contribu-

tors that Cruikshank "has kindly offered his gratuitous assistance in illus-trating this book."[129]

No word about Oliver was offered in the March *Miscellany*. Dickens sent Fagin to his first interview with Monks and then finished the narrative of Bumble's courtship. Composed later than usual in the month, the relevant copy could not have reached Cruikshank much before the twentieth since the subject appears at the end of the second chapter when Bumble, after proposing marriage to Mrs. Corney, interrupts Noah Claypole gourmandiz-ing on oysters and wooing the Sowerberrys' maid Charlotte. Rushing to complete the etching in time, Cruikshank suddenly found he had no cap-tion. "D[ea]r Dickens, Title wanted—will any of these do?" He then offered three, the first punning in his archest style: "Mr. Claypole Astonishing Mr. Bumble and 'the Natives',", "Mr. Claypole Indulging," and the one chosen, "Mr. Claypole as he Appeared when his Master was Out."[130] The square rather than round table, the plenitude of the repast, the postures and de-meanor of the figures—all contrast pointedly to the previous plate illustrat-ing Bumble's romance. Whether Dickens or Cruikshank originated that contrast is undecidable: what is clear is that the illustrations reflect and comment not only on the text, but also on themselves, forming their own narrative of the progress of Oliver and his acquaintances.

The end of February saw Cruikshank coping with several other projects. Barker wrote to him on the 18th from Nottingham, where he edited a provincial newspaper, enclosing "a rough—very rough sketch which I know you will pardon me for troubling you with but I am presumptuous enough to think that you may make a clever thing of it for the 'Nights at Sea' I now forward to Mr. Bentley."[131] Exemplifying what he wants, Barker describes a puppet show enacting a naval battle, and pencils in a showman's head rising among the waves; Cruikshank makes a wonderfully comic picture, "Battle of the Nile," out of this kinetic diorama invaded by the gigantic head of the puppeteer. Barker goes on to complain about Bentley's treat-ment: the publisher has had his novel for nine months and "promised to go to press last October and now in the middle of February the first volume is not yet printed and the way we are going on it will be yet three months and the season well over before the whole is finished—it drives me half mad."[132] Further cause for complaint was Colburn's using Barker's title of "*The* Old Sailor" for a series of articles in the *Naval and Military Gazette*: "What infernal rascals and pirates these publishers are—and yet they call them-selves and wish the public to believe that they are the patrons of litera-ture!!" Barker's animadversions are so like Dickens's at this period that they tend to justify the latter's attempts to wrest authority from his publishers, and to throw more light on Cruikshank's inability to establish his inde-

pendence. In conclusion, Barker laments that he has no publisher in mind for his collected works "as Bentley never can expect that I should endure the vexation of spirit he has imposed upon me," asks Cruikshank for proofs of the subjects he selects, and sums up his own altered situation: "Things are not with me as they used to be."[133] The vogue for nautical novels had passed, and Barker had few other resources to command.

Cruikshank at last also got on "in earnest" with the *Mansie Wauch* illustrations. He wrote to Moir apologizing for the long delay, and to Robert Blackwood asking whether the plates should be copper or steel. "I prefer working upon copper, but think their being upon steel would be so much more to your advantage that I recommend it." *Mansie*, being a classic, "must I think always be in demand," and the steels would hold up much better for multiple reprintings.[134]

How much Cruikshank had to do with *More Hints on Etiquette*, published at the beginning of March, is unclear.[135] The Huntington Library possesses a manuscript partly in Cruikshank's hand, with one leaf written by Dickens, which contains the matter of *More Hints*, but not worded as in the printed text. On the verso of two of these manuscript leaves are preliminary drawings for "Oliver plucks up a spirit": they may indicate that Cruikshank, having drafted a version of the text which was later revised, kept the pages in the studio and used blank sides to doodle ideas for *Oliver*.[136] Dickens's role is equally problematical: he asked Macrone for a copy of *Hints on Etiquette* in April 1836, but never acknowledged any share in the production of its successor. *Sketches of Young Gentlemen* and *Sunday Under Three Heads*, Dickens noted in his diary for 8 January 1838, "are the only two things I have not done as Boz."[137] On the other hand, Walter Hamilton, Kitton, Gordon Ray, and Michael Slater assign a role to Thackeray.[138] What may have happened is that Dickens thought about writing a sequel and turned the idea over to George for illustrating, that George tried his own hand at writing the letterpress as well as furnishing designs for nine wood-engravings cut by Williams, and that Thackeray, hungry for any kind of work, rewrote the text in its final form. (An analogous exchange among the artist and the two authors occurred the following year with *Lord Bateman*.) Whatever the division of responsibilities, all three probably played some role in the production of the little volume, which proved popular enough to run through three editions in less than a year.[139]

This jumble of subjects, mediums, authors, and publishers typifies Cruikshank's schedule. It makes even more remarkable his ability to embed coherence in the sequence of plates for *Oliver*, and to devise a different look, if not a different style, to each commission. He seldom enjoyed the luxury of working on a single project uninterruptedly from beginning to end; not the least of the measures of his competence is his facility in switching from one

topic to another, substituting the burin for the needle and the needle for the pencil, biting up a frontispiece for Barker one day and superintending the engraving of a wood block the next. Those lessons that he had absorbed from helping his father forty years earlier and that he had mastered during the Regency, he continued to apply throughout the 1830s: dexterity, quickness, indiscriminate collaboration, variety, pointedness.

Grimaldi sold well—seventeen hundred copies on the opening day—but Dickens's imperfect and hasty revisions of Wilks's incompetent narrative earned poor marks.[140] John Hamilton Reynolds, Hood's brother-in-law and John Keats's great friend, published a most unflattering review in the 3 March *Athenaeum*: "We should almost venture the belief that Mr. Dickens had never seen Grimaldi on the stage, so little does he possess of that great and utter Clown-love, which maddens those who have laughed *with* and at Joe."[141] Dickens composed a rebuttal, admitting that he was still a boy when Grimaldi retired and that his recollections are "but shadowy and imperfect." Nonetheless, he denied that it was "essential" for a biographer to have known the person in order to write about him.[142] Forster thought it best not to publish this in the *Miscellany*. Cruikshank's twelve etchings, on the other hand, came in for Reynolds's enthusiastic praise: "The sketches by George Cruikshank are capital; full of character, spirit, and fun. He must have seen Joe"—as indeed he had, many times, when he frequented the theaters as a Regency buck and quaffed a bumper with his fellows in "The Crib." For once, the twenty-year difference in age told in Cruikshank's favor.

The contrasting reception of their respective contributions to *Grimaldi* made no difference to the warm camaraderie between illustrator and writer. When the painter John Martin, acting as Secretary of the Artists Benevolent Fund, invited Cruikshank to serve once more as a steward, this time for the 12 May dinner at which the duke of Cambridge would preside, George accepted, but added that since he did not think he would be of much service individually, he had enlisted Dickens as another of the stewards.[143] It may have been at this time that Cruikshank designed the famous *Boz* plate, "Public Dinners," depicting himself and Dickens shepherding a gaggle of charity children into the banqueting hall.[144]

The fate of Oliver was finally established at the opening of the April *Miscellany*. The young thief, wounded and exhausted, is rescued at "Mrs. Maylie's door," as Cruikshank's plate iterates. Once again Oliver Twist finds a Good Samaritan. There are few indications of communication between Dickens and Cruikshank concerning this illustration. Kate, after giving birth to Mary (Mamie) on 6 March, recovered slowly, so in addition to writing his *Nickleby* installment Dickens spent a lot of time comforting her. By 13 March he was "sitting patiently at home waiting [for inspiration] for Oliver Twist who has not yet arrived"; some days later he had just fallen

to work "tooth and nail" when he was called away to attend his wife.[145] At least two preliminary drawings survive, but there is no further correspondence about the image.[146]

At this time Dickens also began thinking about dramatizing the novel himself. He proposed to the actor-manager Frederick Yates a September opening, not foreseeing that at least five different versions would be staged before Yates's Adelphi production premiered in February 1839.[147] Dickens was confident no one could anticipate his conclusion: "Nobody can have heard what I mean to do with the different characters in the end, inasmuch as at present I don't quite know, myself."[148] Yates had already picked the role of Fagin. Maybe in thinking about that dramatization, Dickens recalled Cruikshank's advice to put either a Christian or a Jew in the condemned cell at Newgate. While the ending was still open, Cruikshank drew pictures of both Sikes (fig. 9) and Fagin (fig. 10) in jail, so the two friends might have explored alternate endings with Yates's production in mind.[149] However, nothing came of Dickens's proposal to work with the actor-manager.

Because Dickens was now reserving the first fortnight of the month for his newest novel, *Nicholas Nickleby*, Cruikshank received suggestions for the May *Miscellany*, "Oliver waited on by the Bow Street Runners," very late. Maybe Dickens counted on more expedition from George than from Browne, or maybe he delayed writing *Oliver* because he had to supply Phiz with two subjects, whereas one of George's could come from another part of the magazine and therefore be executed earlier in the month. (For May, the other illustration was to Ingoldsby's "Lay of St. Nicholas.") Cruikshank expected Dickens to drop by on 16 April, but at the last minute Dickens postponed the engagement for five days: "Will you give me a cigar on Friday night, instead of this evening?" However, the twentieth would be too late in the month to broach the novel illustration, so Dickens appointed one o'clock Tuesday, 17 April, to "settle Oliver."[150] After they met, Cruikshank may have joined Dickens, Forster, and Browne on an evening expedition to Greenwich.[151]

Probably Cruikshank designed the May plate before the chapter was written; the only characters he had not already drawn were the Bow Street officers, whose appearance Dickens describes in a brief, businesslike paragraph at the opening of the number that reads like a précis to (or from) his artist: "The man who had knocked at the door was a stout personage of middle height, aged about fifty, with shiny black hair, cropped pretty close, half whiskers, a round face, and sharp eyes. The other was a red-headed bony man, in top-boots, with a rather ill-favoured countenance, and a turned-up sinister-looking nose."[152] That kindly Mr. Losberne mediates between the invalid Oliver and these latest minions of the law graphically

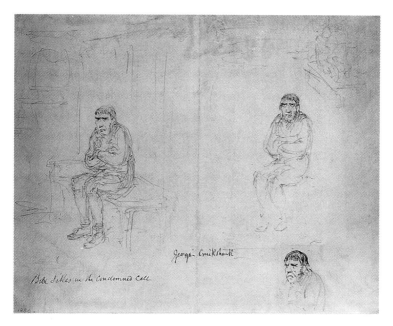

9. George Cruikshank, "Bill Sikes in the Condemned Cell," pencil and pen sketches of unpublished illustration for Oliver Twist, 1838 (courtesy of the Trustees of the British Museum)

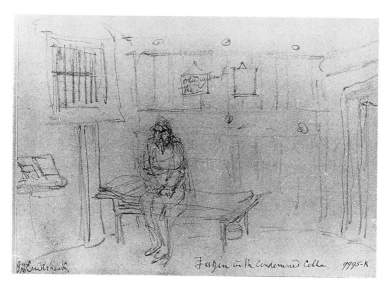

10. George Cruikshank, "Fagin in the Condemned Cell," pencil sketch for Oliver Twist, 1838 (courtesy of the Trustees of the Victoria and Albert Museum)

articulates the foundling's new safety. He passes this examination without harm.

From May onward, Dickens reversed his monthly schedule, writing *Oliver* before *Nickleby*. Bentley was supposed to pay him for the remainder of copy on 1 May, and the whole of the manuscript was to be delivered by midsummer. Cruikshank therefore received the subject in time to produce one of the most powerful plates (fig. 11), captioned on one sketch: "Oliver asleep near the cottage window his enemies look in and recognize him."[153] This is a very difficult scene in which Oliver, between waking and sleeping, incorporates external events into his visions, "until reality and imagination become so strangely blended that it is afterwards almost a matter of impossibility to separate the two." Moreover, Dickens writes, sleeping thoughts may in such cases be materially influenced "by the *mere silent presence* of

11. *George Cruikshank, "Monks and the Jew," Oliver Twist, etching, June 1838*

some external object which may not have been near us when we closed our eyes, and of whose vicinity we have had no waking consciousness."[154] "Monks and the Jew," as the plate was finally captioned, peering through the latticed window of the Maylie cottage into the little room where Oliver cons his lessons, spy the boy drowsing and then flee, *leaving no footprints* behind. This eerie, almost supernatural event combines "reality and imagination" in a passage which Dickens thought "a good one *when* I wrote it," and which George Henry Lewes singled out for commendation.[155] Cruikshank achieves the mingling of two states by juxtapositions of scale: Oliver appears as a diminutive child within a proportionally scaled room, whereas the furniture surrounding him, and the two menacing figures without, are imaged on a much larger scale. The room becomes at once a part of the Maylie's suburban haven and the "close and confined" quarters of Fagin's house, while Oliver is both the maturing student and the small orphan, dwarfed and cramped by his surroundings and intimidated by his companions. Those distortions of size, which in his Napoleonic caricatures Cruikshank had employed to express and deflect anxiety, he now deploys with great subtlety to image a psyche's subconscious sense of its vulnerability.[156]

Throughout the summer Dickens had not only to write his monthly budget for *Nickleby* and *Bentley's*, but also to complete *Oliver.* To make matters worse, the coronation of Victoria on 28 June pushed "magazine day" forward that month to the 26th. There was little time left for play, though Macready found Laman Blanchard, Dickens, and Cruikshank in Forster's study one evening in early May "set in for a *booze.*"[157] Dickens was having trouble again with Bentley, who deducted niggling sums for the half pages by which *Oliver* sometimes ran short, even though Dickens had twice cut his text in order to fit in other matter.[158] This parsimony he discovered after New Burlington Street finally rendered its accounts in late May, and when Dickens protested, Bentley missed two appointments to rectify matters. Hostilities recommenced. Nonetheless, Dickens tried to get Bentley to publish the volume for Mrs. Macrone, and when that overture fell on deaf ears, he turned to Colburn, signing an agreement in August that committed him to furnishing stories by himself and "many other persons known in the world of letters" sufficient to make up one and one-half volumes; Colburn would reprint William Johnson Neale's *Charcoal Sketches* for the remaining volume and a half. He also committed Cruikshank and Browne each to two illustrations, even though by the terms of the agreement for the *Miscellany* Cruikshank would be fined £100 if he worked for Bentley's detested rival.[159]

Cruikshank received his July *Oliver* subject earlier than usual; consequently he was able to make many sketches before etching the conclusion of the beadle's courtship, "Mr. Bumble degraded in the eyes of the Paupers."[160] Cruikshank was also trying to get started on the next year's *Alma-*

nack. He had just about driven the subject of mock meteorology into the ground; and since his writer, Vizetelly, had died, it was time to try something new. Cruikshank persuaded Tilt to hire Thackeray to invent the letterpress for the 1839 *Almanack*. When George Wright, Tilt's office manager, sent the contract, however, the rate of pay was set at £20. "My terms were twenty *guineas* for the 24 pages," Thackeray wrote back toward the end of May; "such rich men as you and Mr. Tilt must not rob me of my shillings—Twenty guineas, and of course no bills." The story Thackeray supplied was "Stubbs's Calendar; or, The Fatal Boots." "I shall see Mr. Cruikshank in the course of the week," he concluded, "and will talk over matters with him. The plan [for short illustrated instalments tied to each month] is the most difficult matter of all."[161] But copy didn't come. By the opening of August Tilt was concerned about the lack of progress, two only of the twelve papers having been delivered; and Thackeray didn't produce the next four until early September. His second daughter, Jane, was a sickly infant, and Thackeray was distracted by debts and fears: please send money, he begs Wright, for "I have a little child lying sadly ill in my house: if please God she recovers." She died the following March.[162]

Until Thackeray provided copy, Cruikshank occupied his time with "*pushing, pestering & driving*" Bentley to print and proof Merle's novel and with the remaining *Oliver* plates.[163] And now the production of that novel became complicated. Dickens began book three in mid-July, telling Bentley on the 10th that he had "planned the tale to the close," and supplying enough copy to artist and printer so that the first two chapters could be published in the August *Miscellany*, accompanied by Cruikshank's "Mr. Fagin and his pupil recovering Nancy."[164] He then composed another Mudfog paper, intending it for the September *Miscellany*. Cruikshank invented two plates, "The Tyrant Sowster" and the sparkling "Automaton Police Office," which left Dickens "in transports" when he saw it on Thursday, 19 July.[165] But a week later Dickens came to the decision that the only way he could finish *Oliver* was to skip a number, "for I no sooner get myself up, high and dry, to attack him manfully than up come the waves of each month's work, and drive me back again into a sea of manuscript."[166] Once more Bentley compromised. In place of Oliver's history, the September *Miscellany* prints the Mudfog piece, Cruikshank's two illustrations, plus his comical "Sir Isaac Newton's Courtship" illustrating Jerdan's August article, and a disingenuous announcement that the length of the Mudfog Report precluded any further installment of the novel.

Meanwhile, Dickens fought against the tide, trying to get enough copy to Cruikshank so that the artist could begin working up not only the monthly plates but also the five illustrations that would first be printed in the three-volume edition scheduled out in November. During August

Dickens wrote several chapters, "not so productive of subjects for illustration" (although one of them described the first meeting between Rose Maylie and Nancy, which was broached as a possible subject); consequently he recommended that Cruikshank look over the August *Miscellany* installment once again, as "possibly there may be one more subject there? I confess that I thought there was, when I wrote it."[167] Cruikshank found the moment when Monks throws away Oliver's mother's locket ("The evidence destroyed"); but either he could not complete the etching in time, or else the press of preparing all the remaining plates slowed him down, for this illustration does not appear until December, *after* it was first published in the volume edition.[168] To forestall any word about the novel's conclusion leaking out, Dickens asked Cruikshank at this time to be very particular about returning the manuscript only to him.

For the October *Miscellany* Cruikshank produced his customary two plates; neither illustrated *Oliver* even though the magazine printed the chapters treating Nancy's first interview with Rose. He prepared drawings for this episode,[169] but was told to find material in "Nights at Sea" and "Marcel's Last Minuet" instead. He complained to Bentley that he couldn't locate a good subject in either and asked for the remaining proof of another piece, an Ingoldsby poem for which he eventually produced "The Handsome Clear-starcher" to accompany "Marcel's Last Minuet."[170]

The *Oliver* chapters for November were also composed in August. "I inclose you a 'go' of Oliver," Dickens told Cruikshank in his mid-August letter, "and although I am of necessity in that part of the story which is not so productive of subjects for illustration as in the sequel it will become when I have cleared two chapters more, I hope you will find something in it suitable to your purpose." The subject Cruikshank selected, in this case independently of Dickens's instruction, was "The Jew & Morris Bolter begin to understand each other." This image of Noah Claypole's cunning and dull conceit Ruskin hailed in *Modern Painters* as "the intensest rendering of vulgarity absolute and utter with which I am acquainted."[171] Becker, the engraver, misreading Dickens's handwriting, lettered the plate "Dolter." "If it is too late to correct this for the Miscellany," Dickens instructed Bentley at the close of October, "he should be careful to do so for the book."[172]

Thus, readers of the *Miscellany* found their expectation of a regular installment of *Oliver* accompanied by a Cruikshank plate disconfirmed by the autumn issues: Mudfog instead of *Oliver* in September; the novel unillustrated in October; novel and appropriate plate in November; and novel installment plus two illustrations, one of them for an August chapter, in December. By then the complete story had been published in three volumes, so anyone interested in how the novel concludes could buy, borrow, or rent a copy.

During September Dickens drafted the two chapters leading to Nancy's second interview with Rose by London Bridge, and this scene became the subject of Cruikshank's other December plate, "The Meeting."[173] On 22 September, Dickens came "to a cessation of hostilities" with his publisher over *Miscellany* accounts and future novels; he invited Cruikshank to join in a celebratory dinner with Bentley on the 26th.[174] "My Missis's love to your'n and will she join us with you?" Dickens adds. (Mary Ann is frequently remembered when Dickens extends social invitations to the Cruikshanks; she seems to have been a favorite with both Charles and Kate.)

His confidence in Bentley having been restored, Dickens turned to with renewed will. By 2 October Nancy was no more; Dickens had finished chapter nine of book three. "I shewed what I have done to Kate last night who was in an unspeakable '*state*', from which and my own impression I augur well," he reported to Forster. "When I have sent Sikes to the Devil, I must have yours."[175] The next day Dickens told Bentley that he was applying "hearty energy" to the last volume. "It is difficult to manage, but I am doing it with greater care, and I think with greater power than I have been able to bring to bear on anything yet." He was eager to meet with Bentley to establish a printing schedule so that the whole story could be issued after publication of the November *Miscellany* installment concerning Fagin, Noah, and the Dodger and before the December one, which would narrate the events leading up to Nancy's murder, reserved for January.[176]

Before 6 October, when Dickens penned the final hours of Sikes's life, he sat down with Cruikshank, handed over a list of possible subjects, and discussed each one.[177] By item 1, "The evidence destroyed," Cruikshank placed a check and the words "in hand." It was the other subject published in August and illustrated in the December *Miscellany*. Item 2, "The interview between Rose and Nancy," Cruikshank crossed out. It was a less dramatic scene than the second interview, witnessed secretly by Noah Claypole disguised as Morris Bolter. If the decision not to produce a plate about the first meeting was made when Dickens first handed over the list, then the discussion must have taken place early enough in September for Cruikshank to pick two other subjects for the October *Miscellany*. More probably, the decision was made after Dickens handed over the list, but before discussing all the rest of the plates, and Cruikshank crossed out that subject several weeks after it had been abandoned. Item 3, "The Meeting," Cruikshank also ticked and marked "in hand." This became the second December plate. Item 4 is first captioned "Oliver's happiness"; Dickens crossed that out and substituted "Rose Maylie and Oliver." It refers to the novel's last chapter, projected but not yet written. Item 5 is "The Last chance" (Sikes's death, completed 6 October). Item 6, first identified as "The Jew's last night ali[ve]," is reentered as "Fagin in the condemned

cell"—a caption that appears on Cruikshank's drawings and on the final plate. Interestingly, Cruikshank marked this plate too as "in hand," and he added after item 5, "4 Sikes attemping [sic] to destroy his dog." It would seem from these annotations that Fagin's fate was decided before Dickens finished off Sikes, and that the illustration of Sikes failing to drown Bull's-eye may have been designed shortly after Dickens wrote it, before he told his artist on 6 October "that the scene of Sikes's escape will not do for illustration. It is so very complicated, with such a multitude of figures, such violent action, and torch-light to boot, that a small plate could not take in the slightest idea of it."[178]

"I am expecting to see you with some designs," Dickens concluded. "When I do, we will settle upon the substitute for this ['The Last Chance']. I shall finish (please God) next week." Since "The Last Chance" is not crossed off the list, it seems likely either that Cruikshank made his annota-tions *before* receiving this letter, or after 20 October, when he doodled more sketches for "The Last Chance" on the back of another Dickens note.[179] But 20 October seems awfully late if four plates then remained to be de-signed; so the earlier timetable fits better, and it helps to establish which preliminary drawings for which final illustrations Dickens might have seen when he and Cruikshank met some time between the sixth and the twen-tieth—certainly "The evidence destroyed" and "The Meeting"; maybe a version of "Fagin in the condemned Cell," although Dickens had not fin-ished that chapter before 6 or perhaps 13 October, when a "Saturday Morn-ing" note informs Forster that "the Jew . . . is such an out and outer that I don't know what to make of him."[180] "Sikes attempting to destroy his dog," which Cruikshank added to Dickens's list, appears to be the substitution for "The interview between Rose and Nancy," so it too may have been designed in time for Dickens to look it over.[181]

The day appointed by the fifth agreement with Bentley for the comple-tion of *Oliver* was Saturday 20 October; Dickens sent the last pages of the manuscript to Cruikshank ahead of schedule, asked for them to be handed to the printer's boy on Saturday afternoon, and then when Cruikshank protested that he had barely had time to read the closing scenes, Dickens countermanded his instructions: "Don't hurry with that MS. The printer bothered me, or I would not have bothered you. If you send it *me* any time tomorrow, that will do. I shall be glad to hear what you think of the last portion of this marvellous tale."[182] On the back of the letter Cruikshank tried out more ideas for Sikes's death and the "Fireside" plate, identified in the list as "Rose Maylie and Oliver." So presumably these designs were not yet fixed.

After tending to *Miscellany* correspondence that he had neglected during the final push on *Oliver*, Dickens proofed the November issue, catching the

error in the caption to Cruikshank's illustration on 27 October. Two days thereafter he set off with Browne for Wales and the Midlands, armed with letters of introduction from Ainsworth to Crossley and other friends. Forster was entrusted to make any last-minute corrections of proof for the volume edition. Meanwhile Cruikshank was working as speedily as he could to bite in, stop out, rebite, proof, touch up, and letter the last four steels. Forster got sheets for the volume issue before Friday, 2 November; on Saturday Bentley scribbled to him a hasty note begging him to return proof promptly as the printers would have to work all the next day, Sunday, to meet the deadline of Wednesday the 7th. [183] Forster had already arranged to take the train to Liverpool to meet Dickens on Monday the 5th. Hearing from Forster on Monday afternoon about the state of the proofs, Dickens determined "to ensure that there shall be no mistakes in Oliver" by returning to London on Thursday the 8th, thereby delaying publication for a day or so. [184] As Forster, writing from Liverpool Monday night, explained to Bentley: "Mr Dickens has altered his plans and returns to town with me on Thursday afternoon, sometime between 12 and 2. Pray have a 'pull' of the revised sheets of the whole book at Doughty Street by that time." [185] What brought Dickens back to town was his concern about the composition of the letterpress, especially of revises neither he nor Forster had corrected of portions of the novel not yet published in *Bentley's*. It was not, as Kathleen Tillotson implies, that "his chief concern was with the illustrations." [186]

When Dickens and Forster arrived in Doughty Street 8 November they saw for the first time complete proofs of the last chapters and preliminaries and also the final plates. Bentley hadn't got the title page right, despite Forster's instructions from Liverpool, and Forster thought it injudicious that the advertising insert announced *Barnaby*, which Dickens had not begun to write, as "*forthcoming*" in the *Miscellany*. But what shocked Forster most was the quality of Cruikshank's etchings. "The others of the third volume are bad enough," Forster wrote to Bentley on Thursday afternoon,

> but these [on pp. 216 and 313] must not really be allowed to remain an instant. I have had some difficulty in prevailing with Mr Dickens to restrict the omissions to these two, which, as they stand now, are a vile and disgusting interpolation on the sense and bearing of the tale, while the evil effects of the others, bad as they are, will chiefly attach to Mr Cruickshank [sic] himself. Let the others, therefore, remain—but, again let me beg of you, lose no moment in getting rid of "Sykes [sic] attempting to destroy his dog (qy—tail-less baboon)" (fig. 12)— and "Rose Maylie and Oliver"—long known as a Rowland Macasser frontispiece to a sixpenny book of forfeits. [187]

Forster often expressed his opinions forcefully even if they offended others. When he first met Bentley at a dinner the publisher gave for Dickens, Barham, and others at Blackwall in July 1838, "This ill-mannered

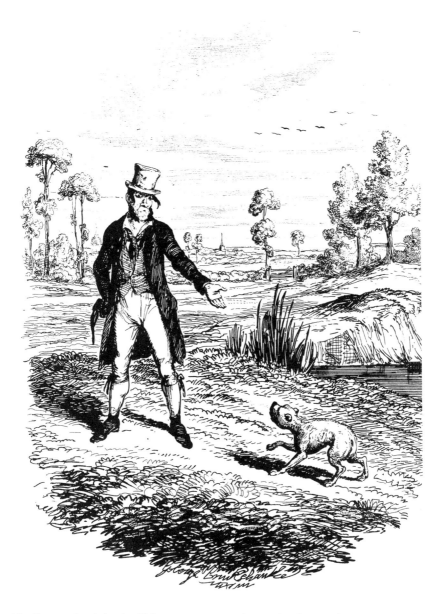

12. George Cruikshank, *"Sikes attempting to destroy his dog,"* Oliver Twist, *etching,*
Nov. 1838

man broke up the pleasure of the party by some rude remarks at several of my guests," Bentley recorded; "so markedly rude, as almost to precipitate personal violence."[188] However close Forster had been to Cruikshank during the past two years, drinking together in his library at Lincoln's Inn Fields, dining at Kensal Lodge and in Doughty Street, consulting about *Miscellany* contracts, and attending the theater, he never was drawn to the artist's forthright personality and extravagant gestures. Forster himself was given to overstatement, though as often in sympathy and support as in attack.[189] Whatever he thought of the eight plates to the third volume, Dickens had already seen at least three of them in print ("The evidence destroyed" done in August for the December *Miscellany*, "Mr. Fagin and his pupil recovering Nancy" published in August, and "The Jew & Morris Bolter" corrected on 27 October for 1 November publication). In October he had accepted designs for some of the others. And Dickens is on record as having a high opinion of "Fagin in the condemned Cell": he told Luke Fildes in 1870, "I want you to make as good a drawing" of one of the cells of Rochester jail, into which John Jasper would be put for the last illustration of *Edwin Drood*, "as Cruikshank's 'Fagin in the condemned cell'."[190] So Forster's letter to Bentley exaggerates both Dickens's unfamiliarity with the plates and his reaction to them.[191]

Indeed, Forster's dislike of the pictures may have influenced Dickens. For although to Bentley Forster says that he has "had some difficulty in prevailing with Mr Dickens to restrict the omissions to these two," when Dickens wrote to Cruikshank the following day only one plate was singled out for replacement. Of no other was Cruikshank asked to etch an alternative, either for subsequent editions of the novel or for its continuation in *Bentley's*. Dickens is in fact very restrained in his request:

> I returned suddenly to town yesterday afternoon to look at the latter pages of Oliver Twist before it was delivered to the booksellers, when I saw the majority of the plates in the last volume for the first time.
>
> With reference to the last one—Rose Maylie and Oliver. Without entering into the question of great haste or any other cause which may have led to its being what it is—I am quite sure there can be little difference of opinion between us with respect to the result—May I ask you whether you will object to designing this plate afresh and doing so *at once* in order that as few impressions as possible of the present one may go forth?
>
> I feel confident you know me too well to feel hurt by this enquiry, and with equal confidence in you I have lost no time in preferring it.[192]

Clearly Dickens is tiptoeing around Cruikshank's potentially explosive temperament. He had seen "the majority" (five of eight) of the plates in the last volume for the first time in proof, even if he had sanctioned some of their designs earlier. There was "great haste" all round in completing the

volume—the Pilgrim editors' footnote to the effect that "Cruikshank's de-
lay has not been explained" convicts the artist of something he never
caused and that never occurred. But if these statements by Dickens were
undeniable, the next one, that both author and artist were in agreement
about the poor quality of the last illustration, was patently untrue. Cruik-
shank had not produced bad work at all: the plate is carefully finished and
shows a handsome young Oliver by the fireside with Mrs. Maylie, Harry,
and a somewhat swan-necked Agnes.

The artist could hardly have been pleased by this missive. First he tried
stippling more shadows into the steel, possibly in order to meet specific
objections Dickens relayed in person.[193] When that expedient didn't serve,
Cruikshank worked up alternative sketches he had prepared at the same
time as the "Fireside" plate.[194] He sent this design to Dickens, who returned
it with the notation that Rose and Oliver looked "too old."[195] Cruikshank
then etched the "Church" plate, a much less attractive composition in
which the characters look old, sad, and ugly. Copies with the revised title
page and substituted plate were available by 16 November.

Other contemporary evidence shows that Cruikshank exerted himself
mightily on these last images. He chose to ignore Dickens's advice that the
death of the housebreaker could not be represented (fig. 13). The "multi-
tude of figures" is indicated by the onlookers leaning out of tenement win-
dows. The "torch-light" is suggested by the illumination picking out the
wall, the chimney, and Bill's leg and features. The "violent action" is reca-
pitulated by the structure, a collision of verticals with diagonals, and by the
imagery, which moves from the background of scudding clouds and fran-
tically gesturing neighbors to the foregrounded tiles of the vertiginous roof
thrust forward onto the picture's front plane, up to Bull's-eye perched pre-
cariously on the apex of the roof, around the chimney and down through
the rope to the ominous dangling noose and the strong T of the guttering.
The streaming tails of Bill's Belcher neckerchief identify the wind whip-
ping past (a trick Cruikshank had used in plate IV of *The Progress of a
Midshipman*) and signify that potential for hanging which has been applied
so often to so many characters in this parable. The abrupt recession onto
the houses behind, whose distance is exaggerated by their diminution,
reads as an analogue of the steep drop into Folly Ditch below. "The tiles of
the roof," Swinburne said, "and the stack of chimneys and the glimmering
walls and lattices and the smoke-swept sky . . . give the fittest and the
fearfullest relief to the imminence of [Sikes's] doom."[196] At the intersection
of these dizzying, energized spaces, the housebreaker balances, legs and
arms straining to hold himself stable by means of the very hemp that will
shortly terminate his frantic activity. The whole plate is bravura pictorial
narration, fully in accord with Dickens's vivid prose yet independent and

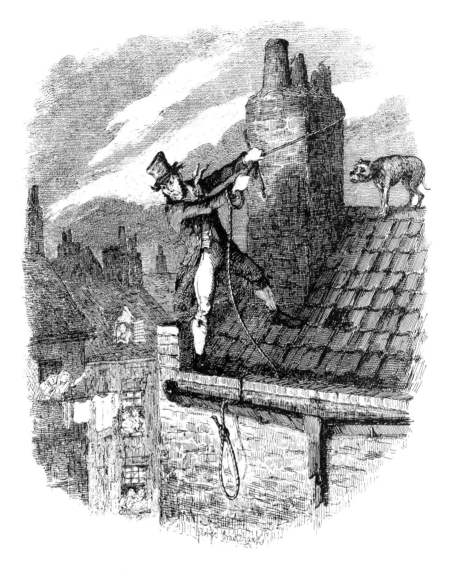

13. George Cruikshank, "The Last Chance," Oliver Twist, etching, Nov. 1838

supplementary, a similar story told by different means. The preliminary drawing is captioned as Cruikshank saw the scene verbally: "Sykes endeavoring to escape by fixing the rope around the stack of chimnies by which he is killed."[197]

Even more indelible is the image of Fagin in the condemned cell (fig. 14). It is arguably the most celebrated etching Cruikshank ever made and

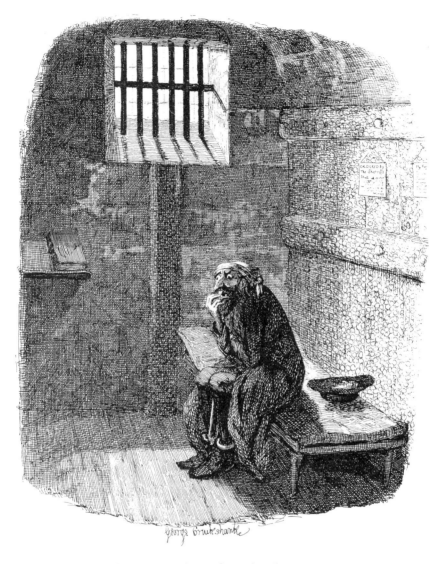

14. *George Cruikshank, "Fagin in the condemned Cell,"* Oliver Twist, *etching, Nov.* 1838

among the most famous book illustrations of all time. Cruikshank was somewhat obsessed by the subject of Jewish fences. He studied one "rascally" denizen of Saffron Hill for weeks, called another to Dickens's attention as a possible subject for *Sketches*, impersonated one before Dickens and Ainsworth at the start of *Oliver*; he took aspects of Fagin's last

appearance from his own posture; he told and retold stories about creating the plate up to a couple of months before his death.[198] At some level, though not a Jew himself, he felt an affinity, an "attraction of repulsion," that chimed with Dickens's depiction of an old man both mesmerizing and repellent.[199]

Fagin appears six·times in Cruikshank's illustrations, always in some commanding pose—greeting Oliver while holding a toasting fork, or bowing before him with mock humility, or spying on him as he dozes, recovering Nancy or appreciating Noah's low cunning. Though Monks is, within Dickens's story, the higher-class originator of the plot against Oliver's character, and Bill Sikes endangers Oliver's body, both in the text and in Cruikshank's plates Fagin emerges as the presiding threat to Oliver's soul: "In short, the wily old Jew had the boy in his toils; and, having prepared his mind by solitude and gloom to prefer any society to the companionship of his own sad thoughts in such a dreary place, was now slowly instilling into his soul the poison which he hoped would blacken it and change its hue for ever."[200]

At no point before the end is Fagin imaged *alone*. All the more significant, therefore, is the reversal of sympathy Dickens and Cruikshank engineer in the final episode, when isolated, hunted, stared at, Fagin himself becomes the prey of a vindictive society. Solitary in his cell, the "old man" refuses the consolations offered by his religion and by the young child who speaks forgiveness; instead he gazes into the heart of darkness, the devastating insufficiency that his philosophy of looking out for "number one" has ultimately disclosed. Cruikshank retained every hint in Dickens's text of those rare moments when Fagin, furtive and frightened, entertains his own private demons. The artist's image of the lonely figure staring with bloodshot eyes into the abyss recapitulates an earlier description of Fagin waiting for Bill Sikes to return so that he can report Nancy's betrayal: "His right hand was raised to his lips, and as, absorbed in thought, he bit his long black nails, he disclosed among his toothless gums a few such fangs as should have been a dog's or rat's."[201] This passage, written around the first of October, may have been influenced by Cruikshank's personifications of Fagin, and may even have been composed after preliminary drawings for "Fagin in the condemned Cell" had been shown to Dickens.

The text provides a number of other pictures of the Jew in his last days: he raves and blasphemes and howls and tears his hair and flays his hands beating on the door and walls. But the moment Cruikshank seizes upon is a moment of psychological rather than somatic fury:

> He cowered down upon his stone bed, and thought of the past. He had been wounded with some missiles from the crowd on the day of his capture, and his

head was bandaged with a linen cloth. His red hair hung down upon his blood-less face; his beard was torn and twisted into knots; his eyes shone with a terrible light; his unwashed flesh crackled with the fever that burnt him up. Eight—nine—ten. If it was not a trick to frighten him, and those were the real hours treading on each other's heels, where would he be when they came round again![202]

Cruikshank may well have arrived at the definitive posture for Fagin as a result of spying his own image in a cheval glass, as he told Horace Mayhew and others.[203] On one visit to 263 Hampstead Road, Cruikshank's address after 1864, Cuthbert Bede witnessed the artist's reenactment of the scene:

> Sitting down . . . and crouching in the huddled posture of "the Jew—the dreadful Jew—that Cruikshank drew"—to quote Thackeray's words—fiercely gnawing at his finger-nails, tossing his hair loosely about his head, and calling up a look of wild horror into his eyes, the artist, with the great histrionic powers that he possessed, seemed to have really transformed himself into the character of the Jew whom he so forcibly depicted.[204]

On another occasion, Cruikshank told Austin Dobson that he was only unsure whether the knuckles should be raised or depressed, and assumed the pose in front of a mirror to study the effects of each position, to the astonishment of a child looking on.[205] Cruikshank probably looked less like his portrait of Fagin in 1838, when he was forty-six, than in 1877, when the poet and collector Frederick Locker was so struck by the resemblance he playfully addressed him as "Mr. Fagin."[206]

What makes the illustration so immeasurably powerful, however, is not only the physiognomy of the figure but also its evocation of Fagin's psychic terror, communicated on the one hand through all the elements of pose, gesture, and facial expression—derived as much from theatrical and graphic conventions as from naturalistic mimesis—and on the other through the poetry of light, texture, and space configured by the unyielding, blotchy stone walls, arched roof, doubly barred window, and bare furnishings. For once, Cruikshank did not clutter the plate either by including the guards keeping watch or by adding more than a simple written notice—the order of execution. Every crosshatch "tells." John Harvey is right about the controlled, rapid, confident, firm, and sensitive line work. But G. K. Chesterton's memorable reaction—"it is not drawn with the free lines of a free man; it has the half-witted secrecies of a hunted thief. It does not look merely like a picture of Fagin; it looks like a picture by Fagin"—registers a deeper truth about the "cramped energy" of a soul burning amidst cold unfeeling stone.[207]

Forster's opinion of the last plates has not been shared by others. In the *Quarterly Review*, Richard Ford said that Sikes attempting to drown Bull's-eye and Fagin cowering in the condemned cell exhibited "a range of power perhaps unrivalled since Hogarth." So great was Cruikshank's achievement

in these plates, Ford went on to say, that "we are really surprised that such judges as Wilkie, Landseer, Leslie, Allan, &c., have not ere now insisted on breaking through all puny laws, and giving this man of undoubted genius his diploma."[208] Once again Cruikshank was encouraged to think of himself as a potential Academician, and once again any such recognition was withheld. Thackeray, in his 1840 survey of Cruikshank's oeuvre, likewise lavishes praise on the same pictures:

> What a fine touching picture of melancholy desolation is that of Sykes [sic] and the dog! The poor cur is not too well drawn, the landscape is stiff and formal; but in this case the faults, if faults they be, of execution rather add to than diminish the effect of the picture: it has a strange, wild, dreary, broken-hearted look; we fancy we see the landscape as it must have appeared to Sykes, when ghastly and with bloodshot eyes he looked at it. As for the Jew in the dungeon, let us say nothing of it—what can we say to describe it?[209]

A different, but equally heart-warming, tribute to the artist's skill was being paid by the young Sala, recovering from an illness that had blinded him for a year, by sedulously copying Cruikshank's *Sketches* and *Oliver* plates:

> I am sure that I tried my hand on "Fagin in the Condemned Cell," and "Sikes Attempting to Destroy his Dog," twenty times. . . . Every touch of the Cruikshankian etching needle I slavishly followed; but it was the slavishness, I hope, of a faithful dog, not that of a cowering serf. I did not know that the dotted lines frequently made use of by George in his flesh tints and in relief to the dark lines in his foreground were produced by a mechanical implement called a roulette; so with the pen's point I stippled in the lines, dot for dot. I did not know that the gradations of tone and depth in the colour were due to successive "bitings" and rebitings of the plates, but I traced with Indian ink, lampblack, sepia, vinegar, gum, and what not, fluids of varying intensity and thickness, to express the different shades between deep dark and tender greys. . . . I drew imaginary portraits, I thought out imaginary biographies of him; and when I went to bed, I dreamt about him.[210]

John Gilbert, a black-and-white artist who was given his diploma, was also at this time copying hundreds of Cruikshank's etchings and wood-engravings; and even Forster twice promised in the *Examiner* to review the *Twist* plates, which "merit, and shall receive, a separate notice by themselves. They advance Cruikshank's claims as an artist to a much higher point than they had reached before." No such notice ever appeared, however.[211]

Still, Forster's disgust registers something important about the difference between Cruikshank's art and Dickens's. The "tail-less baboon" and the "Rowland Macasser frontispiece to a sixpenny book of forfeits" are epithets that name the grotesque, caricatural, and pretty aspects of Cruikshank's art—all part of the tradition of English graphic satire he worked within.

Dickens, however, in addition to being "our modern Hogarth" and "the CRUIKSHANK of writers" was beginning to be compared to artists in a related pictorial tradition, homelier and more "realistic": the Netherlandish masters, Adriaen van Ostade and David Teniers the Younger, and their British genre descendant Sir David Wilkie. The *Weekly Dispatch* said Nancy's death was rendered with "the pen of the Dutch or Flemish painter," and *Bell's Weekly* proclaimed that Dickens was "the Wilkie of the cottage, the lodging-house, and the tavern club."[212]

The theater was to provide the medium which, in a sense, separated Cruikshank's sensibility even further from Dickens's. In spite of Boz's early fascination with the stage, after 1838 Dickens pulled back, both from composing plays and from participating in the dramatization of his novels. When he heard Macready pronounce "the utter impracticability of *Oliver Twist* for any dramatic purpose" and reject his farce *The Lamplighter*, and when he found Almar's adaptation of *Oliver* so bad that "in the middle of the first scene he laid himself down upon the floor in a corner of the box and never rose from it until the drop-scene fell," as Forster relates, Dickens shifted from writing *for* to writing *about* the theater.[213]

Cruikshank moved in an opposite direction. C. Z. Barnett staged a production of *Oliver* at the Pavilion Theatre on 21 May 1838, though Dickens had only reached the midpoint of his tale. One of the play's visual highlights came in Act III, where Cruikshank's plate "The Burglary" was staged as a tableau to close the scene.[214] An earlier moment, reproduced in Findlay's frontispiece to the printed text, dramatized the illustration of "Oliver's reception by Fagin and the boys," although Bull's-eye and Nancy are absent and the props differ. On the other hand, Sikes's ominous shadow, Cruikshank's independent contribution to the scene, is exaggerated by the strong lighting.[215] Another instance of Cruikshank's theatrical influence appears in the frontispiece to the printed text of Almar's version, which premiered 19 November 1838 at the Surrey. Executed by Pierce Egan the Younger "from a Drawing taken during the Representation," it shows how Almar staged Sikes's "last chance." The directions call for both the interior and the exterior of the Jacob's Island crib to be visible, but apart from that modification necessary to performing simultaneously Bill's attempt to escape and Toby's arrest, the set replicates the principal features of Cruikshank's illustration: the steep roof, chimney, and scudding clouds, even the highlighted wall and cross-tree gutter.[216] A third production, possibly authored by J. Stirling Coyne and first performed at the Adelphi on 25 February 1839, makes an explicit acknowledgment of the artist's contribution: "The Scenery either from designs made upon the spot by Mr. Brunning, or from the Etchings which so richly illustrate the Work, by the talented George Cruikshank."[217] One reviewer judged that "the tableaux [were] such

as George Cruikshank himself would not have despised."[218] As Jonathan Hill justly concludes, "Cruikshank would have seen quite enough in the use made of his plates side by side with dramatic tableaux . . . to suggest a path of stylistic development he might follow in future illustrative work."[219] The opportunity to emphasize theatrical effects in his etchings came to Cruikshank quickly; even before *Oliver* finished its serial run in the *Miscellany*, George was scratching spectacular illustrations for Ainsworth's Newgate sequel, *Jack Sheppard.*

28

ALMOST IN LOVE WITH ROGUERY

ON READING AINSWORTH'S JACK SHEPPARD

By Charles Chickens, Esq.

Much have I travailed 'mong the prigs of old,
 And many goodly Sikes and Fagins seen;
 With many Artful Dodgers have I been,
Whom beaks in fetters for Sir Peter hold.
Oft of the Red Room, too, had I been told,
 That deep file, Sheppard, ruled as his demesne,
 Yet did I never know his might serene,
Till I heard Ainsworth speak out loud and bold.
Then felt I like some faker of men's clyes,
 When a new doxy reels into his ken, —
Or like stout Curtis, when, with purple eyes,
 He stared at green of turtle—winked, and then
Looked on each gobbet with a wild surmise,
 SILENT UPON A BENCH OF ALDERMEN!

Theodore Martin[1]

CRUIKSHANK'S cordial relations with Dickens and Bentley were not seriously impaired by the rejection of the "Fireside" plate. As soon as the substitute was printed and corrected editions of the novel released, all three participants in *Oliver Twist* moved into high gear entertaining. Bentley, now Ainsworth's "gentlemanly" publisher, gave a dinner on Thursday 22 November attended, according to Thomas Moore, by "all the very *haut ton* of the literature of the day": Ainsworth, Barham, Campbell, Dickens, Jerdan, Lover, and Moore.[2] The next day Dickens reminded Forster that he was to procure a box for the Cruikshanks to the Adelphi production of *Nicholas Nickleby*, at which, in Dickens's judgment, the "tableaux from Browne's Sketches" were "exceedingly good."[3] But Forster failed to obtain the requested seats, so Dickens had to apply to Macready, as George was in "*an agony of suspence.*"[4]

Dr. John Elliotson wrote to Dickens inviting him and Cruikshank to

attend one of his mesmeric demonstrations at University College Hospital; accordingly, they went with Macready on Sunday afternoon the 25th.[5] On the 28th, the Dickenses gave a dinner for the Cruikshanks, the Burnetts, and John Pritt Harley.[6] A few days later, just as Dickens was about to write to Forster to say that nobody but the two of them would be going to the Adelphi to see *Nickleby* for a second time, a note from Cruikshank arrived saying *they* were going and would pick up the Dickenses in their fly.[7]

On 11 December, Cruikshank and Dickens dined with the Antiquarian Society, on which occasion Cruikshank may have sung "Lord Bateman" in the manner of a street ballad singer.[8] On the 20th, Cruikshank received Ainsworth's invitation to ride out to Kensal Green with Dickens and Forster to celebrate Jack Sheppard's nativity nine days later. Cruikshank got the dates muddled, as Dickens told Ainsworth the day before the party:

> Cruikshank has been here to say how that he thought your dinner was *last* Saturday, how that he now finds it is *next* Saturday, and how he means to come with me and surprise you. As the surprise, however agreeable, might be too much for Mrs. Touchet, I have thought it best to send you this warning. Mind, you must assume the virtue though you have it not, and feign extravagant astonishment at sight of the Illustrious George.[9]

And on New Year's Eve, Dickens stayed at home to receive Ainsworth, Forster, and "the Illustrious George."[10]

By the end of 1838, Cruikshank had, in addition to the monthly embellishments of the *Miscellany*, struck off a number of other images, both comic and serious, for works ranging from the trivial to the influential. Of the "utmost rarity" is his depiction of Eden at the moment when "unto Adam also and to his wife did the Lord God make coats of skins," a frontispiece to a parodic version of *Paradise Lost* by "Lucian Redivivus" (William Watts).[11] He also penciled and tinted a portrait of a pretty girl with ringlets, Frances Ann Payne Georges, a sketch that belies the canard that Cruikshank never portrayed an attractive female.[12] For Bentley, Cruikshank etched six illustrations to Captain William Nugent Glascock's *Land Sharks and Sea Gulls*. The novel is, as the *DNB* judges, "stupid enough," and the pictures recapitulate without notable advance Cruikshank's nautical subjects.[13]

Two other commissions completed this year are implicated more complexly in Cruikshank's career. Fisher, Son and Co. brought out a royal octavo edition of *Pilgrim's Progress* with explanatory notes, a biography of Bunyan, and many illustrations.[14] The one of "Vanity Fair" is by Cruikshank: it is a richly realized image of Christian and Faithful at the Fair, with a Punch and Judy show and other booths soliciting customers. As Thackeray, working on the letterpress for the *Comic Almanack*, may have

been in and out of the studio while George was making the plate, it is conceivable, though not certain, that he saw the picture, and that it lay dormant in his mind until 1845 and the commencement of *Vanity Fair: Pen and Pencil Sketches of London Society.*[15]

Tegg hired Cruikshank to design a wood-engraved frontispiece to a Benjamin Franklin style *Present for an Apprentice.*[16] The picture is yet another version of *Industry and Idleness*. The pervasiveness of Hogarthian paradigms is evident in a project mooted by Barham in the fall of 1838: he outlined to Bentley a *Modern Rake's Progress*, which would "enforce a moral by showing the phases through which a young man who enters upon a career of profligacy rapidly descends from affluence and position to utter ruin and degradation." The writing would be collaborative, just as in the twice-abandoned *Lions of London*: Barham would describe the birth and opening days (rewriting *Oliver Twist* to eliminate the "low" and "Radicalish" elements), Tom Hughes would cover his life at public school (the "germ" of *Tom Brown's School Days*), Barham's son would carry him through a few terms at Oxford, and Sir William Lennox would introduce him to the guards and Crockford's.[17] The venture was never consummated, although Leech drew some illustrations he published independently in *Bell's Life*, while the story went to Henry Cockton, whose *Stanley Thorn*, printed in the 1840 *Miscellany*, contained plates by Leech, Crowquill, and Cruikshank.[18] Cruikshank's best chance to depict the progress of morally contrasting protagonists, however, was about to surface with the commencement of the illustrations to *Jack Sheppard*.

Before Cruikshank could start, he had to get out of the way some lingering commissions. *Melton de Mowbray* was at last published, so he wrote to Merle about the reviews ("'The Athenaeum' gave a very poor & shabby notice & the 'Spectator' I understand cut poor Melton all to ribbons"), about the sales (350 copies of an edition of 500 purchased within a month), and about other details of the accounts. Merle had mentioned that he had encountered in an Italian prison a great bandit chief, a "remarkably handsome fellow & excessively l[ike] yourself," though he lacked the artist's "eagle eye." Cruikshank replied:

> I do not know whether I *ought* consider my being compared to a *Bandit* as a compliment or not but you are not the only one who has made the same remark[.] Mr. Lockhart said my portrait reminded him of some ferocious looking fellow that he saw imprisoned at Rome—or elsewhere.[19]

Finally, on 9 December, the patient Moir wrote again urging Cruikshank to finish up the *Mansie Wauch* plates, since Blackwood and Cadell hoped to publish on 20 December in time to catch the Christmas trade. As further incentive, "Delta" included an extensive encomium on the first four

steels—praising the handling of light and shade, the faithfulness to the details of the text, the conception of the scenes, and the attitudes of the figures.[20]

When Cruikshank turned to Ainsworth's "Hogarthian novel," he had a lot of manuscript to work with.[21] By March 1838 Ainsworth had completed the first of the book's three "epochs"—corresponding to the three volumes in which it was to be published, like *Oliver*, before the completion of the serial run—and had started on the second.[22] But the author's enthusiasm and his voluminous research extended the tale beyond the limits Bentley thought his subscribers could tolerate, so in December 1838, while Cruikshank was preparing the first illustrations, Ainsworth cut substantially. Dispatching two parcels to Charles Ollier, Bentley's literary adviser, on 10 December, Ainsworth attempted to reassure his publisher that he was "heart and soul in the matter": "I am anxious that you should satisfy him of my zeal—and on this head you cannot speak too strongly. . . . The larger parcel contains the MS. as prepared for *The Miscellany*. The smaller parcel contains the excised matter, that Bentley may *satisfy* himself of the *extent* of the alterations."[23]

Among those alterations were ones accommodating the images Cruikshank supplied.[24] More consistently than Dickens's letterpress, Ainsworth's text describes the scene the artist illustrates, detailing the figures, costumes, architecture, wall decorations, furniture, condition of repair or dilapidation, lighting, atmosphere, and anything else that might be included in the plate. These long descriptive passages retard the narrative in many instances and become an exercise in unassimilated antiquarianism, stuffed with the language of bygone eras and the particularities of forgotten fashions and customs. Thackeray would parody this naive historicism in *Punch's Prize Novelists* (1847), but for the moment, in the aftermath of Scott, Ainsworth gained a considerable reputation and following for his research and revival of past cultures. Cruikshank shared in this enterprise of recovery, making thereby yet another bid to be counted among historical artists, and, for the next seven years, much of his illustrative work outside the *Comic Almanack* was devoted to picturing not contemporary London but rather what Cobbett called the "great wen" in the Stuart and Hanoverian eras.

The first illustration for *Jack Sheppard*, appearing in the January 1839 number of the *Miscellany* ahead of *Oliver Twist* (now relegated to the back pages of each issue), shows the master carpenter Owen Wood offering to adopt the son of his former journeyman, Tom Sheppard. Wood stands in a sordid and miserable room in the Old Mint in Southwark talking to Jack's mother, who much later will be revealed as the abducted daughter of Sir Montacute Trenchard. Ainsworth takes forty-four lines to particularize this "sorry lodging" and its inhabitants, and every item so denominated appears

in the plate. Despite Thackeray's dislike of Ainsworth's novel and Newgate fiction in general, he devotes more pages of his 1840 review to these illustrations than to any other of Cruikshank's productions. He judges this "a poor print, on a poor subject" because it is "cut up, to use the artist's phrase, by the number of accessories which the engraver has thought proper, after the author's elaborate description, elaborately to reproduce."[25]

Whether in this instance Cruikshank's drawing preceded Ainsworth's revisions or followed them surviving records do not indicate, but the fit between text and picture is so explicit that neither could have been produced without consulting the other. Moreoever, in this most overt retelling of *Industry and Idleness*, Ainsworth appropriates Hogarth's method of pictorial moral commentary: the wall of Mrs. Sheppard's chamber is scored with a crude drawing of Nebuchadnezzar's punishment and decorated with a handbill advertising the last dying speech and confession of her late husband, hanged at Tyburn for housebreaking. In this instance, as often elsewhere in *Jack Sheppard*, pictures precede text and generate it: Hogarth's, the kinds of pictures he includes in his own plates to gloss his narrative, and the demotic imagery available in the eighteenth and nineteenth centuries for the poor and illiterate—woodcut portraits of the sovereigns (one of the Chevalier de Saint George, alias James the Third, intimates Mrs. Sheppard's Jacobite sympathies), handbills, and crude sketches by the inmates themselves. In various ways as the novel proceeds, Cruikshank's own plates also figure in this interpictoriality: the last four illustrations to *Oliver* run in tandem with the first eight (two per installment) of *Sheppard*.

So from the beginning Cruikshank "illustrated" *Jack Sheppard* in a more complexly referential way than he had *Oliver*. The scenes, characters, and clothing did not refer to originals to be observed in contemporary London; instead, they derived from written materials and prints of earlier times that Ainsworth lent.[26] The artist's reinterpretation was also partly shaped by his new awareness of the power of theatrical adaptation structured around tableaux: Cruikshank represents the text in histrionic freeze frames.[27] Thus, more theatrically and convolutedly than in *Sketches*, *Jack Sheppard* reinscribes prior pictorial narratives. "From their Hogarthian character," Ainsworth told Blanchard Jerrold, "and careful attention to detail, I consider these by far the best of Cruikshank's designs. They raised him to a point he had never before attained."[28]

Not every plate is accompanied by an extensive gloss. The second image for the first installment, of Jonathan Wild discovering Thames Darrell's father in the loft, springs from only two sentences: "Drawing a pistol, and unclosing his lantern with the quickness of thought, he then burst through an open trap-door into a small loft. The light fell upon the fugitive, who stood before him in an attitude of defence, with the child in his arms."[29] In

the preliminary pencil drawing, Cruikshank showed Wild fully emerged from the trapdoor, but with his artist's instinct for dramatic effect, he changed his image in the etching so that the thief-taker is only halfway into the attic.[30] Bentley rowed with Ainsworth over the design, but author and artist finally prevailed.[31] They were right. Eye and mind together read the final version as kinetic, seeing Wild as still in motion up the ladder. This design also reduces the diameter of the lantern's light so that Darrell is more tightly spotlighted. And over Wild, Cruikshank adds a crossbeam from which a length of looped rope depends, one of the many pictorial hints of the gallows that foreshadow Sheppard's end. "The loft is one of the most striking scenes even *you* have produced," Ainsworth told George, "and gives me a higher notion (and it was no mean standard at which I rated you) than I had previously entertained of your powers."[32] Thackeray thought the plate "admirable—ghastly, terrible, and the treatment of it extraordinarily skilful, minute, and bold. . . . One sees here, as in the two next plates of the storm and murder, what a fine eye the artist has, what a skilful hand, and what a sympathy for the wild and dreadful."[33]

The plates for the second installment of the novel, which preceded Sikes's "Last Chance," confirm Cruikshank's *Sheppard* style, unmistakably different from the vignette designs for Dickens. Ainsworth's illustrations are bordered rectangles approximately 4½ inches high by 3⅞ inches wide. Each picture, like an independent plate, is finished all the way to the margins, with a thin white frame between image and etched border. Looking like matted prints, they self-consciously call attention to their status *as* independent etchings, unlike the roughly oval *Twist* vignettes, which radiate from the energy of the figures and fade off into the surrounding white paper. The *Sheppard* plates, like lantern slides or motion-picture stills, are windows onto another space and time that are graphically distinct from the time and space of the facing letterpress. By virtue of their imagistic power they exert a powerful attraction, drawing the viewer into their world.

The hurricane, which deluges London on the night in 1703 when Wood offers to adopt the infant Sheppard, affords Ainsworth the opportunity for an extended set piece: the hazardous passage across the engorged, rushing Thames of Wood, Darrell and his son, Sir Rowland Trenchard, his henchmen, and the watermen. The words ("good loud words too; Mr. Ainsworth's description is a good and spirited one," Thackeray says) go on for pages.[34] To squeeze it all in, Dickens, as editor, thought first of cutting a paragraph beginning "The hurricane had now reached its climax. The blast shrieked, as if exulting in its wrathful mission," and going on through the penetrating and benumbing lash of the rain to the wild apprehensions inspired by the darkness and the tumult: "Imagination, coloured by the obscurity, peopled the air with phantoms. Ten thousand steeds appeared to be

trampling aloft, charged with the work of devastation."[35] But he changed his mind, directing the printers instead to strike out the music accompanying the ballad of "Saint Giles's Bowl" at the beginning of the preceding chapter.

Ainsworth's writing is indeed effective, if labored. For once he inserts information—in this case about London Bridge's flood-impeding piers on which Darrell's baby and Wood are shipwrecked—in a way that heightens, rather than lowers, narrative intensity. After consulting *Chronicles of the Bridge* for his description, Ainsworth sent the book on so that his illustrator could copy the pictures.[36]

Cruikshank's rendition of "The Storm" (fig. 15) is in its own way equally melodramatic and labored, a densely crosshatched configuration of foaming and cascading water, pelting rain, and massive stone, all dwarfing the four figures contending against it. "It is as near to abstract composition as Cruikshank came," Anthony Burton writes,

> and it is the contrasting areas of tone that give it its impact. Technically these are a brilliant representation of the turbulent meeting of air and water, light and shadow at the height of a storm. And formally they make a strong pattern of shapes: the rounded archivolt of the bridge, the curving rush of the water and the counter-curve of the driving rain, the conflicting diagonal courses of the flying spray, and the rectangular frame of the etching which keeps the whole surface pattern taut.[37]

The condition of human beings assaulted by forces beyond their control was a subject that often brought out Cruikshank's most powerful imagery. The combination of arched, unyielding bridge, engulfing waters, and frail human creatures was one he returned to again and again, notably in *The Tower of London*, where the scenes are rendered panoramically, and in the last plate of *The Drunkard's Children*, where the poor girl's flight over the parapet into the river surrealistically articulates the social, psychological, and moral impulses to suicide. The contrast between "The Storm" and Bill Sikes's "Last Chance" could hardly be more marked: whereas the faces of Ainsworth's characters are tiny and obscured by the atmospheric tumult, the drama of Sikes's predicament is concentrated in his posture and features. "The Storm" is meteorological and metaphysical; "The Last Chance" is psychological and moral.

As soon as he completed his month's work, Cruikshank invited the Dickenses, Ainsworth, and Forster to dinner. There was much to talk about. The guests had just returned from Manchester, where Ainsworth and Dickens had been feted by the newly chartered City Corporation and entertained at lavish dinners by Ainsworth's wealthy friends. More pertinent to Cruikshank, Dickens was once again attempting to renegotiate his agreements with New Burlington Street. Occupied monthly with *Nickleby* installments (to October), harassed by his editorial duties, and lionized

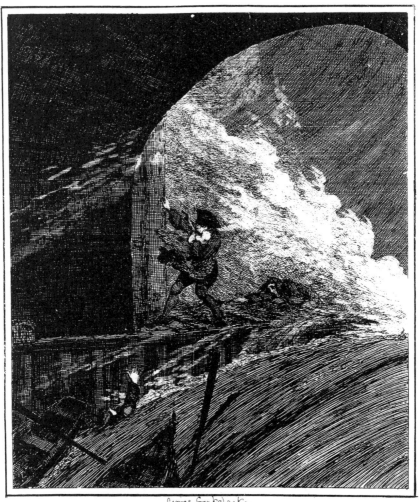

15. *George Cruikshank, "The Storm,"* Jack Sheppard, *etching, Feb. 1839*

socially, Dickens simply could not get on with the writing of *Barnaby*, a
novel that was to focus on the Gordon riots of 1780 and the burning of old
Newgate Prison. Had it appeared on schedule following *Jack Sheppard*, it
would have made the third in the sequence of *Miscellany* Newgate novels,
Oliver dealing with the contemporary prison, *Sheppard* with the earlier edi-
fice, and *Barnaby* with its destruction.[38] And Cruikshank would have illus-
trated all three. But Dickens wanted a postponement of six months in the

delivery date of *Barnaby*, more money, and a chance at the substantial receipts for *Oliver*. Moreover, he wanted out of the editor's chair.

Three days before Cruikshank's party, Forster, Ainsworth, and Dickens settled on the "new arrangements with Bentley" and dined "jovially" afterwards.[39] Later that evening Dickens asked Ainsworth to succeed him immediately as editor of *Bentley's*. Ainsworth consented; Bentley complained; Barham counseled his friend to accept the terms he hammered out with Ainsworth and Dickens on the 30th.[40] So by the evening of Cruikshank's dinner, a revolution had been effected. The artist would now be working for Ainsworth and Bentley, Dickens's next novel for which George had engaged to do the illustrations was postponed, Dickens was no longer editor of the magazine, relations between author and publisher were strained nearly to the breaking point, and Cruikshank was once again at the mercy of events beyond his making or changing. Dickens was furious about the "immense profits" *Oliver* was reaping for Bentley, compared to "the paltry, wretched, miserable sum it brought me,"[41] but his £840 remuneration was nearly three times what Cruikshank received for twenty-four plates at twelve guineas each, and Cruikshank had no prospect of ever buying into the copyright of his productions.

One way the artist might increase his income from plates already designed was to copy them; Cruikshank had been enlarging and reetching *Sketches* since the autumn of 1837, and continued to replicate two plates each month until June of 1839. That task, the two illustrations monthly for Bentley, continuing work on the *Comic Almanack*, a title-page vignette for *Serjeant Bell and his Raree Show*—a book Dickens contracted to write but that George Mogridge eventually penned—and trifling other assignments kept Cruikshank too busy to take on other substantial work.[42] Hence he turned down the opportunity to share with his brother Robert in illustrating William Johnson Neale's *Paul Periwinkle or the Pressgang*, another of the novelist's rather popular sea tales for which Phiz eventually furnished the plates.[43] Instead, in the interstices between Boz and Ainsworth, Cruikshank worked up an illustrated version of his favorite party number, *The Loving Ballad of Lord Bateman*.

He told various stories about when he first heard the ballad, and from whom: the "Preface" identifies a "Tripe-skewer" who sang it outside the wine vaults at Battle Bridge one Saturday night; Cruikshank informed others that his source was a crab-skewer; and in annotations to plates made to illustrate his uncompleted autobiography he is reported to have given Charles Hancock a third account:

> "There are several versions," said Cruikshank to me on one occasion, "of where I first heard 'Lord Bateman' sung; now I will give you the correct one. I

was out one evening for a stroll, having got to Maiden Lane, Battle-bridge. A great many dustmen lived in that quarter, and artists are obliged to mix and make friends with all sorts of people—I must admit some of my friends at that time were not very select. On this occasion I met a friend, a dustman; after talking together for a time, he asked me to come inside and have a song. I accepted his invitation. Of course we had beer, tobacco and pipes—by-the-bye, in those days I was as eager for beer as anyone—other dustmen being there. After a few songs, one of them, by name Bandy Tom, volunteered a song which probably I might not have heard before. After clearing his throat with a draught of beer, he sang 'Lord Bateman' in rather a loud voice. That is the true version of the story."[44]

Since the 1810s, when this encounter probably took place, Cruikshank had perfected his own personal delivery: rolling up his shirt sleeves, and throwing his coat cloakwise over his left arm, he would strut back and forth, flourish his walking stick, swagger, exaggerate his tremulo, and impersonate simultaneously the dandy lord and the cockney dustman.[45] Although by his seventies he may have indulged in this performance a little too often, in the 1830s it was apparently still fresh and delightful.

Dickens also performed the ballad, and it was *his* rendition that inspired Thackeray to write out a non-Cockney version that he embellished with copperplate illustrations and sold to a publisher. When in May of 1839 Thackeray learned that Cruikshank was about to issue the ballad, he wrote:

> I wanted to tell you of an event wh. need not much alarm you—I heard Dickens sing "Lord Bateman," and went home straight and made a series of drawings to it: wh. are now in part on the copper: & sold to a publisher. Only 2 days ago I heard that you were occupied [with] the same subject. I'm not such a fool as to suppose that my plates can hurt yours: but warning is fair between friends and I hope thro' death and eternity we shall always be such.[46]

Thackeray's copperplates were never published, but through an accident his drawings turned up thirty years after his death.[47] Thackeray's Lord Bateman is short, corpulent, coronetted, and carries a rolled umbrella; the savage Turk's daughter Sophia, who helps him escape from prison and makes a vow to stay faithful for seven years, resembles Alice in Wonderland.[48] This is another instance of an idea shuttlecocking from writer to artist to publisher, with each contributor interpreting the subject according to his predispositions. Thackeray's illustrations are in the vein of *Flore et Zephyr* (1836) and the later *Rose and the Ring* (1854), and in eschewing Cockney he standardizes the diction and turns the poem into burlesque pantomime.

Although the prospect of Cruikshank's version seems to have chased Thackeray's from the field, Dickens remained an influential partner to George. He loved "the unique manner of Cruikshank's rendering" of the

ballad, Dickens told Henry Burnett, and urged the artist to publish it "with the tune as you sing it."[49] Dickens studied George's performance, wrote down and altered the stanzas, and composed a preface signed "George Cruikshank?" to which, above a bold squiggled signature, the artist added both a disclaimer ("The above is not my writing, nor the notes either") and an authentication ("I admit the accuracy of the statement relative to the public singer whose name is unknown").[50] Dickens "also added some notes, though it was not easy to make anything of them, for the song's too good." And he sent Cruikshank to his sister Fanny Burnett so that she might jot down the tune as he hummed it: *"Tell her to be sure to mark the shakes and the expression,"* he added. Henry Burnett later claimed credit for the musical transcription, which before he could make a fair copy Cruikshank stuffed in his pocket, "saying, 'It will do quite well.' The clef was one-sided, the notes leaning this way and that—and just so it appeared from Cruikshank's hand."[51] (The idea of printing a musical score to a ballad was not new, but it is interesting to note that both Egan and Ainsworth printed scores to ballads intercalated in the novels Cruikshank illustrated.)

The etchings are like nothing else Cruikshank was then designing (fig. 16). Square like the Ainsworth plates, they are almost pure outline, primi-

Lord Bateman, his other bride, and his favorite domestic, with all their hearts so full of glee.

16. George Cruikshank, "Lord Bateman, his other bride, and his favorite domestic," The Loving Ballad of Lord Bateman, *etching, 1839*

tive, medievalizing, and comical; the figures strike exaggerated balletic poses and stay in the same costume throughout, as if they were performing in a cheap music hall production. Backgrounds are usually sketchy, resembling painted drop-scenes, and Cruikshank makes much of a tapestry hanging on the wall of Lord Bateman's castle, which depicts in successive frames the hunting of a deer (as Lord Bateman, with his new bride and her mother, attend to the proud young porter's announcement of Sophia's arrival seven years after his escape), a shepherd and shepherdess meeting under the darts of Cupid (when the young bride's mother is heard for the first time to speak freely), and the dance of the betrothed couple to the music of pipe and fiddle (as Bateman, Sophia, and the proud young porter foot it neatly to the church). The Hogarthian commenting picture is here burlesqued, while at the same time it carries the subtext of the romantic narrative when Lord Bateman is still entangled with his second fiancée.[52]

Whimsical, light-hearted, delighting in the Cockneyisms and the artful simplicity of the ballad, *Lord Bateman* is almost as unlabored as *Jack Sheppard* is labored, and might be taken as Cruikshank's cheeky send-up of Newgate fictions about imprisonment, noble lords, dashing escapes, and enduring love. Dickens's notes try to keep up the same lightness and to parody antiquarianism and criticism, but they are just a shade too mannered and strained, because, as he recognized, "the song's too good" even for parodic embellishments. It was easier (or Cruikshank made it *look* easier) to render the ballad in another medium than to try to enhance it in its own. "A thousand thanks for Lord Bateman," Barham wrote to Cruikshank in June, "which I shall place among the 'volumes that I prize above my Dukedom.' . . . The preface and notes are admirable and worthy of their subject and illustrations. The proud young Porter is the very beau ideal of juvenile arrogance."[53] Dickens concurred in this high praise: "You never did anything like those etchings—never," he wrote "Georgius."[54]

Anne Lyon Haight, concluding the fullest exposition of the composition of *Lord Bateman* in 1939, expressed the hope "that someday letters will come to light explaining Dickens's reasons for wishing to remain anonymous."[55] The *Morning Post* review of Charles Selby's dramatization, *The Loves of Lord Bateman and the Fair Sophia*, mentioned "that Boz has the credit and, we believe, justly, of having written the preface and notes." Upon reading this, Dickens told Cruikshank to "be strict in not putting this about, as I am particularly—*most particularly*—anxious to remain unknown in the matter, for weighty reasons."[56] Cruikshank annotated the letter with a memorandum to "get the MS. from Printer," presumably because Dickens's autograph would have established his contributions.[57] Surely the "weighty reasons" for Dickens's concern were his reiterated agreements with Bentley "not to commence or write any other work" be-

sides *Barnaby*.[58] Still chafing under the Bentleian bonds, Dickens did not want it known that he was violating his contract. Cruikshank, sympathizing with the author's predicament, became a ready accomplice; later commentators have however sometimes taken the suppression of Dickens's contribution as another instance of the artist's greed for fame. It was nothing of the kind. Dickens had collaborated with Cruikshank on a jeu d'esprit, and neither partner thought *Lord Bateman* should become the cause of further acrimony in New Burlington Street.

Cruikshank was having his own difficulties with Bentley. Ever since the fifth issue of the *Miscellany*, he had been supplying two plates per number at the rate of twelve guineas each, although his agreement was only for a single plate monthly. Other illustrators—Lover, Buss, Browne—had contributed the odd illustration; but when *Jack Sheppard* started in January 1839, the *Miscellany* carried two of Cruikshank's "square" plates illustrating Ainsworth, plus a "vignette" (reprints of the plates completed for the November three-volume edition) illustrating *Oliver*. Bentley wanted this arrangement to continue; so after he accepted Ainsworth as replacement editor, he entered into negotiations with Cruikshank to update and enlarge his commission.[59] On 11 March, at the office, the publisher presented Cruikshank with a Memorandum of Agreement committing the artist to two square etchings at twelve guineas apiece and one vignette at six guineas.[60] When Cruikshank balked at signing, Bentley summoned his assistant, Morgan, to be a witness. Cruikshank's first objection was that there was no need for an addition to the original agreement, as he had fulfilled Bentley's requests for two years. Then he wanted more money (ten guineas) for the vignettes, as Bentley's offer was scarcely above what was paid to lesser artists. He also wanted the choice of subjects for the second article. Bentley and Morgan rejected both stipulations, Bentley explaining inter alia that he had already pledged Cruikshank to authors for illustrations to Charles Hooten's *Colin Clink*, *Vincent Eden*, and the *Ingoldsby* papers.[61] Cruikshank finally conceded Bentley's prerogative to choose the subject of the third plate, but got Morgan to support his request that he be allowed to charge what he felt the third plate was worth: "I persuaded [Bentley] to [agree]," Morgan minuted, "fully believing from the tenor of Mr. C's observations & manner, that he would execute the 3rd plate for 6 gns, though he objected to make a positive pledge to that effect."[62]

No wonder Bentley wanted to make sure of Cruikshank. The three etchings for the March *Miscellany* would have made any publisher proud. Though they derive from different reinscriptions of the industrious and idle apprentice, they trace their own rogue's progress: first Jack Sheppard carving "The name on the beam" (fig. 17), second Jack leaving Mr. Wood's parlor vowing never "to be honest again," and third "Fagin in the con-

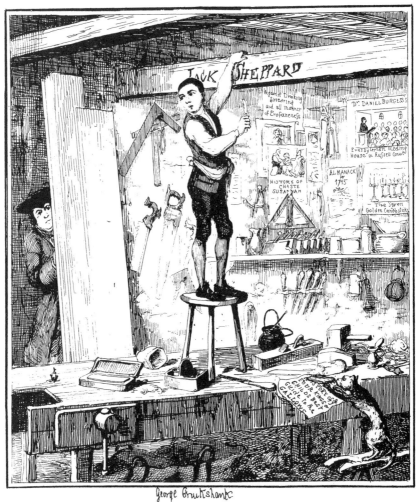

17. *George Cruikshank, "The name on the beam,"* Jack Sheppard, *etching, Mar. 1839*

demned Cell." In the first, the workshop crowded with carpentry tools, lumber, posters, and premonitory hints of the gallows—the upright boards, carpenter's square, and beam in which Jack is carving his name nearly figure the cross-trees; in the second, the lavishly furnished parlor into which the Jacobite woolen-draper Kneebone, and the disguised thief-takers Wild and Blueskin, have insinuated themselves under false pretences; and in the third, the bare, oppressive Newgate cell—sequentially define the

locus and events for the commencement, midpoint, and end of various kinds of crime. Surely this was deliberate pictorial design, since the letterpress about Fagin does not appear until the next month.

Once again Cruikshank compacted into a single indelible image pages of Ainsworth's prose. Every item in the text's catalogue of the workshop furnishings can be located in "The name on the beam." These accessories have a tendency to overload the image, but, as Thackeray remarks, they are better arranged than in the first *Sheppard* plate and "do not injure the effect of the principal figure." Thackeray goes on:

> Remark, too, the conscientiousness of the artist, and that shrewd pervading idea of *form* which is one of his principal characteristics. Jack is surrounded by all sorts of implements of his profession; he stands on a regular carpenter's table: away in the shadow under it lie shavings and a couple of carpenter's hampers. The glue-pot, the mallet, the chisel-handle, the planes, the saws, the hone with its cover, and the other paraphernalia are all represented with extraordinary accuracy and forethought. The man's mind has retained the exact *drawing* of all these minute objects (unconsciously perhaps to himself), but we can see with what keen eyes he must go through the world, and what a fund of facts (as such a knowledge of the shape of objects is in his profession) this keen student of nature has stored away in his brain.[63]

The most powerful bit of the illustration is Cruikshank's realization of Jack's ambiguous physiognomy: it is a portrait based not only on Sir James Thornhill's Newgate painting, an engraving of which Ainsworth passed on to Cruikshank for copying, but also on Ainsworth's analysis of features at once attractively intelligent and marred by signs of coarse indulgence in the shape of Jack's mouth. "Taken altogether, his physiognomy resembled one of those vagabond heads which Murillo delighted to paint, and for which Guzman d'Alfarache, Lazarillo de Tormes, or Estevanillo Gonzalez might have sat:—faces that almost make one in love with roguery, they seem so full of vivacity and enjoyment."[64] The mélange of physiological psychology, Spanish painting, picaresque literature, and historical documentation so characteristic of Ainsworth's writing undergoes further compounding when Cruikshank mixes it with Hogarth, the moral progress, *Oliver Twist*, and possibly—one recalls Merle's and Lockhart's observation that Cruikshank resembled a desperado—autobiographical identification. The result is an image so resonant that when *Jack Sheppard* was staged the theatrical posters and the first scene of most adaptations were copies of "The name on the beam."

As Cruikshank's plates continue to invoke Hogarth, so too do Ainsworth's words. The first chapter of "Epoch the Second," "The Idle Apprentice," contrasts the two cousin apprentices physically and morally: "In Darrell's open features, frankness and honour were written in legible char-

acters; while, in Jack's physiognomy, cunning and knavery were as strongly imprinted."[65] (Thackeray was not impressed by the artist's portrait of Thames—a lad who "seems to wish to make up for the natural insignificance of his face by frowning on all occasions most portentously."[66]) Mr. Wood cautions Jack about his idle ways:

> Avoid taverns and bad company, and you may yet do well. You promise to become a first-rate workman. But you want one quality, without which all others are valueless. You want industry—you want steadiness. Idleness is the key of beggary, Jack. If you don't conquer this disgraceful propensity in time, you'll soon come to want; and then nothing can save you. Be warned by your father's fate.[67]

A few chapters later, the collation spread in Mr. Wood's parlor is likened to that "depicted in Hogarth's delectable print—the Midnight Modern Conversation."[68]

There are also connections to *Oliver*. Jonathan Wild purposes to blacken Sheppard's soul in much the same way that Fagin wants to contaminate Oliver's, though Ainsworth provides a more melodramatic speech. Wild, who hated Jack's father and mother, vows that "when I have steeped him to the lips in vice and depravity; when I have led him to the commission of every crime; when there is neither retreat nor advance for him; when he has plundered his benefactor, and broken the heart of his mother—then— but not till then, I will consign him to the fate to which I consigned his father."[69] Both novels contain a repulsive Jew: Ainsworth's Abraham Mendez corresponds in dress and act, though not in dramatic presence, to Fagin. And both make "radicalish" associations between criminals and respectable society. Dickens ties the two realms together through their mutual adherence to utilitarian philosophy and the law of number one, whereas Ainsworth makes the legal authorities operating through Wild and his "janizaries" as oppressive and immoral as the worst of criminals. Mary Russell Mitford was "struck by the great danger," she told a friend, "of representing authorities so constantly and fearfully in the wrong; so tyrannous, so devilish, as the author has been pleased to portray it in *Jack Sheppard*."[70] In slightly different ways, the two novelists expressed uneasiness about early Victorian social ordering: Ainsworth's novel in particular responds to contemporary controversy about the Metropolitan Police, although it has a good word to say for the Thames river police, who by 1839 had largely extirpated the night-cellar inhabitants who used to prey on shipping and dock life.[71]

The Hogarthian typology transmitted by Georgian interpreters as binarized and morally deterministic breaks down in Dickens's and Ainsworth's retellings. Although Oliver retains the uncontaminated innocence of

Francis Goodchild, he is surrounded not only by incarnations of motiveless malignity (Maginn's essay on Iago, alluding to Fagin and Sikes, is inserted in the January *Miscellany* between the opening of *Jack Sheppard* and the murder of Nancy), but also by Dawkins and Bates, child thieves with re-deeming characteristics and the potential to reform.[72] Ainsworth takes that modification even further. Jack is portrayed as such an uninhibited lower-class "buck" roistering and wenching, he is assaulted by such wicked antag-onists, and he displays such courage and ingenuity in his escapes and such self-sacrificing loyalty to his mad mother and his cousin Thames, that it is difficult to see him in essentialist terms. Moreover, not only his paternal genetic inheritance but also the circumstances of his upbringing condition his subsequent career.

Ainsworth's confusion about the origin of criminals is shared by Cruik-shank. One of George's feet was always planted in the eighteenth century, while the other one tried to take a secure stance in the nineteenth. He felt the truth of the simple moral lessons inculcated by his mother, the Bible, and *Hogarth Moralised*, the truth that good and evil are distinct and op-posed. Yet he himself had experienced a life of temptation and apparent idleness, had enjoyed the boon companionship of low company ("artists are obliged to mix and make friends with all sorts of people"), had represented popular amusements, and had argued visually for their essential harmless-ness against Boz's moralistic declension in "Mediations in Monmouth Street." More than Dickens or Ainsworth, Cruikshank knew what it was like to be an artisan, respectable but lacking the possibility even through hard work of catapulting into the upper reaches of the middle class. He could sympathize with those who felt entrapped, bludgeoned by fate, or circumscribed by impersonal social forces. And so his plates for *Jack Shep-pard* hover between melodramatic moral contrast and catholic sympathy, and culminate, alongside Ainsworth's prose, with climactic escapes and the inevitability of Tyburn.

Artist and author maintained their close collaboration. For the 1 June plate of "Mrs. Sheppard expostulating with her Son" from her bed in a cottage near Willesden Church, Ainsworth made the best drawing he could of the tower as seen from the cottage door.[73] Forwarding the sketch, Ainsworth also reported on a recent letter he had received from the reclu-sive writer and amateur caricaturist Charles Kirkpatrick Sharpe: "He speaks in high terms of your illustrations but says—'what the devil makes him give Jack and his friend such large feet?'"

In return, Cruikshank usually showed the preliminary drawings or trac-ings to Ainsworth before etching them.[74] Since "more than a third" of the novel was written before Cruikshank started the illustrations, it was not until he got into "Epoch the Third" that he was able to make suggestions to

the author prior to Ainsworth's sending the manuscript to press. Dispatching the tracings of "Audacity of Jack Sheppard" and "Jack Sheppard visits his Mother in Bedlam" for the August 1839 issue, Cruikshank explains what he has put into each picture and thinks Ainsworth should insert in his text:

> I enclose the tracing of the second subject—I suppose Wood to be transfixed with astonishment—he is lifting up his spectacles. I thought it would be a point for you to describe him as reading the Bible aloud*—as Jack enters.—Winnifred [Wood, Owen's daughter] in tears and if you do not approve of this, old Wood must read it to himself. The flowers on the Mantleshelf are *drooping*: (i.e.) not fresh gathered. a handkerchief is thrown over the birdcage—Mrs. Wood's portrait has been removed [after her recent decease].

> *Our excellent and Re[veren]d. friend the Prebend [Barham] would no doubt pick you out a good passage.[75]

As John Harvey observes, these "details go straight into the text with an appropriate commentary that is scarcely distinguishable from the kind of popular elucidation that Hogarth's own paintings received at this time."[76] Ainsworth accepted all Cruikshank's points and, from Barham (presumably), obtained biblical injunctions against persecuting murderers that are juxtaposed to Thames's vow of vengeance.

In the same letter, probably written from Margate where George and Mary Ann had removed for a summer holiday, Cruikshank reminds Ainsworth of the previous description of Mrs. Sheppard:

> For fear you might not recollect the attire of Jack's Mother I will just state that her head which is *shaved* is bound round with a *rag* in which some straws are stuck for ornament. a piece of old blanket is tied over her shoulders and the remainder of her dress is a petticoat.

These details too were incorporated into Ainsworth's letterpress, so that while from a *post hoc* vantage point it seems as if Cruikshank's plate illustrates Ainsworth's prose, in fact the picture preceded the final version of the verbal description. In another letter from Margate Cruikshank offers to show Ainsworth a preliminary drawing when he comes up to town, "as I wish you to see my Sketch before I Steel it (by the way I wish that *Jack* would *Steel* his own plates)." That this exchange between writer and artist occasioned no heartburnings is clear from Cruikshank's final words: "I think I have come up to your ideas upon the subject in hand—and hope to do so in the others and to remain my Dear Ainsworth yours very truly."[77]

An illustration for the September number, "Jonathan Wild throwing Sir Rowland Trenchard down the well-hole," was completed before Ainsworth, now rushing to finish the whole novel for an October publication date, could write up to it. "Has Jonathan a club or a pistol in his hand?" he

queried. Has the Jew a link or a candle? What sort of bridge are they on? Does Sir Rowland grasp the railing or the banister or the lower part of the bridge?[78] Cruikshank settled all these points, so that text and picture once more agree.

With so much to be done on the *Sheppard* illustrations, Cruikshank had even less time than usual to spend on other commissions. Thackeray in December grumbled about the "odious" 1840 *Comic Almanack* plates: "Cruikshank I suppose is tired of the thing," he told his mother, "and bends all his energies to the illustrations of Jack Sheppard."[79] The artist also managed to produce six signed and titled etchings to the third volume of Sir John Bowring's *Minor Morals for Young People*.[80] The letterpress was completed in January, but "a variety of engagements" prevented Cruikshank from finding his way to Westminster by February, so he asked Bowring for proofs that he would read and then call in Queen Square to discuss.[81] John Scoffern's *Chemistry No Mystery* got a wood-engraved frontispiece, "Laughing Gas," in Cruikshank's merriest vein, while from a sketch by T. H. Sealy Cruikshank etched the title page of Sealy's *Little Old Man of the Wood*.[82] Bentley announced in July that William Jerdan's "The Beggar's Courtship" would appear in "the ensuing Miscellany." Jerdan dashed off a note to Cruikshank begging him "to say if we are to meet on the subject in common charity, and devise the grapphics. The sooner the better for he gives twice who gives quickly is a right beggars maxim."[83] But Cruikshank couldn't manage a third plate, nor could Bentley find room for Jerdan's unillustrated mendicants.

Social engagements were likewise curtailed. Cruikshank was John Thompson's guest at the Spring Artists Benevolent Fund dinner.[84] He dropped by Kensal Lodge, Doughty Street, and New Burlington Street from time to time, and Ainsworth or Thackeray would look in at the studio. George and Mary Ann went to Margate in August. But they remained largely at home with George's mother, occupied by the usual domestic and professional responsibilities. "Prythee D—n all illustrations for a few hours" and come to dinner, his friend Dr. Charles Julius Roberts commanded.[85] Cruikshank may have complied, for the invitation came after his *Sheppard* labors were over. But in September the work with Ainsworth reached a frantic pace.

Jack Sheppard was scheduled for release in three volumes, with twenty-seven illustrations, by mid-October, the anniversary of Jack's last escape from Newgate falling on the fifteenth of the month. If Cruikshank were to have the text in sufficient time to etch the last nine plates, Ainsworth had to finish writing a month or so prior to publication day. To avoid distractions, he left Kensal Green to spend several weeks at the home of Mrs. Hughes, Tom's grandmother and a regular source of ancient stories supplied

both to Ainsworth and to Barham for *Ingoldsby*. There, at Kingston Lisle in Berkshire, Ainsworth set up his exigent timetable for September:

5th	*Thursday.*	Escape of Sheppard.
	Friday.	Darrell.
	Saturday.	Recapture of Sheppard.
	Sunday.	Newgate.
	Monday.	Ditto.
	Tuesday.	Grand escape.
	Wednesday.	Escape continued: after incidents.
	Thursday.	Discovery of Darrell.
	Friday.	Clearing up.
14th	*Saturday.*	Execution of Sheppard.[86]

Ainsworth composed twenty chapters, eighty-five printed pages containing approximately forty-five thousand words, in ten days. He wrote so fluently and expansively that the final installments had to be printed in smaller type with more lines per page to squeeze all of it in.

As soon as Cruikshank learned what the subjects of the final plates were to be, he began sketching; a finished drawing, sometimes reinforced in pen and watercolor, provided a model for the author and the artist.[87] In a few of the early numbers of *Sheppard*, Cruikshank had enough time to indulge in an elaborate process of biting in and stopping out that gave the plates many degrees of depth and tone. "He showed for the first time," Blanchard Jerrold writes, "that he could realize a middle distance, as well as a foreground and a background." That proficiency may have been demonstrated in previous prints, but Jerrold is surely right in continuing that these plates "are absolutely astonishing, when they are analysed, for the amount of original thought,—for the technical skill in rendering infinite varieties of light and shade, of emotion, of scenery,—which they comprehend."[88] For the concluding *Sheppard* illustrations, however, Cruikshank had to minimize the time occupied by the etching process itself. Consequently, with a couple of exceptions he resorts to a style that requires at least as much drawing but fewer immersions, one that gradually replaces dense atmospheric plates such as "The Storm" with strip cartoon narratives of Jack's escape and hanging.

Cruikshank accommodates necessity to greater artistic effects for a pivotal illustration. During one of Jack's incarcerations he is visited (as was the historical Jack) by Sir James Thornhill, who paints the portrait subsequently engraved by White, widely circulated at the time, and used by Ainsworth and Cruikshank for their portraits of the hero. Cruikshank's etching shows the twenty-one-year-old Jack in exactly the pose Thornhill

captured, with Thornhill on one side executing his painting. Cruikshank thus gives an etching of a painting ("As like as life, sir," says the turnkey peering over Thornhill's shoulder) from which an engraving would be made that provides the basis for the etching.

Ainsworth adds to this circular intertextuality. He places Thornhill's son-in-law, Hogarth, and the poet John Gay in the cell at the same moment. Gay declares that he'll "write an opera, the scene of which shall be laid altogether in Newgate, and the principal character a highwayman. I'll not forget your two mistresses, Jack." Thus the origin of *The Beggar's Opera*. And Hogarth declares that he's got an idea too, "grounded in some measure upon Sheppard's story. I'll take two apprentices, and depict their career. One, by perseverance and industry shall obtain fortune, credit, and the highest honours; while the other by an opposite course, and dissolute habits, shall eventually arrive at Tyburn." So far this is the narrative of Hogarth's *Industry and Idleness*, in which Tom Idle even looks a little like Sheppard. But the difference between Hogarth's moral and Ainsworth's surfaces in Jack's response: "'Your's will be nearer the truth [than Gay's], and have a deeper moral, Mr. Hogarth,' remarked Jack, dejectedly. 'But if my career were truly exhibited, it must be as one long struggle against destiny in the shape of—'." Significantly, Jack cannot identify the shape of the forces that have oppressed him—an indication of Ainsworth's and Cruikshank's modern reading of the causes of criminality. Gay, of the false and shallower moral, finishes Jack's sentence, cutting off further discourse by attributing all Jack's reverses to a villain: "'Jonathan Wild,' interposed Gay. 'I knew it.'"[89]

At this moment, then, Jack's features and history start to generate future pictures and narratives. At this point, too, Cruikshank introduces the strip cartoon (figs. 18 and 19), initially in the form of a square plate subdivided into four tiny claustrophobic panels reading left to right and top to bottom, in which he depicts Jack escaping from the Castle to the Red Room and through its door, and a further one that separates the Red Room from the Chapel ("The Escape. No. 1"), then smashing the door leading into the Chapel, opening the lock on the other side, and forcing the two doors intervening between the Chapel and the leads ("The Escape. No. 2"). The third plate (fig. 20) consists of two oblongs, as if the top and bottom pairs of the earlier sequences had been combined. It illustrates the wider spaces into which Jack has emerged, yet continues to evoke through formal manipulations Jack's imprisonment. Thus in the top section every egress is blocked, so Jack must climb up over the wall standing on the door that opens back into the prison cells. And in the bottom one a massive wall on the right and the pyramidal roofs on the left forbid motion, so Jack exits left

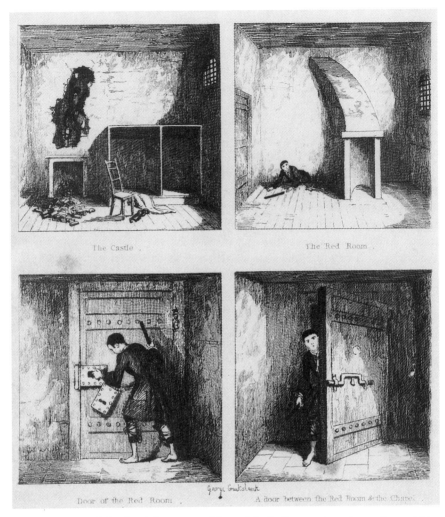

The Castle . The Red Room .

Door of the Red Room . A door between the Red Room & the Chapel .

George Cruikshank

18. George Cruikshank, "The Escape. No. 1," Jack Sheppard, *etching, Oct. 1839*

through an attic door, his flight working *against* the habitual left to right eye motion of most Western readers. The artist, Thackeray raves,

> has produced a series of figures quite remarkable for reality and poetry too. . . .
> Here is Jack clattering up the chimney, now peering into the lonely red room,
> now opening "the door between the red room and the chapel." What a wild,
> fierce, scared look he has, the young ruffian, as cautiously he steps in, holding
> light his bar of iron. You can see by his face how his heart is beating! If any one
> were there! but no! And this is a very fine characteristic of the prints, the
> extreme *loneliness* of them all. Not a soul is there to disturb him—woe to him

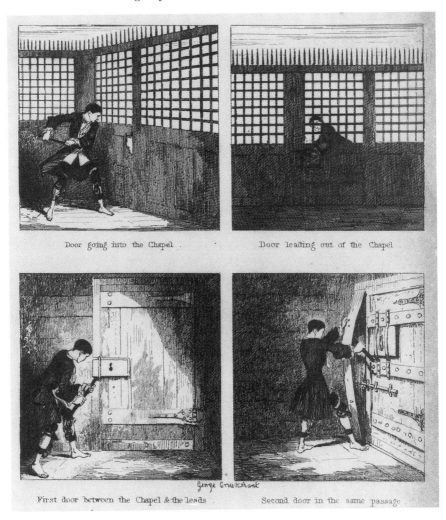

Door going into the Chapel . Door leading out of the Chapel .

First door between the Chapel & the leads . Second door in the same passage .

19. *George Cruikshank, "The Escape. No. 2," Jack Sheppard, etching, Oct. 1839*

who should—and Jack drives in the chapel gate, and shatters down the passage door, and there you have him on the leads, up he goes, it is but a spring of a few feet from the blanket, and he is gone—*abiit, evasit, erupit.* Mr. Wild must catch him again if he can.[90]

"The Escape" plates copy with great faithfulness a 1724 engraving showing the shackles, rooms, and doors Jack broke through.[91] But whereas the old engraving, like George's etchings of the Cato Street loft, offers a diagrammatic cutaway view from which Jack is largely absent, Cruikshank

Lower Leads.

The Highest leads and the leads of the Turners house.

20. George Cruikshank, "The Escape. No. 3," Jack Sheppard, etching, Oct. 1839

organizes his etchings in a narrative sequence featuring Jack actually break-
ing out of, into, or through barriers. The plates put tableaux into motion.
Narrative, movement against all the restraints of prison and pictorial con-
vention, stimulates him to this prefiguration of the film and comic strip.

The style of these illustrations, different from their sources and from the other *Sheppard* plates, is a perfect expression of their different signification.

While Jack is free, the pictures revert to illusionistic and full-page square images. Cruikshank was in constant touch with Ainsworth as these chapters were being composed. Sometimes the pictures were drawn before Ainsworth wrote the scene. For Jack's arrest at Willesden Church during his mother's burial, Cruikshank reported on his plate:

> Jonathan Wild has hold of Jack's left arm with *his* left hand, and grasps the collar with his right. The Jew has both his arms round Jack's right arm and Quilt Arnold has hold of the right side of Jack's coat. This fellow in making his spring at Sheppard may upsett the gravedigger, who nearly falls into the grave.[92]

Ellis instances this as "an example of what Ainsworth terms the 'excessively troublesome and obtrusive' phase of Cruikshank's suggestions," but it is nothing of the kind. Artist and author are working together furiously to meet a deadline in the same way they had collaborated throughout the novel. Ellis quotes additional sentences from this letter in which Cruikshank advises how the "approach of the attacking party" should be managed. In the absence of any text, he too had to think out the narrative in order to position all the figures correctly for the churchyard confrontation. Ellis then says that "a reference to the letterpress of *Jack Sheppard* will show that the author did *not* adopt the artist's plan." Quite the contrary, Ainsworth's text disposes the attacking party in precisely the locations Cruikshank recommends. As so often in accounts of Cruikshank's professional relationships, evidence that supports his claims has been distorted to disprove them.

Cruikshank treats Jack's last journey, to Tyburn, in another strip cartoon series (figs. 21 and 22) which culminates in three pictures of the place of execution that move nearer to and then away from the gallows as time passes. This is the closest Cruikshank can come to devising a graphic equivalent to the temporal successiveness of prose, and he does so while in the same plate exploiting the pictorial advantages of providing a long shot and a close-up of the same scene. And, continuing the pictorial intertextuality that is such an extended feature of the novel, that scene is itself a redaction of the penultimate stage of *Industry and Idleness*, "The Idle 'Prentice Executed at Tyburn."[93]

These last two plates, each comprising three narrow strips read continuously from left to right and from top to bottom, are jammed with figures and incidents. On Tuesday, 1 October, Cruikshank sent to Kingston Lisle the tracing of the first plate, promising the second on the morrow. Having checked a source, he found

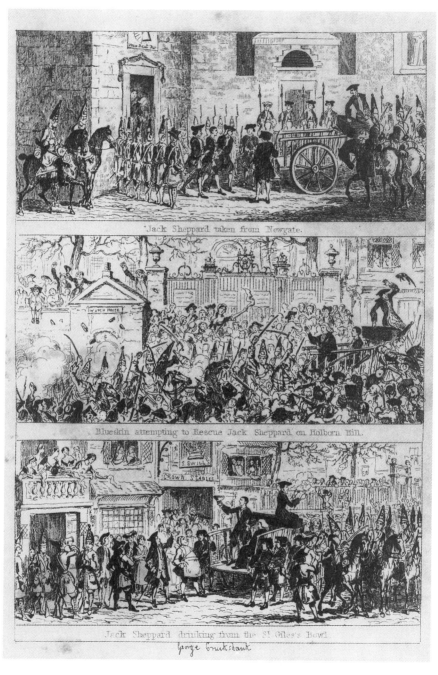

Jack Sheppard taken from Newgate.

Blueskin attempting to Rescue Jack Sheppard on Holborn Hill.

Jack Sheppard drinking from the St Giles's Bowl

George Cruikshank

21. George Cruikshank, "The Execution," plate 1, Jack Sheppard, *etching, Oct. 1839*

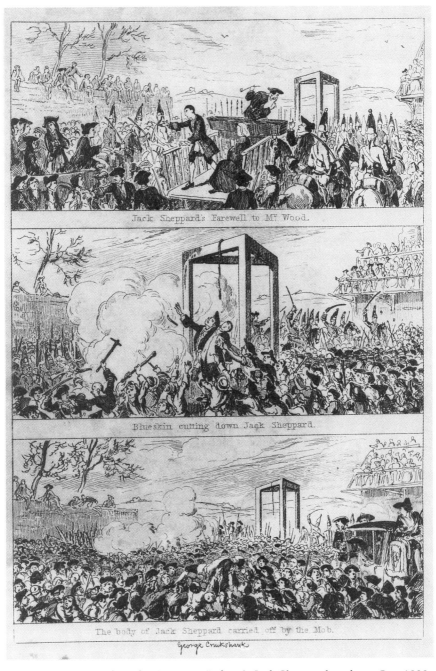

22. George Cruikshank, "The Execution," plate 2, Jack Sheppard, *etching, Oct. 1839*

that the fore part of the cart was to carry the coffin—if I recollect aright you intended to leave the coffin out—I have ventured to introduce it as a seat for Mr. Marvel [the executioner]—let me know if you object—NB The *Spear*men are call'd "Javelin men" at the present day (they attend the judges at the assizes) perhaps they were so styled at that period—[94]

Every one of Cruikshank's emendations was accepted; indeed Ainsworth made much of Mr. Marvel's ride on the coffin and his varying moods as the crowd threatens or the javelin men enforce order. The next day Cruikshank sent the second tracing:

It is with the greatest difficulty that I am enabled to send you the last tracing by this Eve[nin]g. *They* are so *heavey*—& I have (*unfortunately*) met with several interruptions—in consequence of my poor friend Goodyear being upon his Death bed.

The only points which suggest themselves to me are the *necessity* of—*a part* of the mob being armed with *long poles* & *Pikes*—in order to keep back the Military—(qy. fire arms too?)—I have introduced a coach in the last Subject, as you will see—[Jack's] friends would *naturally* have such a machine in readiness—*I* would put a *mask* upon the man who is directing the mob from the coach window—but I would never let *any* body know who *he* was—people might suppose it to be T Darrell.—I have put leaves upon the Trees—if that is wrong send me word

<div align="right">yours in great haste
but very truly[95]</div>

The leaves that had been present in Hogarth's plate came off the trees, it being November, but otherwise once again all Cruikshank's suggestions were incorporated as Ainsworth readied the last pages for the press. When they were in proof, Cruikshank designed a wood-engraving of the simple wooden monument erected to mark Jack's grave, inscribed in sober letters with the same name Jack had carved so exuberantly on the beam. The novel thus closed with an image of a name: picture and word, beginning and ending, in perfect circularity.

The volume edition, published on the 115th anniversary of Jack's last escape, went off briskly: three thousand copies were sold in the first week, and even fifty years later twelve thousand copies were purchased within five years.[96] Stage versions of *Jack Sheppard* appeared immediately; by the end of the year at least ten different productions had been mounted in London, and others appeared in the provinces.[97] Ainsworth and Barham went on 17 October to visit Moncrieff, now totally blind, who was nonetheless cheerful and bustling as he arranged a version of the novel for the Royal Victoria Theatre. Ainsworth promised to send him a copy of the conclusion which the dramatist had not yet received. "Moncrieff," Barham noted in his Diary, "in a very extraordinary manner, went through what he had done,

without having occasion to refer to any book or person, singing the songs introduced, and reciting all the material points of the dialogue."[98]

Perhaps because of his blindness, Moncrieff was less susceptible to the theatricality of Cruikshank's tableaux illustrations, although the playbills extolled the "most ASTONISHING AND ELECTRICAL Representation of the GREAT HURRICANE on the river Thames."[99] But W. P. Davidge, who was staging John Thomas Haines's adaptation at the Royal Surrey Theatre, hired Cruikshank to oversee the scenery and paid Ainsworth £20 to attend a rehearsal and write a letter, which was then reproduced on all the programs, playbills, and newspaper announcements:

> *October 18th, 1839*
> SIR,—Having, in compliance with your request, witnessed your Rehearsal, and perused the Drama founded on JACK SHEPPARD, in preparation at the Surrey Theatre, I am satisfied it will furnish a complete representation of the Principal Scenes of the Romance; and have, therefore, no hesitation in giving my entire sanction to the performance. The fact of the whole of the Scenery having been superintended by Mr. George Cruikshank, must be a sufficient guarantee to the Public for its excellence and accuracy.[100]

Haines's script repeatedly cites the Cruikshank plates in his prefatory synopsis of the scenery and in the text proper. He staged as many of the tableaux vivants as possible, and for the "Escape" plates, he built a set of four rooms through which Jack passes, not top to bottom as in Cruikshank's narratively organized illustration, but from bottom to top.[101] The final journey to Tyburn was performed in front of a rolling diorama that put the last two strip illustrations into a moving horizontal sequence. Cruikshank may already have discussed the staging of this scene with Haines *before* he drew his plates, and thus designed them to be translated into a spectacular theatrical conclusion.[102]

The most acclaimed and long-running version was Buckstone's at the Adelphi, which added music and imported from *Rookwood* the brilliantly showy ("flash") song "Nix my dolly pals, fake away." Frederick Yates, the manager of the theater, wrote to Ainsworth at the beginning of October soliciting his and his artist's aid in staging the novel. Ainsworth agreed to meet with the cast, while Cruikshank received the set and costume designers and helped them to copy his plates.[103]

In the Adelphi production Mrs. Keeley played the slender, beardless Jack as a captivating fellow, naive, assured, bold, humorous, slangy but never vulgar. Buckstone and Yates emphasized realism: real carpenter's chips on the floor and real locked handcuffs, from which Mrs. Keeley slipped her hands only with great pain. The escape scene was so physically demanding that at its conclusion she would collapse offstage into the arms of a man stationed to catch her.[104]

With Blueskin, portrayed by Paul Bedford, and with Jack's two doxies Poll Maggot and Edgeworth Bess, Mrs. Keeley sang and danced "Nix my dolly pals" to rapturous applause. Cruikshank sketched them live at a performance one night.[105] For the sheet music of the song, he designed an eight-compartment vignette cover.[106] Sir Theodore Martin recalls:

> Nix my dolly . . . travelled everywhere, and made the patter of thieves and burglars "familiar in our mouths as household words." It deafened us in the streets, where it was as popular with the organ-grinders and German bands as [Sir Arthur] Sullivan's brightest melodies ever were in a later day. It clanged at midday from the steeple of St. Giles, the Edinburgh Cathedral (A fact. That such a subject for cathedral chimes, and in Scotland, too, could ever have been chosen will scarcely be believed. But my astonished ears often heard it.); it was whistled by every dirty guttersnipe, and chanted in drawing-rooms by fair lips, little knowing the meaning of the words they sang.[107]

The popularity of *Jack Sheppard* extended beyond the British theater. There was a Paris production at the Porte St. Martin, and there were sequels, imitations, mock ballads, and plagiarisms, including one illustrated by "Jack Sketch" who copied Cruikshank's plates. Allusions to the novel appear repeatedly in the early issues of *Punch*; in one cartoon Jack's carving his name is adapted to Lord John Russell's carving his name while an uneasy Peel as Owen Wood spies upon him.[108] The novel itself went through further editions, and Bentley, taking his cue from the serial edition of *Sketches by Boz*, also put out a fifteen-part weekly issue, commencing January 1840, with fine impressions of all the *Miscellany* plates and a new wood-engraved wrapper vignette on which Cruikshank offered another version of Jack carving his name upon the beam. The shilling parts were also stitched together for a one-volume illustrated edition. And someone on the *Punch* staff, perhaps Thackeray, offered a "Literary Recipe" by which amateur chefs might cook up their own ragout à la Sheppard or Twist:

> Take a small boy, charity, factory, carpenter's apprentice, or otherwise, as occasion may serve—stew him well down in vice—garnish largely with oaths and flash songs—boil him in a cauldron of crime and improbabilities. Season equally with good and bad qualities—infuse petty larceny, affection, benevolence, and burglary, honour and housebreaking, amiability and arson—boil all gently. Stew down a mad mother—a gang of robbers—several pistols—a bloody knife. Serve up with a couple of murders—and season with a hanging-match.
>
> N.B. Alter the ingredients to a beadle and a workhouse—the scenes may be the same, but the whole flavour of vice will be lost, and the boy will turn out a perfect pattern.—Strongly recommended for weak stomachs.[109]

As Keith Hollingsworth notes, the Sheppard craze "was an uncalculated, uncalculating paean to the end of the bad old days and the arrival of a time like morning."[110] Humanitarians pressed for legislation moderating the old

carceral excesses of Newgate and the hangman, while the streets of London under the surveillance of Sir Robert Peel's constabulary became safer for pedestrians. Jack was taken as an instance of a boy beset by villains— daring, ingenious, dashing, fun-loving, good to his mother—not a rebel attacking society nor the pathetic victim of an oppressive establishment, so much as an entertaining scamp who flourished in the bad old days and would have survived better in the present enlightened era. He also enacted the countertheme of "excarceration," that is, escapes from confinement, which began to be celebrated in the later eighteenth century and on through the nineteenth as the inevitable complement to the disciplinary regimes established by utilitarians, evangelicals, and social constructionists.[111]

But there were contrary voices, weighty ones that within a few months turned substantial portions of public opinion and authority against Jack, Oliver, and their fictional and dramatic progeny. Thackeray had never entirely approved of Newgate fiction, and in *Catherine*, serialized in *Fraser's* from May 1839 to February 1840, he kept up a running attack on "dandy, poetical, rosewater thieves." In "Horae Catnachianae," he argued that though it was all right to "hug the rogues and love them in private," Bulwer with *Paul Clifford*, Dickens with *Oliver Twist*, and Ainsworth with *Jack Sheppard* were wrong to display those likings in public. Thackeray objected first that the depictions of criminality were false—"the present popular descriptions of low life are shams"—and second that such fictions manifested a debased taste:

> Our public has grown to be tired of hearing great characters, or even ordinary ones, uttering virtuous sentiments; but put them in the mouth of a street-walker, and straightway they become agreeable to listen to. We are sick of heroic griefs, passions, tragedies; but take them out of the palace, and place them in the thief's boozing ken—be prodigal of irony, of slang, and bad grammar— sprinkle with cant phrases—leave out the h's, double the v's, divide the w's (as may be necessary), and tragedy becomes interesting once more.

Thackeray believed writers had a duty not to pander to the public's desire for such entertainment:

> Here is Mr. Dickens about to blaze upon the world with a new novel: may we hear no more of thieves and slang. [The novel would have been *Barnaby Rudge*, but it was postponed, perhaps in part because Dickens sensed that driving another shaft into the Newgate mine might be unwise just then.] Here is Mr. Ainsworth gathering up the ribands of *Bentley's Miscellany*, and driving a triumphant journey with "Jack Sheppard:" we wish it were Jack Anybody else. Gentlemen and men of genius may amuse themselves with such rascals, but not live with them altogether. The public taste, to be sure, lies that way; but these men should teach the public.[112]

The lumping of Bulwer (a favorite target of Fraserians), Dickens, and Ainsworth into a single "type" of writer was a strategy often employed in the ensuing controversy, and it was a strategy that Dickens found intensely annoying. The very companionship that had introduced him to the leading men of letters now threatened to undermine his status. The friendships of the past four years were strained by the unprecedented success of a kind of fiction beginning to seem unwise, dangerous, and cheap.

The *Athenaeum* joined the attack in its notice of the three-volume *Sheppard*.[113] Decrying the economic forces that have "made literature a trade," writers dependent on public patronage, and both writers and readers subject to pressures that narrow sympathy and shape "one common character, cold, monotonous, superficial, polished (it may be), but hard and hollow," the reviewer found in Ainsworth's novel a characteristic sign of the times. "Jack Sheppard . . . is a bad book, and what is worse, it is of a class of bad books, got up for a bad public." Even Cruikshank's illustrations come in for censure: "In these graphic representations are embodied all the inherent coarseness and vulgarity of the subject; and all the horrible and (it is not too strong to say) unnatural excitement, which a public, too prudish to relish humour, and too *blasé* to endure true pathos, requires to keep alive attention and to awaken a sensation."

One week later Forster weighed in with a devastating analysis in the *Examiner* of the novel's snobbery (as soon as Jack's mother is recognized as sister to a baronet she develops symptoms of gentility and refinement), absurd plotting, and dubious morality.[114] Moved to write in part because advertisements for the plays (never reviewed by the *Examiner*) glamorized "the rank garbage stewed up at these places of amusement," Forster declared that "public morality and public decency have rarely been *more* endangered than by the trumpeted exploits of Jack Sheppard." Contrary to the careful discrimination, true refinement, and just morality of Fielding, Hogarth, and Gay, Ainsworth's novel exalts "slavish adulation of high birth" and (in a phrase dripping with class irony) "the moral capabilities, nice emotions, and sensitive affections, which belong to thieves and murderers."

At first such animadversions merely whetted the public's appetite. "Forster's article has been perfectly innocuous, and has done no harm whatever here," Ainsworth told Crossley. "In fact *Jack* is carrying everything before him. . . . They are bringing him out at half the theatres in London."[115] But gradually the potential or actual harmfulness of the subject and treatment began to penetrate the consciousness of some members of the audience. "They say that at the Cobourg," Thackeray told his mother at the beginning of December, "people are waiting about the lobbies, selling *Shepherd-bags*—a bag containing a few pick-locks that is, a screw driver, and iron lever, one or two young gentlemen have already confessed how much they

were indebted to Jack Sheppard who gave them ideas of pocket-picking and thieving wh. they never would have had but for the play."[116]

Fraser's continued its fusillade in February 1840, when the last installment of the serialized *Sheppard* appeared. John Hamilton Reynolds contributed anonymously an article on "William Ainsworth and Jack Sheppard" showing how much the novel deviates from the known facts of the thief's life.[117] Thackeray contributed pseudonymously as "Ikey Solomons" an essay on the bad tendencies of Newgate fiction in comparison to Gay and Fielding. And he contributed under his own name the final installment of *Catherine* with its long diatribe against *Oliver* and *Sheppard*: "In the name of common sense, let us not expend our sympathies on cut-throats, and other such prodigies of evil!"

That readers might learn how to commit crime was an argument frequently advanced by those opposed to Newgate fiction and drama. Their position seemed unmistakably confirmed in June 1840, when Benjamin Courvoisier, valet to Lord William Russell whom he murdered, was reported to have confessed that he got the idea of drawing his knife across his employer's throat from reading about Blueskin's murder of Mrs. Wood and seeing a performance of the play at one of the London theaters.[118] Forster had complained about that very episode in his review. Now he, or Albany Fonblanque, wrote an essay for the front page of the *Examiner* deploring the line of defense taken by Courvoisier's advocate, asking whether it breached professional morality, and once again condemning Ainsworth's novel as contributing to moral degeneration: "If ever there was a publication that deserved to be burnt by the hands of the common hangman it is *Jack Sheppard*."[119] Ainsworth wrote a rebuttal to *The Times* asserting that "the wretched man declared he had neither read the work in question nor made any such statement," but the sheriff of London and Middlesex countered that Courvoisier had asserted to him "that the idea of murdering his master was first suggested to him by a perusal of the book called 'Jack Sheppard,' and that the said book was lent to him by a valet of the Duke of Bedford."[120]

Very rapidly middle-class opinion veered round to condemning Newgate literature and drama. The Lord Chamberlain "had a great many letters from parents and masters requesting that such pieces should not be exhibited because they had such an ill effect on their sons and apprentices."[121] Whether there was an official prohibition on any version besides Buckstone's, or merely an "understanding" between authorities and theater managers, is uncertain; but Newgate plays suddenly dropped from the repertory, and, except for revivals of Buckstone's play in 1852, 1855, and 1858, and dramas retelling the Sheppard story under a variety of obscuring names and strategies, Ainsworth's hero faded from view.

So did Cruikshank's association with the novel and its dramatizations.

The artist's name had been useful to Bentley, Ainsworth, and Davidge; his plates had been influential in the productions designed by Haines and Lacy; but neither revenues from the sale of the novel in formats outside the *Miscellany* nor any of the box office receipts furnished his purse. While he would have preferred to earn by a reputation for moral preaching rather than by notoriety—"there were a great many things" in *Jack Sheppard* "which did not meet with his . . . approval," he told Sala in 1873—even the latter paid him badly, while it coined money for others.[122] Cruikshank needed to find some better way of cashing in on fame; he needed to be a partner, not just a hireling. And that is precisely what Ainsworth proposed for their next illustrated fiction.

29

THE TOWER! IS THE WORD—
FORWARD TO THE TOWER!

Look at one of Mr Cruikshank's works, and we pronounce him an excellent humourist. Look at all, his reputation is increased by a kind of geometrical progression; as a whole diamond is a hundred times more valuable than the hundred splinters into which it might be broken would be. A fine rough English diamond is this about which we have been writing.

William Makepeace Thackeray[1]

"I ACCEPT with much pleasure the invitation to join in celebrating the publication of 'Jack Sheppard'," Cruikshank told Richard Bentley on 12 October 1839.[2] That dinner was about the last time Cruikshank or Ainsworth was to express "pleasure" in Bentley's company. The same tensions that led to Dickens's quarrels with his publisher were beginning to stretch the patience of the *Sheppard* collaborators, while Bentley, sensing incipient rebellion, tried to tighten his contractual net. At the height of his fame and power, Ainsworth, as Dickens before him, discovered that his energies were finite. Committed to all the correspondence entailed in editing the *Miscellany* each month, and to producing installments of *Guy Fawkes* for the periodical, as well as *The Tower of London* for an independent monthly serial, Ainsworth barely had time to breathe between assignments. Cruikshank faced a similar schedule: *Fawkes* plus other plates for *Bentley's*, and the heavy load of designing several full-sized steels and multiple vignette wood-engravings for the *Tower* each month. Bentley worked his artists as hard as he worked his copyrights, but the artists did not suffer the New Burlington Street yoke indefinitely. Fractious from being overworked, they rebelled at being underpaid.

The crux of the problem was success. Bentley invested a little capital in a magazine; under Dickens's editorship and while *Oliver* was serializing, circulation climbed and the investment paid handsomely. Moreover, Bentley

gained additional sums from the publication of the serialized fiction in more permanent formats. Through successive agreements, Dickens was able to wrest increases in his stipend as editor and larger payments for novels in progress or anticipated. When Ainsworth took over as editor and *Sheppard* started its run, sales increased by eight or nine hundred copies an issue, a rise of some 10 percent.[3]

But Ainsworth and Cruikshank continued to receive fixed stipends. Dickens's example seemed to indicate that nothing short of a dramatic renegotiation of contract would enable author and artist to share more equitably in the financial return from their work. Not being hampered, as Dickens was, by existing agreements for future books, they determined to become partners with the publisher in their new venture. "As Mr. Ainsworth and I were at that time on the most friendly—I may say brotherly—terms," Cruikshank remembered decades later, "I suggested to him that we should jointly produce a work on our own account, and publish it in monthly numbers, and get Mr. Bentley to join us as the publisher. Mr. Ainsworth was delighted with the idea of such a partnership, and at once acceded to the proposition."[4]

In August, as *Jack Sheppard* filled Bentley's purse, Ainsworth prepared the ground for future negotiations. He so alarmed the hero of New Burlington Street, he told Cruikshank, that George could make any kind of terms he wanted.[5] As soon as the celebratory dinner was concluded, Bentley sent proposals via Dr. Roberts to artist and author. Cruikshank told his friend that he would not entertain the publisher's offer. When Roberts reported this, Bentley was surprised, then angry. His temper flashed, so he blew up at Ainsworth. Roberts, forwarding a transcript of Bentley's offer to Cruikshank on 13 November, doubted that Bentley would meet with the other parties the next day. Disclaiming responsibility for the language which the publisher dictated, Roberts adds that Bentley "said a great deal this morning, which I can repeat but not write, for it would be nearly enough for a shilling number."[6]

Ainsworth, and possibly Barham, then attempted to bring the publisher round. If Ainsworth continued as editor, if he and Cruikshank followed *Sheppard* with another rousing story for the *Miscellany* illustrated with the same type of square plates, would Bentley not consent to share equally in a concurrent publication in monthly parts? He would be gaining an additional title, which could subsequently be issued in volumes, and he would keep his author and artist happy.

In mid-November Bentley conceded. Cruikshank and Ainsworth were to be joint owners of the new property, which Bentley would publish on commission, deducting all expenses from the receipts and then sharing the net profits. Repeatedly the agreement iterates that Bentley is only the publisher

"and not in any way a part proprietor of the work." This arrangement meant that author and artist had to authorize expenditures for such extras as advertisements; they also had much more authority over the choice of wood-engravers, the disposition of review copies, and the general conduct of publicity. Barham was named arbitrator for any disputes. The Memorandum of Agreement was ratified on 19 November.[7] At last Cruikshank felt he was emancipating himself "from the thralldom of Booksellers" whose slave he had been all his life.[8] Enthusiastic about this project, he urged Ainsworth a few months into its production: "The Tower!—The Tower! is the word—forward to the Tower!"[9]

Bentley may have been induced to conclude this contract, unique in the annals of his firm, in part because of rumors that Dickens was once again growing recalcitrant about the promised *Barnaby*. Released from *Nickleby* by the beginning of October, Dickens turned with renewed energy and enthusiasm to his story of the Gordon riots, although he felt uncomfortable about the storm blowing up over Newgate fiction. "I am going forthwith tooth and nail at Barnaby," he told Cruikshank at the beginning of October, "and shall have MS by the middle of the month for your exclusive eye. Meanwhile as many consultations and preliminary explanations as you like."[10] Cruikshank spoke with Dickens as soon as the final *Sheppard* plates were etched. That conversation introduced uncertainty. "I do not know whether I am correct or not," Cruikshank wrote toward the middle of October, "but the impression upon my mind is that when I saw you last you were in doubt as to having Barnaby illustrated or not, but that you would consider the matter & let me know in a few days—am I right? I have finished all the work I had in hand and have been waiting these last few days."[11]

Why did Dickens waver about illustrations to *Barnaby*? Perhaps he wanted to avoid the kind of sensationalistic translation to the theater that the plates of *Sheppard* had encouraged. Perhaps he, or Cruikshank, was doubtful about whether the artist could take on any more work at this juncture. He may have already encountered the writer's block that by December stopped his composition altogether. He may simply not have wanted to work again with Bentley nor to be identified with the Bentley stable of Newgate productions. (The *Nickleby* celebration dinner on 5 October had not included Ainsworth and Cruikshank, swamped with the final stages of their publication, nor Bentley.) He does not seem to be adverse to Cruikshank, nor to be resentful of the artist's habit of making suggestions; indeed, Dickens seems to invite them ("as many consultations and preliminary explanations as you like").

But by December the furore over *Jack Sheppard*, the continual association of it with *Oliver*, Bentley's imitation of Dickens's work and format in other

publications, and a 14 December advertisement in the *Morning Herald* an-
nouncing that *Barnaby Rudge* was "preparing for publication" combined to
rouse Dickens's wrath. He instructed his solicitors, Smithson and Mitton,
"formally to make known to Mr. Bentley (through his agents with whom
you have already corresponded) what I presume he is already perfectly well
acquainted with, through Mr. George Cruikshank—namely, that I am not
prepared to deliver the Manuscript of Barnaby Rudge to him on the First of
January."[12] Dickens's letter indicates that discussions had been proceeding
for some time between his attorneys, Bentley's representatives, Cruikshank,
and Bentley. That the artist was once again a go-between, conveying
Dickens's determination to his publisher, confirms that Dickens had no
quarrel with the artist, and suggests that Cruikshank still had some stake in
the eventual fate of his friend's new novel. Since by mid-December both
Guy Fawkes and the *Tower* were underway, Cruikshank could not possibly
have managed illustrating a third work simultaneously; the postponement
of *Barnaby* to some later date, therefore, fully accorded with his own com-
mitments.

Dickens's "war to the knife . . . with the Burlington Street Brigand"
seems not to have impacted adversely at this time on Ainsworth's and
Cruikshank's working relations with the publisher.[13] Ainsworth obtained
from William Bradbury and Frederick Mullet Evans estimates for printing
the *Tower* installments on the same paper, using the same type and number
of lines, adopted for the *Miscellany*.[14] By duplicating the familiar format the
collaborators would know exactly how much manuscript would be required
monthly and how the text and plates would look when bound up. These
specifications were then forwarded to Bentley. In early December the *Tower*
partners felt comfortable calling upon their publisher. "Pray come and have
your luncheon here at a quarter past 12 tomorrow," Ainsworth wrote
Cruikshank, "and we will proceed afterwards to Bentley's."[15] Ainsworth
was staying in Southampton Row with the Hugheses while supervising the
first installment of the *Tower*. "You will oblige me much by bringing the
Drawing of the first illustration with you. . . . I shall expect to see you.
Don't fail me." The wrapper was designed and engraved, the first plate was
in hand, the text was about to be set and proofed, advertising up to an
outlay of £80 had been authorized, and the partners were adjusting their
schedules and work habits for the long haul of issuing a new serial in the
format Dickens had popularized.[16]

In his 1872 *Artist and Author* pamphlet, Cruikshank asserted that not
only the concept of joint publication but also the topic of the *Tower* came
from him. When he told Ainsworth that he had a "capital subject" for their
venture, Ainsworth

inquired what it was; and upon my telling him it was the *Tower of London*, with some incidents in the life of Lady Jane Grey, he was still more delighted; and I then told him that I had long since seen the room in "the Tower" where that beautiful and accomplished dear lady was imprisoned, and other parts of that fortress, to which the public were not admitted, and if he would then go with me to the Tower, I would show these places to him. He at once accepted my offer, and off we went to "Hungerford Stairs," now the site of the Charing Cross Railway Station, and whilst waiting on the beach for a boat to go to London Bridge, we there met my dear friend, the late W. Jerdan, the well-known editor and part proprietor of *The Literary Gazette*, who inquired where we were going to. My reply was, that I was taking Mr. Ainsworth a prisoner to the Tower. With this joke we parted. I then took Mr. Ainsworth to the royal prison; and when we arrived there I introduced him to my friend Mr. [George] Stacey, the store-keeper, in whose department were these "Chambers of Horrors"; and then and there did Mr. Ainsworth, for the first time, see the apartment in which the dear Lady Jane was placed until the day she was beheaded; or in other words, the day on which she was murdered!—and which places I had long before made sketches of, for the purpose of introducing them in a "Life of Lady Jane Grey," and which for many years I had intended to place before the public.[17]

There are reasons for crediting Cruikshank's story even while allowing that it is not the whole story. Fierce Protestant that he was, he may well have thought of vindicating Lady Jane, and he often returned to the Tudor period for illustrations. In the course of his urban investigations, Cruik-shank was likely not only to have visited the Tower, but to have conversed with the keepers; that is exactly the kind of convivial snooping that George, as distinct from Boz's "speculative pedestrian," would engage in. The gloomy and neglected fortress, so central an architectural feature of the City skyline and so redolent of historical associations, offered an even better pictorial subject than Newgate.

Ainsworth, who had wanted "for years" to write a romance about the Tower, brought complementary interests to bear.[18] Not only could he see the potential of a vivid historical novel, but also he could take his explora-tion of "criminality" into the highest reaches of state and connect it to another preoccupation surfacing in *Guy Fawkes*, namely the persecution of Roman Catholics by Protestants, and the vengeance exacted by the former on the latter. To set this tale during the brief reign of Queen Jane and the commencement of her successor's rule (July 1553–February 1554) autho-rized his mugging up particulars of dress, weaponry, and food, and melding them with Gothic intricacies of statecraft and secret passages. Moreover, he could leaven the solemnities of theological disputation and political con-spiracy with below-stairs humor, for which he invented triplet giant ward-ers, Og, Gog, and Magog, based on the Guildhall giants, a dwarf Xit, a bearward, a warder, a pantler, a cook, a savage cadaverous headsman

named Mauger, a comely orphan named Cecily, the treacherous jailer Law-
rence Nightgall, his noble rival in love Cuthbert Cholmondeley, a crazed
female prisoner, and Nemesis in the shape of a mysterious old nurse. Fi-
nally, at the commencement of the rule of a young and untested queen,
after more than a century of Hanoverian kings and a decade of controversy
about Catholic emancipation, a story about the rivalry of young Protestant
and Catholic queens was not without tacit contemporary implications.

Three other considerations influenced the partners. Having completed
the Scott illustrations, Cruikshank longed for further work on serious as
well as comic historical subjects. He aspired to be, not a history painter, for
that was beyond his means and besides not such a thriving branch of the
arts, but the premier historical illustrator. In such ways he would succeed,
and supersede, Hogarth, the progenitor of comic history painting whose
illustrative work had been restricted to *Hudibras* and two plates to *Tristram
Shandy*.

Second, both Cruikshank and Ainsworth were aware of the market for
illustrated guide books describing London's architectural history. The
Tower was partially derelict; the menagerie that had attracted crowds since
the era of Henry VIII had just been dispersed, and many of the rooms were
stuffed either with old records or with the household effects of the Beefeater
wardens who lived there. By creating an illustrated fiction about the struc-
ture, Cruikshank and Ainsworth would animate it, give it a living history,
and publicize it for the present generation.[19] Ainsworth mentioned all the
principal buildings, and Cruikshank represented their interiors and exte-
riors and etched a bird's-eye-view map of the moated, crenellated keep and
its precincts. Ainsworth intercalated a history of the Tower's construction
and appended an index to persons and structures; in his "Preface" accom-
panying the final double number, he expressed the hope that the book had
inspired tourists, that "parts of the fortress at present closed" would be
cleaned up, repaired, and opened to the public, and that the indiscriminate
demolition of portions of the ancient monument would be halted.

Third, Cruikshank so designed his suites of steel etchings and wood-
engravings that they articulated several interrelated graphic narratives. The
wood-engravings (fig. 23) showed the Tower as it was in 1840: the rooms,
many of them closed to the public, were neglected or crammed with old chests
or contemporary furnishings that domesticated the legendary spaces. The
steel-etchings (fig. 24) showed the same settings in the Tudor era, tapes-
tried and activated by multitudinous life. The vignettes are static, silent,
picturesque, linear, homely; the etchings are dramatic, noisy, stately, atmo-
spheric, and historical. In a neat reversal of convention, Cruikshank made
the wood blocks, associated with contemporary illustration, dead, while
the etched historical tableaux, in other hands often frozen and stiff, be-

THE STONE KITCHEN.

23. George Cruikshank, "The Stone Kitchen," The Tower of London, wood-engraving, Jan. 1840

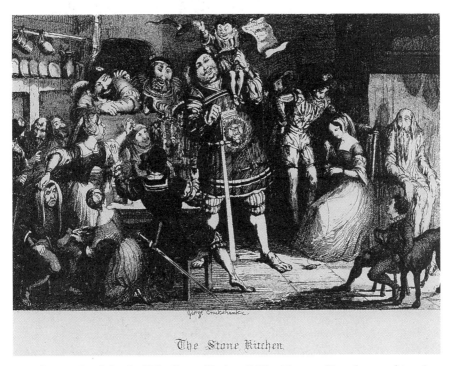

The Stone Kitchen.

24. George Cruikshank, "The Stone Kitchen," The Tower of London, etching, Jan. 1840

came under his needle energetically alive. Moreover, these two reproductive modes are deliberately sequenced as befores and afters, though in an unexpected order. Repeatedly Cruikshank introduces first a vignette showing the demystified Victorian present, then a full-page steel representing

the same spot in the Tudor past. The vignette is an after that comes before; the etching is a before that comes after. The vignettes are without imagination, the steels with, a strategy anticipatory of Browning's mystifications about "alloy" in *The Ring and the Book*. The sequencing also speaks to the liminality of illustration, to crossing the threshold. Indeed, the first wood-engraving (fig. 25) shows the contemporary outside of the Gate Tower, while the first steel (fig. 26) shows the other side of that gate as Queen Jane and her retinue are received by her councilors. Combined, the two effect a highly theatrical transformation scene and evidence the artist's awareness that this novel, like *Oliver* and *Jack Sheppard*, would be adapted for the London theaters using his plates as a basis for the script.

In 1872 Cruikshank "most distinctly" stated that

> Mr. Ainsworth *wrote up to most of my suggestions and designs*, although some of the subjects we *jointly* arranged, to introduce into the work; and I used every month to send him the *tracings* or *outlines* of the *sketches or drawings* from which I was making the etchings to illustrate the work, *in order that he might write up to them*, and that they should be *accurately described*. And I beg the reader to understand that all these *etchings or plates were printed and ready for publication before the letterpress was printed*, and sometimes even before the AUTHOR *had written his manuscript*: and I assert that I never saw a page of this work *until after it was published*, and then hardly ever read a line of it. [20]

Ainsworth gave these "preposterous assertions" a "flat contradiction" at the time. [21] Ellis maintains that although Cruikshank did suggest "incidental details and picturesque accessories," there "is not a fraction of evidence in any of Cruikshank's letters that he ever attempted to influence the course of Ainsworth's plots, or suggested any characters or even a prominent incident: all his suggestions are limited to scenic details and accessories and the situation of the persons depicted in the plate." [22] Unhappily for Ellis's case, the very letter he prints to support it shows the opposite, that Cruikshank invented the masque performed before Queen Mary, wherein the giants using clubs to batter their opponents prefigure their actions during Wyat's subsequent attack on the Tower.

> The *Masque* I have decided upon at last, one of the Giants is dressed up or rather *cased up*, to represent a Tower of strenth, on his head is a turret in which Xit as cupid is seated, under a *crown* of flowers bow & arrow in hand—the other two Giants—as the City Gog & Magog—are defending the Tower & the god of Love—against a Host of Dragons—Demons &c some mounted (ie. on Hobby horses)—there is some *rare* fun & *rough* work for the Giants (mind the Tower uses his arms with a club in each hand) belabour and upsett the assailants. [23]

As John Harvey was the first to show, Cruikshank's claim about his participation in the *Tower* "seems no more than the simple record of the truth." [24] Since the later controversy over the artist's collaboration with Ainsworth

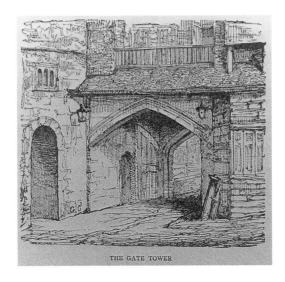

THE GATE TOWER

25. George Cruikshank, "The Gate Tower," The Tower of London, *wood-engraving, Jan.* 1840

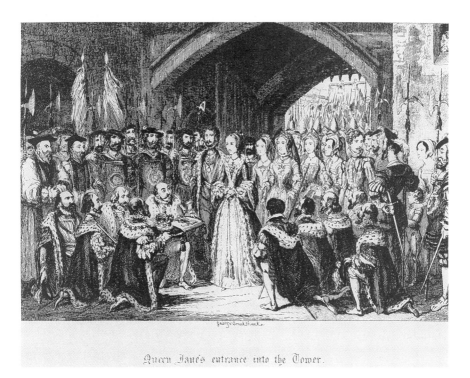

Queen Jane's entrance into the Tower.

26. George Cruikshank, "Queen Jane's entrance into the Tower," The Tower of London, *etching, Jan.* 1840

was, for all practical purposes, decided in favor of the author, and since *that* decision against Cruikshank has been used for over a hundred years to stigmatize his "*character for truthfulness*" and the "*condition of [his] intellect,*" it is important to establish Cruikshank's accuracy, not only as to the facts of the period 1836–1843, but also so that his frustration at not being believed thirty years later will be better appreciated.[25]

The principal characters and incidents were of course determined by history, so, apart from recommending the subject of the Tower during the later Tudor era, there was little Cruikshank or anyone else could do to shape the main narrative. The subsidiary love intrigue of Cecily, Nightgall, and Cholmondeley, and the Machiavellian Spanish ambassador Simon Renard may owe more to Ainsworth's love of villainy than to his artist. But the giants, the dwarf, their loves and marriages and masques and gourmandizing and absurd posturings, were additions that author and artist probably conceived and developed "*jointly,*" just as Cruikshank stated.

Their working relationship quickly assumed a routine: they would meet at the Tower during the first few days of the month, explore its halls, corridors, dungeons, tower, parapets, concealed passageways, torture chambers, gardens, moats, and gates, listen to the legends of betrayals and hauntings that the warders loved to recount, settle on the principal scenes and incidents for the ensuing number, and then separate.[26] Ainsworth would thereafter spend his mornings at Kensal Green consulting old histories and drafting his letterpress, while Cruikshank would return for more on-site sketches before immuring himself in the studio in order to convert the sketches into drawings for the wood-engravers and tracings of the steels, which he would forward to Ainsworth with last-minute instructions about details of the depicted action.[27]

There are at least thirty-three surviving letters between Ainsworth and Cruikshank recording this partnership. They range from appointments to discuss the next installment to lengthy summaries of the text and plates. "If fine tomorrow," Ainsworth writes on 2 January, "I propose to be with you at 10 o'clock, on my way to the Tower, whither I hope you will be able to accompany me."[28] "My D[ea]r. Ainsworth," Cruikshank pens in March, "You will disappoint me exceedingly if you do not come—. . . I have been calculating upon see[in]g. you to decide two or three points about the Tower, now mind unless I see you at 6 oCk. you will throw my work back & throw me out altogether. Yours in half a passion but yours truly."[29] Or, more extensively, Ainsworth sets up alternative plans for meeting his illustrator:

> I return [to London] to-morrow (Monday), and shall be at Kensal Lodge before four o'clock. If, therefore, you choose to proceed to the Tower in the morning, and come out to me by the omnibus leaving Paddington at 3 o'clock, you will be in time for dinner, and we can do a good deal of work before 8, when you can

return by the same conveyance. . . . If not able to come on Monday, I shall depend on meeting you at Pettigrew's on Tuesday at *half past 12,* and . . . I will drive you out to Kensal Lodge, and we can fully arrange our subjects for the next N[umber].[30]

Many of the notes concern titles for the steels. "I don't remember that we arranged about the title of the execution plate," Cruikshank jots on a letter from Ainsworth of mid-April. "It should be [']Execution of the duke of Northumberland on Tower Hill[']."[31] On 20 June Cruikshank forwards three options for entitling the plate wherein Queen Mary discovers Edward Courtenay vowing his love to the Princess Elizabeth, "but I leave it to you."[32] Ainsworth shortened the second of Cruikshank's captions. On another occasion, Cruikshank tightened up Ainsworth's suggestion: "Had we not better change the title to '*The Death Warrant*'?"[33] In one case, neither contributor could satisfy the other. Below the sketch he submits to Ainsworth, Cruikshank pencils "'Entertainment in the Stone Kitchen—upon Xits marriage' will this do for title the other is much—too long—." Ainsworth scores it out in ink and scribbles, "Won't do, at all," though the final title is hardly more succinct: "Xit, now Sir Narcissus Le Grand, entertaining his friends on his wedding-day."[34]

The partners traded a good deal of information about the Tower's history and appearance. Ainsworth lent Cruikshank a miniature of Sir Henry Bedingfield, created lieutenant of the Tower by Queen Mary, for the portrait introduced in "Masque in the Palace Garden of the Tower."[35] "If you look at the Plan of the Tower you will find an odd sort of building *abutting* the 'Salt Tower' which perhaps you may make something of," Cruikshank advised Ainsworth in June; the Salt Tower figured prominently in the July number. "You will recollect that unless [Nightgall, and Cecily, whom he is abducting] pass *through* or *under* that building they would have to go under the *Road* to the buildings which run parallel with the outward ramparts—I discovered from Mr. Worsley that the Path way or Platform *of the Rampart* is hollow and used by the inhabitants of the adjoining houses as cellars."[36] "If we introduce this cut of Northumberland cutting [being executed] surely the Beauchamp tower ought to come in" was another of George's suggestions in April.[37] Ainsworth also asked Cruikshank to furnish him with sketches of architectural features he planned to introduce into the story, but which, being out of town, he could not visit: "Pray, when you are at the Tower, sketch the Gateway of the Bloody Tower from the south; the chamber where the Princes were murdered; the basement chamber, at the right of the Gateway of the Bloody Tower, near the Record Tower, and interior of the Record Tower."[38]

The most significant exchanges that survive occur when Cruikshank, having planned his steels, sends Ainsworth a tracing accompanied by a

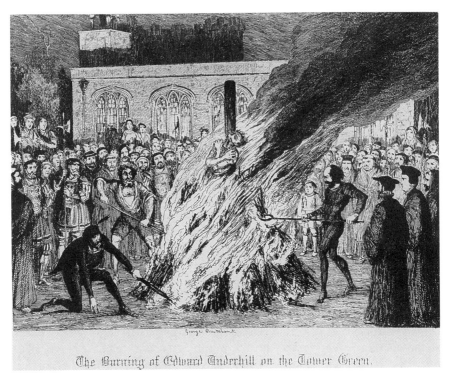

The Burning of Edward Underhill on the Tower Green.

27. George Cruikshank, "The Burning of Edward Underhill on the Tower Green," The Tower of London, *etching, Aug. 1840*

lengthy description of the picture, including notations about how the various participants arrived on the spot, and even conjectures regarding the wind, tide, and weather. John Harvey prints two of these concerning Wyat's rebellion and demonstrates, by quoting extensively from Ainsworth's letterpress, that he does "little more than paraphrase Cruikshank's letter."[39] Other correspondence confirms the practice. In forwarding a tracing of "The Burning of Edward Underhill" (fig. 27), Cruikshank explains:

> I suppose in "the Burning" that Underhill is at the last extremity of human suffering—His thin light hair streaming upwards his moustach & beard erect—his mouth streched to a fearful gasp. the eyes starting from their sockets his body frightfully convulsed—his finger nails tearing the flesh of his shoulders untill the blood—streams down—do not forget the death yell—which might be [echoed] by the wild beasts—or perhaps a total Death like silence might be better, even the wild animals scared by the unearthly sound.[40]

Ainsworth adopted Cruikshank's alternative ending. Underhill commences his immolation without a sound.

But as the flames mounted, notwithstanding all his efforts, the sharpness of the torment overcame him. Placing his hands behind his neck, he made desperate attempts to draw himself further up the stake, out of the reach of the devouring element. But the iron girdle effectually restrained him. He then lost all command of himself; and his eyes starting from their sockets—his convulsed features—his erected hair, and writhing frame—proclaimed the extremity of his agony. He sought relief by adding to his own torture. Crossing his hands upon his breast, and grasping either shoulder, he plunged his nails deeply into the flesh. It was a horrible sight, and a shuddering groan burst from the assemblage. Fresh faggots were added by Nightgall and his companions, who moved around the pyre like fiends engaged in some impious rite. The flames again arose brightly and fiercely. By this time, the lower limbs were entirely consumed; and throwing back his head, and uttering a loud and lamentable yell which was heard all over the fortress, the wretched victim gave up the ghost. A deep and mournful silence succeeded this fearful cry. It found an echo in every breast.

Horrific effects, though in a different key, were the object of several of the final plates, especially "The Night before the Execution," when the specter of Anne Boleyn glides across Tower Green past the scaffold, and "The Execution of Jane." "I am almost afraid the Execution is *too* horrible," Cruikshank told Ainsworth. "Let me know what your opinion is by return of post. . . . N.B. *Very few* spectators at Jane's execution."[41] To leaven the final pages, author and artist invented a marriage for the dwarf Xit—now Sir Narcissus Le Grand—with Jane the Fool, Queen Mary's jester. "The tracing of Xit's marriage—you will have tomorrow," Cruikshank continued. "He is returning thanks & the monkey—who is dressed up in his old clothes is pulling his cloak—Judge his surprise when he *turns around*—the monkey might jump on his back, Xit jumps off the table—runs off with the monkey on his shoulders." Then the artist adverts to a third plate for the final number, "Jane meeting the body of her husband on her way to the Scaffold": "What say you to *Ravens* or *Carrion Crows* hovering over the body of Dudley and *sweeping* over the scaffold? Yours almost distracted."

It was not only in the terrible and in the comic that Cruikshank strove to excel: he devoted countless hours to the images of historic moments, seeking confirmation for every incident and accessory in his plates. The three etchings depicting Wyat's rebellion—oblongs $3\frac{3}{4}" \times 5\frac{11}{16}"$ (done in the manner of giant historical canvases) that had to be printed sideways on the page—demanded almost infinite attention. Recovering from an illness which had set him back three or four days at the beginning of September, Cruikshank summarized his representation of the "Attack upon Saint Thomas's Tower by the Duke of Suffolk" (fig. 28):

The Flotilla consisting of several armed ships with—number of galleys & small craft congregate at Deptford—take in the troops & proceed with the tide to the Tower—the small boats creep along under the wharf wall—landing the men at

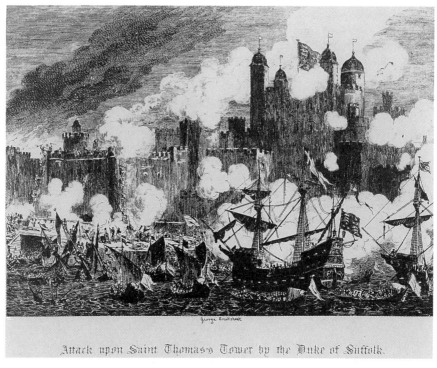

28. George Cruikshank, "Attack upon Saint Thomas's Tower by the Duke of Suffolk,"
The Tower of London, *etching, Oct. 1840*

the stairs who immediately attack "St Thomas's tower"—at the same time that a
party are attacking "the Traitors gate". Meanwhile the other boats land their
men at the *East end,* & indeed all along the wharf seizing the cannon placed
there of course, and turning them upon the Fortress—the guns from the battle-
ments are now in full play—The party on the wharf are covered or supported by
the guns from the Ships—one of which is sunk—several Galleys—&c are sunk
also—at the same moment of the water side assault—a strong body of Essex
men who had congregated at Limehouse—attempt to force the Iron gate & that
also leading to the wharf they approach by "St. Katherines" and the lane leading
to the "Flemish Church"—[42]

Granted both author and artist are drawing on the same sources and each
wants his contribution to accord with history and with the other's inter-
pretation; nevertheless it is unarguable that here as in the program for the
later illustration of the attack on the By Ward Tower, which John Harvey
discusses, Cruikshank's scenario is carefully followed in Ainsworth's text.
The last sentence of the artist's letter is rendered thus by Ainsworth: "A
strong body of Essex men, having congregated at Limehouse, approached

the fortress by Saint Catherine's, and the lane leading to the Flemish church, and were striving to force the Iron Gate and the eastern outlet of the wharf."

The style with which Cruikshank rendered these scenes emulated romantic history painting. Jerrold notes that in giving up copper for steel, Cruikshank felt he was working in a less flexible, but more lasting material. Consequently he extended himself as much as possible to produce images that moved not by virtue of their quirky, spontaneous lines and observations about character, but in consequence of their breadth, solidity, atmosphere, spaciousness, and factual authenticity. To imitate the tonality of eighteenth-century mezzotint engravings of historical subjects, Cruikshank sometimes etched over aquatint, producing "dark plate" illustrations years before Browne did them for Dickens. "In these Rembrandt-like scenes," Jerrold concludes, "he taught the world that his idea that he was a great historical painter who had lost his way, was no wild and vain fancy."[43]

As partners, Ainsworth and Cruikshank were also responsible for aspects of production, distribution, sales, publicity, and selling space in the monthly parts for advertising. Ainsworth wrote up and distributed notices; he and George looked over Bentley's list of country newspapers designated to receive review copies; after obtaining from Morgan the schedule of customary rates, Cruikshank hired a subaltern to collect advertisements to be carried in the monthly parts; and both partners had to sanction charges for reprints and to authorize payments to wood-engravers and to Sands, who helped Cruikshank bite up and press the steels.[44]

It must be understood that all this was accomplished while the partners were engaged in composing the monthly installment which, unlike Dickens's parts, varied in length from one to three sheets (sixteen to forty-eight pages). Chapters and subjects had to be settled by around the fifth, tracings sent to Ainsworth before the fifteenth, wood-engravings completed by the twenty-third so that they could be locked in the formes with the type, proofs of etchings and letterpress pulled and corrected before the twenty-fifth, plates pressed, and sheets printed, folded, collated with the etchings, stitched into wrappers, parceled up, distributed, and set out in the shops by the last Saturday of the month.[45] Repeatedly Cruikshank had to postpone work on his orthographic "View of the Tower of London in 1553," an extra plate that identified all the principal features of the fortress and its environs. "Don't you wish some one would invent a *fast* going *pen*?" he asked Ainsworth. "I would give anything for an Etching point that would go at the rate of a flash of Lightning."[46]

Moreover, all this was going on while Cruikshank was also illustrating Ainsworth's *Guy Fawkes* and etching a further plate per month for a story of Bentley's choosing. In narrating the Gunpowder Plot Ainsworth had

recourse to another body of historical documents that he used more and more overtly as the pressure increased. To some extent, he was on familiar territory, setting the first part of his story around Manchester and bringing in Humphrey Chetham, whose merchant fortune endowed a library and hospital, and the infamous conjurer Doctor Dee, warden of the Collegiate Church. For this tale Ainsworth wrote the letterpress first and then sent it to Cruikshank with suggestions for subjects.[47] Meanwhile the artist prepared the designs for the *Tower*, and the collaborators exchanged novels at midmonth. That way Cruikshank's square plate for *Fawkes* depicted the last scene of the installment, which was often a Gothic fantasy of spirits raised from the dead, assassins lurking in churchyards or Southwark kennels, Roman Catholic priests surprised in hiding, or tortured prisoners under interrogation in the Tower. While author and artist hewed to history whenever possible, Cruikshank even reproducing "Guido" Fawkes's enfeebled signature on his confession, the book straddles two modes—history and Gothic romance—and the plates are a mishmash of theatrical tableaux, historical prints, and illustrations to Walpole or Mrs. Radcliffe. They were not, on the whole, poorly conceived or executed, despite the pressures of time, but they failed to satisfy anyone.

It was over the contributions to *Bentley's* that Cruikshank got into trouble. The scribbled handwriting of his 21 January 1840 letter to Bentley displays his irritation at being driven so hard:

> "Guy Fawkes" was finished yesterday and will be in the hands of the printer this day—Mr. Cocton [Cockton] was with me last Evening between 7—& 8 o'Clock—to settle the subject for "Stanley Thorn" [the other novel for the *Miscellany* Bentley wanted Cruikshank to illustrate each month]—*which I should now be going on with had I not to write this letter* The consequence of which is that I shall not be able to settle down to that subject before the Evening—*I presume that* you are *not aware that any interruption* at a time when I am very busy always throws me back if therefore the Plate of Stanley Thorn should be *very* late this month you will please to recollect that I did not get the MS. untill the 20th. that the design was not settled untill late in the Evening of that day—and also that I have been annoyed and interrupted because the Printer wanted to know whether the Plates were ready.[48]

The "bubbles from the domestic hot well" that rose periodically to his mother's lips also issued from George's. His sense of injury was reinforced by Dickens's example, while on the other side Bentley grew more and more stubborn about not letting a mere illustrator dictate to him as Boz was trying to do. "I saw Cruikshank (who has—of course—quarrelled with Bentley) in the street the other day," Dickens reported to Mitton, "and he told me that Bentley had told Ainsworth that if I did the New Work [*Master Humphrey's Clock*, a weekly serial which Dickens hoped to edit from the

contributions of others] instead of Barnaby, he *intended to publish all the letters I had ever written him!!!*"[49]

During this troubled period, when Bentley was quarreling with Dickens, Cruikshank, Ainsworth (who was "as savage as a tiger with that infernal donkey Bentley"), and Bulwer, Canon Barham attempted soothing gestures.[50] Ainsworth had brought Tom Hughes's grandmother to Cruikshank's studio early in the new year; she had extracted a knife, pencil, and piece of paper from under the "Sopha of your *working room,*" and though "tempted by Satan to *keep* the pencil as a relic to be left to my grandchildren," she returned it with a charming letter.[51] Barham kept up the connection so fortuitously born, advising Cruikshank a month later that there were finnan haddies waiting for him at Mrs. Hughes's, for which he had better send before they were made into Finnan-Haddock-Jelly.[52] Throughout the year Barham served as mediator, though his youngest son died at the end of May, and from this bereavement he never fully recovered, exhibiting thereafter an "indifference and irritability," "a failure of energy and interest in favourite pursuits," previously unknown.[53]

The first week of February brought George new grievances. Having consented to introduce a wood-engraving after a design by his old friend Crowquill in the January *Miscellany,* along with his own plates for *Guy Fawkes* (1), *Stanley Thorn* (1), and *Jack Sheppard* (2), he was now asked by Bentley to consent to more Crowquill plates. Even more vexing, Cruikshank had wanted for some time to illustrate *Ingoldsby,* and now suddenly after long delays, Bentley, who had purchased Barham's interest in the copyright for £100 on 16 January,[54] required him "to execute the plates [for the first collected edition, 1840] when you knew at the same time it would be impossible to do them" without sacrificing his other work for the *Miscellany* and the *Tower.* Moreover, having "positively engaged" Cruikshank for Barham's work, Bentley, over repeated objections, commissioned illustrations from others and indicated his determination to do so in future. "I have also to complain," Cruikshank charged,

> that after having distinctly repeated to you that I would not suffer the plates of any other artist to be mixed up and published with mine, a thing which I have objected to and acted upon for the last twenty years, because I found it was absolutely necessary to my interest to do so; and therefore cannot & will not permit any one to do it now. Nevertheless, well knowing as you did my decided objection to such a plan you have in despite of all I had previously said upon the subject, not only published the one Ingoldsby Plate to which I so strongly objected, but have added others thereto—[55]

Cruikshank thought of himself as *the* artist for *Bentley's,* and indeed both his agreement and the advertisements acclaimed that position. But his very success with the magazine foreclosed other options—first Dickens's novel,

now Barham's legends. He simply could not sustain the level of productivity required to keep the magazine and the separate publication going simultaneously. Crowquill and Leech were by midsummer regular contributors to the *Miscellany*. Cruikshank's inability to retain exclusivity as artist to some extent depreciated his contributions. The strain also affected his health.

A fortnight's indisposition at the beginning of February put George fearfully behind. Bentley had expected to see him about his complaints, but Ainsworth failed to deliver the message that George was sick. A second appointment was scheduled to take up various matters, including the accounts for the first numbers of the *Tower*.[56] As often in author-publisher relations, these accounts themselves caused a good deal of heartburn, since the charges seemed high and the profits low. Cruikshank wanted Ainsworth to join him: "You ought to do so for I wrote to Mr. B to say that *you* & myself wished to see him upon the subject and it makes quite another affair altogather if you stay away."[57] Perhaps Ainsworth accompanied the artist to New Burlington Street on this occasion; in another instance, on 11 March, Ainsworth was absent when Bentley called on Cruikshank and "expressed considerable displeasure" at the illustrations for *Guy* and *Stanley Thorn*. He said that he intended to employ another artist on a regular basis. "Upon this," Cruikshank reported to Ainsworth, "I declined having anything further to do with it, upon which he took his leave, not, however, without a great deal of *hot breath* being expended on both sides." In some ways this rupture was a relief: "I shall be very glad if I can be really quit of him," Cruikshank concluded.[58]

But the break did not occur. Two days afterward Cruikshank was surprised to receive a note from his publisher about the next *Miscellany*, since he had "*distinctly* understood" that his services were no longer required. "However as I find it is your wish that I should still continue to illustrate that work and are determined to hold fast by the *written* agreement—I beg to say that I am ready to fulfil my part thereof although under the present state of feeling I should be *more than* pleased to get rid of it altogether."[59] In a draft of his reply to Bentley, Cruikshank let off more steam in the closing—"I am Sir *not your obe[dien]t S[er]v[an]t*"—but the final version ends conventionally.[60]

At this juncture Cruikshank found himself in a most unpleasant situation, debarred from taking on more promising assignments by the pressures of work and forced into sharing the honor of illustrating the *Miscellany*. About his only recourse was to become punctilious about adhering to the terms of the agreement: if Bentley was going to hold *him* to it, he would reciprocate. "I have to remind you," he told Bentley on 13 April, "that according to the written agreement you are to furnish me with the subject for illustration in the Miscellany—As you now employ other artists in that

work besides myself I shall expect you to make an alteration in the wrapper accordingly."[61]

Bentley could play that game too. He simply replied that Cruikshank should consult Ainsworth about the *Guy Fawkes* plate.[62] (Ainsworth suggested as a subject the "Vision of Guy Fawkes at Saint Winifred's Well," but offered George the liberty of picking another scene if he preferred.[63]) Thereafter Bentley regularly assigned *Stanley Thorn* to Crowquill or Leech, and gave the latter the coveted assignment of depicting Ingoldsby's "Black Mousquetaire" for the October *Miscellany*. Barham still thought Cruikshank had a chance. "I could give a capital idea, I think, to Leech or Cruikshank for an illustration to the *Mousquetaire*," he wrote Bentley from Great Burstead where he had gone with his wife to recover from their loss.

> A very strong effect might, in my opinion, be produced by a clever artist from the contrast afforded by the presence of the real and the sham ghost [twin sisters, the first a violated nun who has died, the second dressed alike to frighten the seducer] in the room together; also by the expression upon the countenances of those who are in the plot, and who only see the spectre of their own contriving, and that of the guilty and horror-struck individual, who sees *both!* I wish to goodness I could put it upon paper myself.[64]

But Bentley asked Leech, who carried out the author's program exactly, though for some reason afterwards the conspirators were deleted from the plate.

In May Dr. Roberts tried to mediate the dispute. He tendered to Cruikshank a Bentleian olive branch.

> Bentley came to me this morning [5 May], begging I would communicate with you as . . . a mutual friend to both parties, & which I consented to do, on the express understanding that whatever I did was for the purpose of *peace-making* & not *peace-breaking*. He thinks that you are wishing to dissolve your present connection with the Miscellany & as this is his idea, he is anxious to know from yourself, whether such is the case or not:—& if it is—he is particularly desirous to part on the most friendly terms, as he expressly assured me he had no other feelings towards you, than those of esteem & regard.[65]

Some kind of reconciliation ensued, for within a fortnight Bentley was corresponding directly with the artist about advertising for the *Tower*.[66] But a few weeks later Cruikshank and Bentley got into a row about the advertising receipts from the monthly numbers: evidently George had not been businesslike about accounting for payments he had received from customers, while Bentley had not kept the right kind of books, so Barham and Morgan between them rectified procedures and mollified the participants.[67]

For some months thereafter Cruikshank worked for Bentley without incident, though also without enthusiasm. In July Dickens persuaded Chapman and Hall to buy out his contracts with Bentley, a step which probably fore-

stalled Cruikshank's ever illustrating *Barnaby*, as Browne was Dickens's regular artist for Chapman and Hall publications. By August Cruikshank was chafing again; Morgan told Bentley that George's "animosity towards you carries him away into the most frantic outbreaks of passion."[68] When the volume edition of the *Tower* was in press, Bentley's stinginess further infuriated the partners. Cruikshank drafted an appeal for arbitration to Barham and sent it to Ainsworth for comments on 10 November: "In my letter to Mr. B[arham] I wish to make the matter as it were *my own* in order that you may not in any way be bothered by Mr Bentlie at present," since Ainsworth still had to work closely with the publisher on the *Miscellany*.[69] The causes of complaint seem at first glance rather picky: Bentley has not used his "*best exertions*" to promote the novel, bought inferior paper for the first numbers, and shirked on collecting advertising. But when Cruikshank attaches to his appeal a schedule of his receipts, amounting to just over £16 per month, the inequality of the owners' shares of work and reward becomes manifest:

The first four months	nothing
May	20.17.10
June	21. 3. 8
July	14. 4. 7
August	34
September	37.16. 3
Octr.	27. 6
November	22.12. 2
	————
	178. . 6[70]

Since final accounts for the profits on individual parts took several months to settle, this record probably represents receipts on only the first eight or so numbers. Even so, at the rate of twelve guineas per square plate paid by *Bentley's*, the forty *Tower* steels, each larger than the *Miscellany* illustrations, would have yielded £504; and in addition Cruikshank had designed fifty-eight wood-engravings. The bargain was unquestionably a financial disaster.

The volume edition came out in December, royal octavo bound in claret (blood?) colored ribbed cloth with a gilt-stamped picture of two guards standing before a gate with opened portcullis on the cover, and a picture of the White Tower on the back. Cruikshank had designed these decorations as another version of the progress from outside to inside, present to past. The standard price was 14s. 6d., but for three shillings more purchasers could obtain a copy bound in half morocco with gilt edges, and for a

guinea, one in full morocco. Artist and author produced a handsome book that was affordable for the middle class. Sales were sufficiently brisk that Bentley was issuing a sixth edition by 1845.

Two dinners were given to celebrate the novel's publication. Ainsworth hosted a small one on 28 November, the date of his preface.[71] A much grander one was cohosted by author and artist on 12 December at the Sussex Hotel, near Bradbury and Evans's offices in Bouverie Street. This was a party both of celebration and reconciliation. James Crossley came down from Manchester for the occasion, on which, Ainsworth promised, "you will meet many persons whom you cannot easily see, except under similar circumstances."[72] The other guests included Dickens and Forster; Thomas Noon Talfourd, who took the chair; Barham; Maclise; Stanfield; H. W. Pickersgill, who was painting a full-length portrait of Ainsworth; John Hughes; Laman Blanchard; Jerdan; Thomas Longman; Major Elrington, the acting governor of the Tower; Edmund Swift; and young John Black-wood, son of William whom Ainsworth had known for eighteen years and with whom Cruikshank had worked and corresponded.[73] Talfourd made complimentary remarks about the distinguished authors, critics, artists, and publishers there assembled, and lauded Ainsworth appropriately. A succession of toasts followed, with Swift, descendant of the Dean of St. Patrick's, making a notable address. Forty years later at a Manchester dinner honoring Ainsworth just before his death, Crossley recalled the earlier occasion:

> The characteristic of the remaining part of the evening was the grand geniality and the utter impossibility of anything like a jar. There were rival authors present, but they did not quarrel; there were hostile critics, but their challenges were limited to champagne; there were men of different schools, but they broke down the partition in order to make the harmony perfect. There was a case of mortal feud, but it was arranged by an armistice which lasted, at all events, that evening.[74]

The "mortal feud" may refer to Forster's attacks on *Jack Sheppard*. But for the evening, all such unpleasantness—excepting the partners' dispute with Bentley who seems *not* to have been invited—was put aside, in order to pay tribute to one of the leading authors, and to the leading illustrator, of the day.

"Geo. Cruikshank was very good," young John wrote home. "He sang 'Lord Bateman' and some others. The claret and champagne were as plenty as could be wished."[75] Cruikshank offered to take care of the post-prandial coffee and cigars, as Ainsworth had to start home to Kensal Green, but he allegedly forgot about the bill, sticking Ainsworth for a considerable sum.[76]

Some other incidents of the year 1840 should not pass without remark. Cruikshank kept up his cordial friendship with John Thompson, dining at Thompson's home along with Henry Cole in February.[77] James Purvis, an etcher living in "industrious idleness" in Suffolk with a well-to-do ailing

wife, forwarded to Cruikshank in March extracts from a letter written by a
former apprentice, Edward Hopley, who after spending an hour in Amwell
Street desired to be taken into Cruikshank's service "like a raw girl from
the workhouse [who] must be first taught what she has to do."[78] Although
Hopley had an aunt "in very good circumstances," he had no ready money;
perhaps for that reason the engagement was never made. The Cruikshanks
dined with George's old caricature patron Thomas Tegg at Norwood Lodge
on 18 March, a connection that while not presently remunerative was still
pleasant for its past associations.[79] Tegg may have asked his guest whether to
lend the artist's woodcuts for Murray's "Family Library," which Tegg had
purchased and warehoused, to the *Westminster Review* for Thackeray's
forthcoming essay about Cruikshank. Whatever the reply, Tegg refused.[80]
The Anti-Corn Law League applied to George for illustrations to their
circular, and one other minor commission—to design a new frontispiece
and title vignette for Captain Chamier's *Ben Brace*—dropped in through
the mail slot.[81]

In late May Merle was at it again, designing a comic envelope for the post
office which Cruikshank was too harried to get etched before others, in-
cluding William Mulready, Leech, and John Doyle, issued theirs:

> I was then so much engaged that I took it to my Brother to forward, but he
> neglected to do so. I then *fell ill again* with a swelled foot *again* (but without any
> pain). I had previously engaged Tilt to publish your Design—and as soon as I
> had "*bit* in" the plate *I took it to him*—after the lapse of a day or two he returned
> the whole [thing] say[ing] that "there were already several imitation envelopes in
> the field, that they sold at a very low price, that very little profit could be made
> out of them—that the public seemed to have had their laugh [at] the thing, that
> he had been acting as wholesale agent for Fores [publisher of Leech's spoof] who
> might consider his publishing one as an unfair interferance—and moreover that
> he was about to leave Town for a week and he had found that it would take two
> or three days preparation before it could be published—which he could not
> possibly give to the matter in question"!!! He forgot to mention two things, one
> is that he is a shabby fellow—and that . . . he might have told me all this when
> I delivered the plate—and gave him the necessary instructions—I will endeav-
> our to find *another Gentleman* tomorrow—[82]

The triviality of Merle's commission, coming in the midst of so much other
pressure, and the emphatic response of Tilt, frustrated Cruikshank and
sharpened the edge of his temper.

But on the whole Cruikshank's association with Tilt remained amicable.
This was an especially important year for the publisher. Early on he had
evidenced a knack for making money, capturing virtually a monopoly on
lithographic picture books imported from France, and enlarging his fortune
by issuing books illustrated with steel-engravings. When he decided to re-
tire early, instead of seeking an outside buyer he reviewed his own staff.
Passing over one assistant with more money than brains, another with "ex-

pectations" and ambition, and a third with considerable practical knowl-edge, he chose the fourth, David Bogue, who had only his "general shrewd-ness and steady application to business to recommend him." One evening Tilt asked the young man to stay after hours. He then proposed taking him into partnership for a limited term, at the expiration of which Tilt would turn over the whole enterprise, allowing sufficient time for Bogue to repay the capital advanced, amounting to forty or fifty thousand pounds. Tilt's confidence was well placed, for Bogue continued the business prosperously for many years.[83] The kindly and tolerant Bogue thus became one of Cruik-shank's principal publishers, sustaining a profitable connection and a friendly relationship that extended to bailing the artist out of jail when in the mid-1840s George took to drinking excessively once again.[84]

The *Comic Almanack*, however, was not thriving. Cruikshank was too busy with other projects and he lacked a regular writer to replace Vizetelly. Over the summer Thackeray sent him some papers that had been rejected by the publisher Alexander Blackwood and cautioned him "ag[ain]st any such folly as imitating his example. They will suit your book [1841 *Comic Almanack*] to admiration." These might be "The Invasion of Boulogne" and "London Lions," both letters written by semi-literate tourists, and "A Lon-don Fog," describing a November "particular" in anaphoric sentences that anticipate Dickens's opening of *Bleak House* a decade later, although these have never been specifically attributed to Thackeray.[85] "I was in such a cursed hurry of business during the 4 days I was in town," Thackeray con-tinues, "as to know that an interview with you was no good. Indeed it wasn't my fault that I broke my promise to you."

Whatever promise Thackeray thought broken, he kept a more important one handsomely. In the June 1840 *Westminster Review*, Thackeray's sixty-page lavishly illustrated notice, nominally of *The Tower of London* but actu-ally surveying forty years of prints, accused the British public of ingratitude in neglecting the artist. Thackeray fulfilled many purposes in this essay, not the least of them being to make some money. So much attention paid to the comic side of Cruikshank's genius deflected criticism away from the artist's participation in *Jack Sheppard*, now at the height of its journalistic contro-versy, and allowed Thackeray at the article's conclusion to rave about the novel's illustrations. The notice also strengthened Cruikshank's hand in future negotiations with Bentley by making him a more valuable asset, and it indirectly advertised the *Comic Almanack* (including Thackeray's contribu-tions). By celebrating the artist's humor, Thackeray downplayed the risqué and the slashing invective of the sharpest Georgian political satires, thereby adjusting Cruikshank's oeuvre to a more sentimental, decorous taste. This latter shift in emphasis may owe something to Cruikshank him-self as he struggled to adapt his vision to early Victorian proprieties. Kenny Cole wrote in May from the *Westminster Review* office in Pall Mall: "We

have trie'd to do you justice and I hope you will think we have Succeeded. I opine it was with regret that Mr Thackeray persuaded me to leave out some of the excellent political Squibs done 20 years ago—and I only yielded to what I understood to be your wishes, hinted at but not expressed—."[86]

As Lockhart had, Thackeray urged Cruikshank to become the sort of artist he admired; but Thackeray preferred the hearty laugh to the gentlemanly smile. He discerned much of the real spirit in his quondam teacher's images, especially the wood-engravings for such 1820s publications as *More Mornings at Bow Street* and *Three Courses and a Dessert.* In some ways, as Guilland Sutherland has pointed out, the article was an obituary for illustrated street literature, now being taken over and dignified by the rising novelists.[87] In that regard, Thackeray was continuing his journalistic campaign to establish a vein of literature in which he might practice superlatively; his praise of Cruikshank is related to his various attacks on the Newgate school, to the Yellowplush and Titmarsh personae through which he looked at the pretensions of contemporary urban life, and to his nostalgia for the Georgian era and its late flowering in the Regency, a period shaped to a considerable degree in Thackeray's reconstructions by Cruikshank's pictures. Celebrating the fifth George was celebrating a healthy cleansing laughter, a sense of the ridiculous, and a sentimentality about everyday life—all foundations of the inclusive satiric vision that within a decade Thackeray would claim as his own especial métier.

As the year drew to a close, one of George's oldest friends suffered a calamity. "Mummy" Pettigrew, as librarian to the duke of Sussex, had access to a remarkable collection of rare books. Maginn, omnivorously curious, asked to borrow a number of these to assist him in a review of Pettigrew's catalogue of the duke's Kensington Palace library for the *Quarterly.* By November, eighteen months had elapsed, but Maginn had neither returned the books nor penned the notice. Despondent over the death of Letitia Elizabeth Landon, fuddled from acute alcoholism, and bankrupt, he was hiding from the bailiffs in a Wych Street garret, so Pettigrew could not obtain his address. Consequently the learned bibliographer feared daily that he would be dismissed in disgrace, as in fact he was.[88] Lockhart relayed this story to John Blackwood, who promptly sent it home in a letter to his brother Alexander.[89]

Finally, on New Year's Eve Cruikshank went to Dickens's grand new home at 1 Devonshire Terrace, unaccompanied by Mary Ann, who was seriously ill. Dickens invited Harley and "one or two more who are friends of all of us" for an informal, lighthearted party of "charades and other frolics."[90] The contretemps over Oliver's last appearance and Dickens's soured relations with Bentley cast no shadow on his affection for Georgius. They would frolic together for another decade.

30

THE "HOC" GOES DOWN

GEORGE CRUIKSHANK—every heart, both young and old, —
Even the middle—most uncertain—aged,
Owns satisfaction as thy name is told;
Renown'd for long successful battle waged
'Gainst devils blue, that so in thraldom hold
English hearts, ever by themselves encaged.
CRUIKSHANK! I do rejoice to see thy name
Reckon'd with AINSWORTH's in the roll of fame!

Union most pregnant! that with grace doth bind
In faithful bonds such pencil and such pen—
Kith bound to kin, and neither less than kind;
So shall young graces bless us now and then.
Heaven marries truly such a mind and mind,
And shall command for both the hopes of men.
Now, trustful, let us forth with thee and AINSWORTH,
Knowing full well it will be well the pain's worth.

"Literary Acrostics," Ainsworth's Magazine[1]

DURING the next four years, 1841–1844, Cruikshank encoun-
tered a succession of setbacks, disappointments, financial reverses,
illnesses, and deaths that harassed and vexed him and sent him back to the
bottle. To the public he was as great a man as ever. Biographical essays
proliferated; notices of his publications were respectful or adulatory; re-
quests for his autograph streamed through the letter flap; projects were
mooted, and stories, poems, and novels were submitted in the hope that he
would supply illustrations; he was repeatedly asked to serve as steward for
this banquet or that; his recommendation was solicited for vacant places,
charitable grants, testimonials; and his company was requested for dozens of
dinners and celebrations. But that public recognition began to divide from
his private circumstances: Cruikshank was increasingly hard-pressed to
meet his bills, he could not win a big audience, former friends turned adver-
sarial, and Mary Ann's health deteriorated.

As the great figures of the mid-Victorian era begin to find their voices and consolidate their audiences, Cruikshank seems to quaver. Even though he etches some of his most brilliant and highly wrought plates, the imitative publications for which they are made do not quite keep pace with changing tastes, styles, and subjects. In refusing to join *Punch*, in not working further with Dickens, in tying himself to second-rate writers such as Laman Blanchard and Gilbert à Beckett, in depending on niche publishers like Tilt and Bogue or Cunningham and Mortimer, Cruikshank slips from preeminence to mere eminence—not a major slide, but since his finances and artistic opportunities were always precarious, a difficult one to stop or reverse.

His principal conflicts arose over the arrangements with Richard Bentley. Cruikshank bitterly resented sharing the responsibility for illustrating the *Miscellany* and finding his images alongside the work of others when *Miscellany* papers were collected and reissued in volumes. The loss of exclusive rights to illustrating the *Ingoldsby Legends* hurt most of all: for the First Series (1840), Cruikshank's two plates were teamed with Leech's three and one by Dalton; for the Second Series (1842), Cruikshank failed to secure the commission for "The Black Mousquetaire" and two other images, but did contribute four etchings.

With regard to the Second Series, Bentley attempted to conciliate his inflammable artist. In August 1841 the publisher signed a formal Memorandum of Agreement with John Leech to supply square plates for the *Miscellany* at £7 apiece.[2] This meant that Leech would in the course of business sometimes illustrate Barham's legends for the periodical and Second Series. After Cruikshank expressed a desire for a particular subject, however, Bentley evidently checked with Leech and, finding that it was not among those Leech planned to draw, reserved it for Cruikshank.[3] In January 1842 Bentley gave Cruikshank Ingoldsby's "The Dead Drummer"—a skeleton leaning against a sign post—and in March he assigned the parody of the trial scene in *The Merchant of Venice* to accompany another of Ingoldsby's pieces.[4] In May, he gave him a fourth Ingoldsby subject, and in December a fifth.[5] Even though the plates continued to deteriorate in quality, as late as April 1843 Bentley was still handing George subjects from Ingoldsby.[6]

When in October 1841 Cruikshank learned about the agreement with Leech, he took extreme umbrage. This was not merely de facto supplementation, a casual and occasional recourse, but de jure cancellation of the original exclusive position Cruikshank had held since the magazine's inception. Ainsworth had tried to forestall this development back in June, telling Charles Ollier that when *Guy Fawkes* completed its serial run, he would begin *Windsor Castle*, warning Bentley that he would "not allow Mr.

Leech, or any other artist than Mr. Cruikshank, to illustrate any portion of the work," and insisting that a clause to that effect be inserted into their agreement.[7] That stratagem failed, however, largely because Ainsworth shortly afterward quit the editorship of *Bentley's* and took the unwritten *Windsor Castle* with him to his own periodical.

On 5 October Cruikshank complained so bitterly that Bentley asked his solicitor Gregory to mediate. According to Bentley's understanding, what was principally at issue was the choice of subject for Cruikshank's monthly plate; if, as the agreement stated, "the subject of the design to be executed by [the artist] for each monthly Miscellany is to be furnished by Mr. Bentley," then Bentley felt he was perfectly within his rights both in choosing which article Cruikshank was to illuminate and in picking other artists for other subjects. Moreover, Bentley seems to have thought that the crux of the dispute was Cruikshank's impression that the treatment for each plate was being dictated. Gregory tried to reassure Cruikshank that "the manner in which that subject shall be treated and worked out" was left to the artist.[8]

Cruikshank spent three days meditating on his reply. After several attempts, he finally composed a response:

> In reply to your letter, I beg to state that your version of the agreement between Mr. Ricd. Bentley & myself, is literally correct, but you are in error if you assume that I desire to put any interpretation upon the words except that which they evidently bear. Their meaning is that I should be supplied with a subject for illustration; and not that I should be required to read through a quantity of matter to search out a subject for myself, this, their clear purport, is in strict conformity with the practice observed from the day on which the agreement commenced—Mr. Bentley's Editors having invariably described to me verbally or in writing, the exact subject they had chosen for illustration, without subjecting me to a task never contemplated, that of seeking a subject from their manuscripts.[9]

At this point in the drafts Cruikshank had included other information: "I beg to add that in *no one instance* has this practice been departed from since the commencement of the work," and "*except in many instances when I have furnished the subjects myself* . . . the plates hav[ing] been etched before a line was written by the author." "All I desire," Cruikshank concluded, "is to adhere closely to the agreement and to the practice. When Mr. Bentley sends me as heretofore a subject for illustration, I shall as heretofore immediately proceed to execute it."

Cruikshank's tactics in this dispute are not very clear. That he wanted to relieve himself of the burden of reading through a whole issue in order to find a subject seems plain enough; and since he could not do so until the make-up of the next issue was fixed, presumably he wanted more time for executing his etching than such a procedure would allow. But it was also his

practice to discuss the plate with the author, and even from time to time to suggest alterations to suit the pencil. He had in the past searched entire articles for an appropriate passage. By insisting on Bentley's dictating the subject he was surrendering a good measure of artistic freedom and potential for influencing the text in order to minimize his *Miscellany* labors. Yet at the same time, with Ainsworth and with the other publications under his own superintendence, Cruikshank sought more extensive control over letterpress as well as pictures. Evidently what he wanted was to bank a regular *Miscellany* payment while reserving his time and energy for other projects.

Gregory conferred with Bentley, then wrote back. Cruikshank in his reply took up another grievance:

> besides the written agreement [of November 1836] between Mr. Bentley & myself there was also a *verbal* one made at the same time; one of the points of which was, that no other artist in my *particular line* should be employed in illustrating the Miscellany. But *this* agreement Mr. Bentley broke through in the second number and *did* employ other artists and after a strong remonstrance with him against this, I was induced to take *Half price* for an extra plate (as Mr. Bentley informed me the *Miscellany* could not afford to pay more) and I became sole illustrator of that work according to the original understanding and agreement.[10]

What Bentley seems to have raised with Gregory was the fact that Cruikshank had produced not one but often two illustrations per number, and that these had been paid for at differential rates. Neither publisher nor artist got the verbal modifications of the original agreement quite right. Cruikshank had promised to etch *two* large square plates per month at twelve guineas each, and a *third*, from a subject of Bentley's choosing, at six guineas.

Cruikshank told Gregory that since he had received instructions to choose among two subjects for the next issue he would in this case pick one "*now*, but for *the future* please to observe that I only require *one* point for illustration."[11] As Bentley had learned to his cost with Dickens, no agreement could force an artist into productivity; if Cruikshank refused to design more than one illustration, and if Bentley still wanted the artist's work, then he was going to have to adhere strictly to the language of the original agreement. So he did. From October 1841 either Bentley or Morgan or Barham sent a description of the subject to be etched, usually with a promise that the relevant portion of copy would follow if desired. The correspondents attempt compliments—they will leave the details to George's genius, Morgan says, and Bentley points out each time he assigns a Barham legend—but the communications by their spareness express how guarded the working relationship had become. Nonetheless, Cruikshank remained a valuable connection for the journal; even "that great bore Lord Nugent," Morgan reported to his boss, wanted Cruikshank to illustrate his paper,

perhaps by designing a wood-engraving representing the map of England as an old woman holding Wales in her lap. "Quelle betise!" Morgan concluded.[12]

Still, as Cruikshank complained to an unidentified correspondent during this period, his plates were "done upon *compulsion*," and he wished "to have nothing further to do with" the magazine.[13] Frustrated by his inability to break the Bentleian bonds, he determined to force a cancellation of the agreement. He told Cuthbert Bede many years later that he used to place his watch upon the table and scratch through the waxed surface of the metal plate with his etching needle as fast as he could. Having made an outline, he would scrawl a perfunctory signature and hand it over to his brother Robert to put in some shading and details. Sands would bite it in quickly with few stoppings out or immersions, and so it was forwarded to the publisher.[14] The results were terrible. "Cruikshank's Miscellany plate," Morgan told Bentley in July 1842, "though embodying pretty accurately Mr. Barham's instructions," "is as bad as he can make it."[15]

In Bentley's absence Morgan struggled to keep the relationship with the artist from deteriorating further. In September 1843, due to a series of misunderstandings, no article suitable for illustration was in proof as late as the twentieth. At the last moment Morgan thought of a mildly risqué paper Dr. Roberts had sent through Cruikshank to Dickens in 1837, and which Dickens had accepted but never published.[16] Given this history and Cruikshank's friendship with Roberts, Morgan hoped the recalcitrant artist would expend some care on "Regular Habits"; he asked the author to call on the artist personally to elicit his cooperation.[17] But the stratagem failed. The plate was "vile." And the day after it was finished Cruikshank applied for payment "in a peremptory manner," Morgan reported to Bentley, "threatening if not at once settled to place the matter in an attorney's hands!"

> On considering all the bearings of the case that occurred to me, I concluded that there was no escape. He has nominally complied with the agreement & if the quality of the plate be objected to, he could shelter himself behind the plea of the lateness of the time when he recd. the subject. Besides the plate, horrid as it is, is not so very much worse than some others he has recently furnished *and which were not objected to by you.* Moreover all this is a matter of opinion & if tested at law the sympathy of the Court would probably be on the wrong side— Pay him therefore I saw I must so I did it at once without demur. It now remains for you to consider—*first* whether this plate shall be used—*secondly* whether you will be plagued with a monthly repetition of his bullying roguery.[18]

Cruikshank had held his publisher to a stand-off, but the protracted quarrel wasn't doing either party any good.

As if bad plates weren't enough provocation, when Ainsworth commenced his own magazine in February 1842, Cruikshank persuaded him to

issue "a few words to the public about Richard Bentley. By Mr. George Cruikshank." Periodical wars were not uncommon: Maginn and the Hon. Grantley Berkeley had fought a duel over one, and a somewhat less focused exchange involving Bentley, Father Prout, "Mr. Buller of Brazennose" (John Hughes), Ainsworth, and Cruikshank developed out of *Jack Sheppard*, *Ainsworth's Magazine*, and Cruikshank's published attack on Bentley.[19] Cruikshank wanted his audience to understand that he did *not* illustrate the *Miscellany*, despite Bentley's advertisements to the contrary. "It is true that, according to a one-sided agreement (of which more may be heard hereafter), I supply a single etching per month. But I supply *only that single etching.*" After chiding his nephew Percy for using the name "Cruikshank the Younger" when cutting Crowquill's plates in the block for the *Miscellany*, he concludes that Bentley's actions show there is something to the joke circulated when the publisher began his magazine:

> "I advertised it," said he, "as the 'Wit's Miscellany,' but thinking it would be difficult to find wit enough every month, I withdrew the announcement, and resolved to call it 'Bentley's Miscellany' instead." "Why, yes," said a distinguished humourist, "there was good reason why you should not call it the 'Wit's Miscellany,' but why go to *the opposite extreme?*"[20]

This was, as Ellis rightly observes, in execrable taste. Ainsworth may have been induced to print it because he himself was unhappy with Bentley, or because George insisted on it as a condition to allying himself with the new publication, or even because distinguishing Cruikshank's affiliation with *Bentley's* from his affiliation with *Ainsworth's* was necessary if the periodical audience was to be weaned from the older journal. In the *Miscellany* Advertiser for January 1842, Ainsworth announced that apart from the single monthly plate for *Bentley's*, all Cruikshank's subsequent periodical work would appear in his magazine: "No other monthly work whatever will be illustrated by Mr. Cruikshank." Despite his initial reasoning, Ainsworth clearly thought better of the decision; it was inappropriate to open a new publication explicitly devoted to the light and genial with such a diatribe. The remarks were suppressed, the index to the first volume makes no reference to the *"few Words,"* and no file copies of *Ainsworth's* examined by the editors of the *Wellesley Index to Victorian Periodicals* contain Cruikshank's statement.[21]

A third area of conflict developed over the *Tower* accounts. Cruikshank and Ainsworth found, as Dickens had, that despite Eliza Ketteridge's meticulous bookkeeping, New Burlington Street took an inordinately long time rendering statements on sales and profits.[22] Bentley and Morgan discovered, and Cruikshank's creditors often did, that the artist though honest in intention was often slow in execution of his debts and muddled in

reckoning his sums. By November 1841 all the parties involved were grow-ing testy. Bentley wanted to determine the profits reaped from selling ad-vertising in the monthly numbers, but as Ainsworth and Cruikshank had taken over that department of the *Tower*, Ketteridge could not close the books until she received information about how much individual adver-tisers had paid Cruikshank. Morgan suggested that Bentley might be per-suaded to abandon his interest in the advertising account if Ainsworth and Cruikshank granted him a share of the volume reprints. (They had the rights to all copies beyond the initial three thousand of the first edition, upon payment to the publisher of the nominal sum of £55.)[23] "If you & Mr. Ainsworth think it worth while to attend to this suggestion I will at any time you may appoint meet you to discuss the details, or refer the point if required to Mr Barham," Morgan closed. Cruikshank started to scribble a reply on the verso of Morgan's note, announcing his intention to produce a report on the volumes of the *Tower*, but suddenly broke off. Bentley's letter dictating the subject for the next *Miscellany* had arrived, so he turned to etching instead.

Then Ainsworth inspected the monthly ledgers and was displeased to see that the previous deficit had not been erased by past-due receipts. He in-structed Cruikshank to send the necessary information about customers' accounts to Morgan so matters could be settled. Ainsworth was also un-happy to learn from Morgan that Cruikshank had sent forth a "miserable advertisement" which was "certainly not calculated to do the book any good."[24] After waiting for six days, Ainsworth posted a peremptory letter to Morgan insisting that he "take immediate steps to collect in the accts."[25] But Morgan still couldn't balance the books because Cruikshank hadn't given him enough information, so Bentley's cashier sent a copy of Ains-worth's letter along with a note politely requesting the data.[26] Cruikshank was more than usually distracted just then as Mary Ann was dangerously ill; but apparently he cobbled together his accounts so that Morgan could furnish a balance sheet to the partners.

In December another variation of the same dance was danced. Morgan sent an account; Ainsworth and Cruikshank declined to accept it because it was drawn up on different principles, apparently on mistaken instructions from Bentley; Morgan produced a new statement which he sent by hand to Cruikshank with a suggestion that the artist discuss adjustments to the *Tower* account with the head of Bentley's advertising department.[27]

By January Ainsworth was taking counsel with William Loaden about the terms of his *Tower* agreement. Loaden advised that the general purport bound author and artist to Bentley as publisher even though he had no share in any volumes past three thousand, nor in any parts after the conclu-sion of the serial run.[28] Only if Barham as arbitrator agreed could the col-

laborators assign their *Tower* business to Cunningham or another firm. Loaden expressed his willingness to argue the matter with Bentley's lawyer before Barham. Meanwhile Cruikshank temporized about Morgan's proposition to give Bentley a further interest in the *Tower* volumes in exchange for his share in the advertising accounts.[29] Morgan replied with a detailed proposal regarding a further thousand volumes, of which a one-third interest in the profits would nearly offset what Morgan calculated to be owing Bentley from advertising and the two hundred or so volumes Ainsworth and Cruikshank sent to friends and potential reviewers.[30] Morgan got Bentley himself to make virtually the same offer to the partners in late February, but before then another passage at arms between Cruikshank and New Burlington Street over the *Tower* advertising accounts took place.[31]

Cruikshank and Ainsworth did not, however, accept Bentley's offer. Somehow they persuaded Barham of the justice of their case—perhaps in part because Charles Ollier told Ainsworth that Bentley calculated *his* profits at £1500, triple what the owners had received.[32] Barham recommended that Bentley be removed as publisher of the *Tower* on 25 February 1842.[33] On 9 March Morgan rendered his last account, showing Cruikshank's profit for the period at £37.2.4. Morgan closed his letter with yet *another* "item unsettled" in connection with the advertising![34] Barham must have handled the negotiations with extraordinary skill, for not only did Bentley give way, but also within three weeks he assigned Cruikshank one of Barham's legends to illustrate. Cunningham succeeded as the *Tower* publisher; his first account credited Cruikshank with only £7.15.0.[35] Clearly the *Tower* was no longer a valuable property, although reissues sold throughout the century.

By the autumn of 1843, these disputes had dragged on so long that all the parties had grown weary. Bentley, less and less inclined to take advice from Morgan, was slipping into a period of rash speculations that impoverished the business.[36] The "vile" plate illustrating Dr. Roberts's "Regular Habits" proved to be the last straw. "I am very glad indeed that you have determined to make a stand against Cruikshank's abominations in future," Morgan wrote to his principal.

> Don't suppose for a moment that I shall ever ask you to reconsider this verdict. I am equally disgusted at the rascality of this low-minded bully—for such he is— without mincing words. [Cruikshank might not have minded such an epithet since he liked to bully opponents.] Perhaps this decision may after all not be very palatable to him; he may suppose you do not like to venture to do without his valuable name—he very likely supposes it to be the pillar on which the Miscellany rests.[37]

In early October Cruikshank got his quittance. Bentley dismissed his artist:

It surely cannot be supposed that the plates you have for some months past delivered to me as yours—though without the usual autograph—in quality or execution or in composition [are] such as were contemplated by either of us on entering into the arrangement. [For months Cruikshank had simply not signed the plates at all; the last few were lettered, though not signed, "Drawn & Etched by George Cruikshank."] As I should not be doing justice to the subscribers to the Miscellany were I to continue to place before them illustrations that are so unequal to your usual efforts, I do not hesitate to avail myself of the power I have to close the agreement between us. You will therefore be good enough to regard this as sufficient notice that I shall not require any more plates from you for the use of the Miscellany.[38]

Having etched over 130 plates and designed wood-engravings and the wrapper, Cruikshank was freed from *Bentley's*. His name was removed from the wrapper after October 1843. Leech supplanted him as principal artist, though his time was increasingly occupied by *Punch*. *Bentley's* limped along, losing circulation and prestige. Unencumbered, Cruikshank did not, like a balloon, rise to new heights. He was still carrying too much ballast, and the flame of his imagination was burning low.

Relations with Bentley were additionally complicated by the connection with Ainsworth. The *Tower of London*, though unremunerative to the part-ners, had proved such a big hit with customers that booksellers clamored for a sequel. One proposed to Cruikshank that if he and Ainsworth brought out a second work of equal interest in the same format he would subscribe for twenty thousand copies a month and pay in cash rather than post-dated bills; another offered to take twenty-five to thirty thousand of each install-ment on identical terms.[39] But Ainsworth, for reasons that remain obscure, preferred the offer of the *Sunday Times*: £1,000 for *Old St. Paul's* to run in weekly installments from 3 January to 26 December 1841, with copyright reverting to the author at the conclusion of the periodical issue.[40] The serial would not be pictorialized, but Ainsworth eventually hired John Franklin, an uneven but sometimes strikingly effective illustrator, to contribute twenty plates for the three-volume edition published by Cunningham in December.

These arrangements struck a severe blow at Cruikshank, who apparently knew nothing about Ainsworth's negotiations. According to the *Artist and the Author*, Cruikshank had told Ainsworth in the autumn of 1840, as they were finishing the *Tower*, that he had a "capital subject for *our next work*. 'Ah! what is it?' said he; to which I replied, '*The Plague and the Fire of London*.' 'Oh!' he exclaimed, 'that *is* first-rate'." Cruikshank's idea was to work in favorite buildings of Old London, and through pencil and pen to render the horrors of the plague and the great fire of 1666. No written agreement was prepared, as Cruikshank thought the deal was sealed by

friendship. Ainsworth, on the other hand, may have considered that Cruikshank had proposed something he had already contemplated, and that in the absence of a contract he was free to take the proposal to the highest bidder. He may also have felt that Cruikshank, still in thrall to the *Miscellany*, would not have time for a sequel as demanding as the *Tower*. And perhaps Ainsworth simply wanted to clear a thousand pounds toward the expenses of moving into Kensal Manor House in March 1841, or to be free of Cruikshank's "troublesome" suggestions. Whatever the reasoning, it was not conveyed to the artist, who discovered from an advertisement what his former collaborator was planning. "Ainsworth has *deserted* me," Cruikshank exploded to Merle; "the disappointment has quite up sett me & my plans—The bribe was too much for him to resist viz *12 hundred* gui[nea]s with the *priviledge* of publishing it in 3 vols. before it was completed in the paper, of course giving him the copyright—!!!!"[41]

In the *Artist and the Author* pamphlet, Cruikshank says that it was upon learning that "another artist [was] working out my pet subject, which I had nursed in my brains for many years, and which I had long intended to have placed before the public with my own hands," that he determined to have nothing more to do with Ainsworth and to start his own publication, the *Omnibus*. Later indignation colored and slightly distorted what the contemporary record discloses. In February 1841 Cruikshank was writing cordially to Ainsworth about the next plate for *Guy Fawkes*, asking to have the subjects thereafter earlier in the month, and communicating his gladness on hearing from Pettigrew that Ainsworth's mother was recovering.[42] By the end of February George was committed to Tilt and Bogue for the *Omnibus*. So Ainsworth's choice of Franklin as illustrator for the December 1841 publication had no effect on Cruikshank's decision to start up his own vehicle.

What seems to have happened was that in late autumn 1840 Ainsworth announced that he and Cruikshank were preparing a "New Work." Then in mid-December Cruikshank saw a notice that Ainsworth's "New Work" would be serialized in the *Sunday Times*. Cruikshank waited over the holidays for a visit, but Ainsworth never came. When the artist saw Ainsworth at Dickens's on New Year's Eve, the author promised an explanation shortly. But he did not refer to the new novel in any of his notes regarding *Guy Fawkes* nor did he call on or arrange to meet with Cruikshank.

Meanwhile Dickens, figuring that George might be free of any obligation besides the *Miscellany*, proposed another scheme. Chapman and Hall envisaged some kind of an *Annual*, with Dickens and Cruikshank as collaborators.[43] Since Cruikshank wanted to emancipate himself from booksellers, this venture might have entailed joint proprietorship of a lavishly illustrated Christmas volume of the kind Lady Blessington edited. The meeting

at Cruikshank's on 11 January attended by Dickens, Forster, and Maclise may have had something to do with this idea.[44] If it had come to fruition, Cruikshank might have terminated the *Comic Almanack*, preferring to throw his energies into a more sumptuous production, untrammeled by the constraint of inventing twelve illustrations of the months every year. All this is mere conjecture, but the alternate proposal Tilt and Bogue made, that Cruikshank should start his own periodical in a large paper format with elaborate etchings and a free range of subjects treated in fiction, verse, essays, letters, articles, and jokes, indicates the direction of George's desire.

Feeling committed to Ainsworth, Cruikshank held off deciding as long as possible. The publishers pressed, and on Wednesday February 17 Cruikshank received a note from Dickens: "Will you let me know whether you are willing or able to go into that matter of the Annual? If you are, I will write you my views upon it and put you in possession of the means of determining whether you shall join it or no."[45]

This was written four days after *Barnaby Rudge* began appearing in *Master Humphrey's Clock*, Dickens's weekly magazine which had become not a miscellany of materials contributed partly by others but instead wholly the container of two full-length Dickens novels, the first of which was the phenomenally popular *Old Curiosity Shop*. That Cruikshank was not chosen to illustrate the much delayed *Barnaby* did not prejudice the friendship or further collaboration. ("Bravo 'Barnaby'," Cruikshank exclaimed to Dickens in April.[46]) They were, in fact, still engaged on the project for Macrone's widow, the *Pic-Nic Papers*. Cruikshank waited upon Dickens later that Wednesday afternoon, carrying with him—and accidentally leaving behind—"one small four & sixpenny umbrella, also two sketches for the 'Pic Nic'."[47] He and Dickens discussed the drawings, one of them, "The Philosopher's Stone," being the frontispiece for the first volume and illustrating Dickens's contribution. Cruikshank also told Dickens about Tilt and Bogue's project, expressing some doubt about whether he could commit to the *Annual*, and presumably mentioning that he was still waiting for Ainsworth's explanation about *Old St. Paul's*.

During the ensuing five days, deliberations with Tilt and Bogue progressed so far that Cruikshank felt compelled to withdraw from the Chapman and Hall venture. He had apparently even broached to Laman Blanchard the possibility of Blanchard's editing his new periodical. So George wrote to Dickens regretfully breaking off their negotiations:

> I find that I have proceeded [so] far in that said speculation with Mr. Tilt that I cannot in honor recede—indeed I am bound under peculiar circumstances to others as well—so that I *must* now go on—
>
> It is of no use expressing my regret that we are not working together (as we ought to have done from the first)—and should this said speculation of mine

unfortunately fail—I shall be ready to join you in any way, & work on, if agreeable, to the last.[48]

It is worth stressing, in view of later discord, that up to this point no estrangement between Dickens and Cruikshank had occurred; Dickens's quarrel with Bentley had removed *Barnaby* from the *Miscellany*, and Cruikshank's work with Ainsworth had precluded an immediate resumption of the Dickens-Cruikshank partnership. George at any rate knew that working with Boz yielded excellent results and looked forward to future collaborations.

Meanwhile, Ainsworth was planning to invite Cruikshank to prepare the etchings for the volume publication of *Old St. Paul's*.[49] Knowing that his friend felt slighted by recent events, Ainsworth asked Pettigrew to serve as go-between. On 3 March the Doctor called on Cruikshank to present Ainsworth's offer. But by this time the artist was too involved with others to accept. His letter declining the offer, penned the following day, speaks of his injuries with forbearance and forgiveness. Since it supplies the most complete contemporary account of these disruptive events, it should be quoted in full:

Mr. Pettigrew call'd here yesterday and stated your proposition. Had this proposal been made any time between last December up to about a fortnight back I should have been happy *most* happy to have accepted the offer—but now I am sorry to say, that I cannot,—no, I have so far committed myself with various parties, that if I were to withdraw my projected publication I am sure that I should be a laughing stock to some, & what is worse—I fear that with others I should lose all title to honor or integrity.

I do assure you my Dear Ainsworth I sincerely regret—that I cannot join you in this work, but what was I to think—what conclusion was I to come to but that you had *cut* me—at the latter end of last year you announced that *we* were preparing a "New Work"—in the early part of December last—I saw by an advertisement that—your "New Work"—was to be published in the "Sunday Times"—you do not come to me—or send for me nor send me any explanation—I meet you at Dickens's on "New Years Eve". You tell me then that you will see me in a few days and explain every thing to my satisfaction—I hear nothing from you—in your various notes about the "Guy Fawkes" you do not even advert to the subject—

I purposely keep myself disengaged refusing many advantagous offers of work—still I hear nothing from you—at lenth you announced a New Work as a *companion to the "Tower"* without my name—I then conclude that you do not intend to join *me* in *any* New Work—and therefore determine to do something for myself—*indeed I could hold out no longer*—To show that others besides my self considered that you had left me—I was applied to by Chapman & Hall—to join with them & Mr. Dickens in a speculation—which indeed I promised to do should the one with Mr. Tilt be abandoned—However I have still to hope that

when you are disengaged from Mr. Bentley that some arrangements may be made which may tend to our mutual benefit.

PS. Mr. Pettigrew pressed me much to acceede to your proposal—and I am sure would be happy to serve either of us—but felt that it would be useless to meet on Saturday should my determination remain the same as I expressed to him—I have written to him to say that it is so—you will therefore not expect to see us—[50]

The reference to Bentley might be taken to imply that part of Ainsworth's strategy in not employing Cruikshank or entrusting him with his plans related to Ainsworth's own desire to sever his connection to the *Miscellany* and its publisher. Had he contracted for another story with Cruikshank, either for the magazine or as a serial, Bentley might have forced his way into the bargain; and had he told the artist of his intentions that information might inadvertently have been communicated to New Burlington Street.

Deferring for a moment the *Omnibus*'s short trip, we can consider the remainder of the artist's collaborations with Ainsworth. The two stayed friendly over the summer as they worked up the final sections of *Guy Fawkes*. "The Omnibus is capital," Ainsworth wrote on receipt of the first number, "and I am sincerely happy to learn it has succeeded to your hearts' content. Pray dine with me on Saturday next at six o'clock, and we will drink success to it."[51] "Hoping all my friends at Kensal Green are well," Cruikshank closes several of his missives.[52] And Ainsworth instructed Ollier on 22 June that he would not accept any artist besides Cruikshank as illustrator of further work for Bentley.[53] In spite of minor differences over the handling of the much abused *Tower* accounts in November, Ainsworth and Cruikshank were still getting along tolerably well.

Then Pettigrew on behalf of Ainsworth approached Cruikshank with a new proposition. Ainsworth, having determined to resign as editor of *Bentley's* in December 1841, and anticipating the conclusion of *Old St. Paul's*, looked to a resumption of the partnership with Cruikshank. As Cruikshank thirty years later recalled the visit:

to my utter astonishment Pettigrew called upon me one day with a message from Mr. W. Harrison Ainsworth to this effect, that he (Mr. Ainsworth) was extremely sorry that there had been any unpleasantness between us, and that if I would forgive him and be friends, nothing of the kind should ever happen again; that he was about to start a monthly magazine, and that if I would join him, and drive my "Omnibus" into his magazine, he would take all the risk and responsibility upon himself, and make such arrangements as would compensate me liberally. To this most unexpected proposition at first I would not listen, but as my friend Pettigrew kept on for some time urging me to be friends again with Mr. Ainsworth, and as I am (as my friends say) in some cases rather *too good*

natured and forgiving, I *did* forgive Mr. Ainsworth, and "shake hands" and agree to work with him again.[54]

George's characterization of himself as '*too good natured*' is self-serving and does not square with his pugnacious responses to being crossed, but on the whole he breathed a fire that seldom singed, and he knit up his estrangements—with Hone and Bentley for instance—before death foreclosed the possibility of reconciliation. In this instance, the reunion was ratified by an invitation from Ainsworth's three daughters for Cruikshank to join them for dinner and dancing on New Year's Day 1842.[55]

Cruikshank drove the *Omnibus* into a shed after the January number. He contemplated issuing it as an *Annual*, or collecting the passengers for reembarkation in a volume, but for the time being it sat in storage. Instead, from 1 February, he primarily illustrated Ainsworth's periodical fiction, at one of the highest rates of pay he ever received, £40 a month for two square etchings on steel.[56]

The next novel was once again, according to the artist, *his* invention: "Well knowing the importance of having an *attractive subject for the first number* of a work, I *then suggested to Mr. Ainsworth* MY *idea of* 'THE MISER'S DAUGHTER' (the plot of which will be seen in my first letter to the *Times* upon this subject, and which I had originally intended to have had written by some literary friend, and have published it in my 'Omnibus')."[57] The letter in *The Times* elaborates on George's idea:

> My idea suggested to that gentleman [Ainsworth] was to write a story in which the principal character should be a miser, who had a daughter, and that the struggles of feelings between the love for his child and his love of money, should produce certain effects and results; and as all my ancestors were mixed up in the Rebellion of '45, I suggested that the story should be of that date, in order that I might introduce some scenes and circumstances connected with that great party struggle, and also wishing to let the public of the present day, have a peep at the places of amusement of that period, I took considerable pains to give correct views and descriptions of those places. . . .
>
> I do not mean to say that Mr. Ainsworth, when writing this novel, did not introduce some of his own ideas; but as the first idea and all the principal points and characters emanated from me, I think it will be allowed that the title of *originator* of "The Miser's Daughter" should be conferred upon, Sir, your obedient servant.[58]

Cruikshank's proposal in this instance combines his lifelong romance with the '45, his fascination with misers, and his affinity for one of the plots of *The Merchant of Venice*, a parodic version of which he would etch for Barham's "The Merchant of Venice" in the April 1842 *Miscellany*.[59] (Cruikshank's identification with Shylock, as with Fagin, seems a powerful if largely subconscious motif running through his art.) His notion for the new work follows the formula for other Ainsworth collaborations: they take a

period of London's past and recreate it through its architecture and fashions. Once again the particular time chosen is one when the kingdom's stability is threatened. And once again there is Hogarthian precedent for this attention to the amusements of the people: Hogarth had engraved a number of prints about Gin Lane, Beer Street, and pleasure gardens, and with Hayman had designed decorative paintings for the walls of the Vauxhall pavilions.[60] There was even a contemporary application to the subject: Laman Blanchard memorialized the "last night" of Vauxhall in the October 1842 *Omnibus*.[61] (Blanchard was probably the "literary friend" who would have written the story had Ainsworth not adopted it.)

Moreover, once again Cruikshank's suggestion chimed with Ainsworth's interests—in eighteenth-century rogues and courtesans, in the role of the beau and the elaborations of wigs and waistcoats, and in the Catholic-Protestant tensions heightened by the plotting of the Young Pretender's allies. Ainsworth could once more devise a narrative wherein historical and fictional persons would commingle, one that could turn simultaneously on a documented incident and on the heroine's choice between two contrasted suitors. "It was part of my original scheme," Ainsworth told Blanchard Jerrold after Cruikshank's death, "to describe the secret proceedings of the Jacobites in Lancashire and Cheshire, prior to the Rebellion of Forty-five, with Prince Charles's entrance into Manchester in that memorable year, and the subsequent march to Derby." These incidents would have been familiar to him from his father's tales and Crossley's research. "But I found these details incompatible with my main plan, and was therefore obliged to relinquish them; contenting myself with a slight sketch of a conspiracy in London, hatched by certain adherents of the young Chevalier. Cordwell Firebras is no fictitious personage."[62]

The Miser's Daughter ran in *Ainsworth's Magazine* from the first issue, February 1842, through November. The collaborators fell into their usual routine: Cruikshank would ride out to Kensal Green to discuss the subject in Ainsworth's commodious library, then return to Amwell Street to work out details of the plates.[63] (In the March 1842 issue of *Ainsworth's* there is a delightful line cut, "Our Library Table," suggested by the author and designed by the artist of the two men in lively conversation, surrounded by the quartos and folios, prints and documents, of Kensal Manor House library.[64] *Punch* parodied it in a cut heading "Our Library-Table" showing Mr. Punch and Toby in the positions of Ainsworth and Cruikshank conferring at a small deal table in their wretched one-room flat, while Judy plays with the baby in a pull-down bedstead.[65]) When he perfected the tracings, Cruikshank would send them to Ainsworth with comments for incorporating in the manuscript, and last they would settle on captions. For one of the March plates, Cruikshank told Ainsworth what names he had invented for the street signs and what features and clothing he had picked for Sir

Bulkeley Price: "a mulberry suit and a port wine complexion"—the colors provided for Ainsworth's text, where the suit hue is transferred to the knight's nose. He also indicated what the other principals were doing in the congested scene of "Sir Bulkeley Price bringing the mortgage money to Mr. Scarve" (the miser). In a paragraph on page seventy-nine, Ainsworth elaborated, but did not essentially alter, Cruikshank's letter.

"The Supper at Vauxhall" is a complicated scene with many players. After the preliminary discussions, Cruikshank figured out how to include Kitty Conway singing with the orchestra in an elevated rotunda, a supper party for six in a grove of trees, the hero Randulph spying on his beloved Hilda (the miser's daughter), and three villains plotting in the background. The letterpress required to describe this scene runs to fifty-eight lines.[66] In sending information about his design to Ainsworth, Cruikshank added, "Recollect that you are now in a position to smash old B's Miscellany if you *like* to do so, and that you may be so disposed and effectually carry out your intentions is the sincere wish of yours truely." Somewhat of the "bravo" of the villains he was depicting had entered into Cruikshank's soul at this point; Morgan was evidently not exaggerating when he told Bentley that the artist was carried away "into the most frantic outbreaks of passion." Four days later Cruikshank posted suggestions for captions which Ainsworth adopted.[67]

The collaborators by now trusted each other so much that either could make alterations without prior approval. When Cruikshank wrote in mid-August about changes he had made preparatory to tracing Hilda's "Discovery of the mysterious packet," Ainsworth had no time to vet them: "I have no doubt I shall approve of your modifications," he replied; "only let me have tracings as soon as possible."[68] Likewise, in September Ainsworth described to his artist in general terms the spectacular explosions at Millbank when the Jacobites are routed by grenadiers, and left it up to Cruikshank to arrange the particulars of the moment depicted in the plate. Forwarding the tracing, Cruikshank explains:

I suppose Randulph to be supporting Sir N[orfolk] Salusbury—who is wounded (badly) and whom he has assisted into the boat—Randulph at the same time is receiving the packet from Firebras—who has just been shot whilst speaking to Randulph by Long Tom—the grenadier—who supposes that Firebras has killed his officer. Sir B[ulkeley] Price [who has fallen into the water] has hold of the stern of the skiff—the [Jesuit] priest is clinging to the post & the steps—He might *creep* into a *small sewer*—and never be seen or heard of more! In the background the soldiers are on a rude plank bridge connecting the summer house garden with the water wheel & mill—Some of the Jacobites are crying out for quarter—or surrendering themselves to the troops—[69]

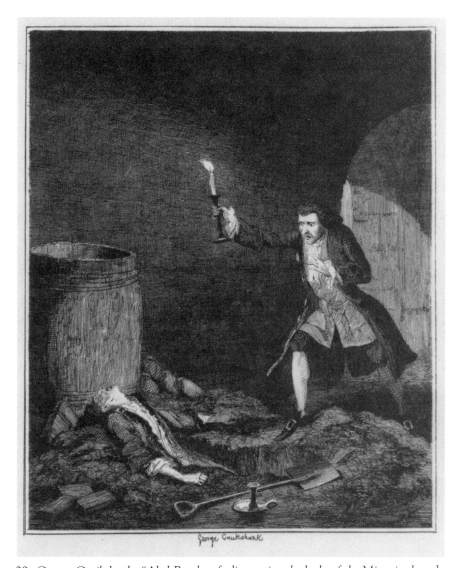

29. George Cruikshank, "Abel Beechcroft discovering the body of the Miser in the cellar," The Miser's Daughter, etching, 1842

Without exception, Ainsworth follows these instructions in his letterpress.

A slightly different situation obtained for the second tracing Cruikshank forwarded at the same time. "Abel Beechcroft discovering the body of the Miser in the cellar" (fig. 29) contains but two figures, and its only recorded activity is Beechcroft's contemplation of this horror. But in order to repre-

sent appropriately the scene of the miser's final hours, Cruikshank had to
imagine what Scarve might have been doing "off-stage": "The Miser has
brought some bags of gold to conceal, in digging, he misses his box of
treasure—his candle goes out, he feels about for his gold, and dies. His
hands convulsively grasping the earth—or rather with his hands firmly
holding a portion of the sandy soil which he has been disturbing—."[70]
Ainsworth transfers this description to the previous chapter narrating the
miser's last night alive; thus the artist's details for a later scene backform
the writer's manuscript of an earlier episode.

Finally, on 15 September, Cruikshank sent the tracing of "Mr. Cripps
detected" in the apparel of his master Beau Villiers just as the valet was
about to be married to a widow he supposes to be wealthy. The composition
had caused the artist much difficulty; only "by the greatest contrivance"
could he squeeze in seventeen persons, three dogs, a monkey, and a macaw.
"You can bring in [Sir Singleton] Spinke, the Barber [Peter Pokerich] and
the fair Thomasine or any other you like to finish the scene," he told Ains-
worth.[71]

A recent critic has judged the *Miser's Daughter* plates to be "of little
interest."[72] But eighty years ago the great collector and authority on English
graphic art, Joseph Grego, singled out what he called this "dramatic *suite*"
of illustrations as particular proof of the artist's "early genius."[73] The exten-
sive notes, working drawings, marginal sketches, and finished watercolors
relating to these plates testify to Cruikshank's intensely personal involve-
ment with the subject and with the opportunity of depicting settings his
great predecessors Hogarth and Rowlandson had limned. The reader, says
Grego, "through the pictorial embellishments which form the basis of the
entire plot, is visually carried through a melodramatic panorama, such as
Cruikshank individually was likeliest to conceive and execute." Many of
the plates re-create with considerable accuracy the structures of the period:
"a correct view" of the Rotunda at Ranelagh and "correct view of Lambeth
Palace," Cruikshank pens at the bottom of his watercolors.[74] These images
are jammed with people, furniture, clothing, and all the accessories of
fashionable life in the reign of George II. And they are in Cruikshank's
most elaborated and refined tableau style. The impression they give is that
more than in any other case Ainsworth is writing up to the pictures.

As usual, both author and artist structure contrasts: in the letterpress,
between high life and its mimicry by servants and the *petit bourgeois*; in the
illustrations, between the noisy, bustling public scenes—the Folly Tavern,
Marylebone Gardens, a midnight attack in Whitcombe Street, a wedding
at Lambeth—and the intensely personal, concealed episodes in the miser's
decaying mansion. Some of these latter misfire; Scarve's death "somehow

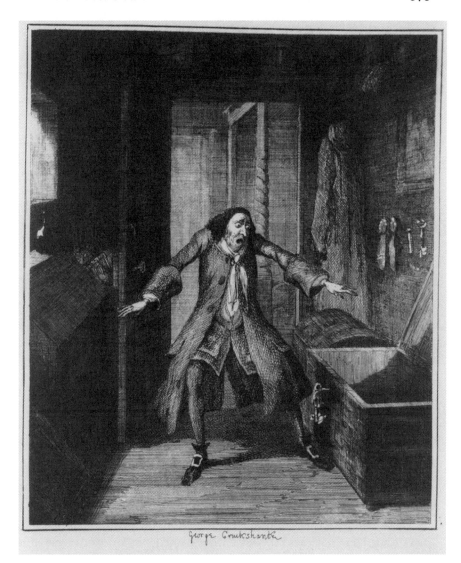

30. *George Cruikshank, "The Miser discovering the loss of the mortgage-money,"* The Miser's Daughter, *etching, 1842*

fails to inspire the macabre thrill that it was meant to" for Anthony Burton, though Grego found it "truly great, and in Cruikshank's most weirdly horrifying vein."[75] "The Miser discovering the loss of the mortgage-money" (fig. 30), however, evokes even for the more resistant Burton a paragraph of praise:

The miser stands "transfixed, with his hands stretched out, his mouth wide open, his eyes almost starting from their sockets." The gestures could easily be made grotesque. But Cruikshank throws the miser into a pose in which he appears to be rooted to the ground by conflicting impulses. . . . His right leg seems to carry him away from his coffer, but his left arm and tilted head reveal a contrary movement. His head seems to have sunk on his chest, suggesting that he is collapsing in despair; or else his shoulders are hunching up round his ears as horror stiffens him. The ambiguous posture conveys an unresolved tension. His horror and despair are thrown into relief by the dull emptiness of his surroundings. Cruikshank never surpassed the mastery of tonal gradation that he shows here. Light enters from the window on the miser's right and has to force its way through the dusky gloom before it can fall on his pallid cheek and brow. Behind him, through the door, we see receding rooms also filled with a strange dusty light that suggests emptiness and disuse. The gaping apertures of window and door mock at the gaping emptiness of the miser's money-chest.[76]

Rarely has "O my ducats! O my daughter!"—with the mortgage money Scarve thought to purchase a wealthy son-in-law—been more vividly pictured.

Immediately upon completion, the novel was dramatized by Edward Stirling at the Adelphi on 24 October, and by Thomas Proclus Taylor at the City of London Theatre on 21 November. The Stirling adaptation relied heavily on Cruikshank's suite of tableaux, and the reviews noted that the etchings had been "vivified." The greatest praise came from the notice printed in Ainsworth's Magazine, and presumably penned by the editor: the audience will "be struck with the exactness and beauty with which Mr. George Cruikshank's varied compositions are placed in living tableaux before the eye. In some instances, they might be mistaken for the artist's actual designs enormously magnified, and mysteriously made to breathe."[77]

Once again, Cruikshank's vision animated Ainsworth's increasingly feeble prose. The tableau illustrations, as Jonathan Hill points out, "actually inclined to lower the quality of the writing accompanying them: their monopoly of narrative highlights and their leaning toward the theatre offered the constant temptation to the novelist [especially as Ainsworth was simultaneously composing Windsor Castle] to save time, simplify his art, and provide only so much text as was necessary to connect the plates and see them on their way to realization in the theatre."[78] In the Omnibus, Cruikshank had tried not only to escape from under the thumb of publishers, but also to conduct his enterprise as a vehicle designed for illustration more than for writing. The collaborations with Ainsworth were unfortunately proving that greatly superior plates depreciated the letterpress; the resultant books gradually disappeared from dealers' inventory. An artist who outstrips his author may end up eclipsing his own illustrations.

When Ainsworth broke with Bentley in 1841, he dashed over to Paris to

enlist the French artist Tony Johannot, illuminator of Molière, Scott, and other famous authors, as his illustrator for a historical novel about Henry VIII, *Windsor Castle*, which Ainsworth intended to release in monthly parts commencing April 1842.[79] But two weeks before the first number was scheduled, Ainsworth's mother died; his grief piled on top of the heavy burdens of owning and editing and writing for his magazine temporarily overwhelmed him. A typically unsubtle publicity campaign had already been instituted in the March *Ainsworth's*: right under the line cut of Cruikshank and Ainsworth planning *their* novel, the author ran a fulsomely enthusiastic notice of Johannot which claimed that *his* illustrations to *Don Quixote* and other classics were the finest ever produced. That may not have been particularly agreeable to George.

Upon resuming his editorial duties, Ainsworth concluded that the best scheme would be to serialize *Windsor Castle* alongside the miser's story, and to raise the price of his magazine 6d. for the extra story. Thus his second novel began appearing in the July issue and ran for twelve months. The strain was killing, as Mrs. Hughes witnessed: "His present double undertaking appears to me as an act of deliberate suicide, and cannot be accomplished without injury to mind and body, besides the minor consideration that the works must suffer by such undue haste in composition."[80] The novel was embellished not only by Johannot's rather vaguely delineated plates but also by W. Alfred Delamotte's numerous designs and plans of the castle beautifully cut into the block by Thomas Williams. Both artists frankly copied the effects Cruikshank had achieved in illuminating *The Tower*.

After the first five steels, however, Johannot quit, and Cruikshank, his *Miser* drawings done, took over. He was not asked to design the wood-engravings; that slight made him touchy. "You had better call on George Cruikshank," Ainsworth instructed Delamotte at the start of the new partnership, "and show him your designs, when you have got them on the wood." Shrewdly, the author advises a consultation after the designs were too fixed for George to suggest alterations. "You must smooth him down as much as possible—for he is a very jealous fellow. Tell him this is a special occasion, and I do not think he will interfere with us. But he must be kept in good humour."[81]

Influenced by Delamotte's minute pictorializations of nature, Cruikshank expended great efforts on the *Windsor Castle* plates, delineating the settings with more explicit detail than usual. The result, unfortunately, is not always commensurate with the ambition: the highly patterned surfaces blunt dramatic intensity. The best effects are achieved in those illustrations featuring the demonic Herne the hunter: when the "tall, ghostly figure," with antlered helm, rises up before Henry on the parapets of the castle

amid the pyrotechnics of a summer thunderstorm, Cruikshank stops out jagged bolts of lightning that seem to glow with a preternatural light that illuminates the shadowy towers and distant hills.[82]

All the resources of etching were now fully within Cruikshank's command. He could design the most dramatic scenes and fill them with dozens of individualized figures each engaged in a characteristic activity. (Johannot notably failed in this regard.) He knew how to scratch every line so its inherent texture read mimetically to evoke stone or foliage or cloth or light. His skies and clouds and shadows breathed atmosphere. Yet that technical proficiency was beginning to get in the way. Trying desperately to be the best, Cruikshank was in danger of losing the fluid, intuitive, impulsive line that had always charged his works.

St. James's: or the Court of Queen Anne (1844) was the last of Ainsworth's historical romances that Cruikshank illustrated, and he did not see the novel through to its conclusion. The formula is the same: a celebrated building at a dramatic moment in its life that is the setting for stories counterpointing high and low life, intrigue and love, real and imaginary characters. The first plates were adequate, though certainly not inspired; but they became more perfunctory as the year wore on. By early autumn Cruikshank had been replaced by Phiz. The only surviving records of the project are five letters transmitting tracings, in only one of which does Cruikshank discuss his composition.[83] Even the statements made years afterwards barely refer to the episode.

Although routine and overproduction may account for some of the artistic torpor of *St. James's*, another drag was money. The firm of Cunningham and Mortimer had never been flush with capital. In October 1843 Ainsworth told Tom Hood that a "dissolution" was imminent.[84] Mortimer apparently bought his partner out, since it is Mortimer whose imprint continues. Early in 1844 he purchased *Ainsworth's Magazine* for £1,000, the author continuing for a time as editor but thankfully relinquishing all the business end. Ainsworth had offered artists and writers the highest rates of pay they ever enjoyed. The new proprietor, a Scotsman, was in Ellis's words "not so generous with the 'siller and bawbees' as the careless and free-handed Ainsworth."[85] By 1845 Mortimer was hard pressed to meet his obligations, and Cruikshank was mediating between publisher and author.[86] When Mortimer skipped paying Ainsworth's monthly editorial stipend in June, even the "careless" writer concluded that he had had enough, and resigned.[87]

Cruikshank thus had two grievances: first, he got less work at presumably a lower rate of pay from Mortimer, and second, the kind of partnership with the owner of a magazine that had induced the artist to discontinue the *Omnibus* was now dissolved. He felt betrayed:

So it really appeared [he wrote in 1872] as if all this gentleman's promises, like pie-crust, were made to be broken; and, as in this instance, also, there was not any *written agreement*, the arrangements which he had made, and the engagements he had entered into with me, when I agreed to work with him in his magazine, all broke down, and I, as it were, again "thrown overboard," or "left in the lurch." And thus ended the second edition of this *author's* extraordinary conduct towards the *artist*.[88]

Cruikshank felt no compunction about severing the connections with the magazine and its founder; never again did he work with Ainsworth on any project. When Pettigrew brought to Amwell Street yet another proposition from the author, presumably in connection with the *New Monthly Magazine* which Ainsworth had purchased from Colburn, his mission was entirely unfruitful:

my friend the Doctor found that it was not at all necessary to *feel* my pulse; for he could plainly *see* that it beat *rather fiercely*, when, in reply, I said, "No, Pettigrew. Mr. Ainsworth has acted towards me in what I consider a most dishonourable manner upon *two* occasions; and I will take care that he shall not do so a *third* time!"

My friend said that "he thought I was quite right in coming to that determination, and that he could in no way defend Mr. Ainsworth's conduct; and should not have again troubled me, had it not been for Mr. Ainsworth's most earnest entreaty."[89]

Not knowing quite where to turn, Cruikshank thought first of reviving the *Omnibus*. That vehicle, designed to carry Cruikshank's etchings and ideas, had started bravely enough in May 1841. Tilt and Bogue, publishers of the *Comic Almanack*, were enrolled on the wrapper as "Conductors," and their shop was named as the booking office. Bradbury and Evans, printers now responsible for issuing *Punch* and within a few years to supplant Chapman and Hall as Dickens's publishers, handled the presswork. And Laman Blanchard, a genial writer of light pieces and number two at a succession of periodicals, assumed the editorial duties. (He also discharged the subeditor's tasks for Ainsworth, for whom he entertained a warmly reciprocated affection.) In spite of the annoyance Percy caused by calling himself "Cruikshank the Younger," his uncle hired him to engrave the humorous wrapper design showing the back of a horse-drawn omnibus packed with passengers inside and out just pulling away: the reader would have to run to catch up and pay the fare of 1s. Merle at the last moment supplied a Latin tag for a characteristic pun: "De Omnibus rebus et quibusdam aliis."[90]

Cruikshank, as Projector, plays a starring role in the first issue. In "A Few Words to the Public, from an old acquaintance," he explains that this vehicle aims to amuse—especially the ladies—that as his interest is greater and more direct than hitherto he will liberally provide varied entertain-

31. *George Cruikshank, self-portrait, engraved by C. E. Wagstaff,* George Cruikshank's Omnibus, *May 1841*

ment, that he relies on many friends to help supply the comic and the pathetic, and that he will avoid periodical wars: "The highway lies too open to admit of his 'running down' any candidate for favour that may have started before him." The address ends with "*Vivat Regina,*" a clear bid for the patronage of the governing class. All the satiric and caricature excesses of the artist's youth have been suppressed in this effort to establish himself as a Victorian bourgeois.

 The first two plates were a handsome youthful stipple self-portrait engraved by Charles Edward Wagstaff (fig. 31), who had gained fame by his "Coronation of Queen Victoria," and an etched rather than written preface in the form of a brilliantly detailed miniature of the globe teeming with varied life. In the second number Cruikshank supplied an explanation of this preface for his juvenile readers—yet another way in which he sought to be adopted by the citizens of home and hearth. But first he had to rectify the lingering impression that he was a bohemian, one recently reinforced

by James Grant in his *Portraits of Public Characters* (1841). Consequently *George Cruikshank's Omnibus* opens with an article about "My Portrait."

Cruikshank quibbles about Grant's admittedly well-intentioned biography.[91] He does *not* "dislike the name of artist"; his youthful eyes *were* short-sighted, but never "weak"; he *did* study characters in a low public house, but only once, in order to depict a meeting of the Sublime and the Ridiculous; his association with Mr. Hone—"the most noted infidel of his day"— did *not* extend to knowing much about the publisher's religion or to having anything to do with impious publications; he is a "liberal" *only* in the sense of "becoming a gentleman, generous, not mean"; he is *not* singular and eccentric, and does *not* spend his Sundays observing public house patrons strolling past his Amwell Street windows; he does *not* quell cabmen with a look, but treats them civilly and generously; and he is *not* a dandy nor possessed of a "prominently receding" forehead.

To contradict such trivia itself signifies a certain insecurity, and to open a new publication with a long disquisition on one's portrait smacks of naive egotism. But Cruikshank was fashioning a new self for a new age, and in so doing, he tried to expunge from the delineation those implications of artistic irresponsibility, loose behavior, and phrenological or ocular deficiency that might stigmatize him as less than a solid respectable citizen and working artist. Nevertheless, certain aspects of Grant's portrait made him laugh. Responding to the statement that "the ludicrous and extraordinary fancies with which his mind is constantly teeming often impart a sort of wildness to his look, and peculiarity to his manner, which would suffice to *frighten from his presence* those unacquainted with him," Cruikshank designed a wood-engraving (fig. 32) of a ferocious, Mephistophelean self alarming an entire drawing room full of gentry and their servants. Reinventing his past, however, caused him strains that show up in the repetition of more ominous subjects and figures, as will become apparent shortly.

The *Omnibus* boarded several of Cruikshank's friends. Merle furnished jokes, verses, and essays under his pseudonym "A. Bird." Blanchard wrote poems and short articles. Marryat and Howard each contributed a piece. Thackeray published one of his worst stories, "Little Spitz," an anti-Semitic anecdote about a dog that comes home from the butcher's during Lent with sausages made out of its own tail, and one of his better poems, "The King of Brentford's Testament." "Bowman Tiller" serialized *Frank Heartwell*, another nautical novel, with monthly plates by the proprietor.[92] There was a fairly spirited piece of reportage when the Tower of London caught fire on the night of October 30, and Cruikshank's friend Edmund Swift axed his way into the grilled Jewel Room to rescue the historic regalia. Cruikshank supplied both etchings and wood-engravings, in the manner of his *Tower*

32. *George Cruikshank, "George Cruikshank frightening from his presence those unacquainted with him,"* George Cruikshank's Omnibus, *wood-engraving by J. Thompson, May 1841*

illustrations, for the December number, and used the conflagration as an excuse to flog copies of the *Tower*. But often the letterpress is dull.

One small cut inspired an increasingly lively marriage of picture and text. In the second number, the last item in "Omnibus Chat" is an exchange between a Driver spying an elderly lady trying to catch up with the rear of the 'bus, and the Conductor who claims "ve're full" and sends the vehicle on its way. That's the sort of joke one could make about busses today, and it fit very neatly by relating the end of the inside of the magazine to the wrapper design of the departing 'bus on the outside (fig. 33). The next issue, for July, expanded on the joke: The Driver spies the same elderly

Bradbury and Evans,]

[Printers, Whitefriars.

[MDCCCXLI]

33. *George Cruikshank, wrapper design for* George Cruikshank's Omnibus, *wood-engraving by Percy Cruikshank, May 1841*

lady hurrying after the 'bus. The Cad informs him that her name on the Booking Office register is Mrs. Toddles, and she's "a toddling off the wrong vay arter all. Vel, drive on, ve can't wait for nobody. Some people alvers *aire* too late, and alvers vill be." To which the Driver responds, "I reckon it must take *her* a couple o' hours to put on that bonnet afore she comes out." Next to this dialogue is a picture of Mrs. Toddles, her features concealed by a huge coal-scuttle bonnet, her short stout body draped in shawl and skirt, and her thin legs encased in black knit stockings. She carries a furled umbrella.

Something in this image of Mrs. Toddles appealed to Cruikshank's readers and to the artist. Succeeding issues elaborated her story. "My Dear Blanchard," Cruikshank wrote from Margate on a Sunday afternoon in late July, "I forgot all about 'Mrs. Toddles' untill the present moment. Should there be room, do you think the following Sketch will be sufficient hints for the purpose—if not we had better perhaps leave her till next Bus." Cruikshank encloses a letter purporting to come from Mrs. Toddles complaining about the impudent remarks regarding her bonnet, the rudeness of sticking her portrait up in shop windows, and the "hurry skurry & flying about" which she as a lady with impedimenta must undergo even though it makes her late for the 'bus. She warns that she has written to her friend Colonel Walker and may if he advises enter an action for damages and libelous treatment. In a postscript she fusses that having missed the omnibus her dress cap was ruined by the rain and her feet soaked. Should this letter be too long, Cruikshank supplies a brief dialogue between the Driver and the Cad saying that Mrs. Toddles has written to this effect to the office.[93]

Blanchard liked the letter, but lacking room in the issue at such a late date he held it over a month, when it appeared in the September issue accompanied by an editorial apology (also partly penned by Cruikshank) advising Mrs. Toddles "to put her feet in hot water, and to take a glass of nice warm rum and water, with a bit of butter in it," and a wonderful wood-engraving (fig. 34) of the good lady reading *Culpepper's Medical Handbook*, soaking her feet in a steaming basin while her stockings dry out on the back of the chair, and enjoying her glass of rum and water. Her bonnet, shawl, and skirt are exactly as before.

The next month Mrs. Toddles is encountered at Margate, her parasol shading her bonnet; but she doesn't understand about tides, nearly gets swamped, rushes back to retrieve her basket, is inundated by a wave, and goes off dripping wet. This time two wood-engravings are supplied. In November "Sam Sly" writes a two-page "Account of the Life and Times of Mrs. Sarah Toddles," thrice married, thrice widowed, retired from the bakery business, enveloped by presents—parasol, stockings, shawl and all—from husbands and relations, and plagued by corns.[94] The December in-

34. George Cruikshank, "Mrs. Toddles soaking her feet," George Cruikshank's Omnibus, wood-engraving, Sept. 1841

stallment relates Mrs. Toddles's "hysterics" at seeing intimate details of her life and age in print, a fit only relieved by the gallant Colonel Walker's application of a strong restorative with a flavor of peppermint. Mrs. Toddles collapsed in a chair, kicking the shins of her maid for bringing her a glass of cold water, affords an opportunity for another delightful wood-engraving of the perpetually bonneted lady. In the final number, two more pages relate Colonel Walker's appearance at the *Omnibus* office threatening on his friend's behalf, their disastrous journey on the rear dickey of a stage which collapses and crashes Mrs. Toddles onto the road, and their recovery in time to dance a cotillion on Christmas Eve, notwithstanding the fractured bonnet, the crumpled dress cap, and the shattered something which she alleges was *not* a bottle. Two more cuts, of Mrs. Toddles falling off the dickey and of the cotillion, complete the saga of the redoubtable widow.[95]

"Mrs. Toddles" is an instance of Cruikshank's thriving in an impromptu and genial comic vein, expanding on an initial joke, creating a personality and a refined Cockney diction and an absurd but lovable portrait, moving beyond image to narrative, and then refining that image and putting it into motion and into other situations. Had the *Omnibus* continued, Sarah Toddles might have been elevated to star status. As it turned out, some of her traits migrated into Dickens's famous nurse Sarah Gamp. But while Mrs. Toddles is a gently caricatured figure, Sairey is far more sharply drawn, with a greater range of expression, a wilder self-constituting imagination, and a capacity for serious mischief. Where Cruikshank's satire is weakening, Dickens's is growing stronger.

That geniality does not fully reflect George's temperament. The sharper side of his needle shows up in the full-page etchings ridiculing the "New Police Acts," but even more so in his illustrations of demons for Ingoldsby and Lord Nugent in *Bentley's*, in his "Monument to Napoleon!"—a skeleton standing atop a pyramid of skulls—for the first *Omnibus*, and especially in his terrifying vision of "Jack o'Lantern," etched for the last number. This dark demon stands, as the accompanying letterpress explains, for temptations—to drink, to gourmandize, to gamble, to glory; and it is offered at the beginning of 1842 as a Christmas picture! We might surmise that something was stirring deep in Cruikshank's subconscious, that some impulse to break out from the restraints of early-Victorian society and to indulge in the old Tom and Jerry license was being half-acknowledged, half-suppressed as the artist crafted a respectable self who would not "*frighten*" the ladies.

Cruikshank took care that the first issue would be widely noticed. He sent copies to influential friends, who returned praise. Ainsworth found it "capital," Forster said it pleased and amused him, Marryat saw it in all the shops, and Dickens hailed it as "wery light, wery easy on the springs, well horsed, driv in a slap up style, and altogether an uncommon spicy consarn."[96] Dickens thought Cruikshank had let off Grant too lightly: "Vermin, when caught, are never tickled, but killed outright; and having got my foot upon that louse of literature, I'd have squashed him ruthlessly." Here too Dickens takes a more savage line than the artist. But Cruikshank, still looking for steady patronage from an audience, merely nudged the "louse" out of doors. Happily, the first number sold well: seven thousand the first morning.[97] Yet the economics were once again against him: on a sale of sixty-five hundred of No. 2 he lost £6, and by October the venture was in the red by nearly £200.[98]

Being proprietor involved Cruikshank in reams of letter writing: to reviewers, to potential contributors, to the printers and the wood-engravers and the publishers and the editor. He and Dickens engaged in a lengthy correspondence about John Overs's piece on "The Postilion," which Dickens recommended and which finally appeared in the last issue: "I think you know," Cruikshank told Dickens, "that I am, like yourself, always ready to lend a helping hand to those who want it."[99] Merle peppered Cruikshank with more than a dozen letters making suggestions, offering squibs—he was hurt that his friend had not invited him to be a contributor from the beginning—and commenting on the contents. "I like yourself much better than you yourself led me to expect," he wrote concerning the artist's self-portrait; "it is more like yourself, it has a graver, almost a more melancholy cast of features, true to nature, tho' I dare say it will disappoint thousands who had made up their minds to see a man with a head grinning from ear to ear."[100] He also congratulated the artist for wrenching free of "the brain-sucking tyrants who fr. years have bound you like a slave & fed & fattened

on your genius."[101] Strangers sent Cruikshank everything from suggestions for a plate to two-volume romances for wholesale insertion in the magazine. As the summer of 1841 drew on, he found himself "more *behind* than ever," with the *Guy Fawkes* plates, the *Omnibus*, the *Comic Almanack*, commissions from Merle, proofreading, the *Tower* accounts, manuscripts to read, autographs to send, print orders to adjust, and countless other niggling matters to settle.

Compounding his distractions, Cruikshank was "almost *pecked* to death with Bills."[102] He borrowed money from Merle he could not conveniently repay, put off other creditors, and scrambled for shillings. Suddenly his balance in the Goswell Road branch of the Finsbury Bank disappeared. The manager, Mr. David Hannay, embezzled all the capital in a fairly casual way, so in August 1841 the depositors were left penniless.[103] "Should there be any thing to divide upon the 'Tower' this month," Cruikshank wrote hastily to Morgan, "you will please *not* to *cross* the cheque with the 'Finsbury Bank'."[104] Whatever cushion George may have put aside against unexpected expenses got swept away overnight. And those unexpected expenses began to mount as Mary Ann's health deteriorated further.

In November 1841 she became "dangerously ill."[105] Pettigrew anticipated her recovery, but Cruikshank was not sure whether he could keep social engagements. Other friends who tried to call at Amwell Street expressed concern, and Ainsworth's daughters hoped Mrs. Cruikshank was better when inviting George to their New Year's Day party. Mary Ann's weakness lingered; but she improved in the sea air at Margate in August 1842, and seemed to be quite recovered by the following May, when she, George, and "two dear little girls," who may have been her Baldwyn nieces, attended the theater.[106] The next eighteen months are clear of references to illness, but from 1845 Mary Ann's indispositions grow more and more serious.

Bentley, Ainsworth, the *Omnibus*, finances, sickness—they all took their toll on Cruikshank's usually resilient spirit. He attended an enormous number of dinners during this period—at Kensal Manor House, where Ainsworth was at the peak of his glorious party-giving, and at the more modest collations of such friends as Merle, Roberts, Pettigrew, the journalist Robert Bell, John Auldjo, and Marryat. Cruikshank saw a fair amount of Dickens while finishing up the *Pic-Nic Papers* in the early months of 1841. In February Dickens requested him to receive Lord Lindsey, a feeble-minded young man who had come to town "to see the live Lions, among whom he justly puts you foremost."[107] When the earl arrived at the Cruikshank's home, Mary Ann saw him first and ran to her husband to report that there was a man downstairs either drunk or mad. "I said, 'Show him up'!—and when he got into my room hang me [if] I do not think that he thought he was making hay—he pitched the papers about so!"[108]

To commemorate Dickens's return from America in July 1842, Forster indited a warm invitation to Cruikshank to join the company at the

Trafalgar in Greenwich for "a small private dinner." "*You must join us* in this impromptu welcome," Forster urged; "Now my dear George—let nothing prevent your coming. Put off all minor Engagements—won't you?"[109] Marryat presided, Jerdan was vice-chairman, Ainsworth, Macready, Stanfield, Barham, and Mahony (whose versified "butchery" of Ainsworth had appeared only two months previously) attended; Cruikshank sang a burlesque ballad; the speeches and toasts were good.[110] According to the guest of honor, Cruikshank went home in Dickens's phaeton standing "on his head—to the great delight of the loose Midnight Loungers in Regent Street. He was last seen, taking Gin with a Waterman."[111] Probably Cruikshank did drink too much and cavort on the way home. But Dickens liked to work up such incidents into ever more dramatic anecdotes; like caricaturists he delighted in the faculty of exaggeration. (Hood, who also rode in Dickens's phaeton, says nothing in his report about Cruikshank's antics.) And thus the story Dickens told to Beard gets elaborated twenty days later for an American friend Cornelius Felton: "George Cruikshank was perfectly wild at the reunion; and after singing all manner of maniac songs, wound up the entertainment by coming home (six miles) in a little open phaeton of mine, *on his head*—to the mingled delight and indignation of the Metropolitan Police."[112] Dickens was probably right to sense a "maniac" quality to George's behavior just then; but his own letter is one of frantic overemphasis: "I indite a monstrously short, and wildly uninteresting epistle." Dickens was embroidering on an earlier image of Cruikshank still current in the United States—one that the pressures of the artist's circumstances caused to pop out again from time to time.

These entertainments were interspersed with engagements of a different kind. Between 1841 and 1845, several of Cruikshank's friends, collaborators, and supporters died. The first was Theodore Hook, "prince of lampooners," a ready wit entertained by the powerful as a hired jester, but dogged by unredeemable debt and domestic afflictions. "Done up in purse, in mind, and in body," as he said of himself, he died at Fulham on 24 August 1841.[113] Cruikshank had socialized with Hook at *Miscellany* dinners in the Red Room of Bentley's shop and was well acquainted with the writer's sprightly satires.[114] The next to fall was Marryat's protégé Edward Howard, author of *Rattlin the Reefer*, the young subeditor of the *Metropolitan Magazine* who had mollified the artist's wrath about the fate of Merle's *Melton de Mowbray*. At the beginning of September 1841, Cruikshank, who was going out of town, deferred a meeting with Howard.[115] Before that meeting could be rescheduled, on 30 December, the forty-eight-year-old Howard suddenly died of apoplexy.

Then the brilliant, feckless Maginn, only forty-nine, succumbed. Hiding out in Wych Street, he sought help from every quarter. Refused aid by the

conservatives on account of his racy journalism, insufficiently supported by the donations of friends, he was finally thrown into debtors' prison, and when he was discharged he had an advanced stage of tuberculosis. He died at Walton-on-Thames on 21 August 1842.[116] Lockhart's outspoken "Epitaph" was much quoted:

> But at last he was beat, and sought help from the bin
> (All the same to the Doctor, from claret to gin),
> Which led swiftly to gaol, with consumption therein;
> It was much, when the bones rattled loose in his skin,
> He got leave to die here [Walton], out of Babylon's din.
> Barring drink and the girls, I ne'er heard of a sin:
> Many worse, better few, than bright, broken Maginn.[117]

Maginn left the first eight chapters of *John Manesty, the Liverpool Merchant*, a tale about the mid-eighteenth century, which Charles Ollier completed, Ainsworth published in his *Magazine*, and Cruikshank began to illustrate.[118] The purchase of copyright, along with a fund raised by Lockhart and Edward Kenealy, provided temporary relief for Maginn's widow and children.

An even more disturbing incident occurred the following October. William Hone, terminally ill, sent for Cruikshank, and after they were reconciled he asked Cruikshank to bring Dickens by "as, having read no books but mine of late," Dickens told Forster, "he wanted to see and shake hands with me before (as George said) 'he went'."[119] On 5 October the two friends called; they came again the next day, staying half an hour, during which Hone never let go of Cruikshank's hand.[120] A month later Hone was dead.

The funeral, held on a foggy drizzly November day, was a small affair in Stoke Newington, over which the Reverend Thomas Binney, a Nonconformist minister at Weigh House Chapel, presided. Dickens wrote to Felton four months later a colorful description of the "mingled comicality and seriousness" of the event:

> Now, George has enormous whiskers which straggle all down his throat in such weather, and stick out in front of him, like a partially unravelled bird's-nest; so that he looks queer enough at the best, but when he is very wet, and in a state between jollity (he is always very jolly with me) and the deepest gravity (going to a funeral, you know) it is utterly impossible to resist him: especially as he makes the strangest remarks the mind of man can conceive, without any intention of being funny, but rather meaning to be philosophical.

When Binney protested to Cruikshank about an obituary notice (attributed by Dickens to Cruikshank) which stated that Hone had been persuaded by Binney to preach at his chapel, "George (upon his knees, and sobbing for the loss of an old friend) whispered me 'that if that wasn't a clergyman, and it wasn't a funeral, he'd have punched his head'."[121]

Forster published this letter in the first edition of his biography of

Dickens; it was rebutted by Binney in the *Evangelical Magazine* and by
Cruikshank in a letter to the *Daily Telegraph*: "The Minister . . . is . . . a
man of high intellect and education and therefore not very likely to use
such ridiculous language as is ascribed to him."[122] Mrs. Hone also denied
that Dickens's account was accurate. Eventually Forster withdrew the letter
altogether; but it was so vivid, accorded so well with a patronizingly comic
image of the artist, and had been printed in such an authoritative work,
that it continues to circulate as an accurate description of the event. Ac-
cording to the Pilgrim editors, "the corrections are matters of detail" only.
In fact, it was characteristic of Cruikshank to threaten antagonists with a
blow; he may very well have been irritated by Binney's irrelevent and irrev-
erent disputation. But the other eyewitnesses found the ceremony much
more sincere and decorous than Dickens did.[123]

Dickens's fabrication of a Cruikshank persona for his American corre-
spondents continued. Felton was a close friend of Longfellow and would no
doubt have passed the story on. Longfellow, who had himself dined with
Cruikshank ("a very original genius") at Dickens's house during an Octo-
ber 1842 visit, received from Dickens another representation of the intoxi-
cated artist: "George Cruikshank got rather drunk here, last Friday night,
and declined to go away until Four in the morning, when he went—I don't
know where, but certainly not home."[124] No wonder then that when Long-
fellow's friend Thomas Gold Appleton sailed for England, and the Ameri-
can poet asked Forster to make the visitor acquainted with Tennyson,
Appleton said he would like that above all things "saving to know Cruik-
shank, which he would like still more."[125] Accordingly, Dickens invited
Cruikshank to a dinner for Appleton on Sunday, 25 June 1843, when the
encounter seems to have gone off without any excesses.

Cruikshank's erratic, pugnacious, and drunken behavior is too well doc-
umented to be disbelieved. "Hic haec always sticks in my throat," he joked
to Dr. Roberts about his little Latin, "but the 'Hoc' goes down."[126] Nor did
Dickens mistake the symptoms of intemperance. What he fails to note is
the artist's multiple worries about projects, finances, and health—and what
he seems to know nothing about is George's early exploration of Tem-
perance. Cruikshank etched four surreal plates for the second edition of
John O'Neill's poem *The Drunkard* during December 1841, and from that
time forward began collecting books and pamphlets proselytizing for absti-
nence and teetotalism.[127] As his professional and marital circumstances de-
teriorated, Cruikshank was drawn subconsciously toward a program that
might steady and reform both him and his audience, while providing a
forum for his moral fervor and a constructive outlet for repressed energies.
Temperance was to become yet another way the artist refashioned himself
for the age of Victoria.

31

THE TRIUMPH OF CUPID

If we were asked who, through [the last fifty years], has been the most faithful chronicler of the ways, customs, and habits of the middle and lower classes of England, we should answer without hesitation, George Cruikshank.

John Paget[1]

The great burgeoning middle class in the nineteenth century was the Puritan body of the population, as well as the core of the reading public. Like other Puritans they were exigent about behaviour and surface decorum, while they were afraid of the churning emotions just beneath that surface.

Robert Bernard Martin[2]

EARLY VICTORIANS redefined comedy. There were at least three traditions to choose among. The one stemming from Hobbes maintained that laughter sprang from the apprehension of "*sudden glory,*" an instantaneous awareness of one's superiority to others. If laughter was associated with scorn and pusillanimity, then decent folk ought to refrain from laughing. "One cannot have a sense of humour unless one be without conscience or responsibility," Goethe remarked.

A second line of argument, originating with Aristotle and reformulated by Kant and Coleridge, held that comedy derives from the intellectual perception of incongruity. In 1846 Leigh Hunt defined "wit" as "*the Arbitrary Juxtaposition of Dissimilar Ideas, for some lively purpose of Assimilation or Contrast, generally of both.*" Juxtaposition could be performed on the same level—two words (puns), word and image, dissimilar objects—or on different levels—sign yoked to thing, the physical to the metaphysical. But such witty connections were not necessarily useful, since they did not lead to didactic and moral ends. "We can easily see, then," Robert Martin summarizes,

the cleft stick in which the Victorians were struggling. If comedy were backed by morality, and valuable for its educational potential, then it finally appealed to scorn, arrogance, and contempt. The alternative seemed equally bad. If the major force of comedy were an intellectual one in which scorn was discarded and laughter became its own end, then it was hard to see that it had any utility.[3]

A third alternative, ratified by eighteenth-century benevolist divines and the school of sentiment, promoted by Richter and Carlyle, sought to facilitate sympathetic identification with the foibles and essential goodness of others. "What the theories of both superiority and the incongruous postulated," Martin continues, "was sufficient distance from the object of comedy to perceive how it was out of joint. What sentimental comedy, like that of Dickens, advocated was the eradication of that distance and an identification between perceiver and perceived."[4] Humor and pathos, as two modes of empathetic imagination, gradually became allied. Dickens, Thackeray, and George Eliot all based their comedy on the extension of sympathy, although George Eliot more than the other two recognized the unsympathetic basis of much coarse humor and the attractiveness of ratiocinative wit.

By the 1870s the sentimental tradition was, in turn, coming under fire. It lacked play, point, even humor, and often degenerated into reinforcing middle-class prejudices. That comedy had a class basis was another determinant implicit in mid-Victorian humor: while middle-class readers of *Punch* were comforted by the gentle cartoons of themselves supplied by Leech and Doyle, they approved of altogether more hostile representations of the Irish as vagrants, ruffians, and anarchists— in short, as apes.[5] Roger Henkle has proposed that comic fictions run in cycles: the first phase is destructive or reductive, like Cruikshank's caricatures; the second phase elaborates and experiments, like Cruikshank's work of the 1820s–1840s; and the third phase is closure of comic development, characteristic of Cruikshank's work from the mid-1840s.[6]

When in April 1871 Charles Cowden Clarke began in the *Gentleman's Magazine* a series of fifteen articles on comic writers, he took his definition of humor from an older, caricature tradition: "a graphically surcharged portraiture of the ludicrous position itself of the principle, or individual."[7] Cowden Clarke prefers wit to humor because the former involves "the inventive faculty, as well as . . . the imagination, and the fancy." Gradually toward the end of the century earlier conceptions of comedy incorporating visual satire, wit, exaggeration, superiority, the ludicrous, the intellectual, the poetically and symbolically evocative, and the regulative reclaimed their status in such statements as Meredith's *Essay on Comedy* ("the test of true Comedy is that it shall awaken thoughtful laughter") and Oscar Wilde's essays and plays.

In the 1840s, however, sentimental comedy held the day. "The humorous writer," declared Thackeray in his lecture on Swift, "professes to awaken and direct your love, your pity, your kindness—your scorn for untruth, pretension, imposture—your tenderness for the weak, the poor, the oppressed, the unhappy." Cruikshank's humor had always depended to some extent on empathetic laughter. To be sure, the most savage caricatures during the first decades relied on coarse imagery, scurrilous allegations, belittlement, cruel distortions, and satire. But the moral and evocative center tended to be the plight of John Bull, the common Englishman (not woman or Irishman), burdened, betrayed, duped, and insular, but staunch, loyal, tolerant, affectionate, and intuitively if crudely moral. Inspired by Crowquill and others, from 1815 to 1825 Cruikshank also explored the limits of comedy produced through incongruous juxtaposition: polyvalent meanings of words, parts of speech and punctuation marks as types of persons, animal and vegetable matter given human characteristics. His devils, demons, and witches exchanged political and religious signification for something more psychological and imaginary. This combination of empathetic, intellectual, and imaginative humor John Paget, lawyer, historian, and journalist, celebrated in his 1863 review of Cruikshank's "genius": "We say this in no spirit of exaggeration, but with a profound conviction that no hand could have produced such works as those of George Cruikshank, which was not the index and the organ of a heart deeply imbued with the finest sympathies of humanity, and an intellect highly endowed with power of the keenest perception and the subtlest analysis."[8]

From the mid-1830s, Cruikshank's art begins to bifurcate. There are the many sympathetic images of common humanity, from chimney sweeps celebrating May Day to romantic couples awkwardly courting and glimpses of everyday heroes. There are also pictures of criminals, still humanized but increasingly vivid, depraved, and demonic: Fagin, Jonathan Wild and Blueskin, Mauger and Nightgall, Simon Renard. So long as comedy roots in empathy, the risible and the terrible are not necessarily opposed. But in the 1840s Cruikshank's art separates into sentimental domestic idyll on one side and images that terrify, that cry out against cruelty, that accuse, on the other. As Thackeray becomes sentimental and cynical, Cruikshank grows bourgeois and bellicose. Both artists register the double nature of industrial capitalism.

These shifts appear over the nineteen years (1835–1853) Cruikshank etched plates for the *Comic Almanack*.[9] What appears in that annual is not solely the product of the artist's invention: Vizetelly collaborated on the contents in the first years; Thackeray contributed monthly installments of a story in 1839 and again in 1840; Gilbert à Beckett, Horace Smith, and the Mayhew brothers wrote for it in the forties and fifties; Tilt, and after his

retirement Bogue, took an active part in designing and promoting it.[10] Nor was Cruikshank immune to the shifts in taste taking place around him; quite the contrary, he intuitively registered and recorded those shifts. Nevertheless, with the *Comic Almanack* he was less constrained by the need to cooperate with a partner, more free to go in his own direction. "In the early numbers of the work," Cruikshank explained to a correspondent in 1852, "I always furnished the subjects for the plates myself—and the general features of the 'No' [number]—without seeing—or indeed—knowing the editor. . . . It was found after a few years—from the constant harping of one mind upon the same subject—necessary to bring in a new mind—with new ideas—not only to relieve me but to give—a character of novelty."[11]

In an almanac format Cruikshank was obliged to depict contemporary life. "Every ramification of society" beneath the realms of Grosvenor Square and Pimlico, Paget observes,

> has been accurately observed and traced out by the pencil of George Cruikshank; from the garret to the cellar, there is not an inhabitant with whom he has not made us familiar. The boarding-house, the school, the tea-garden, the chop-house, the police-office, the coach-stand, the market, the workhouse, and the prison—every scene, in short, where human life is telling its strange and varied tale—calls forth his sympathies, and affords matter for his genial pencil.[12]

The *Almanack* begins in the genre of the street sketch, much like *Sketches by Boz.* A number of plates record comic urban theater: pedestrians coping with mud, fog, pelting rain, blustery March winds, noise, pestiferous urchins, rearing horses, congested streets, wily pickpockets. These crowd-filled snapshots of city life portray mishaps and discomfort, poverty and drunkenness, yet they teem with vitality and good spirits. As in the well-known May 1838 plate "All a-growing," flowers, plants, trees, children, adults, buildings, and signs all exhibit resilience, energy, and genial community. Cruikshank "is endlessly observant of the multifarious play of life in the metropolis," John Harvey writes, "and his seeing and his drawing, his nervous line of sharp perception, is not governed by an eye hungry for the bizarre, but by a generous humor, a sense of the natural relatedness of people and things, and an inexhaustible imaginative humanity."[13] The graphic tropes Cruikshank employs to register that inexhaustible humanity are those of enumeration, differentiation, and supplementation. How many kinds of "boxes" can he parcel up for the "Boxing Day" 1836 print? How many varieties of music might assault the ear on "St. Cecelia's Day" 1837?

The street sketch flourished simultaneously in France. Mercier's *Tableau de Paris* (1781–1788) consisted of short texts giving fragmentary views of the common life of Paris in an attempt "to decipher the moral and political

physiognomy of the city without prejudice."[14] The principle of organization was contrast, and the intention was to capture the nuance of the historical moment. Out of these experiences the observer could infer the moral character of the age. Subsequent tableaux were less ambitious than Mercier's, until the *Livre des Cent-et-un* (15 vols., 1831–1835) employed 160 writers to pass in review modern fashionable Paris from the perspective of one in harmony with himself and his class. This publication stressed sympathy rather than objectivity and ignored the poor and working-class *quartiers*. At the beginning of the 1840s, a new tableau formula influenced by caricaturists was inaugurated with plates by Monnier, Gavarni, Daumier, and Grandville. These emphasize the visual and representational over the textual and claim to depict "modernity"; the vantage point is that of the *flâneur*; the subject is all the life of Paris, lower as well as upper classes; and the organization tends to be thematic. Grandville in his 1842 *Scènes de la vie privée et publique des animaux* marries the tradition of beast-fable and animal-emblem to the tableau, while in the same year Paul de Kock and Balzac are among the important writers contributing to *La Grande Ville* as the tradition enters into the mainstream of art.

Little has been done to compare the English genre of the street "sketch" to the French *tableau de Paris*. Cruikshank was aware of Gallic counterparts to his own images. In the 1820s, Henry Monnier visited Cruikshank twice, first during an 1822–1825 stay, second in 1828. They were almost exact contemporaries and shared similar attitudes toward their cultures. Monnier dedicated his *Distractions* (1832) to his "friend" and claimed that his *Esquisses Parisiennes* (1827) and *Vues de Paris* (1829) were inspired by Cruikshank.[15] George's *Monstrosities* plates, his collaborations with Egan and Dickens, and his street scenes in the early *Almanacks* participate in the same "sketch" tradition. He too goes through stages, from early satires that have a strong moral basis to *parti pris* explorations of "fashionable" life (which in London include visits to the dives of gambling, vice, and degradation) and finally to visual depictions of the fugitive, trivial activities of Londoners. In the later *Almanacks* he even returns to the animal imagery of his Napoleonic caricatures, but in such etchings as "Curiosities of Ornithology" (1841) or "The Stag, the Bull, and the Bear. (A Railway Fable)" (1847), Cruikshank uses this imagery to comment on personality and manners more than on political morality. (When the three animals who speculate in railway shares are ruined they "cut and run" to Boulogne; France in the 1840s becomes in popular imagery the destination of rogues, and by sending them there, the artist effects whatever moral denunciation his narrative requires.) Decades before Baudelaire proclaimed the aesthetic of modern art, Cruikshank imaged modern life in its rapid motion and change, perceiving everything with a passionate intensity belonging to

childhood. "Genius is nothing but childhood voluntarily recaptured," Baudelaire declared, "a childhood now gifted with virile organs of expression and with an analytical mind which allows him to order the mass of materials, accumulated involuntarily." That habit of classification which sharpened and ordered Cruikshank's visual memory becomes now the basis on which he can record, thematize, and universalize the transitory life of a historical moment. Cruikshank becomes for England, as Baudelaire argued Constantin Guys was for France and Edgar Allan Poe was for the United States, the artist of the modern, which is "the transitional, the fugitive, and contingent, that half of art, whose other half is the eternal and unchangeable."

It was easy for Cruikshank to move from generalized seasonal images to pictures of particular events. The *Almanack* for 1836 commemorates St. Crispin's Day and the Lord Mayor's Day, and other annuals celebrate St. Cecilia's, St. Patrick's, and May Day. For the most part these are entertainments provided by and for the lower classes: cobblers and sweeps and the always rumbustious Irish. Indeed, Cruikshank makes a point of contrasting the verve and bustle of those holidays to the relaxation of clerks enjoying a "Holiday at the Public Offices" in June 1836.[16] Occasionally a print will acknowledge the other side of lower-class life: "Michaelmas Day" 1836, one of the traditional quarter days when rents were due, shows a family slipping out of town in the middle of the night with their belongings on their backs. Even here, however, the mood is upbeat: the accompanying verse, spoken by the father, who has evidently sustained himself and his family by petty larceny, takes a larky, punning view of things.

> We've had our fill on *Mutton Hill*;
> In *Cornhill* gain'd our *bread*;
> Dress'd with an air in fam'd *Cloth Fair*;
> In *Grub Street* well were *fed*.
> .
> And, lack-a-day! here's Quarter Day;
> It always comes too soon;
> So we by night must take our flight,
> For we must *shoot the moon!*

Few of these early etchings depict anything more symbolic than the rites, rituals, and hieroglyphs of the people. For New Year's Eve (January 1838), however, Cruikshank flanks a riot of party-goers with portraits of the infant new year on the left holding an overflowing cornucopia and the aged old year on the right, her plenty's horn upended and empty. Thomas Love Peacock found in this plate a resonant allegory which he expressed in "Lines on George Cruikshank's illustration of January, in the Comic Almanack for 1838," published as the last item in the January *Bentley's*:

THE NEW YEAR

A great philosopher art thou, George Cruikshank,
In thy unmatched grotesqueness! Antic dance,
Wine, mirth, and music, welcome thy New Year,
Who makes her entry as a radiant child,
With smiling face, in holiday apparel,
Bearing a cornucopiae, crowned and clustered
With all the elements of festal joy:
All smiles and promises. But looking closely
Upon that smiling face, 'tis but a mask;
Fitted so well, it almost seems a face;
But still a mask. What features lurk beneath,
The rolling months will show. Thy Old Year passes,—
Danced out in mockery by the festive band,—
A faded form, with thin and pallid face,
In spectral weeds; her mask upon the ground,
Her Amalthaea's horn reversed, and emptied
Of all good things,—not even hope remaining.
Such will the New Year be: that smiling mask
Will fall; to some how soon: to many later:
At last to all! The same transparent shade
Of wasted means and broken promises
Will make its exit: and another Year
Will enter masked and smiling, and be welcomed
With minstrelsy and revelry, as this is.

The notion that things get worse instead of better, that life is a decline and fall, receives comic treatment at the hands of Thackeray when he supplies the letterpress for the 1839 and 1840 *Almanacks*. "Stubbs's Calendar; or, The Fatal Boots" tracks the progress of Robert Stubbs from his middle-class birth through a succession of extortions, impersonations, abortive marriage proposals, disastrous wagers, reckless expenditures, cowardice, heartless confiscation of his father's property leaving his mother and sisters destitute, and general perfidy; throughout it all he is dogged by a cobbler whom he once tricked out of a new pair of boots.[17] His over-fond mother and long-suffering sisters are befriended by gentry and end up in comfortable circumstances; Stubbs's final recourse is to write his adventures for a bookseller, who "says they're *moral*." Thackeray hits again at "rogue" literature and produces the kind of plot he will reprobate in the mid-1840s, one in which the good prosper and the bad go to jail. His sympathy lies with gentility, not knavery, and with middle-class comforts, not adventures on the road.

"Barber Cox, and the Cutting of his Comb," which Thackeray invented for the 1840 *Almanack*, enforces the same morality.[18] Cox and his ambitious wife inherit a large fortune; they squander it in a foolish pursuit of upper

middle-class status, lose all their money when a will leaving the property elsewhere is discovered, and return to the barber shop thankfully and happily. Cruikshank's plates, executed before Thackeray composed the letterpress, register the discomforts of fashion—hunting, traveling, boarding school—and the pleasures of a simple country dance amid friends in the cozy atmosphere of the barber shop.[19] When both author and artist sympathize with Cox, however, they celebrate members of the lower middle class, the working worthy, not the feckless poor. There seems to be a subtle notching-up of the class to which the *Almanack* appeals, or else the annual reflects a general turning away of early Victorian book buyers from hearty participation in street life to a contemplation of their own circumstances, poised between the Scylla of profligate upper-class fashions and the Charybdis of improvident lower-class amusements.

That sense of being on shaky ground emerges in plate after plate of the early 1840s—scenes of skaters falling through thin artificial ice (1844), or of one's best clothes ruined by a downpour at the Horticultural Fete (1845). All twelve etchings for 1842 are divided vertically to represent an upstairs/downstairs or before/after situation: a careful Scots bailee suffers night after night from having taken lodgings just under four carousers, one of them his wastrel son supposed to be studying medicine; a handsomely attired beau to whom all the strolling ladies in the park are attracted has quite the reverse effect when down, out, and bedraggled. Most telling is "Going!—Gone!!," an auction of a ruined householder's goods held in the front drawing room where the floor collapses, precipitating the buyers and auctioneer into the parlor below.

An implicit acknowledgment of precariousness begins to invade Cruikshank's art. Whereas the plates of the first few years are etched with a free hand, all squiggly lines and gestures at representation which the viewer must complete, by the mid-1840s the work is more effortful, precise, with little left to the imagination. A certain finish robs some of the images of their impulsive humor. Cruikshank betrays an uncertainty about whether something so impetuous as a sketch will serve his public. He also tries another direction: in 1843 he recapitulates the style and the humor of his caricature period by providing his characters with crowded balloons of dialogue. A conservative politics emerges in 1843 with an anti-Chartist picture, an anti-Owenite socialism plate, and a rendition of *Poor Bull's Burden* decrying "The Tax upon Property." (Peel proposed an income tax on 11 March 1842, some months before Cruikshank devised the plates for the next year's *Almanack*.) The tax turns out to be the expenses of keeping up "The Honour and Dignity of the Family," maintaining a town house and a country house, paying for servants and carriages, giving dinners, suppers, routs, and balls, and supporting the poor relations; still, the misery of a

Guy Fawkes treated Classically—An Unexhibited Cartoon

35. *George Cruikshank, "Guy Fawkes treated Classically—An Unexhibited Cartoon,"* Comic Almanack, *etching, May 1844*

John Bull with £10,000 a year is very different from that of the wartime bull burdened and goaded by the government.[20]

Some direct reflections on the plight of the artist appear in the mid-1840s. "Quarter Day" for March 1844 displays a man (sometimes identified as Cruikshank himself) being torn into quarters by a burly landlady (Lady Day), a Bill Sikes morris dancer (Midsummer), a Michaelmas goose, and a "Xmas" figure composed of plum-pudding head, drum-stick arms, and bottle legs.[21] The accompanying "Essay on Rent" by a "political economist" jokes about the relations among capital, labor, and rent; but the plate, suggested to Cruikshank by Merle, takes a more serious view of the case.[22] The unceasing labor that the artist was compelled to perform in order to meet his bills, pay rent on his town house, and support—if not legions of poor relations, then at least his mother and a couple of servants—was tearing him apart, as his erratic behavior witnesses.

Later that same year Cruikshank etched "Guy Fawkes treated Classically—An Unexhibited Cartoon" (fig. 35). It shows him trying to get a gigantic canvas through the entrance to Westminster Hall. The cartoon and Cruikshank's facing letterpress make fun of the competition for murals to decorate the new Palace of Westminster. By choosing to depict Guy

36. *George Cruikshank, "Born a Genius and Born a Dwarf,"* Comic Almanack, *etching, Sept. 1847*

Fawkes, who failed to burn down the building in 1605, Cruikshank alludes to the fire that destroyed the edifice more than two hundred years later and to the novel he and Ainsworth had just published. He also parodies the Royal Academy grandiose classical style; "resolved to make [the cartoon] a greater work than had ever before been known," because it is too large he is forced to chop off the head and foreshorten the feet, leaving the Guy with "hardly a leg to stand upon." Even so, it could not pass the portal, though he cramped his genius to suit the views of the commissioners. "There is," as William Feaver notices, "a slight air of plaint behind the paradox and parody."[23]

A third plate about artists appears in the 1847 *Almanack:* "Born a Genius and Born a Dwarf" (fig. 36) in two side-by-side rectangles contrasts Benjamin Robert Haydon crouched despairingly in his garret in front of his painting of an Old Testament prophet to Tom Thumb lolling on a sofa in a luxuriously furnished room. Haydon's last desperate bid for recognition, a retrospective exhibition in 1846, had been an utter failure, in part because Tom Thumb had drawn all the customers to the next floor of the Egyptian Hall. Just before committing suicide, Haydon confided to his diary: "Tom Thumb had 12,000 last week, B. R. Haydon 133 1/2 (a little girl). Exquisite Taste of the English people!"[24] Once again, the satire cuts in all directions: at the public for preferring miniature to heroic, at life for promoting

deformity over genius. "Had I conferred on him the Genius thou sighest after," Jupiter tells Tom's mother in the accompanying "Idyll," "he would have felt but Want and Neglect in the world." It also cuts at Haydon for his romantic excesses and thundering prophets and at all the other entrants in the Westminster competition whose vacuous cartoons beat out Haydon's submission. And it alludes complexly to Cruikshank's own situation: he is both Haydon, humiliated by the public's rejection, and Tom Thumb, master of miniatures, though his own art is to be distinguished from the blowsy rhetoric of romantic prophecy on one side and the diminutive trumpery of modern amusements on the other.[25]

In 1846 the *Almanack* plates depict zodiacal signs, the various animals being inserted into contemporary settings. Cruikshank expended much effort on these etchings that marry allegorical signification to commentary on modern life; a number of preliminary drawings are worked up in watercolor, and the steels are remarkably detailed. That of Taurus in the printing office is among the most complex: the displacement from a "china shop" allows Cruikshank to invest this burdened bull with the signification of John Bull as author/artist. The explanatory letterpress parodying a Wordsworth sonnet complains that printers publish such trash, their shops should be destroyed:

> Hadst thou a literary sense of shame,
> How wouldst thou crush, and toss, and rend, and gore
> The printing press, and hands that work therefore,
> For the sad trash that issues from the same.
>
> If they would print no other works than mine,
> The task were nobler; but, alas, in vain,
> Of audience few and *unfit* I complain,
> Bull wont believe in Southey's verse and mine.

What a long way Cruikshank has traveled from the 1820s and his campaign with Hone to defend the printing press as the light of liberty. However parodic in intention, the poem and picture together suggest a degree of disillusionment about a free press and the public's patronage that were never present twenty-five years earlier.

The later years of the *Almanack* register the passing of old ways. Coachmen and post boys are starved out by the railways (1847), and the hard drinkers of Georgian England are lectured into moderation by the Irish teetotal proselyte Father Theobald Mathew portrayed as a water pump. Whereas in an 1836 print the bottles berate the pump, by 1844 "Father Mathew—An ice-man for a small party" urges the family, "if you *must* take any thing—take the pledge," and by 1848 tea seems to be the ladies' choice.[26] The ladies also gain the upper hand in other matters: from 1847

the *Almanack* plates deal much more with their affairs, often from a some-
what jaundiced point of view. "My Wife is a Woman of Mind" depicts a
female poet who neglects her family, much as Mrs. Jellyby will hers in
Dickens's *Bleak House* (1852–1853). There are many 1850s plates lam-
pooning fashions—especially the pneumatic bustle and the voluminous
crinoline. More biting are the etchings of women governing—as for ex-
ample the large folding plate of women trying a breach of promise suit in
the Court of Queen's Bench (1850), and another of "The Effects of Female
Enfranchisement" (1853).[27] These betray a divided sensibility: at one level
they seem to be addressed to a female audience, to speak of their concerns
and potentialities, but at another they speak with the voice of women who
adopt a patriarchal attitude toward what is fitting for the distaff sex.

In many ways Cruikshank was losing his voice and his audience, two
aspects of the same phenomenon. By the second half of the 1840s sales of
the *Almanack* trailed off, while Cruikshank and Charles Tilt got into re-
peated quarrels. The first concerned that perennial source of dispute, pub-
lishers' accounts. Cruikshank tried to raise a little money by selling the
back stock of the discontinued *Omnibus* to the remainder dealer Henry
Bohn, having not succeeded in disposing of many copies through pub-
lishers' auctions. According to Tilt and Bogue, the artist owed them
£87.17.5½. They would not release the stock until Cruikshank
cleared his debt, so they supplied only a summary account, showing that
receipts on *Bateman* (£0.6.8), *Oldbuck* (£27.12.3, see below), *Sketch Book*
(£8.8.7), and *Omnibus* (£11.7.0) had reduced the outstanding balance of
more than £127. Cruikshank penciled in other sums he believed to be
owed him.[28] After angry words had been exchanged, he sent a check with
the stipulation that he reserved the right "to dispute the correctness of the
said account or of any item thereof at a future time."[29]

More acrimony was created by Tilt's meanness. The arrangement for the
Almanack stipulated that the artist receive twelve guineas for each etching
and a royalty on the sales, and that if the plates wore down in the course of
printing, Tilt was to pay Cruikshank for retouching them. "Tilt's shopkeep-
ing nature," Percy Cruikshank recounts,

> endeavoured to evade this, by privately sending the plates to Finden, the en-
> graver, for repair, as the cheaper method, and which, the indignant artist dis-
> covered. Steel plates, wearing out in a small half crown book, showed the sale
> produced immense profits, and which, it was admitted, paid all the expences of
> the establishment, 86 Fleet St. Honest himself, in the execution of his work for
> publishers, and expecting the same in return, the volcanic nature of the artist
> was agitated, by what, he considered, as an insult and a robbery; his mode of
> action always was, to take the bull by the horns; proceeding to Fleet St, he
> found, that the bull had turned tail, keeping himself secure in another part of

the house. Bogue who had then joined Tilt, in partnership, was a quiet man, whose unexcitable Scotch nature endeavoured to soothe the storming artist, his only demand being "to get at him". Tilt shaking in his shoes within hearing of the roaring lion seeking to devour him heard Bogue striving, to prevent the consequences of such a disastrous interview.

This was doubly dirty of Tilt, who, for years had made enormous sums, out of George Cruikshank; but, as the agreement in question had, probably, never been reduced to writing, "*speaking his mind*" was all the satisfaction obtained; while the publisher retired with a fortune.[30]

Then Bogue saw advertised Cruikshank's new magazine, the *Table-Book*. Bogue was hurt by this evidence of defection but wrote a temperate letter wishing his friend success, expressing his sorrow that Cruikshank should be issuing it from his own office instead of Tilt's shop, and giving his reasons why a monthly illustrated magazine was likely to fail: expenses would be too high to be covered by the usual commissions, booksellers and whole-salers don't like to handle such articles, stock-taking is difficult with con-stant returns of old issues and dispatch of new ones, opportunities for peculation abound, and the work is all bunched up on one day a month, leaving the staff idle much of the time. Bogue concluded by hoping that Cruikshank would return to him and by complaining that Cruikshank should not mix him up in the late misunderstanding with his partner; he wanted no interruption of his friendly intercourse with the artist.[31] In reply Cruikshank explained that the "office" was Bradbury and Evans's, that his first intimation of Tilt's misconduct had come from Bogue, that he had assumed Bogue was of the same mind, and that he now regrets his threat to leave the firm.[32]

However, "the difficulty of getting money, amongst the middle class of persons is extraordinary," Cruikshank told one correspondent in 1846.[33] The need for cash persisted. Cruikshank extended a supplicatory top hat to Bogue for payment in an 1846 note; asked him to meet a bill Cruikshank had incurred on behalf of his friend Pulford in June 1848; begged in Sep-tember 1849 for periodic £5 remittances, which Bogue proposed sending as torn halves of one note, the second half not being mailed until Cruikshank reported receiving the first.[34]

In 1848 the *Almanack's* size was reduced and the price cut from 2s. 6d. to 1s., but those moves misjudged the public to whom it appealed. By this time the subjects were distinctly middle class, not upper working class. Circulation did not increase beyond twenty thousand, barely a break-even number for a work with so many illustrations, so in 1850 Bogue and Cruik-shank went in the opposite direction, restoring the original price and for-mat, and adding large folding plates.[35]

But the middle class was not fond of being ridiculed; *Punch* treated them

much better. And *Punch* was wittier, had a higher caliber of jokes and articles, and handled current events and the governing classes with more respect. Ruskin, judging from the illustrations, said *Punch* had never "in a single instance endeavoured to represent the beauty of the poor. On the contrary, his witness to their degradation, as inevitable in the circumstances of their London life, is constant, and for the most part, contemptuous."[36] While Ruskin may have been a little unjust to Mark Lemon and his successor editors, there is general agreement that when Mr. Punch donned his dress coat he appealed to a higher class.

Moreover, there were dozens of competing almanacs in the field, a phenomenon that Horace Mayhew lampooned in "Something about Almanacks" in the first issue of *George Cruikshank's Table-Book* (1845). "Punch's Almanack," published by Bradbury and Evans in December 1844, Dickens thought "brilliant"; he also thought it imitated Cruikshank's.[37] Indeed, even the magisterial *Quarterly Review* conceded that "*Punch* owes at least half its popularity to the pencil of George Cruikshank."[38]

The final numbers of George's *Almanack* were edited by Angus Reach, with contributions by the *Punch* writer Shirley Brooks. They evoked enthusiastic reviews, that for 1852 prompting *Littel's Living Age* to congratulate Cruikshank "upon his having again put forth all his wonted spirit and vigor, and evinced all his power of grasping the humorous features of a subject, social or political."[39] But the 1853 *Almanack* was the last in the series. When Bogue decided it should be discontinued, Cruikshank had to look to some other way of finding a public. Not to *Punch* however. He told Mark Lemon he would "Never!" contribute to that publication because it indulged in ridiculing personalities instead of principles.[40]

How Cruikshank handles dinner parties over the *Almanack*'s run provides a convenient way of tracking some of the changes in his attitudes and assumed audience. The first etching illustrates December 1835. It shows an elegantly furnished dining room blazoned with ornately framed paintings and mirror, a mantelpiece topped by matching candelabra and a clock, heavy drapes hanging from a fringed swagged pelmet, a gas chandelier wrapped with mistletoe, and a roaring coal fire with screen before and scuttle beside. The furnishings themselves speak eloquently of the owners' taste and material circumstances. Host and ample, festively gowned hostess raise their glasses to toast the eight jovial guests, as one servant takes a dish to the scullery maid and another presents the flaming plum pudding. There is no hint anywhere of disruption: the servants are happy and competent, the guests surfeited but genial, the room cramped and overfurnished but bespeaking a comfortable, solid fortune. No other of Cruikshank's dinners enjoys such perfection.

In September 1838 a family in more modest circumstances partakes of a

rather tough Michaelmas gander. The room is smaller and plainer, there are no guests or servants, the dog paws at a bone while the cat meditates an attack, the husband wrestles with carving while the rest of the family gnaws at the meat with distinctly ungenteel manners. In January 1842, "Before dinner and after" contrasts the "dreadful dull demureness" in the drawing room when the party first assembles to the conviviality of the dining room after dinner is served. These guests appear to come from a class above the second and below the first diners, to be a little inclined to stiffness and the anxious observance of etiquette. The petit bourgeois are not yet comfortable in their imitations of gentility.

September 1845 records a more disastrous supper. Mr. and Mrs. Henry Brown, inexperienced social climbers, resolve to entertain in September because it is rarely done and will therefore be remembered. Just as the guests begin to partake of turtle soup, the dinner table flap gives way, dumping sauterne, fish, waterbottles, knives, forks, and epergnes into the lap of the hostess. The accompanying poem, "The Fall of the Leaf," effects a happy resolution by means of verbal play:

> The sudden movement no one could control—
> A slice of bread went off into a roll.
> Decanters seemed disposed to fall,
> As if they'd had a drop too much;
> And stoppers never stopped at all—
> In fact, refused to act as such.
> 'Twas a mishap, and yet, the truth to tell,
> Mister and Mistress Brown both had their wish;
> They hoped the dinner would go off all well,
> And so it did go off—ay, every dish!

Cruikshank's picture, however, memorializes the catastrophic moment. In design and execution he dramatizes the falling leaf: a strong diagonal of arms replicates the slant of the table, while on the back wall pictures of famous falls—Niagara, the Clyde, etc.—and on the floor an open copy of Gibbons's *Decline and Fall* speak to the action in other media. The comedies of superiority and incongruity reinforce and undercut the comedy of sympathy.

The notion of "fall," as we have already seen, insistently reappears in the *Almanacks* of the mid-1840s. In this case, the title of plate and poem may also recall to Cruikshank's audience that series of 1822 prints on "The Fall of the Leaf" affixed to the Achilles statue. Juxtaposing Georgian bawdiness about disfiguring concealments, censorship, and freedom to this illustration of a housekeeping mishap reveals the extent to which Cruikshank's art has become domesticated and decorous. Although the pointing bottle of sauterne may in its formal properties suggest a different point, references to a

larger world outside the house, more significant issues than domestic econ-
omy, or deeper sources of motivation than maintaining decorum, are con-
cealed almost to the extent of being suppressed. Letterpress and print alike
curve their energies inward on themselves, containing potentially disrup-
tive forces within the unstable closures of pun and propriety.

An 1847 essay on "A Dinner Party" emphasizes the "dreadful state of
mind" of the hosts, their parsimony in locking up the remnants of fruit and
wine, their fear that greasy heads will soil the satin damask cushions—in
short, it articulates the anxieties of a couple determined to make a show,
competitive toward their neighbors, and fearful of the expenditure and
wear that such parties entail. The next morning the host "is very surly all
breakfast, and very late for business, and Mrs K. speaks out about the
quantity of wine that was drunk." Only the little K.s, who consume the
leftover jellies and other good things all the following week, have reason for
rejoicing.

In an 1849 *Almanack* plate etched the preceding autumn, Cruikshank
depicts "An Interrupted English Dinner Party in Paris," subtitled "Mourir
pour la Patrie." The visitors, dining in a room decorated with a pastoral
scene, are assaulted by cannon balls shot through the window during the
1848 Revolution. The displacement to France allows the artist to render
explicitly what has been implicit in preceding images: the threat from out-
side of destabilizing forces that will overthrow newly acquired middle-class
comforts. In 1850 "The Happiest moment of my life" narrates the groom's
view of his wedding breakfast, when the bride's father so threatens his new
son-in-law if his precious daughter is not treated properly that the entire
company falls to weeping. Finally, in 1853 Cruikshank supplies a mid-
Victorian version of Fagin's philosophy: "'Taking Care of Number One'—
or,—A Gentleman endeavouring to keep 'Number One'—*out* of 'St Paul's
Church Yard'." He does so by ordering things according to his own notions
of self-preservation, instructing his valet to set out every kind of clothing to
protect him from the fine weather, while commanding his cook to prepare
the most elaborate meals. "Let everybody take care of themselves. I shall
'Take care of Number One'."

Dinners have thus gone from being good-hearted communal feasts to
being the privilege of a selfish, solitary gentleman whose sense of well-
being depends on imprudent eating and dressing. The anxieties of the
middle class, in Cruikshank's drama, overwhelm them; they feel assaulted
by revolutionary forces without and potentially fatal forces around and
within. The solution seems to be an ever greater withdrawal into a personal
sanctuary, a move which necessarily shifts Cruikshank's comedy from em-
pathy to criticism. But as Cruikshank hasn't confidence in an audience
with which to share a full-blown satiric attack, as he himself aspires to

those threatened middle-class comforts productive of isolating self-absorption, the solitary diner becomes almost an analogue of the artist, at once scornful and mindful of the necessity of taking care of number one. Always partly of Fagin's party, Cruikshank by 1853 was in his allegiances more quartered than ever.

Three works Cruikshank brought out in 1844–1845 epitomize the conflicting directions of his art. *The Bachelor's Own Book*, issued by Bogue on 1 August 1844, tells in twenty-four plain or colored etchings the progress of Mr. Lambkin in his pursuit of amusement, health, and happiness.[41] The Hogarthian progress lies a long way behind this narrative, which in its story line bears a nearer affinity to Thackeray's tales about foolish, conceited social climbers. Even more pertinent are the caricature albums of Rodolphe Töpffer, a Genevese writer and artist interested in physiognomy and in telling *"histoires en estampes,"* little stories primarily conveyed through informally drawn sequential panels that prefigure the modern comic strip. Töpffer was associated through his publisher Aubert with Charles Philipon, patron of all the important Parisian periodicals wedding caricature to social and political commentary. Töpffer's first publication was the *Histoire de Monsieur Jabot* (1835); two years later he brought out *Monsieur Crepin* and *Monsieur Vieux-Bois*. These were called to Cruikshank's attention by someone, possibly Monnier, or Thackeray, or Merle who was then spending a good deal of time in Paris. In November 1841, when the *Omnibus* was winding down, Tilt and Bogue entered into an arrangement with Cruikshank whereby they got the *Jabot* and *Vieux-Bois* plates copied at 8s. per page and went equal partners with Cruikshank on the British adaptations.[42] *Adventures of Mr. Obadiah Oldbuck*, as *Vieux-Bois* was called, appeared in Britain and later in the United States, with an illustrated title page after a Cruikshank design.[43]

Cruikshank's version of a Thackeray story told by means of Töpfferian plates fails on a number of counts. The prosy explanatory captions do not articulate a medley of ironic tones, while the plates—though competent and even attractive in their domesticated caricature—lack Töpffer's witty and inventive spareness that so engages the observer's imagination. The play of voices, the bravura elisions, the dash and verve of *Lord Bateman* are here replaced by something much flatter, more illusionistic, more didactic. Lambkin is saved from utter ruin by Cupid. (The triumph of Cupid is another motif Cruikshank frequently returned to in the *Almanack*, and one that was to be the opening subject of his next independent project.) *Lambkin* remains a transitional work uncomfortably situated between a variety of past traditions, British and Continental, and the increasingly divergent future courses taken by political and social satires, cartoons, progresses, and illustrations. Cruikshank thought of etching a sequel about

a young lady, much as Edward Caswall's *Sketches of Young Ladies* had spawned Dickens's *Young Gentlemen* and *Young Couples* a decade previously, but the public's reception of *Lambkin* was too tepid to encourage artist or publisher to venture again in that arena.

A more ambitious attempt "to make myself an independent member of that periodical literature of which I have hitherto been generally a constituent," as Cruikshank put it in a mock election speech on the back wrapper of the magazine, was *George Cruikshank's Table-Book* (fig. 37).[44] Its beginnings go back to the aborted *Omnibus*. When Cruikshank discontinued that publication, he announced that it would return as an annual; believing him, prospective contributors forwarded material for months thereafter. But the work for Bentley and Ainsworth proved too taxing for him to follow through on the pledge. Then in 1844, fired by the former and "left in the lurch" by the latter, he approached the *Omnibus* printers, Bradbury and Evans, to see what could be done about putting the vehicle on the road again by reissuing the previous numbers. (For that purpose he had first thought of buying the stock from Tilt.) Bradbury and Evans wanted to go partners, but "as it was such a long time since my 'Omnibus' had been *on the road*, . . . it would, perhaps, be better to start another vehicle of the *same build,* but under another name. To this I agreed; and thus originated 'The Table Book', which was edited by my friends the late Gilbert A'Becket and Mark Lemon."[45]

Cruikshank made several alterations in the earlier format. He relieved himself of editorial tasks and hired much better writers, including Thackeray who provided *A Legend of the Rhine*, and others who regularly contributed to *Punch*. George worked on a slightly larger page, and he relied more on wood-engravings. Consequently he had more time to devote to the etching of the principal monthly steel and got more variety of voice and pictorial effect into each issue.

The wrapper design, beautifully engraved by W. J. Linton, shows a large family of all ages and types gathered round the table—perhaps an allusion to the famous *Punch* table—looking at copies of the *Table-Book*. Behind them, an exuberantly carved mantelpiece incorporates the title amid a riot of comic figures. The initial etching, "The Triumph of Cupid, A Reverie" (frontispiece, vol. 1), in a sense conflates the two plates that started the *Omnibus*: the engraved portrait and the etched graphic "Preface." Cruikshank, seated in his armchair before a blazing coal fire, with his little spaniel Lilla dozing in his lap, puffs meditatively on his pipe: the smoke billows out into the graphic equivalent of a balloon of dialogue, taking the form of hundreds of tiny characters marching in a triumphal procession before and after Cupid's royal chariot. On the facing page, a wood-engraving depicts couples "Running at the Ring," that is, running through a large

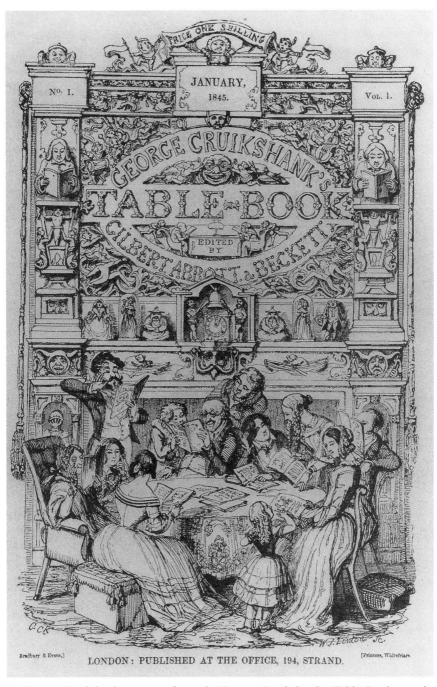

37. George Cruikshank, wrapper design for George Cruikshank's Table-Book, wood-engraving by W. J. Linton, 1845

hoop like a wedding ring. Taken all together, wrapper and opening plates seem to celebrate the triumph of domesticity, founded on love and culminating in communal, empathetic merriment.

But the longer these images are studied, the more subversive they turn. The dozens of cupids within the smoke and around the drawing room knock down and enchain their victims: the coalie loses a boxing match, the prisoners are more securely fettered, the blind pedestrian is forced to kneel, and the Saracen sues for mercy from a cupid whose spear is poised to strike home. In the vanguard, bearing sacrifices to the altar of Hymen, cupids haul sacks of emeralds, pearls, rubies, diamonds, gold, and silver. The celebrant stands on documents representing pin money, estates, title deeds, and marriage settlements. In this allegory of love, the sudden sting of cupid's dart unmans all men, who are then chained to the juggernaut which leads them to a monetary sacrifice, whereas the women, leading the procession, apparently reap some rewards. Love has been redrawn as a financial transaction and a contest for power.

And what is this encyclopedic constellation of lovers? No distinction is made between a sculpted Father Time on a clock, the allegorical cupids, the fancifully animated fire tongs, the theatrical figures of Clown, Harlequin, and Pantaloon, and the hundreds of men and women from every quarter of the globe who populate the plate. Although apparently individuated, they are in fact assimilated to three constants: they are in thrall to love, in thrall to wealth, and in thrall to the artist as products of his reverie. He is the only full-scale realistic figure; even his spaniel resembles one of the imps plaguing the indisposed in *The Headache* and *The Cholic*. If everything is enchained by sexual and economic desire, everything is even more tightly fettered to the etcher whose imagination invents and whose needle scratches them into mimic life. But if in one reading they are dependent on him, in a second he is equally dependent on them—another male, uncompanioned, ringed by the creatures of his fancy, a portrait of the artist as enchanter shackled by the products of his desire which are offered for sale.

Moreover, both wrapper design and etching employ the same structure and texture: a mixture of "real" with "imaginary" figures disposed over a surface that is uniformly busy, linearly agitated. From the standpoint of drawing, there is little differentiation between the actual and the fanciful, between the solidity of the artist and the solidity of dustman or Hymen. The sculpted mantelpiece on the wrapper is almost as lively as the animated family gathered before it. All the figures are products of lines and spaces. The bravura wood-engraving and etching insist on their priority over any mimetic reading that would reduce them to a subordinate role: medium here *is* message. And that message seems to be one about energy, about how lines on a page can read as images of a universal vitality. Just as

Dickens's imagery animates the inanimate and calls attention to its own fictiveness in doing so, Cruikshank's lines insist both on their primacy and on their capacity to evoke representation. Conversely, these images work toward reification: the figures on the wrapper who read aloud, share, and talk about the images in the *Table-Book* are replicated in the carved figures on the mantelpiece, silent, solitary, and incomplete, being mere portrait busts.

There is yet further implication to these plates. In "The Triumph of Cupid" a tiny simulacrum of the artist draws his profile on a canvas: it is the only image represented as two-dimensional in the plate. Another artist, wearing the cap and bells of the jester, sits on the right arm of the chair sketching the smoke figures. This replication of the act of drawing once again calls attention to the powers and priority of art while distinguishing the serious image of the artist from the comic image of his creations and simultaneously conflating them. That complex of ideas is repeated in a different key by the wrapper, where the family looks at images in the *Table-Book* that are no different from themselves at whatever level difference is posited.

Finally, incorporated into the wrapper design are the title, price, issue, and date of the *Table-Book*, signs of the object's status as something manufactured to be purchased so that wealth might be transferred from consumer to producer. At every point the transaction couples "looking" with "paying." To narrate diachronically what the images tell synchronically: a customer buys a copy of the *Table-Book* whose wrapper displays images of fellow customers looking at images of themselves in front of a mantelpiece carved (as the wood block is carved) with images of readers, and the customer then turns to a representation of the artist who created these images and whose Table Book this is, who is imagining himself and his characters jointly in thrall to desire which enchains and transfers wealth, while the artist is himself painted by another artist as a third depicts his pictures in an image he himself as auteur creates. The connection between surveillance and commodification is everywhere present. And that surveillance comprises two vectors: first the voyeuristic narcissism of the customer and artist caught up in a self-reflecting and self-flattering exchange of infinitely regressive mirror images, and second a kind of prying that discloses the private self as a type, on the one hand, and as indistinguishable from all other types on the other, since all types can be "booked" through a code of graphic signs and thereby reduced to the common denominator of fettering and commodified desire. Cruikshank's plates express in all its complexity what a *Table-Book* is—the transformation of desire into an item for sale—and prefigures in early Victorian London symptoms of what Walter Benjamin was to perceive characterizing Second Empire Paris: "Its meta-

morphosis under capitalism into a ghost town populated by phantom figures and phantom desires, an uncanny marketplace in which all objects, all human relations have been transformed into commodities, into reproducible signs of fetishes, each an identical copy of the other."[46]

Tendentious analysis, perhaps, for pictures that are so charming and for an artist so intuitive and unsystematic, but it names from a variety of theoretical perspectives some related tropes that inform many of the most powerful plates in the *Table-Book*. These are surveillance or vision, desire, and economic insecurity. The February, March, and April etchings deal with vision and desire. "Clairvoyance" (February) shows six instances of subjects in mesmeric trances foreseeing the outcome of their present wants. In all cases the visionary will be ruined: the boy playing soldier will become a quadriplegic on half-pay, the heiress will become an economic object for suitors, the drinker will grow gouty, the comfortable widow will end up in the workhouse while her gambler husband goes to the hulks, the cook's larder will be ingested by her admirer, and the gentleman will find his domestics have swallowed the contents of his wine cellar. Mesmerism, the letterpress explains, "goes hand-in-hand with Nature in drawing disease to a conclusion." It is therefore like caricature in tracking present tendencies to future ends; a fellow staring directly at the viewer holds up a screen that stands in place of his body on which these clairvoyances are projected. Thus Nature, vision, and caricature all warn against the unexamined fulfillment of desire.[47]

"A Young Lady's Vision of 'The London Season'" (May) traces her progress from the moment of her coming out to the happy conclusion of her wedding and departure in a carriage indicative of her new position in society. This result is effected at every point by the substitution of art for Nature—the purchase of colorful clothes and artificial flowers, the fixing of a youthful image by a painted portrait, the ride in elegant habit past the Achilles statue (still for Cruikshank an emblem of the natural as opposed to the artificial), through concerts and balls to royal drawing room and opera where "art displays its utmost zeal / The many faults of Nature to conceal." The commodification of desire is spelled out more overtly here than in "The Triumph of Cupid."

In between these two ultimately light-hearted, cautionary plates comes "The Folly of Crime," which in a clairvoyant, premonitory vision tracks the downward progress of any fool tempted into crime by love or greed or pride. His ends are prefigured: the treadmill, the nightmare, the madhouse cell, poverty, flight, transportation. Shackled by guilt and crime, he finally commits murder, at which point sanity departs, he trades the fool's cap for the madman's and is pitched over into the fiery chasm while a demon Blackamoor floats off with his ill-gotten gains, and the flames burn up his paper wealth. As a projection of the anxieties of affluence, the etching is among

Cruikshank's strongest. Moral surveillance yields terrifying vision. And figuratively the shackles connect to "The Triumph of Cupid," making the paired pictures Cruikshank's most complex representation of the Hogarthian paired protagonists, reinscribed as idle but imaginative artist versus active bad child.[48]

Right below the conclusion of the poem "The Folly of Crime," a stanza "On the Present Railway Speculation Mania" connects the folly of the present age to the same demonic ends. The madness of contemporary speculation in railway shares becomes the subject of three other *Table-Book* etchings. "The Demon of 1845," or "Premium, Par, Discount" (May), shows an anthropomorphized locomotive boiler bursting and blowing up all the investors who had hailed its coming at a premium; its bubble pipe goes out and breaks. "Mr. John Bull in a Quandary, or The Anticipated effects of the Railway calls" (November) depicts the average Englishman beset by imps who rob him, remove his wig, tear his clothes, pull off his boots, consume his oysters, load his silver and cash into trains that steam away, and put his town and country homes up for auction. Here Cruikshank recycles the imagery derived from Gillray and Marryat he had once before recycled, only now instead of the assailants figuring symptoms of indisposition (hammering at the skull of a headache victim, cinching the waist of a dyspeptic), they signify the causes, terrors, and effects of railway speculation. They are, in other words, both real and imaginary; they stand for feelings and futures. In the final full-page plate for the year, "The Railway Dragon," a locomotive demon steams into the dining room to eat up the family.[49] It forks the roast beef of England and threatens the plum pudding, while paterfamilias speaks an Anglo-Saxon version of Shylock's complaint: "Oh! my beef! and oh! my babbies!!!"

Surely it is not too fanciful to suggest that throughout the *Table-Book* Cruikshank expresses a multidimensional anxiety about the commercialism of the age, one implicitly acknowledging that moral and even artistic visions are implicated in the same heedless and doomed pursuit of wealth and middle-class domestic comforts. Destabilizing forces such as love, crime, and speculation threaten balance and community; greed, rampant consumption, and commodification endanger the very bases of affectionate, empathetic humor. At the same time, some of the spirited vividness of these images of middle-class suffering may express the artist's rage at the economic forces that bedevil him even more painfully than they do John Bull.

The final article in *George Cruikshank's Table-Book* reports on the experimental lecture of Professor Jollipump on "Happiness"; his concluding tableau, when the curtain rises on the stage behind him for the last time, is a living representation of a marriage ceremony. Only the parties had been married earlier in the day. Jollipump leaves it "to his hearers to determine

whether they had not thus been made happy. This was his last exemplification of beatitude. His lecture would end with a wedding. So far it was like a farce; but, on the whole, he trusted it was much less of a farce than lectures in general." To end a farcical lecture on happiness with a representation of a wedding that is not a wedding, and that may be another farce, depending on the determination of the viewers, says in yet another way that happiness, comedy, marriage, and community have become highly problematic, that a voyeuristic audience has replaced a participatory one, and that the artist now makes his living by showing factitious images to gullible, narcissistic patrons. The article is unsigned and therefore presumably reflects on conscious and subconscious levels the concerns of the *Table-Book*'s originator.

The following year Cruikshank attempted another shilling periodical, *Our Own Times*, published by Bradbury and Evans.[50] He tried out a new, cheaper etching process, glyphography, in hopes that the cost of producing each issue would fall and the profits rise. Only four issues, April through July, appeared. In them George reprised familiar subjects: another Wellington statue (this time Wyatt's equestrian statue[51]), Mrs. Toddles, a wood-engraved self-portrait at his desk, and, to capitalize on the concurrent serial edition of *Oliver Twist*, pictures of the East End and of a Ragged School in Smithfield, an article by Angus B. Reach on Jacob's Island, and a glyphograph of "My Wife's Pet" dog which accompanies a story about a husband who hires Bill Sykes [sic] not to steal it anymore. The uncertain focus— Cruikshank can't decide whether to be serious or funny about the social injustices of the Hungry Forties—verifies his loss of confidence about his artistic purpose and market. Though some of the plates are fine, and all show that he worked conscientiously, the venture succumbed quickly and is now probably the most obscure of Cruikshank's magazines.

No information survives about Cruikshank's commission to illustrate W. H. Maxwell's *History of the Irish Rebellion in 1798*.[52] There is, therefore, no way of knowing what attracted Cruikshank to the subject, nor of ascertaining his own views on the rebels, the loyalists, and the British regulars who savagely put down a savage uprising. Conceivably the publisher, A. H. Baily, approached Cruikshank on the basis of the work he had done for them illustrating Barham's son's book, *Martin's Vagaries*, in 1843. Or they may have been inspired by his historical plates for Ainsworth, or by recalling etchings Cruikshank had made two decades previously for Ireland's *Life of Napoleon*. Baily's advertisement touts the "bold and graphic sketches descriptive of [the] most startling scenes," and those Cruikshank supplied in abundance: twenty-one full-page steels depicting bloody murders and riotous pillage that exercise his talents in narrative, theatrical tableaux, melodrama, and pathos.

Maxwell's account is one of the earliest and most vivid; Cruikshank's etchings likewise have been hailed as the highest point in his invention and the most tragically terrible of all his graphic works. Several authorities have compared them to Goya's *Disasters of War*, and Thomas Wright judged the plates "equal, if not superior, to anything ever produced by Hogarth or by Callot."[53] Cruikshank is unsympathetic to the rebels, giving them broad flat faces, staring eyes, and wide mouths in contrast to the patrician British; yet even in this propaganda for the established order he humanizes the peasants. As Perry Curtis, the leading authority on British images of the Irish, summarizes:

> Given their puffy cheeks and exposed nostrils, some of these rebel faces strongly suggest the presence of a porcine ancestor. But the concave nose and wide gap between the nostrils and the mouth with its grotesque projection, also have something in common with the "Sancho Panza" Celts discovered by ethnologists in Wales and Ireland. However brutish the faces of Irishmen found in British cartoons and illustrations during the 1840s and 1850s, Paddy remained essentially human in outward form until the 1860s, when the era of acute midfacial prognathism began to turn into the age of the simianized Celt.[54]

Moreover, Cruikshank's expressive style stigmatizes the brutish insurgents more than the Irish in general. In "The Loyal little Drummer" (fig. 38)

38. George Cruikshank, "The Loyal little Drummer," History of the Irish Rebellion in 1798, *etching, 1845*

Hunter, a twelve-year-old drummer who stuck his foot through the parchment rather than beat it on orders from his rebel captives, looks quite noble compared to the bogey-faced irregulars who spit him on a pike. Of course the plates contain unfair propaganda, John Fowles remarks,

> and lack the universality of [Goya's] rage against human injustice and cruelty. For all that, they still strike savagely off the page. Look at the brilliantly differentiated faces of the two Irish rebels impaling the loyal Little Drummer . . . : the one is an active sadist, the other is a mindless doer of his job. . . . And then see the child dancing with joy in the background, the blandly watching face of the soldier behind, and the officer seemingly oblivious to what is going on. Ireland 1798—or a certain village in Vietnam . . . ?[55]

Maxwell complained to his publishers about the illustrations.[56] Maybe he didn't appreciate Cruikshank's expressive vocabulary, so at odds with the stiff, formal portrait plates done by stipple-engravers and with his own attempt to narrate with "strict impartiality." Certainly it was not the author's collage of conflicting statements that moved Cruikshank, but rather something much more primitive, savage, outrageous. As in other plates of the mid-1840s, these illustrations shout out against man's inhumanity, an inhumanity manifested not just in the gleeful piking of women and babies, but also in the naive capering of a childish spectator and the heartless indifference of supervisory authority.

Taken together, *Lambkin*, the *Table-Book*, and Maxwell's *Rebellion* register in 1844–1845 a very different art from the bourgeois humor of the *Almanack* or the tragic history of the *Tower*. Cruikshank moved from comedy to pathos, from pathos to protest, and from protest to outrage, while simultaneously seeking to escape from the thrall of publishers by dealing directly with his public. To do so successfully, he would have to find an appropriate subject that engaged middle-class patrons and that could be treated in a medium allowing multiple replications at little cost. And it would have to be a subject about which he felt strongly, one that focused his personal anxieties and permitted his anger. Within two years he would find such a subject in Temperance. Meanwhile, he continued his life-long struggle for artistic independence and financial security, although both goals seemed impossible to achieve.

32

PORTRAITS OF THE ARTIST

About ninety out of every hundred individual subjects, residing in this United Kingdom . . . have some sort of knowledge of George Cruikshank. To most of them, however, he is little more than a mere abstract idea. They have been familiar with his name for many years, —they have often seen odds and ends of his works, —but they can only hope that the two words "George Cruikshank," represent a living man and not a working principle. . . . Well, here is a truthful portraiture of the great artist.

Robert Shelton Mackenzie[1]

WHAT WAS Cruikshank like in the 1840s, before he took the pledge? By pencil and pen he set before his public several revisionist self-fashionings. George's engraved *Omnibus* bust (fig. 31, p. 176) portrays a strong youthful face framed by auburn hair falling from an indeterminate central part to curl around the high cheekbones and flow into the fringe of beard circling the jaw. He defines his chin by two streamers of hair growing down from the corners of his mouth. The brows lie straight below a forehead made more impressive by a receding hairline; the eyes look directly at the viewer with a keen, clear, riveting gaze; the long nose swells below the bridge and again at the tip depending between the nostrils. The lips are beautifully shaped, the upper bowed but thin, the lower more fully curved. One might read in these features decided force of character, intellect, acute perceptiveness, willfulness, good humor, affection, honesty, and virility. One might also discern a modicum of wild fancifulness in the swirling hair, a tendency to eccentricity and self-definition, a moderate vanity in the set of the head and the stylish apparel, and a powerful aura of vitality.

George's profile self-portrait in the *Table-Book* four years later repeats these characteristics. The forehead is perhaps a little more exposed at the temples, but what is strikingly different are the eyes, now looking into the fire and into his own imagination to perceive the writhing figures that

populate his solitude. This full-length picture takes in his long tapering fingers, his slim torso rounding slightly at the pelvis, his shapely calves and narrow feet. His prominent "Roman" nose and wedge-shaped eyes are replicated in the features of the miniature portraitist and in the painted portrait. In this plate a subtext of fecundity seems implied, both by the multitude of figures which teem from the artist's brain, and by his evident physical fitness, sensitive hands, muscled legs, assertive rhinal projection, and long-stemmed meerschaum.

Taken together, these plates tell a great deal about what George wanted to be perceived as being: they stand at the head of his two magazines as the graphic equivalent of a written autobiography. And therein lies an important similarity to a self-revealing text and a significant difference. Whether penciled or penned, an image of oneself declares what one is in terms of what one would like to be seen to be—in Cruikshank's case, a powerful masculine artist with a sympathetic heart, penetrating vision, and prodigal imagination. Unlike a writer's account of inner thoughts and feelings, however, the artist expresses his being through external signs: character is inscribed by the body and by the images bodied forth through the etching needle. When we turn to others' versions of the artist, we see how different Cruikshank appeared to them, how tenuous was his power to control and shape his fortunes, and how oddly external and distanced those portraits seem to be.

To begin with, there is the mystery of his marital life. Only two of his letters to Mary Ann survive. Hundreds of other letters from George were kept by their recipients and transmitted to posterity. But of Mary Ann Walker little trace remains. If she saved George's letters, they are now lost. If he saved hers, they have never surfaced. For all the times she entertained or was entertained by famous writers, publishers, and artists, no substantive mention of her is made in their letters, diaries, autobiographies, obituaries, romans à clef. In Percy's "Memoir" of his uncle, she is never even named. All he says is:

> The position of wife, to a very comic minded husband, is sometimes, from the "incompatability of temper", often seen in genius, anything but a humourous one; and which, from the artist's sometimes inconsistent actions, and violent bursts of feeling, gave the better half, trials, hard to bear. In other moods, suffering and misfortune always produced his extreme tenderness of disposition.[2]

One of her two surviving poems may refer to these domestic trials. "Wedded Love" counsels:

> If e're a cloud of pevish spleen
> Our brighter hours orecast,
> Let fancy quickly shift the scene
> To fond endearments past;

O'er every joy our breasts have felt
Let faithful memory rove,
And teach the hardening heart to melt
At recollections past.[3]

Mary Ann was never the subject of gossip or scandal, nor ever certainly the model for any of her husband's pictures.[4] In no portrait of her husband during the years of his greatest fame is she included or is anything identified with her included. The Dickenses apparently enjoyed her company, her mother-in-law lived with her in domestic tranquility, her out-of-town friends stayed in Amwell Street happily, her husband speaks solicitously of her health and welfare. We catch glimpses of her at the theater, at parties, serving tea, celebrating a christening.[5] Yet she remains a shadowy figure, increasingly confined as her health fails.

At one point early in the 1840s George and Mary Ann stood godparents to Henry Pulford's son George Cruikshank Pulford. Henry was an impoverished man, perhaps an artist or writer, who had to call on his wealthier friend from time to time for loans and gifts and recommendations.[6] George Pulford behaved as a dutiful godson should, sending letters regularly from Croydon to his godparents, inquiring about the spaniel Lilla, which seems to have taken his fancy, sending little drawings and asking his godfather to reciprocate for albums he and his friend are assembling. He thanks George and Mary Ann for a new pair of boots, informs them that his parents are getting the house up so nice for their impending visit, asks George to send him artists' supplies, wants to go to a confirmation with his godfather because he has heard it is a splendid sight, and regularly closes by asking after godmother and the dog.[7] Mary Ann, childless herself, was evidently very fond of her godson; on one occasion when she was quite ill George summoned the boy to her bedside and kept him at Amwell Street for a few days to comfort her.[8]

Allusions to her illness become more frequent, and apparently by 1841 she had summoned her twenty-five-year-old sister Elizabeth to help run the house and care for her.[9] Mary Ann's fundamental complaint was consumption—her breathing eased in fresh air and clenched in fog, damp, and cold. Cruikshank had to leave London suddenly in August 1845 to take the invalid to Margate in the hope that sea breezes would improve her "dangerous state."[10] Two years later he accompanied her to Windsor, telling Robert Shelton Mackenzie that she was "so very ill" that he was "really at a loss, (with that and other anxieties)" to remember where he had put copies of his *Scraps and Sketches*.[11] By the spring of 1848 she had rallied enough that Frederick Dickens wondered whether she would accompany George on the provincial tour of the *Merry Wives of Windsor*, which Dickens was producing.[12] In July she may have been "no worse" but she was staying again in Windsor.[13] At the beginning of September she expressed a wish to visit the

Surrey Zoological Gardens with George "and another little boy" (probably her godson), but by January of the following year Mary Ann was once more confined to bed and unable to witness the christening of yet another godson, this time the offspring of George's old friend Joseph Gibbs.[14]

With his brother's family George's relationship was complicated. He disagreed with his sibling about everything from politics to erasers. Robert espoused republican principles with a touch of revolutionary fervor; George had turned conservative. Robert "pooh! pooh'd!" India rubber; George thought it a "Devilish good thing, if you sometimes used it."[15] In temperament, they were opposite in a contrary way. Robert was grave in manner, entertained jokes with a kind of grim satisfaction, and curtailed argument, especially when he was losing, with "Damn it all, there's quite enough of that." George took a "robust delight" in jokes, and held out as long as he could in any dispute. A bystander could prolong the "screaming farce" between the brothers by tossing in an injudicious word now and then.

Each had a profound disdain for the other's opinions. Robert always mentioned his brother with affectionate admiration.[16] But in private, he would assert in short, solemn phrases, "My brother!—devilish good fellow—irritable—tied to his mother's apron string—when a boy—never went to sea—as I did—knows nothing of the world." Robert was, though polite and respectful, more distant from his mother than George, whereas she evinced a constant partiality for her elder son, perhaps because both in temperament and in constitution he was, in his son's words, "the weaker side."[17] However, it fell to George's lot, rather than Robert's, to provide a home for their mother for thirty years.

George, on his part, though also touched by "scarlet fever," used to pity his brother's military mania, saying confidentially to Percy, "Your father's a perfect savage. Give him a sword, and shield, and he is happy," and inquiring for Robert with a comic look, "How's the Ma-jor?" Percy thought his uncle an equally fanatic devotee of the martial arts, as indeed he was.[18]

Entering George's study one day, Robert observed, "Devilish unpleasant weather." "Weather!" George exclaimed contemptuously, "what's weather? All weather's the same to *me*." Robert indignantly retorted, "Would you say so, if you'd a hole in your boat?" and left. When Louis Philippe escaped to England after the 1848 revolution, Robert celebrated the event and expressed his hope that the new republic would next tackle Russian despotism. George broke out in his old contempt for everything French. Robert then declared himself ready to lead the French Army, to which George roared in defiance: "Then by God, I'd head the Russians, and oppose you!"

Heated disputations were the outward signs of deep fraternal attachment. While a boy, Robert had one day caught his foot in the stirrup and been dragged by a runaway horse, an accident that injured his head se-

verely. He never entirely shook off his bibulous habits, which aggravated that injury, and as the forties progressed his behavior grew more erratic.[19] Weeks would pass in which he lived quietly, soberly, gravely. Then one day on an impulse he would dress in a new frock coat and sally forth "on business." Once, quite drunk, he exchanged coats in a pub with a grenadier who wanted to desert. Arriving at the Strand Theatre so appareled, Robert was arrested and fined for theft of Her Majesty's property. The next morning he lay in bed longer than usual. When his brother arrived bearing the plate Robert was to finish, Percy relates, George

> proceeded to the bedroom. Robert, who heard the approaching storm, imitated the traveller in [the] desert, who hides his head in his robe, before the advancing "sand-flood," by burying his head under the bed clothes. George, although then, not a total abstainer, having, in a serious lecture exhausted the Temperance vocabulary, finally departed, leaving instructions for "beef tea," and finishing the plate; both of which being attended to, things returned to their normal condition.[20]

By the latter half of the forties, "Robert's energy was failing him; he had carried too much sail in his early days, and was on his beam ends."[21]

Robert's son Percy married Harriet Calvert on 8 January 1842; after she had experienced the first visit from her new uncle, who called to congratulate her and stayed to quarrel with his nephew, she concluded that she must have married into a family of lunatics. Nevertheless, they named their first son, born 13 December 1842, after George; Percy quipped in his letter requesting permission to accord that honor, "You are a greater man than you were, being magnified into a great Uncle."[22] As Percy afterwards confessed, this decision became "a future bone for nominal contention": when thirty years later George Percy took up the profession practiced by his father, grandfather, great-uncle, and great-grandfather, George came to regret the similarity in Christian names and to protest in a letter to *The Times* against confusing his great-nephew's productions with his own.[23]

Meanwhile, Percy, a wood-engraver, depended on his uncle for commissions. George was not pleased to have yet another Cruikshank in the field. He once angrily questioned his nephew, "What business do you have in the arts?" Percy's reply, "Because a pencil only costs 2*d*.," alluding as it did to the family's lack of capital, silenced his elder.[24] Reconciled, George then tried to help, or meddle, in Percy's affairs. A year's employment by Bentley to engrave Crowquill's designs for the *Miscellany* led to another dispute when Bentley advertised the artist as "Cruikshank the Younger." Cruikshank the elder blasted his former publisher in the pages of *Ainsworth's*, "never considering, for one moment," Percy ruefully adds, "how he hit his innocent nephew, who had explained his ignorance of [the advertisement], untill published." George then tried to get Percy to quit Bentley and join

with him and Ainsworth, but as Percy heard only promises from the novelist, he declined to change situations unless a stipend was guaranteed. George continued to press for the move. One day, seeing Crowquill's sketch for some comic pumps on Percy's table, he exclaimed "My pumps!" It took the combined efforts of Percy, Cunningham the publisher, and Ainsworth, who together seized the artist by the coat-tails and dragged him back into the room, to prevent George from rushing forth to assault Crowquill for stealing his images. As a justification for his stubbornness, at the end of the year Percy forwarded to his uncle an account of his income from the disputed sources, showing that Bentley had paid him £100, Ainsworth but £2.[25]

Temporarily thwarted, George continued to harass his nephew to the point that Percy offered to quit the field of art altogether if his uncle could arrange for him to obtain a situation in the government. Percy says that George, in a frolicsome mood, proposed calling on John Bowring for assistance; finding him out of town, George decided

> to halt, at an old fashioned public house opposite Westminster Abbey. Not being *then*, a "total abstainer," he "plung-ed in, bade me follow, and so I did." Arriving in the vacant parlor, he called for a pot of porter, pipes, and tobacco; while discussing this monopolising the beer and the conversation he espied some old smoke coloured prints, upon the wall; the love of art being roused, he seized the only light, a tallow candle, and ascending a long table, proceeded striking dramatic attitudes, shading the candle, artistically, with his hand, to criticise the gallery; but finding nothing to interest him, descended, finishing the beer.

On the way home, George's "mood" induced him, whooping and hollering, to chase after some girls who ran away in a great fright. Percy remonstrated with his uncle. "We are very near my home, and as there is a strong family likeness, some *good natured* person might mention *at home*, that *I* had been running after the girls." Abashed at this reproof from the young husband, George took to his heels, calling "Good night!" as he raced to the safety of Amwell Street.[26]

Like others, Percy tended to register the outward eccentricities of his uncle's character and to slight the evidence of tenderness and caring. "His relatives, but three in number, and destined by some inexorable law of fate, to live somehow by 'art,' were a perpetual blister to his thoughts," Percy records; "any success of theirs, working him up to the desperate resolution of doing something, to crush them; which was unjust, and often unfeeling."[27] This reflection may mirror Percy's own attitude to some extent, for George continued to look out for his brother's and nephew's welfares, even though a surplus of otherwise unidentified Cruikshanks in the art market might, as Percy himself concedes, depreciate the value of George's trade name. And Percy was not always responsible. Once, having been given a drawing by his uncle to cut into a block, Percy allowed a fellow engraver to

do the job. The friend however decamped to Paris, taking the engraving with him. When George learned about this from Harriet, her husband having elected to "go out," he threatened to split the friend's head "with a Tomahawk." Luckily the block arrived in the nick of time, though it was poorly executed; and Percy suffered from hearing the story told *"more than once."*[28]

But George could be peremptory, especially when the work of Robert, now sadly deteriorating, and Percy, who though skilled was not so deft a woodcutter as Thompson, Landells, or the Dalziel brothers, fell short of his own high standards. After "considering the matter together" with Robert, George told Matthew Barker in 1845 that Robert would not undertake Barker's commission: "It is a thing quite out of *his way*—at present."[29] After the *Steam Boat*, a monthly imitating Cruikshank's *Omnibus*, hired Robert to furnish two plates per issue and Percy to engrave the wrapper, George despotically stopped their participation. Percy was then living with his father, and when George saw the wood block he inquired, "with mischief in his eye," whether any deposit had been paid on it. Told "one sovereign," he laid that coin on the work table and walked off with the offending block, thereby blowing up the *Steam Boat* as far as Robert and Percy were concerned. To compensate, George gave Percy work on the *Omnibus*, but objected to having "PC" as the engraver's signature cut on the right side of the vignettes because it conflicted with the "GC" on the left. "So the dependent was obliged to submit, and cut it out," Percy complains; "the uncle was great, and the nephew small. This was injurious, as being known to engrave his uncle's work, would have been a recommendation with publishers."[30]

Such interference in his brother's family's affairs, such niggling over initials, may seem unforgivably authoritarian and petty, but there was shrewd sense behind George's high-handed manner. His name was a kind of guarantee and served to earn him many pounds even after his art was superseded by a later taste. When Percy showed his uncle some favorable notices he had received for a comic *Hints to Emigrants* at the time of the California gold rush, George said very composedly, "Oh! yes, the compliment is *to the name*."[31] While Percy found under such "art supervision" that "the name" became "a positive nuisance," he acted in a similar way when his son George Percy proposed, in deference to his great-uncle's wishes, to sign himself "Percy Cruikshank": that proposal met with a decided negative from the outraged father.[32]

George parted freely with advice on personal as well as political and artistic matters. Thinking himself, despite his choleric temperament, a very Chesterfield of manners, he would set himself up as an example to his nephew, insinuating that the young man ought to practice a more urbane

address. "Where can I find a model to emulate?" Percy asked. "Pushing up his spectacles, and staring with astonishment, at the other's mental blindness, he exclaimed, 'Hav'nt you got *me?*' "[33] When balked of his purpose or in a black mood, George would assault his opponent with strong language, until the only recourses were flight or confutation. Once Percy stopped his uncle's rodomontade by accusing him of acting in a "mean and almost cowardly way":

> The slightest allusion to "mean or cowardly" as applied to him, was so surprising, that he pulled up suddenly, demanding an explanation. [Percy] explained, that "as senior [you have] a privilege in the use of words or monopolising all the swearing; while the junior was debarred, by civilised custom, from . . . returning the fire." His battery was silenced—for a time.[34]

Smarting under these professional and personal injuries, Percy nursed strongly ambivalent, and not altogether charitable, sentiments toward his eccentric uncle. Whereas George always remembered his father's encouraging his childish efforts at drawing, Percy remembered his uncle's criticisms. "Young sketchers, among them, Leech, called upon [George] as the father of the 'school' to show their efforts, the faults being critically noticed, while the little beauties were undisturbed."[35] After one such review, the disgusted nephew vowed never to show his uncle anything again. (But Percy could give out as well as George: after viewing the first version of the oil painting *The Disturbed Congregation*, Percy recommended George's calling for a carpenter and having the panel planed down to bare wood. The second Mrs. Cruikshank protested this slight to her husband's genius. George, however, laughed: "Percy's right—to think, that I could ever have done such a beadle, as that!"[36])

Other artists remembered very different treatment. Scores of aspirants made their way to Amwell Street to submit their dreams for inspection, and scores departed in a buoyant spirit after receiving Cruikshank's judicious blend of criticism and praise. A typical experience is recorded in a letter to Cruikshank by Thomas Gunn, residing in the New Kent Road: he had been introduced to the artist by Ainsworth, had showed him some drawings and received encouragement, and now encloses more work along with a request for Cruikshank's advice about possible employment.[37] At the age of fifteen, George Augustus Sala was, in his own words, "a raw, headstrong, moody, and ill-conditioned lad, whose main qualifications for active life were an imperfect acquaintance with three or four languages and a capacity of drawing grotesque figures with pen and ink." Furnished with introductions from Grattan Cooke, oboist son of the famous actor T. P. Cooke, in the spring of 1843, Sala took his drawings first to Edwin Landseer, who was away in Scotland, and then to the celebrated drawing master

William Riviere, who muttered a few meaningless compliments and sent him on his way. At last, somewhat dejected, Sala called on Cruikshank:

> He must then have been about fifty years of age, and, his short stature excepted, was a strikingly handsome man. I can see him now, in a shawl-pattern dressing gown, and with the little spaniel which he has introduced in the meerschaum-smoking reverie in the "Table Book" basking on the hearth-rug. He received me with great kindness, and kept me with him more than two hours minutely examining my drawings, pointing out their defects, showing (with a little curved gold pencil) how the faults might be remedied, but giving me words of bright comfort and hope. I went away trembling all over with surprise, and gratitude, and joy; but I was yet lingering on the doorstep, when he opened the door and called me back into the passage. These were his "more last words." "It's a very precarious profession," quoth he, "and if you mean to do anything you'll have to work much harder than ever the coalheavers do, down Durham Yard."[38]

Perhaps George's fault-finding with his nephew was the product of a bitterly bought lesson about the difficulty of earning a living as an artist and a way of spurring the members of his family to greater achievement. Jealous of others' success he could be, especially when that fame seemed undeserved or depended on what he believed to be unacknowledged borrowings from his vast production. And egoistic he could be, though it was for the most part the confident egoism of someone secure in his opinions, vigorous in their promulgation, and downright in his judgment. But George was seldom spiteful and never meanly disloyal to his relations, however much their manners, habits, and art annoyed him.

Cruikshank expended considerable time, energy, and money on behalf of others. He served frequently as a steward: for the annual dinner of the Artists' Benevolent Fund many times, for the Scottish Hospital in 1843, and for the Anniversary Ball of the Jews and General Literary and Scientific Institution in 1849.[39] The most histrionic of English artists, he trod the boards to raise money for favorite charities. His *Bombastes Furioso* closed the bill of a program got up by Francis Holl the engraver, F. W. Topham, R. J. Hamerton, Tenniel, and others on behalf of the Artists' Fund at the St. James Theatre on 27 January 1846.[40] They raised nearly £80 for the endowment.[41] The same company, under the patronage of the queen and Prince Albert, put on other plays at the St. James on 27 April 1848: Cruikshank and J. F. Redgrave presented a farce, "Plot and Counterplot, or a Portrait of Cervantes." This benefit was not so lucrative.[42] A third fund raiser under the same patronage took place on 18 May 1850, at the St. James; on this occasion George delivered his inimitable rendition of Lord Bateman.[43]

The bulk of Cruikshank's charitable work involved individuals to whom he gave financial, practical, vocational, and emotional support. He lent an old coat to supplement an impecunious actor's shabby wardrobe, assisted in

the subscription and benefit for the relief of the children of the actor Edward William Elton, raised money for the family of Captain Glascock, may have subscribed to a volume of Seymour's prints issued to help the artist's needy widow and daughter, and participated in Dickens's amateur theatricals supporting Leigh Hunt and the family of John Poole.[44]

Even while he himself was being dunned by creditors, Cruikshank would reach into his pocket for a sovereign to alleviate the distress of some friend or begging letter writer.[45] If money was not the appropriate remedy, Cruikshank wrote letters of recommendation to charitable foundations and businesses, sought positions in government for the needy (as he tried to do for Percy, who knew his uncle's habit), and contributed sketches to sell in bazaars, fetes, and auctions.

One of his most extensive benefactions assisted John Wight, his old *Bow Street* friend who started in 1843 (but never finished) a collaboration with Cruikshank on a pamphlet denouncing O'Connell, "Humbug for the Millions."[46] At the age of sixty, Wight was discharged from his position as subeditor of the *Morning Herald* when, in 1845, the paper was sold to Edward Baldwin. Wight had no savings and could not pay off the trifling debts (£30 or so) he had accumulated. On 19 May 1845, supported by Cruikshank and Pettigrew, he applied to the Literary Fund and was awarded £30, enough for living expenses but not for the debts. At the same time, his daughter, engaged for fourteen years, was preparing for her wedding to a young man who throughout that time had been struggling to be called to the Bar. Successful at last, just days before his marriage he was seized by congestion of the brain and died. The daughter, who arrived at his chambers in time to see him die, threw herself out a fourth-story window; although she landed in a water tank and thus sustained no internal injury, her mind gave way.

Cruikshank related this story to Dickens in the summer of 1845; he also passed on memoranda Wight had prepared. Dickens felt he could do little himself but promised to seize any future opportunity. They may have discussed Wight's case when they met in Margate around the eighteenth of August.[47] Dickens found an opportunity to be helpful the following month, when he relayed Wight's story to Miss Burdett Coutts, the banking heiress; she sent £40, which Dickens dispatched to Cruikshank "for investment."[48] Wight repaired to Wales, where his son was a poor curate, telling Cruikshank at the end of October that he was being fattened on Welsh mutton and buttermilk.[49] By December he was back in London and his daughter had recovered sufficiently to express the hope that Cruikshank could persuade Dickens to employ her father on the *Daily News*.[50]

That application Dickens apparently declined to honor, but he furnished Cruikshank with various sums to be expended on behalf of "Miss White,"

as Dickens invariably spelled the surname.[51] Wight was still pestering Cruikshank about Dickens in June of 1846 and continued to make annual applications for relief from the Literary Fund.[52] In 1848 he told Cruikshank he hoped that a portion of the fund Dickens had raised through amateur dramatics would be assigned to the artist, with a small slice to himself.[53] Four years later his son, writing from Harbury Vicarage in Warwickshire, solicited one of Cruikshank's works for the church bazaar.[54] Over a period of eight years, Cruikshank helped Wight and his children by every means at his command. In the absence of modern "safety nets"—medical and unemployment benefits, retirement funds, housing subsidies—practical charity was the only resource of the respectable poor. That such a sober, steady writer as Wight, whose books in their day had been celebrated, could become so dependent on handouts was yet another incentive for Cruikshank to keep working and to keep his production, and the production of any family members using the name, as sterling as possible. Art was his only bank account.

Not even death foreclosed his friends' levies on Cruikshank's time and purse. Four more associates died in 1845. During the preceding year Laman Blanchard's wife had suffered a paralysis from which she succumbed just before Christmas. Despondent, Blanchard killed himself in a fit of delirium two months later on 15 February. He left three children unprovided for.[55] Within a few weeks, young Alexander Blackwood was gone. Expressing deep sympathy to his brothers Robert and John, Cruikshank regretted the "loss of so amiable and excellent a man, whom to know, was to esteem."[56]

The next to fall was Thomas Hood. His weak consumptive constitution undermined by debts, and his spirited gaiety worn out by almost continual attacks of exhausting illness, he broke down utterly just before Christmas 1844. Sir Robert Peel eased his last days by granting a pension of £100 with reversion to his widow, but at his death on 3 May, there were insufficient resources to maintain her. Barham filled out an application to the Literary Fund, "anxious that poor Mrs H. should be assisted to the very utmost extent."[57] Within weeks Ingoldsby too was dead. Debilitated after the passing of his youngest son, Barham had grown increasingly withdrawn and depressed; a cold caught during the opening of the Royal Exchange in 1844 lingered and proved fatal. In the words of Richard Garnett, "He passed through life with perfect credit as a clergyman and universal respect as a member of society."[58]

Dickens was particularly adept at turning the raising of money for families of impecunious artists into an occasion for energetic activity. For Leigh Hunt and John Poole he arranged amateur dramatic performances that involved Cruikshank once again in the Dickens circle. Without a common project their meetings had been less frequent, especially since Dickens left

the country often during the 1840s, going to America in 1842, to Italy in 1844–1845, and to Switzerland and Paris in 1846–1847. The one collaborative publication, *Oliver Twist* reissued in ten monthly parts (1846), afforded Dickens a chance to revise the text and Cruikshank a chance to rebite and add to his original illustrations. Dickens told his publishers on 29 September 1845 that he had "seen George Cruikshank in reference to the *Oliver Twist* cover, which he is more than ready to do. It is clear it would never have done to have handed it on to anybody else. It may be a wholesome reminder to send him a Block in the course of the next few days."[59] Bradbury and Evans paid the artist £24 for "retouching the [original] plates," although George William Reid, F. G. Kitton, and their successors claim that the work was not done by Cruikshank and that he was displeased by the alterations.[60] He indisputably designed the wrapper with eleven scenes from the novel corresponding to a list in Dickens's hand; these were cut into the block by Thomas Williams.[61] Dickens seemed satisfied; he presented Cruikshank with an early copy of his Christmas Book, *The Cricket on the Hearth.*[62]

Dickens periodically invited Cruikshank to join in excursions and parties: in August 1842, to join Maclise and Forster for a walk from Broadstairs to the Norman and early English church at Minster; in October to drink cold punch with Longfellow; in June 1843 to meet Thomas Appleton; on 10 December in the same year to dine along with Ainsworth, Thackeray, Maclise, and Forster; with a large company to gather at the Trafalgar Tavern on 19 June 1844 for a farewell dinner on the eve of Dickens's departure for Italy; and on 1 October 1845 to meet an Englishman from Naples, Charles Ridgway, Stanfield, and Maclise, as well as Count D'Orsay, "who wishes very much to know you better."[63] Cruikshank was also a guest at the 1846 party celebrating Twelfth Night and Charley's ninth birthday.[64] At some point during this convivial period George drew another of his anthropomorphized citrus fruits, "Portrait of Mark Lemon," and signed it along with Lemon, Leech, Frank Stone, Dickens, his brother Augustus, and G. H. Lewes.[65]

Such entertainments testify to the hearty if sometimes patronizing affection Dickens felt for Cruikshank. Nevertheless, the author, who by now was *the* unrivaled king of periodical literature, was troubled by George's faculty of discerning resemblances between fictional characters and real-life acquaintances. Frith records a typical exchange. Cruikshank would say to Dickens at a party,

"Look here: Mrs. So-and-so has been to me about"—Mrs. Nickleby, perhaps—"and she says you are taking her off. I wish you would just alter it a little; the poor old girl is quite distressed, you know," etc. etc. This Dickens told me, and added: "Just imagine what my life would be if George was making the drawings

for 'Dombey' instead of Brown, who does what I wish and never sees resemblances that don't exist!"[66]

An amusing anecdote, reinforcing the notion of George as a "troublesome" collaborator; but of course Dickens *did* take off people he had met, and once or twice got into trouble about it.

Reciprocal invitations from Cruikshank are scarcer, presumably because they were not saved. In one undated response Pettigrew agrees to meet Cruikshank and his friends Dickens and Merle.[67] Cruikshank sent Boz copies of his *Almanack*, one of which (for 1844) Dickens pronounced "prodigious"; as soon as he has done "a Bolt" to complete *A Christmas Carol*, Dickens concludes, "I hope we shall take a glass of Grog together: for I have not seen you since I was grey."[68] In 1844 they also collaborated, along with Charles Mackay, Ainsworth, Jerdan, and Charles Lever, on the London Committee to raise money for the completion of the monument to Sir Walter Scott in Edinburgh.[69]

Their most extensive association, however, was brought about by Dickens's charitable efforts. In the summer of 1845 Dickens was restless and seeking an outlet for his phenomenal energy and love of management. He elected to produce, direct, and star in a production of Ben Jonson's *Every Man in His Humour*, using his friends as actors—Forster was Kitely to Dickens's Bobadil, while Lemon (as Brainworm), Dickens's brothers Frederick and Augustus, Thomas J. Thompson, Frank Stone, Henry Mayhew, Percival Leigh, Gilbert à Beckett, and John Leech took smaller roles. The *Punch* crowd were mainstays of the production. Clarkson Stanfield superintended the scenery and essayed the part of Downright, but he was too frightened to get through the role even in rehearsal; so was Maclise, who resigned before the first run-through.

When Dickens received "Stanny's renunciation" on 22 August, there was less than a month remaining before the performance at Miss Kelly's private theater in Dean Street, Soho. Dickens "gave [his] brains a shake, and thought of George Cruikshank," to whom he immediately "put the case in the artfullest manner."[70] Explaining to George that since the play had been got up "one day at a country-dinner—quite offhand," no one had been added to the cast except two supernumeraries. "We have often wanted, among ourselves, to get you in, but have never had a reasonably good part to offer you." Dickens then went on to set forth the rehearsal arrangements, and how every measure of the play's success had been taken, down to guaranteeing that no person objectionable to any member of the cast would be admitted to the audience, and no names of performers would be printed in the playbill.[71]

Cruikshank was otherwise engaged, however. Dickens then offered the

role to George Cattermole in a short note that reveals how much less wary he was of the latter artist than the former. Cattermole too was unavailable, so Dudley Costello eventually played the part.

There was such a public furor about the first performance, to which Catherine Dickens personally invited Mary Ann, that Dickens decided on a second at the larger St. James Theatre on 15 November to raise a building fund for Dr. Southwood Smith's nursing home.[72] Prince Albert headed a glittering audience who expressed mixed sentiments about the show, some reviewers praising its intelligence, while Lord Melbourne found it "damnably dull."[73] Dickens then determined on a third performance on 3 January 1846 to benefit Miss Kelly at her theater; this time the main play was to be *The Elder Brother* by Fletcher and Massinger, with Richard Brinsley Peake's *Comfortable Lodgings* as the farce. Cruikshank was recruited to play Roué in the latter. While Fletcher's comedy was not so well received as Jonson's had been, the farce reaped enthusiastic notices, especially for Dickens as Sir Hippington Miff ("most ludicrously dismal") and Cruikshank ("excessively amusing, introducing a world of wild energy, and being manifestly in doubt whether he should make Roué a Frenchman or not").[74]

The following year Dickens resurrected his Amateur Company to play *Every Man in His Humour, Merry Wives of Windsor*, and several other farces in London, Manchester (26 July 1847), and Liverpool (28 July). Proceeds were intended to assist Leigh Hunt and the dramatist John Poole, who, despite the popularity of his character Paul Pry, was destitute. When Hunt received a Civil List pension in the midst of Dickens's preparations, London and *Merry Wives* were canceled, but the Midlands itinerary and Jonson stayed.

Dickens invited Cruikshank to play Formal in *Every Man in*—"only one scene,—a drawling puritanical blade, in an enormous ruff," but "a good bit"—and informed him that "Ainsworth is not with us—which will please you."[75] Cruikshank, who fancied himself a talented actor, was "a little discontented," Dickens told Mark Lemon, because he had such small parts. Since "his name" was "very important" to the undertaking, Dickens proposed a new farce, Poole's *Turning the Tables*, wherein George could play Old Knibbs: "I think you would make it funny. There is not much in it, but there are very few words (which, in the short time, is a great point, as I believe you are busy, and not a 'quick study')."[76] Cruikshank accepted. Touting his troupe to the publisher of the *Manchester Examiner*, Dickens identified Cruikshank and Leech as "the best caricaturists of any time perhaps," a recommendation of indeterminate application to acting but important publicity for attracting a full house.[77]

Cruikshank was not completely cooperative. Indeed Dickens grew exasperated by the antics of many in his cast. Blowing off steam to Forster in a

succession of hasty notes, which Forster reprinted in his biography with the names suppressed, Dickens said, presumably of Cruikshank. "Fancy H, ten days after the casting of that farce, wanting F.'s part therein! Having himself an excellent old man in it already, and a quite admirable part in the other farce."[78]

Notwithstanding the countless irritations and crises, the plays were rehearsed, the theaters, hotels, and transport booked, and the day of departure from London appointed. "'The Amateur Actors' leave 'The Euston Square Station'—at 10—tomorrow for Manchester," Cruikshank told John Watkins on Saturday 24 July, "so if you wish particularly to see the Lion [Dickens]—he will be there at *half past* 9—with a long *tail*—a part of which will be yours very truly."[79] Mary Ann accompanied her husband; they shared a first-class railway carriage with Thomas and Christiana Thompson (who found George a "most agreeable nice person") and Frederick Dickens.[80] The Manchester performance was followed by a tremendous supper at which forty-six bottles of champagne were consumed. The reception in both cities was rapturously enthusiastic, the audiences according Dickens a standing ovation and applauding lengthily at the appearance of Jerrold, Leech, Lemon, and Cruikshank, who at Liverpool played in all three pieces.

When it was over, Dickens settled the accounts. He was disappointed to find that expenses cut deeply into receipts, leaving four hundred guineas instead of the five hundred he anticipated. To complete the sum, he proposed writing an account of the tour as a new "Piljians Projiss" by Mrs. Gamp, addressed to her friend Mrs. Harris, and obtaining designs for wood-engraved illustrations from all the artists who participated. Mrs. Gamp, hearing that some of the ladies traveling with the company are in advanced pregnancies and believing that the shock of steam engines brings on labor, decides to forgo her holiday in Margate to follow along in a second-class carriage "in case." As Mrs. Leech had in fact given birth in the Victoria Hotel at Euston Station immediately upon returning to London, Dickens's fiction was a little indelicate, something that Leech or his friends finally persuaded the author to recognize. Although Forster claims that the project failed because the artists deserted, in fact Leech made a sheet of drawings and Cruikshank produced one trial sketch, while Dickens wrote at least half the text.[81]

Mrs. Gamp's encounter with the whiskery artist in Euston Station furnishes a sparkling word picture of Cruikshank, quite unlike his own self-portraits. It is characteristically external as so many portraits of him were, and it emphasizes his eccentricities, but it also depicts his kindly cheerfulness and Mrs. Gamp's flustered responses to his chivalry and picture making.

I was drove about like a brute animal and almost worritted into fits, when a gentleman with a large shirt-collar and a hook nose, and a eye like one of Mr. Sweedlepipes's hawks, and long locks of hair, and wiskers that I wouldn't have no lady as I was engaged to, meet suddenly, a turning round a corner, for any sum of money you could offer me, says, laughing, "Halloa, Mrs. Gamp, what are *you* up to!" I didn't know him from Adam (except by his clothes); but I says faintly, "If you're a Christian man, show me where to get a second-cladge ticket for Manjester, and have me put in a carriage, or I shall drop!" Which he kindly did, in a cheerful kind of a way, skipping about in the strangest manner as ever I see, making all kinds of actions, and looking and vinking at me from under the brim of his hat (which was a good deal turned up), to that extent, that I should have thought he meant somethink but for being so flurried as not to have no thoughts at all until I was put in a carriage. . . .

"P'raps," [Mrs. Gamp's traveling companion] says, "if you're not of the party, you don't know who it was that assisted you into this carriage!"

"No, sir," I says, "I don't, indeed."

"Why, Ma'am," he says, a wisperin, "that was George, Ma'am."

"What George, Sir? I don't know no George," says I.

"The great George, Ma'am," says he. "The Crookshanks."

If you'll believe me, Mrs. Harris, I turns my head, and see the wery man a making picters of me on his thumb nail, at the winder![82]

The portrait was complimentary enough on the surface, but it perpetuated the notion of the thumbnail sketcher from life that Maginn and Maclise had promulgated in 1834 to George's disgust. In spite of Cruikshank's disavowal, the image persisted. It was as if Dickens, like several other of Cruikshank's friends, wanted to preserve him in amber, an eccentric from the past skipping down London's streets, getting uproariously drunk with coalheavers, and taking off the world around him with an instinctive facility that yielded momentary amusement. Dickens was no more prepared than many others to accept George's new self-image, to appreciate the Temperance propagandist and teetotaler. Even while the amateur theatrics continued with high spirits all around, the grounds for divorce that were to separate Cruikshank from Dickens permanently were accumulating.

33

MASTERPIECES WORTHY OF THE GREATEST PAINTER

Many teetotal leaders had what Bagehot called "the first great essential of an agitator—the faculty of easy anger."

Brian Harrison[1]

[The print] is to art as the essay is to literature—compact, pointed, intensive.

Ben Shahn[2]

THE TEMPERANCE campaign was the fifth major reform movement in nineteenth-century Britain. It adopted, elaborated, and exaggerated the strategies and techniques employed by those agitating against slavery in the first decades of the century, for Catholic emancipation in the twenties, on behalf of Parliamentary reform in the thirties, and for repeal of the Corn Laws in the Hungry Forties.[3] Beginning with Father Mathew, whose teetotal campaigns enrolled millions of his countrymen until the Irish famine obstructed his efforts, successive waves of reformers proselytized Britons to moderate their drinking or give it up altogether, and to regulate wholesale and retail trade in alcoholic beverages. As a large-scale program of social engineering, dietary reform, and Parliamentary lobbying, Temperance had the most ambitious of aims. Achievements ultimately fell short of expectations in nearly every respect, but during the heyday of the movement, the 1850s to the early 1870s, a significant number of British men, women, and children found their lives, habits, amusements, meals, and values affected by Temperance.

Its history is complicated, but in general there were two approaches to reform. The National Temperance League (1856), like its predecessor organizations, endorsed gradualist and volunteerist measures and relied on moral suasion for bringing in converts. It championed a counterattractive program, that is, the development and distribution of alternatives to alco-

hol, including unpolluted water and unadulterated tea and coffee. The United Kingdom Alliance (1853) adopted a more coercive approach, aiming at total prohibition achieved at the personal level by a long pledge against consuming or serving any intoxicant and at the national level by instituting legal prohibition. The Alliance comprised many former moral suasionists and even some non-teetotalers who were convinced that change effected through institutional and legislative action had to precede and prop up any successful personal Temperance reformation.

The consumption of alcohol in drinking places, socially graded from inns and taverns ("public houses") down to alehouses, ginshops, and beerhouses, was richly implicated in late Georgian culture. When Cruikshank was growing up, these drinking places provided a principal site for business and recreation. They offered the heat, light, lavatories, and attractive surroundings so often missing from working-class lodgings. The prevalence of bad weather, to which foreign commentators from Montesquieu to Taine attributed British drinking practices, kept men indoors during many of their leisure hours, so drinksellers offered and patrons participated in recreations ranging from darts to gambling, singing, and sex. Moreover, in the coaching era the great urban inns and provincial coachhouses stood at the center of Georgian public life. They were places for exchanging news; refreshing travelers; holding political meetings, auctions, and coroners' inquests; trading; lodging and sponsoring entertainers; meeting politicians; bribing voters; billeting soldiers; and paying workers. Drinksellers operated an extensive informal banking system: they advanced loans to be settled on payday and allowed the government to collect taxes on the premises. Hence in the early years of Temperance reform pledgers exiled themselves from the site of almost all the activities not conducted at work or in the often mean, cheerless, overcrowded homes.

The first wave of Temperance reform concentrated on the privileges built into the licensing system. Those supporting free trade and the 1830 legislation that reduced excise taxes and licensed virtually unlimited numbers of beershops argued that government interference in the drink market led to high prices, adulterated beverages, smuggling, and drunkenness. However, some maintained that the Tories cynically introduced the Beer Act because of trouble over their opposition to the Reform Movement; William Cobbett called the Beer Act "a sop to pot-house politicians."[4] Possibly debauchery increased for a time afterwards, but there were some mildly favorable consequences as well. Since beer was (mistakenly) thought of as a Temperance drink, less intoxicating than spirits, and since most natural water supplies were contaminated and often dangerous, the cheapening of beer and the expansion of the trade may have improved the finances and health of the lower classes.

But soon a new phase of Temperance reform was prepared by a combination of forces. Doctors, including Pettigrew's friend W. G. Lettsom, became aware of the serious medical effects of hard drinking. Coffee and tea traders saw a chance to promote their alternative beverages. Industrialists wanted a sober working force that spent its money on retail goods rather than liquor. And Evangelicals turned Temperance reform into a secularized conversion experience that could lead to an earthly paradise of teetotal prosperity and health. Joseph Livesey, a self-made cheesemonger from Preston, delivered the "manifesto of teetotalism" in his "Lecture on Malt Liquor" (1832), which purported to show from scientific evidence how expensive and unnourishing malt was when converted into beer rather than bread.[5] With such arguments, and with the support of individual abstainers, American philanthropists, and Quakers, who provided money and organizational support, early Temperance advocates proselytized for sobriety. Their efforts were impeded however by their evident class bias; by their tolerance of beer, which could be more intoxicating than refined spirits, and which, in rural England and Wales, was often the principal cause of inebriation; and by their preference for promoting sobriety over reclaiming the intemperate.

Moderationists maintained that a chronic drunkard failed to exercise his will and merited denunciation; such arguments appealed to the respectable classes which viewed their own prosperity as the reward of prudence and virtue. Teetotalers countered that intoxicants destroyed will power and that the alcoholic deserved sympathy. In taking on the reformation of the drunkard, teetotalers transformed the Temperance movement. It became necessary to detach the drinker from his former friends and haunts, to provide alternative locations for fellowship, entertainment, marketing, and banking, to maintain regular meeting times and places for confession and pledging and for sober mentors (much like the present practices of twelve-step programs), and to reinforce the advantages of teetotalism by sponsoring lectures—almost music hall "turns"—delivered by outstanding speakers and exemplary converts.

Teetotalers were often provincial, self-made men, energetic, self-confident, optimistic, and eccentric. The leaders were mainly nonconformist, more often affiliated with the Liberals than the Conservatives, and based in the Midlands more than in London. Few were upper class or Anglican; the established church was associated with the hypocritical Sabbatarianism Cruikshank and Dickens had denounced. Teetotalism and prohibition gained more adherents north of the Thames because the prosperity of London and the home counties depended in part on the immense and ramified drink trade. A typical example of a mid-Victorian Temperance reformer is Thomas Cook, a Leicester teetotaler who conceived the Temperance rail-

way excursion as a way of removing converts from a dangerously tempting environment during weekends, and who built up an extensive travel and banking business founded on middle- and working-class customers.

Cruikshank had been raised in the midst of topers. His father's friends were three-bottle men who circulated the port round the clock, and to the end of her days his mother quaffed her porter with dinner and her toddy before bed. Much of the "life" he witnessed and depicted when a young man revolved around places financed by the bottle: the coalholes and dock-side cellars where he mingled with dustmen and sailors and learned their patois and their songs; the taverns along the Strand and in Fleet Street at which the various "clubs" gathered for conviviality and the exchange of stories; places of entertainment such as Almack's in the West End and Vauxhall where gin and rack punch accompanied dances, musical inter-ludes, and intrigues; sporting arenas from the back rooms of pubs in which cock fights and rattings were staged to the Fives Court and other venues for "milling"; the theaters around Leicester Square and the Haymarket, Co-vent Garden and Sadler's Wells, to which many in the audience came drunk and left drunker; the on- and off-license houses that prospered when saints' days and public celebrations encouraged saturnalia; the venerable establishments in Southwark and the City where gentlemen repaired for oysters and stout, Stilton and port, roast beef and claret; and the famous "country" houses such as the Spaniards on Hampstead Heath where holiday makers refreshed themselves with pints of beer or tumblers of hock-and-soda.

It is impossible to chronicle the culture of Georgian London without reference to these spots. At first Cruikshank was not critical of them per se, not even especially critical (though often satirical) of the drunkenness and profligacy that flourished in them. In particular cases he knew the havoc intoxicants could wreak: his father's death, his brother's debility, Gillray's madness, Tom Greenwood's intemperance, Maginn's deterioration. He de-picted, amusingly but not intolerantly, the painful swollen foot of a gouty toper, the rosy carbuncular nose of a lush, and the stupor of a beer-sodden Irishwoman oblivious to the theft of her chicken and her tarts.[6]

In the twenties and thirties, some of Cruikshank's plates censure gin palaces and drunkenness, but they do not adopt a teetotal line. Etching the illustrations to O'Neill's *The Drunkard* in December 1841 prompted the artist to contemplate his own reformation, although he repeatedly denied that the poem inspired *The Bottle*.[7] As he told a Temperance meeting in after years:

> I am ashamed to say that for many years I went on following the ordinary custom of drinking, till I fell into pecuniary difficulties. I had some money at a banker's

[the Goswell Road branch of the Finsbury Bank]; he [presumably David Hannay] fell into difficulties, took to drinking brandy-and-water, and ended by blowing out his brains. I lost my money, and in my distress applied to friends [Merle, Ainsworth] who aided me for a time, but they themselves fell into difficulties, and I was forced to extricate myself by the most extraordinary exertions. In this strait I thought, The best thing I can do is to take to water; but still I went on for some time before I quite weaned myself from my own drinking habits.[8]

Cruikshank's rhetoric is shot through with the conviction that abstinence is achieved through the exercise of will power, and that will power in turn is activated by confronting the most extreme consequences of continuing to indulge. Moreover, he remains convinced of the direct connection between intemperance and indigence, teetotalism and prosperity. This is his fundamental paradigm of *Industry and Idleness*. Having been an immoderate drinker himself and an intimate witness to the consequences of prolonged intoxication, Cruikshank was predisposed to arguments decrying the slightest indulgence. Dickens, by contrast, as early as 1842 declared himself "a great friend to Temperance, and a great foe to Abstinence." With regard to alcohol, as with every other commodity, he wanted to distinguish between *use* and *abuse*. Furthermore, Dickens believed that drunkenness originated in other causes (poverty, ignorance, misery) and is "not the foundation stone, as your mole-eyed enquirers into Human Nature would have us believe."[9] Dickens was a moral suasionist and moderationist, a position much easier for a middle-class gentleman to sustain than for those who worked directly for and with the poor.

Biases of class and style gradually divided Temperance reformers from Prohibitionists and Dickens from Cruikshank. Drunkenness, Dickens declared in an unsigned 1849 article, "is the vice of the poor and wretched, and the guilty," but "it is not the vice of the upper classes, or of the middle classes . . . [or] of the great body of respectable mechanics, or of servants, or of small tradesmen."[10] Such an absurd statement betrays Dickens's strategy for distancing himself from his origins and early environment, on the one hand by claiming affiliation with the middle class and on the other by advocating sweeping humanitarian reforms for the degraded poor. Cruikshank's own behavior, as well as his advocacies, strained Dickens's tolerance. One morning in the mid-1840s, when Dickens was living in considerable luxury at 1 Devonshire Terrace, Cruikshank burst into the library "smelling of tobacco, beer, and sawdust." He said he had been out all night and was afraid to go home. So throughout the day he and Dickens roamed the streets of London; whenever Dickens turned toward Islington, the truant would protest, "No, no, Charley—not that way." In the aviary of the Pantheon, Cruikshank came suddenly face to face with one of Mary

Ann's closest friends; the ensuing scene, Dickens used to say with patroniz-
ing compassion, was exquisitely farcical. At nightfall the artist departed
homeward, dejected and worn out, to face the music.[11]

W. H. Wills reported another incident of this period, when Cruikshank
refused Wills's dinner invitation because he would be led into temptation at
the table and wanted to stick to water. But later that evening, he showed
up, accepted brandy-and-water, and soon rose to a pitch of hilarity; two
friends who got him out into the street "found the old difficulty in restrain-
ing Cruikshank's boisterous spirits. After trying in vain for something more
than an hour to lead him home, they left him—climbing up a lamp-post!"[12]
Such stories have been regularly taken as representative of the artist's con-
duct over decades. That these particular instances of intemperance came
late in Cruikshank's drinking days, and may have been exacerbated (as
opposed to rhetorically embellished, which they certainly are) by his at-
tempts to get control of his drinking, escapes notice.

Thus when Cruikshank came to the subject of *The Bottle* in 1847, he
had been going through a long evolution in his own thinking and conduct.
"The Follies of youth," he entered in his diary on 27 September 1846,
"punish us in our old age."[13] Financial pressures, Mary Ann's illnesses, the
sad example of his own brother, the memory of his father and Gillray, guilt
about his own excesses—all these influences combined with the powerful
rhetoric of Temperance propaganda to incline the artist to mend his ways.
In choosing to narrate the decline and fall of a family, Cruikshank picked
on a theme of the antispirits movement that was constantly reiterated in
lectures, pamphlets, and illustrations: the sober home is a healthy, happy,
prosperous place, whereas the drunkard's home is filthy, disordered, impov-
erished, violent, cheerless. These contrasting homes serve as metonyms of
their inhabitants, for another favorite device of reformers was the contrast
between good and bad apprentices/brothers/soldiers, or between the good
little boy/girl and the debauched adult. In these self-help tracts, there is
never a limit to an individual's prospects so long as only water is imbibed;
nothing but one's own folly can prevent a rise into the middle class.[14] That
gospel of work and just deserts also informed Cruikshank's personal creed,
so that his parable of *The Bottle*—he originally intended to entitle it *The
Black Bottle*—spoke in the terms made conventional by the movement to
his own convictions and his fears about insolvency and madness.

At the same time, Cruikshank's political conscience was awakening after
a long slumber. In 1840, during the Chartist agitation, he started to etch a
symbol of the well-ordered state: a British beehive, arranged in cells and
levels, putting each worker in his place and capping the edifice with the
queen. Presumably this was the artist's response to calls for greater democ-
racy; like many conservatives he associated an enlarged franchise with

mobocracy and "the scum uppermost."[15] Six years later, the etchings to *Our Own Times* addressed significant contemporary social issues, notably ragged schools (May) and the exploitation of seamstresses (June). The latter was a topic burned into public consciousness by Hood's "Song of the Shirt," which Mark Lemon, despite the advice of his staff, published in the Christmas 1843 issue of *Punch*. The stanza that Lemon cut out of Hood's manuscript could have supplied the program for Cruikshank's illustration of a long line of seamstresses proceeding up stairs and into the funnel of a grinder, worked by an industrialist demon, which turns the laborers into beautiful cheap clothing and money-bags:

> Seam, and gusset, and band,
> Band, and gusset, and seam,
> Work, work, work,
> Like the Engine that works by Steam!
> A mere machine of iron and wood,
> That toils for Mammon's sake,
> Without a brain to ponder and craze,
> Or a heart to feel—and break![16]

In several other of Hood's poems of this period, the combination of powerfully evocative sympathy for a particular sufferer and a generalized condemnation of a mythological enemy ("Engine," "Mammon"), resembles the strategy Cruikshank was employing in his attacks on gin. Hood's "Drop of Gin" in the same Christmas number of *Punch*, written to an illustration by Kenny Meadows, exemplifies the mode that comic artists, poets, and periodicals were adopting to fuse sympathetic humor with social protest.

Yet it was not Cruikshank himself, but a Manchester reformer and writer, who initiated *The Bottle*. Joseph Adshead had visited the Eastern Penitentiary in Philadelphia after Dickens wrote his *American Notes* (1842), and on his return published *Prisons and Prisoners*, "to place in opposition *the fictions* of Mr. Dickens and *the facts*" that Adshead had obtained.[17] He calls Dickens's descriptions "over-wrought" and charges that they were "calculated to mislead the public mind." Dickens, he says, is "our literary Cruikshank," rather an ambiguous epithet considering that Adshead got the artist to etch his frontispiece, "Newgate—Prison Discipline."

In the summer of 1846 Adshead proposed that Cruikshank design and publish on his own a series of prints promoting Temperance.[18] By the end of July George had settled on a series of six or seven plates to be printed on process blocks in a steam press. He also contemplated a series elaborating "The Folly of Crime" ("very imperfectly done in the 'Table Book'") which would incorporate some of the worst aspects of prison discipline as Adshead had described it. Having no work in hand, Cruikshank might get started

immediately, except that he owed money and had spent his savings sub-
venting his periodicals. If Adshead would advance £100, he could begin.

Adshead sent £50.[19] Cruikshank obtained estimates of costs and began
sketching. Adshead sent him mezzotint copies of Edward Villiers Rip-
pingille's *Progress of Intemperance*.[20] These six oils track the degeneration of
a prosperous worker and his family, commencing with "The Invitation to
Drink" and culminating when the husband turns robber. Despite Cruik-
shank's wanting to avoid "any thing like a similarity," lest "plagiarism . . .
be suspected," certain motifs, figures, furnishings, and gestures in Cruik-
shank's series resemble ones in Rippingille's, although the overall effect is
quite different.

For a time Cruikshank vacillated between tracing an unchecked deterio-
ration and an alternative series contrasting "Going Right and Going
Wrong"; in the end the tighter focus of the former, and the innumerable
precedents for cautionary fables, tipped the balance. Anxiety about his
pecuniary affairs and Mary Ann's worsened condition caused George to
break down in August; Pettigrew recommended sea air. Somewhat restored
after a holiday, Cruikshank started working up what were now to be eight
plates. Merle obtruded suggestions from Paris.[21] It turned out to be "a much
more difficult and longer task" than anticipated. Each composition required
weeks to perfect, and some of the finished plates were spoiled in produc-
tion. Consequently Cruikshank begged Adshead repeatedly for further ad-
vances. Not only did Adshead send money, he also put Cruikshank in
touch with Benjamin Rotch, visiting magistrate at Coldbath Fields Prison,
where he was a thorn in the side of George's old friend Chesterton, the
prison governor, because of his impractical schemes for vocational training
and his teetotal fanaticism. (Dickens used Rotch as the "original" of Mr.
Creakle the credulous Middlesex magistrate in *David Copperfield*.) Adshead
thought that Rotch might arrange for the National Temperance League to
underwrite *The Bottle*, but Rotch doubted it.

Crippled by insolvency, Cruikshank nevertheless finished all but the last
two plates by the end of May 1847. Finally in July he was done, and when
"the *last* plate was finished—I sank down on my knees and with tears in my
eyes returned thanks to the Almighty who has supported me through my
difficulties." Then he prayed that the work might reclaim many and pay off
his debts. Not until he visited Manchester later that month with Dickens's
theatrical troupe did he meet Adshead, to whom he dedicated his suite of
prints; but even then he could not present a set, since printers' delays fore-
stalled publication another month.

Part of Cruikshank's difficulty in bringing the series to completion de-
rived from the medium he selected. He and Adshead wanted to sell by the
tens of thousands to the working class. Engraving was therefore out of the

question, and even steel-etching, wood-engraving, or lithography would cost more than Cruikshank wanted to pay. "Had [*The Bottle* and *The Drunkard's Children*] been engraved in the same style as the great Hogarth prints," Cruikshank wrote in a draft response to a review of the Westminster Aquarium Exhibition (1863), "they could not have been sold for less than 5s. for each subject. And I did not have them engraved upon wood as that would have cost too much." Instead, as Hogarth had done in commissioning woodcuts of his *Four Stages of Cruelty*, Cruikshank was willing to sacrifice pictorial quality for cheapness.

He searched diligently for an appropriate process. Dr. Lettsom, eager to promote sobriety, sent the artist a copy of the second edition of Professor von Robell's *Galvanography*, a method of electrodeposit that the Art Union of Munich was using to reproduce subscriber's engravings. He also promised to send descriptions of two new galvanic processes, galvanic etching on iron plates and galvanic precipitation of the iron in the plates onto blocks.[22] But by then, George had already settled on the medium he had used for several plates in the *Table-Book* and for thirty-five images in *Our Own Times*: glyphography.

No matter how hard and uniform the metal, etchings and engravings break down after a few thousand pressings because the force exerted to squeeze the ink onto the paper and to wipe it off after every impression inevitably distorts the narrow valleys; shallow grooves collapse, ones close together (as in crosshatching and roulette shading) amalgamate, and the sensitive surface edges of the incisions lose their delicacy. Moreover, the whole engineering of printing where the ink lies *below* the surface of the plate differs from printing where the ink lies on a raised surface *above* the plate, as in type and relief processes. Glyphography was one of many midcentury innovations addressing these two problems. Cruikshank built up a thick wax ground on the surface of a copper plate, incised it deeply with his needle, then applied more wax to the untouched areas to exaggerate the contrast between ground and groove. By electrolysis he deposited a thin film of copper over ground and into grooves, making a positive mold. This was strengthened on the back with additional metal, and the relief plate could then be prepared for the press.[23]

Glyphographs cannot reproduce the "touch" of an etching: the lines are altered by electrotyping, the beautiful gradations of tone produced by differential bitings-in get simplified, that which was once lively and crisp becomes crude, flat, lifeless. Having discovered in his earlier publications what the shortcomings of glyphography were, Cruikshank endeavored to compensate by designs that were straightforwardly narrative rather than poetic or tonal, and that depicted shallow spaces requiring no atmospheric reductions. To some degree, the story he chose to tell was dictated by the

medium through which he told it; the crudeness of the reproductive process shaped the bareness of the narrative, so that both worked together to yield simple, powerful, inexpensive images. As Cruikshank reiterated to the editor of the *Aesthetic Review* many years later, he put the suite at such a low price "in order that it might be within the reach of the working classes, for when an artist is working for the million, cheapness of price has to be considered and I had them produced by the only available cheap process at that time (now about 30 years ago) and this will account for the roughness of their style."[24]

If Cruikshank was going to sacrifice delicacy for cheapness, then he needed a publisher who could sell a hundred thousand instead of a hundred copies, to customers in all the places around the world where Temperance movements might be taking hold. His objective, he explained in a later reduced-size edition, "was to assist, if possible, in putting a stop to the poverty, misery, wretchedness, insanity, and crime which are caused by strong drink."[25] Proposals for selling by subscription came to naught. Who then might work on the large scale that Cruikshank envisaged? Unfortunately John Cassell had not yet set up his Temperance-oriented printing and publishing firm. A Manchester carpenter who became an itinerant Temperance lecturer and afterward sold tea and coffee in London, Cassell was to start business as a publisher in 1848 with the *Standard of Freedom*.[26] In the 1850s his enterprise expanded considerably, and he issued some of the principal tracts and periodicals for the Temperance movement, such as the *Working Man's Friend* (1850–1853). But since Cruikshank could not yet turn to Cassell, he resorted to his old stand-by David Bogue, describing his idea and asking for an advance of £100, just as he did to Adshead.[27] Cruikshank kept the copyright himself, as Adshead had advised.

Some form of proof was ready by June 1847, for on the fourth of that month Samuel Gurney acknowledged receipt of a copy.[28] Gurney, the largest bill discounter in the British Isles and a great philanthropist, belonged to an extensive Norfolk Quaker family.[29] His older brother Joseph John Gurney was a notable reformer and Temperance advocate, and his sister Elizabeth Fry worked vigorously for prison improvements. *The Bottle* thus put Cruikshank in touch with others who, like Adshead and Rotch, combined an interest in prohibition with other humanitarian causes; it marked the commencement of thirty-years' involvement with Midlands reformers who, in spearheading the Temperance movement, became his patrons and his public.

In the eight plates of *The Bottle* (figs. 39–46), Cruikshank adapted the Hogarthian progress-as-decline to the standard Temperance line and thereby applied a trope in which he held a long-standing interest to a contemporary social issue with ramifying moral implications. He did not

39. George Cruikshank, The Bottle, plate 1, glyphograph, 1847

40. George Cruikshank, The Bottle, plate 2, glyphograph, 1847

41. George Cruikshank, The Bottle, *plate 3, glyphograph, 1847*

42. George Cruikshank, The Bottle, *plate 4, glyphograph, 1847*

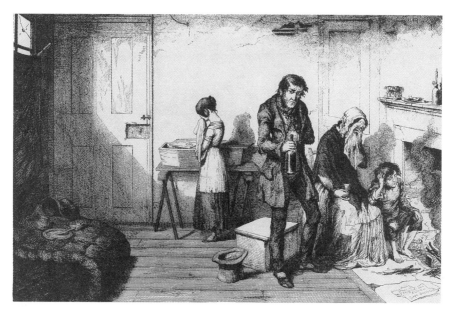

43. *George Cruikshank,* The Bottle, *plate 5, glyphograph, 1847*

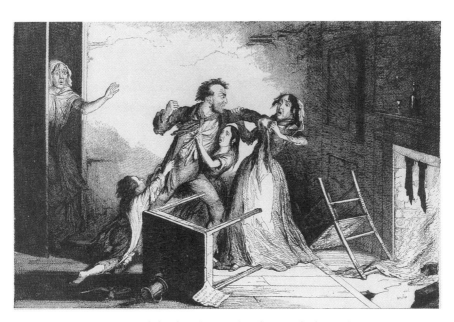

44. *George Cruikshank,* The Bottle, *plate 6, glyphograph, 1847*

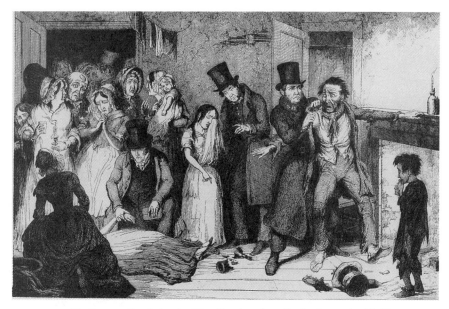

45. George Cruikshank, The Bottle, *plate 7, glyphograph, 1847*

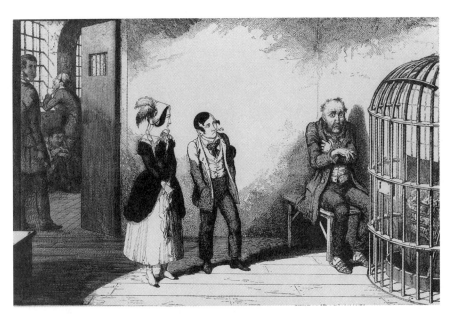

46. George Cruikshank, The Bottle, *plate 8, glyphograph, 1847*

finally choose to counterpoint the bad apprentice with a good one, prefer-
ring to track the dissolution of a single family destroyed by the introduction
of alcohol, and to place responsibility for the tragedy on exactly the kind of
industrious, respectable working man from whom so many Temperance
converts were recruited.

Moreover, Cruikshank tells the story by locating the family within a
single space that deteriorates alongside the people: *The Bottle*, as Louis
James puts it so well, "shows a home becoming a room."[30] The furnishings
within that home—the china ornaments on the mantel, the well-stocked
cupboard, the heirloom grandfather's clock, the picture of the old country
church upon the wall, the sprigs of lavender (stuck behind the mirror) that
perfume the air, the tidy clothing and linen—all speak forcibly to the
material, physical, and psychic health of the inhabitants. As so many other
pictures of this period do, Cruikshank's employ a vocabulary of objects
that simultaneously evokes tangible possessions, their history, the values of
their owners, and the symbolic ideals they incarnate. The grate in the
hearth is a pattern recommended for respectable working-class dwellings
because it was practical, economical, and graceful: what happens to it and
the fire it contains, as what happens to the other objects in the home,
inculcates the lesson. Indeed, the furnishings articulate the degradation,
pain, violence, and disorder at least as much as the human participants do.
And unlike Hogarth's static commenting accessories, these furnishings
suffer through time, share the same dismemberment and ruin as their pos-
sessors. They are dramatic, not simply iconographic, props in the melo-
drama of drink.

Cruikshank was so charged by his idea that he worked up beautiful col-
ored drawings of each plate.[31] From the decency and order of plate 1, "The
Bottle is Brought Out for the First Time: The Husband Induces His Wife
'Just to Take a Drop'," the scene changes drastically in plate 2: "He Is
Discharged from His Employment for Drunkenness: They Pawn Their
Clothes to Supply the Bottle." The house is now messy and the cupboard is
bare. The dissipated father lounges with his hands in his pockets and a pipe
in his mouth, a starving cat licks a plate on the table, the lavender is all but
gone, and the flowers in the vase wilt. Resting against the fender, a poker
points to the cold hearth. The very lock on the door, once a guarantor of
the security and privacy of the home, is now concealed by the articles about
to be pawned, as the interior of the home flows outward into the pawnshops
and gin palaces.

In the third stage the home is denuded of nearly every remaining acces-
sory: "An Execution Sweeps Off the Greater Part of Their Furniture: They
Comfort Themselves with the Bottle." Bible, bureau, carpet, clock, pic-
ture—all are about to make their way through the opened door, past the

corpulent broker, into the streets to be recirculated by secondhand vendors to others of the working poor. The china house tilts precariously on the mantel. The wife still feels regret, though she clutches the bottle at which her youngest child stares, but the husband has found oblivion in a dram. In the fourth plate, the only one to take place out of doors, the family itself circulates in the streets, begging for coppers and learning the strategems for solicitation: "Unable to Obtain Employment, They are Driven by Poverty into the Streets to Beg, and by This Means They Still Supply the Bottle." Caught between the cemetery and the off-license, the boy has become an artful beggar, appealing by his tattered clothes and knuckled forehead to the fine lady who donates without noticing where her money will be spent. (In this plate Cruikshank contrasts the drunkard's older children to two well-dressed priggish counterparts who look on with blank sympathy.) Father, mother, and daughter stand on the cellar door opening from the pavement into the spirit vaults beneath the street: here the realistic detail functions both to reinforce verisimilitude and to adumbrate that capture by spirits which in "The GIN Shop" (1829) was symbolized by the mantrap.

Drinking began as a way of celebrating, then became a comfort in times of distress. In the second half of the suite, which returns to interiors, it consoles, then inflames, and finally maddens. Now the family is enclosed within their bare room, from which the very plaster is falling. In plate 5, "Cold, Misery, and Want, Destroy Their Youngest Child: They Console Themselves with the Bottle." The child's fate, foreshadowed in the preceding image where all but her bare legs are concealed within her mother's shawl, is now confirmed. Daughter and mother weep, son and father stare despairingly, the son into the smoking fireplace now grateless, the father into a space that seems populated with demons.

Events accelerate: "Fearful Quarrels, and Brutal Violence, Are the Natural Consequences of the Frequent Use of the Bottle." This was a theme Cruikshank returned to again and again in his Temperance days: he was convinced that much of Victorian brutality, and most of the murders, were caused by drink, and argued again and again on the platform that no sober person had ever been convicted of violent crime. "I challenge any one," he said at the Grand Demonstration of the National Temperance League in the Guildhall on 19 November 1864, "to point out any teetotaler who has been committed for a brutal assault upon his wife, or for garotting, or picking pockets, or house robbery, or murder."[32] Here the drunkard beats his wife, while the children try to restrain him, and the outside world, in the form of an alarmed neighbor, breaks into their sanctum. The table and chair have been knocked over, and the cloth that was drying on the back of the chair has fallen into the fireplace and ignited. Fire of all kinds is breaking out.

In plate 7, "The Husband, in a State of Furious Drunkenness, Kills His Wife with the Instrument of All Their Misery." The wife's body lies on the left, surrounded by neighbors who have once again invaded the room and who exhibit every variety of pity, anguish, terror, and interest; only the expression of the doctor, who has seen this sordid end so many times before, in its impassivity registers the full horror of the situation. The daughter, who seems in this plate almost like the spirit of her departed mother, points out for a policeman the broken bottle lying at her feet, while the father, aghast, is restrained by a second constable.

Finally, in plate 8, "The Bottle Has Done Its Work—It Has Destroyed the Infant and the Mother, It Has Brought the Son and the Daughter to Vice and to the Streets, and Has Left the Father a Hopeless Maniac." The last scene, in a madhouse, replicates the interior of the home, with a door on the left opening onto other cells and a fireplace on the right, now surrounded by a massive locked iron cage. Before it sits the father, his own fires caged by his crossed arm as well as by the barred windows and warder outside the door through which in his former home he might pass freely. Once again the "streets" have invaded his "sanctuary," this time in the guise of his ruined children dressed in meretricious finery and bearing the sulky, knowing expression of the prematurely debauched. Advertisements connected this plate to the recently serialized *Oliver Twist*—"the boy, a sort of 'Artful Dodger,' and the girl, a something worse than 'Nancy'." The sprig between the boy's lips supplies a mocking echo of the lavender.[33]

The Bottle is Cruikshank's most sustained independent narrative. It therefore exhibits clearly some of the artist's ways of telling a story. To begin with, there is a simple moral determinism that directs events. But that moral simplicity never precludes sympathy with the transgressor, nor is the morality enunciated in the rhetoric of righteousness. Moreover, the interconnectedness of the family's fortunes is such that regret, sorrow, violence, madness, debauchery, and vice are tied together and grow out of one another: there can be no drawing of lines, no cordon sanitaire designed to separate the father's follies from the children's. In spite of his strong moral bias, Cruikshank betrays considerable environmentalist leanings—the son and daughter are what they are because of their father, who by introducing alcohol into their hitherto sober home initiates their subsequent degradation. By displacing blame and causality onto surrender to "the bottle," Cruikshank frees himself to explore compassionately the varieties of havoc it wreaks.

That havoc registers two attendant truths. First, the prudent consumer of the first plate had assembled those artifacts that manufacturers supporting Temperance argued would be purchased if wages were not spent foolishly and unproductively on drink. So along with all the other ways in which

these possessions function in Cruikshank's narrative, there is this additional point: sober workmen provide a market for retail goods. The progressive denudation and destruction of the home represents the loss of another consumer. And the second truth, one that Cruikshank indicates tangentially but unmistakably, is that the family becomes a substitute for manufactured goods in the exchange system: the children are in a sense commodified to survive, while the once distinct spheres of home and street merge.

To some twentieth-century eyes the poetry of objects articulates far more movingly than the physiognomies the pathos of this drama.[34] Perhaps it is significant that the series is named for an object, rather than a person ("The Drunkard") or a Vice ("Drinking: The Road to Ruin"). Mid-Victorian artists invested the objects of everyday life with a range of implications rarely equaled in British art: they are shapes; property whose selection, purchase, display, and iconography tell so much about their owner's culture; and symbols of physical, economic, class, psychological, and spiritual realities. Cruikshank is not so profound as Carlyle in making connections between phenomenal and noumenal, but he shares with his contemporaries that extraordinarily rich apprehension of the material world which an era poised between transcendentalism and naturalism enjoyed. At this moment in his own art, he is able to blend the mimetic and the symbolic, not as in "The GIN Shop" through mixing modes, but through blending them together in the china, firegrate, utensils, furniture, ornaments—even the very lath-and-plaster walls—that dramatize a home becoming a room.

That narrative is told by a series of "stop-action" tableaux, just as in Hogarth's series and in the illustrations to Ainsworth's novels which proved so readily transferable to the stage. Pictures generate text: first the "pithy" captions, later poems, lectures, plays, and sermons. But a provided text is an inessential embellishment; little is added by such verses as these by Charles Mackay:

Weep, children, weep! Be tears of anguish shed.
 Yet not for her alone, your mother slain;
The living suffer—peace is with the dead.
 Yet weep for both, although ye weep in vain.
 See how your father stares!—a burning pain
Settles upon his heart. Ay, weep for him!
 There is a frenzy seething in his brain.
 His breath is thick—his eyes are fixed and dim—
He clutches for support—he shakes in every limb.[35]

Indeed, the effect of Cruikshank's inexorable succession of images is far more powerful when the viewer writes the scenario, filling in the gaps with personal experience and bringing to a reading of the series private fears and

sorrows. By suppressing the narrative bridges between scenes, Cruikshank avoids having to relate the minute diurnal alterations leading to these cataclysmal events; simultaneously he invests the narrative with the psychic energy of each viewer. Those who responded to *The Bottle* frequently attributed to Cruikshank's designs meanings projected from their own troubled lives.

And by seeing the plates in sequence, superimposed on one another (as they almost might be when they were translated into a lantern show for illustrated lectures), viewers received, if only retinally and subconsciously, a diachronic formal lesson as well. For example, in the first plate the husband appears on the left side of the picture, near the door to the outside world where he works and from which he brings the wages that furnish this protected enclosure, while the wife, on the right, sits between the cupboard and the hearth. Each is situated adjacent to his or her culturally assigned sphere of responsibility. Afterwards, the husband is positioned nearer the fire: in plate 2 he trades places with his wife, who sends her daughter outdoors to pawn clothes while he sits by the cold chimney, and in plate 8 he huddles in a corner beside the barred grate. The proper custodian of the hearth thus formally cedes her position to her spouse, with appropriately disastrous consequences. In two plates they contest for the center: during the fearful quarrel of plate 6, and conversely in plate 7, where the broken bottle right in the middle of the composition divides the prostrate body of the woman on the left from the raving man clutching the mantel on the right. Violent collision is succeeded by equal and opposite repulsion. By implicitly juxtaposing compositions Cruikshank makes the necessarily discontinuous succession of images disclose their narrative connections, causality, and consequences.

Not even to the artist himself were all the implications of these pictures immediately revealed. Cruikshank took an early set of proofs to the prominent Quaker William Cash, chairman of the National Temperance League, hoping for his approval and the endorsement and support of his influential association. After studying the prints, Cash asked why, in light of the terrible example he had drawn, Cruikshank was himself not a total abstainer. Jerrold takes up the story at this point:

> Cruikshank, in his own forcible way, described how he was "completely staggered" by this point-blank question. He said, when he had left Mr. Cash, he could not rid himself of the impression that had been made upon him. After a struggle, he did not get rid of it, but acted upon it, by resolving to give his example as well as his art to the total abstainers.[36]

The Bottle was issued in many different editions: for the top end of the market, "An Edition on Fine Paper, Imperial Folio, with a Tint" in brown

paper wrappers for 6s.; for the middle classes, a "Superior" edition at half a crown; and for the working classes, the whole suite for one bob. It could be had with or without Charles Mackay's poem, and within a few years in half-size for half-price, that is, sixpence. Still later, lithographic transfers from the original plates constituted an 1881 edition with the designs in reverse. Any format by which Cruikshank could benefit both the movement and himself he tried. His effort to emancipate himself from the thrall of book-sellers coincided with his finally successful effort to emancipate himself from the thrall of drink. The disadvantages of consigning his future reve-nues to the patronage of teetotalers would not be fully apparent for two decades.

People of very different temperaments and experience reacted with en-thusiasm. Charles Mackay, considered midcentury Britain's greatest song writer and reputedly the natural as well as adoptive father of Marie Corelli (Minnie Mackay), had been hoping to break into print in one of Cruik-shank's periodicals for some years.[37] After studying the glyphographs care-fully, he was moved to write a narrative in Spenserian stanzas: "I have hopes of being able to make such a poem or series of poems on the subject," he told Cruikshank in the summer of 1848, "as shall not submit me to the indignity of being told hereafter, that George Cruikshank's part was im-measurably superior to that of Charles Mackay. I shall not perhaps *quite* come up to you—but I will come as near as I can:—so look after your laurels—."[38] The completed verses were printed separately, or with the plates, or sometimes alongside the Reverend Richard Cobbold's poem, which Bogue thought "awful" but published.[39]

The twenty-four-year-old Matthew Arnold, on seeing a copy of the suite while staying in the country, indited a sonnet ascribing to it a stoic philoso-phy more in accord with his own burgeoning views than with the artist's. The soul, scarified by this "prodigy of full-blown crime," cannot be com-forted by pastoral retreats. Instead, it offers a tonic devoid of earthly or heavenly consolation:

"Why tremble? True, the nobleness of man
May be effaced; man can control
To pain, to death, the bent of his own days.
Know thou the worst! So much, not more, he can."[40]

In France, Edmond and Jules de Goncourt disliked the artistic naiveté and gross details of Cruikshank's designs, but Gavarni held them en-thralled one evening as he took them through a course in aesthetics by discussing each picture and bringing out "its hidden beauty."[41]

Dickens, then staying at Broadstairs, bought his copy at Canterbury. "I think it very powerful indeed," he told Forster, who probably wrote the

complimentary notice ("We recollect nothing half so good that was ever so cheap") in the 4 September *Examiner*. "The two last plates [are] most admirable," Dickens went on,

> except that the boy and girl in the very last are too young, and the girl more like a circus-phenomenon than that no-phenomenon she is intended to represent. I question, whether anybody else living could have done it so well. There is a woman in the last plate but one, garrulous about the murder, with a child in her arms, that is as good as Hogarth. Also, the man who is stooping down, looking at the body.[42]

But Dickens expressed the same objection to the moral of this drama that he had to other Temperance propaganda:

> The philosophy of the thing, as a great lesson, I think all wrong; because to be striking, and original too, the drinking should have begun in sorrow, or poverty, or ignorance—the three things in which, in its awful aspect, it *does* begin. The design would then have been a double-handed sword—but too "radical" for good old George, I suppose.

Too radical, perhaps—for it is unquestionable that Cruikshank's politics were more conservative in the forties than in the twenties. But less powerful, perhaps—because then the contrast between the happy family of the first plate and the ruined remnant of the last would have been blunted, because liquor drunk to celebrate a happy occasion seems so much more innocuous as the precipitating factor in a fatal decline, and because Cruikshank's customers for the shilling edition were more likely to come from the class of prudent working men who might apply the cautionary tale to their own situation than from the ranks of the truly poor and miserable. Robert Chambers, the distinguished Scots antiquarian and publisher, thought the moral enforced "the good aim of the philanthropist and the dignity of tragedy. . . . the triumphs of light literature and comic art are as chaff compared with what they might be if ballasted with a moral object," he told the artist.[43]

Dickens, however, continued to think that Cruikshank was unwise to associate himself so wholeheartedly with teetotalers. "I think those Temperance Societies (always remarkable for their indiscretion) are doing a very indiscreet thing in reference to you—and that they will keep many of your friends, away from your side when they would most desire to stand there." Asked by one of the Societies for his own views, Dickens first sent his reply to the artist to ascertain "whether there is anything that you object to."[44] Other friends seconded these sentiments, but Cruikshank, having taken the pledge, felt honor-bound to promote the cause vigorously. He also felt that despite the setbacks Temperance was the likeliest source of income in the near term.

The plates clearly asked to be dramatized. Within a few days of their publication, playwrights were drafting scenarios. The aged Moncrieff, a pensioner at Charterhouse, told his old friend that he would like to try his hand at an adaptation even though he couldn't see the pictures.[45] Eventually they were staged in eight minor theaters, four of them "Gin Shop Saloons or Tavern Theatres—which makes the matter more surprising," Cruikshank reported to Adshead.[46] George personally superintended the tableaux for T. P. Taylor's City of London production.[47]

A kind of *Bottle*-mania ensued. The plates became "the public furore," wrote John O'Neill; "The walls were placarded, the windows blazoned, the theatres reached, earthenware services decorated, the public mind was engrossed. 'The Bottle' was seen, and heard, and spoken of, in every quarter." O'Neill hoped to attract a little of this attention by republishing *The Drunkard*, with two additional plates that Cruikshank had long promised to provide, under the happier title "The Blessings of Temperance." But Cruikshank asked for ten guineas which Edward Moxhay, who had underwritten the earlier publication, refused to pay, so Cruikshank and O'Neill quarreled, and Effingham Wilson brought out a new shilling edition without the benefit of new prints. Reviewers nonetheless praised O'Neill's work and often said that it had inspired *The Bottle*, an allegation that Cruikshank with some justification attempted unsuccessfully to contradict.[48]

Gabriel Alexander turned *The Bottle* pictures into a penny parts-issue novel. The designs were also copied onto dishes for the infant pledgers of the Band of Hope. Four china firms used the figures on their tableware, and a fifth produced its own version of the theme.[49] Moore and Co. of Sunderland offered a free sample to George as compensation for their piracy, but several Yorkshire potteries simply appropriated the designs without compunction.[50] *Bottle* tea ware was ordered for a sailing vessel.[51] There were waxwork representations, and lantern slides were used extensively in Midlands chapels and meeting houses to illustrate abstainers' lectures.[52] A Glasgow cloth imprinter offered Cruikshank £20 and royalties for the rights to print *The Bottle* and its successor onto cotton; they assured the artist that he would retain the power of contracting with another firm for printing onto silk.[53] J. B. Smithies of the York Temperance Society wanted Cruikshank to produce an enlarged version suitable to be framed and hung in the society's lecture rooms.[54] Two decades later the poet Edward FitzGerald presented "that admirable Sermon" on drink to a beer-swilling Woodbridge sailor with whom he was going partners in a herring lugger, and a chaplain in the Chester prison displayed the prints as illustrations of his sermons to inmates.[55]

Robert Shelton Mackenzie composed a laudatory review of Cruikshank's career, culminating in a précis of *The Bottle*, for the *London Journal*.[56] When

he called to check details of the story, George and Mary Ann had gone to Windsor; Cruikshank gave permission for his portrait to be reproduced, but could not consent to having all eight plates copied in reduced outline for the article because that might jeopardize his copyright.[57] Mackenzie complied, explaining in the essay that as his purpose was to assist not supersede the sale, he described but did not publish two of them.[58]

Widespread enthusiastic notices and unauthorized imitations ought to have ensured a sale in line with Cruikshank's optimistic projections. And indeed Jerrold says "tens of thousands" were sold, while subsequent commentators confidently speak of a hundred thousand going off in a few days. The reality is very different; *The Bottle* was financially "a positive flop."[59] When David Bogue forwarded his statement of sales on 17 January 1848, he confessed that the "balance is not so large as I expected." Neither of the fine editions had recouped their costs; only the shilling edition, in its thirtieth thousand, was yielding a profit. Estimating that Adshead and other agents might sell 900 more copies of the expensive editions, that a further 5,746 of the shilling suites would produce £160, and that the consignment shipped to Wiley and Putnam in New York should eventually yield £250, Bogue reckoned Cruikshank's eventual profit at nearly £900. By his calculations, therefore, less than half had yet been reached. A successful sequel would stimulate back sales, so he urged the artist to push on while the iron was still hot.[60]

The notion of a continuation had been broached by several of Cruikshank's correspondents. Fred Hopwood of the York office of the British Association for the Promotion of Temperance suggested—rather in line with Dickens's commentary—that Cruikshank add one or two plates to the beginning because much happens to a man before the stage at which *The Bottle* commences.[61] J. M. Scollier proposed a sequel "illustrating the upward tendency of the Pledge—by beginning *No.* 1 with a house divested of furniture and all in confusion—and onward to pledge signing to the comforts of domestic life."[62] The teapot manufacturers Stevenson and Co. printed a broadside calling for a tea sequel:

If from the fatal BOTTLE thou has drawn
A scene of misery o'er which we mourn,
Cans't thou not from the TEA-POT sketch a sight
Of homely happiness supremely bright?[63]

Since other continuations were announced, Cruikshank wrote to editors complaining about the piracies and promising an authorized version shortly.[64]

Another plague was unscrupulous Midlands printers who were using *The Bottle* to promote their businesses. E. J. Perry wrote from Birmingham in

December that a firm there had made reduced facsimiles which were put on bills for grocers and distributed gratis. Parry offered to forward copies with the names of the engraver and printer. "I do not act thus either from interested or malevolent motives but . . . I cannot but regret that such beautiful works of art should be so degraded as to adorn common handbills and to the diminution of the artist's fame—as they do not acknowledge the source from whence they derive their designs."[65] A week later Parry explained in more detail what was happening:

> They are printed [with the "pithy" captions changed to "an absurd thing of nonsense"] and sold by a Mr. Billing of Newhall Street in this town and they were reduced & engraved for him by a Mr. Johnson—Engraver of Temple Row Birmingham—both parties are well known. The use to which the blocks are appropriated is this—Various printers in this & other large towns send out Travellers to solicit orders for paper printing &c. and their principal commodity is tea papers or wrappers for Grocers—much competition results therefrom—The parties therefore who introduce the most attractive engraved subjects to print upon such wrappers naturally procure the most & best orders—as a novelty—Mr. B- produces the "Bottle" and unless its career is checked every printer in the country will have the same subject consequently myriads of them will be distributed all over England—which must act prejudicial to the profit of your designs many thousands of them have already been printed.

In a postscript Parry adds that Coley, Rogers and Gough, printers located in Exeter Row, Birmingham, had also brought out a series based on *The Bottle*—in this instance altering the pictures but keeping verbatim the explanatory captions.[66]

Cruikshank wanted copies so he could apply for an injunction through his solicitor William Loaden.[67] Additional digging by Parry and William Howard unearthed names of more recipients, procured authenticated piracies, and identified a Liverpool printer who was also issuing imitations.[68] By March 1848 Loaden had all the materials, but had not initiated any action.[69] The moment for timely action had passed, and Cruikshank was so beset by other difficulties that he evidently could not attend further to these infringements.

Nor was Cruikshank immune from misrepresentation and plagiarism on the Continent. Watts Phillips, studying art in a Paris "as dull as the last numbers of *Dombey*," could not find any French version of *The Bottle*, although Parisians told him it had been done for a newspaper. He hoped that Cruikshank's sequel would fall into more energetic hands than Bogue's.[70] Later that year he reported on Gilbert's large plates for the *Pictorial News* entitled *The Drunkard's Children*: "The first plate represents the *girl* picked out of the water, where she has committed suicide (*this* seems strange)— they call it a sequel to the *bottle*—is not this a matter of some moment—

they are to form 8 plates the only thing is that they by what I can see intend to trace the Son's career as a temperate man—the *series* being called the 'Water Jug'."[71] The *Illustrirte Zeitung* of Leipzig ran the series on its back pages just before Christmas 1847, to caution against holiday indulgence.[72]

Cruikshank published his own sequel to *The Bottle* on 1 July 1848, its appearance delayed by further misadventures during production. *The Drunkard's Children* (figs. 47–54) came out in the identical format and in the same range of editions. This time Cruikshank had two protagonists—the son and the daughter—whose fates he paralleled and counterpointed, an idea that originated with Adshead. The settings are public rather than private spaces, since the children have already been set on the streets to earn their keep. Therefore several of the plates are crowded with figures, activities, motion: the human and physical environment almost overpowers the boy and girl, increasingly without power to direct their destinies. This time, too, the interstices between plates require a good deal more explanation, so captions are longer and more didactic. The first one sets the tone: "Neglected by Their Parents, Educated Only in the Streets and Falling into the Hands of Wretches Who Live Upon The Vices of Others, They Are Led to the Gin Shop, to Drink at That Fountain Which Nourishes Every Species of Crime."

The subtitle of this suite might almost be "Crime and Punishment." Drink seems only an accessory to a whole culture of vice into which the children are precipitated. In the first plate, the Gin Shop introduces the girl to a pimp and a procuress, while her brother is treated to a frothing tankard by two ruffians who will later use him in a daring robbery. (Once again Cruikshank scratches his version of Oliver's falling among thieves.) In the second, the boy frequents a "Low Dirty Beer Shop," where surrounded by tipsy prostitutes, pickpockets, card sharps, punters, and a cacophonous pothouse chorus, he plays cards and smokes his pipe. He does not even drink—his tankard lies neglected on the floor. Meanwhile, his sister has been inveigled into prostitution by the pimp and the procuress, bar maid at a "Dancing Room" where the gentlemen may see "Les Poses Plastiques," that is, the girls in the nude, every evening "before Le Bal." In these first three scenes, Cruikshank depicts a large number of characters manifesting every shade of fortune, temperament, and vice: they are busy, noisy, noisome. A puritan attitude toward pleasure not previously manifest in his works is in evidence, similar to the attitude of many Temperance reformers who became, as F. W. Newman said of himself, "anti-slavery, anti-alcohol, anti-tobacco, anti-*everything*."[73]

The notable Cruikshankian Albert M. Cohn rails against both series of plates, saying that "the masterly hand . . . was stricken with the palsy" and

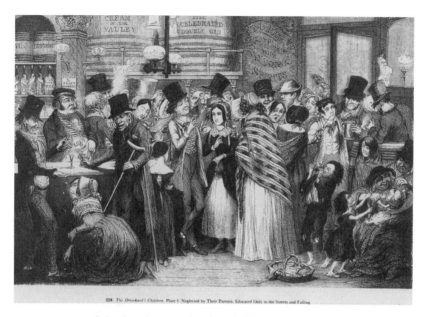

228. *The Drunkard's Children.* Plate 1. Neglected by Their Parents, Educated Only in the Streets and Falling

47. *George Cruikshank*, The Drunkard's Children, *plate 1, glyphograph, 1848*

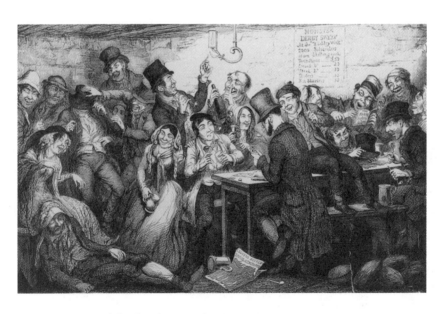

48. *George Cruikshank*, The Drunkard's Children, *plate 2, glyphograph, 1848*

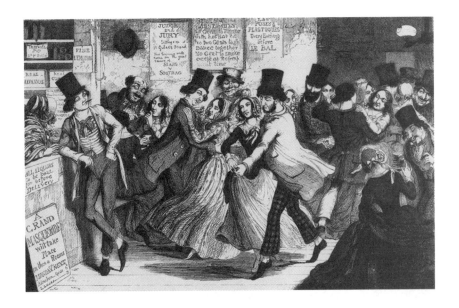

49. *George Cruikshank,* The Drunkard's Children, *plate 3, glyphograph, 1848*

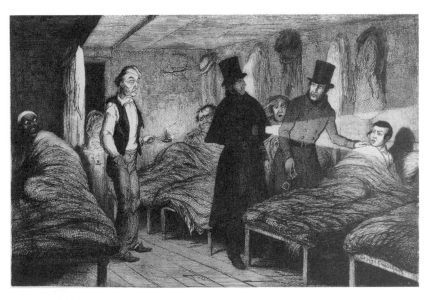

50. *George Cruikshank,* The Drunkard's Children, *plate 4, glyphograph, 1848*

51. George Cruikshank, The Drunkard's Children, *plate 5, glyphograph, 1848*

52. George Cruikshank, The Drunkard's Children, *plate 6, glyphograph, 1848*

53. *George Cruikshank,* The Drunkard's Children, *plate 7, glyphograph, 1848*

54. *George Cruikshank,* The Drunkard's Children, *plate 8, glyphograph, 1848*

that "from an artistic sense they are beneath contempt." John Harvey agrees that
Cruikshank's "art has stiffened and gone hard and dull with propagandist zeal."[74]
Nevertheless, Harvey finds that

> many of the designs are well-composed as to balance, space, and proportion,
> and in the plate showing the Dancing Room (Plate III), the rhythm and move-
> ment of the dance undulates from figure to figure, animating the whole design (a
> lovely characteristic of all Cruikshank's dance scenes). There is a largeness and
> relaxation in the picture that is not habitual to Cruikshank: clothes, for in-
> stance, sweep energetically round, not with all their actual ripples and flutters,
> but in bold expressive simplifications of the way clothes move in dancing.[75]

Cruikshank betrays his own purposes when his etching needle almost of its
own accord delineates the swirl of skirts, the hilarity of high spirits, and the
gestures of erotic enticement that he himself once so unreservedly enjoyed
and now must reprobate as adjuncts to drinking.

Plates 4, 5, and 6 show the progressive evacuation of society from the
images and the lives of those they chronicle. In plate 4, the boy is taken by the
police in a threepenny lodging house for a "Desperate Robbery" to which he
has been incited by his "Ruffian Companions." The lodging-house keeper is
a perfect portrait of bleary dour indifference, while the other sleepers, star-
tled and alarmed, display no inclination whatsoever to identify with or to
comfort the young criminal. In the prisoner's box of the Old Bailey, the boy
is spatially, legally, and emotionally cut off from the lawyers and court
officials directly before him, from the jury to his left, and from the specta-
tors in the gallery who can barely be seen just above his weeping sister. Not
much sympathy for his case can be detected in any of their faces, but Cruik-
shank has not caricatured them as he might have done earlier: the men
seem, on the whole, to be sincerely engaged in their activities and to be
without hypocrisy, malice, or greed. A further separation is effected in the
sixth plate, where the boy, convicted, "Is Sentenced to Transportation for
Life" and says farewell to his fainting sister, acquitted of complicity.

The last two plates portray the final moments of each. The convict dies
on a prison hulk. In a scene that recalls his apprehension in the lodging
house, the other bedmates turn away, while two able-bodied convicts prop
up a screen around the corpse. A surgeon's assistant closes his eyes. The
chaplain, the only person troubled by his death, shuts his Bible and walks
away. The knowing cove who swaggered with his pals, the boon companion
of doxies and touts, the daring partner of experienced thieves, dies friend-
less and alone even in a company of felons.

Initially Cruikshank planned to end the series with the boy's death,
chronicling his sister's fate earlier. Fortunately he changed his mind, reser-
ving his most powerful effects for the last plate: "The Maniac Father and
The Convict Brother Are Gone.—The Poor Girl, Homeless, Friendless,
Deserted, Destitute, and Gin Mad, Commits Self Murder." This has some-

times been counted as one of the great images of nineteenth-century graphic art, comparable to a Goya *Disaster* or Daumier's *Rue Transnonain* or Munch's *The Cry*. Exploiting the planarity of glyphograph, Cruikshank etches almost the entire plate in crosshatched tones of grey. The massive stone bridge fills the surface; its repetitive, rectilinear blocks and simple ornamentation play off against the sweeping quarter-circles of the vault. Under the arch, a full moon (popularly associated with madness) looms through smoky clouds above the spiky masts of ships and shadowed houses. The girl herself is rendered as a birdlike shape, suspended in midair, her unfurled white dress, black coattails, and hair streaming behind her.[76] The edge of the arch intersects her body, "a kind of black rainbow or shadowy wheel," John Harvey writes, "sweeping down, accelerating the girl's fall." All the poetry of motion that subversively undercut the animadversions against dancing reappears, now eerily transformed so that the beauty is the beauty of a body releasing itself from earthly pleasures and restraints in an uninhibited flight downward to death. The girl's black-and-white shape partially echoes the clouded moon, cold, indifferent, heedless of human affairs. But while the remote lunar disk has risen above and beyond the masts, her shape seems about to impale itself on a forest of spars.

Once again a Thomas Hood poem provides a gloss. "The Bridge of Sighs," which he wrote in the spring of 1844, movingly commemorates "One more Unfortunate, / Weary of breath, / Rashly importunate, / Gone to her death!" It was acclaimed at the time of publication for its compassion: Thackeray called it Hood's "Corunna, his Heights of Abraham— sickly, weak, wounded, he fell in full blaze and fame of that great victory." Hood's pervasive note of Christian charity overrides moralizing:

Touch her not scornfully;
Think of her mournfully,
Gently and humanly;
Not of the stains of her,
All that remains of her
Now is pure womanly.

The verses were inspired by the plight of a seamstress who threw herself and one of her illegitimate children into the Regent's Canal. She survived to be tried for the murder of her child and sentenced to death. Hood intended his poem to rebuke the establishment for exhibiting such callous indifference to the suffering of a young woman maddened by privation. Cruikshank changes the scene to Waterloo Bridge over the Thames; upwards of five hundred were drowned in the river each year, a majority being in the condition of Hood's "unfortunate," and of that number as many as thirty annually chose to leap from Waterloo Bridge.[77] The artist may have recollected one stanza in particular when designing his plate:

The bleak wind of March
Made her tremble and shiver;
But not the dark arch,
Or the black flowing river:
Mad from life's history,
Glad to death's mystery,
Swift to be hurl'd—
Any where, any where
Out of the world![78]

Cruikshank introduces another design and narrative element to reinforce the daughter's utter desolation: squeezed into the upper right-hand corner of the image, separated by the massive stones from the plummeting figure, a gentleman stretches out an unavailing arm while his female companion cries out. Reminiscent of the spectators in the gallery over the girl's head at the Old Bailey, they represent a world from which she has already taken leave: the world of the respectable, the sober, the middle class. No matter how much, in their benevolent hearts, they might like to rescue this fallen, falling sister, they are helpless. Waterloo Bridge, "something man-made" and "heartlessly colossal, hard and cold," as Harvey puts it, stands like the bar of the court and the less visible, but even more rigid bar of public opinion, between her and any succor. It simultaneously blocks her from humanity and sweeps her downward to her death.

The girl's final deed is captioned not as suicide but as "Self Murder," a violent act lineally descending from her father's murder of her mother whose reincarnation in some sense she is. The gesture in which she covers her eyes with her hands recalls the previous plate, where her brother's eyes were closed. In the design as well as the caption, Cruikshank manages to incorporate the salient moments of the previous graphic narrative, while simplifying and rendering the scene not in the discursive mode of commenting objects, nor in the symbolic mode of man traps and gin friends, but in the expressive mode. The whole evolution of Cruikshank's art is summed up in this plate: for one matchless moment he fuses the power of shapes, of narrative, of moral outrage, of empathy, and above all of tone and line to make an indelible image. Nothing could be further from, nor more clearly an outgrowth of, his Georgian conviction of people's capacity to ground themselves, to shape themselves and their destiny. The drunkard's daughter has lost all control to forces as impersonal, anonymous, monolithic, uncaring, and unyielding as the bridge: her ambiguously rendered flight (both soaring and falling) is, poignantly enough, the only human thing remaining—in her life and in the design.

Dickens reviewed *The Drunkard's Children* for the *Examiner*.[79] Instancing Hogarth as one predecessor who never scanted the underlying causes of intoxication and who spared neither high- nor low-class topers, Dickens

repeated his thesis that the root causes were unwholesome living conditions, fatigue of body and mind, the craving for stimulation, and ignorance. (Dickens was obstinately blind to the problems of alcoholism in respectable society.) Nonetheless, he declared the power of Cruikshank's closing scene "quite extraordinary":

> It haunts the remembrance, like an awful reality. It is full of passion and terror, and we question whether any other hand could so have rendered it. Nor, although far exceeding all that has gone before, as such a catastrophe should, is it without the strongest support all through the story. The death-bed scene on board the hulks—the convict who is composing the face—and the other who is drawing the screen round the bed's head—are masterpieces, worthy of the greatest painter. The reality of the place, and the fidelity with which every minute object illustrative of it is presented, are quite surprising. But the same feature is remarkable throughout. In the trial scene at the Old Bailey the eye may wander round the court, and observe everything that is a part of the place. The very light and atmosphere of the reality are reproduced with astonishing truth. So in the gin-shop and the beer-shop; no fragment of the fact is indicated and slurred over, but every shred of it is honestly made out.

Yet Dickens parts company over the one-sidedness of Cruikshank's teaching:

> When Mr. Cruikshank shows us, and shows us so forcibly and vigorously, that side of the medal on which the people in their crimes and faults are stamped, he is bound to help us to a glance at that other side on which the government that forms the people, with all *its* faults and vices, is no less plainly impressed. . . . Drunkenness does not begin [in the gin shop]. It has a teeming and reproachful history anterior to that stage; and at the remediable evil in that history, it is the duty of the moralist, if he strike at all, to strike deep and spare not.

Such strictures did not, as yet, sunder the friendship. Cruikshank was still acting in the amateur theatricals. On the very day that this anonymous review appeared (Cruikshank surely guessed the authorship), Dickens forwarded a letter from Archibald Alison of Glasgow inviting author and artist to go to Alison's after the first Glasgow performance ten days later. Also at that moment the two friends shared a particularly painful bond: Dickens's sister Fanny and Cruikshank's wife were both gravely ill.[80]

Nor did Dickens's reservations curtail sales. All the piracies and free borrowings hurt; so did the revolutions of 1848, which captured the attention of the public and deflected public agitation into more overtly political channels.[81] Rotch had little luck persuading wealthy teetotalers to buy large quantities for presentation to workers, and Percy's scheme to go on the road lecturing about *The Bottle* fizzled. (If Percy resented the "drip, drip, drip" of his uncle's water pump he was nonetheless willing to pump himself if it paid.) But the greatest blow was struck by the Americans, who did not take to the productions in anything like the numbers expected.[82]

Cruikshank had been in financial difficulties for some time, the result of *"many years of unsuccessful struggling,"* he told Adshead.[83] He dipped deeply into the pockets of Bogue, Adshead, and the usually compliant Merle. But by 1848 Merle, pressed by defaulting tenants on his estate, could no longer extend credit.[84] In February Cruikshank, straitened by the slim *Bottle* returns, borrowed £357 from Daniel Allen of Kent to keep himself clear of annoyance while he completed *The Drunkard's Children*. Beyond that, Cruikshank thought of other series. Allen proposed one about the royal children in the Windsor nursery, to be called "Worthy of Imitation or a Pattern of Domestic Life."[85] The Society for the Total Abolition of the Death Penalty wanted a series like *The Bottle* inveighing against capital punishment. To the extent that Cruikshank believed in hanging for murder, he was "not of their way of thinking"; but the instances of innocents being wrongfully executed weighed on his mind. "Unless I feel *thoroughly convinced,* that the object is correct, and just," he told Adshead, "I would not—indeed, I *could* not take any part in the Matter. I should be glad to have *your* opinion upon this subject."[86] If much might still be said on both sides, Cruikshank was now inclined to make up his own mind and to speak it, and only it.

Printer's delays, repeated renewals of bills, disappointing sales, and repayments to Merle tightened Cruikshank's economic noose: no wonder he had prophetically made the pound sign into a hangman's rope on the *Bank Note*. On his return from Edinburgh at the end of July, he found himself "a Bankrupt!" He had immediately to go to Windsor to fetch Mary Ann, but the day after, he promised Bogue, he would "have an interview with you to see what is to be done—with the affairs of—Yours truly."[87] Plans for a third set of glyphographs showing the blessings arising from abstinence went out the window. Instead, he offered to execute half-sized copies of *The Bottle* to sell by subscription to Temperance Societies for sixpence a suite.[88]

He had no other recourse. No writers wanted him to illustrate their books and journals, no publishers clamored for his art. He lacked capital to start a new venture. He possessed no savings account, no investments, no home to mortgage. Mary Ann was growing weaker by the day. The amateur theatrics charged him for expenses, put no money in his purse, and at best allowed him to travel to parts of the country where his Temperance views were popular. The few copyrights Cruikshank retained out of forty years' work paid him a pittance. Abstainers, though they had not yet secured his fortune, had to be his future patrons. And so he went back into his studio "to work much harder than ever the coalheavers do, down Durham Yard," reducing his own pictures to a still cheaper format for an ever more impecunious public.

34

ENGLAND IS NOT CALIFORNIA

*As his commercial prospects became blocked Cruikshank
looked towards the Ideal in one form or another, rendering him-
self unapproachable, refusing to work for Punch, turning down
all "unacceptable" offers until nothing but trifles came his way.*

William Feaver[1]

IT WAS NOT so much that Cruikshank rendered himself unap-
proachable or turned down dozens of offers—although after 1847
he did reject anything connected with alcohol—as that commissions for
any kind of work were so scarce he was compelled to accept the most trivial
assignments. By now he was expert in virtually every branch of his chosen
art, and could draw in diverse styles for very different sorts of patrons. Sir
Francis Bond Head wrote a book, *The Emigrant*, based on his experiences
as lieutenant governor of Upper Canada. In 1846 John Murray asked
Cruikshank to design modest embellishments for it. Never having been to
Canada, and not having to hand graphic representations of Canadian
scenes, the artist depicted from the instructions of Sir Francis and his son
the emigrant's hut, the surrounding trees, and an ax for felling them.[2] The
baronet liked the designs, so Murray paid £10.[3]

Cruikshank discussed with T. H. Sealy (for whom in 1839 he had etched
from the author's sketch a frontispiece for *The Little Old Man of the Wood*)
the possibility of illustrating another slender volume; but though conversa-
tions continued for some months, nothing came of them.[4] Mrs. Gore, who
had got to know Cruikshank when he illustrated *Modern Chivalry* in *Ains-
worth's Magazine*, asked him to make four steel-etchings for her 1845
Christmas Book, *The Snow Storm*; in each of the succeeding two years she
provided a similar holiday offering for which Cruikshank supplied compe-
tent vignettes, some of them delicately toned by freehand shading. These
were published by a leading printer of steel-engravings, Fisher, who had
issued the Scott edition and who specialized in annuals (Caroline Norton's
1847 *Drawing Room Scrap-Book*), illustrated travel books (*France, China,*

The Himalaya Mountains), Christian tracts (including the illustrated *Pilgrim's Progress* to which Cruikshank had contributed "Vanity Fair"), and Mrs. Ellis's *Women, Wives,* and *Daughters of England.* A safe, respectable list.[5] In his sprightliest Grimm style Cruikshank illuminated L. A. Chamerozow's *Yule Log for Everybody's Christmas Hearth.* George etched four vignettes, manufactured two glyphographs, and designed a cover block which was stamped in gilt.[6] None of these holiday pictures is bad, but few of them are inspired either. These minor commissions brought in necessary sovereigns, but they led to nothing substantial beyond themselves, either in further projects, fame, or fortune.

Cruikshank's most sustained connection during the latter half of the 1840s was with the Mayhew brothers. Henry, the eldest, was the genius of the family—"lovable, jolly, charming, bright, coaxing, and unprincipled," as an old friend puts it.[7] A brilliant and inexhaustible talker, endlessly propounding some new scheme but never staying the course to put it into effect, he was widely credited with originating *Punch,* but he lost editorial control early on to Mark Lemon.[8] Until 1845 he retained a staff position as "Suggestor-in-Chief," a role suited to his quicksilver mind and hatred of drudgery; then he severed all connections with the periodical. Subsequently he embarked on his extended investigations of London's lower classes and composed occasional jocular pieces. He was married to Douglas Jerrold's elder daughter, who used to write out his stories from dictation, and who coped with the creditors when, in February 1847, Henry applied for a certificate in bankruptcy.[9] Her brother Blanchard, an artist in his own right, was later to become Cruikshank's principal biographer.

Henry's younger brother Horace was the handsomest of the Mayhews, greeted by Thackeray as "Colonel Newcome" and christened by Wiltshire Stanton Austin as "the wicked old Marquis."[10] Horace started working for *Punch* as a subeditor, running errands back and forth between artists, writers, and editor. Soon this post of "pony" was abolished, but "Ponny" stayed on, joining the inner cabinet in the year of his brother's departure. Like his sibling, he was good natured and lively, but less substantial and more inclined to short whimsical articles and to carousing all night. His engagement to another of Jerrold's daughters was quashed by her father, who declared that "one Mayhew is enough in the family."

The seventh and youngest brother was Augustus Septimus, a slighter version of the Mayhew strain. He served as amanuensis for, collaborator with, and general factotum to Henry, tried his hand unsuccessfully at publishing a comic broadside, edited the *Comic Almanack* for seven years, coauthored several plays, and generally followed along in the wake of his seniors.

Cruikshank's acquaintance with the Mayhews preceded their collabora-

tions by several years. In the early forties, he belonged to a tavern club, "The Rationals," which met on Saturday afternoons at the Wrekin in Broad Court, Drury Lane. Cruikshank, Jerrold, Lemon, Henry Mayhew, Stanfield, and Thackeray regularly attended these jolly gatherings, which served as a kind of forerunner of *Punch* dinners.[11] Augustus, who was the most stage-struck, was friendly with Watts Phillips, Cruikshank's sometime pupil who became a moderately successful dramatist in the fifties. And Cruikshank heard about the Mayhews through Bradbury and Evans, Dickens, Leech, and others in the intersecting circles of early Victorian popular culture.

Henry Mayhew's financial difficulties coincided with Cruikshank's. It may have been the artist who brought the author to Bogue, described by the reputed authoress of Henry and Augustus's *Greatest Plague of Life* as "a gentleman of very good breeding" with a diffident grave manner and cheerful disposition.[12] Bogue agreed to publish in six monthly shilling numbers a comic story about Mrs. Caroline Sk—n—st—n's search for domestic help, purportedly written "By one who has been 'almost Worried to Death'." Cruikshank was hired to furnish two etchings per installment and to design a glyphographic wrapper design and title-page vignette.

Kathleen Tillotson, in her "Introductory" chapter to *Novels of the Eighteen-Forties*, points out that during this decade the British novel expanded its frontiers, exploring regions, classes, and situations beyond the narrow confines of the silver fork and romantic history genres.[13] One of those expanded frontiers was the contemporary domestic, rendered by Dickens and Thackeray in *Dombey and Son, Vanity Fair, David Copperfield*, and *Pendennis*, and at the lower reaches by tabloid fiction such as the Mayhews's. It is doubtful whether Henry or Augustus knew much about household economy; their notions derived from secondary sources—anecdote, the theater, and *Punch*. But Cruikshank may have had firsthand experience, since Mary Ann's increasing infirmities threw upon him more and more responsibility. If so, then *Plague* testifies in yet another way to the sea change Cruikshank's life had undergone. It is inconceivable that the Regency buck who stayed out all night and then burst in on Hone or Dickens would have been intimately acquainted with the cares of domestic management, however much he may have learned in public houses and dance halls about life below stairs.

The authoress fears that George Cruikshank "would be too funny for a work of so serious a character" as her plaintive narrative about insubordinate domestics, but Bogue tells her "that Mr. Cruikshank was a man of such versatile genius, that he was sure that the drawings from his intellectual pencil would be quite in keeping with the book."[14] Accordingly, Mrs. Sk—n—st—n visits Cruikshank at home, giving an account of her meet-

ing, which testifies in yet another way to the extent of George's celebrity. She is thrilled to find the brass so highly polished and the maid so tidy, but is even more delighted by her first encounter with the artist whom she considers "the Constable of the day":

> Nature has evidently thrown Mr. Cruikshank's whole soul into his face; there is (if I may be allowed the expression) a fire in his eye which is quite cheerful to look at; and when he speaks, from the cordial tone of his discourse, you feel as certain, as if his bosom was laid bare to you, that his heart is in its right place. Nor can I omit to mention the picturesque look of his whiskers, which are full and remarkably handsome, and at once tell you that they have been touched by the hand of a great painter.[15]

This amiable gentlemen consents to delineate the features of the authoress's former servants, volunteers to do a frontispiece portrait of her—for which she need not sit, as "he had already got my whole form engraved in his mind's eye"—and bows her out the door.

The best *Plague* plates concern the follies of servants: "The Cat did it" illustrates the charwoman's excuse that the breakage of crockery and disappearance of victuals are attributable to the tom she introduced to catch rats. Cruikshank fills the kitchen with such a multitude of cats—one of them a black devil tom with a hammer—that the excuse becomes wildly magnified, the destruction multiplies manyfold, and the whole scene evokes not so much the mundane mishaps of a middle-class dwelling as the mythic depradations of the animals in the Grimm brothers' tale of the Bremen musicians. The second plate (fig. 55) in this part (II) images another servant's excuse, this time the maid's explanation that the handsome soldier who has clearly been paying court to her is innocently engaged: "It's my Cousin M'am!"[16] The plates tend to sympathize with the staff more than the mistress, even though in Cruikshank's case knowledge of "the servant problem," about which *Punch* puzzled its wooden head so often, grew from personal trials as well as from the comic tradition. He and the Mayhews evidently had a good time making fun of anxious housewives to whom cleanliness and show were preferable to old-fashioned kindness and consideration. They could register bourgeois efforts to emulate the gentry without endorsing them.

The *Plague* having answered well enough, Bogue then commissioned the same trio to produce a Christmas fairy tale: *The Good Genius that turned Everything into Gold, or the Queen Bee and the Magic Dress.*[17] A progeny of *Cinderella* and *A Christmas Carol*, this story is enlivened by four Cruikshank etchings, four glyphographs, a wood-engraved tailpiece, and gilt cover and spine designs stamped onto green cloth to make a pretty Christmas gift. In these illustrations Cruikshank takes his facility for exaggerating contrasts of scale to its greatest extreme: the bee turns a forest into

55. *George Cruikshank, "'It's my Cousin M'am!',"* The Greatest Plague of Life, *etching, 1847*

a fleet of ships and a colossus of rocks into a gigantic palace. Bogue issued the work in his series of "Books for the Race, Road & Fireside," subcategory "The Magic of Industry." At this point the collaborators badly needed their own "magic," their own good genius. Mayhew sent Cruikshank "all the gold I have in my locker," promising another pound when he went to the

office to collect money for expenses.[18] Sterling went the other way as well. Cruikshank lent to the youngest Mayhew sums he could not repay: "I am hard at work and have indeed been doing all I can for you," Augustus assured his creditor, but until the *Illustrated London News* paid him for an article not yet completed, he could not forward even a portion of his debt.[19]

In 1848 Bogue, Cruikshank, and the Mayhew brothers elected to capitalize on the most popular joke *Punch* ever published, one originated by Henry Mayhew and printed under "January" in the 1845 [*Punch's*] *Comic Almanac*. Based on the eye-catching wording of a widely circulated advertisement for home furnishings sold by Eamonson & Co., it ran:

WORTHY OF ATTENTION
ADVICE TO PERSONS ABOUT TO MARRY,—Don't![20]

Whom to Marry and How to get Married! or, The Adventures of a Lady in Search of a Good Husband resembled *Plague* in many respects: it came out in six monthly shilling numbers from November 1847 through April 1848, contained twelve illustrations and a glyphographic wrapper design, and purported to be the writing of a lady "WHO HAS REFUSED 'TWENTY EXCELLENT OFFERS' AT LEAST."[21] While busy with these illustrations, Cruikshank turned down other jobs; even so, he could not etch the second plate for the March 1848 number in time.[22] The April plates were delayed too, as Cruikshank could make nothing of the text and supposed he would have to illustrate "the one where the pair are leaving the church."[23] On the inside back wrapper of the last number Bogue advertised the first two shilling parts of yet another series of sketches of London life and character, this time written by Shirley Brooks, Angus Reach, and Albert Smith, and illustrated by Gavarni, "the Cruikshank of France."

While Henry and Augustus wrote books, Horace was helping to edit Cruikshank's *Comic Almanack*, by now falling far behind its *Punch* rival. The *Dictionary of National Biography* speaks of the "brilliant staff" Cruikshank assembled to write for his *Table-Book*, many of whom, including Horace Mayhew, also contributed to the *Almanack*.[24] There were some amusing stories to accompany Cruikshank's often brilliant plates in the later *Almanacks*, though much of the topical humor is unrecoverable. One that elicited favorable notice from the *Literary Gazette* was Horace Mayhew's spoof on highly wrought pseudohistorical fine art furniture. It too latched onto Henry Mayhew's famous *mot*, being entitled "VALUABLE ADVICE" and commencing: "To Persons about to Marry.—Don't buy your furniture at Felix Summerley's Cheap Art-Manufacture Mart." The succeeding story relates the shopping expedition of a fond but imprudent couple who purchase a Stonehenge dressing table, a Grecian washstand, an

Egyptian clotheshorse (the favorite design of Edwin Landseer), and other expensive, ugly, and spuriously historical furnishings. "In this instance," Cruikshank explained in a draft letter to the editor of the *Literary Gazette*, "it does so happen that the very article you compliment so highly I had nothing to do with. It was written by my friend, Horace Mayhew, and was meant as a good natured quiz upon the Fine Art Manufactures."[25]

Horace sometimes fell behind in his editorial duties or otherwise incurred the wrath of his employer. From Ramsgate in August 1848, "Your 'Comic' Editor, (hon. fellow)" begs Cruikshank not to be angry with him, and promises to do any penance to please him.[26] Like his brothers, Horace was a fertile inventor of subjects of comic illustration: he supplied George with the idea for a charming "toy," *The Toothache*, a hand-colored strip narrative in forty-three images depicting the agonies, indecisions, procrastinations, medications, and fulminations of one afflicted with a bad molar and a worse fear of dentistry.[27] Free of any moralizing about Temperance, light-hearted and spirited, inventive in using the confines of a strip cartoon to tell the story, *The Toothache* sparkles as a playful, empathetic, rueful, and altogether funny jeu d'esprit. It is all the more remarkable when put into context. Cruikshank's life by the beginning of 1849 was a nearly insupportable overlay of crises, financial and domestic. His every note to Bogue pleads for money: "I [am] . . . more convinced than ever, that England is not California," he says in one letter, alluding to the gold rush.[28]

As the amateur theatricals soaked up Dickens's excess energies and distracted him from mounting personal cares, so too for Cruikshank—acting got him out of the house and into a situation where there was enthusiastic applause and lots of comradely bustle. During the autumn of 1847 Dickens formed the Society of Amateur Players to raise money for the London Shakespeare Committee, which had helped to purchase the Stratford birthplace and wanted to assist the government in endowing a curatorship to be offered to Sheridan Knowles. Plays by Beaumont and Fletcher, Goldsmith, Jerrold, and Bulwer were considered; in November the choice seemed to fall on Jonson's *The Alchemist*. Frederick Dickens, secretary of the society, who acted as production assistant to his brother, invited Cruikshank to a reading of the play on Tuesday, 16 November, at Miss Kelly's Theatre; by the end of the month Cruikshank had his part.[29] But Jonson didn't suit all the company. Fred then told Cruikshank to look over the part of the tailor Frank in Bulwer's *Money*, Pistol in Shakespeare's *Merry Wives*, and—of all things, just four months after *The Bottle*—the Drunken Butler in Goldsmith's *Good Natured Man*.[30] However insensitive Dickens was to this bit of casting, Fred took a more sympathetic line, asking the following year for signed proofs of *The Drunkard's Children* to match those for *The*

Bottle. Fred had just married, despite much opposition from both families. He was "anxious to make my little home look as *neat,* & as *intellectual* as far as lies in my power, & I couldn't do so, more appropriately, or with more sincerity, than with the works 'last from the press' of the 'Immortal George'."[31]

For a time, *Money* was put into rehearsal; Cruikshank was also booked to play in Jerrold's *The Rent Day*, which was to alternate with it.[32] As late as 21 February, Fred was sending out rehearsal schedules leading to end-of-March performances at the St. James's Theatre, but a week thereafter Dickens was so disgusted by the behavior of some of his troupe who, unreliable about attendance, inconvenienced the rest, that he decided to abandon the performances.[33] By mid-April the project was back on track with a revival of *Every Man in His Humour*, in which Cruikshank played Oliver Cobb. For the afterpieces, Cruikshank reprised his role of Roué in *Comfortable Lodgings* and Old Knibbs in *Turning the Tables*, and also performed comic roles in Mrs. Inchbald's farce *Animal Magnetism* and James Kenney's farce *Love, Law and Physic.*[34]

George was best in exaggerated roles that allowed him free rein to explode all over the stage; subtle shadings of character or subdued, pathetic types were not his style. The *Morning Herald* described Leech and Cruikshank as "the drollest of adjuncts" to Dickens and Lemon in *Animal Magnetism,* and Mary Cowden Clarke, hired to play Dame Quickly, recorded that George as Ancient Pistol "was supremely artistic in 'get up,' costume, and attitude; fantastic, spasmodic, ranting, bullying."[35] Percy demurred. "George Cruikshank, as *Pistol,* did not go off with the loudness belonging to it; in private life, his voice was distinct, and vigorous enough; but in public speaking, by some mismanagement it was ineffective, his delineation of the bullying sot, being deficient in the necessary 'base' tone."[36]

The Society of Amateur Players performed first at the Haymarket in London on 15 and 17 May to mixed reviews. The day following the second performance Dickens wrote to invite the company to a dinner at Greenwich on the 23rd, but Cruikshank was too busy to join them: "Every hour is at present of the utmost importance to me . . . the Rehearsals have absorbed so much of my time" that he could not complete *The Drunkard's Children.* He told Dickens, who planned to announce the provincial touring arrangements at the dinner, that he hoped they would not set forth until the second week of June.[37] But the tour was pushed up to the beginning of the month. Mary Ann was well enough to accompany her husband to the Midlands and to appreciate the thunderous reception he received in Birmingham.[38] In general the audience roared loudest when Dickens appeared, but on 6 June "such a rave of delight was heard at an unaccustomed point of the play," Mrs. Cowden Clarke recalled,

that we in the Greenroom (who watched with interested ears the various "receptions" given) exclaimed, "Why, who's that gone on to the stage?" It proved to be George Cruikshanks, whose series of admirably impressive pictures . . . had lately appeared in Birmingham, and had been known to have wrought some wonderful effects in the way of restraining men from immoderate use of drink.[39]

For the second Glasgow performance on 20 July, Dickens worked up a two-act comedy by Dion Boucicault and Charles Mathews, *Used Up*. He offered Cruikshank a choice between two roles: "The blacksmith, John Ironbrace, is a rough bare-armed strong fellow, always in a passion. Sir Adonis Leech is a middle-aged dandy, with no heart and a mighty appetite. You will observe that there are a good many words in Ironbrace, and that there is not a very long time to study them in."[40] Predictably, George would have nothing to do with the middle-aged dandy. He picked the ranting blacksmith, leaving Adonis for Mark Lemon, who had preferred that role from the beginning. Packed houses greeted the actors in Edinburgh and Glasgow, and a few months after their return Forster presented Sheridan Knowles with a lump sum of £575. Despite John Wight's fantasies, none of the proceeds enriched himself or Cruikshank.

The Amateur Players gave Cruikshank an opportunity to let off steam, to lord it before a blaze of footlights over those who, like Lemon and Dickens, were doing much better off stage, and to obtain a firsthand impression of the effect his Temperance plates were having outside London. After Mary Ann's death, when he was once again able to travel, he took numerous trips north to chair and speak at teetotal meetings and thereby acquainted himself with a wide range of new supporters. He also gained from Mrs. Cowden Clarke a commission to illustrate her 1849 story, *Kit Bam's Adventures*.[41] So the digression into the theater in several ways expanded Cruikshank's narrowing horizons. But it put him behind with his work and marked the penultimate turning point in his friendship with Charles Dickens. After July of 1848 their ways diverged more and more acutely. When at one of Dickens's dinners Cruikshank snatched a glass of wine from the hand of Henrietta Ward, wife of the Royal Academician, Dickens remonstrated forcefully. "How dare you touch Mrs. Ward's glass? It is an unpardonable liberty. What do you mean? Because someone you know was a drunkard for forty years, it is not for you to object to an innocent glass of sherry."[42] One wonders whether Cruikshank subconsciously picked the role of Ironbrace because he gets into a fight with the character Dickens portrayed.

In 1848 Cruikshank started three new assignments along familiar lines. He devised twelve pictures on six plates for a translation of Neapolitan fairy tales. He commenced steel-engravings for an expanded reissue of Frank Smedley's *Frank Fairlegh*. And he began etching illustrations for a shilling

monthly written concurrently by Angus Reach and published by Bogue. In the first instance, Cruikshank returned to the fanciful subjects he had depicted so charmingly in the twenties; in the second, he reprised the collaboration with Boz of the thirties; and in the third, he worked within the patterns developed with Ainsworth in the early forties. Predictably, imitations of last decade's hits failed to stimulate artist or public.

John Edward Taylor translated (with the help of Gabriele Rossetti), expurgated, and adapted *The Pentamerone, or The Story of Stories, Fun for the Little Ones* from the Italian of Giambattista Basile.[43] Taylor, the printer who had been involved in the Grimm project twenty years previously, had taken an intermediate book, *The Fairy Ring*, to Richard Doyle for pictorial embellishing. This time he teamed once again with his Grimm collaborator, and the results were delightful. Cruikshank etched some of his finest plates in the fairy vein; they were first issued uncolored in a volume bound by crimson-figured cloth covers stamped with a gilt design also by him. When this attractive holiday present sold out, Bogue reissued it with the plates colored. Its comparative success encouraged Cruikshank, a few years later, to readdress the subject of fairy tales and to try on his own both to write and to illustrate some of the classics.

Frank Smedley's *Frank Fairlegh* was a different proposition. Smedley, born into a prominent Buckinghamshire family (his father was high bailiff of Westminster), because of a handicap, congenitally malformed feet, could not attend Westminster school where several of his relatives had played prominent roles. He was therefore tutored at home, eventually by his uncle who had once been an usher at Westminster. A delicate, sensitive boy, he however loved sports and the robust activities of his peers. Excepting Tom Hughes, Smedley wrote the best British story about adolescent schoolboys. First published in *Sharpe's London Magazine* (1846–1848), for which Smedley subsequently served as an unpaid editor, "Scenes from the Life of a Private Pupil" received such enthusiastic responses that he decided to expand it and issue it in sixteen-as-fifteen shilling monthly parts.[44] Cruikshank was hired to etch thirty steels and to make a cover design for the blue-green paper wrappers. Both the color of the paper and the design resembled Browne's wrapper for the concurrent Dickens serial about schooldays, *David Copperfield*. The publisher, Virtue, was rapidly becoming a leading house for steel-engravings, so from the standpoint of technical proficiency it was admirably equipped to do justice to the artist's most sensitive lines.

Cruikshank obtained a copy of the magazine serial; in the margins he made notes and around fifty pencil and watercolor drawings, experimenting with the composition of figures, settings, gestures, and faces.[45] Perhaps as Smedley revised there were opportunities for the artist to suggest changes

to suit the pencil, although no correspondence with the author has turned up. The sweetness of Smedley's temperament gentles Cruikshank's portrayals of youthful mishaps and ardor to such an extent that, while the plates are spirited and carefully executed, George begins to resemble Phiz. That was a bad direction to take, for it suppressed Cruikshank's manic primal energy and made Browne the more appropriate illustrator. Accordingly, Smedley's other novels were illustrated by Phiz. All was not lost for Cruikshank, however; a subsequent meeting led him to ask Smedley to edit the last of Cruikshank's periodicals.

George's third collaborator was well known to him, for Angus Bethune Reach had contributed the "Jacob's Island" article to *Our Own Times*. Reach, born in 1821, was the son of an Inverness solicitor and writer to the Signet. He came down to London to earn a living by writing. Charles Mackay, then subeditor of the *Morning Chronicle*, was amply repaid for hiring him when Reach's series on "Labour and the Poor" created a sensation. Reach teamed with his dearest friend Shirley Brooks and with Albert Smith in a successful—sometimes scornful—rival to *Punch*, *The Man in the Moon* (1847–1849). His name, pronounced "Re-ack," led Jerrold (who had often been ridiculed in the *Moon*) to heckle him at the *Punch* table, which Reach joined in 1849: at one dinner, Jerrold asked, "Mr. Re-ack, may I pass you a pe-ack?" On another occasion—for Jerrold could be merciless—when the young man complained about his ill-usage, Jerrold quipped: "Oh, I see. Re-ack when we speak to you, but *reach* when we read you!"[46]

An indefatigable writer, Reach in late 1848 began penning a novel about a three-centuries-long vendetta, *Clement Lorimer, or The Book with the Iron Clasps.*[47] Author took artist into his confidence early in the composition; in one undated letter Reach responds favorably to a suggestion Cruikshank made about putting the prior history of this vendetta into a prologue. Both felt the main body of the tale should deal with the abundant romance found in everyday contemporary London.[48] A short while thereafter Reach finished the pages concerning the frontispiece (illustrating the first chapter of the prologue) and promised to call on Cruikshank with the manuscript.[49] In another letter he planned to come up from Maidenhead to see the artist before George left town. On the verso, Cruikshank scribbled two columns of ideas for twin sixteen-print sequels to *The Bottle*: one sequence tracing the beneficial effects of teetotalism on a family, the other tracking the decline of a family where moderate drinking and smoking are practiced.[50]

At first Cruikshank responded to this friendly collaboration with renewed vigor. The frontispiece (fig. 56), heavily machine ruled and crosshatched, depicts the stairs, doorway, and room of old Raphael Benosa, who, dying on 1 May 1610, bequeaths to his son Michael "The Book with the

THE BOOK WITH THE IRON CLASPS.

GEORGE CRUIKSHANK

56. *George Cruikshank,* frontispiece *to* Clement Lorimer, *etching, 1849*

Iron Clasps," which registers the commencement of the vendetta against the Vanderstein family whose scion is dying across the way. Cruikshank tries to give the tonal effect of an Old Master, and, in particularizing the furniture, vials of poison, opened chest, and flaring candle at the window, he imbues the room with an atmosphere of mystery and menace. Several of the other plates experiment with new modes of framing the image—within an oval surrounded by a ruled border, or contained within the beams of a barn where the Derby favorite is being drugged. Later on, as the scene shifts to contemporary London, the illustrations become oval vignettes without any border, and the last two, rectangles with rounded corners, seem to imitate the shape of early photographs. At first, too, Cruikshank tries to spend a good deal of care on each image: "I wish you would contrive to let me have two more subjects for 'Clement Lorimer'—immediately—," he wrote to Reach on 29 January 1849, "so as to give plenty of time to execute in."[51]

Reach's melodramatic tale hurtles on through its six installments, propelled by increasingly fantastic motivations: a Benosa descendant murders his beloved wife because she is a Vanderstein; the heroine Marion Eske is doped, abducted, and presumed dead; the titular hero is tried for murder. These incidents hardly constitute the romance of everyday life that Reach said he wanted to tell. Faced with such derivative stuff, distracted by Mary Ann's irremediable decline and his own insolvency, Cruikshank put less and less invention into the plates. One, "Miss Eske carried away during her Trance," simply combines the setting under a Thames bridge arch that Cruikshank had used so memorably in the *Jack Sheppard* "Storm" with the lightning effects he perfected in "Herne the Hunter appearing to Henry on the Terrace" for *Windsor Castle*. Cruikshank's work devolved into the same kind of warmed-over pastiche of historical romance as Reach's.

Another direction Cruikshank might have followed was foreclosed when Frederick Marryat died in August 1848. Despite his great inheritance and considerable earnings from fiction, the captain had experienced financial problems during the forties and had taken to writing children's books at a furious rate. George had approached him with an offer to edit a continuation of the *Omnibus* during the unsettled days of Ainsworth's flip-flopping; other projects, however, supervened.[52] Once in February 1845, Marryat came to town to attend a "get-up" at Dickens's house where children and adults had separate balls, suppers, and singing: "Everyone there," he noted, "Talfourd, Macready, Cruikshank, Landor, Stanfield, Forster, and a hundred more."[53] Yet the strain of unremitting authorship impaired Marryat's health. He decided instead to apply to the Admiralty for sea duty; when turned down, he grew so angry he burst a pulmonary blood vessel. As he gradually recovered, word reached him of the death of his eldest son at sea; that news finished him, and he died on 9 August.

And now Mary Ann clearly was weakening. More and more often Cruik-shank took her out of town to be nursed in the country air of Windsor. He struggled to pay the bills, visit her, and keep up Amwell Street in the manner she liked. Sometimes the press of business delayed his trips. "I find it is not possible to get away this Ev[enin]g," he wrote on 26 October 1848, "as it is now half past 4 and Sands has not yet brought the plate—However you may depend upon my coming down in the *morning*—and will bring the Boots with [me.] The mutton shall be ordered and the money I will bring."[54] In January she was home again, but unable to venture forth to a christen-ing. By the spring Cruikshank had to place her in a nursing home in Ealing where little by little her slight reserves of strength slipped away.

She was only forty-two. She had known Cruikshank for nearly thirty years, had shared his triumphs, attended the theater with Boz and Bentley, dined with leading writers and publishers and wits, watched her godson grow up, received all manner of strange and notable persons who came to visit her husband, tended George in illness and low spirits and when he showed up disheveled and repentant after a night's entertainment, tried to befriend his companions (though she told the Dickenses she hated the Hone daughters, who may have been excessively flirtatious), managed to stay on speaking terms with George's redoubtable mother and wayward brother, cared for her home and supervised the servants, and tolerated the fumes and mess and uncertainties of a life that revolved around an etcher's papers, presses, chemicals, and inks.[55] She could do no more. On 28 May she succumbed to the pulmonary consumption which had been certified two years before. She did not die at home, amid the comforts of her own bed, possessions, and spaniel, but at Ealing, attended by Elizabeth Gray, possibly the owner or lessee of the house, or maybe a nurse.

The funeral was a small affair—a simple elm coffin, a one-horse hearse, two coaches, two mutes, a plume of ostrich feathers. The Reverend Dr. Stebbing conducted the service at St. Pancras Old Church, its pastiche Grecian façade blackened by the soot issuing from the adjacent Euston Station. George still hadn't cleared off the £20 bill seven months later.[56]

When he came home from the burial, how did Cruikshank feel? Did he regret past conduct, hasty words, the absence of children? Or did he dwell on memories of courtship, parties, happy private moments? Did he wander through the empty rooms, picking up Mary Ann's favorite objects and put-ting them aside again, bundling up her private papers and sorting through any correspondence for mementoes? Almost nothing remains that testifies to his specific reactions. But the blow was a sharp one, leaving him dazed, ill, and unable to work.

Letters of condolence arrived from many quarters. Octavian Blewitt, sec-retary from 1839 to 1884 of the Royal Literary Fund, sent a report on one of

the candidates George had recommended for a grant, and learned in return of Mary Ann's death. He immediately posted a letter of apology and sympathy on behalf of his wife and himself.[57] Wills penned condolences "for the loss of the companion of so many years."[58] In his acknowledgment Cruikshank betrays a longing for family. He sends his "kindest regards" to Fanny Chambers, one of Robert Chambers's daughters evidently staying with the Willses at Atholl Cottage: "Their kind treatment while I was in Edinburgh was such as to make me feel like a relation towards them."[59] The blunt, cantankerous Forster, who could be such a formidably severe critic and yet such a faithful friend, immediately composed a note of sympathy which George felt "very sensibly."[60]

And then Cruikshank collapsed. The man who prided himself on his physique, his strength, his resilience, suffered a kind of breakdown—not exactly a nervous breakdown, but a general debility that left him without the power to concentrate. As he explained to Merle:

> The many years of anxiety, & the desperate struggle that I have had to keep up my position—as a poor Gentleman—the long—years long, illness of my poor wife—and then the crushing blow of her death! was altogether too much for my strength to bear—and altho' I went on with my usual exertions for a time—I at last sank under my distress of mind—and for the first time in my life knew what illness and the headack was—and for the first time in my life—could not work!! I used to sit at my table—or the easel—and look at them—but *could not work*.[61]

For the next few months letters refer to his "disarranged state of health." His finances were also disarranged, as he explained in refusing Edward Lewis's commission to illustrate "The Sermon on Malt":

> By the rascality of American pirates I lost last year above £500 and I consider that the insane French Revolution—and the mad Chartist riots were the cause of the loss of another 500—added to this—I have with my usual good nature or folly rather—lent about 700—out of which in three years I have not been able to get back more than 80—In fact what with losses in Speculations—lending my money—and being bound for friends—I am almost ruined—and by paying other peoples debts—am now compelled to borrow money to pay my own.[62]

What is not mentioned in this letter is that Cruikshank had been supporting his own household, paying the nursing home bills, and also contributing substantially to the upkeep of his brother Robert, his sister-in-law, and his nephew.[63]

One project started during Mary Ann's last illness did seek to tap a golden seam: Cruikshank resumed oil painting. He had already completed a picture of Robert the Bruce escaping assassins which he hung over the chimney-piece in his study, a work "full of spirit and fire" according to Mrs Sk—n—st—n, though she did not think Cruikshank shone "so much in Oil as he does in Water."[64] Oddly enough, working on canvas with a fine

57. *George Cruikshank,* The Disturbed Congregation, *oil painting, 1849 (The Royal Collection © Her Majesty Queen Elizabeth II)*

brush strained his eyes more than peering through shiny resist at the micro-scopic scratches on the surface of a steel plate or standing over an acid bath blinking back the fumes while he bit in the lines. On 28 March 1849 Cruikshank ordered a pair of eyeglasses to try for a day or two. "I have never yet worn any—nor do I require them for ordinary purposes, but I am now painting a small picture in oil—an unusual sort of thing for me—and as there is a good deal of neat work required in it—I am afraid of straining the eye—particularly as I have to work at it by lamplight. You will understand me better perhaps," he told the optician, "when I tell you that all I want is *preservers.*"[65] Evidently the experiment was not a success, or else Cruik-shank wore "preservers" only in the studio, for photographs never show him with glasses. He remained as sensitive to the charge of nearsightedness as he had been in correcting his "Portrait" seven years earlier.

The picture (fig. 57), painted with or without optical aids, was far enough along to be sent on approval to Buckingham Palace just before Mary Ann died. Prince Albert agreed to purchase *The Disturbed Congrega-tion* for thirty guineas, so Cruikshank completed it during the weeks follow-

ing the funeral.[66] This was a very different way of obtaining royal patronage from the oblique methods of the Georgian era, and gave the aging artist hope that at last he might be recognized by the highest ranks of society.

In August Cruikshank went to Hythe, canceling Temperance engagements but taking with him materials to finish up the *Comic Almanack*. There he managed to complete the large folding plate envisaging "A New Court of Queens Bench" trying a suit for "Breach of Promise." On the attorneys' table lie various books and documents recording such actions, including the program at Her Majesty's Theatre for a performance of *Don Giovanni* and "Boz's Law Reports[:] The Cause of Bardell v Pickwick." Cruikshank had talked over the plate and the accompanying letterpress with Mayhew, but told Bogue that he could not remember the changes Horace suggested and wanted Bogue to consult with the author further and let him know the result. He also reported that although he had not yet quite recovered his customary health, he was once again able to work; that he had colored the plate to provide a model for the rest; and that he needed £5 immediately, another £5 within a few days, and a third installment by the beginning of next week, or else "I suppose the good folks here will be locking [me] up in the cage—of Hythe."[67] In his haste Cruikshank adds an extra letter to some words, another sign that the artist was still distraught.[68]

35

I AM BECOME A NAME

I am become a name;
For always roaming with a hungry heart
Much have I seen and known; cities of men
And manners, climates, councils, governments,
Myself not least, but honoured of them all:
. .
How dull it is to pause, to make an end,
To rust unburnished, not to shine in use!
As though to breathe were life.

Tennyson, "Ulysses"[1]

GEORGE CRUIKSHANK could hardly be compared with Homer's wily Odysseus, but at midcentury he did have much in common with the aging, disillusioned, restless Ulysses of Tennyson's poem. Not only had the time passed when, in his youth, Cruikshank had known councils and governments, sold his caricatures to the Prince Regent and defied laws suppressing free speech, ridiculed an emperor and lampooned a king, but even those in whose memory those moments remained green were passing from the scene. The second generation with whom the artist shared fame and honor—the *Fraser's* circle, Dickens and Ainsworth and Marryat—had either gone off in other directions or died. When Mary Ann was laid to rest, one of the few remaining ties to those earlier eras was buried. Temperamentally and financially unable to rust unburnished, not to shine in use, Cruikshank embarked on other voyages, seeking fame in newer worlds as yet unconquered. But like Ulysses, he was valued for his name, for what it called up about past achievements and battles now almost as mythical as those on the plains of Troy or the fields at Waterloo. On that name, and on the stories he could tell about the past, he contrived to live for another thirty years. But the efforts of the old warrior to return to combat alongside the children and grandchildren of his fallen comrades, and to share the making of policy with Telemachus and all the prudent, decent, unheroic

administrators of the island, were doomed. The loss of name and fame and use was a fatality Cruikshank fought, unavailingly but unwaveringly, to the end of his days.

In this struggle George was companioned, not by an "aged wife," but by a devoted middle-aged spouse and a secret mistress who bore him ten children. Cruikshank's public life displayed the character of unimpeachable mid-Victorian propriety, while his private life was fractured between two very different households, one highly conventional, bourgeois, and exemplary, the other concealed behind pseudonyms and filled with the noise, bustle, and genial disorder created when a large family attended by a single parent scrapes by on the slenderest of incomes. Cruikshank was never able to adapt either his style or his conduct to the era of Victoria and Albert.

That he was able to survive at all as a working artist testifies to Cruikshank's extraordinary efforts to participate in national life; but the ways he survived artistically bespeak the same kinds of fissures that ran through his domestic arrangements. He could not give up the habits, assumptions, and patterns etched into his being during his youth: he either had to suppress them, with an extremity of effort that struck others as ludicrously exaggerated and out of place, or to distort, deflect, and co-opt them. Book illustration issues in narrative oil painting; social and political propaganda gets reinscribed in prints and pamphlets about intemperance, sucking umbrella handles, securing the home against burglary, defending volunteer military corps, or attacking an extension of the franchise. Cruikshank's moderate radicalism hardens into quirky conservatism, and his intuitively conceived, rapidly executed etchings rigidify into formulaic, overdone facsimiles, while his Regency escapades domesticate into complementary parodies of the bourgeois ideal.

A few months after Mary Ann's decease, Cruikshank was invited to Harrogate to visit Linnaeus and Isabella Banks. Named by his father, a Birmingham seedsman, after the great Swedish botanist, Banks had an irregular education, was for a time apprenticed to a cabinetmaker, learned to make silhouette portraits, and eventually became a miscellaneous writer, periodical editor, poet, and advocate of political enfranchisement and social advancement for the lower classes. His wife, Isabella Varley, wrote poems and novels, and together with her husband participated in the intellectual movements and social reforms agitating the north of England. They became acquainted with Cruikshank through Temperance: when he agreed to speak at a "Dejeuner and Soiree," they arranged for a "small friendly cavalcade" to escort the artist on his arrival from the station "to the Bank, our local California."[2]

Before leaving London, George had renewed and deepened his friendship with Charles Baldwyn's niece, Eliza Widdison. Writing daily bulletins

about his northern tour to "Dear Widdy," he reports that Banks is "a very pleasant good natured fellow" and his wife is "a very nice little chatty—agreeable—body." The endearments, the promise to call as soon as he returns, her birthday greetings for which he returns thanks, all confirm that Cruikshank had quickly transferred his affection to Eliza. No wonder that Mary Ann sensed a reserve in Miss Widdison; although no hint of impropriety exists, a strong current of attraction between Eliza and George may have been running for years. When George went to Coventry in October supposedly to stay with Marian Evans's friends the Brays (something went wrong and he was put up by a family of Quakers instead), he resolved not to travel again until Eliza could accompany him.[3]

At the time, Eliza was living at 24 Dalby Terrace, City Road, with her mother and her aunt Amelia, widow of the chemist James Parratt. Eliza, the same age as Mary Ann, had attended a school in Putney from 1826 to 1829, studying French, music (her favorite subject), drawing, and dancing.[4] She never married, went into service, became a governess, or opened a shop. She evidently lived on the small income her mother and aunt received from the estates of their late husbands, and she remained friendly with her Norfolk uncle, George Linstead, the saddler and harnessmaker widowed in 1847, who had taken in Elizabeth and Frances Baldwyn at their father's death in 1824. The Linsteads were a close, supportive family, concerned about each other's welfare, keeping up a regular correspondence between London and Kenninghall, sharing incomes and combining households when necessary, looking after orphaned children and widows, attending weddings and funerals as a matter of course. That "nearer connexion" which Charles Baldwyn had made in spite of his adoptive father's objections functioned much more responsibly than the paternal relations.

Eliza seems to have been particularly reliable. If she depended on her mother and aunt for income, they depended on her to manage the housekeeping. She knew how to make out laundry lists, to budget, to keep track of correspondence. Her kindliness and good judgment made her a natural choice to be executrix of wills, trustee of funds, and guardian of the unmarried. She may not have been well educated, intellectual, ambitious, or exceptionally attractive, but neither was she ill natured, selfish, or reclusive. Her failure to marry had not soured her on men; she kept her own counsel, enjoyed such society as was allowed by her status and station, and when Cruikshank became available, like her aunt before her she wooed the widower and won him.

Within a few weeks Cruikshank was shopping for a new home. Perhaps Amwell Street housed too many memories; maybe he was already contemplating marriage to Eliza. In any case, he thought he found the right one, only to learn that the lessor had changed his mind. "The House will cer-

tainly not suit me as it is," he complained; "I must say that asking 40 gns. [is] rather high—particularly when I compare it with the one I am now in at 55."[5] Then he heard about the house once occupied by Clarkson Stanfield at 48 Mornington Place, a few turnings up the Hampstead Road from the London Temperance Hospital and separated from Regent's Park to the west by the Euston tracks.[6] Robert Brown was the lessor. Cruikshank entered into negotiations with him, and finally signed a lease from Lady Day 1850 at £80 per annum.[7] This was double the rent he had objected to as "rather high," and required, if he were to maintain a middle-class standard, an income of around £800 per year.[8] Given the nature of George's finances, he must have been counting on Eliza's family income to meet the bills.

On 7 March 1850 George Cruikshank married Eliza Widdison by license at Holy Trinity Church, Cloudesley Square, Islington, Barry's 1826 version of King's College Chapel, Cambridge.[9] On the marriage certificate she is identified as a spinster, daughter of John Widdison, "gentleman." There is every reason to believe that Eliza thought of herself as coming from a higher class than George. Her parents had been married at St. George's Hanover Square, also by license, the practice among the wealthier classes that entailed a trip to Doctors' Commons but avoided the publicity of banns. The witnesses were John Sheringham, Cruikshank's old friend, now himself in feeble health, and Isaac Armstrong, Eliza's friend in the City who handled the Linstead family business.

George's relatives received no "official" notice of the impending nuptials.[10] Percy, having heard of the engagement through gossip, ventured to congratulate the fiancé:

> The reply was too startling, and un-romantic, ever to be forgotten. With a melancholy face, and solemn voice dodging the compliments, [Cruikshank] explained "I've got a butter-man's bill of £50—to pay." The large amount suggested that the bill should be examined. "Do you think *all* tradesmen are thieves? That's the amount, and I've got to pay it." . . . so the butter-man was paid, and the artist was married.[11]

The newlyweds went to 20 Marine Parade, Eastbourne, for a fortnight's honeymoon, while George's mother organized Amwell Street, and Eliza's mother and aunt organized Dalby Terrace for the big move.[12]

From 25 March George and Eliza lived in Mornington Place, renumbered 263 Hampstead Road in 1864 (fig. 58). They were joined by the three widows: Mary Cruikshank, now eighty-one, Katherine Elizabeth Linstead Widdison, in her early seventies, and Amelia Emily Linstead Parratt, sixty-five.[13] Cruikshank was all of a sudden surrounded by aged females; they occupied his parlor, ordered his meals, regulated the household. The

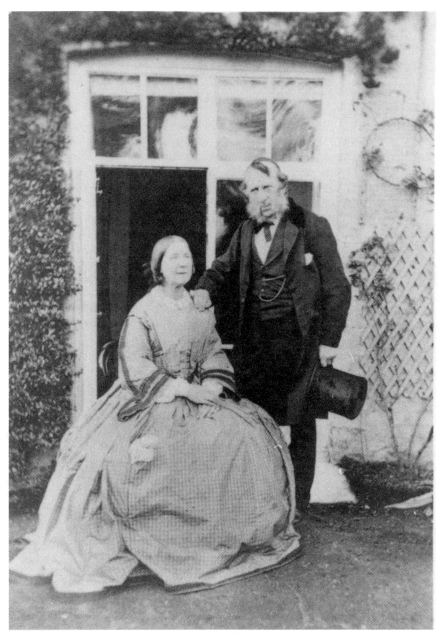

58. *Photograph of George and Eliza Cruikshank in the garden at 263 Hampstead Road, c. 1864*

Linstead widows brought with them Elizabeth Ayres, a married cook from their own county of Norfolk; and as the work was too much for one person, they hired Adelaide Attree, the twenty-year-old spinster daughter of an illiterate laborer from Cheam in Surrey, to serve as housemaid.[14]

Cruikshank was enveloped by his wife's world, as she tried to embrace and organize his. Her friends became his friends; her family network became to a certain extent his; her bankers subsequently accepted his account. Eliza taught him to organize and answer his mail promptly and to docket all incoming correspondence with a précis of the reply.[15] It became their usual practice for her to accompany him on out-of-town visits.[16] She kept track of his engagements, listened to his speeches, supported his campaigns, and conserved his rejected scraps of drawings and jottings. Eliza was in her element, tending to a husband who seemed to her to be famous, admirable, and respectable.

As time went on, Eliza also grew a bit more independent in her circumstances as the company of ailing widows diminished. Aunt Parratt died in September 1851. She left the leasehold of her former home in Euston Square to her step-children, Sarah (Parratt) Chesterton, Eliza (Parratt) Evans, and Dr. James Parratt, bequeathed stock to her brother the saddler and to her two orphan Baldwyn nieces, gave her sister two shares in the Grand Junction Water Works, and entrusted the rest of her estate to Eliza, who served as executrix along with Isaac Armstrong.[17] E. G. Flight, the solicitor and author for whom Cruikshank had just illustrated another book, recommended that the executors open up an account with Coutts; they did, on 14 January 1852. Unfortunately, the cash estate of some £600 barely covered the costs of burial and testamentary bequests. But when Mrs. Widdison died some time thereafter, Eliza inherited the Water Works shares that became a principal source of her financial security. And after Mary Cruikshank died at the age of eighty-three on 10 August 1853, Eliza was left with a clear field to run her home her way.

These particulars document in yet another way the revolutionary changes in Cruikshank's life. There is an enormous gulf between Mary's taking in lodgers and Eliza's businesslike respectability; between the "immortal George" executing a double-shuffle while masquerading as a dusty and the sober gentleman who chaired public meetings alongside bankers and merchants; between the hand-to-mouth artist being counseled by Lockhart to read and the Victorian social reformer who presumed that the correspondence columns of *The Times* were available whenever he chose to write. There is a different, but equally sizable, gap between the convivial artist of the 1830s—setting in for a booze with Forster and Dickens, exchanging japes and ballads around Ainsworth's table with the foremost humorists of the decade, or toasting Charley's birthday at one of Dickens's Twelfth

Night parties—and the teetotaler crisscrossing the country to lecture on Temperance and coming back to the quiet, organized, childless home in Mornington Place.

Any long life may show contrasts between its rising and its setting; and long Victorian lives, extending through years of unprecedented change, often exhibit striking disjunctions. But Cruikshank's art was so inextricably bound up with his life and times that an alteration of one term had far-ranging effects on the others. If the quality, quantity, and originality of his work fell off, what is to blame? That intensity of commitment to a cause which inspired his squibs for Hone and illustrations to *Oliver Twist* and *Jack Sheppard*? That habit of exaggeration which enabled him to ridicule Regency manners, morals, and fashions? That desire for a modicum of financial security which drove him "At it Again" following setback after setback, disappointment upon disappointment? Times change, and though Cruikshank changed with them, the conditions under which his satire could thrive altered out of all recognition. He became a name, entered into a society of middle-class, self-made, largely dissenting, reformers and businessmen, and continued to labor on behalf of the poor and unfortunate. His art narrowed into propaganda or veered into mediums such as painting and pamphleteering for which he possessed little aptitude; and though the engagement with causes stimulated his zeal it impoverished his creativity.

Did he feel that something was lacking? Did he miss having a family, being surrounded by children whose spontaneity and imagination had always been akin to his own and an inspiration for his work? Were the very routine and solidity of his new domestic arrangements stifling? Did he suppose that his second wife could bear children, though his first evidently could not? The 1851 census records Eliza's age as thirty-nine when she was really forty-four. Was that simply a mistake, or had Eliza fudged the facts? Since George had known her for thirty years, the latter supposition is unlikely. Did they try, unsuccessfully, to have a family?

These may seem impertinent or irrelevant questions, but they seek to get at the mystery of Adelaide Attree (fig. 59).[18] A few years after marrying Eliza, Cruikshank set up a second household a few turnings to the west, at 31 Augustus Street. The lessee is variously recorded in the rate books as George or Robert Archibold; other records give his surname as Archibald and his occupation as commercial traveler, engraver, wood-engraver, artist, or draftsman, whereas Adelaide's death certificate calls him a painter. Adelaide takes the name of Archibold, though no record of her marriage can be found. That her spouse bears the Christian names of George and his brother does not prove that George is the person in question; but the coincidences are overwhelming. And her descendants firmly believe that George was their ancestor. After his mother died in August 1853, they say

59. *Photograph of Adelaide Attree, 1850s (courtesy of Hazel Snaith)*

that Cruikshank, "smitten" with the housemaid, "forced himself" into Adelaide's attic bedroom. When she became pregnant, Adelaide refused to name the father. Eliza, who felt "strong affection" for the girl and apparently harbored no suspicion that her husband was the truant, nevertheless had to let her go.[19] Over the next twenty years Adelaide gave birth to eleven children, ten of whom survived infancy: George Robert, born 20 November 1854, Annie Adelaide (named for her maternal grandmother and mother) in 1858, William Henry (named for his maternal grandfather) on 12 January 1860, Albert Edward (named for the Prince of Wales) on 10 January 1863, and then Alfred Mills (1 March 1865), Eliza Jane (16 March 1867), Ada Rose (22 September 1868), Emma Caroline (15 November 1869), Ellen Maude (9 March 1873), and Arthur Attree (17 March 1875).[20] Adelaide was a blue-eyed blonde, strong, healthy, willing and able to accept the burdens of repeated pregnancies, a large family, an impetuous lover, and straitened circumstances. A photograph shows her wide-set, direct eyes, handsome features, and dignified demeanor. She was neither shamed nor embittered by her situation. She named her first daughter and her second son after her parents, never retreated to Cheam to escape unwanted attentions, and took in her widowed mother by 1861.[21] It is not certain that Adelaide was happy about her lot, but the evidence implies that she accepted it with courage, grace, resolution, and energy. If she had doubts about whether she was loved or only used, about whether there would be adequate funds to support the family, and about whether there was any escape from or alternative to this life, she kept them to herself.

While in 1850 Adelaide's liaison belongs to the future, it nonetheless originates at the time of Cruikshank's marriage and thus forms a part of that relationship from the beginning. Congratulations were received by the "happy Benedict," as one correspondent named him, from many friends of the groom and the bride.[22] George Laval Chesterton tried to pay a visit but got lost along the way. Augustus, Dickens's youngest brother who had met Cruikshank when they were fellow thespians in the Amateur Players, apologized for not calling on the newlyweds. His wife was mourning her brother's sudden death during a voyage home from the East Indies.[23] Others wrote, dropped by, invited the Cruikshanks to dinner, and soon George and Eliza were well established within a large company of mutual friends.

Their circle comprised people of diverse backgrounds, histories, occupations, classes, religions, interests, and regions of the country. Old friends included Moncrieff at Charterhouse, Merle, and Crowquill.[24] Thomas Reynolds, who had obtained jobs for the Pulford boys, promised to get Percy employed with the Crystal Palace Company.[25] Octavian Blewitt and Charles Kent, the devout Roman Catholic proprietor and editor of the *Sun*, initiated a lively exchange of social and business engagements.[26]

Two acquaintances with particularly interesting careers were John Hum-
ffreys Parry and Samuel Carter Hall. Parry was a barrister specializing in
criminal cases: he defended the celebrated murderess Maria Manning in
1849. Parry had a resonant voice and a winning way with juries; in private
he was kindly and genial, entertaining large numbers of friends and work-
ing for advanced liberal causes such as moderate Chartism. In 1856 he
became a serjeant-at-law and switched to civil cases, defending the Tich-
borne claimant in 1873 and participating in the celebrated case of *Whistler
v. Ruskin* in 1878. In October 1850 the Cruikshanks dined at the Parrys'
house.[27]

Samuel Carter Hall was a very different sort. He had known Dickens and
Catherine before their marriage, and was present at Charley's christening.
They kept up the association, though Dickens admitted that Hall was the
model for the arch hypocrite Pecksniff in *Martin Chuzzlewit*.[28] From 1839 to
1880, Hall edited the *Art Journal* and championed the cause of artists. He
scored some notable coups: articles exposing the trade in Old Masters (by
comparing sale prices to customs house returns) temporarily made such
pictures virtually unsaleable. As a result, a Raphael could be purchased for
£7, a Titian for half that price. In 1847 he obtained permission to publish
engravings of all the pictures Robert Vernon was giving to the National
Gallery, and in 1851 the queen and Prince Albert allowed Hall to repro-
duce 150 paintings from their private collection. His Irish wife, Anna
Maria Hall, wrote novels and miscellaneous pieces, and like her husband
was both a devout Christian and a fervent believer in spiritualism and in
Daniel D. Home, the fraudulent American medium Browning and Tolstoy
stigmatized. Mrs. Hall was also an active champion of women's rights and
of Temperance; the latter campaign was one reason for the Halls and the
Cruikshanks to become intimate.[29]

Cruikshank even moved occasionally in grander circles. The patronage
of Prince Albert commenced in 1849 with the purchase of *The Disturbed
Congregation* (fig. 57, p. 278). Percy Cruikshank tells how his uncle com-
mandeered the family as models:

> The subject . . . represented the interior of a country church, where a boy,
> having accidentally dropped his peg top on the pavement, is attracting the
> attention of the congregation; among these is the beadle, who gives the con-
> victed culprit, a look; promising him *something*, when service is concluded. The
> design was of course excellent, but the management of light, and shade, re-
> quired an experienced hand in oil. The family hitherto "catalogued" as "lay
> figures" were, on this occasion, looked upon as excellent models, and worth
> being brushed up, dusted, and re-furnished. Percy was presented with a gorgeous
> gold laced beadle's many-caped coat, stick, tow-coloured wig &c., while the
> great nephew, George—then a very little one [and] a future bone for nominal

contention—was made happy with hat, feather, &c, and elevated to the family pew, of some local squire. Sitting for hours, with "spectacles on nose," leaning upon a stick, in a heavy great coat, during a hot summer's day, was tough work; while stern rebuke called the "model" to his senses, when trying to get rid of a fit of the cramp. The juvenile model, although bribed with hat, feather, &c, kicked occasionally, at having to, continually, look round the corner, of the family pew.

When the picture was completed, and George saw it, afterwards, with a fresh eye, he was disappointed; it was a dead failure. . . . [The Beadle] was a stuffed suit, and a straw or two sticking out would have shown its nature. Another panel was procured, and the subject, much to the dismay of the models, was re-painted. This was much better, than the former one, but still defective.[30]

Prince Albert nonetheless paid thirty guineas for the picture. Cruikshank charged very little, hoping that the prince would continue to patronize his art, and that in time he and Eliza might even be presented formally to the queen.[31]

In the meantime, there were only minor commissions and a great deal of Temperance business to occupy him. Francis Higginson wrote a serial enti-tled *The Brighton Lodging-House* which a minor publisher, J. How, planned to issue in sixpenny monthly parts from November 1849.[32] Cruikshank was secured to etch the plates. Higginson prodded the artist, still ailing after his bereavement, for results: "There are circumstances to which I need not here advert, that will make the advent of this sketch be looked for with some anxiety, exclusive wholly of literary considerations—."[33] The first plate, and the wood-engraved wrapper design, were finished in time; a second plate appeared in the December number; and then publication ceased. Whether nobody bought the work, or the publisher went out of business, or the author gave up, has not been determined. Only a few parts survive. For Cruikshank, another dead end.

Never-say-die Merle still pestered his friend with manuscripts to be off-loaded on reluctant publishers. In August 1849 Merle wrote inquiring about the fate of one of his stories and enclosing a self-addressed letter for reply.[34] Cruikshank wrote back informing him of yet another rejection: " 'Charles Albert' is accepted by and will appear on Put your pen through that and send[?] 'All hopes for "Charles Albert" are over—He will not appear upon Earth'."[35] But Merle evidently didn't receive the letter: " 'In a time of need' I lent you a willing hand," he complained two months later, "and, to the best of my poor abilities, aided you to profit by your ideas, wh. like a heap of rich & invaluable manure, lay barren for want of a hand to spread them abroad." (Merle could be singularly inept in his sim-iles.) But now Cruikshank won't even return a self-addressed letter giving further information about the fate of Merle's "Recollections of King Al-bert."[36] Tell me directly, Merle begged, if you don't like my sending pieces

through you. Cruikshank may not have liked it, but considering all his old friend had done for him, he could hardly interdict the transmission of manuscripts. Within a month Merle forwarded "A Mail-Road Adventure in the Days Gone By" for him to place. Cruikshank may have tried Dickens's periodical *Household Words*, for half a year later the subeditor Wills regretted that George's zeal on behalf of his friend could not be more effectual; there were too many stories in type already awaiting space in future issues.[37]

In October 1850, Merle was incensed once again, though for a different reason. Newby had finally accepted one of his novels, but planned to issue it without illustrations. Merle thought that Cruikshank's willingness to supply plates would have induced the publisher to change course; "I wd rather have burnt the MS than have been outwitted as I have been."[38] That Newby did not capitalize on Cruikshank's offer suggests that he may have set type before sending a contract (as Merle suspected), that he envisaged a cheap production, small edition, and one-shot sale, and that George's name might not count for all that much any more.

Mark Lemon, even though he could not persuade Cruikshank to work for *Punch*, still believed in George's talent, especially in fanciful subjects for the holiday trade. He proposed writing a little story, *The Talking Shell*, for the Christmas 1850 season and asked his friend to prepare a frontispiece and title page.[39] Unfortunately, that project too never came to fruition. More and more, the artist was being pushed into recapitulating former triumphs. When Edward Chapman queried Dickens about which artist should do the frontispiece for the Cheap Edition of *Oliver Twist*, Dickens answered without hesitation: "George Cruikshank, by all means."[40] Accordingly, the artist made one last design for the novel, of Oliver confronting Bumble in Mrs. Mann's parlor; T. Bolton cut it into the block. For later editions, Dickens resorted to Browne, until in the final collection published during Dickens's lifetime, the Charles Dickens Edition, the author selected eight of the original Cruikshank plates, including the "tail-less baboon" one, for reprinting.

Increasingly Cruikshank busied himself with Temperance, literary, and elocution society affairs. When he caught up on the backlog following Mary Ann's death, he attended meetings of the Southwark Literary Institution and the Marylebone or Fitzroy Temperance Society. In 1850 he traveled to Chelmsford, Colchester, Hampshire, Bristol, Clifton, Street in Somerset—where he autographed a copy of *Three Courses and a Dessert* which Swinburne and later John Fowles owned—Lewes, Birmingham, and Leicester. Organizations that issued successful invitations included the Greenwich Temperance Association, the Whittington and Metropolitan Athenaeum, the South London Temperance Society, the Adelaide Square Temperance Association, the Industrial Mutual Assurance and Friendly

Sick Association, and the St. Marylebone and Paddington Youth's and Young Men's Festival Society (presumably a counterattractionist effort). He listened to speeches delivered by the English Elocution Class at the Islington Athenaeum, showed up at the Elocutionary Entertainment held in Sussex Hall, Leadenhall Street, and survived the quarterly public meeting of the Elocution Class of the Walworth Literary Institute.

A livelier affair was the meeting of the Metropolitan Sanitary Association on 13 May. Dickens couldn't interrupt his writing to attend, but Cruikshank went. Just as he rose to move the second in a series of resolutions advocating the regulation of funerals, undertakers' men who had gotten in with forged tickets of admission rushed the platform.[41] George escaped unharmed. Benjamin Lumley's garden party at Fulham on 19 June for Eugène Scribe and Elie Halévy was much more decorous, and far grander: three dukes attended, along with representatives of literature (Dickens, Mrs. Gore, Tom Taylor, and Thackeray) and of art (Cruikshank, Doyle, Landseer, and Leech). Wonderful company, but none of George's friends was hiring him for anything.

Cruikshank decided to issue a set of twenty-four etchings or lithographs, to be sold by subscription, illustrating the progress of respectable drinking. He planned two contrasting narratives, hoped to obtain sufficient numbers of subscribers to guarantee all costs, and applied to Robert Rae, then secretary of the Scottish Temperance League, for that society to endorse the scheme and purchase the original plates.[42] Reports from local branches, however, dissuaded Cruikshank from carrying out the scheme; pledgers willing to commit themselves in advance to buying the suite were as scarce as other patrons.

Grateful converts wrote to Cruikshank from cities and villages all over England—though not from Wales and Ireland or much from Scotland—but most of them were not accustomed nor able to support art. According to C. P. Pitt, one version of *The Bottle* reached only £2 in sales in Birmingham.[43] Loaden negotiated a settlement with some of the pirates, but it was very small. And Reynoldson, who adapted *The Drunkard's Children* for the stage, borrowed money from the artist he did not repay. "What am I to think of such treatment?" Cruikshank asked crossly.[44]

Eliza may have paid his butter-man's bill, but her resources were modest and the household was dependent on the annuities and investments of its aging mothers. Cruikshank looked forward to 1851, when hordes of visitors might descend upon the metropolis for the Great Exhibition. If he could capitalize on that event, he might yet earn some money.

36

LOSING BY ALMOST EVERY SPECULATION

Caricature, one must remember, has two mortal enemies—a small and a great: artistic excellence of draughtsmanship, and national prosperity with its consequent contentment.

M. H. Spielmann[1]

The Great Exhibition of the Works of Industry of all Nations, the first international industrial exhibition, owed its success in large part to the vision and energy of Henry Cole and Prince Albert. Granted the magnificent "Crystal Palace" designed and executed by Joseph Paxton seized the public's imagination and remains the single most famous feature of the festival; but without Albert's unrelenting patronage and Cole's equally unrelenting diplomacy the whole enterprise would have collapsed in feuds and insolvency. "A prince of pre-eminent wisdom," Cole said afterward, a man "of philosophic mind, sagacity, with power of generalship and great practical ability, placed himself at the head of the enterprise, and led it to triumphant success."[2]

Albert was not, at the time of the exhibition's inception, a popular consort, nor did he instigate the project—an outgrowth of the national industrial exhibitions he and Cole had been staging with the Society of Arts since 1847—as a bid for public favor. There were political consequences to the decision to make the 1851 exhibition international: many manufacturers feared foreign competition and the specter of free trade. The reactionary M.P. Colonel Sibthorp used every opportunity to attack the project: the green spaces of Hyde Park would be destroyed, he warned; the elms would be cut down (to preserve three, Paxton devised a towering vaulted transept); London would be overrun by foreigners; vagrancy and disorder and crime would endanger British streets and homes. The prince wrote that his opponents were throwing "all the old women into panic" by giving out that "strangers . . . are certain to commence a thorough revolution here, to murder Victoria and

myself, and to proclaim the Red Republic in England," and that "the plague is certain to ensue from the confluence of such vast multitudes."[3]

The result belied the dire predictions: the crowds were enormous but so well behaved there was not a single accident or police report on opening day, British manufacture demonstrated its superiority, and the exhibition turned a tidy profit. The exhibits were arranged to demonstrate the advantages of "progressive" (that is, Western industrializing) civilizations over "stationary" (Eastern labor-intensive) ones with regard to invention and efficiency, though not necessarily artistry. Captured under glass was what Thomas Hardy later called "a precipice in Time," a fault line dividing older, rural, agricultural orders from the burgeoning urban-industrial cultures.[4] As a result of the royal patronage, the crown visibly allied itself to the manufacturing classes: the great coal, iron, steel, railroad, and textile magnates of the Midlands, and the hundreds of thousands of laborers whose production was heralded by this unprecedented tribute.

The Great Exhibition was, in the words of Henry Mayhew,

> the first attempt to dignify and refine toil; and, by collecting the several products of scientific and aesthetic art from every quarter of the globe into one focus, to diffuse a high standard of excellence among our operatives, and thus to raise the artistic qualities of labour, so that men, no longer working with their fingers alone, shall find that which is now mere drudgery converted into a delight, their intellects expanded, their natures softened, and their pursuits ennobled by the process.[5]

This quintessentially Victorian marriage of commercialism, aesthetics, and social engineering seemed to promise a new era for industrialism, one in which the worker became an artisan, a craftsman who imbued the products of his labor with a beauty and individuality that transformed repetitive, mechanical work into a noble, spiritually expressive activity, Carlylean in its fusion of self with sacred purposes.

George Cruikshank followed the evolution of the plans closely. There was much in the program to appeal to him. As an etcher who experimented with new reproductive processes, he could empathize with the plight of innovative workers debarred from the higher reaches of art by time-honored prejudices; after all, no engraver or etcher had yet been admitted to membership in the Royal Academy. Organizing the exhibits so as to elevate the status, self-respect, and aspirations of laborers aimed at precisely the same kind of social improvement through propaganda that Cruikshank had begun to undertake in his Temperance plates. And the connection to the crown placed the festival under the same patronage he was beginning to receive for his paintings. Cruikshank could envisage a new era for his art, wherein he would collaborate with the highest ranks to change the habits and improve the lives of the common people.

At the same time, he was not blind to the commercial opportunities afforded by the hordes of visitors and the reams of publicity. To begin with, there was considerable anxiety about safety. Colonel Sibthorp predicted in the Commons in July 1850 that "all the bad characters at present scattered over the country will be attracted to Hyde Park. . . . That being the case, I would advise persons residing near the Park to keep a sharp lookout after their silver forks and spoons and servant maids."[6] Inspired by the recent murder of a clergyman during a break-in, Cruikshank decided to capitalize on such fears by writing and illustrating a four-penny pamphlet, *Stop Thief, or Hints to Housekeepers to Prevent Housebreaking.*[7] Viewed in hindsight, such a production appears as an absurd veering from the main channels of Cruikshank's talent. But seen from his vantage point at mid-century, it was not quite such a silly venture. Full-sheet caricature and quality book illustration no longer were viable options for him; every one of his periodicals had failed; oil painting was laborious, strained his eyes, and yielded very little income, even when the picture was sold to Prince Albert; and Temperance propaganda didn't pay either. If Cruikshank was, as the reviewers never tired of repeating, a kind of national benefactor, then counseling householders about security was but another chapter in his lifelong career of advising the populace. Moreover, he considered himself an expert on the subject, knowing it from the householder's side and from the thief's. Since the days when he had associated with cracksmen such as Bill Sikes, and perhaps benefiting from his friend Henry Mayhew's recent interviews with those who would not work in London's teeming underworld, Cruikshank had picked up a fair amount of information about how to prey upon unsuspecting families. He interviewed a number of housebreakers who scoffed at the precautions householders believed to be effective and who showed the artist exactly how they plied their trade.

Cruikshank was physically fearless, if not rash, and never seemed uncomfortable in the presence of felons. One night a score of years later, coming home from a Temperance meeting, he caught sight of a burglar escaping through the garden. Without a moment's hesitation the septuagenarian went after the man, caught him by the leg, and held him until a policeman walking his beat passed by. On the way to the station George lectured his captive:

> "Now, my friend, this is a sad position to find yourself in. It's the drink, my friend, the drink. Ah! I can smell it. Now look at me," pausing for a moment under a gaslight. "You see before you a man who for the last twenty years has taken nothing to drink stronger than water."
>
> The burglar looked up at the artist and growled, "I wish to God I had known that; I would have knocked your d——d old head off!"

At which comment George, triumphantly affirming his vigor to his friend William Powell Frith, exclaimed, "The fool thought I had weakened myself by leaving off alcoholic drinks. The reverse—the very reverse is the fact."[8]

As usual, Cruikshank needed money which he hoped the pamphlet would coin. Evidently he had endorsed more bills for friends who could not pay, and was himself unable to come up with the whole of the quarterly premium on a life insurance policy taken out at the time of his second marriage. So Cruikshank went begging to Bogue, first for the premium payment, and then for an advance on the bills. In return, he offered "a little work" he had nearly completed and which Bradbury and Evans were printing. "I shall call upon you to let you see what it is before I go to a stranger with it—if—you can manage to publish it for me I should much prefer your doing so."[9] Bogue declined to issue the crudely produced sixteen-page pamphlet, but he did supply the money: £3.9.5 for the premium, £4.10.0 to engage a lawyer to arrange the matter of the bills so that no declaration would be issued by the creditors against the artist. George hired Percy to execute the wood-engravings depicting various security devices a homeowner could install, but after finding work for his nephew could not meet the charges of £14.19.6 presented on 12 December.[10]

Against such debts, the ledgers recorded paltry credits. A representative from Birmingham forwarded 3s. 6d. in royalties—probably for *The Bottle* and *The Drunkard's Children*—representing the entire November sales.[11] *Stop Thief* was reviewed in a January 1851 issue of the *Bristol Herald*, and free copies were distributed to the governors of the jail, to the police stations, and to the *Bristol Times*, but there is no evidence that such publicity did any good in the west or the West End.[12]

Another possible source of income might be exhibitions. A year before the Crystal Palace opened, James Parry told Cruikshank that there was to be a picture gallery where the artist might show some of his works.[13] On behalf of the Winter Exhibition Rooms which had just opened, F. F. LeMaitre invited Cruikshank in November to supply any sketches or finished drawings on mounts which the committee would frame gratis.[14] Even if Cruikshank took advantage of these opportunities, the only remuneration would come if patrons, having seen his work, commissioned a picture. And since George was already well known to his public for works on paper unsuitable for displaying in an ornate drawing room, such patronage was unlikely. Perhaps as a preliminary to figuring out how to make exhibitions pay, or maybe just out of curiosity, Cruikshank arranged to examine a large collection of Fuseli's drawings recently purchased by L. P. Knowles; but once again, nothing came of these schemes.[15]

So Cruikshank was forced back to book illustrations. E. G. Flight had asked for "some drawings on wood" to embellish a project never completed;

in December 1850 he solicited the artist's pencil once again, for eight designs engraved by John Thompson illustrating one of George's favorite subjects: *The True Legend of St. Dunstan and the Devil.*[16] The "truth" is that St. Dunstan did not pull the devil's nose, but rather nailed a red-hot shoe onto his cloven foot. The devil had to swear never to trouble St. Dunstan again before he would remove the shoe. Hence the custom of nailing a horseshoe over the threshold to ward off evil. Flight has great fun with the story, appending a legal brief on the Satanic covenant. Cruikshank's illustrations are "capital," as the *Literary Gazette* declared; they are spirited in design and execution, sensitively translated onto the wood, and neatly coordinated with Flight's letterpress.[17] Twenty years later the prints were reissued on india paper for a second edition, and later that same year in a third. Eighteen years thereafter they were reproduced in the privately printed *History of the Worshipful Company of Ironmongers.* Notwithstanding their charm and multiple usage, they brought in only a few shillings and led to no further work. Another dead end.

The best idea circulating at this time was Henry Mayhew's. Why not issue a serial about the Great Exhibition? It could commence a few months before the opening, relate the adventures of a provincial family traveling to London for the show, and run concurrently with the festival, incorporating special events as they took place and concluding when the exhibition closed. Mayhew proposed to Cruikshank and to Bogue that if he was paid £50 per part for the letterpress, which he would write in addition to his continuing research on *London Labour and the London Poor,* then the profits could be split three ways. They agreed to these terms, and each partner got busy on his part.

Mayhew decided that the protagonists should come from the country. He traveled north to Cumberland to scout out local customs and expressions, "convinced that to make any impression on the brute public one must be 'peculiar'." As he told "Georgie" in a long letter:

> It is not my intention to make Sandboys [the name taken from the proverb "jolly as a sandboy"] or any one else in the book talk a language that will require a glossary to be understood by the common reader—but to speak merely *oddly* so that the reader may be struck with him at starting. It is however impossible to explain what is as yet crude in one's brain.
>
> The matter I have gleaned here will well repay my trip. The people are as picturesque as their hills—simple and exceedingly handsome. I sent to Mrs. Mayhew yesterday a full description of the Cumberland "top shirt." which is the travelling *outer* garment of the gentry & commoners here—Also of the hood for females. . . . Unless we have an "out-and-out" countryman in London there will be no fun—A country man in manner & mind rather than speech I mean though certainly not talking the snip snap of St. James nor the extreme incomprehensible patois of Cumberland.

Mayhew further reported that he had "tea'd" a prototype of Sandboys, that he had devised a continuous rattle of incidents, and that he had just started writing: "hard unremitting scribble."[18]

Bogue arranged the publishing side. After talking things over with Cruikshank, he decided on printing twenty thousand of the first (February) part—enough to meet the immediate demand, not too many to soak up any profit, and a sufficient stock to allow time for reprinting if required.[19] After Mayhew—still formulating his ideas—deleted specific names of characters from the one-page prospectus, Bogue gave it to Cruikshank, who designed a wood-engraving of "The World and his Wife looking through a Peep-show." This was circulated in advance among booksellers to stimulate retail orders.

Meanwhile, Cruikshank was manufacturing his own products. The notion of "all the world" attending some event was a classic: Grimaldi sang "All the World's in Paris" in 1815 and Cruikshank illustrated the song sheet; he drew "All the World & his Wife" going to a "Fancy Ball" for Part IV of *Scraps and Sketches* (1832); and the world and all things in it ("de omnibus rebus") had been depicted in the graphic preface to *George Cruikshank's Omnibus*.[20] This time George anthropomorphized the World peeping into the show with Mrs. World in the prospectus, and on the wrapper, dressed in a Beefeater's uniform and standing on a showman's cart as a barker pointing to a poster with the title of the entertainment. If all the world—including the Cumberland Sandboys—was slated to go to the Great Exhibition, then it was to be hoped that all the world would also buy the novel.

While Mayhew in his introduction dilates on the variety of visitors— Africans, Yakutskians, Egyptians, Punjabi, Burmese, Esquimaux, Papuans, Maripoosans, Cingalese, the King of Dahomey, the Hottentot Venus, and Truefit the tailor of New Zealand—preparing to journey to London, Cruikshank for his large folding frontispiece etches another of his bravura plates jammed with all the peoples of the world heading to the Crystal Palace.[21] Clearly he was exerting every iota of energy and genius to make this publication a resounding success. However, the plate is fuller of lines than ideas. As John Harvey says, Cruikshank's "inclusive ambition can seem like a cooped-up megalomania, showing his state of mind when his ambition as an artist was undiminished, but had lost the sense that its fulfillment lay more in a single figure vigorously realized, than in a thousand people minutely hinted at."[22] Although Harvey concedes that this plate is "wittily right," the paucity of themes for the *Sandboys* illustrations becomes more and more apparent as the serial progresses.

At first, the illustrations follow Mayhew's slapdash letterpress faithfully. The only one depicting Cursty Sandboys's family, "Looking for Lodgings,"

appeared in the second (March) number. In Mayhew's story the Sandboys initially elect not to attend the exhibition, but when all the local trades-men depart and they can obtain neither coals nor candles, they set off without advance reservations. Arriving in the metropolis after several mis-adventures, they find that every room has been reserved; the best they can do for lodgings is a hammock in a coal cellar.[23] Cruikshank not only follows the letterpress precisely in his image, he also reproduces a portion of dia-logue in the caption.

The same close collaboration applies to the two other March plates: "Manchester in 1851" and "London, in 1851." When researching the odd-ities of the north, Mayhew stayed in Marsden's Temperance Hotel, Man-chester. From there he sent "Gwordie" a sheet of stationery imprinted with a view of Market Street and promised to forward "further information with signs and names of houses (there is a splendid teashop)" or to "get an architectural draughtsman just to knock off a notion of the place."[24] This information was for a picture of Manchester as the Sandboys experience it when changing trains on their way to London: everyone has left town. Unable to get assistance, Mayhew himself drew the street (fig. 60), enlarg-ing the names of the shops and making other notes to help George realize the scene.[25] Cruikshank's version (fig. 61) elevates Mayhem's point of view (as if the artist were riding a cinema dolly) and thus dramatizes the length of the deserted street; he also plasters all over the buildings notices pro-claiming that the tenants have "Gone to the Great Exhibition" and that the businesses (including the Binyons Hunter & Fox Family Teashop) will "Reopen with Great Splendour" at its close. A solitary lounger sits on a stoop puffing a cigar and reading a newspaper about the Great Exhibition while his dog snoozes at his feet. Cruikshank's etching avoids any of the poetic atmosphere evoked by "The Streets—Morning" in *Sketches by Boz*; the comedy here is conveyed principally by the signs and the long prospect of a busy commercial thoroughfare devoid of any traffic, pedestrian, equestrian, or vehicular.

Contrasted to Manchester is the witty pendant plate (fig. 62) depicting Regent Circus "Blocked Up" by hundreds of individually realized figures walking, riding in omnibuses, coaches, caravans, and carriages, parading, blowing trumpets, beating drums, selling fruit, carrying banners (including one advertising *1851*), or hanging out of windows and perching on balco-nies waving the Union Jack and watching the crowds below. The print scarcely overstates the daily traffic jams: "Shoals of omnibuses, crammed to excess, inside and out, frequently got blocked up in immense masses, while hapless drivers in vain endeavoured to win their way," according to one contemporary account.[26] The impeded motion which issued in so many graceless encounters at the queen's levee in 1818, Cruikshank here rein-

60. *Henry Mayhew, sketch of Manchester in 1851, pencil, pen, and ink, 1851* (©
Board of Trustees, National Gallery of Art, Washington, D.C.)

terprets as another version of "All the World" heading toward Hyde Park:
"The Park is Full" one placard declares. His emphasis falls not on the com-
edy of manners but on the overwhelming spectacle of an urban mob scene,
where everyone shares in the festival spirit and the crowd itself becomes a
public show—the "circus" in the Circus. Whereas Cruikshank's Regency
caricatures had pictured mass demonstrations seeking redress of some pub-
lic grievance, this scene—for all its congestion—expresses national unity
and good-feeling: "Peace & Good Will to All the World God Save the
Queen and Prince Albert" proclaims the largest banner suspended across
Regent Street.

Satire requires faction; the best Cruikshank can muster here is lively
comic exaggeration and virtuosic technique. He designs the paired images
so that the streets recede to a vanishing point at the middle of the pic-
ture—the opposite of the frieze structure to which Isaac often resorted.
Then he exploits the recession to point up the contrast between empty and
full, stillness and boisterous activity. The lessons of a lifetime devoted to
telling stories through pictures are incorporated in these etchings; as so
often happens with Cruikshank's illustrations they outdo the letterpress in
comic effect. But since illustrated fiction usually remains in print only if the
text achieves classic status, *1851* was another novel whose feeble narrative

61. *George Cruikshank, "Manchester in 1851," 1851, etching, 1851*

consigned it to the dust heap, thus scrapping excellent plates along with the forgettable story.

Mayhew was infuriatingly late in producing copy. At the end of February he offered to resign. Bogue didn't want that, but he did want each issue finished by the fifteenth of the month.[27] Cruikshank received more bad news on 17 March. Bogue reported that after two months the results were not "so formidable" as he had hoped, and that nothing less than five thousand copies would pay. This figure was only a quarter of his initial expectation. Nonetheless, the optimistic publisher thought the circulation might even exceed five thousand once the novel reached the exhibition itself and visitors flocked to London. As for Mayhew and the next installment, Bogue had "no intelligence."[28]

Disparities in production, and between letterpress and plates, appear from the third number on. Cruikshank had been laid low by influenza for three weeks and was consequently unable to complete anything for the April number.[29] It may have been set in type simultaneously with, and

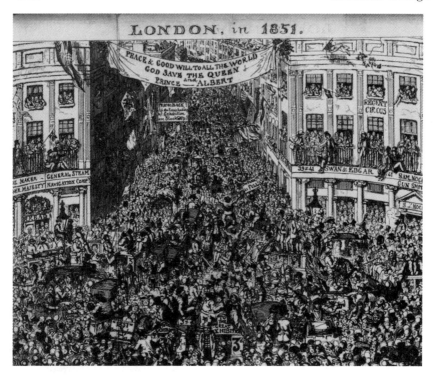

62. George Cruikshank, "London, in 1851," 1851, etching, 1851

independent of, Part II, since the second installment ends on page sixty-two, and the third commences on page sixty-five. It looks as though the compositors expected each number to fill thirty-two printed pages (two sheets of paper printed in octavo) and went ahead with the third install-ment before discovering that Mayhew's copy for the preceding one fell two pages short.

Lack of coordination besets the third and fourth parts in other ways as well. Cursty's trousers, containing all his cash and his marriage lines, are sold to a rag dealer; at the beginning of the May installment (IV), the hapless hero ventures into the Old Clothes Exchange in Houndsditch to recover his property. Though this was a familiar area and subject for Cruik-shank, he chose not to draw it. Perhaps he was afraid of repeating himself. But clearly Mayhew invented the episode to bring out his artist, and inci-dentally to recall for some readers Fagin and Monmouth Street. Instead, Cruikshank drew "The Opera Boxes during the time of the Great Exhibi-tion," although the text makes no mention of the management's renting out the boxes to tourists for overnight accommodation.

In April and May, Cruikshank pressed on with arrangements to depict the 1 May "Opening of the Great Bee-hive," even though in Mayhew's text the Sandboys lose their season tickets and can't get in. The large folding plate depicts the moment when the royal family enters the south portico of the Crystal Palace, but instead of rendering a faithful image of the architecture, Cruikshank alters the central transept to a kind of vitreous beehive. This conception bears no relation to the letterpress, but it does evidence Cruikshank's still-evolving notion of how to represent the mid-Victorian polity, a notion finally realized sixteen years later in *The British Bee Hive*.[30]

In conjunction with the 1851 plate, published in the June number (V), Cruikshank planned two others commemorating the Great Exhibition: a large independent etching from a pencil sketch (eventually submitted to and approved by Prince Albert) picturing the official opening ceremony, and a second of like size intended to "form a good historical companion" which would depict the Royal Fete held at Guildhall on 2 July.[31] Bogue would sell both.

There were hundreds of views of the Crystal Palace executed by etchers, engravers, wood-engravers, and painters in watercolors and oils. In making his sketches during the days immediately preceding the opening, Cruikshank would have encountered other artists similarly occupied. Platoons of woodcutters engraved small squared sections of a master drawing for the leading journals such as the *Illustrated London News*. These were then fitted together, locked into a forme, and printed. Consequently the market for individual views was fragmented; Cruikshank had to compete with architectural and topographical draftsmen and with such accomplished newspaper pictorialists as John Gilbert.

On opening day George, one of the twenty-five thousand season-ticket holders admitted for the ceremony, stationed himself in the gallery of the south-west transept for further studies. The *Times* leader on the following morning reached exalted rhetorical heights in proclaiming the significance of the event:

> There was yesterday witnessed a sight the like of which has never happened before and which in the nature of things can never be repeated. . . . There were many there who had seen Coronations, Fetes and solemnities; but they had not seen anything to compare with this. . . . Around them, amidst them, and over their heads was displayed all that is useful or beautiful in nature or in art. Above them rose a glittering arch far more lofty and spacious than the vaults of even our noblest cathedrals. On either side the vista seemed almost boundless. . . . Some saw in it the second and more glorious inauguration of their Sovereign; some a solemn dedication of art and its stores; some were most reminded of

that day when all ages and climes shall be gathered round the Throne of their Maker.

The young queen, wearing a pink and silver dress and a diamond ray diadem, was herself mightily impressed and grateful. She noted in her diary:

> The sight as we came to the centre where the steps and chair (on which I did *not* sit) was placed, facing the beautiful crystal fountain was magic and impressive. The tremendous cheering, the joy expressed in every face, the vastness of the building, with all its decorations and exhibits, the sound of the organ (with 200 instruments and 600 voices, which seemed nothing), and my beloved Husband the creator of this great "Peace festival," uniting the industry and art of all nations of the earth, all this, was indeed moving, and a day to live for ever. God bless my dearest Albert, and my dear Country, which has shown itself so great today. [32]

Despite this nationalistic fervor, or perhaps because of it, Cruikshank's representation of these stirring events was minutely detailed but rather lifeless. The occasion called for spectacle, not humor; he managed to convey something of the vastness of the vaulted space, though the arch of the transept is cut off by the top frame of the plate, but the figures are so small that the human dimensions of the ceremony are overwhelmed by the architecture. A colored version works much better: tints group figures in masses and thereby supply greater coherence, depth, and spaciousness to the design. [33] On 24 June Cruikshank lent one of the first proofs for Octavian Blewitt to pin up on his wall overnight; George presented the final version to Prince Albert early in July. [34] The *Literary Gazette* commended the steel-etching for "its intrinsic value, and its insignificant price." [35] Even of a print sanctioned by and presented to the royal family, Cruikshank aimed for general distribution: intrinsic value was for him no barrier to insignificant price. In this instance he may have succeeded in both aims: Jerrold says the plate sold out four editions. [36]

The *Sandboys* etchings articulate some things about the festival that the large independent plate fails to convey: they register the global impact of the exhibition in "All the World going to see the Great Exhibition" and the enthusiastic frenzy of the crowds in the paired plates representing London and Manchester. Had Cruikshank stuck to what he did best—imaging the responses of people to an event—and had Mayhew's text taken a less farcical line toward tourism, their 1851 ventures might have been more memorable.

A month later Cruikshank sketched furiously as the Guildhall ball proceeded from the royal family's arrival through the dances and introductions; one preliminary pen-and-pencil drawing is captioned "Mr. & Mrs. George Cruikshank bowing to the Queen & the Prince Consort," and

another pen study on the verso bears the legend "The Prince Consort introduces me to Her Majesty."[37] Whether such a presentation actually took place or not, it was an ideal to which Cruikshank now aspired. He sought royal patronage and looked for some kind of identification as a court artist. Doubtless he was not so foolish as to imagine he might supplant Winterhalter or rival in oils Landseer and Maclise; but as the self-appointed social conscience and comic painter of Victoria's early reign, Cruikshank hoped for the imprimatur of royal favor and an elevation of the status of his art. Eliza may have prompted these ambitions. She was no Lady Macbeth, but more than her husband she desired social respectability and respect. The market, however, seemed unpropitious for this historic document; despite the fact that in the next day's post Cruikshank received enthusiastic praise from Charles Kent, editor of the *Sun*, for his plate of the opening ceremonies, the contemplated companion etching of the Guildhall fete was never completed.[38]

These fantasies may not have been entirely groundless, but they muddled things. George Cruikshank could never be a great or slickly conventional oil painter; nor could his art have tapped its own eccentric strength by serving the tastes and requirements of a domesticated monarch and her high-minded German consort. "Etcher in ordinary to the queen" sounds as absurd in theory as it would have been in fact. But how else, at this juncture, was George to get his output ratified for its social message and its artistic value? How else could he compete against the high artists of the Royal Academy, the journalistic draftsmen, the *Punch* cartoonists, a new generation of wood-block artists beginning to illustrate contemporary poetry and fiction, and rebels like the Pre-Raphaelite Brotherhood whom Ruskin championed against the diatribes of Dickens and the establishment? His dream of being presented to the queen signified not social ambition so much as a frustrated longing for some recognition of all he had done in the past and wanted to do in the present to caution, enjoin, and amuse the people. And although that introduction was to yield future benefits, Cruikshank could not always manage a courtier's bow. According to Percy, when Albert wanted to buy a collection of George's proofs before letters, Cruikshank refused to sell them because the sum named was too low.[39]

Sandboys wound its bedraggled way to the end. On 3 May Mayhew began writing weekly review articles for the *Edinburgh News*. These often repeated, sometimes with a wholly different conclusion, paragraphs from the novel; and when he fell ill in mid-July they stopped altogether. As he recovered, Mayhew evidently felt it was necessary to rededicate himself to *London Labour*. He gave *Sandboys* increasingly short shrift, betraying, according to his most recent biographer, a characteristic "combination of

intelligence and banality . . . [and] intellectual flabbiness."[40] One entire installment deals with minor characters, neglecting any mention of the titular family.

Disgusted by Mayhew's irresponsibility, Cruikshank told Bogue that he was resigning his partnership share and would do the last plates for a flat fee. Bogue never quite understood this, so when the serial continued to lose money he journaled a portion of the debt onto Cruikshank's account. The final etchings are at best perfunctory. Cruikshank used a roulette to make mechanical shadings; "the result," John Harvey complains, "is not a shadowy cloud of dots, but a run of ragged striations."[41] The July number (whose wrapper had no date imprinted) contained three anecdotal plates: one about the first shilling day; one illustrating some of the "drolleries" of the exhibition, notably the anthropomorphized frogs and foxes that caught Victoria's eye; and one about visitors' mishaps. They are rather sketchy and slovenly and they have nothing to do with the narrative. There was no August number, and the September one contained neither any illustration nor any material about the Sandboys. Finally, the October (VIII) part concludes the story. The last etching, "The Dispersion of the Works of all Nations," is as slipshod as anything Cruikshank ever produced for Richard Bentley; the lines are shaky, tentative, uncertain about the shapes they outline, and the biting in has been radically simplified to a couple of immersions, so the scribbly slack design has neither form nor mass nor contrast.

It is oddly appropriate that in Mayhew's story Cursty Sandboys does not try to attend the exhibition until the Monday following its closing; author and artist, like their eponymous hero, missed the show. On 13 October, the very Monday that Cursty intends to sally forth to Hyde Park, Cruikshank wrote another of his frustrated replies to an appeal for help:

> You could not at any time of my life, since I was one & twenty, have made the appeal to me that you have done, when I was less able to respond to it than I am at this moment. The fact is that for the last few years I have been losing by almost every speculation I have entered into—and this year, I have been working from January untill August without earning one Farthing! and this thro' the misconduct of Mr. H[enr]y Mayhew—who has been paid £50 pr. month for writing 32 octavo pages—that are not worth 50 pence—
>
> I regret to find that you are suffering from the bad principle of another. I lost £600 last year from the same cause—& altogather I assure you I have gt difficulty to keep my head above water—and I have many very heavy drags upon me—my relations are all "poor relations."[42]

Cruikshank's life was increasingly fragmenting. He was divided from his youth by the death of wife and friends and a revolution in public taste. A new generation of illustrators and authors effectively excluded him from

significant commissions. His reputation as a living legend was flattering and encouraged him to reach for greater things. (During the Exhibition another American lion-hunter sought out the artist and penned a portrait of "the erratic yet extraordinary genius" when he returned home.[43]) Eliza liked bourgeois respectability and admired her husband's achievement. But George's bank account showed continuing deficits and his desires urged him toward Adelaide. When the wet days of November succeeded the sunshine of midsummer, and the fairy palace in the Park was emptied of its treasures, Cruikshank confronted the dismantling of yet another hopeful scheme. As much for him as for the age, 1851 was a "precipice in Time."

Phase
4

"George Cruikshank, Artist"

1851–1878

37

HITTING RIGHT & LEFT

Cruikshank was a drunkard, till his old age, and then he was a humbug.

<div align="right">

J. W. T. Ley[1]

</div>

Cruikshank [ended up] as a psychotic teetotaller.

<div align="right">

Bernard Denvir[2]

</div>

THE TEMPERANCE movement won an important victory when intoxicating beverages were banned from the refreshment stands at the Great Exhibition. Since the directors of the Crystal Palace showed themselves amenable to the cause, a great rally of provincial teetotalers was planned for the first week of August 1851. Thomas Cook made all the travel arrangements for the twenty-five thousand participants, who went in a mass procession to the exhibition one day and on another attended a grand fete at the zoo. The profits from this enterprise were used to found the London Temperance League.[3] James Silk Buckingham became president: a world traveler and former M. P. from Sheffield in the first Reform Parliament, he was an accomplished lecturer and a waterdrinker of great kindness and liberality. Impressed by Cruikshank's Temperance propaganda, the league named him a vice-president.[4] Another vice-president was John Cassell, whose tea and coffee emporia were now supplemented by an ever expanding printing and publishing firm at the Belle Sauvage Yard on Ludgate Hill. The league began sponsoring lecturers who promoted total abstinence and organizing monthly meetings in Exeter Hall, an auditorium on the Strand already identified with the movement and memorialized in a recent poem:

Its front unassuming, straight, formal and square,
Within it is spacious and lofty and fair,
The large-hearted, cold-visaged men who meet there
Well typify Exeter Hall.

Narrow-browed, gloomy, and frowning on all,
A most orthodox building is Exeter Hall.[5]

The league thus placed at its head three powerful publicists, dynamic speakers who attracted large audiences by their rhetoric, examples, and publications. Among the principal attractions that teetotalers offered to counter the lure of liquor were the Temperance rally, festival, fete, soiree, bazaar, and anniversary celebration. Held in chapels or town halls or parks, these events combined instruction and entertainment with socializing and good works, and borrowed from the sermon, the theatrical monologue, the public confession, the music hall, political oratory, self-improvement classes, and church fairs to achieve their effects. They also cooperated with other middle-class self-help associations: mechanics' institutes, literary and scientific institutes, and elocution societies. In some ways, when Cruikshank mounted the platform he was engaged in an activity not dissimilar to Carlyle's, Thackeray's, or Albert Smith's lecturing, or to Dickens's readings. These performers supplied high-class amusement and more or less didactic instruction to an audience eager to respond to "elevating" messages.

For all his eccentricities, his vehemence, and his rapid transitions from gay to grave, Cruikshank could be an impressive speaker, and not only on abstinence. What came through at the best of times were his sincerity and his passionate, simple conviction. George Eliot observed him at a meeting of authors and artists convened at John Chapman's house in May 1852 to oppose booksellers' trade restrictions. Charles Dickens took the chair, "preserving a courteous neutrality of eyebrow, and speaking with clearness and decision." Cruikshank also "made a capital speech, in an admirable moral spirit. He is the most homely, genuine looking man, not unlike the pictures of Captain Cuttle."[6] Though the description of his appearance might have offended the artist, who preferred to think of himself as something of a gentlemanly brigand, the testimony to his moral sincerity would have been warmly received.

His first teetotal addresses dwelled on his own personal reformation:

I come forth to set by my humble example the opinion of this unthinking world at defiance. Now mark, I believe that by nature, and from the profession that I formerly belonged to, that of a caricaturist, I have as keen a sense of the ridiculous as most men. I can see clearly what is ridiculous in others. I am so sensitive myself, that I am quite alive to every situation, and would not willingly place myself in a ridiculous one; and, I must confess, that if to be a teetotaler was to be a milksop, if it was to be a namby-pamby fellow, or a man making a fool of himself or of others, then indeed I would not be one—certainly not; but if, on the contrary, to be a teetotaler is to be a man that values himself, and tries by every means in his power to benefit others; if to be a teetotaler is to be a man

who tries to save the thoughtless from destruction; if to be a teetotaler is to be a man who does battle with false theories and bad customs, then I am one.[7]

Cruikshank's efforts to urge his own example on others and to encourage their reclamation knew no boundaries. Once when Mayhew was interviewing thieves for *London Labour*, he and Cruikshank entertained a large company of London pickpockets to a Temperance supper. Blanchard Jerrold was there and recalled nearly thirty-five years later how the artist earnestly bid them to renounce their ways, beginning by shunning the bottle and the beer-pot:

> That night, honest, whole-hearted Cruikshank, as with wild gesticulation he talked to "the dear lads"—for the forlornest and wickedest waif was dear to him—was clothed in majesty; and it cowed a man at hand, who acknowledged, within his hearing, that he had smuggled something stronger than water into the room.[8]

As Cruikshank gained experience lecturing and the prohibition movement matured, he dwelled more often on the salutary effects of waterdrinking on his own physical and mental system. "When I left off drinking wine altogether," he told an audience in the early 1850s,

> I became a healthier and stronger man, more capable of meeting the heavy responsibilities that were upon me, and for the following two years I had my life renewed, and all the elasticity of my schoolboy days came back to me. Domestic afflictions then came upon me, ending in death, and my spirits and health were crushed down. In this extremity I applied to my medical adviser. He said, "Medicine is of no use to you; you must drink wine again." I refused, and my medical friend called in some others of his profession; he told me they had had a consultation, the result being that all of them agreed it was necessary I should drink wine to restore my sinking constitution. I replied, "Doctor, I'll take your physic, but not your wine. Let me try everything else first, and only when there is no other chance give me wine, because I feel there is a great principle at stake in this matter." I have said, and I believe, wine is unnecessary, even as a medicine, and I do not wish to do a single act which would tend to weaken or destroy the weight and force of that conviction.[9]

Not only was the reformer convinced that intoxicants were unnecessary even as stimulants, but also he argued that "teetotalers are never ill, or if they are, they get rid of it directly." If he happened to succumb to a cold, he attributed his illness to something "merely atmospheric."[10]

Despite the stories of his private fanaticism, his snatching a glass out of Mrs. Ward's hand or haranguing guests until the host had to intervene, Cruikshank could be quite good humored and moderate when advancing his teetotal convictions. He never denied that he had once imbibed heartily, though on several occasions he protested that the stories of his drunkenness were exaggerated—as indeed they had been. The first time Cuthbert Bede

paid a visit to Mornington Place, on a sultry summer's day in 1853, he forgot himself at dinner and asked the maid for beer or sherry. Cruikshank laughingly explained that all alcoholic beverages were interdicted in his home; and the two men spent a pleasant afternoon debating the merits of moderation versus abstinence. It was the beginning of a long friendship, not the cause of a fierce quarrel.[11] And once while declaiming on the platform about the enfeebled condition of a drunkard, George pressed his top hat to his chest. It was a "gibus," or spring-folding hat, which there-upon collapsed; and his inadvertent gesture so tickled the crowd that he used to smash his hat regularly thereafter as a dramatic figure for the crush-ing effect of alcohol.[12]

On other occasions, the good humor of Cruikshank's friends saved the day. During the first year of his pledge, he attended a ball in Fitzroy Square given by Joshua Mayhew, the haughty and quick-tempered father of the Mayhew brothers. Cruikshank was a lively participant in the dancing and jesting, but when at supper the wine began to circulate he approached the host and declared in an admonitory tone, "Sir, you are a dangerous man. I look upon every wine-drinker as a dangerous man, sir." The company fell instantly silent, anticipating an outburst from the lawyer, who was prepar-ing to toast his sons. Horace Mayhew intervened with a hearty laugh: "Go on, father," he said, "it is only dear old George."[13]

The Mayhews conspired to get back at "dear old George." When he was presiding at a Temperance meeting, Augustus and Horace, abetted by Fred Dickens, slipped some gin into the chairman's gingerbeer. After refreshing himself, Cruikshank made a wry face, looked round the audience, and ex-claimed, "Somebody's insulted me!" Only the perpetrators understood him; and realizing that he could not examine everyone present to ferret out the culprit, Cruikshank swallowed his wrath along with his refreshment.[14]

George's saving gracelessness was his bullying. "With frowning brow, and gimlet eye," Percy reports, Cruikshank

> would *bore* the suspected sinner; demanding in a slow & solemn tone, "do you drink be-e-eer?", prolonging the sound of the last word, to make it effective. If the sinner's nerves were strong, and enabled him to answer "yes!", he would be further asked, in the same deliberate appalling tone, "do you know, what be-e-eer's made from?" The natural answer, malt and hops, would be altogether wrong, for the same crushing tone would say, "dead rats—", and other com-pounds, which, from their offensive nature, are not printable.[15]

In earlier days Cruikshank, Stanfield, and Rouse, reporter for the *Eagle City Road*, used to carouse at the Swan Brewery on Waltham Green; when Percy mentioned his uncle's chemical analysis of beer to Rouse, "the old toper roared with laughter, and in his rough guttural style, said, 'your uncle's swallowed plenty of *dead rats*, in his time'."[16]

George's family were less amused by his teetotal hectoring than his friends. He could not cow his brother into signing a pledge; Robert lapsed deeper and deeper into chronic alcoholism. The rest of the family were so accustomed to the water discourse that it ran off them with impunity, but sometimes in his zeal Cruikshank slipped into blackmail. Once when Percy asked his uncle for money or employment, assent was accompanied by a proviso: "I will not support public houses. I have no reason for complaining of *you*, personally—but I will never give, one farthing to anyone who drinks one glass of beer." Percy determined to make a stand for his independence. "When I was a boy," he retorted, "surrounded, as you were well aware, with the temptation of the soul you complain of, you gave me, when it was necessary, no warning, upon the subject. Having done it [i.e., drunk beer] for myself as a boy, I shall continue to do it, as a man; and further, if you want a recruit for the Temperance cause, have a volunteer, and not a bribed man." With that, Percy walked out of the house. "What the devil do you mean? Come back!" George shouted from the doorway; but later he conceded the justice of his nephew's rejoinder and to some extent eased up on his lectures.[17]

The most impervious to George's zeal was his mother. She expressed the utmost contempt for her son's extreme inconsistency. Having belabored him with tongue and fists when in his youth he showed up groggy and unkempt, she was not about to stand for any backchat from the born-again abstainer. "It was picturesque," Percy says with the tongue-in-cheek of a noncombatant, "to see her limping with a broken leg with crutched stick, wrinkled face, disheveled grey hair, and an old McNaughten plaid around her, raise her withered arm, and refuse, with towering rage, to surrender her principles—a tumbler of porter, and a modicum of whiskey toddy at bedtime. As the old ship carried too many guns, even for him, [George] had to submit."[18]

Shortly after subscribing to the pledge, Cruikshank spoke at a Bristol meeting. Addressing the female population, he advised them not to be deluded by the notion that "nourishing stout" was necessary when nursing infants. He pointed out the adverse moral and chemical effects upon the newborn and instanced himself as a melancholy example of the results of maternal imbibing. "My mother first placed the poisoned chalice to my lips," he declared. When Mary Cruikshank read this speech in the daily paper, she exploded. "What! shall I be told publicly at eighty years of age, that I, who always told him differently, first taught him the vice of drink?" She stoked her fire until George returned to Mornington Place, when she delivered herself of a vigorous reprimand.[19]

Cruikshank was much in demand by Temperance societies. His engagements for 1852 exemplify his activities over the next twenty-six years. On

30 January he chaired a meeting of a London Band of Hope—infant pledgers and their parents.[20] Three days later he received an invitation to preside at the 18 February meeting of the Walthamstow Temperance Society, which would pay his expenses but not an honorarium.[21] During that month he also became embroiled in a dispute about pledge cards. John Jordison of Middlesboro, for whom Cruikshank had designed a Family Pledge Card in the autumn of 1851, received a letter from John Cunliffe of the British Association for the Promotion of Temperance in Bolton castigating him for advertising his as the only one by Cruikshank.[22] Cunliffe's association also distributed one with the artist's design. Jordison reported this information to Cruikshank, who asked Cunliffe for an explanation of the unauthorized print: "There should be nothing unpleasant between us brother teetotalers," he concluded. However, Cunliffe's answer proved unsatisfactory. "I am sorry to say that yr explanation about the pledge card does not at all alter the facts," Cruikshank replied. The drawing was made for the wrapper of a Temperance magazine, and "ought not to be used as an original design for other purposes." It is advertised in such a way that "any one who is not acquainted with the whole affair will of course—suppose that it was done by me for the purposes for which it is now used." Cunliffe rejected the complaint, saying that he did not think there was anything wrong in using a reduced facsimile on his pledge. So much for Cruikshank's copyright.[23]

In March, Cruikshank agreed to chair and speak at the Fifth Annual Festival of the "Boro" of Greenwich Temperance Association held on Good Friday, 9 April.[24] Linnaeus Banks in Birmingham was putting together a lecture series that he hoped would include Thackeray and Albert Smith; would George talk on "Popery and Protestantism, the bane and the antidote"? Eliza dockets the letter "Answered," but does not indicate what the answer was.[25] From Nottingham, J. L. Mahon, a bookseller who was "no relation to Lord Mahon that I know of," wrote asking the artist's help in a scheme to create life-sized oil paintings of *The Bottle*, *The Drunkard's Children*, and Hogarth's *Industry and Idleness* to promote abstinence and sell additional copies of the prints. Cruikshank drafted a reply indicating that he might turn the task over to Percy.[26] And at midmonth Cruikshank chaired a "Grand Concert" given by the League.[27]

Then in July Cruikshank represented the London League at the Glasgow anniversary celebrations for the Scottish Temperance League.[28] In his address, Cruikshank adverted to friends who had been overcome by drink, including his father and D. M. Moir. Some months later Moir's family read accounts of the meeting and protested this slur. Cruikshank drafted and redrafted a letter of apology and self-defense.[29] On his way home from Scotland, he may have stopped at Middlesboro to attend one of John Taylor's festivals.[30]

The demands on Cruikshank's time continued unabated during the autumn. Would he deliver an address on "Total Abstinence Essential to the Intellectual and Moral Preservation of Artists and Literary Men," asked W. Burns.[31] Would he speak at the Annual Meeting of the Kentish Town and Camden Town Temperance Society on 30 November?[32] Would he design gratis a card for the Great Berkhamstead Mechanics Institution? He did.[33] The York Temperance Committee secured Cruikshank's appearance in the chair for their anniversary celebration 18 January 1853.[34] But the Albion Square Literary and Scientific Institution and the Jews' and General Literary and Scientific Institution received refusals.[35] More fortunate was the Leeds Mechanics' Institution and Literary Society, at whose annual soiree Cruikshank seconded a motion. Lord John Russell presided, and others moving and seconding resolutions included Henry Cole, the Dean of Ripon Cathedral, and Austin Henry Layard the eminent Assyriologist.[36]

Finally, in mid-December George presided over another meeting in Exeter Hall, calling forth from Charles Kent's *Sun*, on account of his chairmanship, another tribute.[37] In a thank-you to Kent, Cruikshank lamented that writing pamphlets interfered with etching.

> The truth is, that the *pencil* interferes with the operations of the *pen*. If with the duality of mind—we had also the ambidexterae power—we might then do *double* the work. I wish this were possible—not for the lucre, but to be able to carry out more of our ideas—and only think! what a power it would give to the critic and the satirist—he could then hit "right & left"!

When the ink spoiled his signature, George made another joke for his correspondent, a supporter of Temperance but not himself a teetotaler. "The fact is—and I'm sorry to say it; but my Pen—took a *drop* too much."[38]

These engagements occupied a great deal of time. They also catered to the artist's vanity, introduced him to leading citizens throughout England and Scotland, appeared to confirm his national reputation, and endorsed his work for Temperance reform. They extended year after year: in 1853 he traveled to York and Ramsgate, in 1854 to Brentford, Windsor, St. Albans, Bath, Kent, and Newcastle—and this was during a period when he was so occupied by painting and etching that he had to decline most requests. Conducting and addressing Temperance meetings became a second, unpaid vocation, and accustomed Cruikshank to the limelight. In time he felt confident enough about his place in British life to issue pronouncements on many subjects and to indite a stream of letters to Temperance periodicals and the national dailies.

The sheer quantity of Cruikshank's teetotal activities overwhelms his biographers, who, being mainly interested in his art, pass over much of the last quarter century of his life with a few anecdotes about his risible foibles

and a generally patronizing attitude toward the "fanatic" old man. However, as William Feaver has remarked, "Temperance provided [Cruikshank] with a sense of direction and purpose which reanimated his art."[39] The art production, after 1850, was very uneven, as Cruikshank attempted unfamiliar mediums and increasingly worked with third-rate authors. But he never entirely lost his former skills and when inspired could still execute plates of magical charm or passionate conviction.

It was through Temperance that Cruikshank received many of his commissions. He supplied Buckingham with an etched frontispiece, "The Backslider," for a collection of materials that the president put together for the London Temperance League Bazaar.[40] This volume was published by William Tweedie, to become after Cassell's temporary eclipse the leading Temperance publisher. Prohibitionists were also likely to espouse other reform measures; Cruikshank was no exception. At first, after taking the pledge, he continued to smoke. But in 1849, convinced that nicotine was as unhealthful as the "residuum" of beer, he renounced his worship of Sir Walter Raleigh and the blessed leaf, although he occasionally permitted his guests a puff in place of a quaff. The connection between the two renunciations was proudly announced in his signature on the Middlesboro Pledge Cards: "Total abstainer from all intoxicating liquors and tobacco."[41]

Gambling was another great vice of the poor. The ardent reformer wrote a pamphlet, *The Betting Book*, cautioning against the practices of his former days, and provided five woodcuts illustrating silly geese and cunning foxes, black legs and rook pies, and all the marks who are "*done brown*" by professional sharpers.[42] William and Frederick Cash distributed this little octavo paperback, but incensed the author when they disagreed about payment and republication.[43] Despite some favorable comments in letters and reviews, the work moved slowly.[44] A year after original publication John Humffreys Parry thanked the artist for "a capital exposure of Betting foolery" and complained that if Cruikshank continues so thoroughly chastening evil, Parry will be out of work.[45] Presenting a first edition to another friend, Lovell Reeve, Cruikshank drew a great florid signature quite unlike the more conventional handwriting of his inscription.[46] It almost seems to represent the split in the artist's sensibility, between the sober reformer working with other gentlemen for the reclamation of the poor, and the caricaturist whose sense of the ridiculous leads him to inveigh against gambling by portraying addicts as frock-coated, top-hatted pigeons and gulls.

George had particular reason to be grateful to Reeve, a conchologist who purchased the *Literary Gazette* from Jerdan at the end of December 1850 after all Jerdan's investments were mishandled by a friend. Reeve assumed the editor's chair and also branched out into publishing. He commissioned Cruikshank to design wood-engravings for one of the most improbable of all the books the artist illustrated: *Talpa, or the Chronicles of a Clay Farm.*[47]

'The bright little sentinels of Heaven were taking one by one their watch-posts.'

63. *George Cruikshank, "The bright little sentinels of Heaven," Talpa, wood-engraving, 1852*

The author was Chandos Hoskyns, a Balliol man and lawyer who married a lineal descendant of Christopher Wren, took her name (Wren Hoskyns), farmed her large Warwickshire estate, Wroxall Abbey, and thereafter promoted important agricultural reforms that were eventually adopted by farmers and landlords alike.

Talpa is described as "an agricultural fragment," and for this chronicle of rural life Cruikshank drew "some of the most inventive minor wood-engravings of his career," to quote Hilary and Mary Evans, among the very few ever to have commented on the work.[48] Some of the twenty-four tailpiece vignettes recall those for Clarke's *Three Courses*: mangel-wurzel roots as beet-shaped heads are mangled by the harrow, while an enterprising mole with a small spade teaches the countryfolk great lessons. Other vignettes hark back to caricature: a spiky Jack Frost carrying iron pincers kicks at the farmer's door, and long heads very much like Isaac's drawn more than sixty years earlier discuss the price of corn. In a succession of styles Cruikshank marks the coming of the railway: a heron standing by a waste pond in a neglected field evokes Bewick; then "The Willing Giant," showing an iron horse hitched to a carriage and conducted by a cabman, combines the styles of *Sketches by Boz* and the *Omnibus*; and lastly (fig. 63) a lonely heron gazing into a black pool at dusk while the railway clatters past draws

— ' In which there is Antagonism of interest yet Mutuality of object.'—

64. *George Cruikshank, "In which there is Antagonism of interest yet Mutuality of object," Talpa, wood-engraving, 1852*

resonance from Turner's engravings. Cruikshank thus tracks the progress of industrialism in the countryside by means of graphic conventions. As the Evanses rightly observe, "George is not, of course, being stretched to his greatest powers: but this only makes his performance the more impressive, bringing to each little sketch an inventiveness that gives each one a touch of his genius."[49]

Cruikshank may never have met Hoskyns. Reeve acted as intermediary, sending his artist installments, debating the appropriateness of imagery, and pressing his author for more material. On 3 May 1852 he wrote to Cruikshank about a vignette of "coupled Dogs" (fig. 64) that George proposed to illustrate the relation between landlord and tenant: "The success of the vignette will depend mainly upon the expression you can give to them to indicate what the author calls 'antagonism of interest yet mutuality of object'." He also sent an installment with a passage marked at "laughing at my deep drains," but without intending to dictate the artist's choice: "I must leave it to you. Do what you like." Two other numbers were forwarded without any suggestions about what to picture. In conclusion, Reeve begged, "*pray* don't go to that naughty place Exeter Hall with these in your pocket—."[50] A fortnight later, Cruikshank wanted more subjects; Reeve

wrote to Hoskyns. Then George, having finished eight drawings, wanted payment and reiterated his request for further manuscript.[51]

In the course of subsequent conversations, it was agreed that the "coupled Dogs" would not do. Hoskyns sketched an alternative which Reeve showed to Cruikshank.[52] But as the offensive design had already been engraved, it was published. Another vignette, "Drop it!", showing a footman dropping a hot muffin, was replaced in later editions, though for no apparent reason.[53] Constraints of cost rather than of time seem to have been the reason for not canceling the plate right away, for Cruikshank had still not furnished all the vignettes by October, when Reeve wrote urging his friend to finish the sketches.[54] *Talpa* was unexpectedly a hit, reaching a fourth edition by 1857 and a sixth by 1865. But once again, though it demonstrated Cruikshank's amazing versatility in wood block, it inspired no sequels or related jobs.

Cruikshank may have experienced a powerful sense of déjà vu in the autumn of 1852 when the duke of Wellington died. The funeral arrangements for the Great Duke were the most elaborate since Nelson's, and as George in the company of his father had sketched that procession in 1806, so he determined to record this event in a like manner. Cassell hired him to draw a portrait bust to be cut into the block for his magazine.[55] Cruikshank then applied to the hereditary Earl Marshal, the duke of Norfolk, for a ticket of admission to the service at St. Paul's; he was referred to the dean.[56] No separate print is catalogued by Cohn, although Cruikshank was certainly among the 1,500,000 mourners who lined the streets on 18 November as the ponderous cortege lumbered from Horse Guards Road to the Mall and Constitution Hill, along Piccadilly, through Trafalgar Square to the Strand, and up Ludgate Hill. The somber trappings, the muffled drumbeat, the straining horses pulling a funeral car constructed out of cannons captured during the Napoleonic campaigns, evoked the pomp and circumstances of Britain's greatest warrior and greatest victory, and moved a nation to memorialize a hero whose political conservatism and occasional repressive influence were permanently suppressed by the reiterated image of his integrity and nobility.

Cruikshank had a chance to review his own images of Wellington a few months later. Responding to a request from a Mr. Hogarth to list all the prints in which he caricatured the duke, Cruikshank renounced his previous work: "They are *all* sad rubbish—and I regret to find that I have many times libelled that great & good man—this regret is a little lessened however, upon finding that I have fought *sometimes* on *his* side—and although I was not *at* his side in the field of Waterloo—I have done him all the honor—I could for that good day's work."[57]

Unexpectedly Cassell offered Cruikshank a major commission. Harriet

Beecher Stowe's *Uncle Tom's Cabin*, having created a sensation in the United States when it ran in weekly installments in the *National Era* (1851–1852), was being reprinted by a number of English publishers. Through the instrumentality of Vizetelly, the first London edition appeared in April, but it did not sell particularly briskly for a variety of reasons.[58] American slavery was a remote topic for Britons, and the antislavery movement had degenerated into bickering factions. The economic importance of slavery, and the legislative power of the southern states, made it seem impractical for Britons to campaign for immediate abolition, since the cost would be far greater to their American cousins than when Britain had accomplished its emancipation project decades earlier, and in any case foreigners had little role to play in American national politics. Moreover, the most powerful British abolitionists of an earlier era had died, while many adherents had switched to attacking other home-grown problems: education, Temperance, prison reform, famine relief, religious conversion. And finally, the Great Exhibition had ushered in a period of national complacency, a sense of national destiny fulfilled, that, until the Crimean disaster, lulled the country into political and social somnolence.

However, two unrelated developments converged on Mrs. Stowe's text and catapulated it to unprecedented heights. First, the Booksellers Association, whose price-fixing policies had been submitted to the arbitration of Lord Campbell, lost in April 1852 their right to continue to set high retail prices on books. The result was immediate and intense price competition among booksellers and publishers and the expansion of pioneering efforts by Charles Knight, Cassell, and others to tap the lower end of the market. An American bestseller for which no copyright would have to be paid was an obvious target for enterprising mass market publishers. And there was something about the story that struck deep into the Evangelical conscience, for Mrs. Stowe had cast her fiction in the form of a conversion fable to demonstrate that a society which tolerates anti-Christian behavior threatens each individual and the collective nation's soul.[59] This Evangelical market was to some extent the same as the Temperance market: provincial, lower middle class, nonconformist, reformist.

Two of the most widely circulated editions of *Uncle Tom's Cabin* were sold by Routledge, then beginning its rapid advance to preeminence as a wholesale, retail, and railway terminal distributor, and by Cassell, which dominated the Temperance market. More than a dozen houses released separate editions in 1852, including one that opportunistically combined *Jack Sheppard* with *Uncle Tom*, both illustrated by Cruikshank. In September, one distributor was taking ten thousand copies a day for a month, and before Christmas, more than a million had been sold.[60] John Leech and

John Gilbert were among the artists hired to illustrate the novel over the summer.

Cassell determined to issue his version in weekly twopenny parts, each containing thirty-two printed crown octavo pages and at least two large illustrations engraved by the Dalziel brothers.[61] For the designs he applied to "the faithful and benevolent pencil of our good friend George Cruikshank," his fellow league vice-president. Cassell intended to distribute the parts by means of door-to-door canvassers as if they were antislavery or religious tracts. The artist started work at the beginning of October, though he had few visual models for slave society and found his pencil tracing musical hall minstrels more than American Negroes.[62] He may also have experienced some difficulty portraying noble blacks. There was no such tradition of imagery in England: the phrenologists denied their racial equality, and during the 1840s members of the London Anthropological Society had promulgated the view that the different human species were independently descended from various forebears (polygenesis), of which the Negroes' were the most debased.[63]

The results were not very satisfactory. A few plates, such as the one of little Eva garlanding Uncle Tom as they sit by a rushing fountain (resembling the Crystal Fountain in the Great Exhibition) in what looks like an overgrown medieval cloister, have an innocent, fairy tale quality that might be translated into the evangelical subtext of spiritual conversion and Christian humility. But the more sociological ones of slave trading and hunting caricature black and white Southerners and assimilate them to familiar graphic types—London toughs and colonial Othellos with the stigmata of the phrenologists about them. Part of the grossness of the plates may be attributed to the engravings. The Dalziel brothers were responsible, and evidently were not sufficiently proud of the product to mention it in their "Record of Fifty Years' Work." The blocks, too, may have been of inferior quality, perhaps because Cassell was publishing on the cheap. "Isn't the wood *very* [underlined twice] *indifferent?*" Cruikshank asked his engravers. "I found a difficulty to *express* myself upon it."[64] Moreover, the demand was so great, the plates for the English edition were printed from stereotypes. On 26 October Cassell sent his artist a message saying that he was making provision for the numbers to be better printed in the future, thereby acknowledging that some, at least, of the quality of the illustrations had been sacrificed to keep production costs low.[65]

Despite the inferior illustrations, Cassell's edition captured a fair share of the market. A bound edition from the parts was available by Christmas, and Cassell followed up by reprinting both the parts and the volume, by issuing Welsh and French translations (the latter with superior plate impressions taken directly from the wood blocks), and by producing *Uncle*

Tom's Cabin Almanack, or Abolitionist Memento for 1853, illustrated with wood-engravings after Cruikshank, Browne, Leech, and John Gilbert.[66] On the front wrapper of the copy subsequently owned by W. H. Woodin, Cruikshank inscribed "Not by me," but surviving sketches in the British Museum and a letter from Cassell to him enclosing twelve impressions of an engraving from the *Almanack* indicate that the artist may have been referring only to the wrapper in this instance.[67]

Cassell identified his firm with the abolitionist cause. When Mr. and Mrs. Stowe made their first visit to London in the spring of 1853, Cassell befriended them and joined Mr. Stowe at a Temperance rally. He also obtained Mrs. Stowe's permission to publish other writings by her, her brother, and her father; and when Cassell went to the United States later that year, Mrs. Stowe introduced him to her family and Lloyd Garrison.[68] In return, Cassell commissioned Cruikshank to draw a portrait and "Allegorical Design," engraved by John Thompson, for a shilling Memorial Broadside "intended as a Memento of Mrs. H. Beecher Stowe's Efforts to promote the Abolition of Negro Slavery."[69] That Cruikshank was sincerely interested in abolition is a plausible inference from all this activity; but he never devoted himself personally to that cause as he did to others more closely pertaining to Britain. Moreover, he was slightly offended by Mrs. Stowe's description of him, from their meeting, as "an old man with gray hair . . . and keen eyes."[70] As he was sixty, "old" might possibly be tolerated; "keen eyes" was indeed complimentary; but "gray hair" prompted remonstrance in an address "To the Public" at the end of his illustrated edition of *Cinderella*:

> As my hair at present happens to be *dark brown* (though I hope to live until it does become *grey*), it is quite clear, I think, that Mrs. Harriet Beecher Stowe has mixed me up in her *memory*, with some one else—possibly of the name of Cruikshank.[71]

As Percy remarks, "Had Mrs. Stowe, poetically, touched upon it, as the 'silver streak' or 'a winter, frosty, but kindly', she might have escaped."[72]

One further and topically unrelated Cassell commission: Cruikshank designed, and Thomas Williams sculpted, the wood-engraved cover design for the *Illustrated Magazine of Art*, which Cassell's began issuing in 1853. This rival to the Halls' *Art Journal* evidently targeted families, as others of Cassell's publications now did; Cruikshank's central vignette shows four children drawing and painting a still life of an urn of flowers. This is framed by architectural elements decorated in bas-relief and garlanded with flowers and leaves—a device that suggests the interrelation among nature, structures, art, and families and implies that learning about everything from

"The Families of Plants" to "King's Cross Terminus" and "Engraving and Printing on Copper" can be a delightful educational and recreational activity. While much of Cruikshank's energies were now directed toward hortatory propaganda, he still contributed occasionally to productions that provided enlightening entertainment.

Temperance, however, came first. In 1853 Cruikshank got embroiled in another controversy that provoked him to a pamphlet outburst. A committee had been formed to purchase the Crystal Palace and move it to an enlarged, hilly site on the south side of the river near Sydenham. Teetotalers hoped that as spirits had been banned from the Great Exhibition, the new Crystal Palace would observe the same rules. Instead, management elected to permit alcoholic beverages. There was also disagreement about whether the new establishment should observe the Sabbath or be opened then to provide instructive recreation to laboring families. When the Archbishop of Canterbury publicly opposed Sabbath openings while refusing to support the National Temperance League campaign to close public houses on that day, George burst out with *The Glass and the New Crystal Palace*.[73] He protested, with some justice, at the hypocrisy that permitted the rich unlimited indulgence while circumscribing the pleasures of the poor. Although several of the illustrations take a light-hearted view of the subject, the pamphlet jabs with right and left. *Punch* came back with a hard blow against teetotal fanaticism. When Cruikshank read this riposte, he flew into a towering passion and swore that "he had a great mind, to go down to Fleet Street, and knock the old rascal's wooden head about."[74] That exchange permanently quashed any notion that Cruikshank might eventually work for Mark Lemon.

Even Merle felt that Cruikshank's zeal might be excessive. Merle greatly enjoyed the *Glass*, but cautioned George against quoting Scripture in support of abstinence because there were more texts in favor of the juice of the grape than against it. He also urged his friend to campaign for purer water: "*Up George and at 'em!* I know of no mightier hand to paint the horrors of our London water." Adulteration of food, Merle continues, "is the *Crying and damning iniquity of the age!*" He acknowledges that "the learned tell us '*enthusiasm commences when the brain is betrayed & reason fails*'—yet many of our greatest & best of changes have been effected by—'the enthusiast'—therefore, I say, go on & prosper!" But he also chides his friend for having "blindly pledged your faith to *one good thing*" and for refusing to see that the sin is "*the abuse—and not the use*" of things: "Your view is one-eyed and one-sided while looking through the medium of your glass, yet I say, go on & prosper, for you may do much good" and destroy much evil.[75] Three weeks later Merle suggested that those opposed to Sabbatarian recreation, "the

gulpers of Camels by wholesale who cannot swallow a needle," be sentenced to twelve months hard labor. "They wd then know how to use, & not abuse, the day of rest."[76]

Another who differed amicably with the artist was J. H. Parry. He sided with volunteerists who hoped for individual, self-generated moral improvement, and against those favoring legislative enforcement of Temperance through prohibition.[77] Cruikshank's position was thus not the only one maintained by Temperance advocates. But though he expressed his views in cranky, characteristically supercharged ways, Cruikshank was wrestling with complicated issues of social engineering and dietary reform that engaged many well-meaning Britons. Unfortunately, he had neither the background nor the office to compel those in the governing classes to take him seriously: the *Glass* circulated very slowly at 1s., although Tweedie hoped for better results if issued at sixpence.[78] Once again, Cruikshank found more support at the lower than at the upper end of the social spectrum.

One reason for his interest in the new Crystal Palace was that George hoped to be exhibited there. William Behnes sculpted a bust of him in the spring of 1854 which, despite Behnes's dissolute habits, he did complete in time for the opening.[79] Cruikshank, who now spoke of caricature as "the profession I formerly belonged to," directed that "artist" replace "caricaturist" on the statue. Samuel Phillips, literary reviewer for *The Times* now in the last stages of consumption and racing death to complete his *Guide to the New Crystal Palace*, saw to it just days before his demise that the change was effected on the sculpture, but not in the catalogue. In one of his last letters he told George, "I hope you are not dissatisfied with the terms in which I have spoken of you" in his account of the portrait gallery.[80] On 14 October 1854 Phillips died; Cruikshank was one of the mourners invited to the interment in Sydenham Churchyard one week later.[81]

The celebrated American Temperance lecturer John B. Gough arrived in London in July 1853 and was immediately introduced to the officers of the National Temperance League. George and Eliza hosted a party at their home on 1 August and there established a friendship which strengthened through the years, as Gough and Cruikshank shared the platform at meetings, exchanged letters and ideas, and supported each other's efforts. Gough became so interested in the artist's work that he built up an extensive collection: "He never passed an old bookstore in London or in any other city, with any leisure time on his hands, that he did not look for books containing Cruikshank illustrations."[82] In time he also secured watercolors, pencil studies sometimes strengthened with sepia, wash, color, or ink, and one oil painting, *Grimaldi in a Barber's Shop*, which George presented to his friend at his departure after a second visit to England.

Gough had been born in Kent, but emigrated to the United States when

he was twelve. After working for two years on his relatives' farm, he fled to New York, earning his keep by odd jobs, including sawing logs, sweeping snow, crewing a fishing boat, packing and eventually binding books. But his real love was the stage, where for a time he made a bare living acting in farces or performing in one-man character dialogues of the sort popularized by Charles Mathews. Gough was also a notorious drunkard, who, after the death of his wife and baby, joined a teetotal club and began delivering testimonials as a reformed alcoholic. He simply seized control of his audiences, and by a combination of heartfelt sentiments, beautifully modulated rhetoric, quick wit, self-possession when confronted by hecklers, and oratorical flourishes, he conquered even the largest halls and most skeptical auditors.[83]

The league initially engaged Gough for six weeks in return for his expenses and a two-week paid holiday. Rumors that he was miserly and drank in secret preceded him, and the organizers were anxious to vindicate their choice when Gough opened his tour at Exeter Hall the day after the Cruikshanks' reception. A five-hundred-voice choir sang "See the conquering hero comes" to usher Gough in, but to the dismay of his supporters and the delight of those in the packed hall who had come to scoff, he began in a low, quiet, restrained tone that aroused no enthusiasm. Gradually he warmed to his theme, and his voice and person seemed visibly to swell. As one eyewitness recorded:

> At the outset . . . [his voice] gives no sign of the inherent flexibility and astonishing resources both of power and pathos. It is in keeping with the entire outer man, who at ease, seems to draw himself down to the smallest possible dimensions; but when fired he becomes erect, expanding in magnitude and stature, so as to present another and entirely new man. . . . the merits of Mr. Gough have by no means been overrated. . . . Oratorically speaking, he is never at fault.[84]

The league immediately expanded and fattened the contract, eventually extending it for two years, during which Gough spoke in the largest halls that could be hired in London and throughout England and Scotland.

Cruikshank was much in demand to chair these meetings. His own peculiarities of delivery and his own history of alcoholism complemented Gough's addresses, and they appealed to the same audience of working-class families. At Sadler's Wells in May 1854 (fig. 65), George, filled with memories of the days and nights spent with Joey Grimaldi when he performed there in his prime, delivered an introduction described by the papers as "full of piquant and incontrovertible truth." And when he saw how moved the audience was by Gough's oratory, he rose from his chair, seized some planks to bridge the orchestra pit, and exhorted the men, women,

65. George Cruikshank, *"Temperance Meeting," wood-engraving,* Illustrated London News, *20 May 1854*

and children to come forward then and there to sign the pledge. Ever resourceful, Cruikshank also drew a picture of the scene which was published in the *Illustrated London News*.[85] At such moments, chairing, lecturing, facilitating, proselytizing, and recording the Temperance movement, George had every reason to believe in his own importance. He was the living example of a reformed drinker as artist, whose time, energy, ideas, eloquence, and pencil promoted the people's welfare.

38

WHOLE HOGISM

They
 "Go the whole hog, and look the hog they go,"
as Canning sung of the ex-member for Middlesex.

Richard Ford, reviewing *Oliver Twist*[1]

*Artistically and imaginatively [Dickens and Cruikshank] had
much in common. . . . But in life they . . . traveled a strangely
erratic, collision-bound course. From the asperities of their early
collaboration, they . . . moved on to friendship, then jovial com-
panionship, only to drift gradually asunder, and finally to find
themselves, all unwittingly, in mortal opposition.*

Harry Stone[2]

"MY DEAR Dickens," Cruikshank drafted on the back of an in-
coming letter in April 1851, "I have only this moment heard of the
sudden death of yr little one"—Dora Annie, who died on 14 April—"and I
cannot refrain from expressing to you—and also to Mrs. Dickens—how
much I have been distressed by the intelligence and to offer my sincere
feelings of condolence upon this occasion." A fortnight earlier, Cruikshank
continued, he had passed by Devonshire Terrace and on inquiring why the
blinds were drawn learned that Dickens's father had died (31 March). On that
occasion he had left his card, but Dickens had not responded. "I do not like to
decide hastily for fear of deciding wrongfully—but it has struck me lately
that you have desired to—avoid my society—Under afflictions like this I
cannot help feeling and expressing myself as an old [friend]—altho'—from
what cause I cannot imagine, you seem to wish that friendship to cease—if
that be so I shall always regret the loss of yr friendship but—I."

At this point Cruikshank stopped wrestling with always-for-him intrac-
table language and instead drew a picture of himself holding out his hat.[3]
Eventually he pulled enough words out of that hat to send a formal letter of
condolence and protest, to which Dickens promptly replied.

My Dear George,

I assure you that I have never felt the slightest coolness towards you, or regarded you with any other than my old unvarying feeling of affectionate friendship. A host of those small circumstances that sometimes seem to fly together in busy lives, by a strange attraction, have interposed between us, and prevented our meeting; but I have never had in my heart the slightest unkindness or alienation. If I could find it there, I should be grieved by your letter, besides being touched (as I unaffectedly am) by its tenderness. But it is not there, and it has never been there.

My wife, I am sorry to say, is far from well. She wants quiet, and we are going to Broadstairs very soon, to remain until the end of October. She sends her kind regards to Mrs. Cruikshank. So does Georgina.

I shall come to see you very soon, when I hope with one shake of the hand to dispel any lingering remainder—if any there be—of your distrust. I am quite willing to admit that I have seemed to justify it (though I don't know how) and that I am to blame (though I have never consciously erred in this regard), but pray believe that I write in the utmost sincerity and without a grain of reservation. Being ever—Faithfully Your friend.[4]

There was some bad faith on both sides already, as this exchange, with its inconsistent and defensive tone, reveals. Cruikshank must have been aware that Dickens found teetotalism excessive and offensive and may have sensed Dickens's patronizing attitude. The bright, eager youth of the 1830s had grown into an international literary celebrity, a prosperous businessman with his own magazine and a large home, and a world traveler with rich and powerful friends. The gulf between their circumstances widened every year. Conversely, Dickens surely knew something of Cruikshank's straitened finances and disappointed expectations, through Stanfield or Jerrold or Mark Lemon, if not directly from the artist himself.

Many people still yoked them together. George Nalse sent a Christmas story to Cruikshank hoping thereby to get an introduction to Dickens or Charles Mackay.[5] A Portuguese musician, having obtained from Dickens and Tom Moore subscriptions to her collection of native melodies, wrote to Cruikshank soliciting his patronage.[6] The Dudley Institute asked Cruikshank to a soiree when, if Dickens were willing, the two would meet: Dickens "goes to Birmingham to the Artists's dinner on the 6th January [1853]—do you accompany him?"[7] Even Merle adverted to former times when author and artist shared a bottle: "And does not the spirit of that joyous night under your roof sometimes rise to memory—I shall never forget it & wd not have missed it for much—Dickens—poor Laman [Blanchard]! the moon! & sky with clouds such as never were before & never will be again. & the poor dear Lady [Mary Ann Cruikshank], en chemise, I believe, behind the door, who saved us from excess, Heaven rest her soul."[8]

Despite this tendency to couple Dickens and Cruikshank—a tendency

that persists to this day—their disagreements on social and professional issues were intensifying. It was their very closeness of purpose and general agreement about ends that made their disagreements about means and strategies so acrimonious. In the early 1850s their smouldering disputes burst into flame. Using the pages of their respective journals, Dickens and Cruikshank engaged in a public war that started playfully enough but ended with the remaining amity destroyed. At the end of the decade Dickens's bonfire of correspondence reduced to ash nearly all of the communications that had once passed so regularly and hearteningly between the two families. What was saved after that conflagration were a few notes Dickens sent to Cruikshank, while the artist's letters fueled a fire in which the Dickens boys roasted onions. Dickens ensured that his side of the story survived to a much greater extent than Cruikshank's.

The three topics on which author differed from artist were teetotalism, funerals, and fairy tales. Of these, the first and third contributed far more to the breach than the second.[9] To begin with, Dickens found the August Temperance rally during the Great Exhibition ridiculous. He was disturbed by the fanaticism and monomania of teetolalers, and by their deflection of attention and energy from more fundamental social ills: poverty, ignorance, the indifference of the prosperous toward the poor, and the blighted hopes of laborers. So he decided to write a leader for *Household Words* castigating the Temperance, Peace, and Vegetarian societies, all of which had convened major gatherings in London during the Crystal Palace exhibition and were "making stupendous fools of themselves."[10] It was not only the conjunction of meetings that aroused Dickens; it was also the personnel, like Elihu Burritt ("the Dove Delegate from America") and Benjamin Rotch, the Temperance advocate and prison reformer who had given G. L. Chesterton so much trouble and who asserted publicly that Adshead's *Prisons and Prisoners* had "blown to the four winds of heaven" Dickens's account in *American Notes* of the Philadelphia system.[11] "The public market has been of late more than usually remarkable for transactions on the American principle in Whole and indivisible Hogs," Dickens began. "Those who may only have had a retail inclination for sides, ribs, limbs, cheeks, face, trotters, snout, ears, or tail, have been required to take the Whole Hog, sinking none of the offal, but consenting to it all—and a good deal of it too."[12]

He then proceeded to caricature the August Temperance rallies held in Exeter Hall, St. Martin's Hall, the London Tavern, Rosherville Gardens, and the Surrey Zoological Gardens. He ridiculed the Bands of Hope, the orators, the Grand Demonstration Meetings, and the wholesale denunciations of society indulged in by the Regenerators. Instead, Dickens counseled moderation, *real* temperance. "The Whole Hog of the Temperance Movement, divested . . . of its intemperate determination to run grunting

at the legs of the general population of this empire, would be a far less unclean and a far more serviceable creature than at present. . . . if all of us, in short, were to yield up something of our whole and entire animals, it might be very much the better in the end." In his final paragraph Dickens exhibited his own porker, the cause to which over and over again he turned for thorough regeneration of society: "Even the best Whole and indivisible Hog may be but a small fragment of the higher and greater work, called Education."

Dickens's acerbic attack vexed Cruikshank. It was all very well to preach moderation and education, but the conditions George was trying to change demanded more extreme and immediate measures. Cruikshank believed that alcohol was a poison, and though his grounds for that belief were less than scientific, to a significant fraction of the population any quantity of spirits is as we now know addictive and medically dangerous. For some alcoholics, moderation is an impossible prescription, a fact which Dickens conceded but often ignored. Moreover, affluent drinkers may cause fewer problems, to themselves and to their families, than those whose few shillings are spent in drink instead of necessities for themselves and their families. Providing counterattractions was a critical part of teetotalism. The debate between moderationists and abstainers involved issues of addiction and class that Dickens slighted.

Cruikshank never had much interest in wholesale legislative reforms; he worked to reclaim individuals. Trained in a discourse that personalized and particularized issues, that assigned blame for social evils to government ministers rather than to abstract forces, and that retained a residual belief in the power of each person to shape his or her fate, Cruikshank's faith in and reliance on Benthamite legislation was not very great. Nor had he Dickens's reverence for education as a panacea: he preached hard work, sobriety, and aggressive self-assertion, even though in his own life these virtues were not assuring his continued prosperity.

Finally, part of what rankled was surely the perception that both he and Dickens were devoted to the regeneration of the deserving poor. Why should Dickens use the power of his pen to lampoon well-intentioned and often salutary efforts toward common ends? Was not Dickens, by his sweeping indictment of the Temperance, Peace, and Vegetarian movements, both depreciating a serious and extensive project in social engineering—teetotalism—by associating it with marginal and dubious advocacies such as vegetarianism, and indulging in the very same fanatic whole hoggism he denounced?

Dickens was not about to give up his glass of sherry or cellar of wines, and Cruikshank was not about to recommend that gin-sodden wretches who abused their spouses and squandered their pennies should take just a

few gills less. Dickens sympathized with some aspects of the standard Victorian argument that the upper classes should set an example for the lower. Literature certainly should. In his own novels, however, he often located genuine virtue not among the rich but among the poor. His tipplers are more likely to come from the ranks of the educated than from the impoverished; clergymen particularly succumb—Stiggins in *Pickwick* and Chadband in *Bleak House*—but so too does the incorrigible father of the poor dolls' dressmaker Jenny Wren in *Our Mutual Friend*. Yet drinking was also for Dickens, in his life and in his art, an ingredient in communal celebrations, an essential part of ratifying fellowship, and a sensual pleasure not to be proscribed by or for anyone.[13] However much Cruikshank had shared in those convivial parties in the past, once he was persuaded of their evil tendencies he felt compelled to set a personal example. Talking against intemperance, Cruikshank explained to W. Stephenson in 1853, resulted only in disappointment; teetotalers taught "the great secret, that in order to induce, or influence others, you must *practise* what you *preach*."[14] Both reformers, passionately and largely concerned with the alleviation of human misery, advocated policies that would contribute to better lives; but they could not tolerate each other's solutions.

When Wellington's funeral arrangements were announced, the commercialism that ensued provoked another outburst from Dickens against expensive obsequies, a campaign in which Cruikshank also soldiered. But for all their general agreement, once again artist and author differed in emphasis. During the Crystal Palace exhibition the commercial opportunism of retailers and lodging-house operators had seemed to Cruikshank a source of comedy rather than a cause for complaint. But then he had always enjoyed crowds, fairs, and large-scale public entertainments more than Dickens, for whom mass gatherings smacked of uncontrolled behavior, even possibly riot—as in *Barnaby Rudge* and *A Tale of Two Cities*. Disgusted by the "system of barbarous show and expense," Dickens in a *Household Words* leader, "Trading in Death," inveighed against associating "the most solemn of human occasions with unmeaning mummeries, dishonest debt, profuse waste, and bad example in an utter oblivion of responsibility."[15] Particularly repugnant to him was "the demoralising practice of trading in Death": opportunists advertised rooms and seats along the parade route for as much as thirty-five guineas; Wellington autographs could be purchased for upwards of £20; and locks of his hair might be obtained from his barber or from several ladies. One entrepreneur claimed to have a book that the duke had torn up and thrown out of his carriage as he was riding through Kent; it had been carefully reconstituted and was now available for purchase. Dickens's strictures on "this Public Fair and Great Undertakers' Jubilee" certainly have point; and his outrage registers all the more forcefully because it is so

clearly prompted by his respect for Wellington's "true, manly, modest, self-contained, and genuine character." By focusing on the seamier side of the tribute, Dickens dissociates himself from the jingoistic celebration that evoked Tennyson's "Ode" and Cruikshank's bust. Once again, while Dickens and Cruikshank both revered the duke and deplored wasteful orgiastic funerals, their attitudes toward a public display sharply contrasted.

So far, at least, neither friend had resorted to attacking the other. Cruikshank still thought of Dickens, under certain circumstances, as an ally. He submitted a pamphlet—possibly *The Betting Book*—for publication in *Household Words*, but Dickens declined it.[16] Dickens's send-up of insensitive tract distributors, in the person of Mrs. Pardiggle in *Bleak House*, did not point so specifically to the Cassell Temperance and abolition tracts as to rouse Cruikshank's ire. The final blowup came over something so fundamental to each man's vision that opposition could not be tolerated nor passed over in silence. Dickens and Cruikshank fell out over fairy tales.

In "A Preliminary Word" printed in the first issue of *Household Words*, Dickens declared his allegiance to fancy, his faith in the salvific properties of literature, and his belief that an industrial society required the psychological and motivational nurture found in some kinds of children's stories. His journal, he announced, would "teach the hardest workers at this whirling wheel of toil, that their lot is not necessarily a moody, brutal fact, excluded from the sympathies and graces of imagination." Dickens was careful to distinguish good books from the dreary didacticism of spellers filled with pattern Philips and Little Margerys whose fates were inflexibly determined by their moral natures. "The test in all such matters," Harry Stone summarizes, "was very simple. [Dickens] attacked all childhood literature that was given over to dour prosing; he exalted all childhood literature that was wild or fanciful or free."[17] This was a position that Ruskin endorsed and amplified in subsequent years.

Cruikshank's reason for returning to fairy tales was a good deal more pragmatic. He needed money, and since his illustrations for the Brothers Grimm and other nursery favorites had earned him both a reputation and some shillings, he decided to revive those earlier subjects. This time, however, since no authorial collaborator was available, Cruikshank elected to write, embellish, and publish a series of fairy tales all on his own. He approached David Bogue with this proposition in the autumn of 1852; between them they arranged for the artist to receive advances against receipts to cover the cost of "editing" the texts and etching the plates, and for the publisher to make periodic accountings of each title as it was printed and sold. By May of the next year, however, Cruikshank was anticipating his income to such an extent that even before the plates for the first vol-

ume, *Hop o' my Thumb and the Seven League Boots*, were completed he was overdrawn.[18]

Cruikshank finished *Hop* around the first of June 1853. Eliza read the manuscript carefully and scrutinized the proofs. Whereas Bogue, who tested the story by reading it to his children, thought some emendations might improve it, George and Eliza resisted any changes, except "as it is a childs book—Giant &c . . . should be spelt with *capitals*."[19] In returning proof, Cruikshank hoped that Bogue would hasten publication so that the story might be purchased for the long summer holidays. He also realized that he had not yet selected a colored wrapper paper. The samples Bogue sent did not quite suit; the artist preferred "the colour of the piece of green paper—marked GC," which he forwarded in return. One other item not yet attended to in mid-June: the list of plates, which Cruikshank promised to attend to, and which arrived so late that for the first issue it was printed on a separate slip.[20] "PS," Cruikshank added at the foot of his second note to Bogue, "You took the best possible way of testing the Story of 'Hop o' My Thumb.'—by reading it to yr little ones—their natural feelings—being the best of all criticisms—."

A few other problems cropped up during the final printing. A misplaced comma, Cruikshank informed Bogue, could be removed with a pen knife. "The mistake arises from the *botheration* of writing back wards—and I fear it is on some of the plates—but it is of little consequence." With this note he enclosed checks from which he hoped for change. His balance at Coutts on Midsummer's Day was only 2s. 1d.[21] "Pray hurry on the Publication with the speed of the 'Seven League Boots'" he begged in conclusion.[22]

The initial reception was all Cruikshank hoped for. Mary Cowden Clarke thanked him "in the name of myself & the other grown-up children of our family, together with the numerous little nephews and nieces who form the ungrown-up children among us, for the delightful treat" of *Hop*.[23] To the Reverend Thomas Hugo, the foremost collector of Bewick, Cruikshank sent inscribed china paper proofs of the plates.[24] He dropped off another set of proofs at Ruskin's house, although John and Effie were not at home. He apologized for the plates, "which I am sorry to say—in consequence of the badness of the steel, [did] not come out so well" as he had expected. Ruskin disliked them, but held his tongue and paid the agreed ten guineas directly to Cruikshank, rather than, as had been arranged, to Coutts.[25] And the exultant artist reported to Bogue:

> I hear but one opinion about "Little Hop"—& that is most favorable—T. K. Hervey—is delighted with—it—and I expect a first rate notice from him, and also from my friend [Lovell] Reeve—as well as from others—Had we not better have some more plates worked?—we shall surely want them—and they ought to be well dried—for I see a *little set off* from the ink in those already done

up—"a word to the wise"—from Yours truly, Geo[rg]e. Cruikshank who hopes that you and your family are enjoying & reaping all the pleasures & benefits of the seaside.[26]

George was unmistakably enjoying the pleasures of success. John Forster's review in the *Examiner* hailed "with delight" the return of the "court painter to Oberon": the cover "teems with fancy," the plates are exquisitely finished, the invention outruns even that out of which the legend was begotten. "The ogre's wife . . . is a piece of high art, a work of genius. Who but George Cruikshank could let you see, by her face, how it was that though a tender, womanly sort of soul, she could yet fancy an ogre for a husband." In short, Forster reckoned these pictures "as among the very best works of Cruikshank's genius, and we look forward with a sort of childish longing to the day when we shall have more of them to look at." True, Forster did note that the artist, in his role as philanthropist and teetotaler, has "somewhat sobered" the tale by introducing numerous warnings against drinking, gambling, and the Corn Laws. But this kind of editing, Forster concluded, could "do no harm—for such morals are not here obtruded in any dull way—and in the opinion of many it may be very likely to do good."[27]

The etchings are delightful. They are animated by a tensile freehand line, nowhere marred by machine ruling or other labor-saving tricks, and by bold distortions of scale that fully realize a child's imaginative spatial conceptions. The frontispiece (fig. 66) melds image and word into a synopsis of the story: framed by the spiky grasp of writhing branches, the ogre broods over two scenes, one of Hop's parents plotting to abandon their offspring, the other of the anthropomorphized wood wherein the children dance while their parents steal away. On the other hand, the reformist morals are intrusive; they attribute every misfortune to alcohol, and every good fortune to abstinence and sobriety. Hop's father and the Giant are cruel because they drink, and in the end the kingdom is reformed through prohibition, which eliminates crime and restricts poverty to those too infirm to work. Everyone else is industrious, and the country is prosperous.

Dickens, on holiday in Boulogne, saw Forster's review and, even before looking at the *Fairy Library*, he knew that he wanted to say something quite different about it. On the very day that Cruikshank told Bogue he heard only one opinion of *Hop*, and that one "most favorable," Dickens wrote to Wills for assistance in preparing a critical notice:

> I have . . . thought of [an article], to be called Frauds upon the Fairies—*apropos* of George Cruikshank's editing. Half playfully and half seriously, I mean to protest most strongly against alteration—for any purpose—of the beautiful little stories which are so tenderly and humanly useful to us in these times when the world is too much with us, early and late; and then to re-write Cinderella

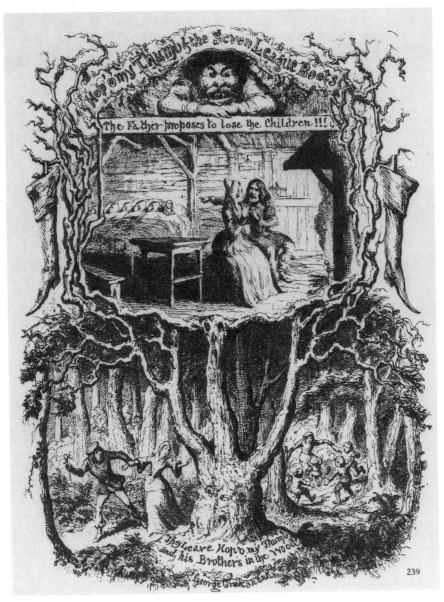

Within the image:
Hop o'my Thumb & the Seven League Boots

The Father proposes to lose the Children !!!

They leave Hop o' my Thumb
and his Brothers in the Wood.

George Cruikshank

239

66. *George Cruikshank, frontispiece to* Hop o' my Thumb, *etching, 1853*

according to Total-abstinence, Peace Society, and Bloomer principles, and expressly for their propagation.

I shall want his book of Hop o' My Thumb (Forster noticed it in the last Examiner) and the most simple and popular version of Cinderella you can get

me. I shall not be able to do it until after finishing Bleak House, but I shall do it the more easily for having the books by me. So send them, if convenient, in your next parcel.[28]

This is a curious letter, one that reveals a great deal more about Dickens's thinking than most commentators have noticed. To begin with, the idea for the article was formed before Dickens read a word of Cruikshank's "edited" text. It clearly relates to his earlier *Household Words* piece mocking Teetotal and Peace societies, and thus taps an animus far deeper and more resonant than Cruikshank's redaction of one fairy tale. Clara Lucas Balfour had already responded to Dickens's "Whole Hogs" essay ("at his wits' end for a real true living argument") in her contribution to *The Temperance Offering*, edited by John Silk Buckingham and published by the London Temperance League.[29] In such ways Temperance writers were helping to drive a wedge between Cruikshank and Dickens. Moreover, Harry Stone surmises that one of the aspects of *Hop* most disturbing to Dickens was its frontispiece, which when he saw it aroused his own resentment at parental abandonment. Thus Cruikshank was less the cause of Dickens's reaction than were a number of social reform movements and personal traumas.

Then, too, the letter suggests, by its quotation from Wordsworth, how important to Dickens imaginative stories were as a refuge from worldly demands. Fairy tales were not simply frivolous; they were "tenderly and humanly useful," softening the rigors of life. Dickens's own practices supply a perplexing gloss on this observation, for as a parent he was something of a martinet, subjecting his children's rooms to white-glove inspections and insisting on tough disciplinary standards. Charley was booked for Eton, not a school notable for its advocacy of fancy. Some of Dickens's anxiety here may be self-directed; chained to his desk and committed to periodical writing for his novels and *A Child's History of England*, and to editing *Household Words*, he may have been registering discomfort at his own rigidification, the loss of youthful spontaneity and gaiety. Those things that might supply tenderness and recapture boyhood's ardent high spirits assumed an ever more essential place in his mind. That such issues preoccupied him the stories from *The Haunted Man* to *Little Dorrit* indicate.

And finally, Dickens's notion that fairy tales should not be altered can hardly mean what it seems to mean. From his first writings, Dickens had altered, inverted, parodied, patched, and recombined childhood reading. The application of fairy tale materials in original and highly inventive ways to other stories and to fables about contemporary life was a hallmark of Dickens's genius. The adaptation of those materials yielded one of his favorite theatrical genres, the pantomine. And surely Dickens was not so naive as to suppose that for each story there was an Ur-version, one utterly

simple, transparent, and harmless that supplied the touchstone for all other variants.[30] Indeed, he betrays an awareness that the stories come in all sorts of guises when he asks Wills to procure the "most simple and popular" version of Cinderella, a request that in itself conflates two criteria not necessarily always conjoint.

What Dickens really was objecting to was the use of fairy tales to teach specific didactic lessons. His dissent was prompted as much by the object of those lessons—prohibition, gambling, and the like—as it was by the notion of didacticism per se. In his own writings he did presume to teach lessons, but his instruction apparently advocated openness, pluralism, fancy, and imagination, not rigid doctrines of psychic or behavioral control. Fairy tales might sometimes be used to indoctrinate, but mainly they should teach an Iron Age to appreciate what they nourished. In fact, fairy tales mean different things to different readers in different cultures, but Dickens believed that they should—and if "left alone" (that is, treated as he treats them) would—inculcate "gentleness and mercy" and inspire "forbearance, courtesy, consideration for the poor and aged, kind treatment of animals, the love of nature, abhorrence of tyranny and brute force."

Such was the burden of his leader, "Frauds on the Fairies," published in the 1 October issue of *Household Words*.[31] He stressed the importance of "enchantment," held fairy tales to be "nurseries of fancy," and while extolling the plates came down savagely on his "beloved friend" Cruikshank for "propagating the doctrines of Total Abstinence, Prohibition of the sale of spiritous liquors, Free Trade, and Popular Education." Dickens objects to tampering with these stories, no matter to what end: Cruikshank "has no greater moral justification in altering the harmless little books than we should have in altering his best etchings." (That formulation begs all kinds of questions; for one, the "harmless little books" were constantly being altered, never having been fixed into a single unalterable form, whereas interpolating additions to an artist's etching might be construed as defacing the original. But in the caricature tradition it was precisely by altering and emending a prior image that an artist made a new one of his own; and Dickens rewrote his predecessors' novels all the time.)

To show what "editing" a fairy tale, according to the idées fixes of platform reformers, might become, Dickens then produces a version of Cinderella in which the heroine, inducted into a Juvenile Band of Hope at the age of four, goes through her trials and tribulations, is told by her fairy godmother to fetch an American pumpkin because some states in that independent country have passed prohibition laws and because Mrs. Colonel Bloomer there established the fashion which leads to Cinderella's sky-blue satin pantaloons, meets a Temperance orator, a prince who can speak for four hours at a stretch, and finally marries him and rules over the king-

dom. The penultimate sentence indicates Dickens's conservatism with regard to some political and social reforms: "She also threw open the right of voting, and of being elected to public offices, and of making the laws, to the whole of her sex; who thus came to be always gloriously occupied with public life and whom nobody dared to love." Dickens may have felt playful while inventing this spoof, but its burden is deeply serious.

In his closing attack on the Whole Hogs who are rooting in the fairy flower garden, Dickens repeats the Wordsworthian complaint from his letter to Wills. "The world is too much with us, early and late. Leave this precious old escape from it, alone." Here, once again, seems to be the nub of Dickens's quarrel. About Bloomerism and women's suffrage he and Cruikshank saw eye to eye, as the *Comic Almanack* plates attest. But about art as propaganda, particularly for some kinds of social and legislative reform, they fundamentally disagreed. Cruikshank's art had from the first been employed in the service of propaganda; the nonpolitical book illustrations had come as a second career, which now Cruikshank hoped to redirect toward the ends of caricature while being an "artist." Dickens's work had once contained a good deal of specific political critique—*Oliver Twist*, *Sunday Under Three Heads*, and *American Notes* for example—and *A Child's History of England* which he was writing at this time was not without its Whig bias. But increasingly Dickens looked to some kinds of literature, and especially to the stories loved in childhood, as a refuge from the strident factions and parties of contemporary Britain. He advocated, not escapist literature, but a literature of escape, one that healed and nurtured those civilizing impulses so threatened by utilitarianism, industrialism, and movements. To see fairy tales enrolled in the literature of power was something Dickens could not witness silently. He elaborated and exemplified his contention in the next novel, *Hard Times*.

Cruikshank was baffled and enraged by this onslaught. If not unprecedented, it was certainly unpredicted. He and Dickens had worked closely together, using their arts in the service of humanitarian causes, acting to raise money for destitute artists and Shakespeare's birthplace, writing recommendations for grants, signing petitions and holding meetings to reform bookselling practices. That Dickens was no friend to teetotalism Cruikshank knew well; but that the *Fairy Library* should receive such a blast was beyond his understanding.

Cruikshank never could articulate well, nor even comprehend, his own internal divisions; he did not see the disjunction between plates that still evoked all the mystery and indeterminacy of fairy tales, on the one hand, and a text that pinned causality in the barest and most unimaginative way to particular vices. When Cruikshank began "editing" *Hop*, he searched for an explanation of parental and ogre cruelty and found it in the bottle, to

which he was accustomed to attribute society's ills. To leave unexplained and unmotivated those cruel acts against the children would not have conduced to a moral, inspiriting nursery tale. Like any good caricaturist, Cruikshank took polysemous material, focused it, pruned some things and exaggerated others, and pointed it in a particular direction. Oddly enough, his art was often rich enough to retain some of the ambivalence and counterthemes, while, as he struggled to express himself in words, he struck out every ambiguity he could find. He never wrestled with his etcher's needle the way he fought his pen. And so even in *Hop* and the two stories that followed in the *Fairy Library*, the illustrations continue to evoke magic kingdoms while the prose cranks out diatribes.

"Frauds" infuriated Cruikshank. When Cuthbert Bede called on him to discuss articles for the projected *Magazine*, the artist was still "smarting from the effects" of Dickens's squib.[32] Cruikshank planned to write a rebuttal, but before he did, other matters intervened. Just after *Hop* was published, on 10 August his mother died, aged eighty-four. During a holiday at Margate she had fallen ill and on her return had taken to her bed. George attributed her sudden demise to "drinking some of Cobb's Ale," but her death came as something of a surprise, considering her spirited denunciations of her son's Temperance lecture, and it left him for the first time without her guidance and opposition.[33] Mary may not have been an outwardly effectual disciplinarian, but she never let George make a fool of himself without speaking her mind. And George, after running away from home in his twenties, had returned to her and provided for her the rest of her life. She was his critic in residence; her tart tongue spoke both in favor of propriety and against the ridiculous scrapes of her "boobies." Eliza too spoke for conventional society, but her remonstrances could not keep George from Adelaide, and her adoration did not extend to admonitions. Cruikshank inscribed a first edition of *Cinderella* "with the affectionate love and esteem of your *most obedient* husband," but whether his underlined obedience was a private joke, an *amende*, or simply a conventional piety, the fact remains that though George never obeyed either his mother or his wives, Mary exerted a kind of moderating influence that Eliza never did.[34]

And then Robert, suffering from bronchitis among other ills, had "fallen away to a shadow."[35] Here was Dickens fulminating against teetotal propaganda, while the evil results of drinking were once more inescapably present in Cruikshank's own relations. What George wouldn't give to save one family from the scourge that had blighted his! And Eliza needed support at this time too; her niece Elizabeth Baldwyn, the orphaned daughter of Cruikshank's early publisher, died on 19 November at the home of her uncle the Kenninghall saddler.[36]

The next two volumes in the *Fairy Library* were duly issued, but the

steam had gone out of the boiler and the enterprise slowed to a halt.[37] The art held up amazingly, but the texts got even crankier—*Cinderella* almost "out-parodying Dickens' parody," as Harry Stone justly puts it. The fairy godmother becomes an intolerably prosy teetotal lecturer, haranguing the king and admonishing him not to serve wine at his son's wedding.

Meanwhile Cruikshank pushed forward with arrangements for yet another periodical, *George Cruikshank's Magazine*, which Bogue was to issue monthly from January 1854. This time the artist hoped to keep all aspects of the publication, from letterpress to distribution, under his control. Consequently he interviewed prospective writers and paid a call upon Frank Smedley who had been hired to edit copy. Cruikshank had never met the author of *Frank Fairlegh*; he was therefore stunned to see the young man confined to a wheelchair. "Good God!" he exclaimed. "I thought you could gallop about on horses!"—as indeed the quasi-biographical hero Frank Fairlegh did. Smedly gently explained his situation, and the two got down to business. It was a hot, sultry day, and Cruikshank had hastened to his appointment on foot; he was now gesticulating so energetically Smedley had difficulty repressing his amusement. Most distracting was a large ivory disk fixed in the middle of the artist's forehead; could it be some secret badge of office or cabalistic sign? Suddenly it fell to the floor. "Wherever did that come from?" Cruikshank inquired. When told, "Your forehead," he paused, bewildered, then seized his hat and looked into the crown. The truth dawned: the ivory circlet had fallen from the ventilating hole and stuck onto his perspiring brow. "When he found out the truth, and fully realized the absurdity of the situation," Smedley subsequently told Cuthbert Bede, "he burst into such a hearty roar of laughter as I have not heard for many a day."[38]

But Cruikshank's sense of the ridiculous did not always save him from folly. A few days after meeting Smedley, Cruikshank summoned Bede to Mornington Place. Bede was asked to write an article which would be accompanied by wood-engravings already cut.[39] The subject was another of the great evils that the artist determined to put down, namely the universal habit of placing the handles of canes, walking sticks, and umbrellas to the mouth, and either sucking them or tapping the teeth with them. Cruikshank was deadly serious: he intended to print a pamphlet at his own expense and to employ men to distribute the tract at railway terminals, omnibus halts, and cab stands. Bede remonstrated, but needing the money went home and dashed off a piece. It did not at all suit, however, because he treated the topic in a jocular spirit.[40] Cruikshank demanded that he draft another essay; Bede declined; and the *Magazine* folded before plates or an alternative text could ever be published. A year later, Bede printed his rejected copy, "Dental Dangers," in a collection of his essays appropriately entitled *Motley*.[41]

For the opening illustration to the January number of his *Magazine* Cruikshank executed another blockbuster. "Passing Events, or The Tail of the Comet of 1853" is a fifteen-inch-long folding etching that squeezes in images of all the leading events of the year: the Peace Conference, the Crimean War, war in China, the queen's review of troops, a naval review at Portsmouth, Spirit Rapping, Table Turning, Derby Day, Betting, John Gough, the Nineveh Bulls, Albert Smith's famous lecture on the ascent of Mont Blanc, Charles Kean's "Sardanapalus," the Australian Gold Strike, Mrs. Stowe and *Uncle Tom's Cabin*, Guy Fawkes, Lord Mayor's Day, Miss Cunningham's Seizure by the Grand Duke of Tuscany, Smithfield Cattle Show, Chiswick Flower Show, Christmas Merry-making, and the Panto-mimes.[42] Since the *Comic Almanack* had stopped the year before, Cruik-shank had had no opportunity to register current events, as he had done for the nineteen preceding years. The tale unfolded in his *Magazine* is there-fore a culmination of those *Almanack* plates, only this time he tries almost too hard to pack everything in, to dazzle customers and fellow etchers with astonishingly varied representations of minutiae. As a further bid for recog-nition, this introduction to the *Magazine* does not ride any particular hobby-horse, though elsewhere in the first number appears a plate ridicul-ing smokers. But this may have been a last-minute addition. The dark weather of early December made it almost impossible for Cruikshank to see his plate, and threw his "work back sadly," he told Bogue. "I have been obliged *to go* on *with the comet*—but at a very different speed, and I am sorry to add that I have not any other illustration for the magazine in hand."[43]

It was in the second number that Cruikshank published his reply to Dickens, in the form of a letter from Hop regarding "Frauds" and "Whole Hogs." How indicative it is that Cruikshank, just months after his mother's death, should assume the persona of the diminutive Hop, betrayed by his parents, responsible for his siblings, and resourceful enough to outwit a giant. Hop makes Dickens into another giant, whose "seven-league boot imagination" has run away with him into his own fairy land. Had Dickens complained about altering any standard literary work, the hue and cry would have been justified; "but to insist on preserving the entire integrity of a Fairy tale, which has been, and is, constantly altering in the recitals, and in the printing of various editions in different countries, and even counties, appears to my little mind, like shearing one of your own 'whole hogs,' where there is 'great cry and little wool'." Furthermore, what tenderness is instilled by a father's deserting his seven children to perish by hunger or wild beasts? Hop's editor, "seeing that such a statement was not only dis-gusting, but against nature, and consequently unfit for the pure and parent-

loving minds of children," found an explanation in drink, "which marks its progress, daily and hourly, by acts of unnatural brutality." And is a description of an ogre slitting the throats of his children the sort of stuff to "*keep us ever young*" and give an innocent delight?[44]

As for the ridicule heaped on the Temperance question, "This is not the place, nor is it my purpose," to discuss it, "but I take the liberty of telling you that it is a question which you evidently do not understand, for if you did, your good heart and sanguine disposition would make you, if possible, a more enthusiastic advocate than my editor." The whole hogs should have been applied, not to the peace party, but the war party; not to teetotalers, but to drunkards "who wallow in the mire." "I have therefore to beg, that in future you will not drive your 'whole hogs' against us, but take them to some other market, or keep them to yourself if you like; but we'll none of 'em, and therefore I take this opportunity of driving them back." Cruikshank closes with a tailpiece of Hop chasing squealing porkers back into the barn, specifically labeled "Household Words" in the pencil-and-ink preliminary drawing, though not in the published wood-engraving.[45]

Though Cruikshank's riposte is rambling, digressive, plaintive, abusive, and friendly by turns, it ends on a comical note—the transformation of Dickens's metaphor into an image of frightened pigs being driven by the manikin Hop. As usual, Cruikshank's aggression finds a better outlet in art than in prose: the illustration laughs "Whole Hogs" out of court, whereas the text, which Cruikshank revised and reprinted both as a pamphlet and as an appendix to two of the *Fairy Library* volumes, reads like the peroration of an incompetent barrister. Whatever justification the artist had for revising these tales, he failed to make the essential case that social propaganda of the most obvious sort should be interpolated into imaginative stories. And he did his side further harm by appending the dispute with Dickens to *Cinderella* and to the much later *Puss in Boots* (1864), robbing the fairy tales of much of their nursery appeal by making them exhibits in a public trial about the character of literary imagination. Nevertheless, at the time he thought he had said the last word. Determined that his adversary should see it, Cruikshank deposited a copy of the magazine at Dickens's front door, knocked, and left.[46]

Dickens's notice stood over against a number of more favorable assessments. There were many who agreed with Forster that the intercalated morals would do no harm, and might do good; there was, after all, a long tradition of adapting fairy tales to morality tracts.[47] John Taylor, a teetotal publisher, thought Dickens's article a sad instance of prejudice and wine warping the judgment even of the most gifted.[48] The *Athenaeum* declared that "never before were Giants so like Giants, and never was the mystery of

the Seven-League Boots itself made visible to the infant eye till now," a review that Cruikshank printed alongside Forster's on the wrappers of his *Magazine*. In an infinitely more subtle and profound way George Eliot, in the 1850s and 1860s, published fictions that digressively argued for particular moral responses. But to put her achievements in the same category as Cruikshank's is to expose the fallaciousness of the taxonomy: arguing for an extension of human sympathies and an adherence to charity and ethics works within the intricately woven tapestry of her narratives, whereas George's intrusive grumbling about "nasty tobacco" and extolling of cold baths summer and winter do not. Cruikshank was a great caricaturist and illustrator but a bad novelist: the propagandistic impulses that nourished his art wrecked his stories.

And within a short while the public agreed. Sales of the *Fairy Library* slumped, and the *Magazine* stopped after the second issue. Cruikshank's final bid for independence and power as a graphic artist and conductor of periodicals was trumped by the opposition of Dickens and the indifference, even dislike, of a new generation of readers. *Puss in Boots* had been projected along with the other tales, but after the failure of *Cinderella* Cruikshank suspended work on it for almost a decade.[49] When he did complete the final volume of his *Fairy Library*, his heart was not in the work: he machine-ruled parts of the plates and unwittingly gave the illustrations a hard, belabored finish. "To rewrite these fairy tales so as to get rid of everything that might be objectionable," he told a supporter in January 1856,

> to give indeed a new character to the story—and at the same time to preserve all the good and extraordinary parts of the original, together with the production of the illustrations upon steel, I have found to be a work taking up a considerable portion of time—and the sale of the work has not been sufficient remuneration to induce me to proceed. Mr Bogue the Publisher as well as myself expected that these books would have had a large sale—but Mr Charles Dickens thought proper to write a very severe, and as I conceive uncalled-for, condemnatory criticism upon the first number, which was repeated by other critics and raised a prejudice against these trifles—and checked the sale—most persons supposing from what he stated that the book was unfit for the use of children.[50]

Dickens did not stop criticizing Cruikshank's advocacies. In the summer of 1855 a Select Committee of the House of Commons heard testimony from the public about the effects of recent legislation to restrict the sale of beer on Sundays.[51] On 19 July Cruikshank testified enthusiastically in support of the act, instancing his own example and the influence of his preaching in support of his expertise. Just as Hone had done nearly forty years before, Cruikshank submitted evidence in the form of prints illustrating the evils of intoxication, and when the committee hinted that they needed better evidence, he silenced them by his forceful exposition. This testi-

mony, widely reported, stirred Dickens to his most unrestrained attack.[52] In another *Household Words* leader, "The Great Baby," Dickens fulminated against the M.P.s and monomaniacs to whom the British public was nothing more than an abstraction, a Great Baby, "to be coaxed and chucked under the chin at elections," and at other times made universally to suffer by law for the excess of the few. The last witness Dickens describes unmistakably caricatures Cruikshank:

> He was one of the greatest drunkards in the world, he tells you. When he was drunk, he was a very demon—and he never was sober. He never takes any strong drink now, and is as an angel of light. And because this man never could use without abuse; and because he imitated the Hyaena or other obscene animal, in not knowing, in the ferocity of his appetites, what Moderation was; therefore, O Big-headed Baby, you perceive that he must become as a standard for you; and for his backslidings you shall be put in the corner evermore.

Then Dickens parodies Cruikshank's reported testimony:

> Mr. Monomaniacal Patriarch, have you paid great attention to drunkenness? Immense attention, unspeakable attention.—For how many years? Seventy years. . . . I am the only man to be heard on the subject; I am the only man who knows anything about it. . . . Nobody ever mourned over the miseries and vices of the lowest of the low, but I. Nobody has ever been haunted by them, waking and sleeping, but I. Nobody would raise up the sunken wretches, but I.[53]

By personalizing his quarrel with Cruikshank and by making George claim what he never claimed, that he alone spoke sense, Dickens dismisses the entire Temperance movement as the rantings of one deluded and egocentric Old Testament prophet, ushered into the committee room by the ghost of John Bunyan. George, and Temperance, deserved better, especially from one who purported to feel nothing but "affectionate friendship" for the former and who says at the end of his article that he "would thankfully see the child of our heart, dead in his baby beauty, rather than he should live and grow with the shadow of such a horror [as intemperance] upon him." Dickens apparently would kill where George sought to reclaim. There were complicated arguments on all sides of this social legislation, arguments about compulsion versus liberty, a national health policy versus parliamentary indifference, and contestations about class and property rights.[54] But Dickens was touched to the quick by the idea that anyone else might dictate what amusements and refreshments he could enjoy on the Sabbath, or at any other time, and so reduced the complexity of the issues to a scathing burlesque.[55] Dickens was, as his admirer Edmund Yates later wrote, "imperious": "The opinions which he held, his likes and dislikes, his ideas of what should or should not be, were all settled by himself, not merely for himself, but for all those brought into connection with him, and it was never imagined they could be called into question."[56]

In the summer of 1857 Cruikshank was invited to attend Samuel Knins's "last Conversazione of this Session," an entertainment entitled "An Evening with Charles Dickens." The invitation does not bear Eliza's usual indication of response, but there can be no question that it was "Declined."[57] After such an affront, Cruikshank refused to touch anything remotely connected to his former friend. He nursed a grievance to the end of his days.

39

KNOCK DOWN BLOWS

*My fate has been for the last few years—a succession of knock
down blows—or rather throws back—but I still fight on.*

George Cruikshank[1]

ONE OF THE things making the *Fairy Library* psychologically im-
portant to Cruikshank may have been Adelaide's pregnancies;
George Robert Archibold, her first child, was born in November 1854.
Cruikshank may have looked forward to starting a family and, in anticipa-
tion of his paternity, begun to recollect the pleasures of his own childhood,
including the wonderful tales told by his nurse at Dorset Street. During the
next few years he thought and wrote a lot about his past, and while such
retrospection often accompanies aging, in Cruikshank's case the coming of
offspring late in life may have given added impetus to his memory.

At the same time, he was more and more frequently called upon to help
his brother's family. That was easier to do now that so many of Cruik-
shank's publications used wood-engraving rather than etching for illustra-
tions. Besides employing Percy to cut his own designs, Cruikshank would
occasionally shunt commissions to his nephew; and when Percy was other-
wise unengaged, George dragooned him into sitting as an unpaid model.[2]

From time to time George also found work for his brother; although
Robert's decline grew more marked, he had not lost all his skill at portrai-
ture. Acting as intermediary, Cruikshank talked John Cassell into hiring
Robert to execute a likeness of Caroline Chisholm, the redoubtable "em-
igrant's friend" who in Australia and England established numerous facili-
ties for reuniting transported convicts with their wives and children and for
assisting poor families to emigrate. Acting as cheerleader, Cruikshank then
forwarded the drawing for Cassell "to look at": while Mrs. Chisholm was to
give another sitting, "I have no doubt but that it will be a first rate likeness
it is *very like now.*"[3]

Cruikshank also attempted to help Eliza unsnarl the tangle of her aunt's

estate, which had gotten tied up in red tape over sums that were either loans or gifts from Mrs. Parratt. Between visits to lawyers, statements to clerks, trips to the office of the Grand Junction Water Works, meetings at Coutts, and consultations with investment advisers, George and Eliza spent scores of hours settling the business, only to find at the end that the balance was wholly consumed by specific bequests and expenses. Eliza got nothing either as executor or as residuary legatee.[4]

Despite the continuous struggle to make ends meet, Cruikshank could not stop aiding others. He gave readily to a testimonial fund raised by fellows of the Royal Society of Literature to assist the bankrupt William Jerdan. Cruikshank contributed two pounds, Thackeray three, and Forster five; Maclise gave three guineas, Stanfield five guineas, and Dickens ten. In the amounts and the denominations (pounds versus guineas) the economic and social stratification separating those who had once gathered together at Kensal Lodge without discrimination becomes once again apparent. Significantly, Ainsworth neither joined the organizing committee nor subscribed to the fund.[5]

On a happier note, the Pulfords were doing well. On 23 September 1853 William Pulford wrote from his office in the stores department of the Great Northern Railway to tell Cruikshank that his godson George Cruikshank Pulford had found work in Australia as a sign painter and writer and "hopes to make lots of money." Pulford asked Cruikshank for help in selecting the right paints and other equipment to ship to Melbourne.[6] Cruikshank kept in touch with his godson. He notified him in the spring of the following year when the pet spaniel Lilla, about which the boy had inquired so regularly, died. She was "playful & wonderfully strong" until stricken by fits. "I had Mr. Wilmore's advice—& Mr. Pettigrew's—and the man Wells, who used to doctor Toby—but it was all no use—we could not cure her."[7] Eventually William Sylvester Pulford followed his brother to the antipodes and flourished there as a reporter for the *Bendigo Evening News* and the *Melbourne Herald*. William Sylvester also turned into a "leading advocate" in the Temperance cause, the Chief Templar of the Independent Order of Good Templars, who asked Cruikshank in 1875 for a copy of *The Bottle* to be presented to the Lodge.[8] G. C. Pulford, on the other hand, returned to England and by the sixties was employed at the Westminster Color Works. Within a few years he ventured out on his own, founding Pulford's Magnetic Paints, purveyors to the British and Indian governments. While the boy's youthful attempts to emulate his godfather's profession came to nothing directly, his knowledge of artists' materials and of sign painting in varied climates evidently provided him with requisite information for selling paints on a large scale.

Another who successfully enlisted Cruikshank's support was Cordelia

Bartholomew, a young woman whose hearing and speech were impaired. Cruikshank asked the publisher Thomas Longman, who voted on applicants to the Asylum for the Deaf and Dumb, to make her his candidate, and also enrolled John Barrow in the cause, adding that he would enjoy making a pen-and-ink sketch for Barrow.[9] The stream of begging letters, the pathetic appeals on the doorstep, the heart-wrenching stories told by sodden men and brutalized women at Temperance meetings—all got a sympathetic response from Cruikshank, who relieved from his own purse when he could and never stinted efforts to find shelter, clothing, charitable grants, and employment for the deserving poor.

Cruikshank's own finances were muddled by his transactions with others. George Bickerdike, who presented himself as a thirty-three-year-old founder of Mechanics Institutes, wrote from Shropshire in the autumn of 1853. He was financially embarrassed and did not want to let his friends or his mother know. Could Cruikshank lend him £10 for six months? When after further prompting Cruikshank obliged, Bickerdike was grateful, but then could not get the bill cashed and was "almost distracted" by his troubles. He asked Cruikshank to keep the transaction confidential, as he did not want his literary friends to know of his circumstances—possibly a legitimate request (although writers were not usually shy of parading their poverty), but more likely an effort to conceal that he had written similar appeals to others known to Cruikshank.[10]

On 4 January 1854 Bickerdike raised the ante, asking for £15 rather than £10, to be paid in early April. Once his debt was settled, he assured Cruikshank, he could return to lecturing and support himself. When he did not receive an immediate reply, he fired off three letters in four days. He was at the last extremity, exceedingly unwell, and in a wretched state of suspense; he promised that Cruikshank would not lose by the transaction; his mother was so ill he dared not tell her of his predicament; if Cruikshank obliges him, he will go forth into the world as a new man with legions of angels at his breast; but if not, he dare not think of his fate. Finally on 14 January Bickerdike got his money and acknowledged receipt with prayers of thanksgiving and vows to succeed.[11]

When the bill came due, Bickerdike could not meet it. He proposed borrowing £15 from a loan society in London and getting a moneylender named William Dickens, whose advertisement in the *Manchester Guardian* he had seen, to pay off Cruikshank's bill and advance £2 to pay off an IOU to the artist. When Bickerdike obtained cash, he spent it to forestall unspecified legal proceedings. Small remittances reached Cruikshank over the summer, but they seem to have been nearly canceled by further drafts on the artist's account. A promise to see if a bill could be renewed is the last

word Mornington Place received from this debtor until George Linnaeus Banks reported twenty years later that Bickerdike was "in clover."[12]

Cruikshank was in demand by groups as well as by individuals. He consented to be appointed a trustee of the Temperance Permanent Land and Building Society in October 1853, etched a view of a model village after Charles Pearson's design, and had a road on its estate named for himself.[13] More significant, he agreed to serve as artistic director of the Surrey Gardens Temperance Crystal Palace Company, later called simply the Surrey Gardens Company. The moving spirit behind this enterprise was a wealthy teetotaler, Stephen Geary, who had amassed a fortune as a publican's architect designing and building showy gin shops and then repented and signed the pledge.[14] Geary wanted to construct a rival to the Crystal Palace in the grounds of the Surrey Gardens. Cruikshank submitted his own design, which Geary damned with faint praise, saying to Percy that "it's good enough, for *his* teetotal head."[15] Needless to say, with a professional architect in charge, Cruikshank's blueprint was politely turned down; George was emphatically not a second Paxton.

To test public sentiment and drum up investors, Geary organized a "fancy fair" and invited "St. George" to attend. Cruikshank decided to go in style. He hired a slap-up carriage, four spanking grays, and a postilion in matching livery. Reclining in the open coach, Cruikshank proceeded from the Hampstead Road through the principal West End thoroughfares, waving to the crowds. At Waterloo Place Horace Mayhew popped his head out of an upper window and gaped at his old friend's rig. Cruikshank retorted by miming anger, shaking his fist at the "naughty boy" who *would* drink, and sending Mayhew into convulsions of laughter. At length, having created a satisfactory sensation, Cruikshank arrived at the Gardens, which did a thriving business that broiling summer's day in tea, gingerbeer, and soda water.[16]

For several years thereafter the management tried to make the Gardens an ideal recreation spot for teetolaters. Money was spent to spruce up the buildings and grounds; in 1855 a panoramic spectacle of the Battle of Sebastopol was staged using one hundred invalided soldiers in the cast and concluding with a dazzling fireworks display. Nathaniel Hawthorne, then consul at Liverpool, attended one performance. The next year the directors sold the scruffy menagerie, all that remained of Cross's Exeter 'Change zoo, and invested the proceeds in a new concert hall where the noted impresario Jullien was hired to conduct nightly programs. Unruly audiences gave the Gardens a bad reputation. The following year Thackeray delivered there his lectures on the *Four Georges* and a full-scale *Messiah* was produced, but by

August 1857 the company was bankrupt. Jullien and his musicians could not be paid; he personally lost upwards of £6,000.[17]

It is unlikely that Cruikshank had much time to contribute to the day-to-day operations of the Gardens; he was hard-pressed to meet his own household expenses. In 1852 the coals account was in arrears.[18] In 1853 he was assessed a shilling fine for letting his subscription to the Artists' Annuity Fund fall behind.[19] That winter John Sheringham approached him with a scheme whereby nine men familiar with the stove grate business would invest £500 each, while Cruikshank would contribute only his "love," to capitalize the manufacture of Sheringham's improved stove design, the Sheringham Ventilator. Cruikshank consented to act as a kind of intermediary. He drew designs for the lithographs depicting the apparatus, installed one in his own studio, endorsed it enthusiastically, may have helped defray some of the minor costs incurred in patenting and publicizing the invention, and served as amanuensis when in 1855 his friend fell seriously ill. But subsequent events belied the "brilliant prospects" which negotiations with the Coalbrookdale Company initially promised.[20] Cruikshank seems to have banked nothing for the time and energy he expended on Sheringham's behalf.

With the collapse of the *Fairy Library* and the *Magazine,* Cruikshank came almost to the end of his professional resources. An appeal to E. G. Flight for a loan was gently but irrevocably denied. Goldsmith's indigent philosopher, Flight replied, was a Rothschild compared to him. There is something mysterious in the fortunes of publications, he continued: "A slow coach like the heavy old Times newspaper, whose success, if measured by merit, would be nil, wins the purse, while many a work of sterling excellence never reaches even the distant post."[21] What Cruikshank needed, however, was not sterling merit but sterling pounds; he turned, as always in the last resort, to Bogue and to Merle, who was in the country staying with Marryat's brother Joseph.[22]

But the Bogue connection was shortly to terminate, precipitating a further crisis. After Bogue's death in November 1856 the executors charged Cruikshank with a very large sum, representing his share of the debts incurred by the partnership that had produced *1851.* At the time the novel was serializing, Cruikshank had told his publisher he was withdrawing as co-proprietor. Whether this was in fact possible solely as the result of a verbal declaration, whether Cruikshank already owed money on the losing numbers, or whether Bogue simply misunderstood or forgot, the accounts showed that *1851* lost a great deal of money, for which the partners were still liable. When Cruikshank, deeply dismayed, protested that he was quite unable to meet any payment, Mrs. Bogue, out of respect for the long friendship, canceled the claim.[23]

Cruikshank had one other shift: he could revert to political caricature, taking advantage of the public's interest in the Crimea. Before hostilities commenced in October 1853 he made a tinted sketch of the European states placating Russia, *Trying to Cure a Bear of a Sore Head*, and published an etching of it.[24] When the Russian vice-admiral, Nakhimov, bombarded the Turkish fleet at Sinope on 30 November and reduced the town to rubble, popular opinion in France and Britain turned decisively in favor of the Turks. Cruikshank peppered the Admiralty with advice about how to destroy the Russian ships harbored at Sebastopol and got Tweedie to issue a December plate, *Imperial Piety; or, the Russian "Te Deum"*.[25] Cruikshank used familiar Napoleonic motifs, the hill of Golgotha and the emperor as anti-Christ, to image the tsar kneeling on a heap of dead Turks. The allies declared war on 27 January 1854; by October the first troops embarked for the peninsula. Among the soldiers was Mrs. Merle's brother, to whom Merle posted one of Cruikshank's squibs to keep up morale.[26]

But separate plates no longer sold; the public bought *Punch* instead and got commentary and humor along with political satire. Nonetheless, the Crimean engagement attracted Cruikshank's attention for several years. He failed to get royal approval for a print commemorating the visit of the French emperor.[27] He did design a wood-engraving, "Bayonetting a Russian," for an 1856 issue of the *Illustrated Times*.[28] He also considered providing a frontispiece, title-page vignette, or illustrative sketches for Linnaeus Banks's history of the war, a project that came to naught, although Banks recognized that Cruikshank didn't need more popularity, but more pay.[29] And finally, among other harebrained schemes that George's financial plight and ego led him to pursue, the maddest was a proposition to team up with his friend Joseph Gibbs, a civil engineer who had drained lakes in Holland and constructed a railway in France. With the assistance of Austen Henry Layard, M.P. and junior minister, they proposed to float a company for building a railroad across Turkey. In July 1856 Cruikshank and Gibbs met with Layard, showed him copies of Gibbs's plan and prospectus, and thought they secured his promise to negotiate with the Turkish government for a concession and, since he was chairman of the Ottoman Bank, to enlist the support of that firm. However, when Layard returned from Turkey in February 1857, he told Cruikshank that the Ottoman Bank already had a railway proposal before the government, and that George was suffering a "complete misconception as to what passed last summer"; Layard had no intention of connecting himself with Gibbs's scheme. Cruikshank was dumbfounded and wrote to Layard requesting an interview "to clear up if possible this extraordinary misunderstanding."[30]

Nearer home, George's brother started a new assignment. Michael Nugent, a parliamentary reporter for *The Times*, intended to write a life of

Edmund Kean. Robert was to supply illustrations, based in part on his and George's recollections of their childhood friendship with the actor. Robert executed a watercolor sketch of Kean dressed as Bluebeard for that memorable amateur performance in Roach's kitchen in Vinegar Yard.[31] Around this time George executed an equestrian portrait in oils of his brother, looking very gentlemanly, as his groom stands by.[32]

While engaged on these projects, the brothers may have reminisced a bit about those times, now so far away they seemed almost legendary, when Mungo Park's stories and Kean's dramatizations excited and inspired them. Robert appeared to be in good spirits and reasonable health, although poverty pinched incessantly. His chief income and greatest pleasure came from painting watercolors for private patrons. The medium exploited his facility for apt composition and prompt execution. His quick eye and ready hand delighted in tracing absurdities in the Tam O'Shanter fashion: earthy, unearthly, rollicking drollery, but executed with precision, finesse, bright hues, and expressive finish. In his personal life Robert behaved like a gentleman. He was convivial to a fault, moderately well read, and inclined to ranting only when under the influence of whisky toddy. His one outdoor recreation was archery.[33]

Kindly, whimsical, easy-going, hospitable, and alcoholic, Isaac Robert caught bronchitis during the winter of 1856, and after a struggle lasting only seven days, died on 13 March in his modest quarters at 13 Pleasant Row, Pentonville.[34] Few took notice of his passing. It was left to George to sort out the joint work, to discriminate between Isaac's hand and Isaac Robert's or his own, and to set down a history of the family in prose and prints. Unfortunately, Cruikshank's autobiography never got further than a few pages of text and some mysterious etchings on glass; thus Robert's achievements lapsed even more into the shadows. Hardly anyone today would recognize his name or care that he was once a dashing Corinthian, friend to the first gentleman of sport, collaborator on the raciest book of its era, satirist of monarchs and ministries, a boon companion, and a talented artist who could make the public laugh.

During Robert's last years, George essayed the medium in which his older brother had thought to make a fortune: oil painting. After the publication of *Frank Fairlegh* (1850), Robert's son reports, Cruikshank began "to complain, that he had wasted his life, in what he called 'scratching upon wood, and steel'; while, for the same designs, in oil painting, he could have realised much larger sums."[35] It had become clear to the artist by midcentury that etching on steel was a dead end, and that designing for wood-engravings put him at the mercy of the carvers, who might do fine, indifferent, or exercrable work depending on their motivation, the amount the publisher would pay for careful execution and printing, and the quality

of the blocks and paper.[36] Moreover, painters with whom he had started out at least on even terms were rapidly pulling ahead, while from every point of view Cruikshank's artistic career was slipping back. So thirty years after Lockhart had advised the artist "to be what nature put within [his] reach— not a caricaturist, but a painter," George took up the brush in earnest.[37]

It was, in fact, Stanfield who had first persuaded Cruikshank to try oils back in the 1830s.[38] One fruit of Cruikshank's early efforts was the picture of *Bruce Attacked, by Assassins* exhibited at the British Institution in 1833 and subsequently rehung over George's mantelpiece. It was, in Percy's opinion, "a very coarse affair" with the Bruce's horse smothered in drapery.[39] When George started in again at the easel, he completed in addition to *The Disturbed Congregation* two scenes from *Rob Roy*, probably both depicting the fray at Jeanie MacAlpine's.[40]

Cruikshank's success with anecdotal genre painting, where his subjects and style amalgamate Wilkie and Mulready with intaglio illustration, encouraged him to persevere in that line. In 1851 he chose a subject from Goldsmith's *Vicar of Wakefield*—*Moses Dressing for the Fair.* This was the kind of design challenge that as an illustrator he knew exactly how to meet, but once again the translation into paint defeated him. Cruikshank confessed that "the etching point feeling was always in his fingers, giving a 'living' sensation to the brush; so different, to the fat touch of the oil painter's brush."[41] The quickness and spontaneity of his etched lines could not be replicated on board or canvas; there the brushwork looked loose, coarse, inharmonious, and sketchy.[42] "A painter should paint from his shoulder, sir," he would say to onlookers, but his own practice of minutely laying in the colors a hair's-breadth at a time belied his maxim.[43] He also executed a comic picture, *A New Situation and a Deaf Mistress* (exhib. British Institution 1851), which Percy describes as "excellent in design" although "imperfectly carried out":

> A footman, with a tray, is entering a room, where his mistress, evidently deaf, is seated, with a speaking trumpet. The man being a new comer, and unknown to her lap dogs, they are attacking him, and seizing hold of his legs, in tight fitting stockings. The lady's attention being engaged, the deafness prevents her noticing the uproar, and coming to his rescue.[44]

During the early winter of 1851–1852 Cruikshank tackled a somewhat different subject, one combining genre realism with fairy figures: *Tam O'Shanter.* He made a number of preliminary studies, trying to move away from dependence on line by using not just pencil but also pen-and-ink, sepia washes, and chalk.[45] Burns proved once again to be a happy choice for subject; the picture was exhibited at the British Institution in February 1852 and inspired an offer to purchase for sixty guineas from a Mr. Horner,

who saw and bid for it prior to the private viewing day and to any reviews.[46] Cruikshank evidently tried another canvas of this same kind; he invited a large number of friends to come to Mornington Place on 5 April to view "another attempt in oils—and which I think is not quite such a failure as was the last."[47]

But then he got into his head the notion that he was destined to be a grand historical painter, a Thornhill rather than a Hogarth. By May of 1852 he was scribbling designs for a vast *Battle of Agincourt* on every available scrap of paper.[48] This was never finished. Percy, who saw it in the studio, describes it as "an endless mob of figures, in the greatest confusion, hammering away at each other; but which nothing, but the hand of a most experienced painter, could ever manage."[49] Not discouraged, Cruikshank started work on two equally ambitious canvases, both Gospel subjects familiar from the vast paintings of Benjamin Robert Haydon, one of Cruikshank's alter egos. These were *The Sermon on the Mount* and *Christ Riding into* [or *Entering*] *Jerusalem*. The former was under way in the summer of 1852, when Cruikshank discovered that his friend Henry Warren had just completed a painting on the same subject and was taking subscriptions for the reproduction. Had he known, Cruikshank said, he would not have ventured comparison "with one so much more able."[50] The other biblical painting was roughed out by January 1853, when John Sheringham, who had been surveying the artist's entire production, told Cruikshank it was the best thing he had yet done.[51] This time Cruikshank attempted to achieve atmospheric effects, to render Jerusalem's walls with archaeological exactitude (the resemblance to a medieval castellated fortress such as the Tower is nonetheless striking), and to paint a crowd of people amid typical desert vegetation. In its biblical realism it aspired to the kind of literal authenticity Holman Hunt sought, but with little of Hunt's typological symbolism. Unfortunately, Cruikshank's ambition exceeded his capacity; the picture never progressed beyond outlining the figures of Jesus and his followers outside the gate. "Without his outline he was all abroad," Jerrold comments, echoing Percy Cruikshank.[52] The canvas lay about in Cruikshank's studio for many years, unfinished, disregarded, testimony to yet another failure.[53]

What Cruikshank's few patrons seem to have wanted from him was not imitations of other artists but rather comic or fanciful paintings that dealt with the same subjects he had treated in his illustrations and *Comic Almanack* etchings. Accordingly, he reassessed his commitment to painting. He tried a number of experiments to short-cut the tedious brushwork, which hurt his eyes so badly that on several occasions he had to give over any painting for months. To better capture his characteristic spontaneity, Cruikshank painted first in watercolor on paper and then finished the im-

age in oils, but the paper soaked up the medium as fast as it was applied, and the result was flat and ineffective, as in his portrait of his brother. "A great deal of time was wasted upon this experiment," Percy comments.[54]

Second, Cruikshank reverted to smaller canvases and anecdotal subjects. "I have been working hard to get a little picture ready for the Rl. Academy Exhibition," he told a friend on 9 April 1853.[55] This was *Titania and Bottom the Weaver.* His native Scots shrewdness had not deserted him—here was an incident that combined all Cruikshank's strengths, his humor and his deft touch with fairies, and that attached to England's most celebrated writer. In fact, the picture hearkened back to hundreds of paintings of Shakespearean scenes commissioned at the end of the previous century for Boydell's Shakespeare Gallery, which the British Institution had taken over in 1806. As usual Cruikshank executed a number of preliminary watercolor studies, shaping his composition within a vertical oval; and in addition to the version exhibited at the Royal Academy, he also started one on board that progressed to the point where the queen of fairies and her court were finished, but Bottom was only outlined.[56] As with most of Cruikshank's oils, the colors are muddy, somber, and vague. His penchant for night and interior scenes may partly explain the drabness of his palette; but perhaps another explanation is that in prints he had always modeled by gradations of black ink on white paper, so in painting he employed darker and darker hues to shape the contours of figures and to indicate recessions and shadows, while in highlighted areas the actual hue of the garment or object was paled through the liberal admixture of white.

Cruikshank could see that his lack of technical training seriously impeded his progress. Vain he certainly was, and unshaken in his belief that he could learn and do anything if he set his mind to it. But his was not the sort of vanity that misjudged the quality of his production. When Percy called the Beadle in the first version of *The Disturbed Congregation* a "stuffed suit," Cruikshank heartily agreed, scrapped the panel, and started all over again. Now it was clear that he needed more study if he was ever to earn the fortune from painting that seemed his last recourse. So on 22 April 1853 George Cruikshank, aged sixty-one, having supported himself through graphic art for more than forty years, entered as a student in the Royal Academy. When he had first applied almost half a century earlier, Fuseli was Keeper; now his application was approved by Charles Landseer, elder brother of the more famous Edwin.[57]

Unfortunately, 1853 was no freer of distractions and financial constraints than 1804: Cruikshank was enmeshed in the *Fairy Library*, in interviews and preparations for his *Magazine*, and in dozens of Temperance appearances. He attended only a few of the "Antique" classes, keeping his hat on to distinguish him from the younger generation, and never got into

the "Life." His studies, which Sala describes, "had a dim affinity to the Cruikshankian horse. They were beautifully shaded, but plump, not to say podgy, and, on the whole, not at all like either Hercules or Hecuba."[58]

"In submitting my probationary drawings for your inspection," George wrote to the President and Council of the Royal Academy,

> I feel that some apology is necessary on account of their very crude & unfinished character. Upon being admitted—as a probationer—I fully intended to have made three careful studio drawings—but circumstances arose in the early part of the time allowed for the purpose that prevented me from attending the R1 Academy for more than a few hours—where I intended to have devoted days— and I make this explanation to assure you ["that in submitting sketches instead of drawings" crossed out] this seeming inattention to the required rules of the academy, does not arise from any indifference to the advantages offered, but simply to the cause stated—and therefore I shall hope that to the list of the R1 Acy—you may please to add the name of

Cruikshank was so troubled by the inadequacy of his submissions that he drafted and redrafted the letter; whether it was ever sent, or the drawings approved, the records do not disclose.[59]

In any event, before the year was out his other commitments, his mother's death succeeded by Elizabeth Baldwyn's, and the unceasing scramble for shillings prevented his returning to Trafalgar Square for any more practice in making finely finished pencil renderings of plaster casts from classical sculpture. What his few lessons may have done, in combina-tion with all the other forces impinging upon him at this time, was rigidify his line, make it overfussy and overfinished, and in fact rob his images of the quirky, electric energy that galvanizes his best coppers and steels. All in all, the Royal Academy was not for the likes of Cruikshank, though not being enrolled in its list guaranteed that he would have to continue that lifetime struggle to earn a living by practicing the "minor" arts.[60]

In the midst of these difficulties, Cruikshank was gratified to receive a letter from a family in Wisbech with whom he had become acquainted, probably through Temperance. Robert Dawbarn and his nephew George were interested in forming a collection of pictures, including ones by living artists. Robert had sent the Cruikshanks a Christmas turkey in 1852, and Cruikshank in return had introduced him to the British Museum print room the following February.[61] In July of 1853 George Dawbarn wrote to say that his uncle had seen Cruikshank's picture of the poor parish boy horrified at the sanctimonious Beadle (an informative misreading of the principal incident in *The Disturbed Congregation*) and would like to pur-chase something similar. He also wanted something from Edwin Landseer, if Cruikshank could influence that eminent artist to sell a canvas.[62] The Dalziel brothers, who had just completed their rather perfunctory wood-

engravings from Cruikshank's designs for *Uncle Tom's Cabin*, tell a story about the sequel to Dawbarn's offer:

> On the occasion of [Cruikshank's] exhibiting a small oil painting called The Dropped Penny [another misreading of the leading incident in the picture] the fact that it was purchased by Prince Albert no doubt called extra special attention to it. One gentleman was most anxious to have it, or if this was impossible, would he make a replica? This George declined to do but undertook a commission only on the understanding that choice of subject and of size were to be left to him. This was readily agreed to. The Dropped Penny was a little thing 18 x 24 inches. . . . When the new work was completed the gentleman was invited to see it. He found, to his amazement, a picture 16 x 20 feet, subject, The Raising of Lazarus. George always thought his true forte was the Grand Historical.[63]

The condescending tone of this account sounds regularly in stories about Cruikshank from the 1850s onwards. There is no truth to the Dalziels' luducrous denouement; the unfinished biblical subjects were all much smaller, and even the forthcoming *Worship of Bacchus*, Cruikshank's largest canvas, was less than one-third the size of the alleged *Lazarus*.

What did eventuate from Dawbarn's interest was a mezzotint of Prince Albert's painting badly engraved by William Turner Davey and published 1 November 1855 by Thomas McLean in the Haymarket and by the firm of Williams, Stephen, Williams and Company in New York.[64] A week before the print was released, Cruikshank hadn't settled on a title for this picture which had been "read" so many ways. He knew that he did not want two different captions, one for proof issues and one for the ordinary prints: "Pray do not think of such a thing," he told his publisher. Instead, he opted for "The Disturber Detected." "This will at once lead the observer to comprehend what is going on."[65] Engravings from oil paintings had been for at least a century the principal means for widely circulating famous images; though Cruikshank acknowledged the modesty of his own effort, he still hoped that notices of it would spark much needed sales. "It is not certainly eng[age]d in the 1st rank of Art," he explained to one reviewer in a letter accompanying a complimentary copy of the mezzotint, "*but* it will be published at rather a small price" and "being the first . . . engraved from an oil picture by me—I shall feel obliged by any notice of which you may deem it worthy."[66] It did not however sell in large quantities—McLean paid the engraver, paid himself, sold the plate to Tegg, and sent nothing to the artist.[67] But just having a print from a painting on sale raised George's hopes that with further steady application he might yet succeed.

Cruikshank returned to the world of fairy for his next subject, *Cinderella*. Its composition was based on the etching prepared for the *Fairy Library* of the Fairy Godmother in the kitchen directing the pumpkin coach, rats, and lizard footmen out the door. "I have *just* finished a Picture which I am *just*

going to take to the Royal Academy," Cruikshank told his godson in April 1854. "It is more like a picture than any thing I have ever done—and every one who has seen it pronounces it to be *my best*—you would be surprised at my improvement in oil as indeed I am myself. I have got several commissions for pictures—and so I shall dash on."[68] This was sufficiently popular to be featured in the *Illustrated London News* and to prompt not one but two offers. Cruikshank had to apply to the council for permission to copy his own work, since he had retained neither drawings nor sketches of the oil.[69] Dickens may have killed the sale of the books, but fairy pictures might redeem Cruikshank's reputation.

That optimism was manifested, too, in Cruikshank's plan to sell two copies of his *Tam O'Shanter* at a hundred guineas each.[70] And it received a boost from a letter by a wealthy Preston gentleman, Henry Miller, who said he had just seen a picture by Cruikshank at the British Institution that depicted his native town in the time of the illustrious Grimaldi. He would have bought it but it was already sold. Might he purchase something else?[71] Cruikshank replied by inviting Miller to his studio, but Miller was eager to advance his commission, so instead of waiting until he got to London in the autumn he forwarded his preference for a comic subject out of fairy land.[72] Stimulated by this practical support, Cruikshank painted *The Fairy Ring*, in Jerrold's judgment "the most imaginative, and as a composition the best" of all Cruikshank's oils.[73] Percy likewise praises this canvas; the composition was effective, and the diminutive figures, dwarfed by foxgloves and other wild flowers, were of a size and character that Cruikshank handled most cunningly. The serene midsummer's night sky, bathed by the light of a new moon, shows up the bats and ghosts flitting among the merry dancers delicately tamping the meadow grass.[74] Cruikshank finished it in time for the spring 1855 Royal Academy Exhibition, but it was returned unhung "because they could not find a proper place for it."[75] This setback came at a time when his wife was seriously ill following the unexpected death of her mother; Pettigrew advised that Eliza recover her health at Hastings. Cruikshank kept his "attempt . . . to paint a little poem" in his studio for a time and invited friends to view it there; over the summer he repainted sections, apparently altering the moon among other things.[76] Miller agreed in the autumn to lend the picture back for the 1856 British Institution exhibition, but wanted to hang it in his house during the holidays.[77] Accordingly, *The Fairy Ring* was exhibited the following February; Miller is alleged to have paid £800 for it, but the only deposit in Cruikshank's Coutts account that is identified as coming from him is for £75.[78] The larger sum may once again be an inflated figure far in excess of what Cruikshank actually received.

The next few years marked the high tide of Cruikshank's career as a painter. In 1855 he exhibited *The Runaway Knock* at the British Institu-

tion.[79] Two urchins knock loudly at the front door of a fine house, then run away as the hall porter, mistress, young lady, and menagerie of pets search for the caller. The picture tickled the fancy of the *Illustrated London News* reviewer, who said it was "one whole scene of excitement" which "makes the spectator enraged" in sympathy with the agitated household.

> The very poodles on the doorstep have an irritated and disappointed look. The runaway knock had the knack and counterfeit sound of the dog's-meat-man— the dogs were, therefore disappointed; the knock had the well-known rat-a-tat of a long-expected friend—all the household are, therefore, disappointed. Delight and disappointment are exhibited in every expressive shape that the fertile pencil of Cruikshank could design.[80]

In the midst of this panegyric, the reviewer pinpoints Cruikshank's strength—"expressive shape"—and weakness—"fertile pencil." The painting "tells" in every shape and detail, down to the bas-relief head carved over the street door, the history and condition of this household, but it narrates at least as effectively in Swain's wood-engraving after Cruikshank's design as in the oil version: it is essentially a story told by the pencil.

What that story is was translated into rhyme by an anonymous versifier for the newspaper. Whereas Lockhart read character through physiognomy in analyzing Cruikshank's portrait of Burns's Jolly Beggar in the 1820s, this viewer reads character through Landseer and Leech, Dickens and Thackeray, Douglas Jerrold and Dion Boucicault. Genre painting, literary cockneys, and melodrama furnish the dialogue for what must be one of the most ludicrous translations of a static painting into narrative ever penned:

<div align="center">

THE RUNAWAY KNOCK

(John Thomas, Hall Porter, *loquitur.*)

</div>

It's a quarter to five, as I am alive! and that knocker's at rest for a wonder;
It's been going all day, as a body may say, like werry good minatur thunder.
I'm used to that now; knockers will make a row; it's their natur, and that
 there's no helping;
But with every rat-tat-tat-tat-a-tat-tat, all Missus's dogs begin yelping!
There's that Hile-o'-Skye—all 'air and no heye, like a muff upon legs—as sits
 up and begs, and turns up his nose at biled chicken
And that fat wheezy span'nel wot they wraps up in flannel, I'd warm his hold
 'ide with a lickin'.
I don't henvy my berth—it's the 'ardest on earth, and it's long since I made
 the diskivery,
Twenty-five pounds a year, no washing, NO BEER! one 'at and but two suits of
 livery.
My powder is found—(that's to say I've a pound, which I puts profit side of my
 ledger,

'Cos I'm in the good books *always* of the cooks, and they flours my 'ead with
the dredger.)

All day in this chair, not a mossel of hair, 'cept when in the square I takes all
the dogs out a hairin',

And the little boys chaff and sings out "Wot a calf!" their imperance really's
past bearin'.

"Rat-a-tat-tat-a-tat," I wonder who's that? "Rat-a-tat," I'm coming as fast as I
can, sir,

What's this! Why, good gracious!! Some one—how howdacious!! Why, there
isn't not no one to answer!!!! (*Closes the door with a bang*).

Has the world come to that! "Rat-tat-a-tat-tat;" there's all them precious dogs
set a-barking.

Who was that, ma'am? Why, ma'am, I can't keep my self calm! With our
knocker some wagabone's larking!

"*Run* and fetch the police!" "I can't do it, ma'am, please. Natur never intended
I *should* run.

By the door, ma'am, I'll stand, with a stick in my hand, and I'll give the next
scoundrel a good one!"

Rat-a-tat-Yow-how-how!—"Mercy! what's happened now?" "Why I've just
been and trod on *dear* Shock, ma'am.

Why, there's no one! We've missed 'em. They'll ruin my system. I shall die of
a runaway knock, ma'am!"

Cruikshank obtained £100 from Joseph Robinson for the picture and
frame, half of which was paid into his Coutts account on 16 June.[81]

In the spring of 1855 Cruikshank may have finished another little pic-
ture about Titania and Bottom.[82] Later that year he retouched Davey's proof
of "The Disturber Detected." The following year he capitalized on post-war
feeling by executing a landscape painting in his sentimental style: "field
farmhouse & trees in the distance, the latter looking like huge lettuces,"
Percy records of *The Soldier's Return* (exhib. British Institution 1856).

> In the foreground, a hedge, and style, at which a wooden legged soldier is stand-
> ing, who having tied his handkerchief to his stick, is telegraphing to a female, at
> the distant cottage door, his arrival from the Crimea. A nasty critic called it a
> poor attempt at "style," & suggest[ed] that the soldier, on account of his wooden
> leg, could not manage to get over, and was signaling for help. Such pictures
> painted with the same skill that Oliver Goldsmith wrote them, would be worth
> seeing; but otherwise they are mere twaddle,

as this one was in Percy's opinion.[83]

In 1857 Cruikshank was so involved in preparing the illustrations for a
biography of Falstaff that he could not tackle any another subject. So he
brilliantly married his temporary obsession with Sir John to his lifelong
fascination with fairies to produce for the 1857 British Institution exhibi-
tion *The Last Scene in "The Merry Wives of Windsor"*.[84] The Herne's oak
scene had been given several pictorial treatments in the 1790s, but then

there had been a hiatus until the 1850s and 1860s, when Cruikshank's was one of several mid-Victorian versions.[85] Though Cruikshank never took much interest in, nor ever expended much time in depicting, arboreal subjects, the combination of Shakespeare and sprites validated and stimulated his fantasy and grotesquerie. This was the picture, Jerrold claims, that "he completed with most thorough satisfaction to himself."[86] It was purchased by a rich ironmaster from Scotland, Mr. Holdsworth, who paid two hundred guineas or more and intended to commission others from Cruikshank.[87] Having a high opinion of his achievement, the artist held out for a substantial payment: "I shall be much disappointed unless I get that sum for this favourite work of mine, and in order to make the matter satisfactory to you, if you send me a cheque for that sum I will paint you a small picture which I shall consider worth 20 or 25 pounds."[88] Why he insisted on a flat amount—possibly 250 guineas—for the single painting, and then threw in another one to make up the putative difference, is a mystery. Perhaps because Cruikshank wanted to say to fellow artists that he received that much per canvas, or because he had promised Eliza that it would fetch such a sum. (Millais got £800 for one canvas in that same year.) In any event, Holdsworth may have paid as much as £270 for the picture or pictures; but before any further ones could be commissioned, he suddenly died.[89]

No paintings dating from 1858 have been discovered, but after Cruikshank completed his Brough designs he may have executed another genre scene, of the Thames bankside near Greenwich, where a ragged bully tries to wrest the wicker basket of food that a well-dressed young boy, accompanied by his brother and sisters, has just brought from the parklike grounds of their Georgian mansion to eat beside the statue of Nelson fronting the river.[90] George tried out another battle scene, this time in oil on metal, depicting Roderick Random's battle with Captain Weazel; it was accepted for the 1859 British Institute exhibit.[91] And in August of 1860 Cruikshank rushed to the terminal at Waterloo bearing a small canvas still wet with varnish to present to John Gough on his departure from the second British tour.[92] *Grimaldi in the Barber's Shop* depicts Joey, while festooned with lather preparatory to being shaved by his daughter, grimacing at the company.[93] "This," Percy declares, "was a success."

But the grand historical, or allegorical, or academy picture lured Cruikshank onto the rocks. At the start of a new decade, he ventured again into murky waters, painting two quite vague and misty representations of the same mythological event, one entitled *Venus Rising from the Waves*, the other the *Birth of Aphrodite*.[94] In the latter, the goddess of love, formed by loose brush strokes and faulty drawing, rises like penumbrous ectoplasm from thick impasto foam into a dark air swirling with cupids and nymphs and arced by a rainbow. Even allowing for its unfinished condition, it is

distressingly bad. Neither the ideal female form, nor the mystery of the daughter of waters, nor Greek and Roman theogony, stimulated one iota of Cruikshank's talent. A waterdrinker, not a marine painter, Cruikshank returned to the familiar cause in 1861, sketching in pencil and watercolor the first version of his monumental oil, *The Worship of Bacchus.*[95] Henceforth domestic anecdote and humorous genre pictures were to be subsumed within a vast exemplary history lesson.

40

WRITE ME DOWN AN ASS

In these times an artist (I don't say a Millais, a Frith, or a Tadema, but a sound, practical, hard-working painter or draughtsman), who had made his way among publishers and his name with the public, would think himself very ill rewarded if he did not earn from a thousand to fifteen hundred pounds a year.

George Augustus Sala[1]

THE BANKING crisis of 1857 coincided with an intensification of Cruikshank's personal financial plight. Many of his friends and connections lost money in "the late monetary convulsion," and he anticipated that "few persons of property will, I fear, escape the effects of that . . . Revolution in money markets."[2] Whereas the topmost end of any luxury market usually is proof against anything short of catastrophe, the middle levels do expand and contract with the economy. Sala questioned whether Cruikshank's average income, "even when he was at his noontide of capacity and celebrity, . . . exceeded six hundred pounds a year."[3] In fact, the deposit totals in his Coutts account show a considerably greater annual income, figured from one midsummer's day to the next: 1852–1853—£712; 1853–1854—£838; 1854–1855—£1,476; 1855–1856—£1,357; 1856–1857—£1,680; 1857–1858—£1,584. The sale of oil paintings markedly affected his deposits. On the other hand, like most people, Cruikshank spent, even overspent, his earnings. For the same years, his balances were slim: 1852–1853—2s. 1d.; 1853–1854—5d.; 1854–1855—£57.6.10; 1855–1856—£61.3.1; 1856–1857—£87.14.0; 1857–1858—£25.1.0.

Two hundred pounds per annum in the 1850s bought a lower-middle-class standard of living; in the country one might contrive to live on less and still keep up appearances. Two decades later Lady Wilde wished she "could have £200 a year," and congratulated her son Oscar for being "so well off as in any case you are certain of £300 a year."[4] Cruikshank's income would thus seem to be more than adequate to maintain himself and Eliza in modest comfort. And yet his letters never cease dunning for funds, apolo-

gizing for the delay in paying bills, and bemoaning the losses suffered in every venture he undertakes. His straitened circumstances resulted from the intersection of two trends: high expenses, some of them professional in nature, others personal; and smaller than expected profits.

Often Cruikshank paid others for working on his plates, then collected from the publisher, a practice which swells both income and outgo without adding anything to the balance. In 1856, for instance, Cruikshank wrote checks totaling £81.10.0 to Percy and £89 to Joseph Sleap. Presumably these are reimbursements for engraving in the first case and etching in the second. There was also the rent on his "studio" at 31 Augustus Street, where Adelaide and the children lived; it came to £40 a year, half what he paid for Mornington Place. Then there were repayments of past debts to Merle and his publishers; checks to begging letter writers like Bickerdike; remittances to his wife's relatives Dr. Parratt and Mr. Linstead, money passed through his account as part of estate settlements; subscriptions to the Artists' Annuity Fund and other institutions; property and life insurance payments; bills from his solicitor; and finally a large number of checks made out to himself, in 1856 thirty-four of them ranging from £5 to £82 and adding up to £542.5.0. Cruikshank probably gave Eliza money to pay the grocer and the butcher and the butterman and the coal merchant, and to buy clothes and accessories for herself; he also paid cash for newspapers, magazines, books, prints, and artists' supplies; for transportation by omnibus, cab, or train; for clothes (he does not seem to have run up spectacular tailors' bills) and shoes; for medicines and haircuts; for restaurants and amusements and tips. And he must have slipped Adelaide cash for all the expenses for herself and by 1860 her three children.

On the other side of the ledger, most of the credits are simply entered as "Received." Hence it is impossible to ascertain what those deposits represent. A few are identified: discounted notes, stipends from publishers, installments from purchasers of paintings. The other clue to the nature of Cruikshank's income comes from his complaints about disappointed expectations. After the *Worship of Bacchus* fiasco, narrated hereafter, Cruikshank reviewed his career in a draft letter:

> It certainly does seem strange, nay extraordinary, that I should have been such a sufferer in a pecuniary sense in consequence of taking up the Temperance cause, but my usual employer [Bogue]—had an idea that because I was a Teetotaler all my wit—as an artist was gone—in which belief were a portion of the public also for I not only was not employed but lost the patronage of a portion of the public.

Cruikshank then calculated that he was £10,000 poorer for devoting himself to Temperance.[5]

Among the losing propositions were the pamphlets that Cruikshank issued during the 1850s. On each he reckoned to have sustained not just a diminution of income compared to what another kind of venture might have brought in, but an actual out-of-pocket loss in the neighborhood of £100. Having first advised homeowners on security, then cautioned punters, and next chastised the Bishop of London, Cruikshank resumed his attack on gin palaces. He revived one of the hoariest of caricature devices, pictures and verses adapting "The House that Jack Built."

In his teetotal version of *The [Public-] House That Jack Built* (1853), Cruikshank supplies twelve designs engraved by Percy Cruikshank and Thomas Williams.[6] "Some," he told Crawford J. Pocock many years afterward, "you will see are very badly engraved."[7] These images are engulfed by four pages of double-columned "Notes," wherein Cruikshank rehearses his grievances against the London clergy and the Church Pastoral Aid Society for memorializing the then Prime Minister, the earl of Derby, to close the Crystal Palace on Sundays, while remaining silent about Sabbath licensing hours. He reminds the Ministers "that a part of the public revenue is derived from the *profits upon drunkenness*." He also praises the enlightened regime of his old friend Chesterton, advocates the Maine Law (prohibition), and depicts drunkards as inevitably violent:

> *made mad—made monsters in guilt*
> By the *Gin* and the *Beer* from the House that Jack built.

In closing, Cruikshank addresses those who charge that his rhetoric is intemperate. You'd shout "Police!" or "Fire!" in an emergency, he retorts.

> There *is* a *fire* raging now, all over the land. The blazing alcohol is burning up men, women, and children by thousands. I am dashing on to try and stop it, and I cannot stay to pick my steps, for fear of treading on some one's tender corns. There *is* *murder* being done.

Unfortunately, once again Cruikshank's sacrificial shout fell largely on deaf ears. Three years after Tweedie issued the penny pamphlet, it still hadn't sold in sufficient quantity to erase the publisher's slate. Cruikshank owed £22.2.3; Tweedie thought there would not be enough business to justify another edition.[8] By the time George got around to paying the bill, it had swelled to £36.7.7.[9]

There were those who did not appreciate anyone's meddling with the right to drink, especially when it touched on the working man's panacea, beer. One report says that because Cruikshank supported restrictions on beer in 1855, his house was attacked and his hands threatened by an angry mob. Such violence reinforced his conviction that the consumption of alcohol inevitably led to brutality. But it did not stop him from speaking out about and acting on his beliefs. When Dawson Burns, secretary of the

National Temperance Society, asked Cruikshank to attend a meeting at the Home Office on 18 March 1856, at which Sir George Grey was to receive a deputation presenting memorials from Birmingham and Leeds calling for a further inquiry into Sunday traffic in liquor, George readily agreed.[10] The next few weeks were particularly busy with Temperance activities: Cruikshank attended meetings to plan a large demonstration at Drury Lane, and had an audience with the Prime Minister, Palmerston, in Piccadilly.[11]

The untimely death of Bogue further complicated Cruikshank's affairs. He was forced to borrow repeatedly even before his publisher died in November 1856, and the situation worsened thereafter.[12] The following year he refused to pay any of the bills that Bogue's executors and Charles Tilt presented until he could "discuss the question more fully." Cruikshank particularly objected to being charged interest on his debt, considering that the time he lost and the inconvenience he was put to as a consequence of Bogue's decease "ought to be taken into account when settling this transaction."[13]

Mid-decade pamphleteering added nothing to George's purse. Irritated by complaints about military bands playing in Kensington Gardens and other parks on Sundays, in 1856 Cruikshank indited a four-page "letter" from "A High Dignitary of the Church" to "The Right Man in the Right Place." This was another of his diatribes against hypocritical Sabbatarianism. The pamphlet pretends to a persona that is not sustained—the "I" who narrates eyewitnessed instances of drunken brutality is the same "I" who designs the wood-engravings, initialed "G Ck." The argument is digressive and ridiculous; Cruikshank offers to preach every Sunday in Hyde Park, to provide music for those who are fond of it, and to set up tent-chapels near all the park entrances, so those who don't attend church can still worship while enjoying the gardens. That very integrity which George Eliot discerned in his character unfit Cruikshank for the act of ventriloquism, for projecting himself into a wholly different persona. He could neither conceive nor execute Swiftian irony, just as in any dispute he had great difficulty imagining a point of view other than his own. The pamphlet does not seem to have attracted many persons, either because the subject was too trivial or because Cruikshank's teetotal Sabbatarianism had wearied his audience. Problems in London parks were not of much interest to the provincial Temperance societies, and the London organizations had larger matters—licensing restrictions and prohibition—occupying their energy and time. Consequently few copies were printed, fewer sold; *The Bands in the Parks* is probably the scarcest of all these ephemeral publications.[14]

Cruikshank's laudable but somewhat incautious ambition to reform all drunkards, his not unmerited, but still inflated sense of his own importance as a spokesperson for charitable causes, his often unbusinesslike procedures,

and his gullibility combined to get him into a great deal of trouble late in the year. A glib con man, James W. Howell, wrote to him on the seventh of April 1856 ("It ought to have been the *first*," Cruikshank grumbled in retrospect):

> The sympathy you have always evinced for the cause of the working-classes induces me to forward you the enclosed prospectus, in the hope that I shall be enabled to secure your support.
>
> The promoters of the undertaking (of whose respectability I shall be glad to satisfy you) are extremely desirous that you should be one of the Trustees—an office involving no pecuniary liability, but one in which we feel you could be of much service to the poor, since their desire is to promote the permanent welfare of the toiling millions.
>
> May I, therefore, beg the great favour of a personal interview.[15]

The enclosed prospectus set forth a plan to establish a "General Industry Life and Fire Assurance and Sick-Fund Friendly Society," which would encourage thrift among the working poor and insure a comfortable independence to the aged, medical assistance to the ill, and financial support to widows and orphans.[16]

At first Cruikshank resisted Howell's blandishments, but after many interviews he consented to associate with the enterprise. According to a second prospectus, Sir John V. Shelley, baronet, was also a trustee, the Bank of London held the account, a Mr. Nickoll had been appointed as solicitor, and Mr. Peck, stated to be M.A. Cantab., was actuary. Howell told Cruikshank that Sir John Shelley had declined chairing the society and recommended Cruikshank; when the artist expressed a desire to meet with Sir John, Howell agreed that it was a good idea, but unfortunately, he said, the baronet had left London for a holiday. Eventually Cruikshank attended several meetings with Howell, Nickoll, Peck, and one fellow director, but all the others were either out of town, otherwise engaged, or sick.[17]

By the beginning of August, when Cruikshank was preparing for a holiday in Scotland, publicity about the society seemed to be arousing considerable interest among potential investors. But before any shares were sold, Cruikshank raised a critical question about the legality of issuing guarantor's shares that Howell never answered directly. Instead, he brazened out a reply, telling George that a barrister to whom the case had been put had fallen ill, and that the Attorney General, a "friend" of Howell's, had said, "Well, Howell, I am now going out of town, and should not like to give you a hasty opinion upon such a matter, although I think it will be favourable to your views; however, I will send you my decisive opinion from the country in a few days."[18] The opinion did not arrive, the barrister continued to be ill, and according to Howell every other London barrister was out of town, so Cruikshank's query remained in limbo.

Back home on 10 September, Cruikshank asked for another meeting with the directors; none showed up. He then told Howell he would get an opinion from Mr. J. Tidd Pratt, registrar of Friendly Societies, about the General Industry's guarantor shares. At first Howell welcomed this decision, but later in the day he requested that Cruikshank defer the appointment, as counsel had just submitted opinion that the prospectus needed redrafting.[19] However, Cruikshank went ahead with his meeting, bringing Howell, Nickoll, and Peck along with him to hear Pratt announce that the General Industry was in direct violation of the Act of Parliament regulating Friendly Societies. Furthermore, Cruikshank learned to his dismay that the society had never been enrolled.[20]

At that point Howell's machinations had ensnared Cruikshank further than he believed. Three times during the summer Howell had written offering Cruikshank the chairmanship of the society and an annual salary; although George did not reply until 18 September, and on that date declined, Howell had already advertised his name as chairman in circulars and journals.[21] No sooner had Cruikshank sent that letter than he heard from Benjamin Scott, secretary of the Bank of London, that no account in the name of the General Industry had been opened with his firm, and that Sir John Shelley's name had been used without his knowledge or consent.[22] Very quickly thereafter Howell's bubble burst. The bank threatened action if its name was used again; one of the surgeons inveigled into paying £25 for shares qualifying him to serve as a medical adviser summoned Howell to Marylebone Police Court to answer charges of obtaining money under false pretenses, and at the second hearing Howell was unable to appear because he was in Whitecross Street Prison, having been arrested—as often before—for debt.[23]

"The question may be very properly asked," Cruikshank concluded his pamphlet recounting these events, "if I had made such inquiries into this Howell's character, as would warrant me in lending my name and personal assistance to any matter which he might bring before me?" The fact is that Cruikshank assumed Sir John Shelley really was a trustee, and upon inquiring in the neighborhood about Howell's reputation, he received assurances of the family's respectability. "It now appears that I was deceived—at least, as far as Howell is concerned; and some persons may smile at my want of penetration, but no one but those who have come in contact with Howell can form any idea of what a clever, I may say a great, actor he is. . . . if all be true that I have since heard he is indeed a most extraordinary actor in the *assurance* line." At the same time that he was secretary and manager of the General Industry, Howell was applying for a thirty-shillings-per-week post as "Inspector of Nuisances" in another London parish and issuing an address to the electors of Sligo, soliciting their votes for his Parliamentary

candidacy. "How he would have qualified himself for Sligo, I know not; but he certainly is qualified, in every respect, to represent a *Sly-go*."[24]

Cruikshank published his pamphlet less as a vindication of his own line of action than as a warning to others to proceed with great caution in founding a Friendly Society. He pledged to work for the passage of an act making it unlawful to use someone's name without written consent. And he called upon those who had been so misrepresented, and the press in general, to assist him in this campaign. To that extent the pamphlet was a disinterested endeavor to right another wrong.

But Cruikshank's own troubles were far from over when he printed his exposé, and despite the initial guarantee that as trustee he would suffer "no pecuniary liability," mopping up after the Bubble took considerable time and money. From August, Howell had been using Cruikshank's name as chairman on communications to the "other" directors and in advertisements.[25] Two days after Cruikshank declined the position in writing, he saw further notices in which he was identified as trustee and chairman. He then, on advice of Nickoll, sent a letter to each newspaper where these notices had been inserted stating that he was not chairman, although—again on advice of Nickoll—he deleted the draft paragraph giving his reasons for dissociating from the society.[26] He also consulted his own solicitor, William Loaden.[27]

Within days, Cruikshank received threatening letters from firms alleging that the General Industry owed them money.[28] An agent for the earl of Harrington reported that Howell had tried to make him believe Cruikshank was responsible for the unauthorized use of Lord Harrington's name.[29] Nickoll advised Cruikshank to call a meeting of his "co-directors," Nickoll declining to issue the invitation himself because he had "ceased to be professionally connected with the company."[30] The *Daily Telegraph* billed Cruikshank directly for advertising, as did Mrs. Beeton for notices placed in the *Englishwoman's Domestic Magazine* and the *Boy's Own Magazine*.[31] Benjamin Scott forwarded to Cruikshank evidence of Howell's chicanery for Cruikshank to take to Police Court; Sir John Shelley missed the summons to that hearing because of his wife's poor health, so confirmed to Cruikshank in writing that Howell had no warrant to use his name or the bank's.[32] Others swindled by Howell looked to Cruikshank for restitution.[33] And notwithstanding the congratulations for exposing the fraud that the duped author received from Adshead and a few other friends, he was held accountable in several actions.[34] "In one," he told Flight in April 1857, "the judge suggested a compromise—which both parties accepted." He had no time to supply details, as he was "dreadfully—put about—but *fighting hard, and working hard*."[35] Two years later Cruikshank still was not free of claims;

the proprietors of the *Insurance Gazette* pressed for payment of their account, threatening suit if he did not comply immediately.[36]

His experience with Howell may have been in mind when he addressed a public meeting held for the benefit of the Jews' and General Literary and Mechanics' Institution. The subject was education. Cruikshank endorsed self-help literacy societies, Ragged Schools (though there should be none in "*Rich* England"), and benevolent Reformatories, but he found something odd about the present practice, whereby a malefactor ("Jack") sent to jail would be fed, clothed, educated to a useful trade, and upon discharge given a basket of tools, while his honest cousin "Tom Rag" had to beg in the street for crusts. Furthermore, while learned gentlemen agree that the starveling needs bread, they cannot agree about the kind of bread or the quantity of butter and end up giving him brandy instead. The result of being trained up in strong drink is for Cruikshank inevitable: "Ignorance, poverty, pauperism, immorality, dirty habits, wretchedness and misery of every description, ruin, degradation, brutality, crime, blasphemy, bloodshed and murder!"[37]

Cruikshank's solution was a national educational scheme for the humble classes, one that provided "a certain amount of book knowledge, and also of moral and religious training."[38] To circumvent the endless quarrels over the nature of that religious training (analogous to the quarrels over the appropriate bread and butter), he proposed to leave such instruction to clergy on the Sabbath, restricting weekday education to secular topics. But at all times, Cruikshank pleads, teaching ought to include moral training, including Temperance: "Educate! Educate! by all means: but there is something more required than reading, writing, and arithmetic; indeed, the present age may be characterised as one of reading and writing rascality."[39]

In recognizing the yoked problems of illiteracy and immoral literacy, Cruikshank was one with his time. Education reform was a byword of mid-Victorian politics, though it took until 1870 to pass an act providing for a nationwide system of grammar schools. (Cruikshank's remarks were republished during the hearings on Forster's Education Act.) Another byword was the growth of "paper" crimes: fraud, phony stock offerings, forgeries, blackmail, plagiarism and copyright infringement, documentary imposture. A society that increasingly accepted the word for the thing (a birth certificate as proof of identity, for instance) was increasingly liable to be imposed upon by those who manufactured the written proof. Such was a part of the indictment Dickens published in *Little Dorrit* (1855–1857), and in an even more comprehensive way Trollope anatomized paper crimes in *The Way We Live Now* (1874–1875). Cruikshank was never so confident as Dickens and Ruskin that the imagination if unfettered in childhood would grow up healthy and humane. Cruikshank's art argued for license, while his propa-

ganda called for indoctrination and state control; by contrast Dickens's public statements often advocated greater freedom while the fictions concealed considerable authoritarian bias.

Thus in publishing his speech, *A Slice of Bread and Butter, cut by G. Cruikshank*, George participated characteristically in the public debate about the place of education in the national life. Cruikshank's pamphlet was not simply a cranky gesture of self-promotion. But the mixture of letterpress and three crude wood-engraved vignettes ("cut by G. Cruikshank"), the downrightness of his expressions, the lack of reasoned argument about the finer points of the dispute, and above all the Temperance monomania which he shared with his publisher Tweedie, limited its appeal. If Dickens thought ignorance the source of poverty and vice, Cruikshank believed it to be drink: "The fact is, that the use of wine, beer, and spirits, is at the root in some way or other, of most, if not all our social evils, and until the use of these intoxicating drinks is done away with, all reforms are so much patchwork."[40] To mix up Temperance in an issue already fraught with controversy because of its religious implications, however, was deadly to legislative enactment, and for most people it was in addition a distraction from the main cause. Though Cruikshank considered himself an important national spokesman on education and stressed the moral imperatives of any comprehensive system, there is no evidence that his views significantly affected either the conceptual or the political struggle for public schools.

Cruikshank hoped to escape from his downward spiral by executing an ambitious project which combined aspects of several strengths: steel-etched book illustration, oil painting, Shakespearean subjects, and comedy. He proposed to construct and illustrate a *Life of Falstaff* derived from the hints and incidents contained in Shakespeare's plays. For this purpose, he borrowed from a former Pentonville neighbor, the actor Henry Barrett, the boots, padding, and leather jerkin in which Barrett had "acquired some little reputation in the various Falstaffs."[41] Barrett even offered to pose in costume; his may be the features presented in the portrait that serves as frontispiece to the completed project.[42] Cruikshank then went on to design twenty large etchings, each more than twice the usual size of a book plate, and every one filled with carefully researched details of setting, costume, and character. He obtained the most authentic views of fifteenth-century Shrewsbury and Coventry, and of the tall spire of St. Paul's before it was struck by lightning, and extended the kind of investigation he had pursued in previous decades when illustrating Scott and Ainsworth, ascertaining the style of furniture, shoes, caps, and robes for the period.[43]

Cruikshank also jotted memoranda about Falstaff's life, but turned over the actual drafting of the biography to Robert Brough, a minor writer of

burlesques and humorous essays.[44] In Grub Street Brough was popular: Edmund Yates recalls him fondly in his autobiography, and George Augustus Sala, who supplied a "Memoir" to the 1860 reprint of Brough's novel *Marston Lynch*, may have been the one to recommend the writer to Cruikshank. Hard working and cheery, Brough was nonetheless dying. He undertook the commission while still in reasonable health, persuaded as Cruikshank was that it would be easy to find a large public for their combined efforts.

When, however, a sample of their work was submitted to the firm of Routledge, a Victorian publisher supplying the mass market opened up by railway travel, the opinion was unfavorable. Charles Tilt, endeavoring to find assignments for Cruikshank so that the Bogue debts could be settled, forwarded a judgment which Cruikshank replied "is at variance with the opinion of every one else to whom I have spoken to upon the subject—."[45] Stubbornly, Cruikshank persisted. Longman eventually agreed to publish. Thomas Williams engraved a large vignette of the rotund hero accompanied by his small squire Bardolph, below which an epigraph from *Henry VI, Part 2* was printed, reading in part, "I am not only witty in myself, but the cause that wit is in other men." That Cruikshank should have chosen this, of all Falstaff's speeches, and called attention to it by causing it to be printed on the wrapper and on a separate, unpaginated leaf between the title page and the "Writer's Dedication" in the bound edition, signifies George's identification with Sir John. Indeed, in one sketch he draws parallel threequarter portraits of the knight and himself, penciling as a caption, "but to say that I know any harm of him—."[46]

Publication was bedeviled by bad luck. To begin with, the large steels Cruikshank used proved to be made of inferior metal imperfectly tempered; the walls of the etched lines crumbled during biting in, so he was compelled "unfortunately *to do all the work over again!*"[47] Partly because he was duplicating his effort, and partly perhaps because he had been battered into a kind of caution, the images are a bit stiff, static, predictable, and formulaic. John Harvey finds them "pleasantly relaxed" versions of the Ainsworth designs and particularly approves Cruikshank's atmospheric unification of figures, streets, and landscape into a single integral picture. "The gables, overhangs, beams, gargoyles, mullioned windows, and all the little ins and outs of Old English houses are drawn with affectionate expertise."[48] Falstaff's rotundity (fig. 67) establishes both a design principle and a style: several of the plates play off the circularities of belly and shield against the lean and the linear, and especially in early ones Cruikshank tries for a three-dimensionality reminiscent of stipple engraving. But in striving for "tone," "color," atmosphere, and authenticity, he etches thousands of tiny fine lines in a way Ruskin was shortly to deplore: "I cannot bear to see his

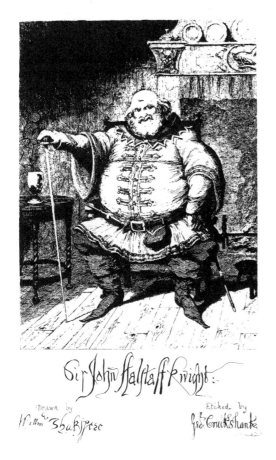

67. *George Cruikshank,* "*Sir John ffalstaff knight,*" The Life of Sir John Falstaff, *etching, 1858*

fine hand waste itself in scratching middle tints and covering mere spaces," he told Charles Augustus Howell in 1866.[49] The effect of shadowy night in "Sir John Falstaff and the Fairies, at Herne's Oak," might have been easier to achieve with mezzotint or aquatint, but George's resolute determination to etch these friable steels into submission led him to a deliberateness of effect that fails to excite. He could not compel an audience into admiration.

The plan was to issue a twenty-page shilling number each month, with the two etchings also offered for sale in proof sets on folio and quarto paper. The plates would thus provide illustrations for the text, depict Cruikshank's staging of the plays, and function like engravings from paintings as prints suitable for framing and hanging in homes. Toward these ends, Cruikshank dispensed with a copperplate engraver for captions, supplying his own full descriptions in his very idiosyncratic script and for many indicating the scene from which the incident was taken. This was also cheaper than pay-

ing an additional craftsman, and in a way it allowed the artist, through his fulsome titles, to tell the story in his own words. But the shilling number and the steel-etching were outmoded by the late 1850s, Cruikshank's style seemed old-fashioned and crude, and no visually literate person could take the etchings to be reproductions from oil paintings—they were unmistakably George Cruikshank's, conceived and executed in the traditions of etched caricature and graphic narrative. The sales were minimal, despite the puffs of such influential friends as Charles Kent.[50]

Increasingly Brough was late with copy as he struggled against declining physical resources.[51] As the year wore on, he missed deadlines. Irregularity of issue further damped sales. For Cruikshank, little profit accrued to set against the Bogue debts, or to pay notes, or to settle the claims of those injured by the General Industry Bubble. "The fact is," he told Tilt in January 1858, as he tried to renew a bill,

> that—what with the interruption in consequence of Mr. Bogue's decease—and what with the bad steel—so much time has been lost that I am thrown back more than ever—however the last two plates are now in hand—and after they are out of the way I hope to get to work upon some commissions which I trust will be a little more profitable than "Sir J. F." has been to yours truly.[52]

Tilt was not especially forgiving; in an interview at Fleet Street he insisted that Cruikshank pay £10 of the note immediately and *in cash* before he would renew the balance for a few more months.

There was little Brough could do to mend matters. He had neither money, health, nor time. In his "Preface" he apologized "for frequent breaches of punctuality in the periodical issue of the work, for which he, alone, is responsible," and he praised Cruikshank for originating the idea of illustrating Falstaff's life and for realizing the images in the text "by faithful attention to chronological and archaeological probability of detail, in a pictorial sense."[53] This was in fact the sort of collaboration Cruikshank wanted to have with Dickens and did have on some of Ainsworth's fictions, but only Brough, making what amends he could for his own shortcomings in the production, forthrightly acknowledged Cruikshank's guiding spirit. Unhappily, neither Brough's generosity and courage nor Cruikshank's assiduous reetching of his last major book illustrations could rescue the project from oblivion.[54]

Two years later Brough died. Cruikshank enthusiastically participated in a benefit performance in aid of the widow and children (fig. 68).[55] The Savage Club undertook the organization, Webster and Buckstone lent members of their acting companies, Andrew Halliday served as secretary, and seventy-eight writers and friends contributed, including Dickens, Wills, Collins, Planché, Blanchard Jerrold, Leigh Hunt's son Thornton,

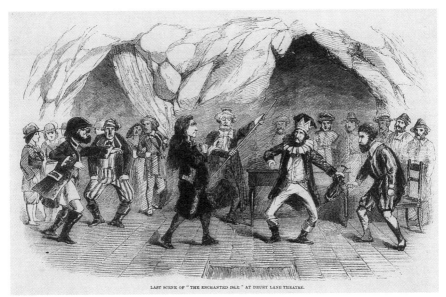

LAST SCENE OF " THE ENCHANTED ISLE " AT DRURY LANE THEATRE.

68. *"Last Scene of 'The Enchanted Isle' at Drury Lane Theatre,"* Illustrated London News, *4 Aug. 1860*

Tom Taylor, Mark Lemon, Henry Mayhew, Edmund Yates, and Dante Gabriel Rossetti. The gala, at the Theatre Royal Drury Lane, was held on 25 July 1860. Sala delivered a specially composed address, Paul Bedford performed a comic scene, and in the final piece, Brough's burlesque of the *Tempest*, Kate Terry was Ariel, Fanny Stirling played Miranda, and George Cruikshank ranted as Alonzo. But Prospero could not resuscitate the writer, nor Ariel weave her magic about the island. George Cruikshank, artist, was foundering.

The other work of these years was piddling. Cruikshank etched twelve illustrations to A. W. Cole's *Lorimer Littlegood. A Young Man who wished to see Society and Saw it Accordingly.* This was first serialized in *Sharpe's London Magazine* and then issued as a one-volume novel, with all Cruikshank's plates and four more by W. M'Connell.[56] Cruikshank's design for the wrappers of *Bentley's Miscellany* was reproduced as frontispiece to the *Bentley Ballads*, but as he and Richard Bentley were still not speaking, no money changed hands.

For a Glasgow printing and publishing firm, Brown and Miller, in the summer of 1858 Cruikshank prepared a frontispiece to *Midnight Scenes and Social Photographs.*[57] This started out in a promising way. Cruikshank furnished a design his employers liked so much that they supplied a steel rather than a copper plate "as it is *possible* a large number may be needed."[58] Great

care was taken in its printing; the proof copies came up clean, fresh, sparkling—everything the printers could wish. Cruikshank was told that his contribution would definitely help sell the work and that the account would be settled at the beginning of August.[59] When no payment arrived, Cruikshank inquired, learning by return of post that the publishers had suffered severe financial losses, a delayed consequence of the previous year's banking crisis. Alexander Brown assured Cruikshank that his security was good, but when Thomas Murray and Son took over the business and stock, the new publisher, while sympathetic to Cruikshank's plight, refused to register the claim in his own books and would not pay anything unless the edition made a profit.[60]

Cruikshank reaped no pecuniary profit from Frederick Locker's *London Lyrics* either, but his frontispiece, "Building Castles in the Air," is one of his more delightfully effortless late etchings. The work had another favorable result: it brought Cruikshank into association with Locker, who was to be one of the artist's most important patrons in the decades to come.[61]

Indirectly even Dickens exercised a blighting influence. He asked Browne rather than Cruikshank to create vignette titles for the Library Edition of *Sketches by Boz* and *Oliver Twist*. And smarting from the failure of his *Fairy Library*, Cruikshank concealed all evidence that he wrote as well as illustrated the ugly little Christmas book *Stenelaus and Amylda*, published for the author by Griffith and Farran.[62] Although Cruikshank managed to keep teetotal advocacy out of most of the story, the concluding sentence identifies the villain: "Antonio D'Alembert was DRINK."

It must have been puzzling to Cruikshank to contemplate the disparity between his "fame" and his income. Though no artistic project yielded great sums, he was more honored, feted, and invited out than ever before. One of the new friendships was with Charles Robert Leslie, friend of Sir Walter Scott and John Constable, painter to the queen, professor at the Royal Academy, author of the unaffected and sensible *Handbook for Young Painters* (1855), and painter of numerous episodes from literature. One of his most popular works depicted *Roger de Coverley Going to Church*, a character that Charles Kent recommended to Cruikshank's consideration.[63] George and Eliza dined at the Leslies' in December 1856; the following month, Cruikshank sent along a workman who had secured the doors and windows in Mornington Place according to the principles espoused in *Stop Thief* and could perform the same service for the Leslies' residence in St. John's Wood. Returning the favor, Leslie introduced Cruikshank to George Long Duyckinck, a New Yorker and younger brother of Leslie's long-term American patron, Evert Augustus Duyckinck.[64]

On 18 February Cruikshank paid tribute to Crowquill and the author of *Handy Andy* in Albert Schloss's visitor's album. Opposite Forrester's Chi-

naman, Cruikshank drew a pigtailed Chinese boy, and under Lover's drawing he sketched a cavalier and wrote, "Alfred Forrester—alias 'Crowquill'—and Samuel Lover, both artists and authors, both clever fellows and good fellows, and both highly esteemed by their friend, George Cruikshank."[65] Later that month he and Eliza sent out invitations to around a hundred friends for an evening party they gave on 11 March. Those invited included the Charles Mackays, Sir Walter and Lady Trevelyan, Benjamin Lumley (lessee-manager of Her Majesty's Theatre), the Lovell Reeves, the Teggs, and William Pulford, none of whom could attend. The Loadens came; so did the Parrys who enjoyed "a very delightful evening."[66]

One who could not attend was Edward Walford, editor (*Court Circular, Once a Week*) and compiler of biographical dictionaries, who had asked Cruikshank for a personal history. "I place this Biographical matter in the hands of my 'better half'," Cruikshank replied; she "has done & said more for me than I could have done myself—."[67] If not the first, this was one of the early requests for personal information, to which Cruikshank's response was to rely on Eliza. He jotted a few notes to guide her but let her write more flatteringly than he could possibly have done himself. This pattern was to persist through a number of other autobiographical trials and to have disastrous consequences when it came time to compose a definitive biography.

There were other important celebrations—in August one for Gough, commencing his second tour of Great Britain, and shortly afterwards a Testimonial Dinner for Cruikshank's dear friend Tom Reynolds.[68] Although John Cassell had temporarily lost control of his business and money was very tight, he still entertained occasionally. At one party, attended by William and Mary Howitt among others, there were afterdinner presentations to take the place of afterdinner drinks. "We had a song from Cruikshank," Cassell told his daughter, "a very droll affair."

> He went out and dressed—my broad-brimmed straw hat pinned up in front, a feather out of Mrs. Cruikshank's bonnet, constituted a good Italian count's hat; in his shirt-sleeves he threw over his shoulder Mama's Geneva cape, plaid outside; a shawl round his waist, my ivory-handle stick for a sword, with moustache and whiskers and dark eyebrows, the production of a burnt cork, constituted his costume. He came in bowing and scraping, and then commenced his song, "Lord Bateman," an old thing which I knew when I was a boy.[69]

Whether one enjoyed these performances was a matter of taste. Cassell's partners Galpin and Petter failed to appear, perhaps because they disapproved of the extravagance of the party or foresaw a dull evening without wine.

The most heartwarming, and eventually heartbreaking, series of tributes to the artist was initiated in an appendix to an 1856 book. Discussing the

characteristics of the Modern Grotesque in volume four of *Modern Painters*, John Ruskin declared that "all the real masters of caricature deserve honour in this respect, that their gift is peculiarly their own—innate and incommunicable. Taken all in all, the works of Cruikshank have the most sterling value of any belonging to this class, produced in England."[70] Ruskin had known Cruikshank's work since, as a child, he had drawn with "incredible" exactness pen-and-ink replicas of Cruikshank's vignettes to Grimms' fairy tales.[71] The following year, in *The Elements of Drawing*, Ruskin advised that if students couldn't get hold of Rembrandt or Dürer prints, they should study Leech's woodcuts or Cruikshank's etchings:

> Cruikshank's work is often incomplete in character and poor in incident, but, as drawing, it is *perfect* in harmony. The pure and simple effects of daylight which he gets by his thorough mastery of treatment in this respect, are quite unrivalled, as far as I know, by any other work executed with so few touches. His vignettes to Grimm's German Stories, already recommended, are the most remarkable in this quality.[72]

Ruskin particularly appreciated the lightness of touch by which the artist achieved his effects in these early plates. Elaborating on his enthusiasm in an appendix, he extolled the Grimm illustrations as "the finest things, next to Rembrandt's" that had been done since the invention of etching. Ruskin found all Cruikshank's works "valuable," but deplored two aspects, the subject matter that touched "on the worst vulgarities of modern life," and the signature facial type, "divided so as to give too much to the mouth and eyes and leave too little for forehead, the eyes being set about two thirds up, instead of at half the height of the head."[73] But, Ruskin added, recognizing dimensions of the artist's achievement that few others had celebrated, "his manner of work is always right; and his tragic power, though rarely developed, and warped by habits of caricature, is, in reality, as great as his grotesque power."

In conclusion, Ruskin recommended that art students could "get great good by copying almost anything of [Cruikshank's] that may come in your way; except only his illustrations, lately published, to *Cinderella*, and *Jack and the Bean-Stalk*, and *Hop o' my Thumb*, which are much over-laboured, and confused in line. You should get them, but do not copy them."[74] Dutifully, Thomas Dixon of Sunderland wrote to Cruikshank asking for the name of the publisher and the price of the Grimm book.[75] However flattering it might be to be equated with Rembrandt and Dürer, since Baldwyn and Robins had long since gone out of business, Ruskin's advocacy was of little practical help to Cruikshank, or, for that matter, to artists who may have had more difficulty locating a copy of *German Popular Stories* than the Renaissance engravings.

On 3 April 1857 Ruskin and Cruikshank both spoke at a soiree given by students of the St. Martin's District School of Art.[76] Cruikshank regretted his lack of early training. He went to the Royal Academy, he said, but the cupboard was bare at home so he had to quit studying and go back to work. Ruskin told the pupils that Cruikshank's "were amongst the most instructive models they could have before them in reference to the peculiar characters of every-day life." He placed the works above those of any other living etcher—they were "greater, more precise, more profound." But, though the class would derive advantage from paying close attention to these etchings, Ruskin hoped that however good he might be, Cruikshank would have been better had he been brought up in such a school as St. Martin's.[77]

From this high point, the connection with Ruskin went slowly, then more precipitously downhill. On 8 October 1858 William Monk wrote to Cruikshank saying he had "now a noble opportunity of introducing you and Mrs. Cruikshank to some of our Cambridge Celebrities." Monk knew that Cruikshank was scheduled to attend a soiree at the Mechanics' Institute at the end of the month; might he not arrange to help inaugurate the Cambridge School of Art, along with John Ruskin and Richard Redgrave, at the same time?[78] This was one invitation that Eliza docketed "Accepted."[79] Though Cruikshank rarely wrote down his speeches, he took time to think through what he should say about formal schooling as opposed to learning-on-the-job, knowing that Ruskin might again trace a graceful curve from praising self-taught talents to advocating instruction. When the three principals arrived at the ceremony, Ruskin got carried away, speaking for an hour and a half. The thirsty audience then rushed to the refreshment stand. Redgrave noticed that "poor Cruikshank felt he was nowhere; in fact, he got up to say he had no time or opportunity to say anything."[80] Noncommunication was to become the hallmark of his relations with Ruskin throughout the succeeding decade.

Once again commendations and compliments came at the wrong time and in the wrong place, leaving the British public to think better of Cruikshank, and Cruikshank perhaps to think better of himself, but unable to find the alchemist's secret for translating the base metal of fame into gold. Ruefully, as he reviewed his life for Eliza and Walford, he scribbled: "'Write me down an ass'—proofs are extant—easily bamboozled—". Steeped in Shakespeare, on this occasion Cruikshank read himself into Dogberry's character rather than Falstaff's. But if Dogberry's condemnation is too severe, he reflected, then put him down "as a good natured man."[81]

41

THE VOLUNTEERS

Captn. Commandant
Havelocks or
24th Surrey—
Septr. 27th 1861
my Birthday—
Aged 69!!!
oh! oh! oh!

George Cruikshank[1]

As the Temperance movement gained clout, Cruikshank's associations with it ramified. Because he was in constant demand as a chairman and speaker, his friendships with the officers of the principal Temperance organizations deepened. Robert Rae, secretary of the Scottish Temperance League, Samuel Couling (an early historian of the movement) and John Taylor, secretaries of the National Temperance League, and Henry John Phillips, an employee of the Chartered Gas Co. in Horseferry Road and secretary of the Temperance Permanent Land and Building Society, were in constant communication. George and Eliza met Samuel Bowly, a wealthy Gloucester business man, ardent abolitionist, president of the National Temperance League, founding president of the Temperance Hospital, and director of the United Kingdom Temperance and General Provident Institution. Bowly was particularly influential in calling scientists' attention to the injurious effects of alcohol. The Cruikshanks also met George Mills, a Glasgow journalist and novelist who had made a fortune in shipbuilding, and the Reverend Dr. Dawson Burns, who wrote the standard *Temperance History*.

Among their friends they now counted some extraordinary physicians—Charles J. Aldis, Ralph Barnes Grindrod, Edward Smith, and the man who was to become their personal physician and executor, B. Ward Richardson, who was introduced to Cruikshank as well as Mark Lemon and Thackeray by Douglas Jerrold, and taught how to win converts by Bowly.[2] For years

Aldis contributed his labor to London area dispensaries; a tireless advocate of sanitary reform, he served as the first medical officer of health in Cruikshank's old parish, St. George's, Hanover Square. Grindrod was a Manchester physician who investigated the healing properties of Malvern waters, debated publicans, converted John Cassell, and wrote *Bacchus. An essay on the nature, causes, effects, and cure of intemperance,* which went into a third British edition by 1840, was then published in America, and appeared in a new edition from Simpkin Marshall in 1851.[3] In 1844 he launched a successful six-and-a-half-year medical Temperance mission, complete with lurid slides, and he proselytized among juveniles years before the first Band of Hope was founded in Leeds.[4] Smith, a specialist in dietetics, in the early 1860s was appointed medical officer to the Poor Law Board, a responsibility which he discharged by upgrading Oliver's gruel on nutritional and practical principles and by improving the hygenics of workhouses and infirmaries.[5] Richardson, knighted in 1893 "in recognition of his eminent services to humanitarian causes," pioneered in anesthesiology, practiced forensic medicine, studied tuberculosis and epidemiology, founded the Model Abattoir Society, wrote papers on medical history and biography (including a two-volume review of the reformer Sir Edwin Chadwick's life and work), lectured on hygenics, and after investigating clinical and pathological evidence declared, in opposition to the prevailing opinion in his profession, that alcohol was "an enemy to life."[6] These men worked intimately with the poor, knew their medical problems, their struggles for housing, food, jobs, money, education, and opportunity, experienced at first hand the ravages of drink on persons, families, and hope. They did not consider Cruikshank a "fanatic," although that derogatory sobriquet began to be applied to the artist in the 1850s and continues to be widely used to disparage his teetotal efforts. Nor could they fairly be characterized as "whole hogs" grunting after absurd manias.

Among more "literary" types, Cruikshank now spent time with minor journalists: James Lowe, David Lester Richardson (proprietor and editor of the *Court Circular*), the publishers Samuel Carter Hall and Charles Kent (whose "warm-hearted hero-worship" of Dickens, Edmund Yates said the novelist fully appreciated during the last decades of his life), and the journalist George Augustus Sala, whose career was intertwined with both Dickens and Cruikshank from 1836 on.[7] The publishers still evincing an interest in the artist's productions were Cassell and Tweedie, publicists for Temperance; W. Kent, who purchased parts of Bogue's business through the mediation of Charles Tilt; Frederick Arnold, another Bogue successor; and John Camden Hotten, whose publications ranged from the respectable (a reprint of the Grimm stories) to the risqué.

Few of these associates were interested in "high art," graphic or literary,

and with the exceptions of Sala and Hall none was concerned with the history of caricature and illustration. These self-made, earnest, hard-working, conscientious, socially enlightened men pursued practical goals—the running of large organizations, the achievement of pragmatic reforms. They tended to respond to Cruikshank's art as an instrument in the service of a cause. Whether secretary of the league or publisher to it or reviewer of its publications or pledger or bystander, they valued his prints insofar as they furthered other ends. Paradoxically, the very utilitarian rationale underpinning Cruikshank's late period failed to elicit the financial support for his art that should have come as a consequence. Imaginative works, beautifully crafted objects, vast canvases depicting contemporary life or classical idylls, and fiction illustrated by wood-engraving—the works of the Pre-Raphaelite Brotherhood, of William Morris and his disciples, of Frith and Alma Tadema, of Trollope and George Eliot illustrated by Leighton or Millais—found patrons in much greater numbers and with vastly greater resources than Cruikshank's propaganda ever did. His fairy style was too escapist, his painting techniques too crude, his real-life pictures too mannered and eccentric, and his zeal too offensive for upper-middle-class sensibilities.

It was not Dickens alone, but Dickens as spokesman for significant portions of the governing classes, who ruled Cruikshank's art out of court. Moreover, the personal relationship was dead: "With respect to Mr. Chas. Dickens," Cruikshank told an autograph seeker in 1869, "I have ceased to associate with him for many years."[8] He and Eliza did, however, befriend Catherine after her separation: for instance, they accepted her invitation to visit the Egyptian Hall together in 1861.[9] And while correspondents still wanted Cruikshank to intercede with Dickens on their behalf, occasionally a letter fed the artist's vanity rather than the author's.[10] Georgiana Thompson, who published uplifting Christian tales, recalled a day when at Islington she served tea (her very first time) to Dickens, William Upcott the radical bookseller and autograph collector, and Cruikshank. Dickens was "very pale, very thin, and as I thought very *cross*, for he said nothing at *least to me*, you and Mr. Upcott talked." For years afterward Upcott predicted she would find herself immortalized as the knob on a teapot in one of Cruikshank's pictures.[11] Another friendship that was to have more beneficial results was formed with Edwin Truman, noted for improving the process for purifying gutta-percha, who in time assembled the greatest first-generation collection of Cruikshankiana.[12] Much of Cruikshank's remaining years was spent authenticating pictures and sketches and assembling copies of his works for his own collection and for Cuthbert Bede, W. H. Bruton, Sir Percy Fielding, Sir W. A. Fraser, Thomas Hugo, Frederick Locker Lampson, G. W. Reid, Truman, and other enthusiasts.

After *Falstaff*, which Cruikshank originated himself, he neither received

nor executed any substantial book commissions. In April 1859 John Taylor of Nottingham inquired the price of twelve illustrations for a post-octavo novel; the query may have been flattering in its way, but the notion that his plates could be bought by any author for cash down may have galled Cruikshank.[13] Eliza's docketed "Answered" does not indicate the nature of her husband's response, but no such novel illustrated by Cruikshank ever appeared. Two years later he declined a request from an employee of Norwich Union Insurance to do a frontispiece for his book.[14]

For a "Hampstead Conversazione" on 4 May, the artist demonstrated etching on copper by producing a plate of a journeyman printer making his self-portrait (vol. 1, fig. 1). But though he could work up a plate with consummate skill, Cruikshank used the needle less and less. At the time when British etchers, inspired by the examples of Charles Meryon and his French colleagues, and by Seymour Haden and J.A.M. Whistler, were reviving the medium as a vehicle for high art and poetic compositions, Cruikshank was exploring any kind of process which might produce large quantities of black-and-white images at a low cost.[15] He may, as some charge, have been a bit naive about the artistic potential of glyphography and cliché verre, and may unwisely have neglected lithography, which served Daumier and his successors so well as both an artistic and a propagandistic vehicle, but he never stopped experimenting with methods that might enhance his reach and capacity to communicate. Cruikshank was no Luddite.

When the philanthropist and M.P. Samuel Gurney presented the first public water fountain to the Drinking Fountain Association, Cruikshank celebrated the event with a wood-engraving for *The British Workman* and lithographs contrasting *The Rival Fountains*, Gin and Water, for which Tegg's son and successor William Tegg paid £5.[16] Gurney's was the first wholesome water fountain for public use erected in Great Britain; as Merle had pointed out to his friend, and many others had stated in public, the thirsty workman was not going to be weaned from beer and spirits until unadulterated water was freely available in places where large numbers of people congregated.

Temperance publications continued to disseminate Cruikshank's pictures. For Tweedie's *Weekly Record of the Temperance Movement* he illustrated the "Autobiography of a Thirsty Soul"; he also threw off fly-leaves such as "A Man a Thing" and "The Loaf Lecture," the latter proving that baked grain was much more nutritious than fermented grain.[17] An ambitious colored wood-engraving for Cassell, *Fruits of Intemperance*, shows a tree whose root of serpents "sucks up a great part of the riches of the land, and is also the root of a vast amount of evil."[18] Growing amid the tombstones of "early fruit," the tree puts forth thirty-six medallion vignettes

showing the destructive consequences of "the social glass," leading to "murder," "the condemned cell," "manslaughter," "transportation," and "the gibbet." This design incorporates teetotal imagery Cruikshank had used earlier in "The Upas Tree" and *The Bottle*, and it anticipates the vast assemblage of anecdotes comprising *The Worship of Bacchus*. In 1861 Cruikshank received a request from the Reverend Charles Caldwell of Norwich for sketches to illustrate the "Autobiography of Mr. Brown," which Caldwell would then convert into lantern slides to accompany his Temperance lectures.[19] The following year the Scottish Temperance League solicited designs for a couple of wood-engravings to decorate each issue of their periodical the *Scottish Review*.[20]

The most powerful of these ephemeral commissions depicted the Manchester cotton famine, caused by the North's blockade of Southern ports during the American Civil War. *The Smokeless Chimney*, engraved by Thomas Williams and published as a broadside with twenty-one verses "as an inducement to the benevolent in aid of the relief fund for sufferers by the Cotton famine," demonstrates the artist's unfailing sympathy for the working poor, whether or not their wretchedness was caused by intemperance.[21] This project originated with a teacher, T. Faulkner Lee of the Royal Grammar School, Lancaster. He obtained permission to reprint the verses and hoped to raise money to buy warm clothing which he stored at the school and distributed to the needy. Despite a "whirlpool of engagements" Cruikshank managed to dash off a design and put it in the hands of the engraver by mid-December, writing then for further particulars about the title and printing. He told Lee to arrange letterpress and picture on a half sheet of demy paper and hoped to have the illustration pressed before Christmas.[22] To take so much trouble for a stranger, in aid of an out-of-town charity from which he would reap no profit, is typical of Cruikshank despite his crowded if increasingly unremunerative schedule.

John Camden Hotten, the son of a master carpenter and undertaker, was apprenticed to a London bookseller at the age of fourteen and then went with his brother to America for eight years. On his return in 1856 he set up in business for himself in Piccadilly, and by his knowledge of old books and curiosa, his shrewd intelligence, the long days he spent compiling and composing dictionaries, guides, directories, biographies, and translations, and his willingness to take risks (such as the publication of Swinburne's "indecent" *Poems and Ballads*), he enlarged his business manyfold.[23] Using his acquaintance with American humorous writers, he introduced into England the works of Artemus Ward, Oliver Wendell Holmes, Bret Harte, and James Russell Lowell. To further "domesticate" Lowell's comic verses, which Hotten advertised as ranking "with the Ingoldsby Legends and alluded to in the House of Commons by John Bright," he hired Cruikshank

to etch a frontispiece, "Bird o' fredom Sawin."[24] This stratagem paid off; Hotten reissued the volume with a colored version of the frontispiece and two years later added two further colored steels selected from the stock of the *Comic Almanack*, which he purchased.[25] Hotten did not allow the connection with Cruikshank to lapse: a few years thereafter he brought out a reprint of *Life in London* with a prefatory history which he composed. There was little work for Cruikshank in these reissues, but at least his early work was being recirculated and prized.

A similar stirring of old papers occurred in 1861, when John Stenton, a bookseller in Lamb's Conduit Street, offered for sale 185 books and pamphlets "illustrated by the Immortal and Inimitable George Cruikshank." The same year Pickering reprinted *The Bee and the Wasp* using Joubert's recently patented acierage process to coat the original copper plates with an iron facing.[26] This produced "so sharp & bright" an impression that the publisher thought even the artist, who had belatedly communicated a desire to retouch his work, would be content. "My best thanks for the very kind manner in which . . . you interested yourself on my behalf," Pickering concluded one letter.[27]

The following summer there was a little flurry about the *Fairy Library* illustrations, which a Mr. Astes proposed reproducing, possibly on song heads. "I should most decidedly object to this gentleman, (Mr. Astes), or any one else, making copies *in any way*—for if so, they would most likely have wood cuts of them done, to put upon their advertising bills—or others would copy them, from [for?] their painted panoramas . . . and as to putting the song with it and making it a sixpenny affair [that] is of course quite out of the question."[28] This contretemps was negotiated by George Bell, who had evidently purchased some of Bogue's copyrights and stocks and had the year before helped Cruikshank to sell to Tweedie those for *The Bottle* and *The Drunkard's Children*—"not that he wants to have the latter," Cruikshank reported, "but I told him they must go together."[29] Tweedie also offered, apparently unsuccessfully, for a half share in the *Fairy Library*.

In September 1862 Cruikshank finally negotiated a settlement with Bogue's estate: Frederick Arnold, "who wishes to be my publisher in future," advanced the money for property held by Bogue's executors as security. As soon as Arnold had, through reissues, recouped his purchase price, or whenever Cruikshank paid him directly for these advances, the copyrights and stock would revert to the artist; in the meantime, Cruikshank retained "the *right* of giving the written *orders* for any *reprint* of *Plates Blocks*—or *Letter press*."[30] Little more than a year later the *Fairy Library* was reissued jointly by Arnold and Routledge, with the addition of the hitherto unpublished fourth story *Puss in Boots* (purged of teetotal maxims) and a succession of afterwords by Cruikshank about his original intentions for the

series and about its initial reception.[31] In his "Address to Little Boys and Girls" he tells of his own nurse's stories about the fairies who "had houses in the white places in the corners of the cellars," and reassures his juvenile audience that he offers these tales "to *amuse* you, and, if possible, to convey some *good lessons* and *advice*, but not on any account to frighten you." A second address, "To Parents, Guardians, and all Persons intrusted with the Care of Children," recapitulates and elaborates on the quarrel with Dickens, concluding:

> And I would here ask in fairness, what harm can possibly be done to Fairy literature by such re-writing or editing as this? more particularly as I have been most careful in clearly working out all the wild poetical parts, and faithfully preserving all the important features of each tale, so that all the wonderful parts are given, that so astonish and delight children, but in what I hope [is] a more readable form, quite as entertaining, and I trust somewhat more useful.

Not content with rehashing this stale quarrel, Cruikshank also warmed over his dispute with the publisher Brooks which commenced in a pamphlet about Volunteers discussed hereafter. Lacking other outlets for his anger, George turned the last volume of the *Fairy Library* into a compendium of complaints, thus enforcing his reputation as a crank without obtaining any effective redress.

Apart from these ephemera and reprints, Cruikshank's commissions for book plates were scarce and humbling. He tried out Joubert's acierage process himself for a spirited frontispiece and illustrated title page to Robert Blakey's *Old Faces in New Masks*, and evidently prepared for W. Kent some hand-colored undivided proofs.[32] More fairy subjects, for which there was at least some limited demand, cropped up in a music sheet cover to *Fairy Songs & Ballads* and frontispieces to three of Hotten's publications, a spoofy "Shaving a Ghost" for Dudley Costello's *Holidays with Hobgoblins*, "Puck on Pegasus" for H. Cholmondeley Pennell's similarly titled novel, and an animated "Flight of Witches" for Robert Hunt's *Popular Romances of the West of England*.[33] These assignments let Cruikshank work on an unresolved psychomachia figured by the demons of drink on one side and the usually beneficent fairies on the other; in ways still to be explored by historians of *mentalité*, the Victorians' fascination with the supernatural may issue in part from their bewilderment at the unnameable forces shaping—often deforming—human lives.

James Hain Friswell, a friend to Angus Reach and Albert Smith, was a miscellanea writer involved with educating working men and improving inexpensive literature for boys. He asked Cruikshank to design six full-page wood-engravings, cut by Swain, for *Out and About, A Boy's Adventures*, the sort of wholesome Christian reading that on the evidence of *Frank Fairlegh*

the artist could sympathize with.[34] Though popular during Friswell's life-
time (the book went into a second edition in its first year), it is now utterly
forgotten. Another once prolific author now eclipsed is Stephen Watson
Fullom, who had used Leech as an illustrator in the 1850s and in February
1860 told Cruikshank he "should be glad to obtain a frontispiece from your
pencil."[35] The results were at first not quite to his liking—Cruikshank was
slow, had difficulty getting the correct costume, and endowed the heroine
with too much embonpoint and age, when she ought to be sixteen, slight,
and fragile. But the final version he liked "extremely, though the woman is
hardly my heroine, but a great advance on the first."[36] Cruikshank regret-
ted that the lady did not embody Fullom's dreams, explained that the cus-
tomary headdress of the age in a figure so small always made a woman look
older, and hoped that if he had the pleasure of illustrating any of Fullom's
other works he might be allowed more time. Later that month he broached
the possibility of dramatizing Fullom's novel; the author was agreeable,
though he knew no one in the theater.[37] Nothing further seems to have
happened.

Cruikshank's Temperance loyalties nearly lost him one commission.
Three years after Douglas Jerrold's death in 1857, Hotten proposed bring-
ing out a collection of his writings, edited by his son Blanchard; and as
these pieces would all be reprints, Hotten suggested the title "Old Wine in
New Bottles." In a gesture that many biographers have ridiculed, Cruik-
shank declined because of his prominence in the teetotal movement to be
"mixed up—in any way—with the *names* of those humbug poisons—
Wine—Beer & Spirits," even though he wanted to illustrate the writings of
his "old & esteemed friend." "I fear you will think me a little *too* particu-
lar," he concluded.[38] (He was at that moment soliciting every Temperance
organization in the United Kingdom for subscriptions to the print of *The
Worship of Bacchus*, so perhaps he was especially sensitive to any appear-
ance of conflicting advocacies.) What often gets left out of this story is its
sequel. Hotten preferred the waterdrinker to the wine; the book was reti-
tled the *Brownrigg Papers*; Cruikshank quickly prepared a colored fron-
tispiece, "The Actress at the Duke's"; and Hotten hit the bookstalls six
weeks after the artist's initial rejection of the project.[39]

George's "whirlpool of engagements" included scores of Temperance
meetings and dozens of private charitable acts. He presided at Gough's
Exeter Hall lectures in 1859 and made the security arrangements with the
police; the following year he attended Gough's farewell series and enter-
tained him on the eve of his departure for America. Cruikshank was elected
a vice-president of the City of London Temperance Association, along with
Samuel Gurney, John Cassell, and George Thompson. He also continued
to serve the National Temperance League, received mortgages and presided

over public meetings as a trustee of the Temperance Land and Building Society, attended meetings of London groups from Hoxton to Bishopsgate and from Holborn to Southwark, and journeyed around the country from Northampton to Bristol to Liverpool.

For individuals he solicited jobs, wrote letters of recommendation, attended benefits. Through Cruikshank's efforts Alfred Phillips, possibly a relation of John Phillips of the National Temperance League, found employment at the Union Bank.[40] For Gibbs, Cruikshank wrote to Thomas Clegg, a Manchester cotton merchant, communicating Gibbs's plan for raising cotton in India.[41] Henry Barrett solicited Cruikshank's support for his summer 1859 benefit at Sadler's Wells.[42] Then there were the begging letters. George Curtis wrote from Plantation Road, Oxford, asking for the loan of half a sovereign, as he could not earn a living by his poetry and wanted therefore to establish a confectionery business.[43] John Daniell applied to Cruikshank for relief from starvation, purchased clothing with further gifts, went to work as a compositor, then without authorization used Cruikshank's name when soliciting other donations. Upon inquiry, Cruikshank found that Daniell had imposed upon Gough and other Temperance leaders, that he was a poor workman, and that he probably was turning donations into drink. Cruikshank disowned him.[44] More than a decade afterwards, however, Daniell praised the artist's generosity and admonitions:

> Had I followed your advice 11 years ago, I would not be now as I am, neither need I come to any man's door. . . . But I fell in with the accursed habit of drink, lost my own self-respect, so that in coming to you today I have only to appeal to your *mercy* and not to your justice.[45]

Wiltshire Stanton Austin conveyed an even more harrowing need for succor in October 1862. A barrister and journalist who supplied the essay on smoking for the first number of *George Cruikshank's Magazine* and was one of the original staff on *Temple Bar*, he was in the words of his editor Sala a "handsome, richly lettered, witty, humorous" man who muddled his life away.[46] Writing agitated letters from the Reform Club, Austin begged Cruikshank to see his wife, who had turned violent and repeatedly threatened his life. After George paid his visit, he believed that Mrs. Austin's condition was caused by laudanum, but Austin, still terrified, insisted that drink was the culprit and that he would not return home until she was rational.[47]

Sparing money was no easier than sparing time. Cruikshank's finances were a terrible, ongoing mess. His midsummer balances amounted to less than £100. He appealed to "Joe," probably Sleap: "A state of great emergency—makes me *try* to get a Bill cashed. Oblige me by—writing your

name across the enclosed—and return by Hill—as I wish this to be *quite private*—and be so good as to make it *payable at 86 Fleet St.*"—the address of his publisher.[48] The "*quite private*" intimates Adelaide. And from 1859 Cruikshank makes irregular small payments to a Mr. Archibold: £5 in 1859, another £5 in 1862, then £4.10 to Mrs. Attree in 1863, and a flurry of checks amounting to £56.10 to Mr. Archbold or Archibold in 1865. Since the oldest Archibold child would then only have been ten, there may indeed have been a Mr. George Archibold, or Robert Archibald as the 1861 Census has it, who assumed the role of husband and father. Maybe the surname is not an invention but the name of an actual person. Yet the children were widely credited, even during his lifetime, to Cruikshank; at least one grandchild was told that George Cruikshank was her grandsire; and after Cruikshank's death there is no further mention of any Mr. Archibold. The identity of the man to whom Cruikshank wrote checks is therefore something of a mystery.

Merle, his own substantial property at last secured, was the best resort in periods of financial stringency, so Cruikshank borrowed from him extensively. Merle could not quite understand why George never had any money and he worried about the precariousness of his friend's finances: "Accept a *certainty*," he counseled, "rather than look to the hope of better things & brighter suns wh[ich] may—*or may not*—come to pass." He tried to be sympathetic and responsive to the unceasing requests: "It is true that you have no children crying out for—'bread!—bread! for I am starving Father'—but you have a wife whom you love & honor."[49] Obviously Merle knew nothing of Augustus Street; he would have found it difficult to condone past actions, possibly impossible to sanction and support a continuing relationship. Poverty thus forced Cruikshank into a certain amount of hypocrisy and deception, behaviors hard to reconcile with his usually straightforward nature. They added strain to his already strenuous and much divided life.

Two activities absorbed most of Cruikshank's energy after 1859: heading a teetotal Volunteer Corps and painting his massive canvas *The Worship of Bacchus*. The first, in several odd ways, led him to recover connections with his past; the second climaxed and terminated his efforts as a painter and Temperance propagandist.

Fears of a French invasion, reinforcing anxieties promoted by the Indian Mutiny, impelled *The Times* to advocate the establishment of a home force of volunteers. Although at first the paper did not reflect majority sentiment, by May of 1859 enough arguments had been marshaled to gather considerable support. A volunteer force, it was maintained, would be an appropriate military expression of the gospel of self-help. It would demonstrate the deep patriotism and loyalty of ordinary citizens. It would protect the island

from external threats and free regular troops for overseas duty. It would afford young men open-air exercise, training, and discipline, thus providing a constructive option for their leisure time and improving their health. It would cost very little, especially in comparison to a comparable enlargement of the regular army. It would knit the classes together, harnessing the military aspirations of the middle classes and breaking the aristocratic monopoly on commissioned officers, while giving the working classes a less subordinate role. And as a trained organization of youths from all regions and classes, the Volunteers could co-opt into national service what might otherwise be pugnacious and threatening energies. [50]

On the 12th of May the Volunteer Force was authorized by the Secretary of State for War, who placed the corps under the highest civil officer of each county, the Lord Lieutenant. General Peel's circular made it clear that the Volunteers were to be called out for defense of the realm, not to quell riots. Prince Albert himself drafted a second circular, issued a fortnight later; he sought to shape the corps into small, independent, middle-class, rural or small town units, capable of mounting local actions. When Sidney Herbert succeeded Peel at the War Office in June, there were attempts to redirect the militia toward the duties proposed for the Volunteers, but the Under Secretary of State, earl de Grey, deputed to organize the new body, was more sympathetic to the force than his chief and spent the next six years superintending its growth and development. Albert's death succeeded the initial spurt of Volunteer enthusiasm; and the nature and habitation of these recruits determined that they would be increasingly urban and working class.

At first the movement met with little sympathy and less encouragement from official sources. But during the winter of 1859–1860 it took hold and was strongly reinforced by further threatening gestures made by the French, who strengthened their ironclad Channel Fleet and annexed Savoy and Nice. On 23 June 1860 a grand review of Volunteers was held in Hyde Park. George Augustus Sala waxed ecstatic in a pamphlet commemorating the event, which was witnessed by the queen, Prince Consort, king of the Belgians (Victoria's uncle), Prince of Wales, duke of Cambridge (commander-in-chief), Sidney Herbert, and thousands of well-wishers, wives, sweethearts, children, journalists, holiday-makers, and vagrants. The various corps were divided into mounted rifle, artillery, engineering, and infantry units, and were further subdivided into regiments by county and occupation. Among those for Middlesex were the 19th (Working Men's College), the 21st (Civil Service), the 23rd (Inns of Court), the 26th (Customhouse officers), and the 38th (Artists). According to Sala,

> Captain Millais marched by the side of Full Private Holman Hunt, both gentlemen fully capable of perpetuating to such immortality as canvas can ensure

whatever great deeds it may be in the womb of time for the 20,890 volunteers of Saturday to accomplish. It was curious to observe in the instance of this corps how true it is that the higher the intelligence of a man, the more competent he is to perform better than others less intelligent even the commonest things.[51]

The drummers' tattoo beat vibrantly in Cruikshank's breast. The sight of neighbors and friends in their regimentals drilling on Saturday afternoons recalled for him the invasion scare of 1803–1804, when the "Loyal St. Giles's and St. George's, Bloomsbury, Volunteers" wheeled out of the old gate of Montagu House and marched to Hyde Park, where they acquitted themselves on review in a soldierlike manner. General William Napier, hero and historian of the Peninsular Campaign, but now old and enfeebled, wrote to *The Times* a letter doubting the utility of past volunteers, "mere mimics" without artillery or cavalry unless borrowed from the regulars. "Soon all would have had to trust to their legs."[52] Napier's aspersions incensed Cruikshank, who converted his pen into a *Pop-Gun* to defend the Volunteers of 1803.[53]

He argued that the men had been well drilled, and that their presence, united with the militia and regular troops, "made 'Little Boney' (as Napoleon the First was then called) hesitate about carrying his *threat* of invasion into execution, or, rather, made him abandon the idea altogether." As for trusting to their legs, Cruikshank continued, when a report reached the south of Scotland that the French were landing near Dalkeith, all the area Volunteers raced one another to the threatened locality:

> Sir Walter Scott, who belonged to a cavalry regiment, was, I believe, the first in the field; and much disappointment was felt when they found that neither Mr. Boney or any of his men were there. These men, depend upon it, *meant* fighting, and had there been an enemy to encounter, would have given them, I believe, a "warm reception;" but, according to General Napier, they would, after running so many miles to meet the foe, had they met him, they would have had, to *run back again!*[54]

Cruikshank's anecdote is psychologically revealing. It was no longer possible for him to celebrate his Scots ancestors at the Battle of Culloden; the Hanoverian succession had reached its apogee with Queen Victoria. But that admiration of his Highland and Lowland forebears, which had always been a deeply felt part of his psyche, could find legitimation in the Volunteers, especially when they secured Scotland from the French. He could not but believe that his father's corps, and all the other corps, were a credible contribution to the defense of the realm.

Amateur soldiers were not the only ones who nerved the country to resist Bonaparte. The same results, Cruikshank maintained, were achieved by artists:

> I recollect the great excitement that then prevailed, the public meetings, the national songs of the "fireside," and the street ballads, and the caricatures, by

Gilray, Rowlandson, and others; and also my father was so much employed in this way, ridiculing little Boney and the French, that he could hardly find time to attend his drills; the dramatic pieces also, and the cheers of the audience at any allusion or compliment paid to the valour of the true Briton, and the shouts of derision and contempt at any allusion to our enemies, particularly to "*Little Boney*."[55]

At this formative period of his life, Cruikshank witnessed artists and soldiers combining their forces to rid the nation of its enemies. That the same coalition might once again be forged, and not only against human opponents across the Channel, but also against more insidious sappers and miners at home—alcohol and tobacco and ignorance and lax discipline—raised his spirits to a pitch they had not attained in a decade.

The result of this hopeful ebullience was a diatribe exceptional even among Cruikshank's pamphlets for overstatement, immodesty, and inconsequence, mixed up with fervent patriotism, martial ardor, and the fitful donning of the sage's mantle. When he writes about 1803, or about his own service in the "Loyal North Britons," he provides delightful pictures roseate with innocence. When he depicts a Volunteer review on Wimbledon Common, with breaks for refreshments and "salutes" to the ladies, however, he tacitly acknowledges the "mimic" and comic aspects of a sham fight. But his assertions about his own qualifications to serve in the cavalry, artillery, Horse-Marines, or as a naval gunner, and his half-serious, half-parodic claim to have designed a superior helmet approved by the duke of Wellington and pirated by the Russians, cast doubt on his judgment and perspective. Indeed, beginning with the title, the pamphlet consistently undercuts its serious tone: some of the wood-engravings are as whimsical as any in *My Sketch Book*, and at several points in the text Cruikshank anticipates his readers' amusement:

> as . . . I shall have to place myself in a military attitude before the public, I expect there will be a good many broad grins at their old friend G. C., but *I* shall be all the better pleased at their being merry, if any good result should arise out of my experience and suggestions; so laugh on! "*Laugh,* but hear," and if they should discover that I really do possess any soldier-like qualifications, it is to be accounted for only from the accident of my being "just out of arms" at a time when this country was all "up in arms."[56]

One member of the public who was up in arms about the *Pop-Gun* was a Fleet Street publisher named Thomas Brooks, doing business as Read and Company. To illustrate the necessity of self-defense, not only to protect one's own interests, but also to ensure "the happiness, and comfort, and the lives of those dearer to us than our own," Cruikshank introduced a cut of himself in frock coat using a pair of tongs to pull the nose of a top-hatted sandwichman bearing a signboard lettered "Brooks alias Read. Publisher

Johnsons Court Fleet Street." "St. George" thus casts himself once again in the role of St. Dunstan and calls the publisher a "devil" without ever using the word. Moreover, the use of "alias" was potentially actionable, as Brooks had purchased the business from its perfectly respectable former proprietor, Read.

The origin of the dispute was Brooks's advertising of a collection of fairy tales illuminated by Percy as illustrated by "Cruikshank." This act George felt did him "VERY SERIOUS INJURY," for while Percy was "a very excellent, industrious, worthy, good fellow," the plates were, according to George's friends, "far inferior to my usual works."[57] Cruikshank had been irritated by Brooks for years. Percy's fairy illustrations were crude things, "pot boilers" done up in gaudy colors for children's toybooks. When Read and Company began to bring them out, just as the *Fairy Library* was drooping, Cruikshank accused his nephew of muddying the waters. Percy explained that he had tried to suppress all mention of the name, and failing that, to get his Christian name added—to no avail. Cruikshank then determined to pay a call on the fellow and "see about it." Brooks, warned of the impending visit and knowing George's pugnacity, seized a heavy wooden ruler to protect himself from physical onslaught. "Had the artist been courteous," Percy scolds, and had he explained "that the professional man's distinction of name, was as much his right, as the business man's 'trade mark', he would have been right; while the other could not, without putting himself in the wrong, have refused to make this reasonable alteration." But George fell into the imperative mood, and the interview terminated in mutual indignation. When Percy was engraving the cuts for the *Pop-Gun*, his uncle withheld the one about Brooks and had it done by another craftsman to spare his nephew embarrassment and further involvement.[58]

This trifling matter even Cruikshank conceded might be inappropriate to instance the importance of self-defense. It registers, not a public and national threat, but a personal and private one, which compromised the artist's professional identity and achievement. Caricature melds exterior and interior discourses, applies psychological responses to political and social issues, enacts and deflects aggression through humor. Satire insists on conflating what other modes of address separate. Cruikshank understood all this, but did not seem to realize that he could not have it both ways—could not speak as an authority on martial arts while infusing his argument with levity. His grievance may have been real, but the manner in which it was handled infuriated his target while destroying his own credibility with regard to the larger issues.

Sympathetic friends rallied to his support. "Bravo," said Merle. A true history of more than half a century, Charles Aldis proclaimed. There ought

to be copyright for identity as well as for design, Isabella Banks suggested.[59] But Brooks contemplated legal action.[60] Could he countersue, Cruikshank asked his publisher Kent. Yes, Kent's solicitor opined, but added that holding a man up to public ridicule is a libel, and a jury might find against the artist. Kent thereupon refused to prosecute unless Cruikshank indemnified him for all costs.[61] Cruikshank wrote letters to the newspapers disclaiming responsibility for Brooks's publications and replied to the publisher's letter by stating, "Your real complaint is that I have made known the fraud you have been practicing on the Public at the expense of my professional reputation and to your pecuniary advantage. . . . I have no fear of the result of meeting you before a jury on cross actions for making free with each other's names and reputations as you were the aggressor and added a fraud on the public for gain."[62] Kent, however, *did* fear the possible outcome of a trial, so he withdrew the pamphlet from circulation. Cruikshank met with Loaden, his old friend James Bacon now Q.C., and a Chancery barrister, all of whom advised him neither to seek another distributor for the *Pop-Gun* nor to enter an action; "The lawyers tell me there is no redress," he informed Merle sadly at the end of the month.[63] But the hapless artist still seethed with indignation, so much so that when he encountered Percy soon afterwards, he greeted him with fury. Eventually the uncle and nephew signed a truce.

Whereas George's pop-gun discharged only paper pellets, he longed to shoulder a real weapon. The opportunity came in the autumn of 1860. Teetotalers, inspired by the Hyde Park review and the example of other corps which formed around an occupation, set up Temperance companies in two counties: the London Temperance Rifle Corps, formed by F. Gough in early September, and the South London Temperance Rifle Corps established at a public meeting around the first of December.[64] Ensign Malthouse, secretary of the latter organization, wrote from headquarters in Walworth to ask Cruikshank if he might be enrolled in the Honorary Council, along with G. C. Campbell, treasurer of the National Temperance League, Cruikshank's solicitor William Shaen of Shaen and Roscoe, Joseph Payne, an assistant judge of Middlesex, and H. W. Dry, a prominent Walworth physician. Cruikshank accepted with alacrity. He believed that the exercises and field trips would provide pledgers with healthful alternatives and that the drills and discipline would inculcate sobriety and self-improvement simultaneously.

Malthouse, ambitious for the corps, immediately signed Cruikshank up for "a great public meeting" to raise volunteers.[65] This was the opening salvo in what escalated into a serious corps battle. For there was an inherent overlapping of interests between lords lieutenant supervising county regiments and metropolitan corps composed of barristers or civil servants

who might reside anywhere within the surrounding counties. By the start of the new year the South London Corps had gained the patronage of Hannah Havelock, widow of one of the Indian Mutiny heroes, General Sir Henry Havelock, the stern puritan commander who relieved Cawnpore and Lucknow. She provided an annual subscription and interested herself in corps affairs by advancing the men money for uniforms, contributing to the Band fund, working a "stand of colours," and encouraging Temperance organizations to support her regiment. By dropping the geographic designation in favor of Havelock and Temperance, Malthouse believed that he could recruit throughout the metropolis.

Cruikshank was a valuable addition; his presence at a meeting was sure to attract attention. Moreover, his enthusiasm, his experience as a Volunteer fifty years previously, and his forceful character all recommended him for command, which was tacitly granted by March 1861. The regulations stipulated that the officer in charge was alone vested with all corps assets and liabilities, and that he could recover subscriptions and fines before a magistrate. In effect, the provision meant that Cruikshank was both field commander and quartermaster. In instituting this arrangement, the government tried to ensure that senior officers would be middle class, responsible, and solvent; they had in Captain Cruikshank a fiery sergeant but a shaky financier.

The 24th Surrey (formerly South London) Havelock Volunteers received its commission from William King-Noel, the earl of Lovelace, whose first wife was Byron's daughter and who served as lord lieutenant for fifty-three years, 1840–1893. Authorized for one company pending review of the request to grow to battalion size (eight companies of at least sixty men each), its officer-in-charge was Captain Commandant George Cruikshank (commandant indicating the possibility of regimental strength), and its acting adjutant (paid for by the government from February 1861) was A. L'Estrange. In April 1861, 107 men took the oath, and headquarters was moved to 39 Bridge House Place, Newington Causeway, by the Elephant and Castle on the Surrey side of the Thames.

From the beginning, the 24th experienced the same troubles that vexed many Volunteer companies. Working-class recruits often could not afford their specially designed uniforms, equipment, and rifles. The latter was a particularly charged issue. Democrats complained that laborers should not be put to such an expense; Quakers disliked arming civilians; liberals feared that the force might be turned against reform. The campaign for enfranchisement got entangled with the Volunteers: "No vote, no rifle" went the argument. The government decided it was prudent to keep control of firearms, even if that meant paying for them; by July of 1859 grants purchased 25 percent of the rifles, and from January 1860 all arms and ammunition

were owned by the War Office and supplied for exercises through requisition. Moreover, the records-keeping to establish the number of efficient Volunteers (ones who served a stipulated number of days and drilled properly) and to keep track of weapons required some steady administrator, so the government also began paying for adjutants. Then the cost of uniforms threatened to weed out the working classes, so additional support was voted, culminating in 1863 with capitation grants based on efficient rolls. At the same time, regulars were seconded to Volunteer battalions as drill sergeants.

At first the popularity and prestige of the force ran high. Ninety M.P.s held commissions in 1868; the Volunteers included Matthew Arnold, Thomas Hughes, Frederic Leighton (for many years colonel in the Artists' Regiment), and the future architect of national education, W. E. Forster. Street urchins and Cockneys may have derided the gaudy uniformed corps of customhouse officers or educators, but the public cheered. As the Volunteers expanded, however, their cachet dropped: regular army officers looked down on Volunteer commanders, while the middle classes felt uncomfortable associating with factory hands, shop clerks, or servants of aristocratic patrons who commissioned entire companies from their households. Rifles may have been a great leveler—anyone (especially poachers and gamekeepers) might excel at target practice—but the other dimensions of military service tended to separate the classes. By 1868 the Edinburgh Advocates' and Writers to the Signet companies had dissolved, and in London "the supply of the higher middle-class men was unequal to the demand."[66]

Cruikshank's service exactly corresponds to this rise and fall. His eight-year career has never been appreciated in the context of the problems generally experienced by the force; consequently his command has been judged idiosyncratically inept. But many of the crises he surmounted were familiar to other corps officers; where disputes waxed particularly hot, over indiscipline, intemperance, and insolvency, more often than not he had right—not always tactfully exercised—on his side. Previous accounts have not taken into consideration his many acts of forbearance, kindness, and charity, nor explored the evidence supporting his versions of controversies. Since the tumultuous Temperance Corps affairs not only ransacked his energy and time, but also promulgated stories about his eccentricity and fanaticism seized on by his opponents in other contexts, a narrative of his command, while marginal to a history of his art, is central to understanding his life at the time and as interpreted by posterity.

The number of duties any officer in charge had to execute would have taxed a full-time soldier; even with his indefatigable zeal Cruikshank was overwhelmed. He leased, equipped, and staffed a headquarters, ordered

stationery and supplies, filled out requisitions, forms, reports; he attended recruiting meetings and administered the oath; he designed and commissioned uniforms, established a band, obtained colors; he rented practice fields and halls, drew up drills, scheduled parades and reviews; he advanced money to poor recruits, wrote recommendations for jobs and references for lodgings, got involved in his troops' domestic crises; he raised funds, solicited patrons, planned entertainments, sought favorable publicity; he adjudicated quarrels (one officer was accused of behaving too freely with other men's wives and girl friends), granted leaves, endorsed and forwarded recommendations for promotion, substituted for his officers when they were called away by sickness, bereavement, transfer, or exchange of commission; he attended policy councils, pressed his cases at the War Office, negotiated with lords lieutenant; he paid the bills, muddled the accounts, impulsively anticipated his reimbursements, plunged deeper and deeper into debt; and through it all, with ramrod back, flashing eye, exaggerated protocol, and boyish delight Captain (soon Lieutenant Colonel) Cruikshank barked orders, wheeled his mount backwards and forwards along the flanks of marchers, demonstrated the proper form for presenting arms and saluting dignitaries, and imparted his opinions on martial strategy, tactics, supply, defense, and discipline. In 1865 he attended drill virtually every weekend, forty-four in all within twelve months.[67]

As recruiting intensified, the corps encountered opposition on civilian and military fronts. Honorary Council member Dr. Fry invited the officers and noncoms of the 1st London Temperance Corps to march with the 24th Surrey in a review on 27 June 1861. He also reported that one of the Finsbury councilmen, Lieutenant Sanders, and Captain Jones of the Sussex Hotel were interested in transferring to the Havelocks. After a meeting at the Sussex Hotel, the two companies voted to amalgamate. In August the War Office began supplying sergeant instructors, but when rifles were issued, Cruikshank was distressed to find that the number fell short of his muster. It was hard enough to keep men who came from a mixture of motives—patriotism, loyalty to the Temperance cause, curiosity, comradeship, or for a lark—and then discovered that their captain was serious about drills and drink. They grumbled about exercises in inclement weather or at inconvenient times, scoffed at rules and regulations, slacked off on polishing boots and buckles. It was therefore all the harder for Cruikshank to enforce discipline when the best carrot he could offer, a shooting stick, was unavailable to some volunteers.

In his exchange of views with Lovelace and the War Office, Cruikshank learned that because so many of his company resided in Middlesex (partly as a consequence of the amalgamation), he was treading on sensitive toes. Marching into the War Office, he saw Lieutenant General Sir William

McMurdo, the inspector general, for the first time on 22 August. During that interview, and in subsequent correspondence, Whitehall discovered that the 24th had more than enough recruits for one company. In response, Cruikshank explained that although he had kept Lovelace fully informed he had received no replies, that he believed since the corps was the Havelock Temperance Rifles he might recruit throughout the metropolitan area just as the Scots and Irish Corps did, and that since Lovelace knew that neither the commanding officer nor his acting adjutant lived in Surrey he assumed residential qualifications were not stringently enforced. As for not following the regulations book, it had been misdirected so Cruikshank had only recently seen a copy.

Undaunted, Ensign Malthouse set up further meetings, either to explain the Temperance Corps to teetotalers and anti-war societies or more overtly to enlist men. Meanwhile, the War Office and Lovelace were trying to determine the muster; Sir George Lewis from Whitehall told Cruikshank to hold an inspection and determine the roll of effective members as of the end of September. The day after Cruikshank's sixty-ninth birthday, recorded so ruefully amid jottings about the corps, he sent in an Inspection Return, on the copy of which he drafted a petition for help, as the 24th Surrey "is in such an unsettled state."[68] But when Lovelace received the roll he said it was incorrect and should have been based on the muster of 1 August, the date at which sergeant-inspectors were first assigned to the Volunteers.

While that dispute was simmering, a meeting on 8 November at Deptford, at which recruits were signed up, provoked a firestorm from Viscount Sydney, lord lieutenant of Kent, whose complaint that the Havelocks were poaching in another county was passed on by an icily disapproving Lovelace. Cruikshank apologized to both men, saying that he had misapprehended the South London county boundaries. McMurdo told Cruikshank privately that if the lord lieutenant of Surrey continued his objections over the War Office's ruling that headquarters and location of drills, rather than residence of members, determined county jurisdiction, the 24th should reform in Middlesex where the majority of members lived.[69] A second recruiting session in Deptford on 22 November led to renewed complaints from Kent and Surrey. Cruikshank insisted that this meeting had been organized without his knowledge and that he thought it was to answer questions from the Peace Society.

Taking McMurdo's private advice, the 24th Surrey reorganized in Middlesex under the aged marquess of Salisbury. It took months to complete the transfer, to resign former commissions and receive new ones, to move the headquarters and change the stationery and turn in one company's supplies so they could be issued to the other one. In January 1862

Cruikshank formally requested that the 48th Middlesex be authorized at eight companies, battalion strength, which if granted would mean his promotion to lieutenant colonel and the appointment of a slew of officers for each unit. Salisbury approved the application on 1 February, and the commissions became effective at the end of that month. Malthouse was promoted to lieutenant, L'Estrange confirmed as adjutant, Joseph Payne made lieutenant and paymaster, and Dry appointed surgeon to the corps. A great swearing in was held at Cruikshank's home on 13 March; at the end of May the celebrated composer Grattan Cooke conducted a benefit concert for the Band fund; a new headquarters at 6 Cook's Court, Lincoln's Inn Fields was leased; more volunteers signed up; and the expenses mounted alarmingly.

So alarmingly, in fact, that by the start of 1863 Cruikshank felt he had to resign. He simply could not continue to be responsible for the Havelock's debts. Even if capitation grants were voted, they would come as reimbursement for prior expenditures based on the muster of efficient volunteers. Thus his income would depend on how many volunteers stuck with the program; some would leave if it were too lax, more if it were too strict. But he couldn't know for certain how many might stay when calculating his outlay for corps expenses. Furthermore, there was no regular bookkeeper, and Cruikshank's accounting skills were worse than negligible, they were creative and heavily laced with morality. He worked out a proposal, signed by his officers, to resign in exchange for an honorary colonelcy; but the application was rejected by his superiors. Volunteering had become involuntary.

To add to Cruikshank's accumulating difficulties, *The Worship of Bacchus*, his bid to astonish the art world and convert the nation to water, was a dead failure. "Oh! oh! oh!"—Cruikshank entered his seventh decade foiled and baffled, but unconquered and resolute to soldier on. He couldn't quite decide whether the passive or the active better suited as a motto, whether "nil desperandum" or "vis fortibus arma" or "at it again" signified his Punch-like ability to recover from the blows of fate.[70] But somehow he would lead the Volunteers, *Bacchus*, and the Temperance movement forward to victory.

42

DIAGRAMS OF DRUNKENNESS

Occupation: Drawing & painting to prevent evil & try [to] do good.

George Cruikshank[1]

CRUIKSHANK got the idea for *The Worship of Bacchus* (figs. 69 and 70) during one of the weekly meetings of the Committee of the National Temperance League.[2] He had long been wanting to knock out opposition to teetotalism. What he conceived of at this moment in 1859 was a monumental painting depicting all the phases of drunkenness, from beggar to lord and from cradle to grave. Speaking with the prophetic voice of a Carlyle or Ruskin and working on the scale of John Martin's biblical paintings about Old Testament destruction, Cruikshank would finally and definitively enjoin his society against the consumption of poison. He would go beyond Hogarth by displaying the innocent beginnings that lead to inebriation, and he would not stay his hand from criticizing Belgravia as well as Bermondsey.

Exhibiting gigantic canvases was by midcentury a familiar, almost outmoded practice. In 1820 Haydon had enjoyed one of his rare successes with *Christ's Triumphal Entry into Jerusalem*, shown to large crowds at the Egyptian Hall, where Géricault's *Raft of the Medusa* also drew thousands of spectators. Dioramas and panoramas, growing larger and larger as the century progressed, provided comprehensive scenes of contemporary and ancient London; some of them contained as many as a hundred thousand figures. Cruikshank may have recalled Haydon's picture when he painted his own version of Christ's entry, as he may have had in mind the panoramas, both painted and staged, that attracted crowds to the Surrey Gardens in the 1850s. The *Illustrated London News* published a twenty-two-foot strip-engraving of the Great Exhibition, while George Augustus Sala and Henry Alken collaborated to produce a sixty-seven-foot aquatint of Wellington's funeral. Although such huge spectacles were fading from fashion,

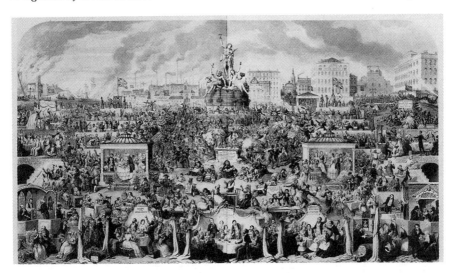

69. *George Cruikshank,* The Worship of Bacchus, *etching and engraving, 1863*

a few artists such as Frith and Holman Hunt still enjoyed great success with large works: in 1862, eighty-thousand people paid 1s. apiece to see Frith's *Railway Station* in a gallery next to the Haymarket Theatre.[3]

Bacchus would be a culmination not only of Cruikshank's own work but also of more than a century of English popular graphic art. It was a cliché, now, to speak of George as Hogarth's successor. When Sala published his essays on Hogarth ("Who is it that writes in the 'Cornhill Magazine' about Hogarth & pays you such a high homage?" Merle asked), he digressed to praise his friend and mentor: "Am I stilted or turgid when I . . . say of Hogarth and Cruikshank that George is not the greatest pictorial humorist our country has seen only because he is not the first?"[4] Castigating folly and vice, crying out on behalf of the neglected and abused, forging a powerful voice out of weakness to exhort the powerful to their higher duties, had been the mission of graphic satire through Gillray and Rowlandson and Isaac Cruikshank down to Hone and Isaac's sons. *Bacchus*, a compendium of vignettes about intoxication, would encompass all the lessons caricature had taught him and that he taught through caricature—lessons about telling stories in pictures and about the kinds of stories his pictures told.

Although the idea for the whole came to him in an instant, it took many months of preliminary sketching before he settled on an arrangement for the dozens of instances he wished to show. In February of 1860 the design was far enough advanced to show to Gough, and a fortnight later it was exhibited to a company of distinguished Temperance leaders.[5] These men

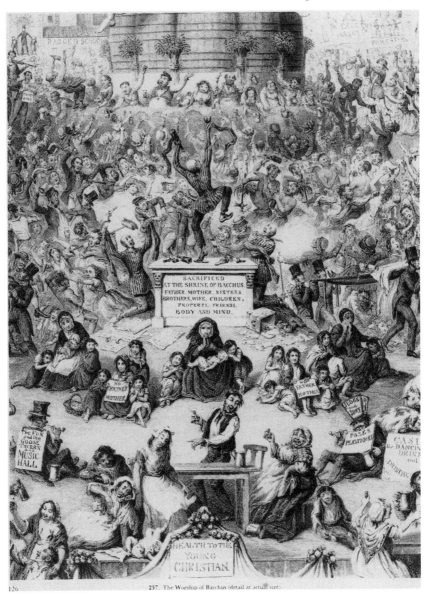

70. George Cruikshank, The Worship of Bacchus, *detail, 1863*

included Francis Crossley M.P., proprietor of the world's largest carpet factory, who would be created a baronet three years afterward for his philanthropy and public service; John Stewart, an art critic who, according to Jerrold, "was a fervent admirer and devoted friend of the artist"; Hugh

Owen, later knighted for his energetic promotion of education in Wales and for many years chairman of the executive committee of the National Temperance League; John Taylor the publisher and his brother Joseph; and William Tweedie.[6]

Cruikshank then asked these friends to assist him while he completed the painting. Agreeing to a proposal by Stewart, they formed an Acting Committee with the aim of patronizing and carrying through the project. It was Cruikshank's understanding that he and the committee were jointly committed to finishing *Bacchus* for the sake of the Temperance movement. Exactly what form the picture was to take, exactly what kind of help the committee was to provide, and exactly how the work was to promote teetotalism, became subsequently matters of heated dispute, and Cruikshank's reconstructions do not altogether agree with the recollections of others and the accounts of Percy Cruikshank and Blanchard Jerrold.

What George believed was that the committee would provide him with "spending money" while he etched a plate of the design. Sales of the prints would then refund the committee's advances, and with the profits Cruikshank could go on to paint the canvas, which would be exhibited in London, the provinces, and America, accompanied by a lecturer and a printed description. "But as the Artist by his position could not paint such a picture upon speculation—or be in any way connected with its exhibition—the only way in which this could be carried out would be by forming a company of Limited liability—of shares—say—at one guinea each." It was anticipated that a good dividend might be returned, especially from the American tour.[7] Support in the interim was not given to him personally, but on behalf of Temperance; and though Cruikshank himself assumed much of the financial risk, he was convinced "that the Temperance world would meet & cover with their kindness any loss which may have occurred."[8] So the sequence at the outset was clear: finished drawing, steel-engraving, sale of prints, oil painting, exhibition, and tour.

While Cruikshank proceeded with the final watercolor design, the Acting Committee through John Taylor its secretary rounded up additional members, including Merle, who said he would join and purchase an artist's proof, but not quit drinking; Samuel Gurney M. P., who agreed to take the post of treasurer; and Francis Fuller, who joined late in the summer.[9] Cruikshank himself invited the earl of Shaftesbury to serve as president.[10]

Strenuous efforts were made to obtain subscriptions for the print. At the beginning of May, Cruikshank evidently tried to get a list of the heads of every Temperance organization in the realm, but Couling could produce only a partial roll.[11] Merle found it difficult to sell teetotalism in Staffordshire, but hoped for better results in Guernsey, where he did obtain one order for a single copy.[12]

Additional impetus would be provided by exhibiting the finished water-color.[13] Printed invitations to view the design at Cruikshank's Mornington Place studio between one and five o'clock on any day between Wednesday 25 July and Saturday 28 July 1860 went out to as many influential people as possible—Temperance leaders of course, but also journalists and critics such as Eneas Sweetland Dallas.[14] Eliza served as amanuensis.

Cruikshank, believing that the exhibition had been an unqualified suc-cess, was eager to get on with engraving the design: "Every one who has seen it declares it to be the best thing I have ever done—Frith was much taken with it—and sent his wife & children & some friends to look at it—This is very complimentary is it not?"[15] He and Charles Mottram agreed to divide the labor of making the plate, Cruikshank outlining the figures and Mottram filling in the details "in the style of Engraving as seen and decided upon by Mr. J. Stewart." They signed an agreement with Samuel Gurney and Hugh Owen on 27 September.[16] It provided for a payment of £400, a reduction from the four hundred guineas originally proposed, but did not specify how that payment was to be divided between the two men. One-third was to be paid when the engraving was half done, the balance on completion. No entity was named as holder of the copyright, although presumably, as Gurney and Owen were acting on behalf of the committee, it was the owner.

In order to meet his expenses, Cruikshank once again borrowed from Merle.[17] In requesting the loan, George mentioned that a bookseller wanted him to produce a work on spirit rapping; had Merle written anything on the subject?[18] Merle replied with anecdotes about his own experience at a seance marked by "humbug & trickery" and promised to forward an un-published account he had composed. He also repeated his "directly op-posed" opinion on teetotalism: all things are good in moderation, and "even turtle soup is a glorious remedy, tho' seas of green-fat lead to apo-plexy."

Suddenly things became complicated. Perhaps because sales of the print and shares in the committee were going so slowly, John Stewart called at the studio on 17 November to say that the committee wished Cruikshank to put aside the needle and take up the brush. Blanchard Jerrold tells a different story. He says that Cruikshank's impatience led him to neglect his plate and work instead on the canvas. "In reply to remonstrances, he gave the reasonable explanation that no man could etch all day long. The committee then agreed that he should work as fast as was prudent at the engraving, and 'for rest' take a turn at the big picture."[19] Cruikshank's notes not only attribute the change of direction to Stewart (who might have been the member of the committee who Jerrold says dropped in and caught the artist painting instead of etching), but also state that he commenced painting three days *after* Stewart's visit, at-

tended a meeting of the committee on the twenty-sixth, and was informed on the twenty-eighth that Gurney approved the change in plans. Whoever precipitated the reversal, it seems to have been generally accepted, although it no doubt further checked print subscriptions.

At this point Cruikshank required the help he had always anticipated needing. Stewart found a young man to assist in preparing the canvas, outlining figures, and maintaining the studio. Such an assistant, however, had to be paid, and as the months passed Cruikshank ran up other bills in connection with *Bacchus* and his personal life. Since work on the plate had been interrupted, there was no payment for it and precious little from other sources. Tweedie was a regular contributor, though whether for services rendered to his firm, as advances from the committee, or as personal donations, the accounts do not specify. Merle renewed, possibly doubled, his loan. Cruikshank's midsummer balances sank below £100.

The painting became a weary labor. Cruikshank's eyes ached, his limbs grew stiff from stooping and stretching to fill every square inch of the canvas, 7 feet 8 inches high by 13 feet 4 inches wide. Getting the details right took infinite pains. Since *Bacchus* concerned contemporary London, the artist did not need to do historical research on costumes and customs, but he did want to encompass every variety of life, every style of uniform and dress, every class of manners, and every occasion and setting when liquor was conventionally served. Its subtitle was to be *The Drinking Customs of Society*. As he brushed in the vignettes, varying the composition, the features, the degree of inebriation, and the reactions in each scene, the separate anecdotes narrated particular, sometimes powerful stories, not unlike the vignettes told in Mayhew's *London Labour*. But when George stood back and looked at the whole with a fond yet critical eye, he could not shake the conviction that the sum was less than its parts. In one of his periodic bouts of despondency he scribbled a note to Merle expressing doubt about the worth of this herculean undertaking and about his own stamina. Merle rushed over to the studio, only to find it temporarily unoccupied. After studying the picture carefully, he returned to Princes Terrace and dashed off a heartfelt letter of support:

> Courage mon ami! You must & will obtain the great end which your enthusiastic mind, your genius and gifted hand have designed. . . .
>
> *You* say that you do not find "an effect" in proportion to the labor bestowed— I say you must not expect it—"the Derby Day" wh. attracted & riveted the attention of so many thousands produced no *striking effect* at first sight—it was a map of John Bull's carnival to be *studied in detail*. So it will be with your "Leviathan" which, in design & magnitude beats the "Derby day" out of the field—. . . . If I understand your intention rightly, your gigantic map of human frailty

leading to death, damnation, misery, and a host of crimes wh. are but the stepping stone to murder, it is to be a thing wherein to lecture & for this purpose I think your "*Leviathan*" is admirably conceived. Even I, much as I differ in opinion, cd. take a rod in hand and whip up the wine-bibbers to eternity while I travelled over the canvass & pointed out the frightful and hideous result of excess.

But you must not expect the educated & higher order to admire your picture tho' powerfully painted for its good purpose. All claiming the slightest pretention to the title of "Gentleman", or "Lady" know & feel that with them the *beginning* wd. not lead to *the end* as pictured above their heads. They, in winning *moderation* have obtained a victory more difficult, infinitely greater than *abstinence*. Your admirers, your success, will be with a humbler class & may God in his mercy prosper the labor wh. you have in hand![20]

In discriminating the probable reactions of higher from humbler classes, Merle (who consorted with the former, not the latter) saw clearly the social divisions rifting Temperance campaigns. A few aristocrats did renounce "wine-bibbing," but most went on as before. As for the "humbler class," some of them were not keen on having their drink or drinking hours curtailed, and roughed up teetotalers to express their feelings. By and large Temperance attracted middle-class reformers and artisan-class workers, while turning off county families, clubland, the universities, the City, agricultural and factory laborers, and the Irish. While Cruikshank had targeted a respectable mechanic's family in *The Bottle* and *The Drunkard's Children*, *Bacchus* aimed at those other recusants.

Merle added an afterword from Lodway House, near Bristol, to which he had journeyed before finishing his letter: "You must not get your beautiful women too ruddy—they have a rouge appearance now, such as we see on painted dolls—even your brandy-noses wd. be better if *sobered* down." Even this advice betrays a difference in sensibility between the caricaturist, working within graphic, satiric, and theatrical conventions where debauchees have empurpled noses and flushed jowls, and the gentleman who likes his pictures to be restrained, realistic, respectful. And maybe religious—George's title offended some dissenters who could stomach "The Triumph of Bacchus" but not "The Worship." At Merle's suggestion, Cruikshank changed the placard in the madman's hands from "Sacrificed to the God Bacchus" to "Sacrificed at the Shrine of Bacchus": he "did not like to use this sacred word ['God'] for such a purpose."[21]

At last every one of the 14,720 square inches of the canvas was perfected, and *The Worship of Bacchus* could be shown to the world. Tweedie rented space next to the Lyceum Theatre in a little gallery at 21 Wellington Street, Strand, barely half a mile from the artist's boyhood home in Dorset Street. The canvas was trundled down from the Hampstead Road, invitations were sent for a private viewing from one in the afternoon until dusk

on Monday, 4 August 1862, and the doors were thrown open to the invited guests. Upwards of five hundred attended.[22]

What they saw was an overwhelming, dizzying, somewhat murky painting, more panorama than picture. It was divided into five horizontal bands, intersected at the midpoint by a strong vertical element separating the left side from the right. At the top, against a sky fouled with the smoke from burning buildings and ships and with the effluvia from the chimneys of breweries and distilleries, are silhouetted smokestacks and a steeple, three gibbets and a scaffold. ("You must put in a *clear bit of bleu* with your shipping in left hand corner near the top *to give distance,*" Merle had counseled.[23]) Ranged across the background in the second band are buildings housing pubs, breweries, and all the institutions necessitated by them: a police station, a reformatory, a ragged school, a house of correction, two hospitals, a cemetery, a workhouse, a jail, and a lunatic asylum. The central band contains a number of scenes, from a sailor being flogged (in proximity to the burning vessel on the left) to a drunken picnic and a runaway locomotive on the right. The fourth band shows more interior scenes, stretching from established (left) to dissenting (right) clergy offering wine respectively to a Muslim and a Hindu who both for religious reasons refuse, and incorporating an upper-class drawing room and a middle-class reception. The lowest band chronicles the major ceremonies in life at which liquor is customarily proffered: a pot of beer to fortify the nursing mother, champagne to drink the health of the newlyweds, wine to toast a christening, triple X ale to be tapped "when Tommy comes of age," and a drop of wine to comfort grieving mourners.

At the top center stands the altar to Bacchus, represented as a comely youth. But though in moderation spirits enliven and make pleasant their imbibers, in excess they render men and women brutish and degraded. Hence at the god's feet are a tipsy Silenus and a debauched Bacchante. Encircling the plinth are the priests and priestesses—drunken unscrupulous publicans—who will take anything, including stolen goods and a baby, as offering. Radiating from the counter are on the left scenes of entertainment (harlequin, opera dancers, singers) and on the right scenes of conviviality (clubs of Freemasons and Odd Fellows). In between are episodes of violence—muggings, beatings, robbery, murder—and these cluster about the counter statue of Mad Tom, capering in his straight waistcoat on the tomb of his father, mother, sisters, brothers, wife, children, property, friends, body and mind, all of which have been sacrificed to the god of the grape. Huddled beneath the tombstone are the destitute families left without fathers or mothers, the awful complements to the maniac who survives them all.

Cruikshank thus strives to impose several kinds of structure on his "map-

ping out of certain ideas for an especial purpose."[24] From the worship of Bacchus comes all the environmental and human pollution of contemporary life; the design radiates from that altar. Drink operates over time, so the stages of intoxication and addiction are traced again and again. It affects families and classes in different ways, so the varieties of custom are portrayed and often contrasted left to right. And the results of chronic drinking belie the genial effects of its early stages, as displayed in the generally left-to-right narrative of the vignettes.

Above all, by showing drunkenness as a progressive and addictive phenomenon, Cruikshank distinguishes his lesson from the one that Hogarth preached in *Beer Street* and *Gin Lane*. John Stewart saw the focus on the childhood origins of habitual intoxication as constituting "vast progress" in "general thought" as well as "artistic idea":

> Hogarth dealt with results, which is all that observation recognizes; Cruikshank, with the instinct of an ancient seer, is not satisfied till he reaches the causes from which the results spring. . . . The one traces the progress of rakes and harlots from simplicity and innocence to insanity and double death; the other adds the domestic processes children undergo preparatory to the appalling consummation—the casting in the seed which yields a hundred-fold in infamy and crime. Hogarth appeals to men and women, and, by the eloquence of misery and the stern logic of embodied fact, warns them to resist temptation. Cruikshank, with a deeper insight, snatches the trumpet of the inspired sage to awaken the mothers and fathers of the land to their responsibilities respecting the training of their children by demonstrating that they are fostering the fiend they dread by making the prime agent in temptation a chief symbol of their social joys.[25]

Not all those invited to the opening could attend. Charles Kean was engaged; he sent his apologies and tickets to *Henry the Eighth*.[26] Some of those who did come were moved to support Cruikshank's enterprise. David Lester Richardson inserted a notice in the *Court Circular* and asked for a ticket of admission so that he might return to the subject in a future article.[27] Frith, who had admired the watercolor so much he dragged his wife and daughter to see it, bundled them off to Mornington Place even before the private viewing and took them to Wellington Street several times thereafter. One member of the party, already decided in her hatred of Cruikshank and his wife, loathed the experience, the more so as it interrupted a favorite activity:

> I shall never forget what we suffered . . . from his horrible picture, *The Worship of Bacchus*. Papa was very particular about his wine, and in those days a charming German wine-grower used to come round at a certain time of the year and obtain orders for hock; we were not so pleased to see the wine which followed his visits, as we were to see the grower, who generally brought us sweets, and was always kind and nice to us; for we had to sit on the flight of steps leading to the

kitchen and count the bottles as they were stowed away by our man-servant. We were employed in this task one day when Mr. Cruikshank called, and to this was due the fact that we were commanded to repair to his house, somewhere in the Regent's Park direction, to see his dreadful work. Papa was the most abstemious of men, and we are one and all teetotalers, not from any matter of principle, but simply because we do not like wine; and it was a double insult to us to be made to listen to the rabid abstainer while he described bit by bit the hideous picture he had spent years in painting. . . . we went [back] so often that if it were necessary I could describe it perfectly from the start of the infant, at whose christening party most of the guests were hilariously drunk, while the mother was being given a foaming glass of porter by the old nurse, to the end, where a lugubriously black coffin was being carted to a pauper's grave on the shoulders of red-nosed men, with enormous hat-bands round their hats, this being the inevitable conclusion to the career of any one who indulged in anything stronger than water.[28]

Mrs. Panton's is an interesting voice to consider. She herself grew up to be an acerbic commentator on interior decor (*From Kitchen to Garret, Suburban Residences and How to Circumvent Them*) and to publish several autobiographical volumes. Her dislike of the Cruikshanks focused particularly on their style. Mrs. George she thought "scraggy" and "ugly," and she deplored the way in which the "faithful and adoring wife" worshiped her spouse. She hated sacrificing her "very best hat" and "sacred red 'opera cloak'" to make a costume for "Lord Bateman." And she relished pricking what she conceived of as Cruikshank's hypocrisy with respect to Adelaide ("such a sternly virtuous individual as George Cruikshank could never have strayed so far from the right paths as to have had a second establishment") and to alcohol:

I have seen George Cruikshank eat quantities of the good old-fashioned jellies into the composition of which much sherry had entered, watched him consume with gusto soup in which port wine figured to an appreciable extent, and finally end up with plum pudding served with a special sauce composed of butter and sugar and brandy beaten up together until they resembled Devonshire cream, and in which one could smell the brandy quite well. As Mr. Cruikshank had not always been a teetotaler, I can only suppose he had forgotten the taste and smell of all spirituous liquors; he could not have been the blatant humbug this consumption of wine in cookery would otherwise make him out to be![29]

Humbug was precisely what she wanted to imply he was, and yet, from a purely chemical point of view, in two of her three instances cooking would have boiled off any alcohol. Another reading of such behavior might commend Cruikshank for not making a fuss about comparatively small amounts of spirits used in the preparation of food. But plausibly he was not always as fierce an abstainer as the incidents with Mrs. Ward and Mr. Mayhew have led posterity to believe.

In any case, Jane Ellen Frith Panton was the daughter of a man who once at least would have understood and sympathized with the world in which Cruikshank moved as a young man. Frith's parents started life in domestic service; his father rose to become landlord of the Dragon Hotel in Harrogate, no doubt dispensing a great deal of beer and whisky in the course of business. Frith attended a school that resembled Dotheboys Hall, rattled around for a few years, scraped together some guineas by drawing portraits of Lincolnshire farmers, and entertained himself and his friends with grotesque caricatures. He left that raffish background behind once he became an Academician (he was elected to fill the position vacated at the death of Turner), and raised his twelve children in the stolid comfort of St. John's Wood. Thus insulated from her father's early experiences and from Georgian manners, Jane was enveloped by mid-Victorian respectability. Whereas her father retained some affinity for the past, for the underclasses, and for Augustan and Georgian heartiness—an affinity heavily overlaid with decorous sentimentality—she, and much of her generation, simply found music hall turns in the drawing room and Temperance lectures in the studio intolerable. If Mrs. Panton was the audience Cruikshank hoped to reach, he sadly miscalculated.

Cruikshank's friends rallied round. Sir Walter Trevelyan conveyed his "approbation."[30] Hall's *Art Journal*, finding "more of a Bunyan than a Hogarth" in this "discourse under many heads," declared that the artist "has eloquently preached a thousand sermons to the understanding and the heart." The *Daily Telegraph* dubbed Cruikshank "the Garibaldi of the pencil." Comparisons were made to Hogarth (*Morning Post, Daily Telegraph, Morning Star, Literary Register, British Temperance Advocate*) and to Leech (*Illustrated London News, Court Circular*).[31] The ladies of the Plymouth Temperance Society applied to Cruikshank for permission to exhibit his "grand picture" at their bazaar.[32]

But many were, like Richardson, puzzled to make out the significance of the crowded field of incident. So the committee held a soiree in the exhibition room on 28 August, at which John Taylor introduced Cruikshank, who then gave his first descriptive lecture.[33] This was also the occasion on which, at Taylor's instigation, Cruikshank first showed some of his other drawings.[34] Tweedie reprinted the proceedings from a verbatim account in the *Weekly Record*, along with John Stewart's wildly enthusiastic essay: "He will live among the great men of all time, and with this glory over the ancients, that, while they as artists appeal chiefly to those educated in art, he chiefly appeals as a man to men." Stewart also stimulated the market for the forthcoming print, saying that Rembrandt and Cruikshank have in common

that their prints are more perfect than the pictures from which they are produced. The shrewd old Dutch burgomasters, alive to this fact, secured Rembrandt's most matured works by subscribing for impressions of his plates, and the wisest admirers of Cruikshank's genius are following the same course, not doubting that his finished etching of this great work will be the most finished embodiment of his grand idea.

Thus Richardson had his explanation and the public its key to the diagram.

But nobody came to Wellington Street. Blanchard Jerrold recalled one painful visit:

> I remember seeing him standing in his exhibition room. It was empty. There was a wild, anxious look in his face, when he greeted me. While we talked, he glanced once or twice at the door, when he heard any sound in that direction. Were they coming at last, the tardy, laggard public for whom he had been bravely toiling for so many years? Here was his last mighty labour against the wall, and all the world had been told that it was there. . . . A great committee of creditable men had combined to usher it with pomp into the world. All who loved and honoured and admired him had spoken words of encouragement. Yet it was near noon, and only a solitary visitor had wandered into the room.[35]

Jerrold thought of an earlier visit, to Haydon at the Egyptian Hall. No one had come then, either. Blanchard, who borrowed his father's ticket, was one of the two or three who answered the artist's summons. Haydon was so distraught that he thought the caller was the father, not the son. And at the time Cruikshank, perturbed that the crowds patronized Tom Thumb instead, had etched his memorable plate for the *Comic Almanack*, "Born a Genius and Born a Dwarf." Now it was his turn to be ignored.

The sponsoring committee grew alarmed. At some point Samuel Gurney required that the watercolor drawing be made over to him as security for the £400 he had contributed to the "spending money."[36] John Taylor suggested that Cruikshank surround his picture with copies of his previous works. This display might attract more customers, even though they would no longer be coming exclusively for a Temperance sermon. Nonetheless, any expedient had to be tried. So Cruikshank gathered up eleven hundred sketches, studies, watercolors, portraits, proofs, etchings, wood-engravings, magazines, books, toys, song sheets, caricatures, broadsheets, pamphlets, and oil paintings and spread them out along the walls and on screens within a new space rented at Exeter Hall.[37] A catalogue was prepared. Cruikshank composed a preface explaining that "The George Cruikshank Gallery" originated in a desire to prove that he was not his own grandfather but rather one and the same person who had amused three generations of Britons. Another private view was announced for Saturday 15 November. (Thackeray was flat on his back in bed and could not attend.[38]) The December *Bookseller* called the artist "a household mirth-inspiring god."[39] Un-

expectedly, William Michael Rossetti hailed Cruikshank as "a master-craftsman," a genius with obvious defects but still more obvious powers. Rossetti did not like the "unsightly, often repulsive" caricatures; he preferred the period from 1825 to 1845 when Cruikshank was publishing "truly masterly series of etchings" for book illustrations. He did not admire *Bacchus*: "Not a good picture, and can scarcely, we think, be considered a good total-abstinence lecture." But he honored the artist whose effort, regardless of the artistic and propagandistic results, "deserves respect."[40]

And still no one came. As one member of the committee remarked, "The public neither spake nor moved."[41]

In his free time Cruikshank returned to the steel, completing the figures he had stopped outlining in November of 1860. He also employed his pencil to draft and redraft his exposé of spiritualism.[42] His *Discovery concerning Ghosts; with a rap at the "Spirit-Rappers"* was a rambling, punning, digressive text purporting to disprove ghosts on the grounds that they always appeared clothed, yet it was a "GROSS ABSURDITY" to conceive of clothes as a part of the soul and therefore possessing an afterlife.[43] Along with Merle and many fellow countrymen, Cruikshank had been disturbed by the fashion for seances and for the American spiritualist D. D. Home. Relaxing after more than twenty months of intense concentration, George let his mind play with the subject, drawing ghostly vignettes of King Hamlet suited in armor, of Daniel Lambert "as light as a feather" dancing upon the tight rope, of wigs and pigtails and stockings, and most delightful of all, for the second edition a tailpiece of a devil lying on his back, leering, and supporting a table with his cloven feet and forked tail. He had already executed a wash and sepia "spirit-rapping picture," *The Ghost*, in intervals snatched from *Bacchus*.[44]

Cruikshank tried to arouse attention by delivering "an historical description of his Sketches & Etchings" and looking out for any opportunity for favorable publicity.[45] The press corps, whom he thanked "most sincerely" in his catalogue preface, helped. "The George Cruikshank Gallery" gave journalists the opportunity to review sixty years of the artist's productions, and they did so with gusto. F. W. Fairholt praised George's humanity and morality in the *Art Journal* and said he had a right to ask for public honors. *The London Review*, though deploring *Bacchus*, devoted two notices to the early works. When Cruikshank arranged to take the painting to St. George's Hall at Windsor for a private viewing, the *Art Journal* reported that the queen "occupied considerable time in the examination, was graciously pleased to express approval of the design and execution of the picture, and to compliment the artist in warm terms."[46] And over the summer three important critics weighed in with thoughtful essays in major journals.

The first was Thackeray, making up for his previous silence with a notice

in *The Times*.[47] He too, since the days of irreverent youth, had put on the parson's shovel hat and mounted the pulpit. And he treated respectfully the artist's "great sermon at Exeter-hall, where preachers of all sorts and sects are accustomed to hold forth." Thackeray tried to construct a bridge between those who remembered the fun of the teens and the present day:

> Now is the time for elderly persons to review the amusements, the scenes, the dresses, the boxing matches, the coaches, the short waists, tall neckcloths, narrow skirts which in good old days seemed so killing; and now youth pursuing the study of history may see how their fathers were habited, amused, occupied— their fathers?—their grandfathers, who have been depicted by the indefatigable veteran who still cheerfully labours in the public service.

Cruikshank could hardly find words to express his gratitude. He drafted and scratched out and reformulated a letter to his longtime and now ailing friend, thanking Thackeray on behalf of himself and his "better half" for "this specimen of yr. great talent—and strong mark of your friendship," and praising his "generous nature—& kind disposition."[48]

Next, Francis Turner Palgrave published in the July 1863 *Saturday Review* an essay which in tone and strategy recalls Lockhart's 1823 call to Britons to think more of Cruikshank.[49] After reviewing the stages of the artist's career, Palgrave declared that he "deserves a different, if not a higher kind of popularity" than that accorded by the "unliterary classes." Why has Cruikshank been neglected in the drawing rooms? Because his early work opposed the dominant classes, because his drawing retains some caricatural mannerisms deforming faces and ladies' figures, because so many of his works were fugitive pieces, and because his "high tragic power has been exercised mainly against those abuses by which the poor and the helpless suffer. His sympathies are clearly those of a man of the people for the people; and this excludes a drawing-room popularity." Cruikshank did not flatter, but told stern truths too plainly for comfort. And finally, his mode of art still suffers from the depreciation which led Horace Walpole to deny that Hogarth was a painter. "Time has done justice to the artist of the 'Rake's Progress'," Palgrave concluded; "We do not doubt that he has a like reparation in store for George Cruikshank."

Palgrave, who had never met the artist, sent him a copy of the review. Cruikshank replied by proposing to wait upon the *Golden Treasury* anthologist at his home, 5 York Gate, Regent's Park.[50] Palgrave had analyzed Cruikshank's plight acutely and with touching sympathy, but neither he nor anyone else could make the middle classes appreciate either the art or the man. Even he, surrounded by beautiful objects in a luxurious home, may have been taken aback by the vehement gesticulations of "old George

Cruikshank"; they seem not to have taken to one another or corresponded thereafter.

The third, and in some ways the most perceptive, review was penned by John Paget for *Blackwood's*.[51] Paget, like so many other Victorians, was accomplished in several fields. Called to the bar in 1838, he had practiced law and served in the 1850s as secretary to two lords chancellor. He was also a skilled draftsman, author of works on ecclesiastical courts, a principal reviewer of books on history and the fine arts, and from 1864 a police magistrate. Paget was not offended, as Palgrave and Mrs. Panton were, by the sulfurous odor of Georgian license. He commenced his notice with praise of Gillray, "the father of English political caricature," and connected Cruikshank's beginnings to Gillray's end. "In another [walk of art], requiring more refined, more subtle, more intellectual qualities of mind, George Cruikshank stands pre-eminent, not only above Gilray, but above all other artists. He is the most perfect master of individual expression that ever handled a pencil or an etching-needle." (Rossetti, nurtured on Italian and Pre-Raphaelite painting, thought Cruikshank's faces "vapid.") Paget identified Cruikshank also as the "most faithful chronicler" of the middle and lower classes, a stern yet kindly moralist who has sounded the depths from the pauper's deathbed to the murderer's cell, exquisitely discriminating degrees of vice. The finest publication of this nature, Paget maintained, was *Oliver Twist*, and seven years before Dickens died, in the pages of a major literary journal, he awarded laurels to both men for their collaboration:

> Charles Dickens and George Cruikshank worked cordially hand in hand in the production of this admirable work, and neither will grudge to the other his share in the fame which has justly attended their joint labours. The characters are not more skilfully developed, as the story unfolds itself by the pen of Dickens, than by the pencil of his colleague. Every time we turn over this wonderful series, we are more and more impressed with the genius that created, and the close observation of human nature which developed, [the characters, including] . . . the immortal Mr Bumble—a character which has furnished new terms to our vocabulary, and the glory of producing which may be fairly divided between the author and the artist.

By identifying expression as the mode and the middle to lower classes as the subject of Cruikshank's art, Paget was able to avoid dichotomizing the works between comic and tragic or fanciful and moral. He took the achievement of the Temperance glyphographs seriously, although objecting that to attribute all the family's disasters to drinking a glass of whisky on an unlucky day casts doubt on universal axioms of morality. "If such a character is to be destroyed, and such habits [of sobriety and self-denial] are to be upset so easily, what becomes of our trust in our fellow-man?" Nonetheless, he celebrated the achievement, especially of the final plate in the second

series: "Few works have ever exceeded it in intensity of expression and terrible reality."

Equally masterful, Paget asserted, were the fairy pictures, down to and including the illustrations to the *Fairy Library*. And he maintained that the plates for Ainsworth, though less vigorous in individual expression, reached new heights in rendering the "historical-picturesque"; Cruikshank took advantage of the accessories of place and costume and of daring chiaroscuro to design scenes of which "it is impossible to speak in terms of too high commendation." Paget believed that the age had cause to be grateful both for the fancies which delighted the sickbed and cheered the nursery and for the artist's "undying declaration of war against the demon 'Drink'." As "a philanthropist and a benefactor," Paget concluded, "George Cruikshank is entitled to a high place amongst the worthies of the nineteenth century."

Most people, however, thought the Exeter Hall show confused rather than clarified issues. If the purpose was to preach a teetotal sermon, using *Bacchus* as a diagram, and to convert the wayward, as one actor was said to have been converted after seeing the painting years later, then the conspectus of Cruikshank's lifework was distracting, beside the point. If on the contrary a customer was inveigled into the exhibit by a dim memory of past fun, the coarseness and crudity of the early political satires and the thundering warnings of the Temperance moralist might readily disconcert or offend. Paget was one of the few who could see the moralist in the humorist, and vice versa.

Ruskin, by contrast, could extol the imaginative etcher and even respect the ardent reformer, but he could not endorse Cruikshank's reformist art. In chapter two of the *Cestus of Aglaia*, originally printed in the March 1865 *Art Journal*, Ruskin coupled "for honour and for mourning" Cruikshank's "grave and terrible earnestness" with Bewick's "rustic faithfulness":

> But the genius of Cruikshank has been cast away in an utterly ghastly and lamentable manner: his superb line-work, worthy of any class of subject, and his powers of conception and composition, of which I cannot venture to estimate the range in their degraded application, having been condemned, by his fate, to be spent either in rude jesting, or in vain war with conditions of vice too low alike for record or rebuke, among the dregs of the British populace.

Having written this sentence, Ruskin reflected on its implications, and then paid at least a subjunctive tribute to the artist's "vain war":

> Yet perhaps I am wrong in regretting even this: it may be an appointed lesson for futurity, that the art of the best English etcher in the nineteenth century, spent on illustrations of the lives of burglars and drunkards, should one day be seen in museums beneath Greek vases fretted with drawings of the wars of Troy, or side by side with Dürer's "Knight and Death."[52]

Two years later, in his letters published as *Time and Tide*, Ruskin lamented that Cruikshank had "warped the entire current of his thoughts and life, at once to my admiration and my sorrow," and a day later he defended his position: "It is no more *his* business to etch diagrams of drunkenness than it is mine at this moment to be writing these letters of anarchy."[53]

Finances directed the next developments. "The George Cruikshank Gallery" was not paying its way. Tweedie's books indicated that the artist had received over £2,000 as yet unrecouped.[54] The committee still had no print to sell. And its principal backers were restive. The first thing to do was publish the print. Mottram finished his part by early summer and sent in a bill for services which Cruikshank forwarded to John Taylor. Taylor sent Mottram the whole £400 on the understanding that Mottram would then pay Cruikshank for the outlines.[55] So the originating artist had to apply to the copyist for payment for the work he had done on his own picture.

Once the engraving was published, the committee tried to push its sale. They found few customers. "The long delay had damped the ardour of subscribers," a member of the committee told Jerrold. "The engraving is a noble work, unique as a steel etching in its great size and multiplicity of figures. Each one is complete; nothing is scamped. Its power as a teacher has yet to be fully felt."[56] Yet the proceeds were nothing like sufficient to recover advances.[57] In the long run, every self-respecting teetotaler owned the reproduction, according to Norman Longmate, and "it became the standard present for retiring temperance society officers."[58] It, the painting, and slides taken from the painting, furnished vivid illustrations for countless Temperance lectures throughout the remainder of the century. But meanwhile something had to be done to stanch the cash flow.

The committee reached an unfortunate decision. It borrowed £500 on the security of the plate and engravings; Cruikshank seems to have believed that in fact his whole collection was put up as collateral. Jerrold glosses over the specifics, saying only that "there were bickerings—nay, there were absolute quarrels, in the course of these entanglements," and he goes on to repeat the canard that "Cruikshank was an unmanageable business man, and prone . . . to fall out even with his most devoted friends."[59] That Cruikshank was overly trusting in business affairs and often negotiated from a position of weakness which roused his temper is true, but up to 1863 he had lost only three friends through quarrels—Ainsworth, who behaved badly; Bentley, with whom everyone quarreled, and with whom at that moment Cruikshank was making up; and Dickens. What the struggling artist felt about the committee's management he could scarcely articulate; his hurt, bafflement, and sense of vulnerability sound through the fragmentary drafts of his protest:

No one can appreciate more than I do the sincere & kind friendship of the Acting Committee—and whilst the work was going on I deeply felt & appreciated the kind & valuable assistance—but had I known that these gentlemen were merely acting for my interest I never would have allowed them to run such a risk. However I sincerely thank them for what they did to help in the work—up to the time the £500 was borrowed upon my property—but that affair upset all the good that was done as far as I am concerned—and all I want now is to get my property back & I believe that the Temperance world should return it to me—and not allow me to lose any thing by this work which is no doubt of national importance.[60]

After the Exeter Hall show closed, *The Worship of Bacchus* went on tour through the Midlands. Percy accompanied it to Birmingham where, he told Merle, two thousand people saw it in two nights and bestowed incessant applause. But the receipts were only £12.[61] The perambulating diagram created more converts than cash, leaving the acting committee even more indebted. At this juncture the National Temperance League disclaimed all responsibility for the fiasco. The acting committee was composed of gentlemen acting in their private capacity, not on behalf of the league, it declared. Cruikshank was even more baffled. He had resigned as vice-president over the financing of the picture. Now he asked the league to inform him officially of the names of any members of the league "who sent the unfortunate picture upon its travels."[62] Of course it was impossible to answer such a query, since, although the league may have kept its legal distance from the committee and the proposed Limited Liability Company formed to produce the painting and the print, the officers of the committee were all leading figures in the Temperance movement, and from the start the project had been promoted on behalf of teetotalism. The failure of the enterprise sent formerly enthusiastic backers into hiding.[63]

Eventually *Bacchus* was purchased for the nation and sent to the South Kensington (now Victoria and Albert) Museum. A committee of subscribers raised several thousand pounds which were expended in discharging previous debts.[64] R. E. Lofft gave generously, as did Samuel Gurney, who, like Cruikshank, may simply have forgiven previous loans to clear the balance. By Cruikshank's estimate only £1,000 was raised in new money; and Jerrold asserts that £800 came in a single benefaction.[65] If so, then the subscribers may have been thin in number though well stocked in assets. One of the richest former supporters was Sir Francis Crossley; he turned down Cruikshank's personal request for a contribution to the purchase money, pleading heavy commitments elsewhere.[66] But though the painting was eventually secured by this second committee, the subscription did not put money in Cruikshank's purse.[67]

In spite of all the frustrations, Cruikshank retained his sense of humor.

Designing a certificate to be presented to subscribers, he conflated his early image of Nelson's funeral car (1806) with his depiction of the Gin Juggar-nath (1835) and the 1844 *Almanack* plate showing a monstrous picture of Guy Fawkes stuck at the entrance to Westminster Hall.[68] While he sits on the top of the frame, his patrons strain to pull the gigantic canvas along the street while spectators cheer. *Bacchus* is at once a hero, a corpse, and a monstrous engine (Juggernaut) and image (Guy Fawkes) of destruction; Cruikshank is Nelson, Wellington, and Haydon; the occasion is simul-taneously a celebration and a spoof. That self-mockery often present even in Cruikshank's most vainglorious moments shows up as the last word on one of the most painful and disappointing experiences of his life.

During the Exeter Hall show Cruikshank experienced another painful moment. He was losing friends, not through argument, but through death. Thackeray's seizure and sudden death shocked him. As he stood by the gravesite at Kensal Green on a beautiful crisp winter's day, 30 December 1863, Cruikshank began conversing with his friend Moncure Daniel Con-way, American abolitionist and pastor of an ultra-liberal congregation in Finsbury. "I am getting to know this road well—very well," Cruikshank said. "Many a fine fellow has been buried at Kensal Green, but never a finer or a truer than Makepeace Thackeray. How little did they know the man who thought him a hard, cold, and cutting blade. He was much more like a sensitive, loving little girl." Cruikshank then told Conway about that terri-ble trip when Thackeray's wife Isabella had thrown herself overboard and about her husband's tender care. When Thackeray decided to take up art, George continued, I was his teacher, "but he had not the patience to be an artist with pencil or brush. I used to tell him that to be an artist was to burrow along like a mole, heaving up a little mound here and there for a long distance. He said he thought he would presently break out into an-other element and stay there."

The conversation shifted to other funerals Cruikshank had attended. "It would be more pleasing to think of Thackeray as resting by the side of Douglas Jerrold, but Jerrold was not buried at Kensal Green. I remember well the day when we were standing beside the grave of the poor suicide Laman Blanchard at Clapham Way, and Jerrold said he wished to be buried at a spot hard by, which he pointed out; and there he was buried. Poor Blanchard!"

At that moment the hearse appeared. Visibly moved, Cruikshank fell silent. John Leech walked over. The two friends looked at one another and shook hands, but did not speak.[69] Ten months afterwards, Leech died and was buried one gravestone away from his *Punch* companion.[70]

43

SURELY THERE NEVER WERE SUCH TIMES—!!!

One of the greatest masters now living in England learned the dialect of the lowest and guiltiest classes of the poor in London, and disguised himself and lived among them until he knew them thoroughly, and then devoted all the remaining energy of his life to redeem them from the habits of drunkenness which he supposed to be the origin of their misery. That is the primal characteristic then of modern art—its compassionateness. It draws the poor instead of the noble.

John Ruskin, in an unpublished lecture on "Modern Art,"
regarding "Compassionateness," or "turning the muse
of painting into a sister of Charity."[1]

"*FEBRUARY 4TH* [1867]. *Monday.* Called on George Cruikshank and made him happy."[2] So John Ruskin wrote in his diary on a particularly happy Monday when a letter from Rose La Touche arrived in the morning post. Ruskin figured either directly or indirectly through his secretary Charles Augustus Howell in many of the enterprises with which Cruikshank was associated in the 1860s. Taken one by one, these enterprises have little relationship; seen together day by day, they manifest the increasing fragmentation of Cruikshank's life. Occupied throughout the decade with *The Worship of Bacchus* (which Ruskin deplored while honoring the effort), Cruikshank was also engaged in commanding the Volunteers, in collecting and reprinting earlier works (one prefaced by Ruskin), in making some relatively minor prints (for Ruskin and others) and a few paintings, in experiments with etching on glass (involving Ruskin and Howell), in writing an autobiography (sponsored by Ruskin), in unceasing Temperance business, in providing financial assistance and counsel to friends and relatives, and in pamphleteering on behalf of the destitute and unschooled. If modern artists turned the muse of painting into a sister of Charity, Cruikshank was indeed a preeminent example.

But compassion didn't pay. Ruskin, with his large expectations, could afford to pension dependents; Cruikshank could not. Money flowed through his Coutts account like water over Ruskin's beloved falls at Schaffhausen: checks were posted to pay off old loans, past due rent, corps obligations, merchants' bills, and household expenses for Mornington Place and Augustus Street. Cruikshank borrowed and postponed settlements and anticipated income and barely ducked out of law suits and never stopped giving and lending more than he owned. Pecuniary desperation drove him to dangerous expedients; a £10 advance from a friend was sometimes the only stay against insolvency. Charles Augustus Howell sent Cruikshank £50 in March 1868. George owed his landlord Robert Brown back rent, paid with Howell's bill, and as Brown refused to give "*any change,*" Cruikshank was left with a balance of 16s. "Surely there never were such times—!!!—" he cried.[3]

To add to Cruikshank's frustration, some of his earlier productions— especially the book illustrations admired by Rossetti—had never been more in demand. Despite the contemporary preference for black-and-white wood-engravings designed by Millais or Leighton, Tenniel or Du Maurier, and the publication by Edmund Evans of Walter Crane's first colored plates to a depoliticized version of an old Cruikshank family staple, *The House That Jack Built* (1865), during the 1860s there was a revival of interest in Cruikshank's etchings, sparked and fueled by Ruskin and leading in several directions.

Richard Bentley played an important role. Cruikshank encountered him in St. James's Park in the early summer of 1863; after a moment's skirmish, the two old men decided to forget past quarrels and ratify peace with a hearty handshake. Within a few weeks Bentley wrote to Cruikshank asking if he would supply designs for wood-engravings to accompany a new edition of Barham's *Ingoldsby Legends*.[4] This was stretching the alliance rather taut, since Cruikshank would have to share the credit. "You know that I object to have my works mixed with the works of other artists," he reminded Bentley, "but in this case I make an exception in favor of Messrs. Leech & Tenniel—but I should not like any *other fingers in the Pie.*"[5] Bentley seems to have given Cruikshank first choice of subjects; at the end of June, in the moments spared from the *Bacchus* exhibition, Cruikshank was reading the *Legends* and picking which ones, and how many, he would illustrate.[6] In July there were further discussions between the two principals; as Bentley was in a hurry, Cruikshank agreed to have his designs cut not only by the Dalziels but also by Thomas Williams (who worked in the tighter, more controlled style the artist preferred) and possibly by Josiah Wood Whymper. "As I told you the other day," Cruikshank informed Bentley in a burst of confidence, "that I could soon put *half* a dozen wood engravers to work—I

now tell you that I shall be able to put a *dozen* to work—and I beg you to understand that I undertake to do all the remaining subjects on the list."[7] Shortly thereafter the Dalziels urged the artist to send as many designs as possible so they could start engraving; at the same time ten were sent to Thomas Williams to carve; in late August Cruikshank fixed on a final list of twenty-four subjects; by early September he had finished most of them and was about to design a title page (not used), and at the close of the month Williams had proofed the "tailpiece" to "The Lay of St. Cuthbert," where Beelzebub is tying knots in the "blind drunk" Lucifer's tail.[8]

Hanging around the Dalziels' workroom, Cruikshank irritated the brothers with his boastfulness:

> Amongst his many grievances (and George Cruikshank's stock was an assorted one) he complained bitterly of the treatment he had received at the hands of Charles Dickens, with reference to the authorship of "Oliver Twist." Cruikshank maintained "that he had not only suggested the subject to Dickens, but that he had also given him the entire plot, sketched the characters, arranged all the incidents, and, in fact, constructed the entire story; so much so, indeed, that the book was, to all intents and purposes, HIS; for all that Dickens had to do with it was TO WRITE IT OUT, and any man who could hold a pen might have done it better"; concluding with, "I am only sorry now I didn't do it myself." Those were the old man's identical words, as spoken to us.[9]

The reunion with Bentley may have stirred up Cruikshank's recollections of happier times and released the resentment he felt at Dickens's subsequent treatment. It may be that John Paget's August *Blackwood's* remarks giving equal credit to artist and author for *Oliver* were a response to hearing George's complaint, or conversely, Paget's article might have prompted the outburst. In any case, the story Cruikshank told the Dalziels in 1863 he repeated to several people during the remainder of the decade.

Cruikshank handled Bentley cautiously, although as usual he was too distracted with other commitments to complete the work as expeditiously as the publisher wanted. One day Bentley dropped by Mornington Place to urge his artist on and was told that George was not at home. Anxious that a wrong impression might have been given, Cruikshank explained that he had a studio "some short distance from home"—this being the Augustus Street establishment—"and I have this, that I may not be interrupted by persons calling—for when I am at home—I am never *denied*—I mention this that you may not suppose that when I am *not* at my *residence* that I am *not* at *work*."[10] George's underlinings betray him—he protests too much. For however hard he "worked" at Adelaide's, he also strayed there with her growing family: seven children by 1870. The sister of Charity met clamorous petitioners on his own doorstep.

Cruikshank's cuts found one gratifying admirer. Barham's daughter

wrote that his were the only pictures to carry out the spirit of her father's stories.[11] Six years later Cruikshank was again thinking about his old friend Canon Barham; meeting Barham's son one day in Brighton, Cruikshank "happened to tell him that I thought of publishing a print representing his father surrounded by a number of the characters he has described in his 'legends'."[12] Barham, then preparing an annotated edition of his father's works, conveyed the idea to Bentley, who contacted the artist. Cruikshank said he was "tired" of etching and never did any if he could avoid it. However, for his old friend and to oblige the Barham family, he accepted the commission.[13] After thinking about the design for a month, Cruikshank settled on one that echoed his *Table-Book* self-portrait: "Ingoldsby" at his desk surrounded by his characters, just as George in a reverie by the fire was enveloped by the wraiths of his fancy. From Brighton, where he had gone to recover from a series of ailments, Cruikshank first asked Barham's children, and then Bentley, for a portrait of the canon.[14] He worked up a number of careful designs, some of them reinforced by pen and ink, and within a month he thought he could promise proof in ten days. He also informed Bentley that the plate would be accompanied by an explanatory caption.[15] But the drawing was so detailed that when Cruikshank placed it on the etching ground and rolled paper and plate together in the press in order to transfer the design, it smudged and blurred and could not be used. So he had to prepare a new ground, make another tracing, and try again. Consequently the proofs were delayed until the end of October.[16] In this case Cruikshank's tardiness was immaterial, since R. H. Dalton Barham, himself in "broken health," took until October to complete his annotations.[17] And the published image remains one of Cruikshank's most accomplished plates—a little fussy and overdone, perhaps, quoting more of his own wood-engravings than either Leech's or Tenniel's, and with a title that betrays his lack of confidence in the immediate "readability" of the picture—but still a spirited, good-humored, sympathetic portrait of the author and the fantastic creatures of his imagination.

The market for devils, witches, ogres, and fairies held up better than most other Cruikshankian subjects. George Routledge planned to reissue the whole *Fairy Library*. He wrote to Mornington Place, where Cruikshank was recovering from "half a dozen bad colds" and a sprained foot, to arrange an appointment about "terms."[18] The following day, at Routledge's Ludgate Hill offices, he and Cruikshank hammered out an agreement that Cruikshank believed incorporated Routledge's commitment to handle all publicity for the series and to pay some outstanding bills for stationery and painting supplies.[19] As the plates had been lithographed, there was no opportunity for Cruikshank to make alterations; the whole series was printed quickly by Thomas Harrild.[20] Routledge thought of following up with a

republication of Mr. *Lambkin* in September, and a year later, after consulting with the artist, gave John Wrench, an optician-lecturer, permission to reproduce the fairy illustrations as magic lantern slides accompanying his performances.[21] This was an increasingly popular use for prints; Ainsworth, apparently without consulting his former collaborator, authorized photographs of the *Tower of London* plates for John Henry Pepper, exhibitor of "Pepper's Ghosts," an apparatus creating optical illusions.[22]

George Bell was another publisher interested in reissuing Cruikshank's earlier works. A Yorkshireman who came to London in 1832, he had prospered as a publisher through strenuous work and cautious dealing in editions of classics for the schools.[23] He befriended Henry Cole, the Reverend Alfred Gatty whose sermons he published, and David Bogue. Out of the first relationship came handbooks, guides, works of antiquarian scholarship, and the beginnings of the venerable *Notes and Queries*; out of the second grew the children's list authored by Mrs. Gatty and her daughter Mrs. Ewing; and out of the third Bell, by helping to wind up Bogue's business, obtained the British rights to *Webster's Dictionary* and to some of Bogue's Cruikshankiana.

In 1854 Bell took as partner Frederick R. Daldy, who stayed with the firm until 1872, then left and eventually became head of Virtue and Co., the fine art publishers.[24] During those eighteen years of partnership the business expanded into Cambridge, where Bell acquired Deightons, booksellers to the university. Bell purchased Pickering's list—including the Aldine poets—in 1854 and Bohn's "Libraries" and London premises a decade later. In 1868 while Bell was ill Daldy rashly agreed to absorb the firm of Alexander Strahan. This proved to be a financial drain, and the crisis was compounded by the seizure in the United States of a large lot of books shipped on consignment; Daldy had to cross the Atlantic twice in 1869 before he could free the property and dispose of it at considerable loss.

It was at this moment in the firm's history that Bell proposed reissuing the *Omnibus*. He offered a payment of £7 per hundred copies, terms which, had the publication succeeded, would have produced a substantial sum for the Coutts account.[25] But there were immediate hitches. Bradbury and Evans refused to release the stereos because either Cruikshank or Bogue's estate still owed them money. Not even a direct appeal from Cruikshank moved them. Bell and Daldy refused to advance money for the stereos, though they would sign over to Bradbury and Evans Cruikshank's republication profits if the artist so directed. They advised, however, that Cruikshank should not be called upon to pay a debt arising from another transaction and recommended that the work be reset in a more modern style instead.[26] However, it proved impossible to obtain clear title to the *Omnibus* without settling the Bouverie Street claims, so some accommoda-

tion was reached. It extended to the *Table-Book* as well; Cruikshank got its stereos and wood blocks from Bradbury and Evans in exchange for £94 in promissory notes secured by George's copyright. A year later the *Omnibus* steels were finally released.[27] In short, the republication of Cruikshank's magazines entailed for him more pecuniary risk and potential loss. Perhaps if George Bell had been in better health, or Daldy's venture had not turned out badly, Cruikshank could have made money from the firm, whose plans envisaged republishing almost all his former independent works.[28] But Bell and Daldy were themselves beset by personal and financial stresses, so the ambitious projections were never realized.

Illustrations of legends secured Cruikshank two minor commissions, to which he brought the usual combination of meticulous etching and dilatoriness. John Camden Hotten, another of the publishers exploiting Bogue's former stock of Cruikshankiana, agreed to publish Robert Hunt's *Popular Romances of the West of England*. Thinking that Cruikshank might enjoy etching frontispieces for these Cornish legends, he dropped off a parcel of galleys at Mornington Place in August 1864. A month later Hunt demanded to know from his publisher what the hold up was. Hotten forwarded to Cruikshank a prospectus indicating the importance of the project and asked for a decision.[29] Reluctantly, for George was in the midst of experiments with a new method of etching on glass, he consented. Six weeks later, Hotten wrote again about Hunt's book. "*I am under an agreement with him to produce it within a given time* and I only fear your delay may be of a serious consequence to me."[30] At the same time, Hotten pumped Cruikshank for recollections of Leech for a memorial he thought of issuing. Neither of these appeals produced results.

Cruikshank caught a cold at the end of the year which incapacitated him through much of January 1865. He promised Hotten that the etchings would be done in a fortnight, but by the third week in February had made little progress. Hunt tried approaching the artist directly. He reiterated that he and Hotten were seriously injured by the delay: "I am not disposed to be impatient, but really I must press you to bring this work to a conclusion."[31] But Cruikshank, through a mixture of reluctance, conscientiousness, exhaustion, and distraction, still temporized, writing letters to Hunt but accomplishing nothing further on the plates. Hotten, exasperated, reined in his temper and penned another patient entreaty: the text had been printed since November, he noted, and while he didn't want to cause Cruikshank anxiety, if the plates could not be finished soon the book would have to appear without them.[32] To make matters even worse, when Hotten saw "The Giant Bolster striding from the Beacon to Carn Brea," the exaggerated foreshortening of the figure's head struck him as wrong; friends con-

curred. Cruikshank had to explain his representation of the twelve-miles-high figure in a letter Hotten published with the book:

> In order to get a sight of the *head* of such a Giant, the spectator must be distant a mile or two from the figure. This would, by adding half the "*stride*" and above 11 miles perpendicular, place the spectator about 15 miles distant from the Giant's head, which head, in proportion to the other parts of the body, would be about three-quarters of a mile, measuring from the chin to the crown of the head.
>
> Now let any one calculate, according to the laws of perspective, what size such a head would be at such a distance. . . . and it must . . . be recollected that every part of such a huge body must lessen in the same way—body and limbs—smaller by degrees, if not beautifully less.[33]

The seventy-three-year-old artist, having published several thousand pictures over three score years, was reduced to explaining his effects. The March of Intellect made it necessary to be scientific about every thing, even fancy; and yet such scientism rendered imaginative scenes incomprehensible to men of Fact. This doubting hurt Cruikshank all the more because "Bolster" reminded him of his first "*very large* figure in perspective," the unpublished drawing of Milton's Satan, who "Prone on the flood, extended long and large, / Lay floating many a rood." The *Paradise Lost* sketches, made in 1825 and recently snapped up by Truman for his collection, included other giants in perspective, including "Satan calling up the fallen Angels," which Cruikshank considered "*the best drawing that I ever did in my life.*"[34] Had Cruikshank lost his touch, or his audience, or both? Fortunately, Hotten had no problem with the other frontispiece, depicting a "Flight of Witches," although its heavily crosshatched sky was the sort of overemphatic effect Ruskin was shortly to castigate. At least the commission did not rupture relations with either Hotten or Hunt, to whom Cruikshank was writing about the reissue of the *Comic Almanack* five years afterward.[35]

Through Frederick Locker, Cruikshank was introduced to Sir William Fraser, politician and writer. The baronet asked Cruikshank for a frontispiece to his *Poems by the Knight of Morar*; he wanted a horrific style, like Sir Rowland Trenchard's death in *Jack Sheppard* and the ghostly appearances of Herne the Hunter in *Windsor Castle*.[36] Cruikshank complied with an atmospheric plate in the requested mood depicting the monk's ghost tearing at his own grave in the poem "Kyrie Eleison."[37] In subsequent years Cruikshank occasionally socialized with Fraser and etched four plates for others of his publications, but once again neither the commission nor the acquaintance led to anything substantial.[38] No wonder when Bentley solicited an etched frontispiece for *Ingoldsby* the artist hesitated.

Cruikshank had not worked with a major writer for twenty years. The downside of going independent was now belatedly apparent to him. He did

not know the rising generation of authors and publishers; he no longer frequented Grub Street or Fleet Street; and his friends among the art estab-lishment were either dying off (Leslie, Leech, Maclise) or moving on (Frith). His art—or more accurately, memories of his earlier art—still cap-tivated a few admirers, but they were rarely in the forefront of the age.

One partial exception was Martin Farquhar Tupper, best-selling author of compilations of proverbial wisdom. J. Bertrand Payne, manager of the firm of Edward Moxon, in September 1865 told Cruikshank that Tupper "hugely desires that you should contribute a design" to a new edition of the illustrated *Proverbial Philosophy*.[39] Even this compliment was insufficient to waive Cruikshank's rooted objection to sharing the art work with others. He told Tupper he would look over the text and try to oblige him.[40] When the author proposed a portrait of himself, Cruikshank replied that Tenniel had already done a figure armed with pen and surrounded by figures. "I therefore feel a difficulty in making a similar design—as it would look like borrowing an idea from another artist—a thing which I have always avoided." Instead, Cruikshank offered to sketch a frontispiece that would "convey a general idea of the Character of the work." But Gustave Doré, Tupper answered, had already done the frontispiece; what about a picture of the author in a reverie "with crowds of fancies flitting about him"?[41] That was a straight quotation from Cruikshank's *Table-Book* self-portrait, and though he would adapt the design for Barham four years later, he was not willing to draw this plate to Tupper's order.

Negotiations dragged on through the winter, with Payne, Tupper, and Cruikshank meeting in Dover Street or Mornington Place, renumbered 263 Hampstead Road in the summer of 1864.[42] Payne got Cruikshank to design a vignette for his book list, the first published commission that Cruikshank etched on glass (Hancock's process), and later asked him to draw a coat of arms.[43] Tupper sent the artist his Shakespeare "Ode," which mentioned most of the characters Cruikshank had depicted in prints and paintings.[44] Cruikshank introduced Payne to Charles Kent.[45] And Payne's in-terest in illustration led him to commission Doré to execute steel-engravings for the Moxon edition of Tennyson's *Idylls of the King* and to send a set of artist's proofs to Cruikshank with a request that he etch a small portrait of Tennyson from a photograph.[46] All this activity and these new connections added to the busyness of Cruikshank's life and to his sense that he re-mained in the thick of things, but in fact no plate was ever finished for Tupper's book, the issues he raised and the length of time he took to pro-duce a design reinforced his reputation as a difficult artist, and the plum commission to revive steel-engraving in conjunction with the poet laure-ate's celebrated epic went to a French rival who was providing formidable competition.

In 1868 Doré established a "Gallery" in London to exhibit his most edifying paintings. Lionized by British society, Doré nevertheless found time to drop by Hampstead Road—unluckily when Cruikshank was out; then Cruikshank called in at the German Gallery in New Bond Street when Doré was out; so Cruikshank arranged to meet Doré at the Gallery at noon on 17 June and invited Howell to join them. "I . . . shall be glad to see you there at that hour—nay *much obliged*—as he does not speak a word of English—and I *very little French*—so with your assistance *we three* might have a little Chat."[47]

From this point the two artists' careers show striking parallels. Doré had determined that to break out of his "graphic prison" he had to "kill the illustrator and be known only as a painter."[48] He too had tackled grand subjects on grand canvases, as large as 30 feet × 20 feet, and had seen them ignored at the Paris salons. But unlike his British counterpart, Doré still fetched high prices for these monsters—£60,000 in all. And his Gallery, unlike Cruikshank's, admitted more than 2.5 million people at a shilling a head over the next twenty-three years. Doré became one of the richest artists of his era.[49] He also prospered from contracts with Cruikshank's friends and supporters. Cassell published the immensely successful Bible, and Blanchard Jerrold succeeded in persuading the Frenchman to return to London in 1869 and make a series of drawings about society and its outcasts. The result, *London, A Pilgrimage*, published after the Franco-Prussian War, provides for many the definitive images of the mid-Victorian capital.[50] This was beating Cruikshank at the game he had played for sixty years, and though Ruskin deplored Doré's art as "one slimy efflux of the waters of Styx," for once the sage of Denmark Hill failed to dissuade his countrymen from patronizing an artist.[51]

Ruskin was not altogether successful in gaining Cruikshank an audience either, though he tried, hard and often, in the fifties and sixties. In all of his commendations, however, Ruskin relied on his memory of the plates to *German Popular Stories*. He did not in fact like the direction Cruikshank's art subsequently took, and in the *Elements of Drawing* he excepted the *Fairy Library* from praise.[52] Increasingly Ruskin was disturbed by the debasement of Cruikshank's art, but he initially laid that fault to the age rather than to the artist. In *Modern Painters* 5 (1860), he extolled the illustration of Noah Claypole's interview with Fagin as "the intensest rendering of vulgarity absolute and utter with which I am acquainted," but added in a note: "Among the reckless losses of the right service of intellectual power with which this century must be charged, very few are, to my mind, more to be regretted than that which is involved in its having turned to no higher purpose than the illustration of the career of Jack Sheppard, and of the Irish Rebellion, the great, grave (I use the words deliberately and with large

meaning), and singular genius of Cruikshank."[53] Thus Ruskin's response to Cruikshank in the sixties, when he was himself increasingly disillusioned, was complex: he wanted the artist to return to an earlier style that captured for him the happiness of the nursery; he knew little about, and cared even less for, the early political satires, most of the other book work, and the Temperance propaganda; and by means of Cruikshank he held on to a time less evil, physical, and morbid than the present rendered by Doré.[54] No wonder that Ruskin's 1867 *Diary* entry associates a letter from Rose, his young and innocent protégée, with making Cruikshank happy.

In January 1865 Hugh Owen and Joseph Taylor initiated a private appeal to relieve Cruikshank of his financial embarrassments. Thirteen months later Howell, whom Cruikshank had known since Howell was a youngster, learned about the artist's straits and the continuing unprofitability of *Bacchus* as it lumbered about the countryside.[55] At the time Howell was serving as Ruskin's errand boy and one day he mentioned Cruikshank's sad plight. Ruskin asked Howell to come down to Denmark Hill on Sunday, 25 February 1866, and "tell me about Cruikshank."[56] When he heard the story, Ruskin conceived the idea of writing an introduction to a reissue of the Grimm tales and illustrations. Howell was instructed to convey this tactful offer of charity to the artist.

George's affairs had grown so chaotic that Eliza was spending much of her time as secretary and gatekeeper. To Howell's proposal that he and Cruikshank meet twice, once to discuss the Grimm plates and a second time over dinner so that the private appeal could be raised, she replied by changing the second appointment to a tea—and then back again to dinner when Howell complained.[57] Presumably during the first meeting Cruikshank explained the history of the illustrations, including Baldwyn's sudden death and the transfer of rights and stock to Robins. Throughout the 1860s Cruikshank was involved in settling the estate of Baldwyn's daughter Elizabeth for her married sister Frances Whitehead (his wife's niece) and her two children Amelia and Emily.[58] Among other things, George and Eliza had to find out who was entitled to that £500 legacy from Henry Baldwyn which had been placed in trust forty years earlier; in the course of their research they determined that William Devereux Baldwyn had died and that some of the proceeds might be disbursed to the Whitehead children.[59] Perhaps in connection with this final resolution of Charles Baldwyn's estate, the original copper plates for *German Popular Stories* came to light, for about this time they were obtained by Edwin Truman.

"How curious all that is about the Grimm plates!" Ruskin exclaimed when Howell relayed the story. As it seemed unlikely that the Grimm reprint could be effected, Ruskin suggested an alternative: "I wish you would ask Cruikshank whether he thinks he could execute some designs from

fairy tales—of my choosing." Moreover, Ruskin wanted the artist to return to his 1820s style: the designs should be "of the same size, about, as these vignettes [from Grimm, presumably], and with a given thickness of etching line; using *no* fine lines anywhere."[60]

Meanwhile, on 21 March Howell told Cruikshank about the proposed Testimonial previously discussed with Eliza.[61] At first the artist was so "*astounded*" by the "*stunning*" communication that he could only answer Howell's query about the form of benefaction by suggesting cash.[62] But the next day, when he had recovered a little, he thought a "double purpose" might be served: the committee both marking their personal regard and presenting to the nation the Exeter Hall collection, to which Cruikshank would add watercolors and oil paintings. The Testimonial would thus not come simply as personal charity but as the result of providing the nation with a record of Cruikshank's work—"the long much wished for object of my heart."[63]

When Cruikshank heard that Ruskin was prepared to collaborate on a collection of fairy tales, he was overjoyed. Ruskin, in turn, persuaded Edward Burne-Jones, who was then making preliminary studies for Ruskin's portrait, to help him rewrite the tales he picked. Almost immediately, however, Ruskin ran into difficulties. The stories he had read with his childish comprehension he remembered as limpid narratives appealing to his imagination. The stories he now read seemed overwrought. "I am puzzled," he told Howell, "as I look at the fairy tales I have within my reach, at their extreme badness; the thing I shall attempt will be a small collection of the best and simplest I can find, retouched a little, with Edward's help, and with as many vignettes as Mr. Cruikshank will do for me." He settled on the "Pied Piper of Hamelin" (fig. 71) as one selection and, though he planned to put it into prose, he sent Cruikshank the only version he could lay his hands on, Browning's versification, marking the particular lines to be illustrated and issuing very specific instructions to the artist:

> I want the piper taking the children to Koppelberg hill—a nice little rout of funny little German children—not too many for clearness of figure—and a bit of landscape with the cavern opening in the hillside; but all simple and bright and clear, with broad lines: the landscape in Curdken running after his hat, for instance, or the superb bit with the cottage in "Thumbling picked up by the Giant," are done with the kind of line I want, and I should like the vignette as small as possible—full of design and meat—not of labour or light and shade.
>
> I would always rather have two small vignettes than one large one. And I will give *any* price that Mr. Cruikshank would like, but he must forgive me for taking so much upon me as to make the thick firm line a *condition,* for I cannot bear to see his fine hand waste itself in scratching middle tints and covering mere spaces, as in the Cinderella and other later works.[64]

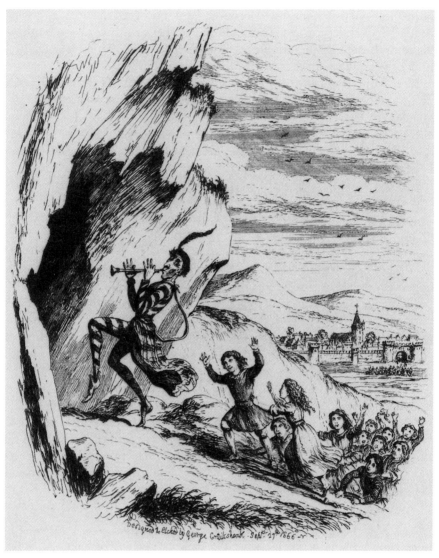

71. George Cruikshank, "The Pied Piper of Hamelin," etching, 1866

Howell relayed these instructions to Cruikshank, who wrote to Ruskin a "very beautiful" letter of thanks. He also told Ruskin about the Testimonial. Ruskin was delighted: "I do not know anything that has given me so much pleasure for a long time as the thought of the feeling with which Cruikshank will read this list of his Committee. You're a jolly fellow—you are, and I'm very grateful to you." Ruskin subscribed for £100, then left for

the Continent with Sir Walter and Lady Trevelyan and two children, Joan Agnew and Constance Hilliard. Lady Trevelyan died at Neuchâtel on 13 May, and Ruskin found Europe "quite ghastly in unspeakable degradations and ill-omenedness of ignoble vice," but he still managed some glorious walks and a lot of pleasant treats for the young ladies. Howell reported that Cruikshank would be willing to illustrate other Grimm tales, and that offer from the "dear old man" Ruskin found "capital." Whatever additional stories had to be chosen he would select with Burne-Jones, Howell, and William Morris, who had also been roped in to the project.[65]

Back in London, Howell and his fiancée Kate were becoming quite sociable with the Cruikshanks, despite nearly a half century's difference in age. They met in the Hampstead Road or at Howell's place, dined together, attended entertainments.[66] As soon as Ruskin returned to Denmark Hill, he sent to town to help Cruikshank in some further way.[67] Howell provided additional samples of the artist's work, things apparently unfamiliar to Ruskin. He thought one of the *Jack Sheppard* plates "quite awful, and a miracle of skill and command of means," and found the *Boz* illustrations "all splendid in their way": "The morning one with the far-away street I like the best." About "Public Dinners" he made a Delphic observation: "Withering: if one understands it. But who does? or ever did? The sense of loss and vanity of all good art—until we are better people—increases on me daily."[68]

These exchanges increased Ruskin's appreciation for the artist's work and situation but did not advance the Grimm project, now running on parallel tracks since Hotten had secured permission from the Taylor family to reprint Edgar Taylor's original translations.[69] When Ruskin looked at other fairy tales, he didn't like any of them. So he fell back on the notion of making "that old Grimm a little richer" by picking out further tales for Cruikshank to illustrate.[70] But then he funked even that assignment: "Wouldn't Cruikshank choose subjects out of Grimm?" If not, Ruskin sent a subject for a second vignette, taken from "The Blue Light": "The old soldier having lost his way in a wood comes to a cottage with a light in it shining through the trees. At its door is a witch spinning—of whom he asks lodging. She says 'He must dig in her garden, then'."[71]

While these were being etched, Howell was working with Eliza on assembling the collection that the Testimonial would purchase and also on plans for a birthday party 27 September which had in the end to be postponed.[72] So far everything was going very well. Eliza caught cold, possibly from the strain of work, but George bit in the "Pied Piper" etching and brought a proof to Howell on 28 September. As Howell recalled fifteen years afterward, George in high spirits

balanced the etching on his head and burst out into a most elaborate hornpipe approaching me with folded arms and such zigzagging of crooked knee and ankle that one might almost have thought him to be the last child dismissed by the Piper, back from Transylvania, and dancing itself into other worlds.

"There my boy" he exclaimed bringing himself to a dead stop, and along came the etching spinning horizontally through the air—like a Catherine wheel shorn of its fastener. "Who the devil says I can't etch? Look at that! The vagabonds are all drunk and know nothing about etching. I'll show them what I can do!"

But Howell was sadly disappointed in the representation of a crowd of joyless men and women who looked like an aggressive gutter rabble and in the blinding inscription fringing the grass in the foreground. "Mr. Ruskin is so fond of frolicksome children," Howell ventured, "that I fear he will consider these a little too old looking."

"That, my boy, can be altered in a jiffy, just tell me the age you would like and you shall have it."

So Cruikshank returned to the studio, burnished out the figures, brought the effaced plate back to Howell "to show you that I am going to re-etch the little ones completely," called at Howell's a couple of days later with a lightly rebitten plate for Howell's approval, and finally on 3 October submitted the finished proof—not materially improved over the first version, in Howell's opinion. [73]

Ruskin agreed. "The etching will not do," he declared. "The dear old man has dwelt on [a] serious and frightful subject, and cultivated his conscientiousness till he has lost his humour. He may still do impressive and moral subjects, but I know by this group of children that he can do fairy tales no more." [74] Eighteen years thereafter, Ruskin explained that "it was precisely because Mr. Cruikshank *could not* return to the manner of the Grimm plates, but etched too finely and shaded too much, that our project came to an end." [75] The plates were overdone, but Ruskin was unfair to suppose that Cruikshank could erase forty years on demand. And as Ruskin had himself nearly abandoned the effort to find stories that matched with his memories, the project was probably doomed as much by the unreality of his goal as by the artist's incapacity. Ruskin tried to soften the blow by offering to purchase any plates that Cruikshank felt it his duty to produce, such as "illustrations of the misery of the streets of London." "Give my dear love to Mr. Cruikshank," Ruskin instructed Howell as he ducked out of a direct confrontation, "and say, if he had been less kind and good, his work now would have been fitter for wayward children, but that his lessons of deeper import will be incomparably more precious if he *cares* to do them." [76]

Please let me see Ruskin, Cruikshank begged Howell. Or forward my

letter. Surely we can work something out. Impossible, Howell rejoined. Ruskin is quite retired and neither sees me nor reads letters.[77] In fact, Ruskin was experiencing "complicated and acute worry" and couldn't think about Cruikshank or anything.[78] Howell evidently arranged to salvage something from the wreckage, for although Ruskin paid for the plate, a number of "Pied Piper" proofs were pulled and offered for sale privately to friends of the artist. Ruskin also canceled an old debt of £100 that Cruikshank had secured by bonds, counting the discharge as the hundred he promised toward the Testimonial.[79] It was therefore not available toward the purchase of the collection. However, in Letter 19 of *Time and Tide*, dated 10 April 1867, Ruskin once again wrestled with the Cruikshank donation, declaring that to pay £100 would mean that he could not afford a trip to the Alps that summer. But it was more important that he should "with some stoutness, assert my respect for the genius and earnest patriotism of Cruikshank," than go to Switzerland. Of course he never had to make such a draconian choice.

Ruskin's defection neither scuttled the plan for the collection nor estranged him from Cruikshank, thanks in part to Howell's pertinacity and tact. Howell went on gathering information about Cruikshank's career, and Ruskin continued to provide encouragement. He went by the house several times, once on 4 February 1867 when he made Cruikshank "happy." Eliza told Howell, "We were both much delighted, with his very kind friendly manner; and George was very much gratified at the way in which he spoke of some of his Sketches" for an autobiography that George now purposed writing. Ruskin offered to subvent it.[80]

As a supplement to the Testimonial, Sir James Fergusson, George Mills, and others memorialized Lord Derby about a Civil List pension, granted in the amount of £95 per annum later that spring. "Which I think is a very *polite* thing for Earl Derby to have done," Cruikshank told Horace Mayhew in ebullient spirits, "and I shall always consider—the 13th of May—as my 'Derby' day'. But I find upon calculation that it would take a hundred years for this, 95 pr. annm.—to repay me for what I have lost in 'tin'—and time—in endeavouring to instruct and to save my fellow creatures—from destruction."[81] Ruskin may have made George "happy" yet again by influencing the Royal Academy, which voted Cruikshank a £50 annual stipend from the Turner Fund.[82] Not that these awards cleared the "dear old man" of debt; he was nearly as behind as ever within a few months, and Eliza was wondering if the government could make the odd sum an even one.[83]

Cruikshank also anticipated his Testimonial, taking £121.19.0 from Howell in April when creditors grew so pressing that "every *Moment* becomes more & more painful."[84] He bought back the watercolor of *Bacchus* at auction, gathered up old proofs, and started on a catalogue. He etched

the first plate of his projected autobiography on glass, a much less expensive process than using copper. He apparently explored with Howell the possibility of paying off some of the *Bacchus* debt.[85] And in June, just after instancing Cruikshank as the compassionate modern artist, Ruskin appointed Howell as his agent in underwriting the cost of completing the autobiography. Cruikshank once again was made "happy" by Ruskin's support, but having been burned by the *Bacchus* fiasco, he determined to make this subvention "a plain matter of business" by turning over the copyright to Ruskin as security for any advances.[86]

In July 1867 the constant anxiety made both George and Eliza so ill they escaped to Margate for three weeks. *The Times* published the Testimonial; Howell decamped on his honeymoon; by October Cruikshank wanted another £100 from the Testimonial balance "for *other* matters—besides *the collection,*" and £50 from Ruskin on the autobiography account.[87] With respect to the latter, he told Howell and Ruskin that he had completed seven drawings and was working on seven others, that the design for a steel-etched frontispiece had been made, and that during the forthcoming winter evenings he and Eliza would put the letterpress together. By mid-December he had proofs to show Ruskin.[88]

Suddenly George's concentration and progress were interrupted by mutiny in the corps and rumors that after all Hotten was going to republish the Grimm tales and the original plates.[89] The venturesome publisher had told Ruskin he had found Cruikshank's coppers in Germany and would produce a new edition if Ruskin composed a short introduction to it. Ruskin agreed, then discovered in November 1867 that Hotten was lying, that he had failed to purchase the plates from Truman, and had instead commissioned facsimiles. When Hotten renewed his request for the introduction, Howell drafted a stiff protest on behalf of Ruskin:

> You know well enough that the plates never crossed the channel—and as for the poor little man—clever enough by the way to be richer, if he was more fortunate—who did them, I believe he never crossed any thing beyond the streets between his house and yours, and would be at a loss to enlighten anyone as to the geographical position of even Primrose Hill.
>
> I deal fairly by my friends and people in general and like to be fairly dealt with.[90]

Ruskin approved of this "admirable" letter but also authorized Howell to tell Hotten he would write the preface if the text was exactly copied from the first editions and the plates were fine. Edgar Taylor's sister pressed hard for the consummation of the project, and finally on Easter Day 1868 Ruskin completed his essay.[91]

Since the Taylor translation was still in copyright, Cruikshank thought of circumventing Hotten by applying directly to Edgar Taylor's widow,

whom Howell knew, for an assignment of rights, and then asking Truman for the original coppers. "I cannot help thinking that if any one was to have any advantage from the publication of *my* Designs & Etchings it ought to be the man that did them," he said to Howell, "and I am sure that you will think so likewise."[92] But Howell did not think so. The book belonged to Mrs. Taylor, and she could reissue it any way she pleased; the plates belonged to Truman; and Cruikshank, he concluded, had no claims on illustrations parted with years ago.[93] Though Hotten's project continued to rankle, Cruikshank did nothing further about his complaint. He trusted Howell's judgment, continued their friendship, and tried to get on with his writing and etching on glass. He even got involved with Howell and Ruskin in a suit concerning delivery of a £3,000 mineral collection that Ruskin was lecturing on and cataloguing.[94]

By December of 1868, however, the thought of the Grimm book coming out with another artist's copies of his originals so disturbed Cruikshank that he confronted Hotten once again. The publisher was conciliatory:

> I was pained by a message you left here this morning, because after consulting with Mr. Howell I really thought you would be well pleased with the large paper copy, proof plate, which I am having bound for your kind acceptance.
>
> We very distinctly say that our plates are *after* your beautiful designs, and there is nothing in the whole book but what is not intended a compliment to your genius.
>
> If the book is a success I shall be very glad to ask you to accept a share of the profits.[95]

Cruikshank could not let the matter drop. Although the title page does say that the illustrations are "after the original designs of George Cruikshank," and both Hotten's and Ruskin's introductory essays refer to them as copies, the cloth cover was embossed in gold with the words "ILLUSTRATED BY" followed by a facsimile of Cruikshank's signature. On 19 January 1869 he went down to Piccadilly and demanded that Hotten quit using the autograph and allow him to etch under every plate a notice that they were copied from his originals. Hotten refused. Cruikshank begged Howell to intervene: "If you will kindly tell him what he ought to do—I feel pretty sure he would follow your directions."[96] But once again Howell declined to act. Hotten sold the book as it was, and Cruikshank's only comfort came from friends such as Crawford Pocock, who thought Cruikshank should have publicly stated that the reprint appeared without his sanction. Pocock was astounded that someone of Ruskin's reputation would lend his name to a misrepresentation calculated to do Cruikshank a direct injury.[97] This went even further than the artist was willing to go. His concern was for his representation and only secondarily about the forfeiture of income from

this unexpected and to him unfortunate outcome of the Grimm project Ruskin had initiated three years previously.

Other disappointments came thick and fast. The Testimonial never reached its goal; less than £1,000 was pledged, and most of that sum Cruikshank drew in advance.[98] When funds had to be raised to discharge the *Bacchus* liabilities, the Testimonial collapsed. The notion of a collection presented to the nation dropped into limbo. Likewise, progress on the autobiography ceased. Eliza hoarded her notes, docketed and abstracted the few pages she or George had drafted, puttered around the studio sorting and annotating prints.

Collectors were always at them for lacunae. Frederick W. Cosens wanted to buy any rough sketches for the Dickens books.[99] Crawford Pocock asked Cruikshank to authenticate items in his collection; in reply, Cruikshank recommended Frederick Pailthorpe, who from his shop in Gray's Inn Passage, Bedford Row, was collecting, selling, verifying, and copying old plates. As for Robert's corpus, Cruikshank asserted that "I assisted him in almost every thing he produced under his name," a statement that can only refer to prints, not to Robert's miniatures, and that to be at all reasonable must be confined to works prior to the 1830s.[100] Even then, George exaggerates.

With Truman, owner of the disputed Grimm plates, Cruikshank stayed friendly. And with Frederick Locker, his wife and daughter Elizabeth (who married Tennyson's son Lionel), George and Eliza developed considerable intimacy. Cruikshank had etched a frontispiece for *London Lyrics* in 1857; in 1866 he executed another frontispiece for Locker's *Poems*, a collection never officially published. One hundred twenty impressions of the plate were taken and then it was destroyed; Elizabeth hand colored some of the twenty large paper copies.[101] For a catalogue of Locker's *Rowfant Library*, Cruikshank designed one of his most delightful pictures, "Fairy Connoisseurs inspecting Mr Locker's Collection of Drawings."[102] This was a tribute not just to Locker's taste and friendship but also to some of Cruikshank's artistic heroes: Correggio, Holbein, Michelangelo, Ostade, Raphael, Titian, Van Dyck, Watteau, and Wilkie. Prominent in the foreground is Hogarth's caricature of John Wilkes, a 1503 print by Dürer, and a Rembrandt landscape which is being inspected by the king and queen of fairies: three images by master printers to whom Cruikshank had been compared by Ruskin. William Feaver complains that Cruikshank's wit is here whittled down into "harmless, charming whimsy."[103] But as a refutation of Ruskin's charge that Cruikshank could do fairies no more, and as a covert reminder of the company Ruskin said he kept, "Fairy Connoisseurs" has a measure of unobtrusive, deliberately playful, bite. To achieve the lightness of effect which Ruskin had found wanting in his trial etchings, Cruikshank

obtained an old piece of copper that took delicate incisings. There was not much that the "dear old man" didn't know about etching by now.

Time and time again Cruikshank picked himself up and started over. George William Reid, working at the British Museum, asked in July 1866 for Cruikshank's patronage as he tried for the position of Keeper of the Print Room.[104] Ultimately successful, Reid then proposed making an authoritative catalogue of Cruikshank's work, which among other things might stop the practice by dishonest dealers of fobbing off imitations as the genuine article. George Bell agreed to publish the catalogue; Eliza had the information she had been assembling for Howell; George agreed to go through thousands of scraps, initialing his and identifying the hand of Isaac or Robert. The museum was in no position to buy the ill-fated collection, but when Cruikshank found a portfolio of early prints Reid offered for many of them.[105] Consultations extended for several years; when the monumental catalogue finally appeared in 1871, with over five thousand separate entries and Reid's handsome introductory assessment, it used as frontispiece "Fairy Connoisseurs." Of all the places where Cruikshank's statement of his antecedents and peers might be found, this might be the most appropriate.

44

I AM LOOKED UPON AS A *FANATIC*

You have given up time, money, and comfort to attend to your country's good and you have been treated with the blackest ingratitude by a set of "men"? not fit to black your boots. I can well understand how a high and noble spirit wearied with combating these poisonous gnats prefers to abandon the contest. With foes so mean so cowardly the weapons that these men have used would have soiled the hands of the veriest wretch God ever let crawl in infamy upon His earth. The nobility of your devotion to the cause of driving the pest of drunkenness from the homes of the People, has been twisted and garbled into a foul means of attack by men whose very dust will be blown away by the four winds of heaven whilst your honoured name will live green in the hearts and memories of a people whose best you did to drag them up from the foul mire which had gathered round them, and shown them the way to that brighter path which leads from a purified life, to Heaven.

Captain Edwin Hurley[1]

IN THE COURSE of digging through a lifetime's accumulation—Cruikshank still had sketches and proofs from the turn of the century—he came across a design initiated during the Chartist uprising of 1840. It showed a cutaway beehive, in the layered cells of which every worker, from navvy to queen, plays a part in sustaining the state. The midsixties debates about extending the franchise triggered a response: Cruikshank determined to adapt his design to the present day and to accompany it with a letter to his fellow workers setting forth his ideas about a representative monarchy and the folly of giving the vote to those who had neither the need nor the moral self-discipline to choose responsibly. He had opposed the Radical program for universal suffrage in the first decades of the century; fifty years later he maintained the same position. Though his grandfather had been a Whig and his father a Tory, as a youth he had been "*rather* Radical" and now was a Conservative, "so that altogether I consider

myself a Tory-Whig-Liberal-Conservative." Cruikshank's views had not changed, the political parties had. Thus when he issued *The British Bee Hive* in March 1867, he incorporated nearly eighty years of imagery about the British constitution and John Bull's role in government.[2]

The beehive held rich associations.[3] As a trope for a polity it had been used by Aristotle, Pliny, Cicero, Erasmus, and Elyot. Hobbes and Mandeville derided the analogy between selfish men and cooperative bees: whether and how self-interest could serve larger social ends was debated throughout the eighteenth century. Moreover, the image of a hive had often been applied to the British state in particular; Macaulay used it in describing the country after the Glorious Revolution as a "busy and populous hive, in which new wealth was every day created," and in 1818 Cruikshank had represented British shops selling unadulterated tea as "the respectable hives of honest industry."[4] In Napoleonic graphic satires British bees warded off robbers, wasps, and the French. "Sting Sting the Viper to the Heart my good Bees," Farmer George (George III) says in one plate, "let Buz Buz be the word in the Island." "Curse those Bees they sting like Scorpions," Napoleon complains; "I did not think this nation of Shopkeepers could have stung so sharp."[5] Cruikshank recalled the image when describing the invasion threat of 1803: "Great Britain at this time might well be compared to the state of a bee-hive when its inmates have been disturbed by accident or an intruder."[6]

The beehive was not only associated with nationalistic traits, it was also connected to moral and religious virtues ever since "Mr. Watts of busy beeical memory," as the popular novelist Rhoda Broughton put it.[7] The communitarian hive wherein bees worked hard in specialized ways to manufacture honey and multiply their numbers offered a paradigm for utopian manufacture; hence the *Bee-Hive* (a separate publication) was the organ of the London trades societies in the 1860s.

At times, indeed, the incessant appeal to the genus *apis* as model for human imitation provoked dissent. In an August 1844 *Punch* cartoon Richard Doyle made fun of Prince Albert's new Windsor Castle hives by depicting them as transparent domes wherein the bees act as porters, reapers, laborers, and artists, enriching the royal family. Twenty years later, Eugene Wrayburn in Dickens's *Our Mutual Friend* protests snappishly against "the tyrannical humbug" of the bee:

> Conceding for a moment that there is any analogy between a bee, and a man in a shirt and pantaloons (which I deny), and that it is settled that the man is to learn from the bee (which I also deny), the question still remains, what is he to learn? To imitate? Or to avoid? When your friends the bees worry themselves to that highly fluttered extent about their sovereign, and become perfectly distracted touching the slightest monarchical movement, are we men to learn the

greatness of Tuft-hunting, or the littleness of the Court Circular? I am not clear
. . . but that the hive may be satirical.[8]

Wrayburn's objections were not shared by Cruikshank, who throughout
his lifetime found the analogy in various ways apt. Even the shape and
cellular structure of the hive facilitated its use as a political image. The
vaulted roof echoed the arches and temple domes that Cruikshank had
employed as signs of a consensual, Parliamentary monarchy in the 1820s—
architectural motifs reaching back into the previous century and featured
in some of his father's prints. He had often opposed such shapes to the
pyramid of totalitarianism and repression. During the forties, as Cruik-
shank listened to the arguments of the Chartists, he groped for a shape that
would express the uniquely mixed nature of the British constitution and
that would incorporate, as the earlier forms of temple, arch, and pyramid
did not, the citizens of the state, ranged in classes and levels of work from
the most physical and menial to the most intellectual and exalted. Evi-
dently dissatisfied with the 1840 design of *The British Bee Hive*, he put it
aside, but elements of its composition infiltrated a major comic illustration
for the 1847 *Our Own Times*, "An Outline of Society." Organized in three
levels, this "Outline" groups women and children in ascending orders: the
depths contain fools, misery, poverty, starvation, violence, incipient alco-
holism and murder, and madness betokened by a female fury (descendant of
Revolutionary *citoyennes*) holding a firebrand and dispensing tumblers of
gin to eager children. One sullen and determined boy clambers up to the
next level, clutching moneybags in both fists. At that elevation modest
decency and industry prevail; mamma presides, sitting in her chair and
receiving domestic tributes from her family. Ragged school boys receive
elementary instruction before proceeding to their jobs as porter, black-
smith, navvy, carpenter, and mason. One child tumbles backward over the
ledge, while several are scaling the heights, some with assistance from
above. At the top, a fine lady dispenses scientific and literary instruction to
budding philanthropists, engineers, musicians, architects, chemists, and
writers. At her feet rests a beehive bedecked with flowers.

This conception of society does not yet imply that all toil is cooperant to
one end; indeed the design has more in common with traditional Last
Judgments than with social utopias. But placed between artisan and upper
middle classes, the hive emblematizes the potential harmony among working
classes. Underneath the sunny optimism, however, runs a countercurrent
particularly appropriate to the Hungry Forties and early Victorian anxiety
about rising expectations: the picture could as easily be read from top to
bottom, as the middle classes through a failure of self-control sink into folly
and vice. And, even more radically, it suggests that the civilized but pallid
virtues of the upper classes (etched lightly) depend on, indeed are nour-

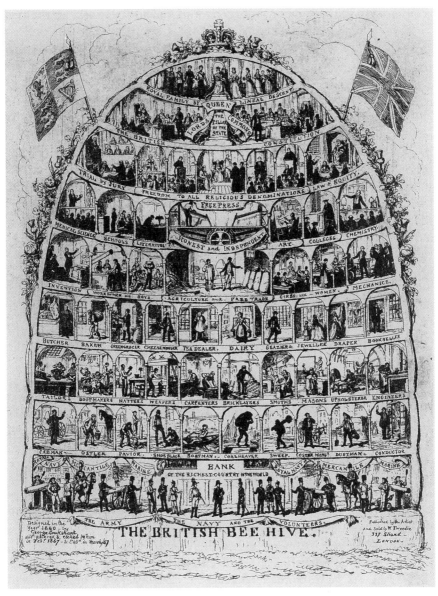

72. *George Cruikshank,* The British Bee Hive, *etching, Mar. 1867*

ished by, the primitive vitality, playfulness, aggression, and impulsiveness of the lowest orders (drawn and etched more vigorously, and situated closer to the front picture plane).

By 1867 the tidal oppositions of earlier years had subsided. *The British Bee Hive* (fig. 72) merges contraries into a whole at once hierarchical and

consensual, abstract and organic, constitutional and commercial, energetic and disciplined. Its foundation is not the Commons nor John Bull nor bayonets and swords propping up a reactionary oligarchy, but rather the Army, the Royal Navy, the Mercantile Marine, and the Volunteers, a military establishment that includes professionals and amateurs, defense and trade. The cannons are turned outward to defend "Threadneedle Street Honey" against "any WASPS that might attempt to take possession of our Hive." The Bank of England, once pilloried by Hone and Cruikshank for cruelly punitive laws against even the inadvertent passing of forged bills, is now celebrated as the "Bank of the Richest Country in the World." Cruikshank prefigures the market imperialism of Disraeli and the Edwardians.

The bottom three rows of honeycomb cells, arched and colonnaded like a cast-iron frame warehouse, illustrate individual trades, rising from lower-class laborers (cabman, ostler, pavior, and the like) to artisans (such as tailor, bootmaker, hatter) on to citizens of the "Nation of Shopkeepers" (butcher, baker, greengrocer, and so on). No pubkeepers or pawnbrokers, brewers or distillers, contribute to this Temperance hive.

The cellular division of labor into trades retains the favorable connotations of the hive analogy and recapitulates the fascination with vocational types that prompted nineteenth-century artists in France and England to issue hundreds of albums fixing identities through signifying and collectivizing uniforms. Henry Mayhew had amplified these graphic taxonomies in *London Labour and the London Poor*. The colonnaded cells, an image vacillating between organicism and industrialism, also imply that division of labor which Marx, Ruskin, and Durkheim would shortly deplore as a primary disadvantage of industrial capitalism. There is, therefore, still something both individualizing and dehumanizing in Cruikshank's elaboration of the hive analogy.

The next two rows of cells figure labor in Carlylean terms, as that characteristic physical, mental, and spiritual activity portrayed by Ford Madox Brown in his famous painting *Work* (1850). Industry is depicted by work for men and boys, women and girls; it is associated with inventions and mechanics (which make more, rather than fewer, jobs in this anti-Luddite interpretation of industrialism), and with agriculture, which prospers under free trade—a more pointed reference in 1840, perhaps, than in 1867. Brain work occupies the next rows: schools and colleges, literature and art, medicine and chemistry. In the center is an "Honest and Independent Free Press"; its location signifies that it supports and is reciprocally illuminated by religious tolerance and in turn fosters "Agriculture and Free Trade."

Above the press, Cruikshank places a row of cells depicting the legal and religious principles that both undergird the British constitution immediately overhead and guarantee the liberties of the institutions and people

below. Parliament is a place where orderly debate ensures that responsible voices are heard. Warning his "Fellow Countrymen" against further reform, Cruikshank argues that the essence of all government is "co-operation," whether between labor and capital or between ministers and people. He maintains that "the PEOPLE, in one sense, govern the country; for the members of the commons are returned by a portion of the people, representing the nation, and acting, as it were, for the interests of the whole." He opposes an extension of the franchise on the grounds that it would lead to widespread electoral bribery and "Mob Law." The essentially conservative nature of Cruikshank's politics by the 1860s is both concealed and revealed by a cellular and hierarchical structure of class and function that emblemizes representative rather than fully participatory democracy. The harmony of this hive depends on each worker's knowing his or her place in the system and staying there. To that extent, it is an unrelievedly static representation of an extraordinarily dynamic society.

The crown of this hive is the queen. The sex of the reigning monarch consorts happily with Cruikshank's metaphor (as it did not under the Hanovers). Moreover, Victoria's domestic fecundity, which as an aspect of sovereignty posed conceptual and artistic dilemmas in other contexts, here strengthens her claim to leadership.[9] Subliminally recalling the prolonged crisis of succession, 1811–1837, Cruikshank hails the principle of "Royal Family by Lineal Descent," so that—"fortunately," as Cruikshank thinks— "there is no election needed"; campaigning for a crown might throw the country into serious confusion and engender serious animosity. A hereditary, unelected ruler stands against regicidal republicanism and universal suffrage; it legitimizes and stabilizes a constitutional monarchy.

Above the hive the Royal Standard and the Union Jack wave bravely, while roses, thistles, and shamrocks indicative of the three kingdoms bedeck the whole. The hive resembles that quintessential English ideal, the rose-covered cottage, the castle that is every Englishman's constitutionally protected home, the utopian House that Jack Built.

Much more than the accompanying letterpress, the picture of *The British Bee Hive* articulates the history of Cruikshank's politics. While he acknowledges that the system is not quite perfect, he expunges from this image any sign of the drunkenness, violence, poverty, and oppression which inform so many of his other plates. He was not so naive as to suppose that in reality no children were abused and neglected, no wives beaten, no husbands thriftless and idle, but insofar as the design of the empire is concerned, it guarantees freedom, liberty, safety, and prosperity. Once again Cruikshank's difference with Dickens and the environmentalists is inscribed: in this hive vice and misery result from individual failings rather than deriving from the basic dynamics of the state. That is more a Georgian caricatur-

ist's than a Victorian reformer's analysis. *The British Bee Hive* recapitulates and crowns Cruikshank's political graphics, but it hardly serves as an adequate representation of the midcentury polity. Nevertheless, as an image of harmony, order, and due degree—a nineteenth-century redaction of the encomia of Shakespeare's John of Gaunt and Ulysses—it expresses an ideal not only for its own age but also for ours. It was imprinted on the drop curtain for *Sweeney Todd* and reproduced in the program for the original Royal Shakespeare Company production of *Nicholas Nickleby*, but in both instances it may have functioned ironically either as a representation of a Victorian society the play belied or as a mocking image of a world we have lost.

The *British Bee Hive* was completed on 20 March 1867, as Cruikshank informed Howell triumphantly.[10] (The iconography could hardly have been more antithetical to Ruskin's ideas and mood, but Cruikshank seemed oblivious to the differences.) So convinced was he that his staunch patriotism and moderation would appeal to the Crown that he furnished Windsor Castle with a copy.[11] The wheel of fortune had revolved full circle; instead of being paid not to caricature the king, Cruikshank was now sending his sovereign a free copy of his laudatory print. Ironically, whereas his satiric squibs had caused him to be noticed by royalty, his paean of praise brought no response.

Neither did his two remaining pamphlets generate much interest. In 1869 Maria S. Rye proposed through the newspapers to raise a subscription to assist in transporting to Canada and the western United States neglected girls aged 5–10—but not boys, who she believed were provided with sufficient Reformatory accommodation.[12] Outraged by this caricature of humanitarianism, this proposal to sweep up denizens of the gutters "like so much guano, or like so many cattle, for a foreign market," Cruikshank flamed into print with *Our "Gutter Children"* (fig. 73).[13] Adopting the old broadside format, he headed his letterpress with an etching on glass showing the girls being swept into a refuse cart under the superintendence of Miss Rye, whip in hand. Cruikshank fulminated once again against the corruptions of the age. The reason there are destitute and neglected children, he thundered, was "BECAUSE THE CHRISTIANS *and the* JEWS USE INTOXICATING LIQUORS AS A BEVERAGE." It was "nonsense," he declared, to hold out education as the cure; how many will be murdered while we wait? And the evidence for its reforming power was ambiguous, to say the least—most now hanged can read and write. Among teetotalers, he assured his audience, there are no thieves, roughs, tramps, paupers, or deserted and neglected children. As he rose to his peroration, he mixed up passionate conviction with equally passionate complaint:

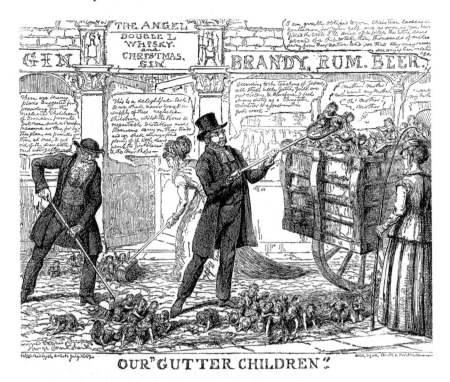

OUR "GUTTER CHILDREN"

73. *George Cruikshank, "Our 'Gutter Children'," wood-engraving, July 1869*

I am looked upon as a *Fanatic*, and I only wish that every one was so fanatical as I am in this respect, for then there would be no murders. My joining this good cause has cost me thousands—a fortune—and it is rather galling to find, that those who attempt to save their fellow creatures from destruction should have to pay heavily for their benevolence, whilst [others] . . . are rolling in wealth.

Cruikshank's obsession with murder and martyrdom indicates deep conflicts within his psyche. He was growing angrier and compensatorily more rigid. If fire was once let out, or firewater taken in, he was convinced that destruction would be the inevitable result. But self-control, and channeling his aggression into charitable and reformist activities, yielded scant rewards and little diminution of frustration. Locked into professional, fiscal, and psychological cells, he had only the caricaturist's innate escape—extravagance of thought, speech, gesture, and line. The contraries oscillating within "An Outline of Society" now bedeviled both his life and his art.

Cruikshank sent two copies of *Our "Gutter Children"* to Major-General Sir Thomas Biddulph, secretary of the Privy Purse, begging him to suggest to

Her Majesty that as Parliament was not then in session she should authorize an Order in Council prohibiting the exportation of orphans.[14] Biddulph replied that this application ought to be made to the president of the council rather than to the queen, who would act upon the recommendation of her ministers.[15] Cruikshank also wrote twice to the Colonial secretary, the third duke of Buckingham, pleading with him to arouse the Colonial office to opposition. But Buckingham, though complimentary about Cruikshank's caricature which reminded him "of one of the great pleasures" of his youth, found after inquiry that it was impossible for the bureaucracy to interfere.[16] Merle was one of the few personal friends to respond. "Many thanks for the children you have so cleverly picked up from the gutter," he wrote. "Dickens made a great mistake when he said, since you 'had got water in your brain, there was no spirit in your works'—your sweepings are richer than gold dust."[17] Dickens's comment provoked the artist:

> You quote something that Mr. Chas. Dickens has written or said about me—if *said*—can you tell me "when & where"—& if *written* can you refer me to the article—Mr. C. D. is what may be termed a clever sort of fellow.—& it may be flattery on my part but *My brain* does think that it is a little better than his—I should be sorry if it was not.

In a postscript Cruikshank added that despite Dickens's opinion, many others believe that his best work has been done since he took the pledge.[18]

George's last reformist manifesto was issued by Tweedie in 1870. The year previous, Nonconformists in Birmingham founded the National Education League to lobby for the passage of a secular compulsory national primary education system; the redoubtable Joseph Chamberlain was chairman of the Executive Committee.[19] On 9 March 1870 Cruikshank joined other league representatives in a delegation to the leaders of the movement to establish national schools, Gladstone, earl de Grey and Ripon, and W. E. Forster. As a follow-up he penned *A Few Remarks on the System of General Education as proposed by the National Education League*. This was printed and bound up with a reissue of *A Slice of Bread and Butter*.[20] In it he advocated moderate and secular policies, both as a political expedient to circumvent conflicting denominational interests and because he had never liked, nor responded well to, external compulsion. With regard to the controversial issue of enforcing attendance, for instance, Cruikshank urged that children be "*led*" or "*induced*" to school rather than being "*dragged*" or "*driven,*" as was militantly advocated by the league, worried that the "lower tenth" of the population would never voluntarily send its offspring to school when they could be working. Cruikshank's comparatively restrained prose and his participation in the Parliamentary delegation correct the impression that he had become a "fanatic"; while for him water was more

salubrious than books, he recognized the importance of a national commit-
ment to elementary schooling even though learning would not eliminate
murder. Forster's Education Act was passed later that year along many of
the lines the Birmingham League promulgated, although its passage was
owing to legislative maneuvering about bread-and-butter issues rather than
to George's *Bread and Butter*.

Cruikshank's efforts to paint in oils also came to an end in the sixties.
When the Shakespeare Tercentenary Committees began formulating plans
for the 1864 anniversary, Cruikshank hoped to participate.[21] He might
follow up his *Midsummer Night's Dream* and *Merry Wives* pictures with an
even grander tribute. In the end, however, he designed only a Subscription
Card for the Workman's Memorial which the Dalziels engraved.[22] At the
request of the great art dealer Ernest Gambart, Cruikshank also performed
"Lord Bateman" and "Billy Taylor" at a 5 April 1864 benefit for the Na-
tional Shakespeare Celebration Fund. Isabella Banks may have played the
Turk's daughter.[23]

A more substantial contribution began in plenty of time but dragged out
over two years. In January 1863 Cruikshank sketched a picture of a baby in
a cradle surrounded by human beings and fantastic creatures (fig. 74).
This, a version of the "Reverie" plate and a precursor of Barham's portrait,
was *All the World's a Stage. The first Appearance of William Shakespeare on the
Stage of "The Globe"*. Potentially another bravura piece, the subject gave
the artist an excuse for depicting all the bard's principal characters within a
single frame. If not as large nor crowded as *The Worship of Bacchus*, it was
more varied in the range of figures, from devils and witches to fairies and
asses and kings, and it had a lively, swirling, undogmatic line. But so many
other matters supervened that Cruikshank could not complete anything
more than a finished watercolor, and even that took until May 1865, thus
missing the tercentenary festivities by a year.[24] The drawing was eventually
sold to a Mr. Morson. The proprietor of the Autotype Printing and Publish-
ing Company tried to borrow or copy it in order to reproduce it in autotype;
the process was particularly good for pictures crammed with figures and
incident, and thus the *First Appearance* or earlier *Fairy Ring* would have
demonstrated its capacities well. But as Morson was reluctant to entrust his
property to the firm, the watercolor did not get autotyped until 1872.[25]

The last oil painting took Cruikshank five years to complete. Sheridan
Muspratt, a chemist at the College of Chemistry in Liverpool, had acquired
Titania and Bottom the Weaver. In January 1864 he asked whether Cruik-
shank had a companion piece, possibly because he had heard about *First
Appearance*.[26] Later that spring he broached the idea of engraving his *Ti-
tania*, but settled for the promise of a new work instead. At Christmas two
years thereafter, he wondered when the picture would be ready. Cruikshank

74. *George Cruikshank,* All the World's a Stage, *tinted drawing on canvas, 1863 (courtesy of the Trustees of the Victoria and Albert Museum)*

had selected an incident related by Professor Wilson in an 1826 issue of *Blackwood's*: an eagle having stolen an infant, its mother risks her life to rescue the child from the eyrie. The subject had been painted before. George Dawe, who when he studied with Isaac at the turn of the century had so riled Robert and George, submitted as his last important Royal

Academy picture *The Mother Rescuing her Child from an Eagle's Nest* (1812). This had been reproduced by Mansell in autotype in 1866; the process, subject, artist, and date make it likely that Cruikshank had run across it in one of the shops or galleries. Once again his late work recapitulated aspects of his beginning.

In January 1867 the picture was well advanced. Cruikshank decided to add two eaglets to make it more complete (and to contrast maternal instincts). He asked a hundred guineas, but if Muspratt would consent to its being engraved at a cost between £150 and £200, he would lower the price to £70 and give Muspratt all the proceeds from the engraving until its costs were recovered. The copyright and steel plate would then revert to the artist.[27] An agreement was reached along these lines, and Muspratt then pushed for an oil version of *First Appearance*.[28] He lent out *Titania* for copying and urged Cruikshank to exhibit the completed *Mother's Love* in the 1869 Royal Academy exhibition.[29] The picture was sent in, and Cruikshank called anxiously on three separate occasions to learn its fate. It was not accepted. Not only that, but his application on behalf of Howell for a ticket of admission to the private view was also unsuccessful.[30] Two years afterwards Muspratt died; in settling the estate, the family wrangled extensively with Cruikshank about the cost of the painting and its engraving.[31] The rejections and difficulties, the absence of other patrons willing to purchase canvases, the distractions of Temperance projects, the enervating scramble for shillings, and his abiding doubts about his ability with the brush, combined to thwart Cruikshank's campaign to storm the battlements of Burlington House. He could not, as Doré resolved, kill the etcher within. Thenceforth he would stick with the medium he had mastered.

Muspratt was far from being the only friend whose death involved Cruikshank in complications. Joseph Gibbs succumbed to ill health and disappointment around the time of Thackeray's fatal attack.[32] His family looked to George and Eliza for various kinds of assistance, emotional and practical. Cruikshank was named one of the executors and also volunteered, with Edward Duncan, to open an account at Coutts to receive contributions for Gibbs's widow and children.[33] Very little was forthcoming. Life insurance amounted to less than £100.[34] The Gibbses alleged that Cruikshank had had hundreds of pounds off his friend. "I must here express my great surprise that you should repeat any thing that might be detrimental to me—uttered by one of unsound mind," he chided. "The great and wonderful mind of our dear departed friend had been breaking up for several years—for had it not been so, he would have been one of the most wealthy and have stood first in the public as an engineer and a man of genius."[35] Despite this contretemps, Cruikshank persevered on behalf of the survivors. He applied to the Benevolent Fund of the Society of Civil Engineers, which

voted a £50 benefaction to the three eldest daughters. This Eliza paid out in installments, apparently to ensure that their brothers did not appropriate it all.[36] Of Joseph's sons, George, the most reliable, also needed financial assistance if he was to stay clear of the corrupting influence of his siblings.[37] Childless herself, Eliza devoted her managerial energy and protectiveness to the Gibbses just as she had with the Baldwyn orphans.

The father of George's Pulford godson died on 28 February 1866. In this case the problem was not the financial or moral condition of the children— both William Sylvester and George Cruikshank Pulford were gainfully employed and making their way in the world. The problem was debts Cruikshank had run up with William and was unable to pay except by renewing notes.[38] (That he was a debtor to his friend suggests that Mrs. Dudderidge Gibbs may have been right in suspecting that Cruikshank owed the Gibbs estate something.) These were signed over to William's nephew and were desperately renewed for several years, George's godson protesting on at least one occasion that they really must be settled. But the artist's bad habits, founded on the easy reckonings of his youth and compounded by the charity he continued to dispense and the unquenchable optimism about ultimately unprofitable ventures, precipitated crisis after crisis. Due date on any bill of exchange marked a day of frantic improvisation. So long as a merchant would extend credit or a friend renew the note, Cruikshank could stave off debacle. Death, however, put an end to such postponements.

The living also stole time away from art. Leech's wife obtained through Cruikshank an introduction to Frederick Locker who might purchase some of her late husband's pictures. Albinus Martin wanted Cruikshank's opinion about some Dighton heads. Dickens's subeditor W. H. Wills required an autograph for a friend. Percy Fitzgerald, later in life an ardent Dickensian, wrote from Dublin on the eve of publishing his biography of David Garrick asking for anecdotes and pictures of the actor's widow whom George and Robert had known.[39] So many friends and strangers applied for photographs—especially in the newly fashionable form of cartes de visite—that in April 1866 George and Eliza sat for Talbotypes; Eliza moved, so her proofs were blurry and had to be reshot.[40] George also had portraits taken by Mayall in his rifle-green Volunteers uniform, and by A. and G. Taylor in high Victorian mufti standing by a writing desk.[41]

These were minor, and in their way gratifying, distractions. The major, and increasingly vexatious one, was the corps. The second phase of Cruikshank's command opened as it closed, with insubordination and rebellion. During a meeting at headquarters on 14 February 1863 Ensign John Woodward, secretary to the corps, behaved disrespectfully, challenging Cruikshank's authority and insulting him. He was abetted by Major Ebenezer Saunders, who became one of the colonel's principal "enemies."

Then there was trouble over appointments. Both Havilland de Carteret and his brother Philip John de Carteret wanted promotion to adjutant, but after much delay Francis Walton was given the commission. Within a year Havilland, then Philip, resigned to return to Jersey where they hoped to extricate themselves from debt. Sums owing to the corps Cruikshank, after calling in the sheriff, cleared with his personal funds, taking notes from the de Carterets' parents. That arrangement was not well received by Havilland, who grew more and more wretched as nothing turned up, even in France. Cruikshank lent such support as he could through loans and recommendations throughout the remainder of the decade.[42]

Another typical instance of the complications Cruikshank encountered as commander had to do with the subscription of Lieutenant C. B. Cobb, nephew of Surgeon Dry who was one of the original Honorary Council of the South London Temperance Rifle Corps. When the officers' subscriptions were increased in the autumn of 1863, Cobb told Cruikshank that he couldn't pay the increase and that if his uncle wouldn't pay for him, he would have to resign. Dr. Dry refused, so Cruikshank assumed the matter was concluded and sent in a termination of Cobb's commission. Cobb protested this high-handedness; Cruikshank drafted and redrafted long letters justifying each step of his proceedings.[43]

Cobb's problem exemplified a major area of conflict: money. In order to be an efficient Volunteer, exempt from militia duty, one had to buy a uniform, attend drills and inspections, and voluntarily pay the subscription toward corps expenses. If the membership was wealthy or sponsored by a wealthy commander, those charges might be defrayed in various ways. But neither Cruikshank nor his troops fell into such a category. Consequently there was endless squabbling over dues and bills. When a Volunteer shot dead a horse on Willesden Range, Cruikshank himself paid £48 compensation which some officers refused to allow as a legitimate claim on the capitation grant. Sometimes Cruikshank was reduced to issuing personal bills in lieu of cash. Benefits consumed time and energy whether or not they succeeded; a ball given by the 5th Company failed even to meet expenses.

Volunteers defected in large numbers, discouraged by the demands on their resources and disillusioned by the petty jealousies and rivalries. So many quit the corps that Cruikshank was given three months from 27 April 1864 to bring the numbers up from 349 to full strength (480); otherwise his authorization would be reduced to fewer than eight companies. One compromise he was forced to make: membership ceased to be wholly teetotal.[44] That some Volunteers kept the pledge while others turned up drunk on parade further complicated his disciplinary problems.

It was no easier to keep officers. Walton, the successful applicant for the adjutantcy, performed superbly, but he couldn't afford the position and had

to resign. Colonel Cruikshank, moved by an appealing letter instancing a wife and young family who needed support, then appointed Julius J. Hockley, applying from the Rectory, St. Clements, Oxford, as the new adjutant. Major Hockley determined to take charge of the accounts, to set up the books anew, and to pull Cruikshank out of the financial quicksand into which he was sinking. The new system of capitation grants had encouraged the corps' commander to anticipate revenue in order to meet heavy expenses; as a result, he was some £700 in debt. Many other officers in charge had done the same thing, so in February 1867 the War Office issued a ruling that capitation grants could not be drawn on in advance.

The declining popularity of the Volunteers in the years immediately preceding the Franco-Prussian War was reflected within the corps. A Captain Norman caused a ruckus, and during the ensuing correspondence Salisbury and Packington of the War Office expressed their dissatisfaction with corps affairs. Major Saunders and Lieutenant Collier, after investigating the accounts, concluded that they were full of errors caused by their commander's inefficient bookkeeping and dilatoriness. Cruikshank vigorously rebutted the charge, blaming the shortcomings on Captain Norman's failure to act as financial officer and the unwillingness of the corps' finance committee to take responsibility. Others spoke out against their colonel: Captain Edmonds told Cruikshank "that if you could command a regiment as well as you could illustrate a book we should not grumble," while Major Hockley, who had progressed to ringleader of the opposition, called him a "conceited old fool" and "a D—d old fool."

Enraged, Cruikshank mounted an attack. He dismissed Saunders, Edmonds, Woodward, and Wilkins, and severely reprimanded Captain Chambers for signing an unfavorable report that the other men had forwarded sub rosa to Salisbury:

> As to my taking *every* opportunity to degrade and *humiliate* my Officers, why *the very reverse is the* case; for at several of the Council meetings lately, certain Officers *as you know* have taken *every opportunity* to *degrade* and *humiliate* me, and I determined not to submit to such *insolence* any longer; and therefore spoke out *strongly*; at the annual Meeting and will speak out a little *stronger* at the adjourned Meeting for tho' I am said to be too good natured if you and they suppose that I am the man to put up with an insult, you never made a greater mistake in your lives.[45]

There does seem to have been a conspiracy to replace Cruikshank. The old man may have looked slightly ludicrous playing soldier at the age of seventy-five; he certainly had enough quirks and vanities to inspire ridicule and enough temper to blow up every challenge to his authority into a Court of Enquiry case. But some of his officers actively plotted to oust him. A newspaper story which they may have planted alleged that Cruikshank had

forgotten the proper salute at a Brighton review, a charge to which he of course felt it necessary to respond in print.[46] Rumors circulating in the press that the corps was in an unhealthy state prompted its commander to write once again to *The Times.*[47]

The unpleasantness dragged on into 1868; it got a little more unpleasant when the marquis of Salisbury died in April and was replaced by the second duke of Wellington. The dismissed officers found in Wellington a sympathetic advocate, whereas Cruikshank found his post filled with contemptuous replies. "If the Colonel is determined to break his word," Wellington retorted about one dispute, "the Duke requests that he will inform Mr. Chambers of that decision, for Col. Cruikshank has no right to make the Duke in appearance tell a falsehood. The Col.'s notion that it is right that he should perform his duty by insulting others who have nothing to do with it, is peculiar."[48]

Set against this criticism was the support of many of the officers and men, including Ensign (soon Captain) J. Cruikshank Roger and Edwin Hurley, captain of the 8th Company. Hurley attributed the "falling off" in the corps and the "*disgraceful attacks*" upon its commander in council to the malign influence of Major Hockley, who met frequently with the ousted officers, warmly sympathized with their cause, and knew all about "the late attempt to displace the Colonel." Moreover, Hurley was told that some of the dissidents "had had several interviews with the Duke of Wellington who was 'hand in glove' with them."[49] Hurley perceived the opposition to be based on a conflict between civilian and military authority that was in fact a general problem throughout the history of the Volunteers. The mutineers wanted the corps to be run as a civil organization "with yourself merely *as Chairman.*" Then "they would be able to indulge in any expressions they might think fit without any risk of being called to account for insubordination." Cruikshank, though not always punctilious about regulations himself, nonetheless vigorously asserted his military prerogatives against such democratic undermining. (His corps experience may have contributed to his views on the Second Reform Bill.)

Finally Cruikshank had enough. Salisbury had twice turned down the promotion to major of Cuthbert Vickers, a thirty-two-year-old "gentleman of independent property and of good connexions," but when Wellington signed the papers, Cruikshank moved to put his own resignation in hand. At the end of July he called his staff to what "will probably be the last meeting you will attend as one of my officers," and the following day he asked Vickers to succeed him. Vickers consented to the proposal and after several weeks of negotiation agreed to accept corps debts of £527 transferred from Cruikshank and to help his former commander recoup prior

advances. Cruikshank in turn promised to assist in recovering all monies owed the corps.

But even his leaving turned rancorous. The dissidents kept up their pressure. Cruikshank demanded Hockley's resignation, then withdrew charges because his own resignation and Vickers's appointment could not be acted upon so long as the charges stood. Days later the *Observer* ran an offensive article (written by a Volunteer reporter friendly with the rebels) suggesting that as one of the dismissed former officers had been reinstated in another corps, all of them might in time be so vindicated, while Cruikshank had been forced to resign by this reversal of sentence.[50] If this weren't galling enough, Cruikshank's hope of being named Honorary Colonel, thus signifying the War Office's endorsement of his efforts, was curtly rejected by Wellington, who pointed out that such an appointment was only granted to members of the Royal Family or to military heroes distinguished in battle.[51] Captain Roger's effort to get the officers to memorialize the duke notwithstanding met with little enthusiasm; some feared it would be perceived as an insult to their new commander. So on 30 September 1868 Lieutenant Colonel George Cruikshank took his farewell of the 48th Middlesex at a small dinner which Ruskin and Howell, among many others, declined to attend. Roger, who got saddled with organizing the tribute, worried for a while that no one would come; but despite his fears and a stack of regrets, enough former officers, members, and friends accepted to allow the affair to pass off "in a highly successful manner."[52]

That should have been the end, but it wasn't. Soon Vickers was plunged into the same fiscal morass from which Cruikshank had just extricated himself. Alarmed by the size of the debts and the unrelenting costs, Vickers tried to economize and to collect from Cruikshank interest on past debts. At the same time he "applied the pruning knife vigorously to both officers & men."[53] For another year Cruikshank communicated with Vickers about finances, testily giving in about small sums but resisting larger claims which he believed had been accepted as part of the deal to transfer command. The corps at first appeared to experience a resurgence: Major Hockley was reinstated as adjutant and the roll of efficients climbed to 538 in 1871. On the other hand, Cruikshank heard reports that the bickering was worse than ever and that the 48th Middlesex was about to disband.

The Havelock Rifles gave the aged artist a chance to exercise command, something he had never been able to do as a caricaturist, illustrator, magazine proprietor, oil painter, or Temperance propagandist. Intensely patriotic, still vigorous, boyishly exuberant about military exercises, he brought to his regiment an enthusiasm, a kindness, a generosity, and a public visibility that undoubtedly filled the ranks with volunteers. But he also brought liabilities—his mother's temper, his father's improvidence, his own touchy

vanity, and his and Eliza's straitened circumstances—that nearly erased all the good he could do. Although General McMurdo, posted to Dublin, sent a warm tribute to Lieutenant Colonel Cruikshank on the occasion of his retirement dinner and consented nine years later to act as one of his pall-bearers, few persons in authority, whatever their own limitations, found George an easy or altogether satisfactory officer. In this as in so many of the other ventures of his later years the deck was to a considerable extent stacked against him; but Cruikshank's virtues as a satiric observer of life and manners and as an independent artist were undermining his achievement. The facility of easy anger, the equally quick impulse to sympathy and charity, the assertion of exemplary moral authority, and the inevitable though mistaken sense of himself as a prominent player on the public stage authorized a graphic persona but disabled him as a practical leader. Through art Cruikshank could inspire, humiliate, ridicule, accuse, charm, delight; he could arouse pity and terror and laughter and love. In life, however, he did not manage his talent or his temper so well.

45

CELTIC STRAINS

With regard to myself, as my ancestors were all natives of Scotland—some Lowlanders and some Highlanders—I should indeed be pleased to have my name associated with any national work of art that might be placed in the land of my forefathers, and I should consider it one of the greatest honours that could be conferred upon me if it could be written on the pedestal that this monument in honour of KING ROBERT THE BRUCE *was designed by the Artist,*

GEORGE CRUIKSHANK[1]

CRUIKSHANK was by now rarely out of the news. The Volunteers controversies and the *Worship of Bacchus* debacle aroused the public's interest. When John Camden Hotten or Bell and Daldy issued another republication, reviewers appraised his life's work. Friends offered to insert glowing notices about new projects.[2] Temperance and education leaders engaged in friendly debates with George about his pronouncements.[3] Those responsible for the Testimonial resorted to newspapers to explain their policies and results. Whenever George completed a major project, he managed to get the queen to view it at Windsor, occasions for much publicity. G. W. Reid, completing his *Catalogue* for the British Museum, booksellers and private collectors, and others interested in Cruikshank's history began posing questions, either in the columns of *Notes and Queries* or directly to the author.[4] Sensing that the septuagenarian might not survive much longer, memorialists prepared valedictions. And Cruikshank, ever certain of his positions and unshaken in his conviction that the "dear lads" and ladies believed in him, regularly inscribed letters to the newspapers about his politics, projects, and patronym.

Autograph seekers besieged Hampstead Road. George and Eliza distributed cartes de visite to correspondents from Australia and America as well as the British Isles and the Continent. He was photographed full-length as an artist and in bust-length as a man of character. His likeness was also featured in full-page portrait caricatures. *The Period* published a colored one on 17 September 1870 (fig. 75) showing the artist (his name misspelled) as

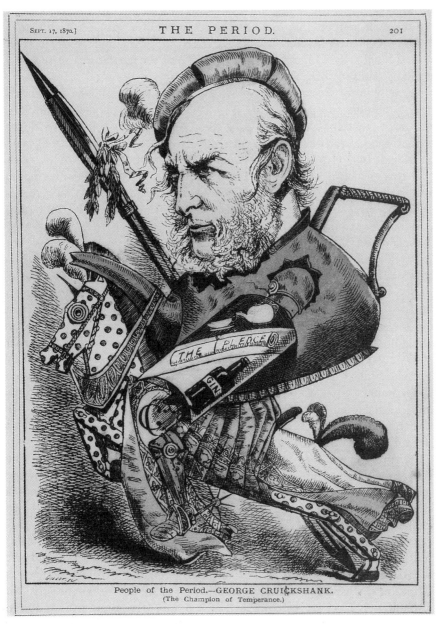

People of the Period.—GEORGE CRUICKSHANK.
(The Champion of Temperance.)

75. *"People of the Period.—George Cruickshank,"* The Period, *17 Sept. 1870*

St. George riding the hobby-horse of Temperance.[5] A year later *The Hornet* printed a lithograph (fig. 76) of "The Venerable George" before his easel seated on a barrel marked "ONLY WATER," a public and topical correction of Maclise's 1833 image (vol. 1, fig. 78) of the caricaturist seated on a beer keg and sketching on his top hat.[6]

Such pictures imaged more than the mere fact of George's celebrity. They promulgated a representation of the artist as the people's champion, the ardent teetotal knight, wielding the tools of his trade in the battle for human souls. In so doing, they erased earlier versions. To the age of Disraeli and Gladstone, Cruikshank was an eccentric, a national treasure in a culture that has always loved eccentrics, well intentioned and persevering on behalf of water, always good *for* copy but not necessarily *to* copy. There was still something unruly about George; his audience had to contain him, either by referring to his age ("venerable") or by limiting his signification to Temperance. "'Drawing & painting to prevent evil & try [to] do good" got subtly shifted in the minds of Cruikshank's commentators: the means, art, gave place to the ends, themselves controversial.

The result was a paucity of commissions. Over the last twenty years of his life, Cruikshank received very few invitations to produce new works on paper, and of those he did tackle, some were as minor as pictorial business cards and personal bookplates.[7] His wood-engraving for Samuel Carter Hall's Temperance morality, the *Trial of Sir Jasper*, was along with plates by Doré, Tenniel, and other illustrators, converted to a lantern slide and used to accompany a reading of the horrific verses in countless chapels and town halls.[8] But more often the printings were small, the audiences private—as was the case with the five india paper etchings Cruikshank provided for a second edition of the Knight of Morar's *Coila's Whispers*.[9]

Coming somewhere between public and private circulation, the one hundred thirty-five sets of Reid's *Catalogue* were standing in proof by the end of January 1870. The second and third volumes contained reprints of many of Cruikshank's fugitive plates. But Edwin Truman, who had loaned Reid his collection during the cataloguing, spied a number of errors. Insisting that publication be held up until he had gone through the entries carefully, he met with Reid and Cruikshank, and all three read proof together.[10] When the *Catalogue* was finally released, it prompted more reviews of Cruikshank's career and stimulated other collectors to pester the artist for rare items. George and Eliza made a little money from these sales and from an occasional consignment of prints auctioned at Sotheby's.

In 1870 Cruikshank etched what was to be his last broadsheet social satire, a colored etching of *The Chignon* accompanied by his own verses.[11] This fashion for a coiled hairpiece was denuding the head but lining the pockets of hundreds of Italian country girls; it gets a wonderful send-up in

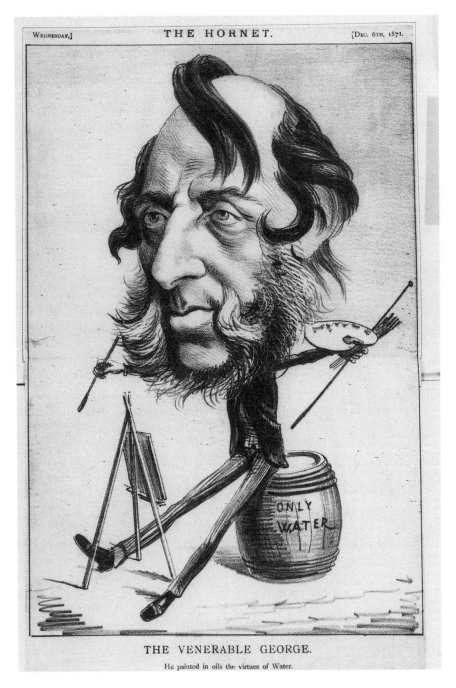

THE VENERABLE GEORGE.

He painted in oils the virtues of Water.

76. *"The Venerable George,"* The Hornet, *lithograph, 6 Dec. 1871*

Anthony Trollope's *He Knew He Was Right*. The following year George reacted strongly to the excesses of the Paris Commune, which he taxed in *The Leader, of the Parisian Blood Red Republic, or the Infernal Fiend!* with being responsible for the Franco-Prussian War, the burning of Paris, and the slaughter of fifty thousand women and children.[12] Cruikshank refurbished much of the graphic rhetoric he had deployed sixty years earlier. The Fiend has cloven spiked hooves and bogey eyes; it brandishes a bloody dirk and a spitted skull capped by a *bonnet rouge*. Cruikshank also adds more recent motifs: the bottles of brandy and petroleum slung at the Fiend's waist equate personal firewater with the incendiary liquid which has sent the French capital up in smoke. The neoclassical buildings burning in the background intimate the connection between policies of liberty, equality, fraternity, atheism, and communal property, on the French side of the Channel, and threats to the British constitution which are imaged as another Great Fire of London. "As there is a 'Red Republican' party in this Country," Cruikshank explains in his caption, "some National means should be taken to show these mistaken men that such plans if carried out, would not only destroy the laws of civilized society but also be subverting the laws of Nature." (There may be a private symbolism in this plate as well: the Great Fire of Chicago, which the playwright Harry Smith said reminded him of the burning of Moscow as depicted in Cruikshank's Combe plate, and a lesser fire in Boston, wiped out all chance of obtaining large sums from the United States to enrich the Cruikshank Testimonial on which Howell had been working for years.) This, George's last political satire, enjoyed a modest success among friends. A Mrs. Smith colored one hundred of them; twenty-five were sent to Paris; one Covent Garden dealer sold out his stock by Bastille Day; and for a few months George lectured on the subject at Temperance gatherings.[13] As usual, the rewards were incommensurate with his passion: £1.17.3 from one of the three principal dealers, and no offers for further designs.

Two projects that once again brought Cruikshank before the public in various guises were his fairy illustrations and his design for a statue of Robert the Bruce. Both engaged aspects of his Celtic inheritance, and both amounted to much less than he or the projectors hoped. Tapping atavistic strains in his psyche, Cruikshank deployed his imagination and energy but did not enhance his reputation or bank account.

Juliana Horatia Ewing was the daughter of Margaret Gatty, a devoutly religious woman, a calligrapher, copperplate etcher, and amateur phycologist who loved German literature, wrote domestic stories, and in May 1866 became editor of *Aunt Judy's Magazine*, a monthly collection of stories and illustrations for and about children. Mrs. Ewing inherited her mother's talent; she became a principal contributor to *Aunt Judy's Magazine*. Her tales

were less pietistic than Mrs. Gatty's; they sometimes implied mystical
meanings but stayed faithful to the details of domestic and natural life.
Above all, they were imbued with her intense interest in and sympathy
with the young, from toddlers through adolescents.[14] During the autumn of
1869 Mrs. Ewing was planning a collection of her tales, to be published by
George Bell. These included "The Brownies," printed in Charlotte Mary
Yonge's *Monthly Packet* for December 1865, "The Land of Lost Toys,"
"Three Christmas Trees," "An Idyll of the Wood," "Christmas Crackers,"
and "Amelia and the Dwarfs."[15] When she first completed "The Brownies,"
she discussed with Bell the possibility of hiring Ludwig Richter or J. Abbott
Pasquier for the illustration. "You know my weakness! I must have *fat*
bairns!!!—& a good Owl."[16] Like her mother, she admired "a Germanic
style of quaintness & imagination."[17] But such plates as were eventually
printed were not very good.

So when she renewed the subject in December 1869, in the midst of
settling into an Aldershot "Hut" on the X Lines, South Camp, where she
and her husband were to be stationed for nearly a decade, she proffered "a
very bold suggestion":

> Would it cost "a mint" to get G. Cruikshank to illustrate the whole? *He has* a
> "name"—which I have not. I think he would do me good—& I hope, as stories
> go, I shld. not greatly discredit him, it the public wld. buy & read!
>
> When I think of what *he* wld. make of the fantastic toy scene in the under-
> ground bazaar in The Land of Lost Toys—and then think of the Mrs. Markham
> of [Alfred] Cooper's imagination with the Cap of the period—& the Rosewood
> backed chair of the period, & the attentive young people with the hair & knick-
> erbockers of the period as "natteral" as a photograph!—it makes my mouth
> water for a bit of his weird conceit. He *did* the original legend of the Shoemaker
> & the Elves in Grimm & wld. I think make something good of the Brownies
> perhaps with the Owl in the shed. I think one can imagine his Tutor in Xmas
> Crackers!—
>
> I know of course that this idea would waste the illustrations that have been
> made, except as regards the Maga: But it might be worth it—do you not think?
> G. C. has a name—& his things are being republished—However it is just for
> your consideration.[18]

Initially George Bell did not think Cruikshank a good choice. The *Fairy
Library* indicated that Temperance propaganda might infect any children's
book illustration. He proposed Ernest Griset or Richard Doyle. Mrs. Ewing
preferred Doyle: he was never careless like Griset, and his name, or Ten-
niel's or Cruikshank's, might attract customers whereas Griset's would not.[19]
She sent further comments regarding illustrations, complaining about the
placement of the plates for the January 1870 issue of *Aunt Judy's* and con-
demning John Gilbert's contribution: "My poor high flown Parson has

come out like *the very* coarsest of fat medical men feeling the old lady's pulse!! His 'nether lip' gives me the shudders."[20]

In January the pertinacious author nagged Bell again. She knew that he had approached Cruikshank, for the artist had told her that in reading her stories "the Fairies came and danced" to him.[21] She conceded that Griset's illustrations to *Aesop's Fables*, then appearing in *Cassell's Sixpenny Almanac*, had "*astonished*" her, but "who is to count on the honesty of his pencil" when he offers ill-proportioned, overloaded grotesques? She stuck by her preference: "Have you got any answer from Mr. Cruikshank?"[22] Two days later she was at "the tinkler" (her private name for Bell) once more. "What do you say to using some of the best of the A. J. M. illustrations—& letting a good man do the rest—& advertize it as illustr. by Cruikshank (or Doyle) & other artists—."[23] (She did not know about George's antipathy to sharing with other illustrators.) When Bell countered with a proposal to have an engraved portrait frontispiece, she turned resolutely obstructive: "I shall never get up Mr. Pecksniff's legitimate satisfaction in 'my bust by Spiller—my portrait by Spoker'—as long as I live!! You must wait for my decease." Believing that "a good frontispiece is a *great* help to the Vol.," she then provided two further ideas: a colored illustration by Helen Allingham or Alfred Bayes, or "(if you dislike colour & would rather go in for fine art) would a real *etching* (such as those exquisite frontispieces—one of witches & one of a giant—[to Hunt's *Popular Romances of the West of England*] . . .) by George Cruikshank cost more than a scene engraving? I would make a push to do a *weird* fairy tale for this, that should give his imagination full play, & make them 'come & dance to him'."[24]

By the end of the week she had her wish. Bell had sent Cruikshank a draft agreement the day after New Year's, but not having heard from the artist and anxious lest the terms not be satisfactory, he said nothing until it was signed.[25] "Delighted" to hear that Cruikshank had consented to do three designs for wood-engravings, she nevertheless pined for an etched frontispiece, wondered if he charged as much as £12 a steel, and tried to console herself with the recollection that the "awful Moloch the Public & the Purveyors for the Public—to whom one's most delicate tastes are sacrificed" insist on inexpensive volumes to the exclusion of fine art illustrations.[26] She was "*delighted*" three weeks later to hear of Bell's enthusiasm for Cruikshank's drawings and to learn that George intended carefully to supervise the engraver, Horace Harral, who introduced the firm black sixties outline into the plates (fig. 77). "[Cruikshank] is too good an artist to draw 'below himself'—even for a child's story, & I am very much pleased." She then struck while the iron was hot. What about an illustrator for her next volume, assuming Cruikshank would not be available and Bell wanted someone better than Alfred Cooper or John Gilbert? John Wolf, the

77. George Cruikshank, "Amelia and the Dwarfs," The Brownies, *wood-engraving,*
Dec. 1870

ornithological painter? But he would not suit for stories "*not* in the menagerie line." Tenniel she supposed was too expensive. Doyle? Walter Crane?[27]

Finally the cuts were ready. Mrs. Ewing was "utterly delighted" by them, writing to Cruikshank directly to thank him and to praise the engraving as well. She told Bell they were better than his Grimm etchings. Her anxiety about Cruikshank's ability to draw animals was wholly eased. "If we had remembered Bill Syke's [sic] Bull Dog in Oliver Twist—we should have credited Cruikshank with being able to render dogs!" He had also painted a watercolor of "Amelia and the Dwarfs" which her family considered one of his very best, superior in beauty and delicacy to the wood-engravings.[28] With regard to the picture for "Three Christmas Trees," Mrs. Ewing exclaimed:

> when I think of the fashionable boy in a bedstead from Heal's Catalogue with plenty of washstand, toilette-glass carpet & towels to make up for lack of imagination that we shld. have had if any of our old friends had taken it up, I sigh with satisfaction over Cruikshank's rendering! The extra tall bedstead gives a dreamy spiritualized effect [to] the scene—like the *very* long draperies of Blake's disembodied spirits besides height[en]ing the effect of the tree. *The way Cruikshank makes unimportant accessories subordinate & never draws them carelessly & the way certain other gentlemen make them prominent & never draw them well*—is a contrast I would like to engrave on the noddles of some of our rising illustrators!!![29]

Julia's mother, to whom the collection was dedicated, concurred. Mr. Gatty thought of taking one of Cruikshank's drawings to a "semi-millionaire at Sheffield," a rich old relative who could afford the ten-guineas charge.[30] It was, however, already sold. More disturbing to mother and daughter was the news that, after dithering for months about a release date, Bell had decided not to aim for the Easter market but instead to hold the book back until Christmas, when in fact it competed with other holiday publications including *Aunt Judy's Christmas Volume* containing more of Julia's stories.[31] Mrs. Ewing had to plead for an advance against future royalties. "If this book does not sell," she told Bell, "I shall indeed despair of getting a hearing, & should imagine you would by no means feel disposed to help me!"[32]

Cruikshank was secured for the *Christmas Volume*, but the illustration to Mrs. Ewing's "Timothy's Shoes" did not suit her mother. "It is pretty," Mrs. Gatty said to Julia,

> but not, I think, equal to *Amelia*. He has surely got hold of the *wrong class*. You didn't mean cottage life surely, and the fairy godmother or friend seems out of place. . . . I began timidly because I had a sensation that you and G. C. were *en rapport*, and that Bell had praised this so much, but I was vexed I own. It is Cruikshank's sin that he must be either grotesque or in low life. Of "high art" he

has no notion. Amelia's dance is the *prettiest* thing I ever saw of his. But what treason I am talking! . . . Well! après tout, it is an amusing illustration and Mrs. Grundy is not critical.[33]

What she does not observe is that by dividing the vertical plate into three compartments (a variation on the device he had used in the frontispiece to *Hop*), Cruikshank retold the whole story in one graphic cut.

Three years later Mrs. Ewing brought out *Lob Lie-by-the-Fire*, a further collection of previously published stories (excepting "Lob"), for which George provided three wood-engravings in compartments, one serving as the frontispiece to the whole.[34] *The Brownies* went immediately into a second edition; *Lob* did not. On the whole, the family thought both works failures and never knew that the first story inspired Baden-Powell to rename the "Rosebuds" the "Brownies" because "he naturally felt that it was far better for the small girls to be active in *doing* things, rather than to be merely decorative and 'flower-like!'."[35] In 1882, Mrs. Ewing regretted that both books had led a "dog's life"; she determined to break them up and try republishing them as separate stories.[36] Randolph Caldecott, by then her principal artist, designed new plates. He did not care for his predecessor's images, which he thought were in George's "worst style": "Don't ask me to explain why I do not like Cruikshank's illustrations to *Lob*," he remarked. "I should have to use violent language about a very clever man."[37]

These last incidents were, of course, beyond Cruikshank's ken, and much of the negotiations between author and publisher he never knew. But the story of these fairy plates exemplifies for the end of George's career the kinds of problems he faced, having become "a name" and a national monument, and the kinds of patronage he could still attract. Although Mrs. Gatty thought Cruikshank could only picture low life and the grotesque, her daughter considered him superior to any of the rising generation because he understood both drawing and narrative and never scrimped or shorted his customers. His weird imagination seemed peculiarly congenial to her quaint Germanic antiphotographic preferences, and his skillful pencil seemed perfectly adapted to the task of depicting fat bairns (Ruskin would not have agreed) and animals such as the owl with her "fluffy face" and eyes "going round like flaming catherine wheels." The very plate that Forster castigated at the end of *Oliver Twist* reassured Mrs. Ewing that George could draw dogs.

But the artist himself seemed to her somehow unapproachable, almost legendary, and prohibitively expensive. When he did make the fairies dance for her, he worked within the outdated linear mode of his prime, eschewing the broader treatment of the midcentury wood-engravers and the colored wood blocks that Edmund Evans printed for Caldecott, Green-

away, and Crane. Conversely, that rising generation of illustrators appreci-
ated, but did not much admire, the "venerable" George's achievement; they
studied him, then did something different. And it was their regard which
was to influence the commentators who, after Cruikshank's death, tried to
evaluate his enormous output.

Faires afforded something of an escape for him. If he could not please
Ruskin or Dickens, he yet had admirers among the ranks of contemporary
children's authors. Their productions still sparked his live-wire line to limn
the magical interventions of wee beings. When Bell postponed *The Brownies*
for eight months, however, Cruikshank experienced once again the familiar
pattern of expectations deferred and diminished. On a much larger scale,
that was the trajectory of his reconnections to his Scots ancestry.

As Temperance projects and the Volunteers were degenerating into
costly squabbles, George tentatively explored a potential new source of ac-
claim and commissions. He was invited to join the Grampian Club, and on
2 November 1868 was elected to the council, which met on the first Mon-
day of each month at 4:00 p.m.[38] Associating with fellow Scots reawakened
the artist's affiliation with the north. In time it prompted others to engage
him in Caledonian projects. Colin Rae Brown indited a Christmas 1872
note asking Cruikshank if he really were Scots, and if so, would he allow
his portrait to run in, and contribute to, a new journal giving Scots artists
more public exposure. He also reminded George of a promise to attend a
Robert Burns birthday dinner at Brown's Hertfordshire home the following
month.[39]

Such activities, and especially the energetic role Cruikshank was playing
in the effort to commemorate Bannockburn, inspired the Grampian Club
to send a memorial to "the Secretary of State for the Home Department"
soliciting a knighthood for George. Such an honor for an artist, while rare,
was not unprecedented: Joseph Noel Paton, famous for his fairy paintings,
had in 1866 been named Her Majesty's Limner for Scotland and knighted,
and John Gilbert had been dubbed in 1871, the year of his election to
president of the Royal Society of Painters in Water Colours. The club ar-
gued their case on two grounds: first, that for fifty years as an artist Cruik-
shank had supported "sound morals and good government"—an extraor-
dinary sanitizing of his political satires—, and second that he had raised by
his patriotism a regiment of Volunteers and latterly devoted "the principal
share of his time to works of philanthropy." The Reverend Charles Rogers,
secretary of the Grampian Club and J. Cruikshank Roger's cousin, seems to
have been the instigator of this memorial, which "astounded" Cruikshank
when he first heard about it in March 1873; he had, he told Rogers, a
strong objection at present to such an action.[40] Nonetheless, Rogers per-
sisted in lining up support from other institutions, lobbied Lords Shaftes-

bury and Ebury, and finally persuaded the former to approach Gladstone.[41]
Eliza received Gladstone's reply from the earl at the end of April: "With
great respect to Mr. Cruikshank, [Gladstone] does not think he can recom-
mend Her Majesty to confer the honor of Knighthood on him."[42]

Undeterred, Rogers persisted, gaining more signatures, inveigling the
support of William Michael Rossetti and Howell, and finally dispatching
the petition in December. Misdirected, it went astray and was returned to
the Grampian Club, where the president, the duke of Argyle, forwarded it
to Gladstone with the noncommittal statement that "he makes no applica-
tion—but simply sends the memorial on." Someone in Gladstone's office
minuted the document with characteristic civil service hauteur:

> I think there can be no doubt that this is not a case. The Memorial mentions 1.
> his merits as an Artist 2. his services as Lt. Col: of Volunteers.
> In both lines, there are very many others far superior to him. There is actually
> no Artist so rewarded, since Sir E. Landseer's death, Sir F. Grant [PRA 1866],
> Sir W. Boxall, and Sir J. Gilbert being knighted in virtue of their offices.[43]

So Cruikshank got no New Year's honor from the queen. Had he followed
Lockhart's prescription for distinguishing himself in the arts, had he been
born into the gentry and married into the aristocracy like Grant, had he
been a fashionable London portraitist like Boxall, above all had he been
both a successful painter and president of one of the royal societies, he
might have come down to posterity as Sir George, a Victorian St. George.
But he was the poor son of a poor father, a draftsman who never learned to
paint from the shoulder, a satirist who made fun of too many people ever to
be enrolled in the lists of the establishment. He could draw exuberant
pictures of holiday scenes and Christmas trees, but his own stocking hung
empty and threadbare from the mantel.

George's biggest disappointment in his late years grew out of his last
major undertaking. In April 1870 Rogers invited Cruikshank to join Sir
John Bowring, Frederick Locker, and other members of the Grampian Club
and the Historical Society of Great Britain in planning a "National Monu-
ment to King Robert the Bruce."[44] Cruikshank had already engraved a rep-
resentation of the monument to Wallace on which Rogers and the Wallace
Monument Committee had been engaged for thirteen years.[45] The earl of
Mar, whom George and Eliza had encountered at social events relating to
the earlier enterprise, had consented to chair a subscription committee.
Cruikshank declined serving on this committee; he was engaged in too
many other projects, and had after scores of disappointments little stomach
for another fund drive.[46] But "as 'The Bruce' was one of my heroes," he
informed the public some years later, "I promised to give [the members] all
the assistance I could, and suggested the attitude for the figure, which they

all approved of, and at their first meeting they decided that I should be requested to make the design for the statue."[47]

Cruikshank proposed erecting a twenty-two-foot-high monument (fig. 78). The figure of the Patriot King, cast in bronze, would rest on a rocky pedestal of grey granite.[48] It would be no allegorical tribute in the form of an antique nude like the much-ridiculed Achilles statue, but a lifelike representation of the monarch in full armor. George had painted the Bruce nearly fifty years previously, taking care to get the correct costume. This time he double-checked with Canon Barham's son-in-law, Mr. Bond, Keeper of Ancient Manuscripts in the British Museum, with whom he was on good terms as a consequence of the new *Ingoldsby* portrait. From fourteenth-century illuminated manuscripts he confirmed that Bruce wore chain mail and shaved closely, since any facial hair would have caught in the links. He also ascertained the style of coronet the king had donned, a diadem spotted before the commencement of hostilities by one of Edward's foreign cavaliers who made a single-handed attack and was killed by King Robert.[49] George then proceeded to sketch a design depicting the conclusion of the battle. "Bruce is there represented as if he were looking down with pity on the slain, and as if he were saying, '*The fight is o'er, the day is won: I sheathe my sword*'."[50]

Symbolically, the moment is complex. It was the decisive victory that secured Scotland her independence for centuries. Yet, as the committee explained in its solicitation, by stemming "the torrent of Southern ascendancy," reanimating "a nation almost reduced to servitude," and placing "on a solid and permanent foundation the liberties of his country," Bruce also made it possible for a proud, independent nation to unite with its former enemy. The queen, the committee pointed out, "occupies the throne both of Bruce and the Plantagenets."

Hence Cruikshank conceived of the figure as "looking down with pity on the slain" from both sides as he settles his sword in its scabbard. George wanted the pedestal carved with two interlaced branches, one of laurel for the victors and the other of willow for the slain. Below, inserted between "Victoria" and "Queen" in the legend "Erected by Public Subscription in the Reign of Victoria, Queen of the United Kingdom of Great Britain and Ireland," he designed a circular wreath composed of roses, thistles, and shamrocks, within which a male and female hand are joined, signifying "the union by marriage of the two families of England and Scotland." The design thus publicly commemorated both a victory over a foe and the subsequent reconciliation of the two nations. Although the figure is a warrior male, he is sheathing his sword and mourning while standing on a solid rock inscribed to the ultimately victorious Victoria who had conquered through dynastic marriage and (though this may have been an inadvertent

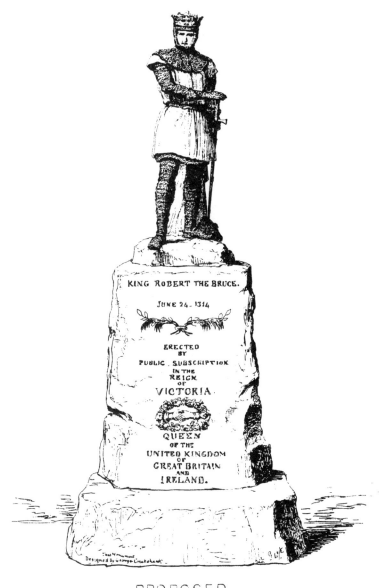

KING ROBERT THE BRUCE.

JUNE 24 _ 1314.

ERECTED
BY
PUBLIC _ SUBSCRIPTION
IN THE
REIGN
OF
VICTORIA.

QUEEN
OF THE
UNITED KINGDOM
OF
GREAT BRITAIN
AND
IRELAND.

This Monument
Designed By George Cruikshank

PROPOSED
MONUMENT TO KING ROBERT THE BRUCE. DESIGNED
BY GEORGE CRUIKSHANK. ESQ

78. George Cruikshank, "Proposed Monument to King Robert the Bruce," etching, 1871

implication) through the imposition of English language and law, a point made repeatedly in Scott's novels.[51]

The committee planned to erect the statue on the spot where King Robert raised his standard on the eve of battle. Thus Cruikshank's design also conflated the start of the engagement with its end. Toward the end of May, Charles Rogers sent him photographs of another Bruce statue model, but the artist returned them immediately, explaining that to ensure his own originality he "never if possible, look[ed] at any [designs] made by other artists of the same subjects, until mine are finished." He was "sorry—very sorry" that a rival model had been made, "for it is to be feared—when mine appears that it will be supposed to be a *Copy*." Cruikshank apologized for not having shown Rogers his own sketches earlier; he had been delayed by "looking about for a suitable *suit* of armour."[52] Once he located the mail, he arranged for his friend John Adams Acton, who had spied George's design and asked to participate, to sculpt a five-foot-high model. George donned the armor and posed as the pitying Bruce, a last and crowning instance of his lifetime habit of identifying himself with others (and vice versa). This model was then shown in Cruikshank's studio to "noblemen, gentlemen, and friends" on Monday, 6 June 1870.[53] The meditative appearance of the warrior struck Cruikshank's audience powerfully.

Over the next fortnight George discussed the project with Rogers several times. By the middle of the month the artist was convinced that he had been commissioned to execute the monument and to prepare copies of the model for exhibition in Scotland and at the International Exhibition in London. Adams Acton and he would execute the full scale version as soon as £800 was paid them.[54] On the twentieth of June Cruikshank requested permission to bring the model to Windsor so that Her Majesty could inspect it and George could explain the design. Biddulph asked "if the Model has been approved by the Committee & if the design is to be carried into execution."[55] From W. C. Hepburn, secretary of the committee, Cruikshank secured a copy of the resolution directing him to prepare in plaster and cast in bronze the model he had designed, and from Charles Rogers he obtained extracts of the minutes.[56] Cruikshank thereupon assured Biddulph that the committee had commissioned him to proceed with the monument and with the exhibition of the model at the International, for which space had been reserved. Informed that this was indeed THE model, the queen signified her assent on the 29th.[57]

Friday, July 1st, about 9 o'clock, Cruikshank and the model arrived by rail at Windsor. With the assistance of the royal staff he placed it in a room (he had requested one with north or east light) to show "to the best advantage." By midmorning he was ready for his sovereign.[58] Evidently the meeting went well; George returned in triumph. Immediately he sent out letters to all his friends and to Bruce descendants inviting them to view his design

on Tuesday or Wednesday, July 5th and 6th; reporters were asked for the second day and composed enthusiastic notices.[59] Then Cruikshank etched his design for a revised circular, handled bills for the sculpting, casting, packing, and carting of the model, received Rogers's authorization for three moderately priced copies, and awaited further results.[60]

In August Rogers took a plaster cast of the sculpture to Edinburgh. By now the committee knew that a flag-staff had been erected at precisely the spot for which the statue had been planned. Rogers told Cruikshank that an alternative site on Calton Hill or somewhere else at Bannockburn would be approved, and he asked George to obtain a subscription from the queen.[61] The revised prospectus was released, showing Cruikshank's design as prepared for the Executive Committee. A copy was sent to the queen with a penned note saying that in Glasgow the bronze could be cast for one-half the English estimate of £2,000.[62] And then—subscriptions dried up.

Ostensibly the delay was caused by the outbreak of the Franco-Prussian War, "which terrible contest so entirely absorbed the public mind, that 'The Bruce' was quite forgotten."[63] Unbeknownst to Cruikshank, a lot was taking place behind the scenes. There were other contenders in the field, just as there had been for the memorial to Wallace. The Reverend Mr. Graham, hon. secretary of (another) Bruce Monument Committee, wrote to Biddulph on 3 April 1871 about a proposal to erect a granite statue eight feet high, on a ten-foot pedestal, at Lochmaben, Bruce's birthplace. He forwarded this design, "The Bruce March," but Biddulph replied that "the undertaking is hardly in a condition for me to submit it to the Queen."[64] So far, at least, Victoria had shown favor to only one project.

Then there was the unresolved question of site. Although the Edinburgh Town Council had approved a position on Calton Hill, it did not vote any funds. The Bannockburn alternative seemed unfeasible because of the flag pole. Rogers reported that the "Stirling folks" were moving ahead; eventually Major-General Sir James E. Alexander, chairman of the Bruce Local Committee of Stirling, applied to the Secretary of State for War for a space on the Esplanade of Stirling Castle. The request was granted in February 1872.[65] Earlier that month Cruikshank had received a letter from a stranger, Dr. J. S. Muchet of Stirling, praising his "chaste, beautiful & classical design."[66] But the funds in hand were simply insufficient for a heroic bronze figure. So reluctantly George told Rogers on 11 March 1872 that he would agree to having his model carved in stone by Andrew Currie, a Scots sculptor and friend of Rogers who underbid Adams Acton. Nonetheless, Cruikshank felt that some compensation ought to be offered to the original sculptor, so he proposed that on the pedestal there be carved an inscription:

Designed by George Cruikshank 1870
Modelled by John Adams Acton 1870
and Sculptured by Andrew Currie 187–.

At Rogers's suggestion Cruikshank also agreed to renounce all further claims in consideration of £100, plus traveling expenses to Scotland to inspect Currie's work. He promised to settle himself with Adams Acton.[67]

Almost immediately thereafter Sir James Alexander told George he was applying to the Treasury for funds to cast in bronze. Rogers thereupon urged George to keep up his correspondence with Alexander, because if the funds were forthcoming, George's claim "in regard to executing the work would be tremendously strong."[68] Alexander and Rogers didn't always agree, but in the ensuing months Cruikshank heard reports that funds were again being raised.

Knowing that the Stirling site had been approved and hoping still for the bronze version, Cruikshank at Sir James's prompting in 1874 modified his etching of the model so that "the head is now elevated, and Bruce *is supposed to be looking across the Esplanade towards the field of Bannockburn,* which is a mile and a half from Stirling Castle."[69] This is a far less effective design. It distances the monument from the ground where the conflict began and ended, and makes the king look as if he were expecting trouble instead of reflecting on the price of victory. Nevertheless, Cruikshank printed up an *Address and Explanation to the Scottish People* which concluded by saying that as a Scot he would be pleased to have his name publicly associated with any work of art placed in the land of his forefathers, and that subscriptions of about £1,000 in addition to what had already been raised were required. In a covering letter to the committee that suggests that he may not have received prior permission for this broadside, Cruikshank says he published the address "because this Bruce monument seemed to have come to a perfect standstill."[70]

A slight hitch now developed. William Christie, designated as secretary to the Bruce Committee of Stirling, peremptorily informed Cruikshank that the committee did not recognize George's correspondence with Sir James and warned the artist not to go behind the committee's back.[71] But that contretemps was resolved, and George assumed that his design would be executed in bronze as soon as the money was raised.

Two years later John Adams Acton read an article saying that Cruikshank's design had definitely been given to Currie. Since neither he nor George had been notified of this development, Cruikshank asked Sir James for an explanation.[72] Christie replied that since there wasn't enough money for the bronze figure, Currie was carving in stone. No mention was made of the fact that Currie was following his own, rather than George's, design. Thus neither Cruikshank nor Adams Acton expected that when the statue was unveiled on 24 November 1877, it would be substantially different from Cruikshank's model and make no acknowledgment of their efforts.

Cruikshank felt "very much aggrieved." When throughout December he

attempted to tell his side of the story via letters to the Scottish and London newspapers, he provoked responses that stigmatized him as a "caricaturist" and impugned his honesty.[73] Cruikshank disliked Currie's version, which gave a bearded Bruce different armor that obscured the royal coronet. He had to defend himself against the charge that his design—and especially the action of Bruce sheathing his sword—had been copied from Currie. It had, it turned out, been Currie's sketch of which Rogers had sent a photograph in 1870, but George insisted that he had tossed it aside as unsuitable. As Cruikshank's design was so complexly related to the original site and to a commemoration of union rather than battle, the peaceable gesture was surely inseparable from his whole conception. However, his prescience then in fearing that his own design would "be supposed to be a *Copy*" was unhappily confirmed.

Cruikshank was also baffled by the unacknowledged rejection of his work. In 1872 his terms for release, including the inscription on the memorial of his and Adams Acton's names, had seemed to be accepted. Moreover, subsequent events led him to believe that the bronze would be financed. And then he was chided for taking so much money—£85 in all—which he explained to William Christie was spent in preparing the model, taking photographs of it and etching it, transporting it to Windsor and back, making four copies, crating and shipping them, and otherwise furthering the project.[74] Moreover, he never received the £100 Rogers had promised on behalf of the London Committee, and had therefore never paid Adams Acton anything.

Too unsystematic and agitated to assemble his evidence carefully, Cruikshank drafted version after version of his letters to *The Times*, the *Stirling Observer*, and other journals. With a few minor exceptions and some allowance for overstatement, he reconstructed the history accurately. There is no question, when all the surviving documents are studied, that he was treated shabbily, used and misused, as Rogers's longtime opponent Colin Rae Brown expressed it, as "a 'stalking horse', to suit certain persons, and, no doubt, *much* of the comparatively *little* money that was got, was obtained by putting *you* forward as the designer."[75] Certainly from the time Cruikshank showed his model to the queen through his modified design published in his *Address to the Scottish People*, he was officially acknowledged as the designer of the monument for which funds were solicited. It was during this period that Rogers proposed George for a knighthood, urged him to keep in touch with Sir James about the Stirling effort, and dedicated a book to him.[76]

What happened to cause Rogers to alter his opinion of George's effort is unknown, but alter it he did. In a letter to the *London Scottish Journal*

printed directly under a notice of Cruikshank's acute illness and in fact published the day after the artist's death, Rogers asserted that

> Mr. Cruikshank's only claim to be the designer of the model which bears his name rests on the fact that his friend, Mr. Adams Acton, was willing he should adopt his work. The design of the monument sketched on paper by Mr. Cruikshank in May, 1870, and the model prepared by Mr. Adams Acton one or two weeks afterwards, are now before me, and I venture to assert that Mr. Adams Acton's work vastly surpassed that of the great caricaturist. The London Committee did adopt the sketch, but knowing how the cause had suffered through its publication, the Stirling Committee *refused to print and circulate it;* neither would they print and circulate a second etching prepared by Mr. Cruikshank in 1874. In connection with these etchings, Mr. Cruikshank obtained eighty-five pounds; in connection with his model, Mr. Adams Acton, it seems, got nothing![77]

This is unjust. The money was expended by the London Committee on the models years before the Stirling Committee acted, and when it did take over the subscription drive in 1873, its circular identified Cruikshank as the designer.[78] As for the design itself, Cruikshank planned the program, established the attitude, related the figure to its original and altered settings, ascertained the correct armor, modified the old inscriptions to suit a theme of reconciliation between kingdoms, and promulgated this iconography to queen and country. His sketches were incidental; the model inspired praise and donations. Rogers was himself embroiled in "Thracian warfare" with "Mr. Rea-Brown, now Mr. Rae-Brown, auctioneer and picture dealer," who had "traduced [him] in the interest of Mr. Cruikshank." Journals in which Rae Brown's defense were printed and which were posted to Rogers's neighborhood had the offensive articles especially marked. "What," complained Rogers in closing, "do the people of Forest Hill care about a Scottish controversy?"

Cruikshank cared. He began the Bruce Monument as a last important effort to establish his reputation as an artist who served the people of his ancestors and the nation of his birth. In its program he himself sheathed the sword of conflict, renounced that "pugnacious" streak and that glorification of the manly art of fighting which had been an article of faith since boyhood. It was as if he no longer wanted to conquer by the caricaturist's needle and acid, but hoped to set up a model (as he had once offered himself to Percy as a model) of heroic yet humane leadership. What Bruce had done to lift up a people almost reduced to servitude Cruikshank had tried to emulate in rescuing his countrymen from the thrall of oppression, bad government, alcohol and tobacco and cruelty and ignorance. In repudiating his contribution to this memorial, the committee rejected much that Cruikshank had fought for in his life and art.

46

DISAPPOINTMENT . . . ON DISAPPOINTMENT

Cruikshank's desire to usurp his novelists is well-known as an aberrant nuisance, and I have wanted to show that, far from being simply a function of his conceit and eccentricity, this desire is understandable and deserving of sympathy. Everyone said he was the new Hogarth, and he must surely have felt he had the right to be not less than an equal in any collaboration.

John Harvey[1]

"ISNT THIS a frightful calamity?" Pailthorpe exclaimed to Cruikshank the day after Dickens died.

"What! about Dickens?" George replied. "One of our greatest enemies gone."[2]

On 10 June 1870 Cruikshank felt embittered toward Dickens on several accounts. Although both strove to improve the lot of the working classes, Dickens had achieved prosperity and renown far surpassing Cruikshank's. He was a great enemy, in Cruikshank's estimation, to Temperance. His blighting effect on the *Fairy Library* seemed to extend even over the collected reprint, moving off the shelves at a very sluggish pace. And in their continued intercourse with Catherine Dickens, George and Eliza doubtless heard stories unfavorable to the apostle of family life. Cruikshank told Pailthorpe that he "so hated the fellow" he thought of canceling Dickens's facetious notes to *Lord Bateman* and substituting his own.

Dickens's death unleashed a spate of reminiscences and biographies that were often hazy about events thirty or forty years old. One such exchange took place in "The Head of Sir Walter Scott," an Edinburgh antiquarian bookshop where in the autumn of 1870 one of Cruikshank's models of Robert the Bruce was being exhibited. An American declared that he believed "the reputation of Mr. Dickens' early works was in a great degree attributable to the admirable illustrations" by Cruikshank; another asserted

that Cruikshank had only illustrated one or two of Dickens's works; where-upon a publisher who was present undertook to write the artist in order to settle the dispute.³ In reply, Cruikshank said that indeed he "did not illus-trate the works of the late Mr. Charles Dickens to the extent that most people suppose," although he was the first illustrator, suggested the "greater part" of the "second vol." (Second Series, presumably) of *Sketches by Boz*, and did *Oliver Twist*, "which was *entirely my own idea & suggestion and all the characters are mine.*"⁴ A version of this incident reached the United States, where it was picked up by several newspapers.

Meanwhile, two potboiler biographies of Dickens asserted Cruikshank's claims. Robert Shelton Mackenzie, incorporating material about Dickens from his earlier publications, completed a *Life* of the novelist on 1 August 1870. In it he recounted an incident from 1847 when, while waiting in Amwell Street for his friend to finish an etching, he saw a portfolio of twenty-five to thirty very carefully finished portrait drawings of the prin-cipal characters in *Oliver Twist*. Mackenzie asked the artist about them. Cruikshank told him they were for his long-projected "Life of a Thief." Dickens

> dropped in here one day just as you have done, and, while waiting until I could speak with him, took up that identical portfolio and ferreted out that bundle of drawings. When he came to that one which represents Fagin in the condemned cell, he studied it for half an hour, and told me that he was tempted to change the whole plot of his story; not to carry Oliver Twist through adventures in the country, but to take him up into the thieves' dens in London, show what their life was, and bring Oliver safely through it without sin or shame. I consented to let him write up to as many of the designs as he thought would suit his purpose; and that was the way in which Fagin, Sykes [*sic*], and Nancy were created. My drawings suggested them rather than [his strong] individuality suggesting my drawings.⁵

Mackenzie's anecdote, first printed in an American periodical, the *Round Table*, in 1865, was additionally recirculated by Hotten in his own 1870 biography of Dickens.

John Forster, old, ill, jealously guarding his cache of Dickens memories and pushing his enfeebled constitution to its limits in order to complete an "authorized" biography of his dearest friend, noticed Hotten's account of the origin of *Oliver* when he was composing the first volume. As J.W.T. Ley, Forster's champion and Cruikshank's detractor, admits, "Forster had never been particularly distinguished among his contemporaries for ami-ability or graciousness."⁶ Although he had once tolerated Cruikshank and even exchanged cordial visits in Lincoln's Inn and Amwell Street, he fell out of sympathy with the artist and his works in the 1850s.⁷ Blood boiling at what he interpreted as a gross libel on Dickens's originality and artistic

control—a battle Forster fought, at some cost to truth, with regard to Seymour's claims about the origin of *Pickwick*—he reprinted one of the *Round Table* paragraphs as a footnote and upon it unleashed a torrent of invective. Calling it a fable worthy of Sir Benjamin Backbite, Forster could not say if it was entirely the product of Mackenzie's imagination. Since it had traveled across the Atlantic, however, "the distinguished artist whom it calumniates by fathering its invention upon him, either not conscious of it or not caring to defend himself, has been left undefended from the slander." By reprinting Dickens's request that Cruikshank redesign the "Fireside" plate, Forster asserted that this evidence spared him "the necessity of characterizing the tale, myself, by the one unpolite word (in three letters) which alone would have been applicable to it." In a side note to the first edition, next to that portion of Mackenzie's *Round Table* article where Cruikshank describes Dickens's reaction to the portrait drawings, Forster printed "Falsehood ascribed to a distinguished artist."[8]

The first volume of Forster's *Life of Charles Dickens* appeared in December 1871. Mackenzie published his rejoinder to the "slander" on the same page of the Philadelphia *Press* as its review. Mackenzie taxed Forster with not having asked Cruikshank directly about the "wonderful story," and instanced the history of Cruikshank's letter to McClellan as confirmation of it.[9] Mackenzie sent Cruikshank a copy of the printed letter defending himself from "a very unjustifiable attack" and followed up a week later with a letter saying he had seen George Bentley's defense in *The Times* against Forster's misstatements about his father, but nothing from Cruikshank. This was obviously a veiled plea for Cruikshank to give Mackenzie public support.[10]

The American journalist did not know that, reluctantly, Cruikshank had already spoken. A second notice of Forster's *Life* in *The Times* on Boxing Day referred to the "ridiculous story" propagated in America and repeated in England to the effect that Cruikshank's plates "suggested the incidents" of *Oliver*. The artist felt he had to respond. In his statement published 30 December, Cruikshank went over his version of *Oliver*'s origins—his proposal that Dickens write the life of a London boy who falls among thieves but because of his honesty and natural good disposition eventually prospers, his calling Dickens's attention to the inquiry about the St. James's Workhouse, his pointing out Field Lane and Jew receivers not only to Dickens but also to Ainsworth, and his desire to have either a Christian or a Jew in the condemned cell at Newgate. Cruikshank slightly misrepresented his case when he alleged that he "never saw any manuscript" until the work was nearly finished; often he had drawn the plates from verbal descriptions or notes, but sometimes Dickens had sent portions of his holograph text or proof to the artist. On the other hand, Cruikshank's account

of the creation of the last plates if anything understates the rush and confusion at the novel's end:

> the letter of Mr. Dickens, which Mr. Forster mentions, only refers to the last etching—done in great haste—no proper time being allowed, and of a subject without any interest in fact, there was not anything in the latter part of the manuscript that would suggest an illustration; but to oblige Mr. Dickens I did my best to produce another etching, working hard day and night, but when done, what is it? Why, merely a lady and a boy standing inside of a church looking at a stone wall!

Cruikshank asserted that he was preparing a publication that would deal with the origin of *Oliver*—probably as part of his Autobiography—and that he regretted it would now not be published during Dickens's lifetime. Over the years he had spoken to many besides Mackenzie about his collaborations with Dickens. Edward S. Morgan, the Dalziels, J. Bertrand Payne, and Frith had heard him on the subject; the story about designing "Fagin in the condemned Cell" had been enacted in many a parlor; Merle substantiated George's version of those days; and R. H. Gooch told Thomas Wright that he was present in Amwell Street when Cruikshank was sketching the original of Bill Sikes while Dickens took shorthand notes of the burglar's conversation.[11] The Reverend J. B. Deane, Rector of St. Martin's, London, wrote to Cruikshank confirming that Pettigrew had told the Antiquarian Club about the St. James parish outrages before the commencement of *Twist*, and that Pettigrew had said Cruikshank suggested the topic to Dickens. Unfortunately, Cruikshank could not persuade Deane to respond publicly to counteract the aspersions printed in the *Evening Standard* and the *Daily News*, even though "a word from a man in your position would be of *vast importance* to me just at this moment."[12] Deane did send George a fuller account of his recollections along with a covering note giving permission for the letter to be published.[13]

For the most part, journals took Forster's side. *The Graphic*, while praising George as "a captain in art and a lieutenant-colonel of volunteers (the association sounds something like that of 'the father of modern chemistry and brother to the Earl of Cork')," nevertheless scolded him for taking "untenable ground" in considering himself "in any other than a pictorial sense, as associated with 'Oliver Twist'."[14] The artist may have made suggestions to the author; but writers pick up materials everywhere. If the scenes that are described seem familiar, well, "the essence of this kind of art is the reality it conveys." But, the article concluded, "those who know the peculiar requirements for a literary work of art are aware that the art lies in the use made of the materials, not in the materials themselves." Cruikshank tried to clarify his notions in a reply that the journal did not publish: nothing had been determined as a subject for Dickens's *Miscellany* serial

until he recommended the life of a London boy, so his "position was not, as has been alleged, that of a mere illustrator, inasmuch as the story emanated from me and not from Mr. Dickens. . . . To any share in the literary portion of this work," Cruikshank concluded, "I as a matter of course lay not the slightest claim."[15]

This exchange pinpointed the nub of the quarrel. Neither Forster nor most of his mid-Victorian contemporaries thought of illustrations as other than subordinate to the dictates of the writer. Artists such as Leighton or Millais might consent to draw for an occasional book, but their reputation derived from their independently conceived oil paintings. Dickens had been influential in establishing the dominance of author over illustrator: Browne proved tractable, as did his successors, although in the 1840s Dickens had to put up with a certain amount of resistance from good friends like Maclise, Stanfield, and Leech when they contributed plates to his Christmas books.

But Dickens did not start out his career with that measure of control. Seymour originated the characters and plot of *Pickwick*. Dickens's *Sketches* translated into prose urban scenes and types already codified by artists. He had then been called "the CRUIKSHANK of writers," and in his proposed titles to the work had equated his contribution with the artist's, "Sketches by Boz and Cuts by Cruikshank." George Hogarth, in Dickens's favorite review of *Boz*, had called the two "coadjutors." The creative ferment of the *Fraser's* circle in the 1830s was brewed by writers and artists in equal measure; the projects they mooted were usually collaborative, sometimes with several hands contributing both to letterpress and to illustration. Dickens, Ainsworth, Leech, and Cruikshank were once jointly to produce *The Lions of London*, and in the same period Dickens contemplated supplying text for Cruikshank's etchings satirizing the London theater. In 1840 Thackeray had declared that "the artist wanted the attractive subject of a boy growing up from the meagre poverty of workhouse childhood to the graceful beauty of happy youth, and the letterpress was written 'to match, as per order'."[16] Two years later, Samuel Warren had asserted that in Dickens's early works "the writer follows the caricaturist, instead of the caricaturist following the writer; and *principal* and *accessory* change places."[17]

Moreover, Cruikshank's long-standing practice as a caricaturist had been to sign on the plate the identity of the person—amateur, fellow artist, or publisher—who had brought the subject, characters, scene, and situation to him for imaging. While the phrasing sounded extreme in 1872, his assertion that he originated *Oliver* was, given the usage he had practiced for more than sixty years, no more than a fully justified acknowledgment of his coordinate, rather than subordinate, role in the novel's inception.

No one who knew the illustrious George doubted his sincerity or truth-

fulness. To account for disbelieving this story, therefore, his friends called it a "delusion." "My intimacy with Cruikshank," Frith stated, "enables me to declare that I do not believe he would be guilty of the least deviation from truth, and to this day [1888] I can see no way of accounting for what was a most absurd delusion."[18] That it might simply be true of an earlier time and a different balance of power between some writers and at least one illustrator seemed inconceivable. They "have attacked me most undeservedly," Cruikshank complained, "for they do not understand the case in fact know nothing at all about it, as all literary or other Gentlemen now living under 45 years of age being too young at that time to know any thing what occurred."[19] The "delusion" was more a projection by George's critics than a diagnosis of his condition.

Even when Forster's argument, reiterated in the second volume of the *Life*, was subjected to skeptical analysis, the results went unheeded. John Richard Dennett in the *Nation* pointed out that Dickens's letter about the last plate in the book had nothing to do with Cruikshank's assertion that he had suggested the subject, characters, and plot, "that Dickens did in fact modify his own plan, and did, to some extent, adopt Cruikshank's notion":

> Now, how does Mr. Forster meet this? Not, in our judgment, and so far as we know the facts, with candor; and not with cogency and conclusiveness by any means. What he does is to print a facsimile of the letter which the author wrote to the artist about the plates above mentioned, which nobody ever contended were not perfectly under his control, and which Mr. Cruikshank has since said, if we recollect right, were made in accordance with Dickens's wish and against the artist's judgment. If any one had denied the existence of Dickens's letter, Mr. Forster's action in this second volume would have been pertinent. As the case stands, however, we should say it is very like an evasion of a difficulty, or a singular misapprehension of it.[20]

A month later the *Atlantic Monthly* weighed in, conceding that Cruikshank probably claimed too much in saying that he furnished the characters and scenes, but still allowing the probability that Dickens, engaged at the time in writing *Pickwick* and *Nickleby* as well, changed his plot after seeing Cruikshank's sketches. This review chided Forster for his grudging reparation to Mackenzie: "But, then, graciousness is not a characteristic of this odd biography, in which the unamiable traits of the biographer combine with the unamiable traits of his subject to give the book as disagreeable a tone as a book ever had."[21]

But these were publications addressed to an American audience, stigmatized then and recently as more "credulous" than their British counterparts.[22] The fact is that the United States journals were more distanced both from the controversy and from the influence of the British governing classes and opinion makers who were canonizing Dickens. Americans were

also much further away from Cruikshank, who had been embroiled in epis-
tolary disputes for such a long time that even his best friends began to tire.
The publishers Kidd and "Read alias Brooks," his relatives Percy and
George "Junior," enemies within the Volunteers, teetotal opponents—on
how many subjects could George insert his private opinions in the "Letters"
columns? But Cruikshank felt honorbound to clear Mackenzie. Few were
still living who remembered the events of 1837: Bentley, Barham, Dickens,
and Mary Ann were dead. He appealed to Ainsworth for verification, but
received no answer. So, characteristically, he leapt into the breach himself.[23]

The Dickens controversy was extended at least another year because
Cruikshank incorporated it in a second, related dispute with Ainsworth.[24]
By now the literary lion of Kensal Lodge was a forgotten man, churning out
tedious novels which minor publishers bought for a fraction of his earlier
payments. Without friends or money, he lived obscurely in the country.
One evening in the sixties Forster and Robert Browning attended a dinner
hosted by the publisher Frederic Chapman. Browning remarked that
a "sad, forlorn-looking being stopped me today, and reminded me of
old times. He presently resolved himself into—whom do you think?—
Harrison Ainsworth!" "Good heavens," Forster exclaimed, "is he still
alive?" This is, as Ley justly observes, "one of the saddest anecdotes" ever
told.[25]

On Easter Monday, 1 April 1872, Cruikshank's old friend Andrew Halli-
day staged *Hilda! The Miser's Daughter*, adapted from Ainsworth's novel
and as usual relying primarily on the illustrations to create a succession of
tableaux vivants.[26] For Edward Stirling's original adaptation, based largely
on Cruikshank's suite of etchings, Ainsworth had published a fervent trib-
ute. Halliday's treatment was reviewed in *The Times* of 2 April. Cruikshank
fired off a letter on the 6th, published on the 8th, "to inform the public"
that "the first idea and all the principal points and characters [in the novel]
emanated" from him. This phrasing repeated that in his assertion about
Oliver Twist. Again, there was some justification for his usage: he had sug-
gested to Ainsworth the subject of a miser torn between love of money and
love of his daughter, and he had wanted to incorporate aspects of the '45 in
which all his "ancestors were mixed up" and accurate representations of
"the places of public amusement of that period." Grudgingly, Cruikshank
allowed that Ainsworth "did introduce some of his own ideas." But once
again Cruikshank wanted "the title of originator." Ainsworth fired off a
reply published the following day, in which he gave "the statement a posi-
tive contradiction." He also charged Cruikshank with suffering under a
"singular delusion in regard to the novels he has illustrated. It is not long
since he claimed to be the originator of Dickens's *Oliver Twist*." Cruik-
shank retorted on the 10th, published on the 11th. He promised a "full,

true, and particular account of all the professional transactions" with Ains-
worth, introduced his claim to have originated the *Tower* as well, and in a
postscript tried once again to clarify what it was he was asserting: "It is one
thing for an artist to illustrate an author's own ideas, and quite a different
matter when a literary man adopts and writes out the ideas and suggestions
of another person." Ainsworth disdained to reply to Cruikshank's "prepos-
terous assertions" except by repeating his "flat contradiction." At that
point, the editor declared that he would publish no more letters on the
subject.

George proceeded immediately to pen *The Artist and the Author*, which
Bell and Daldy published in June and reissued, with minor changes, around
12 July. (It was sufficiently a curiosity for T. J. Wise to produce a forged
third edition.)[27] In it he reprinted the newspaper correspondence, took up
Oliver once again, adverted to a biography of Ainsworth that had appeared
in the December 1871 *Illustrated Review* which omitted any reference to
Cruikshank's contributions to Ainsworth's fictions, elaborated on the cir-
cumstances surrounding the inception of those novels, and instanced a
number of friends, now dead, who had been acquainted with these facts,
besides "a clergyman of the City of London" (Deane) and a "dear and
valued friend" (Merle). Above all, Cruikshank was at pains to distinguish
his way of working on the disputed texts from "the usual or ordinary way of
producing illustrated novels" published serially. In the latter, the author
writes out the text first, then gives the manuscript or a description of the
scene to be illustrated to the artist. In the former, however, Cruikshank
originated the story, then met with the author "to arrange and settle what
scenes, or subjects, and characters were to be introduced; and the Author
had to *weave in* such scenes as I wished to represent, and sometimes I had to
work out his suggestions."

The distinction between a subordinate hired illustrator and a full-fledged
collaborator is valid, though not always quite as clear-cut as Cruikshank
wants to make it. But however truthful George was, his over-emphatic ex-
position and his insistence on his importance undermined his credibility.
Some of his friends privately supported him.[28] Watts Phillips counseled
against stooping to such exchanges. To wrestle with Dickens, he told his
old teacher, is to be like Jacob wrestling with an angel. But Dickens is "a
very different being from an author whose Parnassus was Shooter's Hill and
whose Helicon was the 'Bowl of St. Giles'." The admiration of men like
Messonier, Gavarni, Grandville, and Thackeray should induce Cruikshank
to pardon Ainsworth's small vanities, he concluded.[29] But journalists would
not let the matter drop, and subsequent biographers of all three principals
to various degrees ridiculed Cruikshank for his assertions. Samuel Marsh
Ellis was among the most unrestrained:

the artist's claim of "originator" was, in all conscience, so original that one is lost in wonder at the far-reaching possibilities of the new theory he so modestly enunciated. Pursued to its consistent and logical end, the whole history of literature would have to be rewritten. . . . appropriate to this new ethics of literary composition, Wordsworth's *Idiot Boy* and Coleridge's *Young Ass* can claim joint fame with the bards who hymned them; and to pursue this fascinating theory to inanimate things, Notre Dame was the "originator" of Victor Hugo's masterpiece, and the Auld Brig o'Ayr of Burns's immortal poem.[30]

Ainsworth never responded to Cruikshank's detailed history of collaboration during the artist's lifetime. He could hardly sustain a point-by-point refutation in the teeth of so many surviving documents.[31] His best bet was, having associated his case (which was quite different) with Dickens's, to remain silent, trusting that posterity would accord him the same preeminence it granted Boz. He did compose "A Few Words about George Cruikshank" for Blanchard Jerrold to incorporate in his life of the artist. He called Cruikshank's complaint about the lack of credit for the *Miser's Daughter* an "absurd pretension," charged his former colleague with being "in his dotage," stated emphatically what Cruikshank had never disputed, that not a single line of any of his novels had been written by the artist, accused Cruikshank of "overweening vanity," threw in a few compliments about George's "wonderful cleverness and quickness," repeated the preface to the cheap edition of the *Miser's Daughter* which credited one incident therein to Mrs. Hughes, and enumerated every novel written during the early forties without addressing any of Cruikshank's particulars.[32] Although he harped on the fact that Cruikshank hadn't raised any cry for thirty years, he withheld his own defense until his antagonist was dead. With that one exception, he hewed to his policy of denial; and for a century, he won his wager with the public.

The nearly unanimous discounting of *The Artist and the Author* intensified Cruikshank's frustration. No one seemed willing to take his word on anything. As a legend, he was almost a nonperson. Cultural amnesia had wiped the slate of hundreds of images; his contemporaries supposed him either his own grandson or a deluded crank. A clerk at the Inland Revenue, admitting "it savours of the Emerald Isle to write and ask a man whether or not he is dead," nonetheless begged a few lines to assure him and his colleagues that Cruikshank was still alive. George provided the assurance in person.[33]

Like many who feel they are not being heard, Cruikshank spoke louder, oftener, and more shrilly. At Manchester—Ainsworth's birthplace—in 1874 George responded to a vote of thanks from the mayor for an address on intemperance by reiterating his grievances: "Dickens behaved in an extraordinary way to me," Cruikshank declared, "and I believe it had a little

effect on his mind. He was a most powerful opponent to Teetotalism, and he described us as 'old hogs'."[34] This persistence in quarreling with the dead only added to Cruikshank's notoriety as an eccentric.[35] George had out-lived his fame. He was fighting a losing battle against being caricatured, all the while providing ammunition for unsympathetic *portraits chargés*.

Nor would others drop the Dickens connection. Cruikshank sent a set of his *Fairy Library* to Nicholas Trubner, publisher and orientalist who had been one of Douglas Jerrold's close friends. Returning thanks for stories that his whole family had appreciated, Trubner told Cruikshank that he had the advantage in his conflict with Dickens about fairy tales; Dickens was unaware of their Eastern origins and cultural migration.[36] A stranger applied to George for reminiscences of Dickens; a friend asked help in preparing Dickens readings for public performance. Help me to obtain Dickens's autograph, begged one correspondent; explain your grounds for claiming to have originated Dickens's characters, demanded another.[37] To all of these inquiries Cruikshank made polite replies.

As if his disappointments with *The Worship of Bacchus*, oil painting, the Volunteers, fairy illustrations, and credit for past collaborations weren't enough, these were also the years in which the long-running Testimonial dragged to its acrimonious end. Originally the money raised was to "be handed over in bulk" to George and Eliza, rather than being expended on the purchase of an object.[38] Some members of the committee—Ruskin the president, Sir Walter Calverley Trevelyan, vice-president, and Louis Huth, treasurer—"were sanguine enough to anticipate that a very large sum (from £8,000 to £10,000) would be realised without much effort," Howell re-ported on winding up his responsibilities, "but I, who had the real work in hand, soon perceived that nothing but the greatest personal exertion would realise anything beyond the cost of stationery and stamps for the necessary correspondence."[39] Many, however, refused to donate until they had an as-surance that none of the money would go toward payment of Cruikshank's debts. Since extricating the artist from the obligations he incurred while working on *The Worship of Bacchus* was an object of the Testimonial, Howell found this restriction perplexing and inhibiting. No such assurance could be given, even though that refusal shut off some subscriptions. And since the funds were to be paid to the Cruikshanks eventually, Howell reluctantly not only advanced George money from the balance but loaned further money against anticipated future subscriptions.[40] When about £600 had been raised (and spent), "all further efforts began to fail."

This was the condition of the Testimonial at the end of the sixties. Meanwhile, *The Worship of Bacchus* Committee had borrowed £500 at 15 percent annual interest, putting up the Exeter Hall collection of Cruik-shank's works as security. Furthermore, Tweedie had taken possession of

the *Bacchus* plate, presentation drawing, and prints and held them in trust for Cruikshank until he had repaid all Tweedie's advances with interest.[41] These included the heavy outlay for the exhibition of the painting and its provincial tour, which cost around £2,000 more than receipts. By Tweedie's figuring, Cruikshank had received £2,547 in hard cash during this period.[42] After a couple of years, the committee turned over the £500 note to Cruikshank for settlement. In 1870 he reckoned on having paid £300 in interest on it, and was no further along either in diminishing the principal or in reducing his debit with Tweedie. "By the time I may get this collection back," he explained to Howell, "I must pay several hundreds more [in interest]—thus sweeping off all that was raised by the Testimonial—and the g[overnmen]t grant also!!!"[43]

Exasperated, Cruikshank turned once again to the surviving members of the *Bacchus* Committee: Hugh Owen, Joseph and John Taylor, and Tweedie. But they rejected any imputation that they were acting on behalf of the National Temperance League or that they had any further personal responsibility. "I read it," John Taylor replied, "that the original loans principal & interest remain unpaid & that all the proceeds have been handed to you & I cannot do more."[44] His brother Joseph pointed out that he personally advanced nearly £800 to Cruikshank and only recouped £650 from friends. He could not understand why such a large sum had been of so little benefit.[45] Balked in that quarter, George then applied to wealthy individuals for large gifts or more favorable terms on the loan; he was rebuffed by Sir Francis Crossley (who donated £10 to the Testimonial instead) and R. E. Lofft, but Charles Leaf took nine packing cases crammed with the Exeter Hall collection as security for a loan of £575 at 5 percent, thus allowing Cruikshank to clear his debt to the committee and to reduce his annual interest payment considerably.[46]

"Pretty well ruined in circumstances—in consequence of being a teetotaler," Cruikshank advanced another scheme in February 1871.[47] If Tweedie would release the steel, Bell and Daldy would reprint the *Worship of Bacchus* engraving in sections, each accompanied by a printed description. This quarto volume would be sent to America, Australia, and New Zealand, where Cruikshank optimistically predicted it would have a large circulation that in turn would reawaken demand in Britain. From the proceeds Tweedie's debt could be liquidated and "at *last* some money from the sale thereof might come into the hands of yours truly."[48] This balloon never rose off the ground. So in April George tried to raise £500 by means of a circular addressed to the Total Abstainers of Great Britain and Ireland. He noted that large crowds studied his painting every day at the South Kensington Museum, and that the King of the Belgians had sat before it while Henry Cole explained every detail. Limited in distribution, this address

prompted a few to send five to twenty-five pound donations directly to Hampstead Road.[49] But Cruikshank's allegation that the committee had been responsible for the picture's faulty financing provoked a pained retort from John Taylor ("so ungenerous & unfair to myself & others") and a special meeting of the league at which it repudiated having anything to do with the *Bacchus.*[50] Cruikshank then resigned from the league, asking Robert Rae as a parting shot to find out, since the league did not sponsor the painting's three-year tour, "who the parties were that did send it on its travels."[51]

At this point Cruikshank's situation became—if possible—worse. He broke with Tweedie, using Thomas Clegg as an intermediary to try to find out what he owed and how the debt might be discharged. Tweedie refused to renew any more bills; so, for a time, did George and Thomas Mills of Glasgow, old supporters of Cruikshank and Temperance. Cruikshank thought his private letters to Tweedie might be published; "Should they be brought before the public," George threatened, "the answer that I should give would damage you [and John Taylor] for life in the opinion of the public and would be a most dreadful injury to the glorious Total Abstinence cause."[52] Tweedie backed off, ruefully charging the artist with ingratitude: he "should have . . . realised the truth of the old proverb That you may carry a man's load for a year & offend him by giving it a wrong hitch at last. It has been so with me only I have carried the load Eleven years."[53]

At this point Cruikshank got support from two old friends: John Gough and Charles Howell. Gough, to whom one of the circulars had been sent, thought he might raise £400–£500 within a few weeks. Unfortunately, Mrs. O'Leary's cow and a subsequent conflagration in Boston ruined American prospects. In the end the best Gough could manage was £100.[54] Increasingly, therefore, Cruikshank's one resource was Howell. They came into almost daily contact, either in person or through the post; Howell became more George's factotum than Ruskin's. First of all he closed down the Testimonial Fund. Louis Huth sent the balance of under £16 on 26 July 1872.[55] George scribbled a receipt, Howell composed an accounting, and the whole was published for all subscribers.

Those who contributed, while not perhaps comprising "almost every illustrious man in England" as Howell asserted, were an odd and impressive group: Disraeli but not Gladstone; two other M.P.s; a number of Academicians including Frith, Sir Francis Grant, Leighton, and Sir John Gilbert (then an associate); the Pre-Raphaelites—all three Rossettis (who obviously solicited all their friends) plus Ford Madox Brown, William Holman Hunt, William Morris, William Bell Scott, and Henry Wallis. Other artists, craftsmen, and authors pitched in a pound or two: William Allingham, William Burges, Edward and George Dalziel, Mr. and Mrs. Hall, the

Lockers, Westland Marston, Palgrave, Bryan Proctor, Tupper, G. E. Street, Philip Webb, and from America James T. Fields, Longfellow, Lowell, and Charles Eliot Norton. Scholars and critics contributed their mite: Robert Buchanan (but not his nemesis Swinburne who admired Cruikshank's work), F. J. Furnival, David Masson, George Trevelyan, and most unexpectedly Thomas Henry Huxley. A few publishers and booksellers rose to the occasion: Blackwood, Galpin and Petter, Hotten, Alexander Macmillan, John Murray, Edmund Ollier, but not Bentley, Bell, Daldy, or Tweedie. The balance was augmented by subscriptions from Cruikshank's customary supporters—people like Cosens, Merle (and George de la Pole), George Mills, the Muspratts of Liverpool, Edward Smith (but not B. W. Richardson)— and by Eliza's step-cousin Doctor James Parratt. Collectors such as Bruton, Pailthorpe, Pocock, Reid, and Truman are nowhere to be found. The largest single donation, apart from Ruskin's £100 which represents debt forgiveness, was made by John Paget. Significantly, the Temperance establishment gave little, and the Volunteers nothing. Howell found that those classes "had generally to confess themselves poor, and to regret the absorption of all available funds in the furtherance of the 'good cause'." No fewer than seventeen persons wrote to inquire about Cruikshank's eyesight. "On my answering that it was excellent," Howell reported, "some, apparently horrified, never wrote again, while others wrote saying that they were half-blind themselves, and that Mr. Cruikshank ought to feel only too thankful for such blessings as friends, and eyes to see them with."

Only by virtue of some fancy calculations could Howell present the Testimonial as a success. Having set a reduced goal of £3,500, he realized but £841 by subscription. However, taking into account the value of the government pension and the Royal Academy grant, he could claim that the equivalent of £3,741 in capital had been achieved. (Since Cruikshank had spent all the ready money, and was paying out much of his pensions in interest on the £500 loan without any prospect of paying off it or Tweedie's balance, Howell's figures gave the beneficiary scant comfort.)

Knowing that he was glossing the truth, Howell forwarded a dozen copies of the subscription list to the Cruikshanks but not one copy of his printed report. However, Eliza learned of it from a leader in the 15 May 1873 *Daily News*, searched out a copy, and exploded. She was "never so much *pained*" in her life, she told Howell; his "Egotistical Report" "*degraded*" her husband's good name. Howell had made it seem that Cruikshank himself initiated the Testimonial, when in fact it was started by Howell and others months before they communicated their intentions to the artist. And as for the government pension being a part of their successful efforts, George Mills had begun that campaign a long time previously and had already told the Cruikshanks that a £200 annual stipend was in

the offing before Howell ever appeared on the scene. On 25 June 1866 Howell had volunteered to take up the matter with Gladstone, whom he knew; then he threw Mills overboard, took all the credit to himself, and asserted that George had appealed to the government for the pension![56]

It had become apparent to Cruikshank that he would find more support for his art than for his social causes or personal finances; to that end he had once again, a year before the Testimonial concluded, turned to Howell. They devised a new appeal, based on the proposition that two or three thousand pounds would redeem his collection so that it might be presented to the nation. Accordingly, they launched a two-pronged campaign: on the one hand, to induce an individual, and on the other, to solicit a group of wealthy patrons, to ransom the art and give it to the National Gallery, the South Kensington Museum, or the British Museum. Cruikshank indited a letter of intended gift to the nation on 31 May 1872.[57] The first fruits were once again meager: Sir Richard Wallace (with whom George became acquainted during the Wallace and Bruce Monument enterprises) offered only £50.[58]

Meanwhile, Howell experienced difficulty obtaining any kind of accounting from Tweedie so that he would know exactly how much George needed to get completely out of hock. Tweedie was tired of these incessant inquiries; contrary to George's perennial optimism, the plates weren't selling and due to interest the debt was if anything going up, not down. Eventually Howell told a disappointed auditor that the engraving would not be seen for a very long time—the deficiency was nearly £500.[59] Well, then, George fired back, how much is due on the engraving alone, how much stock does Tweedie have in hand, how much have photographs of the painting produced, what are the names and addresses of the other creditors?[60] Patiently, Howell inquired; impatiently, Tweedie said it would be a waste of time to inventory once again what had been counted a year ago. This excuse George scotched as "perfectly ridiculous!—The fact is, he *does not want to let me know* how it stands."[61] But Tweedie remained adamant, not even releasing the names of other debtors.

Forward, therefore, Cruikshank went with the plan of a "Cruikshank Art Collection Fund." He devised one appeal which he wanted Howell to recast as coming from him; Watts Phillips then composed a second, prefaced with Ruskin's encomium on the Grimm plates and Thackeray's earlier question, "Is there no way in which the country could acknowledge the long services and brave career of such a friend and benefactor?"[62] Originally the secretary and treasurer of the Cruikshank Testimonial, that is Howell and Huth, were designated as recipients for new subscriptions. But the public was wearied and confused by these unending solicitations. Cruikshank had to explain that the Testimonial, though recently wound up,

dated from 1866; Howell's and Huth's names were canceled on a proof of Phillips's circular; then the circular itself was replaced by another, explaining that the Testimonial had raised "a few paltry hundreds, of little use to a man who has sacrificed so much money, time & labour in the cause of humanity."[63] This, and a reference to the losses he had sustained as a Temperance advocate, riled many. Eliza corrected proofs of the circular and catalogue of the collection, each printed in a hundred copies.[64] Dr. Richardson took the chair and Richard Barrett, a close friend of Tweedie's, consented to serve as a kind of general secretary. He even printed up a list of wood-engravings and etchings that would be desirable additions to the collection.[65]

Results could not come fast enough for George. His finances were a disaster. He was still borrowing to pay old notes, struggling to keep up the interest on the *Bacchus* loan, and supporting not only himself and Eliza but also Percy's family (George paid their rent) and Adelaide's. His expectations for money from reprints, America, and the Bruce committee had been dashed. He had to ask Howell to send his promissory notes covertly through Mr. Archibold.[66] Howell's credit was now periodically endangered by Cruikshank's perpetual insolvency; their relations grew so strained George removed him as executor from his will.[67] And Tweedie, dying, grew more and more obdurate. Eventually—probably through the mediation of Barrett—George forgave him and "saw him on his death bed . . . poor fellow, he was much pleased." When Tweedie's affairs were examined, Cruikshank felt vindicated: others had lost substantially, and the estate's unfunded liabilities amounted to nearly £13,000.[68]

Good news from Rogers in late May 1875: "An opulent M.P." might become a liberal subscriber.[69] This was Francis Fuller of Manchester, who wanted to buy the whole collection for £5,000 or a portion of it for £1,000 and exhibit it for two years at the Manley Hall Winter Garden before returning it to London.[70] Merle as a member of the committee opposed subdividing the works even temporarily.[71] Both Cruikshank and the committee eventually concurred. George asked Fuller to fulfill his original offer of £5,000 for the whole collection; since it had been announced, all public subscriptions had stopped.[72] Fuller tried to pay by Cruikshank's eighty-third birthday, heeding not only the committee's demands but also Eliza's desperate secret letter saying that George's health had been seriously undermined by the delays.[73] But "the Collection has all come to a smash," George told Howell four days before his birthday.[74] Dogged by bad publicity and shaky financing, Fuller promised he would leave no stone unturned in the attempt to fulfill his contract, but "disappointment appears to wait on disappointment in this affair of yours," he told Cruikshank five days later.[75] Anonymous letters to the Manchester papers had frightened those who had

agreed to become shareholders in the Garden. All Fuller could do was offer an explanation to the committee and the public.[76] Frantic and "very un-well," Cruikshank tried to borrow some money from Fuller personally, or to get back a drawing he had given Fuller so that he could raise some cash. Neither strategy worked.[77] Shortly thereafter, Fuller died; Cruikshank had to file suit to recover his picture.[78]

But this beggar's opera, like Gay's, concluded on a happier note. Apprised of Fuller's collapse, two of Cruikshank's Royal Academy friends—possibly Frith and Charles Landseer—came forward to help.[79] The Royal Aquarium and Summer and Winter Garden Society offered to purchase the collection for £2,500, its appraised value, to make a down payment of £1,000 on or before the end of March 1876, to purchase a life annuity of £35 for whoever, George or Eliza, survived the other, and to hire George for £100 to arrange an exhibition.[80] By the first of August 1876, debts on the collection having been paid off, the etchings, wood-engravings, and oil paintings—all framed and glazed—had been collected from various depositories and installed in the Westminster showrooms. The press was invited to a private view on that date; the opening of the exhibition afforded journals yet another occasion to evaluate Cruikshank's achievement. Cruikshank's friend William Stebbing, assistant editor of *The Times*, cooperated by planting a favorable notice. Merle congratulated George on this recognition and also on bringing the project to consummation, since he had heard that the "fishery" was not doing well.[81] It wasn't. The collection turned no profit. Ten months later Cruikshank still had received nothing for his labor installing the exhibit.[82]

47

THE VENERABLE GEORGE

*When we look to the length of [Cruikshank's] career we are
disposed to wonder, not that he should have partly failed to keep
pace with his age, but that he should have adapted himself so
readily to the changing requirements of successive generations.
He began his career by the practice of a kind of drawing which
carries us back into another century. . . . and it is a high tribute
to the versatility of Cruikshank's genius that he was able alto-
gether to abandon this earlier phase, and adapt himself to the
needs of a writer so modern as Dickens.*

J. Comyns Carr[1]

*[Cruikshank's] nature had something childlike in its transpar-
ency. You saw through him completely. There was neither wish
nor effort to disguise his self-complacency, his high appreciation
of himself, his delight in the appreciation of others, any more
than there was to make himself out better, or cleverer, or more
unselfish than his neighbours.*

Punch[2]

ON MONDAY afternoon, 8 March 1875, George and Eliza cele-
brated their silver wedding anniversary.[3] The rosewood drawing-
room furniture and the mahogany dining table and sideboard had been
polished to a deep sheen, the blue and white china, supplemented with
borrowed plates, held an ample supply of sandwiches and cakes, and the tea
service was regularly replenished.[4] Two hundred guests called. The law,
personified by Vice-Chancellor Sir James Bacon and John Paget, paid its
respects; William Stebbing of *The Times*, Charles Kent of the *Sun*, and
Samuel Carter Hall represented the Press; future antagonists Colin Rae
Brown and Charles Rogers shook hands over George's table. However much
they disliked the old man's extravagant grievances, George and Edward
Dalziel attended; so did Catherine Dickens. Collaborators like John Adams
Acton and Charles Mackay joined the celebration; Andrew Halliday came,

no whit embittered by George's having claimed a share in the *Miser's Daughter*.[5] Collectors swelled the crowd: H. S. Ashbee, who often studied old prints by the three Cruikshanks with George but kept his *Secret Life* secret, the Lockers, G. W. Reid. Wealthy philanthropists added their congratulations: Sir William Fergusson, the M. P. Samuel Morley, R. E. Lofft of Bury St. Edmunds, and Francis Fuller whose capacity to finance the Cruikshank collection would shortly thereafter collapse. Old friends were there in numbers: Sir Charles Wheatstone, normally so reclusive, the Blewitts, the Ellises of Leicester, two of the Gibbs daughters, Merle though not his "wee wife," Dr. and Mrs. Richardson. One godchild (George Cruikshank Pulford), one namesake (George Percy Cruikshank), and one possible kinsman (J. Cruikshank Roger) multiplied the George Cruikshank reflected in the gilt-framed chimney glass.[6] His old corps marshaled a guard of honor for the occasion.

Nearly a hundred guests sent letters of regret and congratulations. These included the publishers Bell and Blackwood, George's creditor and future executor George Mills, his Temperance supporter Dr. Grindrod, Academicians Frith and Richard Redgrave, the great authority on caricature Thomas Wright, and the Pococks of Brighton. Notices of the party appeared in several newspapers, one as far north as Liverpool.[7] Although the London Temperance League was conspicuous by its underrepresentation, on the whole the guests encompassed Cruikshank's wide range of services: to art, book illustration, social reform, public and private charity. Subsequently Colin Rae Brown proposed to Charles Rogers that they get up a "Silver Wedding Testimonial Fund"; Rae Brown received £6.5.0 before George and Eliza stopped the effort, fearing it would interfere with the drive to purchase the collection.[8] Compared to the £1,600 collected on the occasion of the Halls's golden anniversary the previous year, the £6 were more cloud than silver lining.

This celebration belies Cruikshank's reputation as a quarrelsome friend.[9] Although when angry at his publishers he fumed and stamped like Rumpelstiltskin, he healed every breach save that with William Kidd. In most cases, Cruikshank changed publishers only when the founder died or the firm went out of business; he stayed with Humphrey and Fairburn and Fores and Tegg, with Robins and Tilt and Bogue, with Cassell and Tweedie, and Bell and Daldy, until the connection no longer paid either partner. Similarly, with rare exceptions—Dickens and Ainsworth are the only prominent instances—Cruikshank's close friendships lasted until death: Auldjo, Barker, Flight, Forrester, Gibbs, Goodyear, Horace Mayhew, Pettigrew, Watts Phillips, Sheringham, Thackeray, and Wheatstone, who predeceased him, and three who survived, Sala, Richardson, and Merle. The family connections often extended into the second and third generation:

George Cruikshank Gibbs asked his godfather for help placing a favorable article about his felt dyeing invention in *The Times*, and Frederick Barker, grandson of the "Old Sailor," used George's contacts to land a job with a London publisher.[10] On the other side of the ledger, the executors of William Behnes's estate presented a claim for £575 which George did not settle.[11]

For the most part pensioners remembered Cruikshank's benefactions without resentment, while dependents continued to look to him for support long after the formal ties had been severed. Six months before his silver anniversary George spent days trying to obtain a pension or grant for Joseph Sleap's widow, who after fifteen years of supporting herself and her daughter by needlework had broken down in health.[12] A blind widow asked Cruikshank to stock a basket with stay laces, cotton reels, pins, and needles so that she might earn a living in the street for herself, her three children, and her elderly mother.[13] Miss Barbara Allen of Eccleston Square S. W. solicited a contribution to maintain the widow of Henry Kingsley, Charles's younger brother who died miserably of cancer and left her unprovided for.[14]

Many who were invited to share this anniversary loved the private man—not the ardent teetotaler on the platform or the ink-stained etcher in the studio, but the energetic pedestrian, the ready philanthropist, the lively dinner guest. He would walk into Watts Phillips's home in Redcliffe Road, announce himself to the servant as George Crookedlegs, then sit in the parlor drinking tea, eating muffins, and joking by the hour.[15] When he called upon the Lockers, he occasionally spoke about his troubles, but more often he dwelt on the past, on old friendships and triumphs.[16] The unsympathetic gossiped about his vanity, his assertiveness, his ostentatious behavior; those who cared saw "a tenderness and grace, an earnestness and a lively sympathy, which were entirely his own."[17]

Remarkably active and strong for an octogenarian, George prided himself on his physical condition. He overpowered a burglar when he was seventy-five, although he may not afterwards have enforced the lesson by contrasting his own state to that of the drink-soaked ruffian, a ridiculous "invention of one of the several studio-tattlers," according to Cruikshank's physician.[18] If all the Archibold children were indeed sired by George, they provided living testimony to his prowess, although he could only allude to such vigor indirectly through sword dancing and other feats of agility. His mind was not entirely reliable; like many older persons, he had a clearer memory for distant events than recent ones and a tendency to mix up names. For some reason he always called John Cordy Jeaffreson "Mr. Griffith." Jeaffreson, a popularizing writer who worked in the Public Record Office under Duffas Hardy, reports one scene when Eliza corrected her spouse.

"My dear George, you do make such strange mistakes with people's names. This is Mr. Jeaffreson. His name isn't Griffith."

"Nonsense, my dear!" George retorted testily. "This is really too ridiculous of you. 'Tis really too ridiculous of you. This is my friend Griffith. I have known him for years, and never knew him by any other name." Turning quickly from his ridiculous wife to me, the veteran added, sharply, "You surely haven't changed your name?"

"I haven't changed it," I replied, "since I made your acquaintance."

"Of course you haven't. There, my dear," George ejaculated triumphantly, "you hear what he says. He says his name is Griffith. Does that satisfy you?"

Jeaffreson got Eliza quietly aside to protest that this innocent confusion was doing no harm.

"But it is rude and foolish of him to call people by their wrong names. You are not the only person he misnames."

"You'll annoy him and do no good by calling his attention to a weakness that sometimes troubles good men in the evening of their days. Anyhow," I said, "leave him alone in respect to the name he has given me. He likes me as Griffith, and it pleases me to know he likes me. Known to him by another name, I should perhaps be less acceptable to him."[19]

For all the gleaming wood and sparkling crystal, George and Eliza were living on the cusp of the middle class. Their residence was hardly in a fashionable neighborhood. Frederick Wedmore describes it as a "dreary quarter" where "the dingy squalor of St. Pancras touches on the shabby respectability of Camden Town."[20] And after all the Testimonials and pensions were deposited, they struggled unsuccessfully to pay the landlord on Quarter Day. In February 1877 Sarah Wootton, a spinster, rented the two upper drawing rooms together with the use of the back kitchen for half a guinea a week.[21] The house was shabby; bad drains gave Eliza enteric fever. But neither the former owner nor the new one was conscientious about making repairs, especially since George fell as much as three quarters behind in his rent.[22]

In addition, there was the constant anxiety about Adelaide. Cruikshank managed to give her £500 from the Aquarium sale, but still he was hustling money for her from every conceivable source. From Pocock he secretly borrowed £30, explaining that he had lent such a large sum to relatives he dared not tell Eliza. Then he tried to substitute drawings or proofs for repayment of the loan, but Pocock insisted that he be repaid, though without interest. George replied with a long list of his friends who were wrestling with a financial depression and concluded with the request that Pocock write thereafter to Mr. Archibold, enclosing an envelope addressed to himself:

As my wife has to write an answer to all letters—she opens them *all* & as my losses have been most severe—and as the money that my relatives have had amounts to a very large amount—for her sake I am obliged to keep matters as secret as possible—& as she has always sent—& written to you she was surprised to find that *I* had sent a proof to you, instead of as usual getting her to do it.

The manager of the Post office [to whom Pocock had addressed previous correspondence] is going for a Holiday so in case you want to write to me again—I enclose an envelope for you to put your letter in—He [Archibold] is a person that I employ & being aware of the reason for having a private correspondence with my relations—keeps all letters safe until I see him—[23]

Sneaking around was terribly hard on George's fundamentally honest, childlike nature. To those initiates who were acquainted with the existence of the other family it was also difficult. Eliza must have known something, although the full extent of George's obligations was not apparent until his death. Nevertheless, the silver wedding was a strain on the honorees and on some of the guests. Embowered by bouquets, Eliza wept at the conclusion of Samuel Carter Hall's toast. George sustained a farrago of jests and smiles until nearly the end, when he felt faint and withdrew, quipping to Walter Hamilton as he passed, "You are down on our list of visitors for the Golden Wedding."[24] Privately, Hamilton thought that few of the guests could have imagined "what a hollow mockery the whole affair was, more particularly those who saw (as I did) the intense distress of Mrs. C. when, towards the close of the reception, G. Cksk fainted from the fatigue & excitement."[25]

Cruikshank's art mediated his vision. His pamphlets addressed his convictions more directly, but only on a limited range of subjects at a particular moment in political and social history. For a full straightforward exposition of his life and creations, he counted on his autobiography. He had been making notes for it since 1828, when he declared on the first leaf of a new memorandum book: "I have determined to write my own Life—as long as I live—and I do this for two reasons, the first is that my character may appear in its true colors, & secondly, with the Hope that it may do some good."[26] This resolution to keep a diary, periodically renewed and abandoned over the next decades, resurfaced in the 1860s.[27] When he discovered Charles Hancock's process for etching on glass, he decided to use it for the illustrations. He and Eliza began drafting and redrafting the opening passages, and from time to time obtained plates from Hancock on which he scratched designs.[28] Then he entered into the agreement whereby Ruskin would subvent the writing, an arrangement which did not last long. In 1872, desperate once again for ready money, Cruikshank hocked his autobiography to Bell and Daldy in return for their discounting a £50 note

for three months. If he failed to deliver "the MS of the Recollections of My Life by the 28th of February 1873," he would undertake to repay advances they had already made upon it and to withdraw the cuts prepared for it.[29]

At this point the publishers also prepared a publication agreement, never finally executed, which gives more information about George's plans.[30] The title was to be "The Recollections of George Cruikshank—Artist—with Sketches, Etchings & & & To which is added An address to Posterity." The etchings on glass were only a portion of the whole project, for he intended to provide forty or fifty illustrations in all, some etched on copper, some engraved in wood, and some reproduced by "other processes." The letterpress would run to around 250 *Omnibus*-size pages. He also sketched a cover design which incorporates a variant of the contract title.[31] Evidently George conceived of a multidimensional work—part written recollections, part prints chronicling the stages of his artistry, part exposition of his beliefs for posterity. For this section he may have started a treatise on "Universal Christianity," in which he maintains that creation is a self-acting principle and that it displays *purpose* and *design* everywhere.[32]

Around this time, too, George scribbled a list of "Preferences." Some of these are predictable. He disliked humbug and alcohol, and believed in the virtues of drilling and athletic exercise. His favorite monarchs were Queen Victoria, Lady Jane Grey, George III whom he would have remembered better than his contemporaries, and then those whose legends had undergone refurbishing in recent decades, Alfred the Great and Arthur. His heroes were Nelson, a constant, and Wellington, a revision. Most admired authors were Shakespeare, Burns, and Scott—no surprises or changes of heart there. His artistic preferences are a bit more eccentric: Raphael first, a painter as far removed from George's own line as could possibly be imagined (was he momentarily responding to the arguments of the PRB?), then characteristically, himself, and finally Hogarth. No mention of Rembrandt, Dürer, or Gillray. He prized among all other virtues honesty and honest charity. And he stated his ambition in becomingly modest terms: "To rank with the worthy."[33]

Such scrappy efforts at expressing himself did not, however, constitute a publishable text. No manuscript was ready for Bell in 1873; *The Artist and the Author*, trouble over the Bruce statue, preparations for selling his collection, all interfered with writing. From time to time he fiddled with the glass plates.[34] He and Eliza sailed to Edgware to look at his old school, but it had been pulled down.[35] Yet something very deep in his psyche kept him from composing any kind of orderly account, either in words or pictures. By 1874 he was diverting himself with irrelevant designs. George Nottage, managing partner of the London Stereoscopic Company, appealed to Cruikshank's "wonderful multum in parvo ingenuity": could he design a wood-

engraving of the word "PORTRAITS" wherein each half-inch-high letter would embody a funny little figure? After complying, Cruikshank scratched his image three times onto a glass plate as an instance of how accurately he could copy his own work, and this became another of the autobiographical illustrations.[36]

George's literary incapacity played havoc with posterity in more ways than one. Walter Thornbury, who had published an article on "The English Caricaturists and King Cruikshank" in 1861, "beseeched" King George to finish his *Recollections* because they would embrace the whole history of English caricature and, accompanied by his own drawings, be as permanent as George's fame.[37] Frederick Locker's brother Arthur, who edited the *Graphic* and wrote novels, wanted to publish some biographical matter, but George begged him not to because "the idea of being *anticipated—puts* me out—altogether."[38] The same motive impelled Cruikshank to deny others permission to write about him. Ignorance about him and his family abounded, even for someone like Walter Hamilton who had published one series of articles and was preparing another on the early works.[39] He wondered if "R. Ck." was a brother, "I. R. Ck." George's father, and "P. Ck." another brother?[40] In the face of such confusion, it is hard to fault George for resorting to *The Times* to sort out his relations. Temperance fans urged him onward. A Nottingham journalist thought he ought to say something about the advantage to artists of the pledge; so far as he knew no other octogenarian had ever written and illustrated a book as George was doing, thanks to teetotalism.[41]

Anecdotes about George proliferated, commentaries on the text of his name and published persona. His quirky lines and characteristic images facilitated the production and dissemination of Cruikshankiana. In person and in private correspondence, however, he was often less exaggerated—sometimes, in fact, rather dull. His jests could be as spontaneous and trivial as his father's, and his conversation as unremarkable. What William Clarke observed in the 1820s remained true to the end of the artist's life: George was memorably humorous only with his pencil, and said few good things.

The other aspect of his oddly elusive personality that his satires and public quarrels belie is his extraordinary empathetic faculty. He felt instinctively and readily for the struggles and needs of others, and in the case of fellow artists, for their visions as well. Perhaps this sympathy contributed to his fierceness: he warred with a part of himself when he contended against someone like Dickens whose values he had shared and imaged. This intuitive sympathy drew many who were not naturally, artistically, or politically allied to his side. It is startling, for instance, in the diaries of A. J. Munby, a civil servant and poet obsessed with working-class women, to find Cruik-

Square 8vo., cloth extra, bevelled boards, gilt edges, price 5/-

PEEPS AT LIFE;
AND STUDIES IN MY CELL.
BY THE LONDON HERMIT,
Author of " Songs of Singularity," &c.

ILLUSTRATED BY GEORGE CRUIKSHANK.
N.B. The profits from the sale of this book will be devoted to the **Byron Memorial Fund.**

SIMPKIN, MARSHALL & CO., Stationers' Hall Court, London.

79. *Advertisement for* Peeps at Life, *1875*

shank, "wonderful old man, looking scarce more than 50, with grey restless eyes & shrewd face, dancing quadrilles vigorously" at Westland Marston's birthday party, admist such notables as Hepworth Dixon, Swinburne, the Duffas Hardys, and Tom Robertson the playwright; or four years later at another of Marston's gatherings in the company of Dante Gabriel Rossetti and Richard Hengist Horne.[42] That the editor of the *Athenaeum*, the leading Pre-Raphaelites, and the most popular West End dramatist all enjoyed Cruikshank's company is a fact neither his letters nor his public images would prepare one to expect.

George's art advanced little more than his "life." There was, however, a kind of appropriateness to his last three plates, all of which he signed "Age 83 1875." Together they encompassed much of his career. He designed two wood-engravings for *Peeps at Life; and Studies in my Cell*, by the London Hermit.[43] The vignette title (fig. 79) depicts an elderly bibliomaniac in a garret near St. Paul's reading far into the night. The support of readers, especially bibliophiles, had always been important to Cruikshank, and was

to be crucial in outlasting the eclipse which his reputation suffered after his death.[44] The title-page cut pays an entirely appropriate, though still somewhat grotesque, tribute to those enthusiasts. Opposite it, the full-page frontispiece might be said to recapitulate his achievement in illustrating history, fiction, and Shakespeare: picturing "A Wild Ride with Herne the Hunter," it conjures up memories of *Windsor Castle* and *Falstaff* and *Merry Wives*, Dick Turpin's gallop and John Gilpin's and the Epping Hunt, the horses going to the dogs and George's stable of queer nags and knackers. Together, vignette and frontispiece display Cruikshank's mastery at designing for wood-engravings. Additionally, since profits from the book's sale were devoted to the Byron Memorial Fund, Cruikshank's commission connects to his important Byron illustrations and to his lifelong efforts to memorialize heroes. Both plates were reproduced in the Christmas 1875 *Bookseller*, thus associating the artist with a season he celebrated memorably and with the periodical press which so often devoted columns to him. Ironically, the thrust of this review essay is that Cruikshank's name "represents amusement, instruction, money." Book dealers advertise their stock not by the name of forgotten authors, the article informs the trade, but by the name of their evergreen illustrator.[45]

George's last published print was an etching of a fairy subject illustrating a book he had been midwifing for some years. While he was engaged on the plates for *The Brownies*, Octavian Blewitt's wife Ann asked him to place a story which he found "very charming" and which conveyed "a beautiful and most important moral lesson." Notwithstanding his enthusiasm, Bell and Daldy declined to publish it, so George submitted it to *Aunt Judy's Magazine*.[46] Evidently Mrs. Gatty likewise rejected it, for two years later Mrs. Blewitt wondered plaintively whether there was any chance of her tale's being accepted somewhere.[47] She entertained one possibility in 1875, offering Cruikshank a share in the profits or a guaranteed fee; she was sure that his name would sell the book.[48] He made a couple of sketches which if she approved would necessitate a "slight alteration" in the text.[49] She agreed to the adjustment, so George etched his final book plate, the frontispiece (fig. 80) to an inconsequential story about how the rose and the lily, his two favorite flowers, became the emblems of Britain and France. But the publishers backed out at the last minute, leaving the project in limbo. Fifteen months later Andrew Chatto offered to publish the *Rose and the Lily* "upon the condition that it shall be illustrated by our friend."[50] By September it was advertised. Mrs. Blewitt thanked her artist profusely for his help; but for his goodness, she believed it never would have been published.[51]

Of Cruikshank's late designs, this is the most haunting. Framed by luxuriant foliage growing on the banks of a lake at the foot of verdant hills, a shaggy-headed monster (*The Demon of Evil*) emerges from the water, its

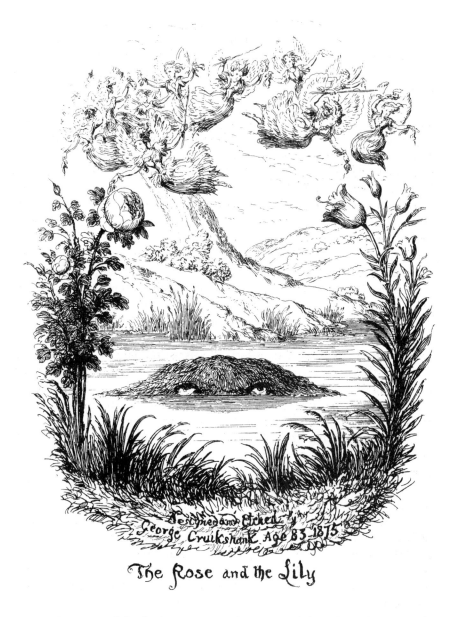

Designed and Etched by
George Cruikshank Age 83 1875

The Rose and the Lily

80. George Cruikshank, *frontispiece* to The Rose and the Lily, *etching, 1877*

widely separated eyes glowering at the aerial corps de ballet of fairies water-
ing the rose and the lily. The design harmonizes the disparate elements:
nature and the supernatural, beast and fairy, blessing and envy. All kinds of
tensions are evoked, however. Titania's wand-bearing sprites tend the
flowers, so nature and the supernatural are not opposite categories but com-
plementary ones. By contrast, the demon seems completely at odds with its
aqueous habitation; it resembles the fiend in Scott's *Demonology*, a "huge
haystack" rolling in the ocean. Something within the plate genders it as
male: his fascination with and envy of the fairies articulates desire, but
whether for fairies, flowers, or the beauties of imagination is unresolved.
His gaze is as riveting as that of Hans of Iceland or Nancy's suppliant eyes or
George's keen scrutiny. The demon's prowess in this instance derives not
from physical dexterity or strength, not from seven-league boots or gigantic
limbs, but from a more inner force of looking, seeing, spying, and thereby
capturing the spirit of the Other. Fearsome yet contained, he might be a
disarmed artist bound by his surroundings and unable to create, or a viewer
mesmerized by the delights of art yet frustrated because they are unobtain-
able. He could figure the satirist, nay-sayer at the feast, or that primary
inextinguishable force erupting through the waters of unconsciousness
which energized Cruikshank's etching needle. Considered as a mythical
archetype, the monster defines himself against the fluid and the feminine,
more substantial than the fairies and powerfully relating through his gaze to
all the worlds around him. He is the male antitype to the birth of Aphro-
dite which George had painted so badly. Moreover, there is something
attractive about his defiance, a "naughty boy" challenge that resembles
Cruikshank's defiance of Ruskin and his own earlier achievement by deftly
etching a composition incontestably reminiscent of his Grimm plates.
However one interprets the picture on its own as well as in the context of
Mrs. Blewitt's tale, it resonates with issues central to Cruikshank's whole
oeuvre.

By inscribing his age on the plate Cruikshank participated in the fiction
of his own "venerableness"; he offered this work as an example of un-
diminished vitality and accomplishment. Paradoxically, however, signing
his age provides an excuse, seems to say that the plate is remarkable only
because it was done by such an old man. He might have retired with his
laurels. His scrambles for money were in some ways merely excuses for con-
tinuing to impel the public to pay attention; his needs were real, but it is
likely that a different ordering of priorities would have reduced them within
the compass of his income. But George couldn't stop. There was no mem-
brane separating his conduct from his principles, his counsel from his cari-
catures, his beliefs from his pictures. To be "worthy" for him was to be
integrated, honest. Hence the strain of his relationship with Adelaide,

honorable enough in its own terms, yet to many incompatible with the "preachy-preachy" righteousness he assumed when scolding others.[52] To be "worthy" was to be all-of-a-piece, not "all-of-a-twist" as Watts Phillips punned on his Dickens claims.[53] And so he was incessantly "at it again," asserting himself in letters to *The Times* on everything from traffic accidents to capital punishment.[54] Vanity was not George's motivating force or abiding weakness; he was driven by a sense of self engendered by the practice of Georgian caricature which was at odds with Victorian culture: an absence of division between the public and the private realms which entailed that every act be submitted to public scrutiny for normative judgment. George was the printing press, the *oculus dei,* and that which they gazed upon: subject and object, printmaker and print. Although at times he had hesitated to use the word, in the end his autobiographical manuscript was entitled "George Cruikshank—*Artist.*"

His art, though increasingly out of favor, had in countless ways soaked into the roots of nineteenth-century European culture and influenced its flowering. He had been the principal graphic artist transmitting Hogarth to a new century. Every black-and-white draftsman, from Robert Seymour and John Leech to John Gilbert, George Du Maurier, and Randolph Caldecott, learned something from his examples. Whistler and Walter Sickert considered Cruikshank the greatest nineteenth-century English artist.[55] On the Continent, two generations of French artists imitated aspects of his work: Monnier, Géricault, Delacroix, Daumier, Grandville, Gavarni, Doré. One of Edouard Manet's early prints, executed on commission from the publisher Cadart but never issued, is *Le Ballon* (1862). Said to have been strongly influenced by Goya, whose own art responded to and in turn influenced British graphic satire, this scene of a large passenger balloon in the midst of a street fair is filled with Cruikshankian motifs from broadsheet prints: the lively and individualized crowd, the puppet show, the man climbing a greasy pole, and above all the balloon—aeronautical machine and image of fraud, folly, illusion.[56] The penultimate scene in the *Wizard of Oz*—the film as well as the original book being a compendium of popular motifs—might have derived from such representations.

Cruikshank's Napoleonic caricatures circulated throughout Western Europe. They were pirated, copied in the same or other mediums, applied to different subjects or points of view. His depictions of George IV affected that monarch's reputation in perpetuity. His book illustrations were reprinted on the Continent either without attribution or signed by another artist. He has been credited with innovating the dynamic use of dialogue balloons, interlocking them to indicate a rapid-fire exchange of repartee.[57] One of his plates became the first modern "cartoon," picture plus dialogue or punch line printed underneath the cut. In many ways he anticipated

Punch and its manifold descendants. Some of his book illustrations, such as "Oliver asking for more," have gained a separate life as progenitors of a large family of adaptations. Other etchings shaped the theatrical realizations of novels, down to and including David Lean's *Oliver Twist* and Lionel Bart's musical *Oliver!*. And among cartoonists—editorial, political, and social—Cruikshank still holds a special place. As a twelve-year-old living in New Jersey, Charles Addams was an avid admirer; Arnold Roth learned from George; Maurice Sendak "just went after everything I could put my hands on illustrated by Cruikshank and copied his style. It was quite as simple as that."[58] Ronald Searle and Draper Hill assembled collections of Cruikshankian scraps and sketches, and David Levine drew the master drawing us.[59]

The contemporary artist with whom Cruikshank continued to have most in common was Doré. Like George, Gustave tried to force himself on the establishment by essaying every branch of art. Unlike Cruikshank, Doré could count some successes. He had friends powerful enough to get him the Legion of Honor; Cruikshank's patrons could not procure for him a knighthood. However, when the two stormed the citadel of heroic sculpture they met similar repulse: Doré for his statue of Alexandre Dumas, Cruikshank for Robert the Bruce. Each tackled a gigantic project that yielded ambiguous results: George's elephantine *Bacchus* matches in ambition Doré's eleven-foot-high bronze tribute to viniculture, *La Vigne*. With intent opposite to George's, Doré's vase celebrates intoxication; he wanted it to be part of a fountain in his never-completed museum, or to be purchased by the Municipality of Paris, whereas it ended up far from home in San Francisco's Palace of the Legion of Honor. Even after death their fates were intertwined: Blanchard Jerrold wrote both biographies, dedicating Cruikshank's to Doré.

48

GEORGE THE 1ST AND LAST

I never knew a man who made such effective exits as did George Cruikshank; and it is (as all actors know) an extremely difficult thing to quit the stage with éclat. When George left you with a flourish of the [large gingham] umbrella, or a snapping of the fingers (or sometimes with a few steps of a hornpipe or the Highland fling), he never failed to extort from you a round of mental applause, and you felt yourself saying, watching his rapidly departing form (for he was as active at eighty-one, ay, and at eighty-five, as a County Court bailiff), "God bless the dear old boy! how well he looks, and what spirits he has."

George Augustus Sala[1]

As the winter of 1877–1878 advanced, the Cruikshanks scarcely moderated their busy schedule. George, indignant at the fate of his Bruce statue, blew up an epistolary blizzard. He accepted an invitation to chair one Temperance meeting on 8 January, another on the 16th, and a third on 5 February.[2] He received a ticket for Walter Hamilton's lecture on his early works to be delivered at the Chelsea Literary and Scientific Institution on 11 January, and one for a lecture on Old English Ballads to be given three days later.[3]

On a bitterly cold morning in mid-December he breakfasted at the Lockers with Austin Dobson. The conversation centered on Cruikshank's visits to prisons and criminals in connection with *Oliver Twist*. Bright and alert, George "appeared to have an excellent memory for the circumstances of his career." Dobson, who was to write the Cruikshank family's entries for the *Dictionary of National Biography*, asked whether it was true that the artist had hit upon Fagin's attitude in the condemned cell by accidentally catching his own reflection in a cheval glass. "False!" Cruikshank exclaimed. He had never been in any doubt about the main points of his design; he studied his own reflection in the mirror to determine whether the knuckles of the hand Fagin was biting should be raised or depressed,

much to the astonishment of a young relative looking on. He then enacted his account, looking so much like his character that Locker playfully addressed him as "Mr. Fagin." "I did not see at the time," Dobson told Blanchard Jerrold,

> why he was so tenacious. But, of course, what he wished to impress upon us was that the drawing of Fagin in the cell, which shares with Sikes attempting to destroy his dog the post of honour in "Oliver Twist," was the result, not of a happy accident, but his own persistent and minute habit of realization; and though there appears to be a modern disposition to doubt that a man can know anything about his own past, I for one shall always prefer Mr. Cruikshank's story to the others.[4]

On New Year's Eve Samuel Carter Hall forwarded to Hampstead Road some "pure breed" American apples which had been shipped by one of George's Yankee admirers.[5] The present was particularly appropriate just then, for winter flu abounded. Merle had been very ill. From Bournemouth where he had gone to recuperate in the bracing sea air he indited a letter of reminiscence. "Do you remember," he asked his "old friend & true," "when I used to call you George the 1st and last? meaning 'we shall never see his like again'." He advised George to be careful of his own health.[6] During the first week of the new year Cruikshank was his usual self. Grace Stebbing, daughter of the minister who had presided at Mary Ann's funeral and sister of *The Times* subeditor, "met him hurrying along the streets with cheerful, eager aspect, to keep 'a business appointment.'"[7] He also called at George Bentley's home, where he "footed the difficult and rapid shuffle of the hornpipe" to demonstrate his vitality to R. H. Horne.[8]

But the apples could not ward off a recurrence of the upper respiratory infection that had often attacked him in recent years.[9] Reluctantly he took to his bed. The old campaigner who insisted that waterdrinkers never got sick had difficulty shaking off this ailment. Eliza declined further Temperance invitations until he recovered.[10] At his lecture on the 11th Walter Hamilton reported Eliza's letter informing him of her husband's illness. News of the severity of George's indisposition leaked to the press, which began running brief bulletins. Concerned friends followed the ups-and-downs of the fever chart. The infection intensified. Dr. Richardson diagnosed acute bronchitis, the same affliction that had killed Robert, but by the middle of January Cruikshank appeared to be improving. The post brought letters daily from intimate friends as well as strangers and admirers who rejoiced in his temporary recovery and expressed anxiety about relapses.[11]

Eliza nursed her husband around the clock. She had always believed in his genius, rated him even higher, possibly, than he rated himself. To organize his life, deal with his correspondence, fight for his recognition, fore-

stall or mitigate disappointment, support him in public and in private, were responsibilities she accepted happily. Trained from childhood to care for others and coming late to a childless marriage, she lavished her attention, energy, and affection on her St. George. A sinewy and grizzled veteran, he now lived most intensely in the past. Like the sailors whose progress he had depicted a half-century earlier, Cruikshank loved to rehearse old victories. His mind ran on the heady days when with Hone he brought the Bank of England, the government, and the king to heel. He dwelt on his Corinthian escapades and on his triumphs for Dickens and Ainsworth. His memory traveled back to his legendary forebears, those stalwart Stuart sympathizers who sacrificed jobs, homes, and family for a losing cause; he found in their honorable history a comforting precedent for his own case.

But as the short January days passed, George's light dimmed. On 21 January *The Times* rejoiced "that the acute symptoms have not returned, that the exhaustion is somewhat less, and that, though all danger has not yet passed, Mr. Cruikshank's medical adviser takes a more hopeful view of the case than he had been able to take during part of last week."[12] Dr. Richardson overestimated his patient's recuperative powers. Once or twice before Cruikshank had collapsed after a heavy blow—most notably in the months following Mary Ann's death. The Bruce debacle, piled on top of so many other disappointments, sapped his constitution more than anyone realized. Day by day he lost ground, slipping into almost constant slumber.

Thursday night, 31 January, Cruikshank experienced "dreadful pain." Eliza sent for a poultice at 10 a.m. the next morning. After a hard frost, the day turned bright and fine, the temperature rising from 29 to 39 degrees Fahrenheit. But George did not rally. At last Cruikshank's physician, though himself an ardent teetotaler, recommended a medicinal dose of brandy to fortify the patient. Cruikshank refused, taking instead a "composing draught." Afterwards the eighty-five-year-old artist lay "easy and quiet until he passed away" in his sleep at 7:20 that evening. Dr. Richardson stayed with Eliza until the end.[13]

For once George got his timing right. He died at a moment when the public had renewed its interest in him. His collection was on show at the Aquarium, his name had resurfaced in connection with the Bruce, and his three weeks' illness alerted editors to the possibility that they would need obituaries written and portraits made. As soon as Dr. Richardson confirmed the death, George Cruikshank Pulford took the account to all the newspapers. *The Times* devoted twenty-four column inches the next day to a leader probably written by Tom Taylor.[14] Other London dailies gave the story prominence, the best eulogy being penned by Sala for the *Daily Telegraph*. The following Saturday the weeklies ran their tributes. The *Athe-*

naeum, Academy, Saturday Review, Graphic, and *Judy* were all complimentary. *Punch,* surprisingly, carried one of the warmest assessments: "There never was a purer, simpler, more straightforward, or altogether more blameless man."[15] The *Illustrated London News* published a large oval portrait of the artist on the 16th, and Curtice and Co. issued a broadsheet memorial of the "Painter, Philantrophist [sic], and Patriot" imprinted with a flattering likeness and a four-verse elegy (fig. 81).[16]

George's knell resounded far beyond Fleet Street. The *Birmingham Daily Mail* noticed his passing. The *Christian Herald* disseminated the peal to Anglican parishes by plagiarizing Sala, while Mrs. Law's *Secular Chronicle* predictably dwelt on Cruikshank's Hone propaganda. In Paris, *L'Art* declared that Cruikshank was the chronicler of English life for his century. *The Reliquary and Illustrated Archaeologist* numbered him among its "Departed Contributors and Literary Friends." Belatedly in mid-April George's old friend W. L. Sammons began an incoherent three-part reminiscence in the *Cape Templar,* the official organ of the Western Grand Lodge of South Africa at Cape Town. For Americans the June *Scribner's* carried a long article accompanied by twenty-three illustrations. And Temperance literary societies were immediately informed that J. Francis Bursill had prepared a "highly instructive and interesting Lecture" on the artist's life and labors, illustrated by "a beautiful series of dissolving views" of his art.

Obituarists relied on Thackeray's essays, the 1863 Exeter Hall brochure, and Reid's 1871 *Catalogue.* Hasty reading and preceding inaccuracies perpetuated mistakes. Two of the most frequently repeated concerned Dickens: *Sketches by Boz* was often dated 1838, and at least three journals declared that the controversy over Cruikshank's claim to have originated *Pickwick* was still unsettled. In the face of such journalistic ignorance the artist's frustrated efforts to establish the facts seem at once more justifiable and more quixotic. Moreover, false pieties assimilated his embattled seniority to comforting Victorian paradigms: the *Morning Post,* for example, assured its readers that his "old age was spent in repose and comfort."

Many reviewers confessed that Cruikshank's productivity confounded any effort to be inclusive in evaluating his art. The high spots mentioned were almost always the same: *Tom and Jerry,* fairy tales, the book illustrations for Dickens and Ainsworth, *The Comic Almanack, The Bottle,* and *The Worship of Bacchus.*[17] Oddly, several writers took Cruikshank at his own assessment and proclaimed that the *Bank Restriction Note* was his greatest achievement; the *Morning Post* concluded that a man who can boast that his art stopped hangings "can scarcely be said to have lived in vain." As an artist his strengths were conceded to be his humor (purged of Georgian bawdry), his earnest morality, and his perpetuation of Hogarth's example. Some appreciated what Ruskin discerned, namely Cruikshank's tragic

IN MEMORIAM.

BORN SEPTEMBER 27, 1792. DIED FEBRUARY 1, 1878. INTERRED AT KENSAL GREEN CEMETERY, FEBRUARY 9, 1878.

PAINTER, PHILANTROPHIST, AND PATRIOT.

Painter of "THE WORSHIP OF BACCHUS," which was Exhibited to the Queen in 1863, and ultimately presented to the Nation for Exhibition in the National Gallery. The Series of Pictures entitled "The Bottle" were also designed by him. After completing this latter work he became a Total Abstainer in 1847, and took an active part in the Temperance Movement.

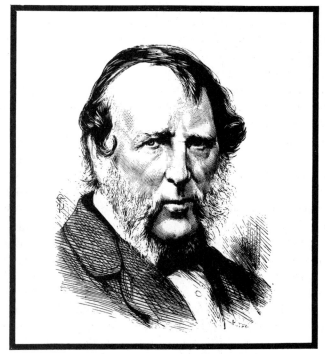

Where the cold and silent grave
Closes o'er the true and brave:
Where the warrior's work is done,
And the voice is hush'd and dumb,
 There he sleeps.

Where the pencil, brush, and pen,
Speak no more to living men:
Where the vices of the day
No more grieve the lifeless clay—
 There he rests.

Where the ties of earth are riven,
Where reward is freely given,
Where no merit can withstand
Fame to those who bless their land—
 There he lives.

Where until the glorious dawn
Of a bright and better morn,
Where the sleeper shall arise
To a home in yonder skies—
 There he waits.

81. Memorial broadside, Feb. 1878

capacity. His chief weaknesses were identified as an eccentric style and an inability to portray female beauty, a principal requirement for the rising generation of graphic artists such as Du Maurier.[18] His philanthropic endeavors provoked admiration even from nonpledgers. Several of the eulogists confessed to having known Cruikshank personally; all endorsed Tom Taylor's praise for his "simplicity and honesty." Sala's characterization was lovingly partisan but not unique:

> He was, to sum up, a light hearted, merry, and, albeit a teetotaler, an essentially "jolly" old gentleman, full physically of humorous action and impulsive gesticulation, imitatively illustrating the anecdotes he related; somewhat dogged in assertion and combative in argument; strong-rooted as the oldest of old oaks in old true British prejudices; decidedly eccentric, obstinate, and whimsical; but in every word and deed a God-fearing, Queen-honouring, truth-loving, honest man.

Encouraged by Sala to hope that George could be buried in the crypt of St. Paul's, Eliza delayed the funeral.[19] George Pulford, who made himself indispensable at this time, went as one member of a delegation to the Very Reverend R. W. Church, Dean of St. Paul's, who informed them that "he would most willingly comply with the wishes of the Deceased's friends as he held him in high esteem, and considered that he had done great good in his life-time," but repairs then under way precluded any interments for some months.[20] He wrote directly to Eliza on Friday the 8th promising that George's body might be placed there eventually, so with that assurance she concluded arrangements for a Saturday burial.[21]

The English oak coffin (lead-lined in anticipation of its future removal) was conveyed on the same open car that had been used at the funeral of Douglas Jerrold twenty years earlier. The pallbearers were Sala, Hall, Lord Houghton—the former Monckton Milnes, who sought out every artist and writer of the period—Charles Landseer, Edward S. Ellis of Leicester, and General McMurdo. Among them they signified Cruikshank's involvement with graphic art, journalism, illustrated books, painting, social reform, and the Volunteers. F. W. Cosens was among those mourners instructed to be at the house by 12:15 p.m.[22] The cortege left Hampstead Road at one o'clock and slowly proceeded to All Souls' Cemetery, Kensal Green, along the route that had grown so familiar to the artist. At the chapel, the Reverend Charles Stuart, chaplain, read the service—a last tribute by a Scots descendant of George's putative ancestors. The pall was then borne to the grave in a procession headed by a detachment of Volunteers. A "great concourse of spectators," as Eliza expressed it later in draft inscriptions for funerary monuments, gathered for the ceremonies: Dawson Burns accompanied a few others from the Temperance League; Frith, John Tenniel, and George Du Maurier paid their respects to a fellow artist—one who, in Du

Maurier's case, had repeatedly lampooned his grandmother seventy years earlier; John Paget bid farewell to a friend he had championed for the past fifteen years; George Bell, Octavian Blewitt, Charles Kent, and Frederick Locker shared their sorrow; and Doctors Richardson and Parratt supported the grieving widow.[23] Cruikshank's oldest friend, Merle, was too ill to attend; he too was sinking and would die within a few months. The mourners strewed the simple coffin with immortelles before the sexton plied his spade.[24]

For weeks Eliza was distraught. Already exhausted from nursing her husband, she was overwhelmed by correspondence—nearly a hundred letters of sympathy and condolence had arrived by the Monday following his death—and downcast by his will. After the funeral she stayed in bed for a while, then gradually began receiving callers, ordering mourning clothes, writing cards of acknowledgment, and consulting with Dr. Richardson, George Bell, and Sydney Gedge, the estate's solicitor, about Cruikshank's affairs. In mid-July she renewed her request to Dean Church, who replied a little testily that the crypt would not be ready for two or three months, and until then, "nothing can be done. . . . This I fully stated at the time when I gave my consent to the arrangement."[25] Eventually he appointed Monday 29 November as the day for the removal.[26]

Accordingly, the coffin was dug up, the wood and inscription slate were cleaned, and it was taken by a hearse and four to Hampstead Road. Eliza entered a mourning coach drawn by a pair of horses draped in sable velvet hammer cloths and crowned with plumes, which followed the hearse and honor guard of Volunteers into Bloomsbury, past Holborn and St. Giles, along the Strand and Fleet Street by George's boyhood haunts, and up Ludgate Hill to the South Porch of the Metropolitan Cathedral. Just after the conclusion of the evening service, ten hired bearers carried the coffin down the stairs into the crypt, where at the conclusion of a simple service read by the Dean it was lowered into the ground.

Eliza's obsequies did not end then. She devoted the rest of her life and modest assets to enriching both graves. In 1881 John Adams Acton completed a monumental bust in white marble which was installed in St. Paul's above an inscription composed by Dr. Richardson with Eliza's enthusiastic support:

> In Memory of His Genius and His Art,
> His Matchless Industry and Worthy Work
> For all His Fellow Men, This Monument
> Is Humbly Placed Within This Sacred Fane,
> By Her Who Loved Him Best, His Widowed Wife.
> <div align="right">Eliza Cruikshank</div>
> <div align="right">Feb. 9th 1880.[27]</div>

To the objection that "widow" would be sufficient she responded energetically: "I *strongly object* to the word *widow* being mentioned at all, *as widowed wife*, Eliza Cruikshank is a far more *uncommon sentence.*"[28] It was her one public stand against Adelaide, and so covert that only a few close friends understood the implication. She also planned a cenotaph commemorating the first grave in Kensal Green which was executed by George Hulse in 1884. Her final embellishments of the crypt monument were superintended by Lady Richardson after Eliza died in December 1890.

Even in death, George Cruikshank was divided from his fellow artists. On the south side, an entire bay, known as "Painters' Corner," houses memorials to Blake, Constable, Hunt, Landseer, Lawrence, Leighton, Millais, Opie, Reynolds, Turner, Van Dyck, West, and the architect of St. Paul's, Christopher Wren. But Cruikshank lies across the aisle to the west, alongside monuments to Walter Besant, William Ernest Henley, and George's dear friend Canon Barham. At least he rests not far from two of his heroes: Lord Nelson, whose coffin stands under the center of the dome, and the Iron Duke, Wellington. As so many of the obituaries said, George was a "warrior" too, fighting enemies foreign and domestic. He would have relished the perpetual company he keeps.

EPILOGUE

His Life has yet to be written.

"Doubleyew" in the *Illustrated Sporting and Dramatic News*[1]

☞ THE MANNER of George's life left Eliza with three interlocking problems: his Will, his Autobiography, and his art. She spent the rest of her life purposefully working on them, never uttering a word of reproach or faltering in her promotion of her late husband. Hers became a chronicle of narrowing resources and resolute determination, as she "who loved him best" forged ahead, uphill all the way, to perpetuate Cruikshank's achievement. Across the Euston tracks to the west, Adelaide found her life somewhat eased by George's passing. Although she could not mourn in public, she "behaved very well" according to Sydney Gedge, who paid her £2 a week subsistence until the estate was settled, thus providing her in the interim with a dependable income.[2] Eliza bore the name and tried to keep it in circulation; Adelaide raised the children who transmitted the "bandylegged" genes but not the patronym.

On Sunday February 3, Eliza entered in her diary: "Miss Gibbs called in the afternoon, after Tea she accompanied me to Dr. Richardson's H[ouse] and [?heard about] the W[ill] and all the sad affair; was heart broken Oh dear dear."[3] George bequeathed to his "dear and beloved wife" fifty pounds in cash, his plate, linen, china, glass, furniture, and other household effects, one hundred pounds in pictures, and one further picture regardless of value. As she was "well provided for" he made no other bequest to her. Everything else went into a trust for "Adelaide Archibold otherwise Adelaide Altree" and her family. Cruikshank directed that all his books, pictures, prints, engravings, drawings, and etchings on copper and steel situated at 263 Hampstead Road be sold, that the proceeds be combined with any cash residue and invested in fully paid up shares of the Temperance Land and Building Society, and that the trustees pay to Adelaide during her lifetime the entire annual income from such investments. At her

death, the corpus of the trust should be paid in equal shares to the ten children individually named. She retained no power to anticipate the principal, but she received outright "all such furniture books wines and household effects belonging to me" as were located at 31 Augustus Street.

This will, signed 28 February 1876, is by Victorian standards and George's own principles a curious document. At the time of its making Cruikshank knew that Eliza would receive the £35 per annum survivor annuity from the Westminster Aquarium purchase. She also had inherited five Grand Junction Water Works Company bonds from her Aunt Parratt, and owned some property, including a house at 202 Fleet Street being used by a shellfish monger for wine and beer cellars, a luncheon bar, dining rooms, and flats.[4] Furthermore, George may have been assured that she would continue to receive his government pension (as in fact she did).[5] Most of the furniture in the Hampstead Road belonged to her family; George's presumably was moved bit by bit to Augustus Street. Nevertheless, snatching away all the books and works of art must have denuded the rooms and increased Eliza's sense of desolation. But she needed the space badly to rent out for supplementary income. Beginning in September 1878 she let a substantial portion of the house to the family of Alexander Melville.[6]

And what is to be made of the provisions for Adelaide's family, for whom, according to her descendants, Cruikshank expressed concern on his deathbed: "Oh, what will become of my children?"[7] Does the fact that she is "Archibold otherwise Altree" confirm that "Mr. Archibold" was a fiction, or merely that she never married him legally?[8] (She is called Mrs. Archibold and Mrs. Altree interchangeably by the lawyers.) Does the trust George set up establish beyond doubt his parentage of all her children? How had the trustees, Dr. Richardson, George Mills of Glasgow, Dr. Hardwicke the Central Middlesex Coroner, and Professor Erasmus Wilson (who witnessed the will), taken the news that they would be managing a trust for another family? And what were "wines . . . belonging to me" doing in Augustus Street, at the home of a woman whom Cruikshank had met some time after he took the pledge? Could it be that the acerbic Jane Ellen Frith Panton is right, that George was a hypocrite and a backslider, that he regularly consumed alcohol-laced dishes and tippled in the arms of his mistress, that he was not through and through, as the obituarists unanimously averred, an honest man? It seems inconceivable that the same person who instanced his water-induced health to "dear lads" and burglars could be guilty of systematic fraud concerning his own teetotalism, but there is the will; on the other hand, it seems equally inconceivable that Dr. Richardson and the other executors would have continued to respect George and his testament if they knew he drank secretly.[9]

Although Eliza was familiar with the general nature of George's provisions, Walter Hamilton felt "she was much surprised at the way the property was willed."[10] As soon as the funeral was concluded, she began organizing the studio detritus for auction—books to Sotheby's, art works to Christie's.[11] When she attended the viewing at Christie's, "she appeared quite dejected & heartbroken," Hamilton recalled. Her labors became more and more important as the estate's schedule of debts and expenses mounted to £3,235, including a claim secured by George's £400 life insurance policy that had climbed to £683 principal and interest. Eliza herself was owed £500 and the Whitehead daughters had lent £167 each which Cruikshank never repaid. Tom Reynolds had never seen any of the £200 he advanced.[12] The first auctions netted only £1,800; the oil paintings fetched very low bids.[13] Eliza assured Gedge that a second sale of prints and drawings would make up the difference, but he told Dr. Richardson he feared "there will be nothing for the children."[14]

Minor incidents caused Eliza considerable pain. Crawford Pocock applied to her for repayment of George's secret loan, conceding now that he would accept a drawing from *Peter Schlemihl* or an etching in lieu of cash. She could only register his debt with the estate, as she had no power to dispose of art works privately. Her cautious letter offended Pocock; in reply to his remonstrance she stated that had she "expressed any *regret*" because she could not accept his proposal, she "would have *implied* that I was dissatisfied with the Terms of my late Husband's Will."[15]

She also had an unpleasant encounter with Percy. Sedulous to conserve any family records, she obtained George Dawe's oil portrait of Mary Cruikshank. Percy was infuriated. Eliza was no blood relative, only a second wife. The picture was an heirloom and ought to belong to him and his family. One can imagine the counterarguments that ran through Eliza's mind: after all, George—not Robert—had maintained a home for Mary for upwards of thirty years; and to the day of his own death he had been supporting Percy's family. But to avoid an open breach she gave in, informing Percy starchily through a third party that if he "thinks it a matter of such vast importance" she will present the picture as a gift to him.[16]

Dr. Richardson hoped that solvency might be achieved by publication of the "Autobiography" which Eliza would complete. This was the second "bounden duty" she undertook to benefit the Archibolds, whose descendants remember that she continued out of her own purse to support them, even "helping to send the girls to finishing schools."[17] To enhance their own project Dr. Richardson and Eliza refused requests for materials and authorization for alternative biographies by others. In early July she told Bates that the "Recollections" were in a "very forward state" and would be ready for publication by August; therefore she begged Bates not to proceed with his

own book.[18] Percy, in poor health and desperate for money, started on a "Memoir" of his father and uncle. Blanchard Jerrold wrote offering to help edit or write a life. James Aston, to Eliza's horror, proposed to publish a self-portrait that George himself had presented years before. To the latter two suppliants Eliza returned negatives.[19] Some potential biographers quit because of the repeated announcements in the journals that George's own version was about to be published, while others worked on in isolation from the source of material and in competition with each other.[20]

George Bell held the estate in a contractual vise. Not only did he still own stereos of the *Table-Book*, *St. Dunstan*, and *Lord Bateman* which he refused to turn over for the auctions, but also he presented a bill for more than £500 on account of advances against the long-deferred "Recollections," which he shrewdly suspected were nothing more than jottings. Various proposals to resolve this stand-off were exchanged among Bell, Gedge, Richardson, and the Court of Chancery. Eventually Eliza found more drawings to sell so that the estate could pay off Bell. In September 1880 his stock of plates was delivered to Andrew Chatto, who intended to publish Eliza's edition of the Life illustrated by George's glass etchings until Jerrold arrived at the publisher's office with his completed manuscript. An attempt was made to compromise the two interests. Chatto suggested issuing a two-volume biography of which the first volume would be by Jerrold and the second by Dr. Richardson, based on the glass etchings and Eliza's notes. That didn't work. Eliza ferreted out further drawings which were sold at another auction in 1881, thereby raising enough money to bring the estate close to solvency.[21]

Gedge then proposed that the remaining creditors take the sixty contested glass etchings in lieu of their debts, present them to Richardson, and let Richardson publish them for the benefit of the children. At this point everyone had given up hope that Eliza could stitch together a coherent narrative out of George's fitful recollections. Whatever the Archibold family got immediately, they never received much from the ill-fated Autobiography. *Drawings by George Cruikshank Prepared by Him to Illustrate an Intended Autobiography* was finally issued in 1895 by Chatto, and in 1896 a rival publication limited to two hundred copies was offered by W. T. Spencer using Hancock's glass etchings and commentary and Cruikshank's provisional title, *A Handbook for Posterity: or Recollections of "Twiddle Twaddle."* This was such a demeaning title and both books had such inconsequential annotations that few could be bothered to buy or read.

The biographies that did appear were almost as damaging to Cruikshank's reputation as those that did not. Many of the artist's friends, confounded by the existence of a second family, puzzled over what to make of George's integrity. "I hear reports about the children—& other painful

details," Blanchard Jerrold told Dr. Richardson. "These must be thrust aside."[22] William Bates, who despite Eliza's wishes had the first edition of his Life out before the end of October, insisted that the artist's "singularly pure and healthy nature refused the assimilation of evil."[23] In other words, however irregular the liaison with Adelaide, it was somehow uncontaminating. Samuel Carter Hall was much relieved by this assertion. "You have taken a generous and, I believe, a just view of poor George," he told Bates in accents Pecksniffian. "Who is he that will cast the first stone? Who are those that judgeth another? I am thankful that there is no Asmodeus to take the roof off my house—and 'look in.' How few are there who could bear that process?"[24] Walter Hamilton tried to make allowances but told Bates he could not get over the fact that George had left the whole of his little property away from his wife. (This news, which hit the papers as soon as the will was proved, was couched in suitable Victorian periphrasis: the *Illustrated London News* said Cruikshank's estate was "to be held upon certain trusts for the benefit of several persons in whom he was interested."[25]) A Congregational minister from Halifax in charge of a Band of Hope comprising eighteen hundred members asked Bates directly whether the rumor of illegitimate children was true; once it was confirmed, he sadly put by his lecture on the Champion of Temperance. "Terribly shocked," he promised not to "point out the spot on the sun's disc, not even to [his] bosom friends."[26]

Thus publishing anything at all about George ignored his widow's interdiction and risked exposing that which his friends were at pains to conceal. Nonetheless, Percy for one pressed on, scrounging his memory for racy stories about the Corinthian days. Somewhat embittered toward the uncle who had taken the lion's share of the family talent and repeatedly persecuted his brother's descendants, Percy also chafed at his dependent status in many of his uncle's ventures. As a result, his rambling, ill-written "Memoir" contained wonderful but discreditable stories told in a confusing manner without recourse to dates and facts. According to Percy, among other infirmities George subjected publishers and relatives to intemperate scoldings and physical abuse and chased after women in public. Percy showed his manuscript to George Bentley in hopes that his portrait of the artist might be acceptable to the son of his uncle's former antagonist. It was not. Bentley doubted that his father had ever run away from anyone as the "Memoir" alleged. Eventually Percy gave his materials to Blanchard Jerrold, who was gathering from everyone excepting Dr. Richardson written recollections of the artist. Jerrold recognized that the "Memoir" had to be partially suppressed. "It must never fall into Mrs. Cruikshank's hands," he warned Chatto, "as it contains details never intended for public eyes."[27]

As a biographer Jerrold suffered several disadvantages. To begin with, his

father's relationship to Cruikshank had not been characterized by steady intimacy, although they retained a friendship until Douglas Jerrold's death. Blanchard was of an entirely different generation, a cosmopolitan at home in Paris as well as London and a disciple of the *Punch* circle which Cruikshank refused to join. Moreover, there were few models of British artists' biographies for Jerrold to follow: Walter Thornbury's of Turner was leaden and disorganized (Ruskin said "Hamlet is light comedy" by comparison), while Alexander Gilchrist's of Blake, although excellent, dealt with an artist whose intellectual power and refinement greatly exceeded Cruikshank's.[28] Grego's thoughtful monographs on Gillray and Rowlandson and Thomas Wright's synoptic *Caricature History of The Georges* provided models of research and socio-historical context Jerrold was ill equipped to emulate. At the outset of the first account of Cruikshank's career (1833), William Clarke had apologized because he was going to be "provokingly parenthetical and divaricating"; his unfortunate precedent had been followed by Thackeray and most subsequent biographers of the artist. Furthermore, Eliza would not admit Blanchard into any kind of biographical partnership, so his access to primary documents was restricted. And finally, he seemed incapable either of forming independent judgments about the artist's designs or of deciding George's rights in various disputes.

Consequently Jerrold inserted some of Percy's paragraphs almost verbatim, patched together a succession of reviews to supply analysis of the art, relied on informants for facts and personal anecdotes, fudged the quarrels, and composed an unbalanced, hit-and-miss narrative that canonized certain distortions. George becomes a decorous satirist, disorderly genius, fanatical teetotaler, and quarrelsome friend who overstated everything including his share in collaborations. While several reviews were friendly, the *Critic* found the artist's work coarse, trivial, and sterile, and the *Saturday Review* chided the author for carelessness.[29] In publishing this work in place of the Autobiography, Chatto tapped what was left of the public's rapidly diminishing interest in Cruikshank, thereby ruining the near-term prospect of fulfilling Eliza's desire to issue George's verbatim "Recollections." Moreover, poor as they were, Jerrold's two volumes reigned for over a century as the standard authority.

In 1880 when her lease expired, Eliza moved. Doubtless it was during her preparations for a shift in residence that she discovered further drawings, proofs, and prints. She arranged with the family of Madame Tussaud to rent a flat in a mansion block, Salisbury House, on Marylebone Road, at the rate of £5 per month, a 25 percent reduction from her Hampstead Road rent.[30] Before she left, she sold the furniture out of one bedroom, her drawing-room and dining-room suites, three plaster busts of her late husband, and various kitchen utensils.[31] Settled in more modest quarters, she then

used her income and some of her principal to assemble a huge collection of
Cruikshank's work similar to those that had passed through her hands
since 1863.[32] She bought proofs and drawings, watercolors and oils, what-
ever came into the market that she could afford. By December 1883, she
was ready. At the time of her move she had given the South Kensington
Museum the presentation watercolor of *The Worship of Bacchus* repurchased
from Samuel Gurney, a painting of *The Birth of Shakespeare*, and two other
items.[33] Now she was prepared to offer approximately three thousand speci-
mens of Cruikshank's art on certain conditions: first, that a portion of it be
always exhibited at the museum along with a copy of the Adams Acton
bust, and second, that from time to time other portions be exhibited at the
Bethnal Green Museum in the East End and in provincial museums, for
which purpose she had liberally purchased duplicates. R. H. Soden Smith,
Museum Keeper and Librarian, examined her treasure trove, then can-
vassed his staff. They were of the opinion that it would be impossible to
manage if space had to be permanently set aside, but Soden Smith overrode
the objections. In his Report he said:

> Altogether the Collection, containing as it does so much that is unique, repre-
> sents the artist's work as but few others can. It embraces a period of nearly
> seventy years, and thus incidentally illustrates the variations of costume, the
> circumstances of public and social life, the London history of the 19th Century,
> in a manner intentionally grotesque, no doubt, but wonderfully vivid, and full
> of subtle observation.

He found it hard to estimate its value, since Cruikshank was "now being
collected wherever English is spoken."

On 3 April 1884 the board accepted Eliza's gift and conditions.[34] Exhila-
rated, she added early caricature plates that another collector had wanted
to purchase from her and set about planning a catalogue with the assistance
of H. W. Bruton, the most significant of the "second generation" Cruik-
shankophiles.[35] And then disappointment set in. Friends go to the mu-
seum, she complained a year later, but see nothing. What has happened to
my gift? Soden Smith determined that all the prints had been registered
and stamped, then told his staff to "Get the drawings selected for exhibi-
tion framed at once." A year later Soden Smith told Eliza that "screens are
being erected at present" and that she might see some of the items framed
for the show.[36] This evidence of progress pleased her so much that she made
further gifts during her lifetime and bequeathed another £1,000 worth of
miscellaneous items delivered to South Kensington four months after her
death.

Eliza did not stop at one museum. She gave £100 in memory of George
to the Artists' Benevolent Fund, presented etchings to the London Tem-

perance Hospital, and planned to make a large further donation to the British Museum. This however had to be postponed.[37] Then, ill and aged, she had to move in bitterly cold weather into yet smaller quarters and to sell some of her bonds. In 1888 she discovered that the trustees of the National Gallery had made a "perpetual loan" of *The Worship of Bacchus* to a provincial museum and were disinclined to take it back, even under pressure from her and Dr. Richardson.[38]

In anticipation of her own death, Eliza established three further benefactions. She added to the Victoria and Albert gift and designated 3,869 plates and sketches for the British Museum "upon the understanding that some of his Works shall be always hung up and exhibited in the galleries now being built."[39] This increment swamped the curators. For the first 1,882 items the Binyon catalogue gives individual information. The remaining parcels, however, were treated in bulk: "320 Caricatures," "81 Portrait Sketches," "969 Miscellaneous Sketches." Needless to say, the "understanding" was never implemented.

Finally, Eliza left £400 to the Royal Academy to endow a biennial George Cruikshank Prize awarded for "the best work of art proposed & approved of by the Academy." She also bequeathed a medallion portrait of Cruikshank designed by George Halse as a model for "a gold medal of the value of £20" to be presented to the winner and £50 for making a die. Dr. Richardson's son Aubrey, a solicitor, informed the council after Eliza's death in December 1890 of this bequest and of the fact that her estate could not fully fund all the gifts. In that case, the council declined to accept the legacy.[40] Cruikshank's was not a name or an achievement that an organization of artists whose president was the distinguished neoclassical painter Lord Leighton wanted to commemorate.

The nineties held the work of preceding generations of black-and-white artists in contempt; nothing Eliza did in her lifetime or through her will could reverse that revolution in taste which swept over Europe and America as well. Practitioners of fine-art etching deprecated the popular and comic etchers celebrated by Thackeray, just as midcentury authorities had criticized the license of Georgian satirists. Joseph Pennell, an American who came under Whistler's influence, lived in Britain for decades, and wrote many books about modern illustrators, pronounced on behalf of his contemporaries the *quietus est* of early Victorian etchers: "I suppose," he said in 1895, "that among artists and people of any artistic appreciation, it is generally admitted by this time that the greatest bulk of the works of 'Phiz', Cruickshank [*sic*], Doyle, and even many of Leech's designs are simply rubbish."[41]

Genealogy

Attree/Archibold Family

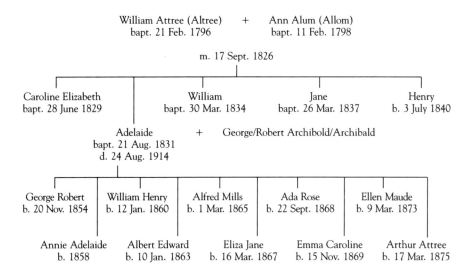

William Attree (Altree) + Ann Alum (Allom)
bapt. 21 Feb. 1796 bapt. 11 Feb. 1798

m. 17 Sept. 1826

Caroline Elizabeth	William	Jane	Henry
bapt. 28 June 1829	bapt. 30 Mar. 1834	bapt. 26 Mar. 1837	b. 3 July 1840

Adelaide + George/Robert Archibold/Archibald
bapt. 21 Aug. 1831
d. 24 Aug. 1914

George Robert	William Henry	Alfred Mills	Ada Rose	Ellen Maude
b. 20 Nov. 1854	b. 12 Jan. 1860	b. 1 Mar. 1865	b. 22 Sept. 1868	b. 9 Mar. 1873

Annie Adelaide	Albert Edward	Eliza Jane	Emma Caroline	Arthur Attree
b. 1858	b. 10 Jan. 1863	b. 16 Mar. 1867	b. 15 Nov. 1869	b. 17 Mar. 1875

Emendata

A number of minor errors and inconsistencies in volume one will be corrected should there ever be need for a second printing. Four changes of more significance are recorded here.

1. The move to 117 Dorset Street, pp. xix, 25.

John Wardroper points out that the ratebooks show [Isaac] Cruikshank replacing someone called Stead in 1808. He doubts that the move from 27 Duke Street occurred in 1793–1794, as I state, since Isaac joined the St. Giles's and St. George's Bloomsbury Volunteers in 1803, and a Bloomsbury location would have been convenient for Isaac's work at the British Museum.[1] True. Moreover, Margaret Eliza, born 29 August 1807, was baptized on 27 September 1808 at St. Bride's, Fleet Street; the parish register lists her address as 117 Dorset Street. The gap between birth and baptism, while not unusually large, might be explained by the Cruikshanks' move into a new parish around the time of her birth.

On the other side of the debate, the ratebooks indicate that the Cruikshanks did not reside in Duke Street after 1794, the house depicted by Cruikshank for his Autobiography is unmistakably the one in Dorset Street, and the "naughty boy" incident and others he recalls and depicts around that location seem to have taken place about 1800. If the "Lion-in-the-Wood" drawing really dates from 1799 (Wardroper thinks 1807 more likely), as it was near Dorset Street it places George in the neighborhood then.

2. Death date for Archibald Cruikshank, p. 31.

Jonathan Hill has evidence that George Cruikshank's younger brother, Archibald (or Archibold as Hill gives it), born around 1806, died from a fall on 10 August 1810.[2]

3. The Mary Anne Clarke affair, p. 65.

The date should be 1809, not 1807; she dominated the caricatures not for two years, but for five months.

1. John Wardroper to RLP, 4 Jan. and 15 Aug. 1993.
2. Jonathan E. Hill, *George Cruikshank: A Bicentennial Exhibition* (Philadelphia: The Rosenbach Museum and Library, 1992), p. 5.

4. *George Cruikshank's first wedding day,* p. 216.

Simon Houfe has discovered the entry for George Cruikshank's marriage by license to Mary Walker, in her parish of Dunstable in Bedfordshire, on 16 October 1827, both parties being then over the age of twenty-one. The witnesses were the parish clerk and his wife. If Mary Ann had just turned twenty-one, her birthdate is 1806, not 1807 as I calculated (p. 215). The wedding seems to have been a very private affair with no family present. Someone—possibly George's mother—may have objected to the union. References to Mrs. Cruikshank prior to this date which have hitherto seemed ambiguous refer to Isaac's widow, not to George's wife.

Concerning Transcriptions and References

Approximately eighty-five hundred letters by or to George Cruikshank survive in several hundred repositories around the world. There are major British holdings in the Victoria and Albert Museum, the British Library, the British Museum, the Bodleian Library, and the Middlesex County records in the Greater London Record Office. In the United States Harvard, Princeton, the University of North Carolina at Chapel Hill, and the Berg Collection at The New York Public Library have sizable archives.

With rare exceptions, these letters have not been published, transcribed, or catalogued, and in some cases they are only now being sorted by date or correspondent. The miscellaneous printed and written ephemera relating to Cruikshank in the John Johnson Collection at the Bodleian Library have recently been distributed into boxes. The George Cruikshank Collection at Princeton contains, in addition to more than six hundred letters by the artist, many letters to him and to related persons; a revised and expanded finding list had not yet been prepared when I worked on the collection. The Southern Historical Collection at the University of North Carolina, Chapel Hill, contains 1,955 items, mainly incoming correspondence, some with draft replies scribbled on the sides and back, and papers that once belonged to Cruikshank's physician Sir Benjamin Ward Richardson; these have not been individually catalogued. British Library holdings are referenced by Additional Manuscript number or press mark, and those in the George Cruikshank Collection at the Victoria and Albert Museum are given the original accession number or press mark.

Thousands of sketches, drawings, watercolors, tracings, proofs, prints, and other materials Cruikshank prepared for his twelve thousand or more printed images are scattered throughout the world. Those in the V&A have accession numbers without regard to chronology of production; the Binyon catalogue of *Drawings of the British School* in the BM starts by listing individual Cruikshank items, but degenerates into collectivities after number 1881: Packet 9 contains, for example, 969 miscellaneous sketches. Thus references to correspondence and artwork cannot be made in a uni-

form code; but I have tried to supply enough information to identify each item unambiguously. Picture dimensions, height before width, are given in inches or centimeters depending on the authority.

I have adopted a fairly flexible attitude toward transcription, especially in the case of Cruikshank's rough drafts. Some spelling has been silently corrected, though I have reproduced characteristic nineteenth-century forms such as "untill" and "Gilray." Cruikshank employs the dash more often than a full stop; for the most part these have been preserved. Other accidentals have been treated in accordance with the original, if that can be deciphered, and with American rather than British conventions. For consistency or comprehension I have sometimes silently changed a case or furnished a punctuation mark, especially in quoting from the unpublished "Memoir" of George's nephew Percy Cruikshank.

After the first footnote, short-form citations are employed. Periodical references are as complete as possible, given the vagaries of Victorian publishing. Additional abbreviations are as follows; at the request of certain librarians more specific location information is provided here than in volume one.

ACC 534	George Cruikshank Collection (14 folders) in Corporation of London—Greater London Record Office, Middlesex County, ACC 534/1–14.
AM	*Ainsworth's Magazine*
Berg	Henry W. and Albert A. Berg Collection, The New York Public Library, Astor, Lenox, and Tilden Foundations
Binyon cat.	Laurence Binyon. *Catalogue of Drawings by British Artists.* Vol. 1. London: British Museum, 1898.
BL	British Library
BM	British Museum
BM	*Bentley's Miscellany*
BMC	*Catalogue of Political and Personal Satires.* Vols. 6–11. Ed. M. Dorothy George: British Museum, 1938–1954. For prints, followed by catalogue number, thus: BMC 15795. Date and publisher are usually given for the Cruikshanks, but not for other artists.
Borowitz	*George Cruikshank and His Contemporaries* [The Library of David Borowitz, part 2]. New York: Sotheby Parke Bernet, sale no. 4107, 11 April 1978.
Bradburn	A collection of letters by and concerning George Cruikshank formed by Frank S. Bradburn and stored in two binders, one red and one blue; now in private collection.

C 107, etc.	Albert M. Cohn. *George Cruikshank: A Catalogue Raisonné.* 3 vols. London: Bookman's Journal, 1924; with entry number. [This work is bound variously in one, two, and three volumes. My edition, annotated by Frank S. Bradburn, is separated into three volumes with volumes 1 and 2 devoted to "Part 1: Printed Books," and volume 3 to "Part 2: Caricatures and Separate Prints." The continuously numbered items are distributed among the three volumes—1: Items 1–363; 2: Items 364–863; 3: Items 864–2114.]
Coutts	Accounts of Mrs. Eliza Cruikshank, with Isaac Armstrong, as executors of the estate of Amelia Emily Parratt, opened 14 Jan. 1852; George Cruikshank Esq., opened 23 Oct. 1852; George Cruikshank Esq. and Edward Duncan Esq., treasurers for a fund for the widow and family of the late Mr. Joseph Gibbs, opened 27 Apr. 1864; and Mrs. Eliza Cruikshank, widow, opened 1 July 1878, at Coutts and Co., London.
Cuno cat.	*French Caricature and the French Revolution, 1789–1799.* Ed. James Cuno and Cynthia Burlingham. Los Angeles: Grunwald Center for the Graphic Arts, Wight Art Gallery, University of California, Los Angeles, 1988.
Ellis	S[amuel] M[arsh] Ellis. *William Harrison Ainsworth and His Friends.* 2 vols. London and New York: John Lane, 1911.
EPC	M[ary] Dorothy George. *English Political Caricature.* 2 vols. Oxford: Oxford University Press, 1959.
Forster	John Forster. *The Life of Charles Dickens.* 3 vols. London: Chapman and Hall, 1872–1874.
Forster, Ley ed.	John Forster. *The Life of Charles Dickens.* Ed. J.W.T. Ley. New York: Doubleday, Doran [1928].
FSB	Frank S. Bradburn annotation on materials in his collection or ones passed through his hands by dealers for authentification and identification
Hackwood	Frederick W[illia]m Hackwood. *William Hone, His Life and Times.* London: T. Fisher Unwin, 1912.
HP 6, etc.	George Cruikshank. *A Handbook for Posterity: or Recollections of "Twiddle Twaddle."* London: W. T. Spencer, 1896; with plate number.
Jerrold	Blanchard Jerrold. *The Life of George Cruikshank.* 2 vols. London: Chatto and Windus, 1882.
JJ	John Johnson Collection of Printed Ephemera, Bodleian Library, Oxford University

Johnson	Edgar Johnson. *Charles Dickens: His Tragedy and Triumph.* 2 vols. New York: Simon and Schuster, 1952.
K 154, etc.	C. C. Kohler. "Catalogue of George Cruikshank sale," 1974; typescript in Victoria and Albert Museum; materials in private collection.
Lib. 105., etc.	Sotheby, Wilkinson, and Hodge. *Catalogue of the Illustrated and General Library . . . of . . . George Cruikshank,* sold 17–18 May 1878 (copy annotated with purchasers' names and item prices, FSB Collection), followed by lot number.
NLet	Charles Dickens. *Letters.* Ed. Walter Dexter. 3 vols. Bloomsbury: Nonesuch Press, 1938.
PCk "Memoir"	Percy Cruikshank. "George Cruikshank, With Some Account of His Brother Robert Cruikshank," unpublished Memoir, Manuscripts Division, Department of Rare Books and Special Collections, Princeton University Libraries.
PLet	Charles Dickens. *Letters.* Ed. Madeline House, Graham Storey, et al. Pilgrim Edition, vols. 1–6. Oxford: Clarendon Press, 1965–1988.
Podeschi cat.	John B. Podeschi. *Dickens and Dickensiana. A Catalogue of the Richard Gimbel Collection in the Yale University Library.* New Haven: Yale University Library, 1980.
Princeton	For manuscript material, references are to the Manuscripts Division, Department of Rare Books and Special Collections, Princeton University Libraries; George Cruikshank Collection (CO 256) unless another collection is specified. These collections were not in their finally processed form when research was undertaken; thus the special collection identifications may no longer apply.
PULC	*George Cruikshank: A Revaluation.* Ed. Robert L. Patten. *Princeton University Library Chronicle* 35, nos. 1–2 (Autumn–Winter 1973–1974). Republished in hardcover under the same title by Princeton University Library, 1974, and in paperback by Princeton University Press, 1992.
R 107, etc.	George William Reid. *Descriptive Catalogue of the Works of George Cruikshank.* 3 vols. London: Bell and Daldy, 1871; with entry number.
Ruskin, *Works*	John Ruskin. *Works.* Ed. E. T. Cook and Alexander Wedderburn. 39 vols. London: George Allen, 1909.
Sala	George Augustus Sala. "George Cruikshank: A Life Memory," *Gentleman's Magazine* 242 (May 1878): 544–568

Searle | Materials formerly in the collection of Ronald Searle, now in private collection

Suzannet cat. | *The Catalogue of the Suzannet Charles Dickens Collection.* Ed. Michael Slater. London and New York: Sotheby Parke Bernet, 1975.

Thackeray, "Essay" | William Makepeace Thackeray. "Essay on the Genius of George Cruikshank," *Westminster Review* 34 (June 1840): 1–60.

UNC-CH | Wilson Library, University of North Carolina at Chapel Hill, George Cruikshank Papers, #11,005, General and Literary Manuscripts Group, and Whitaker Papers #3433, Southern Historical Collection

V&A 9995.N, etc. | Victoria and Albert Museum, George Cruikshank Collection, accession number

Vogler thesis | Richard A. Vogler. *Cruikshank and Dickens: A Review of the Role of Artist and Author.* Ph. D. dissertation, University of California, Los Angeles, 1970.

Vogler/Borowitz | Richard A. Vogler. *The Inimitable George Cruikshank: An Exhibition of Illustrated Books, Prints, Drawings and Manuscripts from the Collection of David Borowitz.* Louisville: University of Louisville Libraries [for the J. B. Speed Art Museum], 1968.

WMTLet | William Makepeace Thackeray. *The Letters and Private Papers.* Ed. Gordon N. Ray. 4 vols. Cambridge, Mass.: Harvard University Press, 1946.

Wilson | Letters and manuscripts offered for sale by John Wilson, Oxford, now in private collection

Notes

25. MIDDLE-CLASS CHARACTERS

1. Review of *Sketches by Boz* Second Series, *Spectator*, 26 Dec. 1836, p. 1234.
2. Frith, chapter 3.
3. GCk to Blackwood, n.d. [c. 1834], Searle; GCk's letter may respond to one from William Blackwood and Sons of 25 Nov. 1834, Princeton, asking the artist to illustrate for republication George Moir's "Fragments from the History of John Bull," which ran from Dec. 1831 to Jan. 1835 in *Blackwood's Edinburgh Magazine*. GCk is requested to supply his ideas about appropriate subjects and treatments for four to six etchings, preferably on copper.
4. Ellis 1:256. For a modern assessment of Ainsworth's career on which I have drawn extensively in subsequent chapters, consult George J. Worth, *William Harrison Ainsworth* (New York: Twayne, 1972).
5. Ellis, 1:121–122.
6. Ibid., 1:175.
7. Ibid., 1:189.
8. Miriam M. H. Thrall, *Rebellious Fraser's* (New York: Columbia University Press, 1938), p. 5.
9. Ibid., p. 9; *The Wellesley Index to Victorian Periodicals 1824–1900*, ed. Walter E. Houghton et al., 5 vols. (Toronto: University of Toronto Press, 1966–1989), 2:310; hereafter *Wellesley Index*.
10. Ellis 1:257.
11. Ibid., 1:269.
12. Ibid., 1:262.
13. Ibid., 1:262–263.
14. Johnson 1:103.
15. Ellis 1:272.
16. Ibid., 1:273.
17. Mary Howitt, *Mary Howitt: An Autobiography*, ed. Margaret Howitt, 2 vols. (Boston and New York: Houghton, Mifflin, 1889), 1:271.
18. Quoted in Ellis 1:273 n.1.
19. Frederic G. Kitton, *Charles Dickens by Pen and Pencil* (London: Frank T. Sabin and John F. Dexter, 1890), p. 19.
20. Quoted in Ibid., p. 19.
21. Forster, Ley ed., p. 73n.; Ley, p. 80 n. 84, says "the whole story was an absolute fabrication"; but Edgar Johnson credits it, saying "it accords with all the known circumstances," 1:Notes, *ix.*65.
22. Vizetelly, 1:104. Having quarreled with Tilt, Hood had taken his *Comic Annual* to another publisher; Tilt was eager to establish a rival periodical (Logan D. Browning, Jr., "Charles Tilt/Tilt and Bogue," in *Dictionary of Literary Biography* 106: *British*

Publishing Houses, 1820–1880, ed. Patricia J. Anderson and Jonathan Rose [Detroit and London: Gale Research, 1991], pp. 296–298, 296).

23. "Preliminary" to Chatto and Windus reprint, *The Comic Almanack* First Series 1835–1843, p. 1; Vizetelly, 1:104. For bibliographical details on the original *Almanack* annual issues, see C 184.

24. Back in 1819, GCk had collaborated with Moore in the production of a frontispiece, black and white or hand colored, to Moore's *The Age of Intellect*, which Hone brought out (C 574).

25. Vizetelly borrowed the name from Sir Walter Scott, who called John Ballantyne "Rigdumfunnidos" after a genial character of the same name in Henry Carey's 1734 burlesque of contemporary drama, *Chronohotonthologos*.

26. Thackeray, "Essay," p. 46.

27. C 31, 1834.

28. [H. L.] Angelo to GCk, 9 Oct. 1834, Princeton.

29. C 772, 1834; C 70, 1835. Berenger began life as Charles Ransom, a print colorer for Ackerman and a crack rifleman who joined GCk's volunteer troop and grew chummy with both brothers. Befriended by a wealthy banker at whose house he was sometimes invited to dine, he met there and married a wealthy German baroness, appropriated her title, and used her money to purchase Cremorne Gardens and to convert the property into a fashionable "Stadium" for athletic exercises. The sight of the baron and his four sons in undress uniform and clattering sabers riding through Pentonville to visit the Cruikshanks used to "set all the neighbourhood agog," Percy recalls (PCk "Memoir," insert at end of MS).

30. C 103, 1835.

31. C 441, 1835.

32. C 442, 1839; FSB notes at C 441 and opposite C 212.

33. C 470, 1835.

34. Mary Cruikshank to GCk, postmarked 26 Aug. 1835, Princeton.

35. GCk to Laman Blanchard, 13 June 1835, Huntington Library.

36. Ellis 1:274; PLet 1:88–89. Vogler thesis, pp. 28–30, conjectures that Macrone's former partner, James Cochrane, with whom GCk worked on *Roscoe's Novelist's Library* (1831–1833) and on James Hogg's *Altrive Tales* (1832), introduced the artist to the publisher, and that Macrone then introduced the artist to Ainsworth.

37. Chapter 1; this is, incidentally, an early and apparently conventional application of the epithet "inimitable" to GCk, some years before it was transferred to Dickens.

38. J. W. T. Ley, the conscientious editor of Forster's *Life of Dickens*, could not "discover how Dickens became acquainted with Ainsworth" (Forster, Ley ed., p. 78 n. 82). Ellis claims that "it was some time in 1834," and that Ainsworth, impressed by Dickens's periodical tales and sketches, urged that they be collected and published as a book (1:274). Edgar Johnson says that Ainsworth encountered Dickens in the Strand offices of the *Morning Chronicle* in 1834 (1:98), but the PLet editors think "1835 seems more likely" (1:115–116 n. 2).

39. Johnson 1:99–100.

40. Ibid., 1:104.

41. Barker to GCk, after 1 Nov. 1835, extract from a dealer's catalogue pasted onto a rear page of C, volume 3.

42. CD to Mrs. William Austin, 3? Oct. 1835, PLet 1:75.

43. CD to Thomas Beard, 14? Oct. 1835, PLet 1:76.

44. CD to Catherine Hogarth, 22? Oct. 1835, PLet 1:79.

45. Title conjectured by PLet editors, 1:82 n. 1.

46. CD to John Macrone, 27? Oct. 1835, PLet 1:81–84.

47. Thomas Hatton, *Retrospectus and Prospectus: The Nonesuch Dickens* (Bloomsbury: Nonesuch Press, 1937), p. 55.
48. CD to John Macrone, 27? Oct. 1835, PLet 1:81–84.
49. Ibid.; it was never published prior to its appearance in *Sketches* First Series.
50. CD to John Macrone, 29? Oct. 1835, PLet 1:84.
51. Ibid.; Dickens says he wants to lend the book to George Hogarth, but letters to Catherine of 29? and 30? Oct. suggest that she was anxious to procure it, PLet 1:85–86.
52. Ibid.; CD to Catherine Hogarth, 5 Nov. 1835, PLet 1:88; CD to Macrone, 27? Nov. 1835, PLet 1:98.
53. CD to Macrone, 7 Nov. 1835, PLet 1:88–89.
54. For a convenient summary of all the material on Dickens's reading, see Duane De-Vries, *Dickens's Apprentice Years: The Making of a Novelist* (Hassocks, Sussex: Harvester Press; New York: Barnes and Noble, 1976), pp. 4–8, 26, 31–32, 43, and *passim*.
55. Not the firm which had employed the twelve-year-old Dickens, but one owned by that proprietor's brother Robert Warren; see Richard D. Altick, *The Presence of the Present: Topics of the Day in the Victorian Novel* (Columbus: Ohio State University Press, 1991), pp. 231–234.
56. CD to Macrone, 14 Nov. 1835, PLet 1:93–94.
57. CD to Macrone, 18 Nov. 1835, PLet 1:94.
58. Vol. 1: "A Visit to Newgate," "The Prisoners' Van," "A Christmas Dinner"; Vol. 2: "The Black Veil" and "The Great Winglebury Duel."
59. CD to GCk, 23 Nov. 1835, PLet 1:96 and n. 1.
60. CD to Macrone, 23 Nov. 1835, PLet 1:96–97.
61. CD to Macrone, 27? Nov. 1835, PLet 1:98.
62. CD to GCk, 30 Nov. 1835, PLet 1:100.
63. He sends his compliments to "Mrs. Cruikshank," whom I presume to be GCk's wife rather than mother, when he explains to GCk his reasons for stopping by (PLet 1:100).
64. CD to Catherine Hogarth, 30? Nov. 1835, PLet 1:99.
65. CD to Catherine Hogarth, 1 Dec. 1835, PLet 1:100–101.
66. CD to GCk, 8 Dec. 1835, PLet 1:101–102.
67. CD to Macrone, 9 Dec. 1835, PLet 1:102–103.
68. PLet 1:102 n. 2, citing an undated extract from *Autograph Prices Current* 6:49; this draft letter has not surfaced in my canvass of GCk correspondence. Vogler thesis, pp. 57–58, suggests plausibly that this fragment may refer to the abortive second volume of the Second Series of *Sketches*, and therefore have been written in Oct. 1836.
69. Undivided proofs confirm; see Vogler thesis, pp. 306–308. Some proofs of the Second Series of *Sketches* were executed four to a steel.
70. Ibid., Appendix I, esp. pp. 293–302.
71. J. Hillis Miller, "The Fiction of Realism: *Sketches by Boz, Oliver Twist*, and Cruikshank's Illustrations," *Charles Dickens and George Cruikshank* (Los Angeles: William Andrews Clark Memorial Library, 1971), p. 33, and Jane R. Cohen, *Charles Dickens and His Original Illustrators* (Columbus: Ohio State University Press, 1980), p. 18, both note that CD's pen and GCk's pencil invoke art, and Hogarth in particular, as precedent for their representations, making them for Miller interpretations of another set of signs rather more than linguistic or graphic figures pointing to something "real" outside and apart from linguistic and graphic conventions.
72. CD to Macrone, 17 Dec. 1835, PLet 1:108.
73. CD to GCk, 21 Dec. 1835, PLet 1:701.

74. CD to Macrone, 21 Dec. 1835, PLet 1:110.
75. CD to Macrone, 22 Dec. 1835, PLet 1:111.
76. CD to Macrone, 26? Dec. 1835, PLet 1:112.
77. CD to Macrone, 30 Dec. 1835, PLet 1:114.
78. CD to Macrone, 7 Jan. 1836, PLet 1:115–116. An undated note from GCk to Dickens may come from this same period: "I just drop this note to apologize for not answering your note before—and to assure you that in two or three days you may rely upon see[in]g me with proofs" (Suzannet cat., p. 173).
79. CD to GCk, 7? Jan. 1836, PLet 1:116.
80. CD to Macrone, 7 Jan. 1836, PLet 1:115–116.
81. Ibid.
82. Ibid.
83. CD to Catherine Hogarth, 22? Jan. 1836, PLet 1:119–120.
84. CD to GCk, 1? Feb. 1836, PLet 1:122.
85. CD to Macrone, 2 Feb. 1836, PLet 1:123–124; CD to Macrone, 6? Feb.1836, PLet 1:125.
86. Not the 7th, as Johnson 1:109, nor the 18th, as Cohen, p. 16.
87. CD to Macrone, 14 Feb. 1836, PLet 1:130 and n. 1.
88. *Sunday Herald*, the *Satirist*, both quoted in W[alter] D[exter], "The Reception of Dickens's First Book," *Dickensian* 32, no. 237 (Winter 1935–1936): 43–50, p. 46 and p. 45 respectively. Subsequent quotations from reviews have been taken from the same source. For the reception of Dickens's sketches at their first publication and when republished in collections and for further information about London literary life at this time, consult Kathryn Chittick, *Dickens and the 1830s* (Cambridge: Cambridge University Press, 1990).
89. CD to Macrone, 11 Feb. 1836, PLet 1:129–130.
90. See, for example, Cohen, p. 16.

26. A PICTURE OF EVERY-DAY LONDON

1. Mario Praz, *The Hero in Eclipse in Victorian Fiction*, trans. Angus Davidson (London: Geoffrey Cumberlege, Oxford University Press, 1956), p. 27.
2. Ellis 1:223–225 and 1:280.
3. GCk to John Macrone, 1 Mar. 1836, Suzannet cat., p. 173, lot 7.
4. For signed pencil, sepia, and watercolor sketches, see Binyon cat. 701– 718.
5. Ainsworth to Macrone, 8 Mar. 1836, Ellis 1:278.
6. Ainsworth to Macrone, "a few days" after the preceding letter, Ellis 1:278.
7. Ellis 1:277–278.
8. Robert Lee Wolff, *Nineteenth-Century Fiction*, 5 vols. (New York and London: Garland, 1981), Ainsworth to Macrone, 30 Mar. and 11 Apr. 1836, 1:15–17. The Wolff Collection is now at the Harry Ransom Humanities Research Center, The University of Texas at Austin.
9. See WMTLet 1:255 and Cohen, p. 235.
10. Lewis Melville, *William Makepeace Thackeray*, 2 vols. (London: John Lane, The Bodley Head, 1910), 2:115–116; see also WMTLet 1:311–312 n. 16.
11. Johnson 1:140.
12. WMTLet 1:facing p. 308; PLet 1:201 n. 2 places this meeting in Nov. 1836, but Thackeray was in Paris then.
13. Robert William Buss to John Forster, 11 Dec. 1871, Suzannet cat., p. 281, lot 312.
14. Fredcric G. Kitton, *Dickens and His Illustrators* (London: George Redway, 1899), p. 146.

15. CD to Leech, 24? Aug. 1836, PLet 1:168–169, and CD to Chapman and Hall, 24? Aug. 1836, PLet 1:169–170.
16. Johnson 1:140.
17. Merle to GCk, 28 Dec. 1837, Princeton.
18. PCk "Memoir," pp. 127–128.
19. The date 13 May appears on the final leaf of advertisements, but the *Fraser's* notice appeared in April, so copies may have been ready earlier than mid-May for editors and reviewers.
20. William Maginn, review of *Rookwood*, *Fraser's Magazine* 13 (Apr. 1836): 488–493, repr. in William Maginn, *Miscellaneous Papers*, ed. R. Shelton Mackenzie, 5 vols. (New York: Redfield, 1857), 5:219–225; R. H. Barham, "The Hand of Glory," BM 3 (Mar. 1838): 300.
21. On 29 July Ainsworth instructed Macrone to "insert the clause prepared by Copley and make the conditions relating to *Rookwood* refer to *this edition*, and I shall be abundantly contented" (Ellis 1:291), and throughout the summer Ainsworth, who owned the other moiety of copyright, negotiated with Bentley for republication in editions of various sizes and prices (Gettmann, p. 89).
22. Ellis 1:285.
23. Suzannet cat., p. 280, lot 309: an extract from one of four letters from Ainsworth to Macrone, dated 22 June, 28 July, 14 Nov., and n.d., 1836.
24. Ellis 1:292.
25. Ibid., 1:290–291.
26. CD to Macrone, 17? June 1836, PLet 1:153.
27. GCk to Lighton and Sells, before 25 June 1836, which was publication day, undated Rendell cat.
28. CD to Macrone, 17? and 23 June 1836, PLet 1:153.
29. CD to Macrone, 3 Aug. 1836, PLet 1:160.
30. CD to Tegg, 11 Aug. 1836, PLet 1:163.
31. PLet 1:648–649.
32. CD to Macrone, 24? Aug. 1836, PLet 1:170; Ellis 1:291–301.
33. T. Knox to GCk, 11 Oct. 1836, UNC-CH.
34. C 189, 1836; pencil notes in GCk's hand, V&A 9457.50.
35. *Charles Dickens, 1812–1870: An Anthology*, annot. Lola L. Szladits (New York: Arno Press [for the Berg Collection of English and American Literature, The New York Public Library], 1970), p. 17.
36. Apparently GCk had corresponded in March about these plates: GCk to "M. Feuillet," 24 Mar. 1836, Wesleyan University, Connecticut. An American engraver, Mr. Andrews, brought back to London further instructions, which GCk then followed. See GCk to M. Feuillet de Conches promising to forward his sketches "in a day or two," 16 Sept. 1836, BL Add. MSS 33,964, folio 180. GCk illustrated "Un Fou et un Sage" and "L'Ane vêtu de la peau du Lion"; other Britons contributing to the edition were the octogenarian Stothard, Wilkie, Edwin Landseer, Clarkson Stanfield, and Newton Fielding, and in France, J.A.D. Ingres, Delacroix, the duc d'Orléans, Horace Vernet, and Rosa Bonheur (Félix Sébastien Feuillet de Conches, *Souvenirs de première jeunesse d'un curieux septuagénaire*, 2d ed. (Vichy: no publisher given, 1877), pp. 382–383).
37. That "Boz" was Dickens was first disclosed in a 30 July *Athenaeum* advertisement; but the news was still sufficiently noteworthy for BM to publish an "Impromptu" by C. J. Davids in March 1837:

> Who the *dickens* "Boz" could be
> > Puzzled many a learned elf;
> Till time unveil'd the mystery,
> > And *Boz* appear'd as DICKENS' self!

38. CD to J. P. Collier, 29? Sept. 1836, PLet 1:178–179; see also CD's letters of the same date to Bentley and to Banks, 1:177–179.
39. CD to GCk, 3? Oct. 1836, PLet 1:179.
40. CD to Macrone, 6? Oct. 1836, PLet 1:181.
41. CD to Macrone, 8? Oct. 1836, PLet 1:181.
42. CD to Macrone, 10? Oct. 1836, PLet 1:182.
43. GCk to Macrone, 11 Oct. 1836, Suzannet cat., p. 173, lot 7.
44. CD to Macrone, 19? Oct. 1836, PLet 1:183; it seems more likely that the letter, dated "Wednesday Morning," was written on 12 Oct. The Pilgrim editors suggest that "Macrone presumably kept Cruikshank's letter . . . for a week before showing it to CD," but tensions had lessened by 15 Oct.
45. GCk to Macrone, 15 Oct. 1836, Suzannet cat., p. 173, lot 7.
46. CD to Mary Ann Cruikshank, 28? Oct. 1836, PLet 1:186.
47. Ellis 1:300–301, "in November, 1836," but from other remarks in the same letter, quoted below, before the twelfth.
48. Ibid., 1:300, and for Blanchard, 1:302.
49. PLet 1:649–650 prints the agreement. According to Edward S. Morgan, "A Brief Retrospect," unpub. MS dated 4 July 1873, University of Illinois Bentley Papers, Bentley was fuming because his ex-partner Henry Colburn still owned a money-making periodical, the *New Monthly*. Morgan, who formerly clerked for Colburn and Bentley and went with the latter at the break-up, claims he suggested starting a cheaper rival with Boz as editor and GCk as artist, an idea which his employer greeted with "almost frantic . . . approbation" (p. 13).
50. CD to Bentley, 12? Nov. 1836, PLet 1:194.
51. Draft Memorandum, 9 Nov. 1836, signed by Bentley, Princeton; Agreement, 29 Nov., signed by both parties, BL Add. MSS 46,612, folios 328–329.
52. Ainsworth to Macrone, 12 and 14 Nov. 1836, Ellis 1:305–307.
53. John Sutherland believes the delay was orchestrated by Ainsworth because Macrone could not or would not "come through with the £350, or some portion of it, owed to the novelist" for the copyright. See his "John Macrone: Victorian Publisher," *Dickens Studies Annual* 13 (1984): 243–259, 254. While respecting, I disagree with a number of Sutherland's postulations, including this one. In his letters Ainsworth seems genuinely harassed by the interminable writing of *Crichton*.
54. Ainsworth to Macrone, n.d., "Wednesday" [Dec.? 1836], Bradburn 41 red; quoted in Ellis 1:309–312. The competition between the two writers worked the other way as well; in *Pickwick*, Sam Weller quotes one of the *Rookwood* ballads, "Bold Turpin vunce on Hounslow Heath."
55. Ellis 1:310.
56. V&A E.273–1948, bequeathed by H. H. Harrod, with pencil notes making these identifications. Preliminary drawing, V&A 9672.A, and two other copies of the print, V&A 9672.1 and 9672.2; see also V&A 9641.A, pencil sketch for the frontispiece. The Ainsworth quotation is from his response to the toast in his honor at a Manchester banquet, 15 Sept. 1881, quoted in Ellis 2:327.
57. CD to GCk, 18 Nov. 1836, PLet 1:197.
58. Jerrold 1:211–212.
59. CD to GCk, 26? Nov. 1836, PLet 1:198.
60. CD to GCk, 28 Nov. 1836, PLet 1:200. E. S. Morgan remembered that Dickens had influenza; when he called at Furnival's Inn Dickens explained that his illness would delay the start of *Oliver* until February (p. 14).
61. CD to Bentley, 30 Nov. 1836, PLet 1:202.

62. CD to GCk, 5 Dec. 1836, PLet 1:206; GCk may have informed Macrone of his progress the next day: see Suzannet cat., p. 224, lot 194, which includes an A.L.s., GCk to John Macrone, 6 Dec. 1836, contents not specified.

63. See CD to Hansard, 1? and 2 Dec. 1836, PLet 1:203–204 and 1:203 n. 1. Contrary to Sutherland, p. 250, Forster did not act for CD in this negotiation; he did not even meet CD until Boxing Day 1836.

64. CD to Hansard, 7 Dec. 1836, PLet 1:208–209, 1:208.

65. Early Dec.? 1836, PLet 1:691. The text of this letter is taken from an 1880 catalogue, where it is identified as being from CD and opening with "Dear Mr. Macrone." The Pilgrim editors believe that if the letter is genuine it is from Macrone to CD. I have accepted their emendations with some misgivings. Would a book dealer make such a fundamental transposition and misrepresentation? Why might not CD be saying these things to Macrone, any day after 8 December, when Hansard's had the entirety of the copy? On the other hand the wording sounds more like Macrone than CD.

66. CD to Bentley, 10? Dec. 1836, PLet 1:209.

67. Payments to GCk for the enlarged copies of the *Sketches* plates totaled at least ninety guineas (Chapman and Hall Account Books, Harvard).

68. Geoffrey Tillotson, *A View of Victorian Literature* (Oxford: Clarendon Press, 1978), p. 119. For recent essays on nineteenth-century images of the city, see in addition to the pieces collected by Nadel and Schwarzbach the classic paper by E.D.H. Johnson, "Victorian Artists and the Urban Milieu," in *The Victorian City*, ed. H. J. Dyos and Michael Wolff, 2 vols. (London: Routledge and Kegan Paul, 1973), 2:449–474; the attack on it by Caroline Arscott, Griselda Pollock, and Janet Wolff, "The partial view: the visual representation of the early nineteenth-century city," in *The Culture of Capital: Art, Power and the Nineteenth-Century Middle Class*, ed. Janet Wolff and John Seed (Manchester: Manchester University Press, 1988), pp. 199–233; and the Benjamin-influenced essay by Peter Brooks on Balzac and "The Text of the City," *Oppositions* 8 (Spring 1977): 7–11. General remarks on GCk's *Boz* illustrations and London will be found in many places, including Cohen, p. 18, and Louis James, "Cruikshank and Early Victorian Caricature," *History Workshop* 6 (Autumn 1970): 107–120.

69. Philip Lopate, "Bachelorhood and Its Literature," *Bachelorhood: Tales of the Metropolis* (Boston/Toronto: Little, Brown and Company, 1981), pp. 249–281.

70. Virgil Grillo, *Charles Dickens' Sketches by Boz* (Boulder: Colorado Associated University Press, 1974), p. 10.

71. Miller, "Fiction of Realism," p. 27.

72. Ibid., p. 14.

73. G. K. Chesterton, *Appreciations and Criticisms of the Works of Charles Dickens* (London: J. M. Dent and Sons, 1911), pp. 6–7. Cf. Lopate: "It is not a paradox that the bachelor should have large doses of both young boy and old man inside him" (p. 280).

74. This passage hardly exemplifies the "genial, mature, omniscient . . . reassuring voice that is oracular in wisdom, prophetic in vision" that Grillo identifies as Boz's persona throughout the *Sketches*, p. 63.

75. Contrast also structures T. R. Lamont's *Hard Times* (1861), wherein a teary widow pawns her late husband's pocketwatch while blasé urchins turn in a bundle of clothes (Julian Treuherz, *Hard Times: Social Realism in Victorian Art* [London: Lund Humphries; Mt. Kisco, NY: Moyer Bell; in association with Manchester City Art Galleries, 1987], pp. 34–35).

76. Miller, "Fiction of Realism," pp. 61–64.

77. Ibid., p. 65.

78. Forster, Ley ed., p. 77.
79. Miller, "Fiction of Realism," pp. 53–57.
80. Praz, p. 27.
81. Among the many who have praised this etching is Sacheverell Sitwell: "No painting of Venice by Canaletto is more true to its subject" ("George Cruikshank," in *Trio: Dissertations on Some Aspects of National Genius* by Osbert, Edith, and Sacheverell Sitwell, the 1937 Northcliffe Lectures at the University of London [London: Macmillan, 1938], pp. 221–248, p. 237).
82. First printed in the *Evening Chronicle*, 21 July 1835.

27. *OLIVER TWIST* AND THE "APPLES OF DISCORD"

1. Jerrold 1:223–224.
2. Q.Q.Q. [Samuel Warren], "Dickens's American Notes for General Circulation," *Blackwood's Edinburgh Magazine* 52, no. 326 (Dec. 1842): 783–801, 785.
3. Henry James, *A Small Boy and Others* (New York: Charles Scribner's Sons, 1913), p. 120.
4. PLet 1:210 nn. 1 and 2. Letter from CD to H. P. Hullah, 11 Dec. 1836.
5. PLet 1:239–240 n. 2.
6. This was a substantially higher rate of pay than Bentley offered to Browne (six guineas), R. W. Buss (£5.7.6), and Samuel Lover (four guineas): John Buchanan-Brown, *The Book Illustrations of George Cruikshank* (Newton Abbot: David and Charles, 1980), p. 21.
7. CD to Thomas Beard, 28 Jan. 1837, PLet 1:231.
8. PLet 1:682, Appendix D.
9. *DNB*, s. v. Barham; Blanchard Jerrold attributes the query to Jerdan, at a dinner to celebrate the preliminaries of the magazine (Jerrold 1:207–208n.); PLet 1:202 n. 2 attributes it to Douglas Jerrold. GCk used it in his attack on Bentley in the Feb. 1842 issue of *Ainsworth's Magazine*. For Hook's quip, see Barham, 2:16.
10. R. J. [William Maginn], "The Song of the Cover," *BM* 1 (Apr. 1837): 402.
11. GCk to the Editor, *The Times*, 30 Dec. 1871. Subsequent quotations are from this source.
12. The comparison of *Oliver Twist* to Hogarth has been frequently made: for recent examples, see John Dixon Hunt, *Encounters: Essays on Literature and the Visual Arts* (New York: Norton, 1971), p. 132; Harvey, *passim*; and Cohen, pp. 23–24. CD subtitled his novel "The Parish Boy's Progress" through 1846; in that parts edition he retitled it *The Adventures of Oliver Twist* and thereafter dropped the Hogarthian subtitle. All quotations from the novel are taken from *BM*.
13. While CD probably knew the byways of Saffron Hill intimately, it is conceivable that GCk touted Field Lane as a suitable topic for one of the *Chronicle* sketches some time between Nov. 1835, when he met CD, and Sept. 1836, when CD composed "Meditations in Monmouth Street."
14. V&A 9503.A/P, sketch of a prisoner in Newgate, with sketches for "Don Cove" on the verso.
15. Jerrold 1:264.
16. Richard L. Stein, *Victoria's Year: English Literature and Culture, 1837–1838* (New York and Oxford: Oxford University Press, 1987), discusses in the chapter "The Stolen Child" the cultural anxieties about orphanhood and child kidnapping surfacing at the start of Victoria's reign. Stein's analysis of GCk's illustrations for *Oliver Twist* emphasizes the artist's success in representing the "epistemological obscurity" of the text, settings, and characters.

17. For a discussion of *Oliver's* pictorial prototypes, see Vogler thesis, chapter 4, and his "*Oliver Twist*: Cruikshank's Pictorial Prototypes," *Dickens Studies Annual* 2 (1972): 98–118; see also Michael Steig, "Cruikshank's Nancy," *Dickensian* 72, part 2 (May 1976): 87–92.

18. See Kathleen Tillotson's "Introduction" to her ed. of *Oliver Twist* (Oxford: Clarendon Press, 1966), pp. xv– xvii.

19. CD to Richard Bentley, 7 Jan. 1837, PLet 1:221.

20. CD to GCk, 9 Jan. 1837, PLet 1:221.

21. CD to Richard Bentley, 18? Jan. 1837, PLet 1:223–224.

22. Drawings in Rare Book Room, Free Library of Philadelphia, in Berg, and in a private collection. Information about preliminary sketches is largely taken from Vogler thesis, Appendix I, and Tillotson ed. *Oliver Twist*, pp. 392–397. Tracings for seven of the plates are in V&A 9995.P and 9797.A–F, and nine others are located in the Widener Collection, Harvard.

23. On 19 Apr. 1836 Pettigrew published a pamphlet about this inquiry, *The Pauper Farming System. A Letter to the Right Hon. Lord John Russell, . . . on the Condition of the Pauper Children of St. James's, Westminster*; Harvey, *Victorian Novelists*, pp. 201–203, finds "little truth" to GCk's assertion that the Pettigrew investigation influenced CD, but Harvey reaches this conclusion because the 1836 controversy preceded the novel by nearly a year. If, however, GCk were discussing possible subjects with CD as early as 19 Nov. 1836, it is conceivable that the artist, who saved everything, would have available a copy of Pettigrew's pamphlet and might call the subject to CD's attention.

24. Vogler thesis, pp. 149–157, and Vogler, *PULC*, pp. 61–91.

25. Quoted in Vogler thesis, pp. 156–157; GCk wrote on 3 Jan. 1872 to thank Deane for his support and ask him to communicate with the editors of the *Evening Standard* and the *Daily News* who doubt his veracity (Free Library of Philadelphia).

26. Praz, p. 137.

27. For a further analysis of the changes in Oliver's features, consult Steig, "A Chapter of Noses."

28. [William Makepeace Thackeray], "Charles Dickens and His Works," *Fraser's Magazine* 21, no. 124 (Apr. 1840): 381–400, 400.

29. Morgan, pp. 14–15.

30. Burton M. Wheeler provides the closest examination of the hypothesis that Dickens radically changed his plans in the course of publication, "The Text and Plan of *Oliver Twist*," *Dickens Studies Annual* 12 (1983): 41–61. See also the sympathetic appraisal of GCk's claims by Robert Tracy, "'The Old Story' and Inside Stories: Modish Fictions and Fictional Modes in *Oliver Twist*," *Dickens Studies Annual* 17 (1988): 1–33.

31. PLet 1:230–231 n. 7.

32. Ellis 1:318.

33. CD to Bentley, 24 Jan. 1837, PLet 1:227; CD to T. J. Culliford, 24 Jan. 1837, PLet 1:228.

34. CD to GCk, 8? Feb. 1837, PLet 1:234.

35. Some preliminary sketches in the Widener Collection, Harvard, reproduced in Tillotson ed. *Oliver Twist* facing p. 392, show that confining Oliver became a stronger motif with each revision; the bar separating him from the magistrate's desk, not mentioned in the text, is also not featured in these preliminary sketches. The Meirs Collection at Princeton has a pencil drawing of Oliver tagging along behind Bumble's heels, so perhaps GCk did not immediately follow CD's directions; see Cohen, p. 240 n. 37.

36. Praz, p. 137.

37. Antal, p. 191.
38. GCk to J. Henry George, 23 Feb. and 4 May 1837; 6 June 1837 bill from Stephen Sly to Henry George; all Huntington Library.
39. C 778. GCk's acquaintance with the family extended for many years: John Fremlyn Streatfeild owned a copy of GCk's *Pop-Gun* inscribed by the artist on 20 Feb. 1860 (Joseph J. Felcone Inc. cat. 50, item 36).
40. Pencil studies in the Huntington Library on versos of leaves 14 and 15 of GCk and CD autograph manuscript, *More Hints on Etiquette* (publ. 1838).
41. CD to Bentley, 20? Apr. 1837, PLet 1:249.
42. V&A 9995.C, reproduced in Cohen, fig. 8; seven pencil, wash, and tint portraits on one sheet, Berg. Kitton, *Dickens and His Illustrators*, p. 6, mentions another portrait taken one night when author and artist attended a meeting of "The Hook and Eye Club": "Sit still, Charley, while I take your portrait," GCk is alleged to have exclaimed.
43. CD to Thomas Beard, 12? Apr. 1837, PLet 1:248.
44. Harvard owns a pencil drawing surrounded by details and captioned by GCk "Oliver introduced to the Respectable old Gentleman by Jack Dawkins"; BM Prints and Drawings has a drawing with watercolor washes, possibly done later.
45. CD to GCk, 20? Apr. 1837, PLet 1:249.
46. CD to GCk, 21? Apr. 1837, PLet 1:250.
47. CD to GCk, 24? Apr. 1837, PLet 1:252.
48. CD to Bentley, 28 Apr. 1837, PLet 1:253–254.
49. PLet 1:253 n. 2.
50. CD to Ainsworth, 17 May 1837, PLet 1:260–261.
51. GCk to Bentley, 16 May 1837, Princeton.
52. GCk to Bentley, 19 May 1837, Princeton.
53. GCk to Merle, 26 May, misdated 26 June 1837, UNC-CH; the "pressing invitation" was probably from Baron Feuillet de Conches, to whom there is a GCk draft letter of 18 Aug. 1837, thanking him for a present sent to Mary Ann, K 59. Merle evidently chose the Bentley option, and later that summer (13 July) penned a request that GCk proofread the sheets for him (Princeton).
54. Macrone to GCk, 6 June 1837, Sotheby's "Ruskin" cat., Dec. 1977.
55. GCk to Macrone, 15 June 1837, Suzannet cat., p. 224, lot 194; sketches, V&A 9995.O verso.
56. Two pencil studies and an ink drawing for *Oliver*: Binyon cat. 751–752.
57. GCk to CD, 15 June 1837, draft on verso of sketches of "Oliver amazed," Binyon cat. 751, quoted in Kitton, *Dickens and His Illustrators*, p. 14.
58. CD to John Forster, 9? June 1837, PLet 1:269–270.
59. CD to Bentley, 17? June 1837, PLet 1:272.
60. CD to Bentley, 15? June 1837, PLet 1:272.
61. PLet 1:653.
62. Payments to GCk for the enlarged copies of the *Sketches* plates totaled at least ninety guineas (Chapman and Hall Account Books, Harvard).
63. CD to Forster, 19? June 1837, PLet 1:274.
64. CD to Bentley, 26? June 1837, PLet 1:278.
65. CD to Bentley, 14 July 1837, PLet 1:283–284.
66. Ibid.
67. Agreement with Richard Bentley, 17 Mar. 1837, PLet 1:650–651.
68. CD to Chapman and Hall, 27 July 1837, PLet 1:288.
69. GCk to Bentley, 21 July 1837, Princeton; Becker identified in PLet 1:419 and n. 1. Drawing, V&A 9995.M.

70. *BM* 1:226. The Good Samaritan theme is discussed further in my "'So Much Pains about One Chalk-faced Kid': The Clarendon *Oliver Twist*," *Dickens Studies* 3 (Oct. 1967): 160–168.
71. In "Cruikshank's Peacock Feathers in *Oliver Twist*," *Ariel* 4 (Apr. 1973): 49–53, Michael Steig contends that the feathers surmounting the picture, traditional emblems of misfortune, intimate Oliver's recapture by Fagin shortly afterward. If so, this is another instance of GCk's anticipating a part of the story not yet composed, but discussed with CD.
72. Quoted in Ellis 1:333–334.
73. Ainsworth to GCk, 23 Dec. 1838, Princeton.
74. Ellis 1:332 and Ellis's essay "Jack Sheppard in Literature and Drama," in *Jack Sheppard*, ed. Horace Bleackley, Notable British Trials Series (Edinburgh and London: William Hodge, 1933), pp. 64–126, cited in David Paroissien, *Oliver Twist: An Annotated Bibliography*, Garland Dickens Bibliographies (New York and London: Garland, 1986).
75. Quoted in Thomas Wright, *The Life of Charles Dickens* (New York: Charles Scribner's Sons, 1936), p. 118.
76. William Makepeace Thackeray to John Mitchell Kemble, n.d. (c. 1837–1840), quoted in Gordon N. Ray, *Thackeray*, 2 vols. (London: Oxford University Press, 1955–1958), 1:201.
77. Ray, *Thackeray*, 1:facing 238.
78. CD to Forster, 5? Aug. 1837, PLet 1:292.
79. PLet 1:292–293 n. 5.
80. CD to Bentley, 15 Aug. 1837, PLet 1:296.
81. Preliminary sketches and drawings are at Princeton and the Pierpont Morgan Library; Harvard owns a finished pencil drawing with the variant title. That GCk spells the name "Sykes" may be a slip, often repeated by subsequent commentators on the novel, or may tend to substantiate CD's debt to "Hell and Fury."
82. CD to Bentley, 18 Aug. 1837, PLet 1:296–297.
83. CD to W. Wilson, 30 Aug. 1837, PLet 1:300–301.
84. CD to GCk, 30 Aug. 1837, PLet 1:301–302.
85. GCk to Bentley, 15 Sept. 1837, Princeton.
86. CD to Bentley, 16 Sept. 1837, PLet 1:308.
87. Barham, 2:20–24.
88. GCk to Bentley, 16 Sept. 1837, Princeton.
89. CD to GCk, 16 Sept. 1837, PLet 1:309.
90. CD to Forster, 21? Sept. 1837, PLet 1:310.
91. PLet 1:654–655.
92. CD to Bentley, 7? Dec. 1837, PLet 1:339–340.
93. Burton, *PULC*, pp. 93–128, explicates the sequencing of the illustrations into their own narrative about Oliver's entrapments by, and escapes from, the adult world, pp. 122–128.
94. CD to Bentley, 9? Oct. 1837, PLet 1:317.
95. CD to John Britton, 9 May 1850, PLet 6:96–97.
96. PLet 1:662–664.
97. CD to GCk, 9? Oct. 1836, PLet 1:318.
98. CD to GCk, 13? Oct. 1837, PLet 1:319.
99. V&A 9995.L in brown ink; Harvard has sketch with alternate caption.
100. The shadow in this plate, which was reproduced in theatrical stagings, picks up on the terrifying shadows presaging violence GCk etched into "Oliver asking for more" and subsequent illustrations: see Stein, *Victoria's Year*, pp. 135–138.
101. CD to Ainsworth, 30 Oct. 1837, PLet 1:324–326.

102. CD to GCk, 16? Nov. 1837, PLet 1:332; the letter is undated, though CD's handwriting points to November, but no other evidence confirms that GCk attended the party.
103. There is a page of studies in the Widener Collection, Harvard, signed in ink (probably much later) "Sketches for 'Oliver Twist'—Suggestions to Mr. C. Dickens the *writer*," and a further drawing lately in the collection of Arnold U. Ziegler captioned as in the etching and with a variant, "Oliver cleaning the Artful Dodger's boots."
104. CD to GCk, Nov.? 1837, PLet 1:329.
105. CD to GCk, Nov.? 1837, PLet 1:333; headnote suggests that "the drawing" may refer to the Barker illustration, but PLet 1:329 implies that CD wants to talk about *Oliver*.
106. Inglis died 20 Mar. 1835. The manuscript was probably seen through the press by Eliza Inglis, mistakenly identified by GCk on an 11 Dec. letter from her as "The Authoress," FSB annotation, C 433. See also Mrs. Inglis to GCk, 27 Nov. 1837, JJ. The verso of one sheet of *Oliver* sketches (V&A 9995.M) has studies for an Inglis plate.
107. C 793.
108. C 640, publication date 1838 but probably issued for the Christmas 1837 trade; *Allibone's Dictionary of Authors s. v.* Goodrich.
109. D. M. Moir to GCk, 6 Nov. 1837, Princeton.
110. GCk to Bentley, 7 Dec. 1837, UCLA.
111. GCk to Merle, 11 Dec. 1837; Merle to GCk, 22 Dec. 1837 continued 2 Jan. 1838; 28 Dec. 1837; 5 Jan. 1838; and an especially angry letter of 24 June 1838: all Princeton.
112. CD to Bentley, 5? Dec. 1837, PLet 1:337.
113. Ibid.
114. Preliminary drawings in pen, V&A 9995.N; proofs, V&A 9996.2 and 3.
115. Brian Robb, "George Cruikshank's Etchings for 'Oliver Twist'," *Listener* 74 (1965): 130–131, 131.
116. CD to Forster, 12 Dec. 1837, PLet 1:342; Andrew Lang, *Life and Letters of John Gibson Lockhart*, 2 vols. (London: John C. Nimmo, 1897), 2:182.
117. Ainsworth to unidentified person, 16 Jan. 1838, Suzannet cat., p. 281, lot 310; see also Ainsworth to Crossley, 8 Feb. 1838, Ellis 1:332.
118. PLet 1:630.
119. E.D.H. Johnson, *PULC*, p. 11.
120. CD to Forster, 16 Jan. 1838, PLet 1:355–356.
121. CD to GCk, mid-Jan.? 1838 but evidently after the sixteenth, PLet 1:353.
122. Vogler, *PULC*, p. 71, conjectures that the discrepancy "may well be because the text was written after the illustration had been drawn and because Dickens' account in the note of having described the details in the illustration was faulty at one point." Sketches are in the Pierpont Morgan Library and V&A 9995.F.
123. Cohen, p. 24, and Vogler, *Graphic Works*, p. 151 item 154.
124. Thackeray, "Essay," p. 57.
125. D. M. Moir to GCk, 21 Jan. 1838, Princeton.
126. CD to Ainsworth, 25 Jan. 1838, PLet 1:358–360.
127. GCk to Becker, 1 Feb. 1838, Huntington Library.
128. CD to Forster, 15? Feb. 1838, PLet 1:373–374, and nn. 1 and 2, 1:374.
129. CD to Allan Cunningham, 12 Feb. 1838, PLet 1:372.
130. Kitton, *Dickens and His Illustrators*, p. 14, sketch reproduced opposite p. 16; drawing in V&A 9995.H. GCk had in 1824 executed an aquatint satirizing Richard Martin's Cruelty to Animals Act; he depicted Martin about to enforce his bill by

interrupting three men seated around a table consuming a tub of "Natives," *BMC* 14696, [Jan.] 1824, J. Walker.

131. Barker's pen-and-ink sketch is in the Meirs Collection, Princeton.
132. *Topsail-Sheet Blocks, or the Naval Foundling*, with three very fine etched frontispieces by GCk, 1838 (C 57).
133. Photocopy of letter supplied by H. M. Fletcher.
134. GCk to Robert Blackwood, 26 Feb. 1838, National Library of Scotland.
135. Presentation copy from GCk to Richard Bentley dated 3 Mar. 1838, Woodin sale lot 202.
136. On a 5 Jan. 1838 letter from Merle asking GCk to forward such publications of his over the previous four years as were "worth the labor," the artist has jotted down a list of titles, including *More Hints* (Princeton). Was GCk simply proud of the wood-engravings, or did he have an even greater investment in the work?
137. PLet 1:630; in 1897 Kitton concluded that there was no reason to believe CD "in any way collaborated in the production" of the work ("Pseudo-Dickens Rarities," *Athenaeum*, 11 Sept. 1897, pp. 355–356).
138. Kitton, letter in 23 May 1903 *Athenaeum*; WMTLet 1:515 n. 7; Suzannet cat. E3.
139. For the fullest discussion of this title, see Vogler thesis, pp. 106–110.
140. CD to Forster, late Mar.? 1838, PLet 1:391.
141. *Athenaeum*, 3 Mar. 1838, p. 165.
142. CD to subeditor of *BM*, Mar. 1838, PLet 1:382–383.
143. John Martin to GCk, 16 Mar. 1838, and GCk draft reply on verso, Bradburn 40 red.
144. *Sketches by Boz* VIII, June 1838. Ruskin called the plate "glorious" yet "withering: if one understands it. But who does? or ever did?" (Ruskin to Charles Augustus Howell, 2 Sept. 1866, *Works* 36:512). Cohen interprets this cryptic remark to mean that the children are being exploited for the sake of amusement and profit, pp. 18–19.
145. CD to Forster, 13 Mar. and mid-Mar.? 1838, PLet 1:387.
146. Pierpont Morgan Library; John B. Gough, *The Works of George Cruikshank* (Boston: The Club of Odd Volumes, 1890), reproduces (Plate XIII) another drawing for this composition.
147. CD to Frederick Yates, mid-Mar.? 1838, PLet 1:388–389, and nn. 1–5; for fuller information about dramatic renditions of *Twist*, see Richard P. Fulkerson, "*Oliver Twist* in the Victorian Theatre," *Dickensian* 70, part 2 (May 1974): 83–95, and H. Philip Bolton, *Dickens Dramatized* (London: Mansell, 1987). Meisel studies George Almar's "highly pictorial" Surrey Theatre production, pp. 252–257.
148. A similar remark is recorded in a letter by Barham of 29 or 30 Apr.: "How *Oliver Twist* is to end I know not, nor does the author; at least he tells me so" (Barham, 2:54).
149. Studies of Bill Sikes, BM Prints and Drawings—John Harvey thinks that as the features of the figure identified as Bill Sikes do not resemble those of the character in the published illustrations, GCk misleadingly labeled another drawing in order to bolster his claims for originating *Oliver* (*Victorian Novelists*, pp. 205–207); it is equally plausible, and a little more in character with GCk's basic honesty, to suppose that the drawing was made prior to establishing Sikes's physiognomy, and therefore to conclude that the unlikeness supports GCk's story that he drew this scene *before* Dickens settled on the text. Sketches of Fagin in the condemned cell: V&A 9995.J, 9995.K (reproduced in Kitton, *Dickens and His Illustrators*, opposite pp. 24, 26); Gimbel Collection, Yale Univ.
150. CD to GCk, 16 Apr. 1838, PLet 1:396.
151. PLet 1:633.
152. BM 3:417; sketches in V&A 9995.G and Princeton.

153. Widener Collection, Harvard.
154. BM 3:534–535.
155. CD to G. H. Lewes, 9? June 1838, PLet 1:402–404 and 1:403–404 n. 2.
156. Paul Davis, "Imaging *Oliver Twist*: Hogarth, Illustration, and the Part of Darkness," *Dickensian* 82, part 3 (Autumn 1986): 158–176, thinks that "the internalization of . . . narrative . . . was alien to Cruikshank's dramatic Hogarthianism," though he admits the achievement of "Fagin in the condemned Cell" as an exception (pp. 172–173).
157. William Charles Macready, *Diaries*, ed. William Toynbee, 2 vols. (New York: G. P. Putnam's Sons, 1912), 1:456, 9 May 1838.
158. CD to Bentley, 31? May 1838, PLet 1:401–402.
159. Agreement with Henry Colburn, 10 Aug. 1838, PLet 1:664–665.
160. CD diary entry for 7 July 1838 ("Finished Oliver for the Month, at half past eleven"), PLet 1:633. V&A 9995.I, pen-over-pencil drawing, has caption in CD's hand; Princeton has four preliminary pencil drawings on three sheets.
161. Thackeray to George Wright, 23 May 1838, WMTLet 1:365.
162. Charles Tilt to GCk, 3 Aug. 1838, Bradburn 12 blue; Thackeray, two letters to George Wright and one to GCk describing the May through July scenes, all 4 Sept. 1838, WMTLet 1:369–372.
163. GCk to Merle, 25 July 1838, UNC-CH.
164. CD to Bentley, 10 July 1838, PLet 1:413; CD sent Becker the caption, "Mr. Fagin and his pupils"—plural, as in the list of illustrations at the beginning of the volume edition, but not in the plate—around the twentieth (PLet 1:419). Woodin owned a first edition, first issue three-volume *Oliver Twist* with a pen-and-ink drawing which Cohn asserts was an original for this illustration: see Vogler thesis, p. 288. There is also a drawing in the Berg.
165. CD to Bentley, 19? July 1838, PLet 1:418.
166. CD to Bentley, 26? July 1838, PLet 1:421.
167. CD to GCk, two letters in Aug.? 1838, PLet 1:426.
168. Sketches in Yale Gimbel Collection, H 1734, and in V&A, 9995.J and possibly 9995.B; Cohen, p. 21, argues that GCk was asserting his independence by placing the lantern Monks holds "*over* rather than *lowered* into the well as [Dickens] described," but in fact GCk depicts the scene an instant earlier, when Monks throws back the large trap door. There doesn't, however, seem to be enough rope around the pulley to allow the lantern further descent.
169. V&A 9995.J; Widener Collection, Harvard.
170. GCk to Bentley, 12 Sept. 1838, Princeton.
171. John Ruskin, *Modern Painters* 5.9.7, *Works* 7:349–350; preliminary studies, V&A 9995.J and possibly 9995.B; a page of studies in Widener Collection, Harvard.
172. CD to Bentley, 27 Oct. 1838, PLet 1:445.
173. Princeton has a pencil sketch of the figures and the staircase.
174. CD to GCk, 20 Sept. 1838, PLet 1:436, and agreement with Bentley, 22 Sept. 1838, PLet 1:666–674.
175. CD to Forster, 2 Oct. 1838, PLet 1:438–439.
176. CD to Bentley, 3 Oct. 1838, PLet 1:439.
177. Widener Collection, Harvard.
178. CD to GCk, 6? Oct. 1838, PLet 1:440.
179. CD to GCk, 20? Oct. 1838, PLet 1:441 and headnote.
180. CD to Forster, 6 or 13 Oct. 1838, PLet 1:441.
181. Princeton owns a drawing showing the figures of the housebreaker and his dog only.
182. CD to GCk, 20? Oct. 1838, PLet 1:441.

183. PLet 1:449 n. 3.
184. CD to Catherine Dickens, 5 Nov. 1838, PLet 1:449–450.
185. Ibid., n. 4.
186. Tillotson ed., *OT*, p. xxiv.
187. PLet 1:451 n. 1.
188. PLet 1:410 n. 3.
189. For a fuller consideration of Forster's personality and services to literary men, consult James A. Davies, *John Forster: A Literary Life* (Totowa, N. J.: Barnes and Noble, 1983).
190. Kitton, *Dickens and His Illustrators*, p. 214.
191. Kathleen Tillotson agrees in her ed., p. 393; Forster in his *Life* says that on 8 Nov. CD saw only the last three plates for the first time, 1:132.
192. CD to GCk, 9 Nov. 1838, PLet 1:450–451.
193. George Somes Layard, "Suppressed Plates III," *Pall Mall Magazine* 17 (Mar. 1899): 341–348.
194. Princeton has a sheet of sketches for both plates, indicating, according to E.D.H. Johnson, that "the artist had these alternate designs in mind from the outset," *PULC*, p. 17; V&A 9995.D is a pencil vignette of the Fireside scene, and there are other sketches for it on the verso of the 20 Oct. letter from CD to GCk; a sheet of drawings in the Widener Collection, Harvard contains sketches for this and the unpublished Rose and Nancy interview. Additional studies for the Church plate appear on a sheet in the Berg.
195. William Glyde Wilkins, "Variations in the Cruikshank Plates to *Oliver Twist*," *Dickensian* 15, no. 2 (Apr. 1919): 71–74; in his attempt to make early passages of the text concordant with later ones, and to bring the whole story in line for volume issue, CD waffled about the age of Oliver: he's eight revised to nine at Mrs. Mann's, eleven for Noah and Grimwig but over twelve for Monks. No wonder GCk had trouble fixing on an appropriate look.
196. Algernon Charles Swinburne, *Charles Dickens*, ed. Theodore Watts-Dunton (London: Chatto and Windus, 1913), p. 13.
197. Harvard; the Berg owns a pencil drawing with watercolor washes, possibly (as with the BM watercolor of "Oliver introduced") executed later.
198. For prototypes of Fagin, see Vogler thesis, pp. 192–197, and Vogler, "*Oliver Twist*: Cruikshank's Pictorial Prototypes," pp. 108–112; see also Obituary of GCk, *Daily News*, 2 Feb. 1878; Cohen, pp. 22–23; and Harvey, *Victorian Novelists*, pp. 205–206, who maintains that the "First idea and sketch for Fagin in the Condemned Cell" (V&A 9995.J) has been misleadingly titled by GCk, being in fact a study for an unused vignette in the wood-engraved wrapper design for the 1846 serial issue. However, it is drawn on the "London Super" blind stamped paper used for the 1837–1838 drawings; and there are other images of Fagin sketched for the 1846 vignette wrapper design on V&A 9995.A. In Harvey's favor, on the same sheet a second image of Fagin and one of Monks with the Bumbles are surrounded with decorative borders, and under this image of Fagin GCk has written "wood cut." It would not be atypical for GCk to reuse, some years later, a sheet on which he had already scribbled first thoughts; but on the whole GCk's attribution of V&A 9995.J is problematical.
199. For CD's use of cultural stereotypes, see Edgar Rosenberg, "The Jew as Bogey," in *From Shylock to Svengali: Jewish Stereotypes in English Fiction* (Stanford: Stanford University Press, 1960), pp. 116–137, and Lauriat Lane, "Dickens' Archetypal Jew," *PMLA* 73 (Mar. 1958): 94–100, rebutted by Harry Stone, "Dickens and the Jews," *Victorian Studies* 2 (Mar. 1959): 223–252; for an exploration of the psycho-

logical connections between the Jew and CD, consult Steven Marcus, "Who is Fagin," *Commentary* 34 (July 1962): 48–59.

200. Juliet McMaster, "Diabolic Trinity in *Oliver Twist*," *Dalhousie Review* 61 (Summer 1981): 263–277, identifies Monks, Sikes, and Fagin as demonic parodies of the Trinity (respectively benevolence, omnipotence, and knowledge gone bad); *BM* 1.540.

201. *BM* 5.66; Cohen makes this point, p. 23, arguing that GCk was "evading" CD's last description of Fagin beating against the walls and door.

202. *BM* 5.419.

203. Jerrold 1:227–231; George Hodder, *Memories of My Time* (London: Tinsley Brothers, 1870), pp. 107–108.

204. Jerrold 1:227. Cuthbert Bede was the pseudonym of the Reverend Edward Bradley, Rector of Stretton, Oakham, and author of many articles and the charming novel, *The Adventures of Mr. Verdant Green*.

205. Ibid., 1:229–230.

206. Vizetelly 1:106.

207. Harvey, *Victorian Novelists*, p. 210; G. K. Chesterton, *Charles Dickens* (New York: Dodd Mead and Company, 1906), p. 112.

208. Richard Ford, review of *Oliver Twist*, *Quarterly Review* 64, no. 127 (June 1839): 102.

209. Thackeray, "Essay," pp. 57–58.

210. Sala, pp. 548–589. See also Ralph Straus, *Sala* (London: Constable, 1942).

211. *Examiner*, 18 and 25 Nov. 1838.

212. Quoted in Paroissien, p. 104, 9.26; and pp. 100–101, 9.14.

213 Macready, *Diaries*, 1:476; PLet 1:456 n. 3; Forster, Ley ed., p. 125.

214. Fulkerson, p. 85.

215. Jonathan E. Hill, "Cruikshank, Ainsworth, and Tableau Illustration," *Victorian Studies* 23, no. 4 (Summer 1980): 429–459, 443–444.

216. Ibid., pp. 443–445. As Meisel points out, the Almar version, especially in its first half, "capitalizes thoroughly on the vividness and familiarity of the plates" (p. 253).

217. Quoted in Ibid., pp. 445–446. For playwright, see Bolton, pp. 113–114.

218. Quoted in Bolton, p. 114.

219. Jonathan E. Hill, "Cruikshank, Ainsworth, and Tableau Illustration," p. 446.

28. ALMOST IN LOVE WITH ROGUERY

1. [W. E. Aytoun and Theodore Martin], "Review of Unpublished Annuals," *Tait's Edinburgh Magazine* n.s. 8 (Dec. 1841): 749–756, 749–750.

2. PLet 1:460 n. 5.

3. CD to Forster, 23? Nov. 1838, PLet 1:459–460.

4. Ibid.; CD to GCk, 24? Nov. 1838, PLet 1:461.

5. CD to GCk, 24? Nov. 1838, PLet 1:461.

6. CD to John Pritt Harley, Nov.? 1838, PLet 1:465: "Dine with us on Wednesday." If Nov. rather than Dec., then probably after the publication of *Oliver*; not Wednesday the 21st, as CD was attending *Nickleby* at the Adelphi that night; therefore the 28th.

7. CD to Forster, 4 Dec. 1838, PLet 1:465–466. On one other occasion in the winter of 1838–1839 CD had to postpone an engagement to join the Cruikshanks for an Adelphi program: "There is the one consolation in this, that by so doing we shall see better pieces" (CD to GCk, Winter? 1838–1839, PLet 1:486–487).

8. CD diary entry, PLet 1:636; Walter Hamilton, quoted in Jerrold 2:24–25.
9. CD to Ainsworth, 28? Dec. 1838, PLet 1:480.
10. CD diary entry, PLet 1:638.
11. C 624.
12. Collection George Watson, Cambridge, England.
13. C 353. Some book dealers take Glascock's service initials to stand for his Christian names: Captain R. N. Glascock.
14. C 99.
15. Edwin Truman owned a set of twenty-five wood-engravings to *Pilgrim's Progress* which he said in 1903 GCk had designed "more than forty years ago," that is, before 1863 (C 100). It is possible these were produced in 1838: on the verso of GCk draft letter to an unidentified person, 22 Jan. 1839, Princeton, is a list of illustrations to Bunyan's work.
16. C 673.
17. Barham 2:65–67.
18. C 147. Books illustrated by more than one artist working in different styles raise the question of mimesis in an interesting way. If the plate is not a "mirror" of the text, if the figures and "look" of the image differ from picture to picture, then how do the plates "represent" the letterpress? The issue has particular relevance to CD's *Master Humphrey's Clock* and Christmas Books, but also to books illustrated by a single artist who employs more than one style, as GCk did using both wood-engravings and steel-etchings for *The Tower of London* (1840) and Thackeray did in supplying emblematic initials and full-page "realistic" plates for *Vanity Fair*.
19. Merle to GCk, 24 Sept. 1838, Princeton; GCk to Bentley, Nov. 1838, Indiana; GCk to Merle, 26 Nov. 1838, Princeton.
20. D. M. Moir to GCk, 9 Dec. 1838, Princeton.
21. Ainsworth to Crossley, 29 May 1837: "I mean to write a sort of Hogarthian novel—describing London, etc., at the beginning of the Eighteenth Century" (quoted in Ellis 1:328).
22. Ellis 1:334.
23. Ainsworth to Charles Ollier, 10 Dec. 1838, Ellis 1:345.
24. Pencil, pen-and-ink, and sepia sketches, Binyon cat. 777–814.
25. Thackeray, "Essay," p. 55.
26. "Jack Sheppard escaping from the condemned hold in Newgate," BM 6:facing p. 236, copies and dramatizes the frontispiece of *A Narrative of all the Robberies . . . of John Sheppard* (London: John Applebee, 1724), reproduced in Bleackley facing p. 20 and in Meisel, p. 270. GCk's "Escape" plates dramatize the *Exact Representation* of the chimneys, locks, bolts, and doors of Newgate (London: T. and J. Bowles, 1724), reproduced in Bleackley facing p. 28 and in Kunzle, *History of the Comic Strip*, 1:191.
27. Jonathan E. Hill, "Cruikshank, Ainsworth, and Tableau Illustration," *passim*.
28. Ainsworth, "A Few Words about George Cruikshank," the author's "final explanation" of the *Artist and the Author* controversy, sent to Jerrold and published there, 1:258–269, 268.
29. BM 5:24 (Epoch the First, ch. 4).
30. Drawing reproduced in Ellis 1:facing p. 380.
31. Ainsworth to GCk, 16 Dec. 1838, Bradburn 48 red.
32. Ainsworth to GCk, n.d., "Sunday" [23 Dec. 1838], Princeton; see also a second letter by Ainsworth praising this plate quoted in Ellis 1:381.
33. Thackeray, "Essay," p. 55.
34. Ibid., p. 54.
35. BM 5:127 (Epoch the First, ch. 6).

36. Ainsworth to GCk, n.d., "Sunday" [23 Dec. 1838], Princeton.
37. Burton, *PULC*, pp. 109–110.
38. For a fuller discussion of the interplay among Newgate fictions, see Keith Hollingsworth, *The Newgate Novel, 1830–1847: Bulwer, Ainsworth, Dickens, & Thackeray* (Detroit: Wayne State University Press, 1963).
39. CD diary entry, PLet 1:638.
40. PLet 1:498–503 and nn.
41. Forster, Ley ed., p. 116.
42. *Serjeant Bell*, C 569.
43. William Johnson Neale to GCk, 20 Feb. 1839, Princeton.
44. *HP* 18. James Henry Dixon, in an article in *The Local Historian's Table Book 2* (Newcastle on Tyne, 1843), notes a number of broadsheet versions circulating in the early nineteenth century and says that GCk's rendition and music are authentic. John Wardroper, who forwarded this information to me, comments that there is "no reason to doubt Cruikshank's statement" that he heard someone singing Lord Bateman outside or inside a pub near Battle Bridge (John Wardroper to RLP, 15 Aug. 1993).
45. See description in Percival Leigh's letter to Blanchard Jerrold, 18 Feb. 1878, quoted in Jerrold 2:26–27, and for other details consult CD's letters quoted hereafter.
46. Thackeray to GCk, May? 1839, WMTLet 1:380–381. GCk in some unpublished autobiographical notes says that Thackeray "insisted upon writing a preface" to an adaptation inspired by GCk (PLet 1:536 n. 1); this may be a garbled recollection of events some thirty-odd years past, or it may be that CD's rendition derived from GCk's which then ultimately "inspired" Thackeray, or indeed Thackeray may have proposed collaborating in the way GCk and CD ultimately did.
47. Anne Thackeray Ritchie, "Lord Bateman: A Ballad," *Harper's New Monthly Magazine* 86 (Dec. 1892): 124–129.
48. See Anne Lyon Haight, "Charles Dickens tries to remain Anonymous," *Colophon* 1, no. 1 new graphic series (Spring 1939): [39–66].
49. Reminiscences by Henry Burnett of May? 1839 sent to F. G. Kitton, quoted in PLet 1:552 n. 1. GCk used his own publisher, Tilt. He could not offer the book to Bentley because of CD's involvement.
50. CD to GCk, May? 1839, PLet 1:552, and "Preface" to *The Loving Ballad of Lord Bateman* (London: Charles Tilt, 1839), C 243. On the conjugate leaf of the CD letter GCk has penciled a line from the ballad with the variant spelling "Darter" for "daughter," Suzannet cat., p. 231, lot 203.
51. Quoted from Burnett's reminiscence to Kitton, PLet 1:552 n. 1.
52. Charles Selby's burletta adaptation, *The Loves of Lord Bateman and the Fair Sophia* (New Strand Theatre, 1 July 1839), not only drew upon the plates by number in staging the individual scenes, but also put them all onto a miniature diorama that in the introduction is slowly rolled by at the back of a toy theater while a cockney showman delivers facetious commentary (Jonathan E. Hill, "Cruikshank, Ainsworth, and Tableau Illustration," pp. 450–452). The staginess of GCk's plates is thereby emphasized and elaborated.
53. Barham to GCk, 15 June 1839, quoted in a letter from S. Hodgson to the editor, *TLS*, 13 June 1935, p. 380.
54. CD to GCk, 3 July 1839, PLet 1:559; "My Dear Georgius" opens CD's letter of 29 Mar. 1839 returning part of the *Bateman* manuscript (PLet 1:536).
55. Anne Lyon Haight, [p. 49].
56. CD to GCk, 3 July 1839, PLet 1:559.
57. Suzannet cat., p. 232, lot 204.

58. Agreement with Richard Bentley for *Barnaby*, 27 Feb. 1839, PLet 1:674. The Pilgrim editors concur, though they also suggest, less plausibly, that CD might be concerned "because the ballad was rather 'low'" (PLet 1:559 n. 4).
59. PCk "Memoir" alleges that Bentley came to Amwell Street for consultations, and that GCk was so enraged by the terms of the offer that Bentley beat a hasty retreat. George Bentley, the publisher's son, expressed his doubts in a holograph comment on the margin of PCk's manuscript: "I query my father's running away from any one—Courteous in manner, he knew how to make himself respected" (pp. 136–140).
60. BL Add. MSS 46, 612 folios 329–330.
61. GCk eventually produced one illustration from *Clink* (C 409) for the May 1839 *Miscellany*, and one from *Vincent Eden* (BM 5:facing p. 627).
62. E. S. Morgan, "Minutes of a Conversation between Mr. Cruikshank, Mr. Bentley and myself," 11 Mar. 1839, quoted in Buchanan-Brown, p. 25.
63. Thackeray, "Essay," p. 55.
64. BM 5:223 (Epoch the Second, ch. 1). Observing Sheppard in Newgate, the poet John Gay suggests that Jack should write his adventures. "They would be quite as entertaining as the histories of Guzman D'Alfarache, Lazarillo de Tormes, Estevanillo Gonzalez, Meriton Latroon, or any of my favourite rogues" (BM 6:447, Epoch the Third, ch. 16). Ainsworth worked hard to generate narrative out of physiognomy and vice versa.
65. BM 5:229 (Epoch the Second, ch. 1).
66. Thackeray, "Essay," p. 56.
67. BM 5:227 (Epoch the Second, ch. 1).
68. BM 5:242 (Epoch the Second, ch. 5).
69. BM 5:565 (Epoch the Second, ch. 16).
70. Quoted in Ellis 1:376 n. 1.
71. BM 5:571 (Epoch the Second, ch. 17).
72. Kunzle, *History of the Comic Strip*, 1:322–331, points out that in the later plates Goodchild countenances gluttony, perjury, bribery, and riot; Hogarth engraves a more ambiguous contrast between his protagonists than some of his interpreters discerned.
73. Ainsworth to GCk, n.d. [May 1839], UCLA. Thackeray thought the little glimpse of the church "very beautiful and poetical: it is in such small hints that an artist especially excels; they are the morals which he loves to append to his stories, and are always appropriate and welcome" (Thackeray, "Essay," p. 56). In this instance some of the credit ought to be given to Ainsworth as artist.
74. Ainsworth, "A Few Words about George Cruikshank," Jerrold 1:259.
75. GCk to Ainsworth, n.d. [July 1839], Harvard.
76. Harvey, *Victorian Novelists*, p. 36.
77. GCk to Ainsworth, 12 July 1838, Harry Ransom Humanities Research Center, The University of Texas at Austin.
78. Ainsworth to GCk, n.d. [Aug. 1839], Princeton. GCk's pencil and tint sketches and notes for this plate are on the verso of an undated letter to him from Forster saying he is too ill to attend GCk's party, National Gallery of Art, Washington, D.C., B.11.212.
79. Thackeray to Mrs. Carmichael-Smyth, 1–2 Dec. 1839, WMTLet 1:395.
80. C 87.
81. GCk to Sir John Bowring, 4 Feb. 1839, Collection James Ellis.
82. C 728; C 735.
83. GCk to Bentley, 17 June 1839, Princeton; William Jerdan to GCk, 5 July 1839, UCLA.

84. John Thompson to GCk, 25 Apr. 1839, Princeton.
85. Charles Julius Roberts to GCk, 5 Nov. 1839, UNC-CH.
86. Ellis 1:353 dates this Oct., but the calendar for 1839 confirms that the month is Sept.
87. See for example the "Original Sketch" for "Jack Sheppard tricking Shotbolt, the Gaoler" (1 Oct. *Miscellany*) reproduced in Gough, *Works*, Plate XIV.
88. Jerrold 1:241.
89. *BM* 6:447–448 (Epoch the Third, ch. 16).
90. Thackeray, "Essay," p. 57.
91. When GCk assisted in the Surrey Theatre production, Ainsworth asked him to explain to the crew "how the *doors* in the Great Escape should be managed." It is on such effects, Ainsworth explains, and on the huge diorama moving behind an immense mob of citizens, soldiers, and horses at Jack's execution, that "the main interest of the drama will hinge" (Ainsworth to GCk, n.d., "Tuesday night" [1 Oct. 1839], Princeton).
92. GCk to Ainsworth, c. 25 Sept. 1839, Ellis 2:95. At least one theatrical adaptation (Haines's at the Royal Surrey) staged this scene exactly as GCk drew it (see below, p. 123).
93. See Harvey, *Victorian Novelists*, pp. 47–49.
94. GCk to Ainsworth, n.d., "Tuesday 1/2 past five" [1 Oct. 1839], Princeton.
95. GCk to Ainsworth, n.d., "Wednesday" [2 Oct. 1839], Princeton. Vogler thesis, pp. 170–172, transcribes and discusses these two letters, then in the collection of David Borowitz. The *DNB* says Goodyear died on 1 Oct., but the sequence of the two letters and the postmark on the envelope to the first indicate that the second letter was written on the evening of 2 Oct.
96. Gettmann, p. 74 n. 2; Ellis, "Epilogue," in Bleackley, pp. 77–78, quotes Barham urging Ainsworth to release on 16 Nov., the day of Jack's execution.
97. Ellis 1:362 says "eight"; Hollingsworth repeats the number but actually lists nine (p. 139); J. R. Stephens, "*Jack Sheppard* and the Licensers: The Case against New-gate Plays," *Nineteenth Century Theatre Research* 1, no. 1 (Spring 1973): 1–13, uses Hollingsworth as source for his "eight" but supplies a slightly different list; Jonathan E. Hill, "Cruikshank, Ainsworth, and Tableau Illustration," p. 447, counts six by his "own conservative calculation" (n. 29). Collating all the accounts we get productions opening on 17 Oct. at the Pavilion, on 21 Oct. at the Surrey, Royal Victoria, City of London, and Queen's, on 28 Oct. at the Adelphi and at Sadler's Wells, and later productions at the Coburg (about which Thackeray wrote to his mother in December), the Garrick, and over Christmas Harlequin Sheppard at the Drury Lane. Provincial productions were staged in Edinburgh and at the Theatre Royal, Sheffield, the latter an adaptation by Thomas Hailes Lacy of Haines's Surrey Theatre script. Ellis, "Epilogue," in Bleackley, pp. 91–125 gives the most complete account of nineteenth-century stagings. Meisel discusses the Adelphi, Surrey, and Sadler's Wells productions, pp. 271–279.
98. Barham 2:91.
99. Quoted in Ellis, "Epilogue," in Bleackley, p. 94.
100. Ellis 1:362.
101. See Jonathan E. Hill, "Cruikshank, Ainsworth, and Tableau Illustration," pp. 446–454, for an analysis of the theatrical adaptations of the *Jack Sheppard* illustrations, and the reciprocal influence of anticipated stagings on GCk's designs.
102. Ainsworth to GCk, n.d., "Tuesday Night" [1 Oct. 1839], Princeton, says he has pledged himself to Buckstone but will help GCk's friend (Davidge?) by sending an early copy of the last installment if GCk will send proofs of the final plates to Buckstone.
103. Ainsworth to GCk, 6 Oct. 1839, Princeton.

104. Curiously, Marie Duval, a Continental actress who also specialized in playing Jack Sheppard, injured herself acting the escapes. So she retired and commenced a second career as Europe's only nineteenth-century female caricaturist, the inventor of *Ally Sloper* (Kunzle, *History of the Comic Strip*, 2:316–322).
105. Ellis 1:facing 364.
106. C 698.
107. Quoted in Ellis 1:366. See also Bon Gaultier, "Illustrations of the Thieves' Literature—No. 1. Flowers of Hemp; or, the Negate Garland," *Tait's Edinburgh Magazine* n.s. 8 (Apr. 1841): 215–223, 220–221.
108. See *Punch*, 11 Dec. 1841. p. [259].
109. "Literary Recipes," *Punch*, 7 Aug. 1841, p. 39.
110. Hollingsworth, p. 141.
111. Peter Linebaugh, by putting the original Jack Sheppard into his historical context, illuminates the ways in which Jack's social status, crimes, and punishments reflected large social movements, including passage of such major repressive legislation as the first Workhouse Act, at the start of the Hanoverian era. Jack, a workhouse brat before Knatchbull's Act authorized every parish to establish workhouses, thus prefigures Oliver, a workhouse brat caught between the eighteenth-century legislation and the nineteenth. This is another instance of the dense interplay between the two novels. See Peter Linebaugh, *The London Hanged: Crime and Civil Society in the Eighteenth Century* (Cambridge: Cambridge University Press, 1992), especially ch. 1.
112. William Makepeace Thackeray, "Horae Catnachianae," *Fraser's Magazine* 19, no. 112 (Apr. 1839): 407–424; inset quotations, pp. 408, 424.
113. Review of *Jack Sheppard*, *Athenaeum*, 26 Oct. 1839, pp. 803–805.
114. John Forster, Review of *Jack Sheppard*, *Examiner*, 3 Nov. 1839, pp. 691–693.
115. Quoted in Ellis 1:358–359.
116. Thackeray to Mrs. Carmichael-Smyth, 1–2 Dec. 1839, WMTLet 1:395.
117. Thackery forwarded this paper, and hence was supposed for more than a century to be its author; see Micael Clarke, "A Mystery Solved: Ainsworth's Criminal Romances Censured in *Fraser's* by J. Hamilton Reynolds, not Thackeray," *Victorian Periodicals Review* 232 (Summer 1990): 50–54.
118. *The Times*, 25 June 1840, and J. R. Stephens, pp. 3–4.
119. *Examiner*, 28 June 1840.
120. *The Times*, 7 July 1840.
121. William Bodham Donne, the Examiner of Plays, testifying before an 1866 Parliamentary inquiry into theatrical licensing, quoted in J. R. Stephens, p. 5.
122. Sala, p. 551.

29. THE TOWER! IS THE WORD—FORWARD TO THE TOWER!

1. Thackeray, "Essay," p. 59.
2. GCk to Bentley, 12 Oct. 1839, Princeton.
3. Morgan, p. 16.
4. GCk, *The Artist and the Author* (London: Bell and Daldy, 1872), pp. 7–8.
5. Ainsworth to GCk, n.d. [Aug. 1839], Princeton.
6. Roberts to GCk, 13 Nov. 1839, Princeton. GCk jots memoranda about these negotiations on the verso of his draft of a letter to Dickens about *Barnaby* c. 16 Oct. 1839: see Suzannet cat., item J.13, p. 144 and photograph of verso, p. 145. In accordance with the Pilgrim dating (1:589) of a letter from CD to GCk as 3? Oct., this draft is dated 2? Oct.; but since GCk did not complete the plates for *Sheppard* until the seventh or eighth at the earliest, and says he has finished all his work and has been waiting for a few days, the draft must have been written around midmonth.

7. R. H. Barham's copy, signed by Ainsworth, Bentley, and GCk on 19 Nov. 1839 and witnessed by Barham, then sent by Barham to GCk on 27 Aug. 1840 in connection with arbitration, is now at Princeton; the cut-off signatures once owned by H. W. Bruton are now in Berg. A second agreement composed after Ainsworth and GCk had settled on the precise format specified seventy-five hundred copies and prevented stereotyping for the present: 5 Dec. 1839, Princeton.

8. GCk draft letter to unidentified person, n.d. [Dec.? 1840], V&A 9910.H.

9. GCk to Ainsworth, 11 Mar. 1840, Berg; quoted, spliced into other undated correspondence, Ellis 1:411.

10. CD to GCk, 3? Oct. 1839, PLet 1:589.

11. Draft letter from GCk to CD, PLet 1:589 n. 4, dated 2? Oct. in Suzannet cat. but certainly later in the month; see this chapter, n. 6.

12. CD to Messrs. Smithson and Mitton, 16 Dec. 1839, PLet 1:616–618.

13. CD to Thomas Beard, 17 Dec. 1839, PLet 1:618–619.

14. Ainsworth and GCk to Bentley, 29 Nov. 1839, Princeton. See also the printed page of *Jack Sheppard* with note by Ainsworth, countersigned by GCk, asking if this model, minus one line (that is, forty-eight rather than forty-nine lines), would do, considering that the letterpress will be stereotyped (Princeton).

15. Ainsworth to GCk, n.d. [Dec. 1839], UCLA.

16. Ainsworth and GCk to Bentley, 29 Nov. 1839, Princeton. Shilling monthly numbers, 13 as 12, Jan.–Dec. 1840, and in one volume, Dec. 1840, C 14.

17. GCk, *Artist and Author*, p. 8.

18. Ainsworth, "Preface" to the *Tower*.

19. A contemporary account of the Tower and its publicity is contained in [Leigh Hunt], Review (Article IX) of John Bayley, *The History and Antiquities of the Tower*, and *A Short History of the Tower*, in *London and Westminster Review* 29, no. 2 (Aug. 1838): 433–461.

20. GCk, *Artist and Author*, pp. 8–9.

21. Ainsworth to the editor, 8 Apr. 1872, *The Times*, 9 Apr. Ainsworth was there responding to GCk's claim to have originated the *Miser's Daughter*, *Oliver Twist*, and the *Tower*. The artist's elaboration of his case for the latter novel was not published until after the editor of *The Times* declined to print further correspondence on the subject.

22. Ellis 2:94.

23. GCk to Ainsworth, n.d. [June 1840], Princeton, partly quoted in Ellis 2:94–95 where it is identified as the second half of a letter enclosing the "4th tracing." That letter from GCk to Ainsworth in its entirety is owned by Princeton and dated "Friday Eve." [19? June 1840]. The description of the masque must have been written earlier in the month, to give Ainsworth time to compose the text.

24. Harvey, *Victorian Novelists*, p. 39.

25. GCk, *Artist and Author*, p. 3.

26. Edmund L. L. Swift, keeper of the regalia in the Jewel House at the Tower, writes on 23 Oct. 1840 to inform GCk that the Lord Chamberlain has sanctioned sketching the interior and to offer every facility within his promise to artist and author (Princeton).

27. Ainsworth's routine, Ellis 1:412–413. GCk's sketches in various mediums, Binyon cat. 12–16, 834–965, 1044–1045, 1208v; V&A 9373, 9906.A–V, 9907.A–Z, 9908.A–Y, 9909.A–Q, 9910.A–H, 9911.A–J (tracings), and 9950.R; five watercolors and one sepia drawing in Berg; other sketches and watercolors at Princeton.

28. Ainsworth to GCk, n.d., "Thursday" [2? Jan. 1840], V&A 10,048.O.

29. GCk to Ainsworth, n.d. [Mar.? 1840]. Huntington Library; quoted in Ellis 2:93 as "proof that the artist could not work, or decide any matter, upon his own respon-

sibility." The tone of the letter does not suggest that GCk feels subordinated. See also Ainsworth to GCk, 9 Mar. 1840, Bradburn 45 red, and n.d., "Friday morning" [1840], Ainsworth inviting GCk to join him and Crossley at the Tower, Vogler Collection, Grunwald Center, UCLA.

30. Ainsworth to GCk, 2 Aug. 1840, quoted in Ellis 2:92–93.
31. GCk to Ainsworth, n.d., "Sun. night" [18? Apr. 1840], Princeton.
32. GCk to Ainsworth, postmarked 20 June 1840, Huntington Library.
33. GCk to Ainsworth, n.d. [Sept. 1840], British Author Collection, Box 1, Folder 2, Department of Special Collections, Stanford University Libraries; quoted in Harvey, *Victorian Novelists*, p. 41.
34. N.d. [Nov. 1840], V&A 9913.B.
35. Ainsworth to GCk, June 1840, Christie's Prescott sale, 6 Feb. 1981, lot 77. Bedingfield's lineal descendant, Sir Henry Bedingfield, Bart., furnished Ainsworth with information about his ancestor which the author gratefully acknowledges in the "Preface"; he also inscribed to Bedingfield a copy of the bound volume, now in Berg.
36. GCk to Ainsworth, n.d., "Friday Eve." [19? June 1840], Princeton.
37. GCk to Ainsworth, n.d. [Apr. 1840], Princeton.
38. Ainsworth to GCk, 2 Aug. 1840, quoted in Ellis 2:92.
39. Harvey, *Victorian Novelists*, quotes letters from GCk to Ainsworth of 16 Sept. and "Sunday Evg." [20 Sept.] 1840 in the Huntington Library. They are also quoted in Vogler thesis, pp. 164–166.
40. GCk to Ainsworth, postmarked 15 July 1840, Princeton.
41. GCk to Ainsworth, n.d., "Thursday" [12 or 19? Nov. 1840], Princeton.
42. GCk to Ainsworth, postmarked 14 Sept. 1840, Princeton. GCk inserts additions not transcribed here about the effects of the tide and ancillary attacks on the "Lion Tower" and the wharfs.
43. Jerrold 1:250–251.
44. Ainsworth to GCk, n.d., "Thursday" [2? Jan. 1840], V&A 10,048.O; J. Marsh for Bentley to GCk, 8 Feb. 1840, Princeton; GCk to Morgan, 17 Mar. 1840, Princeton; reply, Morgan to GCk, 17 Mar., Princeton. See also Bentley to GCk, 18 May 1840, Princeton, advising that the advertising may cost more than it produces. The partners fired Bentley after the first numbers because he was so lax in selling advertisements. J. Marsh to GCk, 14 Apr. 1840, UCLA: the last 250 copies of Part I are being stitched, and "as the work is much in demand, it will be necessary to go to press without delay. Mr. Morgan desires me to suggest the printing 2500 of this part, and to inquire if you will sanction our printing this number." In a letter to Morgan on 12 Sept. 1840, GCk says he has directed the printer, Bradbury, to equalize back numbers at 1,000 each, agrees with Morgan's recommendation that the next number be increased to 8,500, and asks that the etchings be reprinted only in batches of 250, as he wishes to make alterations (Princeton). Bill from Sands, 21 Sept. 1840, Clark Library, UCLA; see also undated letter from James Yates to GCk requesting paper for the plates so that when the steels are ready there will be no delay (William Andrews Clark Memorial Library, UCLA), and letter from Henry Howe to GCk, 16 Sept. 1840, offering to print the *Tower* illustrations at 17s. 6d. per 1,000, yielding a savings of nearly £9 per month (Princeton).
45. Ainsworth to GCk, n.d., "Sunday night" [21? June 1840], Princeton. This time table corresponds only to the month of June in 1840, though Ainsworth is off by a day in one instance; but other information in the letter—his inability to get to writing up a history of the Tower which appears in the May issue—suggests April.
46. GCk to Ainsworth, n.d. [c. May 1840], Princeton. GCk announced a second postponement the following month: GCk to Ainsworth, 16 May 1840, Berg. See also

Ainsworth to GCk, n.d. [Aug.? 1840], Berg. inquiring about the progress of the "View."

47. See for example Ainsworth to GCk, 16 July 1840, Vogler Collection, Grunwald Center, UCLA, describing the two subjects for the Aug. installment.

48. GCk to Bentley, 21 Jan. 1840, Princeton.

49. CD to Thomas Mitton, 29 Jan. 1840, PLet 2:13–14; Bentley never followed through on his threat, though later his son George set the letters in type (PLet 2:14 n. 3).

50. Ainsworth to GCk, n.d., "Thursday" [1840], Vogler Collection, Grunwald Center, UCLA.

51. Mrs. M. A. Hughes to GCk, 5 Jan. 1840, UCLA.

52. Barham to GCk, n.d. [3 Feb. 1840?], Princeton.

53. Barham, pp. 93–94.

54. Gettmann, p. 81.

55. GCk to Bentley, 7 Feb. 1840, Princeton. GCk received £153.4.6 from Bentley to reprint his illustrations in the first edition of five thousand copies; Tenniel got £180.4.4, and Leech £40.4.6. Bentley cleared over £1,000 (Gettmann, p. 81).

56. GCk to Bentley, n.d., "Tuesday Evg." [18? Feb. 1840], Princeton.

57. GCk to Ainsworth, n.d. [Mar.? 1840], Huntington Library, quoted in Ellis 2:93.

58. GCk to Ainsworth, 11 Mar. 1840, Berg; quoted in Ellis 1:403–404.

59. GCk to Bentley, 13 Mar. 1840, Princeton.

60. GCk to Bentley, draft letter, n.d., "Friday Mng." [13 Mar. 1840], Princeton.

61. GCk to Bentley, 13 Apr. 1840, Princeton.

62. Bentley to GCk, 14 Apr. 1840, Princeton.

63. Ainsworth to GCk, n.d., "Sun. night" [19? Apr. 1840], Princeton.

64. Barham to Bentley, 4 Sept. 1840, Barham 2:105–106.

65. Roberts to GCk, 5 May 1840, UCLA.

66. Bentley to GCk, 18 May 1840, Princeton.

67. Draft of letter from Morgan? to GCk?, n.d. [after? June 1840], Princeton.

68. Morgan to Bentley, 27 Aug. 1840, Bentley Papers, University of Illinois.

69. GCk to Ainsworth, 10 Nov. [1840], Princeton.

70. GCk draft letter to Barham, 10 Nov. 1840, UCLA; see also three further pages of *Tower* accounts, UCLA. The agreement stipulated that Bentley should have the accounts made up and supporting vouchers ready by the seventh of each month, but country booksellers had a month's grace to submit their statements. The July figure is supported by a letter from Morgan to Bentley, 9 July 1840, Bentley Papers, University of Illinois.

71. GCk to Ainsworth, 10 Nov. [1840], Princeton: "amongst you[r] invitations for the 28th I hope you have not included *Willimas* [probably Samuel Williams, the wood-engraver]—if you have—I think you *must* put him off 'sine die'."

72. Ainsworth to Crossley, 7 Dec. 1840, quoted in Ellis 1:414.

73. Swift recalled the occasion thirty-five years later: Edmund Swift to GCk, 15 Feb. 1875, Princeton.

74. Quoted in Ellis 1:418.

75. John Blackwood to his family, 14 Dec. 1840, quoted in Margaret Oliphant, *William Blackwood and His Sons*, 3 vols. (Edinburgh and London: William Blackwood and Sons, 1897), 2:261.

76. Ellis 1:415–416.

77. Thompson to GCk, 7 Feb. 1840, V&A 9909.I; the party was held on the next day. GCk many years later annotated the invitation: "The Great—the wonderful Artistic Engraver on wood—and who used to engrave my drawings as no other man ever did."

78. James Purvis to GCk, 13 Mar. 1840, Bradburn 14 blue.
79. Printed card, n.d., Searle.
80. Thackeray, "Essay," p. 53.
81. George Wilson to GCk, 1 May 1840, UNC-CH; C 130.
82. GCk to Merle, 4 June 1840, Princeton; an earlier letter on the same subject, GCk to Merle, 25 May 1840, written on verso of a printed envelope with Mulready's design, Christie's 22 Oct. 1980 sale, lot 206. See the collection of parodies on Mulready's design, JJ Envelopes 8.
83. Vizetelly 1:108–110.
84. Ibid., 1:107.
85. Thackeray to GCk, 1840?, WMTLet 1:489; n. 137 suggests that the papers are for the 1840 *Almanack*, impossible since that was issued in Dec. 1839. WMTLet 1:490 prints a brief note of 1840 to GCk asking for the return of "my M S." as soon as possible; this may refer to the papers mentioned previously, or to the MS of Thackeray's June 1840 panegyric in the *Westminster Review*.
86. Kenny Cole to GCk, 16 May 1840, UCLA.
87. Sutherland, "Cruikshank and London," in Nadel and Schwarzbach, p. 118.
88. Pettigrew 4:30; PCk "Memoir" alleges that Pettigrew was dismissed because an indiscretion nearly caused a duel between the duke and someone, p. 155.
89. Oliphant 2:257.
90. CD to Harley, 18 Dec. 1840, PLet 2:169.

30. THE "HOC" GOES DOWN

1. V.V.D.D., "Literary Acrostics. II. George Cruikshank," AM 1 (June 1842):facing p. 273.
2. Memorandum of Agreement, 25 Aug. 1841, BL Add. MSS 44,614 folios 52–53. For vignettes, Leech was to be paid at the rate of £6, and for wood-engraving designs, 25s. each.
3. Joseph Reily to GCk, n.d. [1842], Princeton. The subject, a wedding, was not finally etched by GCk, however.
4. "The Dead Drummer," BM 11, no. 62 (Feb. 1842); Barham's elaborate instructions to GCk: n.d. [Jan.? 1842], Berg; Bentley to GCk, 14 Mar. 1842, Princeton; "The Merchant of Venice," BM 11, no. 64 (Apr. 1842).
5. Bentley to GCk, 14 May 1842, Princeton; "The Lay of St. Cuthbert," BM 11, no. 66 (June 1842); J. Marsh to GCk, 13 Dec. 1842, Princeton; "Legend of St. Medard," BM 13, no. 73 (Jan. 1843).
6. "Jerry Jarvis's Wig," BM 13, no. 77 (May 1843).
7. Ainsworth to Charles Ollier, 22 June 1841, quoted in Ellis 1:404–405.
8. John S. Gregory to GCk, 6 Oct. 1841, Princeton.
9. Copy of letter from GCk to Gregory, 9 Oct. 1841, Princeton; drafts, Princeton.
10. GCk to Gregory, 18 Oct. 1841, Princeton.
11. He etched "Wat Sannell's Attack on the Witch's Cat," illustrating Paul Pindar's "Wat Sannell's Ride to Highworth," BM 10, no. 59 (Nov. 1841).
12. Morgan to Bentley, 18 Sept. 1843, Bentley Papers, University of Illinois. GCk produced a sketchy plate of devils sending Belphezor off in an aerial car for the first part of Lord Nugent's "The Marriage of Belphezor," BM 14, no. 80 (Aug. 1843).
13. Draft letter from GCk to "Madam," n.d. [c. 1842], Princeton; possibly to Isabella F. Romer, whose story "The Two Interviews" GCk illustrated with a plate of the same name in BM 11, no. 65 (May 1842). Less likely, to Mrs. Gore, whose "Hush!" he illustrated with "The Self-playing Organ" in BM 14, no. 79 (July 1843).
14. Quoted in Jerrold 1:248–249n.

15. Morgan to Bentley, 21 July 1842, Bentley Papers, University of Illinois. In this instance Morgan had to rewrite the story "Don't be too sure; or, disasters of a marriage-day" in proof to harmonize the letterpress with the plate, which owing to Barham's hastiness in composing instructions for the artist differed from the manuscript in several details; story and plate appeared in *BM* 12, no. 68 (Aug. 1842).
16. CD to GCk, 8? Feb. 1837, PLet 1:234.
17. Morgan to Bentley, 21 Sept. 1843, Bentley Papers, University of Illinois.
18. Morgan to Bentley, n.d. [23? Sept. 1843], Bentley Papers, University of Illinois.
19. See references in *AM* 1 (1842): 191, 261, and discussion in Ellis 2:17–33, where large extracts from Mahony's "Cruel Murder of Old Father Prout" (*BM* 11, no. 65 [May 1842]: 467–472) are printed. Ellis says of this "butchery of Ainsworth" that it "was a clumsy, *dirty* operation in which the wounds were inflicted [by Mahony] with a jagged saw." Layard, *Cruikshank's Portraits*, pp. 30–31, reprints the manifesto.
20. The joke appears yet again in *AM* 1 (Apr. 1842): 191 in the sidenotes to Ainsworth's mock Tudor "envoi" to Hughes's "Magpie of Marwood. An Humble Ballade."
21. *Wellesley Index* 3:11.
22. She had been bookkeeper for Robins previously and thus knew GCk well.
23. Morgan to GCk, n.d. [Nov.? 1841], UCLA; Buchanan-Brown, p. 245 n. 22.
24. Ainsworth to GCk complaining about GCk's attempt to sell volumes of the *Tower* by taking advantage of the 30 Oct. fire in the Jewel House, 10 Nov. 1841, UCLA.
25. Ainsworth to Morgan, 16 Nov. 1841, UCLA.
26. J. Marsh to GCk, 17 Nov. 1841, UCLA.
27. GCk to Morgan, 16 Dec. 1841, Princeton; Morgan to GCk, 16 Dec. 1841, UCLA and copy, Princeton; GCk to Morgan, 17 Dec. 1841, Princeton; Morgan to GCk, 22 Dec. 1841, Princeton.
28. Loaden to Ainsworth, 14 Jan. 1842, UCLA.
29. GCk to Morgan, 20 Jan. 1842, Princeton.
30. Morgan to GCk, 21 Jan. 1842, UCLA.
31. GCk to Morgan, 10 Feb. 1842; copy of Morgan to GCk, 11 Feb. 1842; GCk to Ainsworth, n.d. [15? Feb. 1842]; Morgan to GCk, 22 Feb. 1842; all Princeton.
32. Ainsworth to GCk, n.d., "Monday night" [2? Jan. 1841], Princeton.
33. Buchanan-Brown, p. 245 n. 22, says GCk made in all, 1840–1842, £517.16.7, less than GCk would have received on piece rates.
34. Morgan to GCk, 9 Mar. 1842, UCLA.
35. Hugh Cunningham to GCk, 8 Apr. 1842, Princeton.
36. Morgan, p. 23.
37. Morgan to Bentley, 26 Sept. 1843, Bentley Papers, University of Illinois.
38. Bentley to GCk, n.d. [Oct. 1843], BL Add. MSS 46,612 folio 332.
39. Cruikshank, *Artist and Author*, p. 9.
40. Ellis 1:422.
41. GCk to Merle, 11 Jan. 1841, Princeton.
42. GCk to Ainsworth, n.d. [Feb. 1841], Princeton. See also Ainsworth to GCk inviting him to Ainsworth's birthday party, 2 Feb. 1841, Vogler Collection, Grunwald Center, UCLA.
43. CD to GCk, 17 Feb. 1841, PLet 2:213; n. 4 identifies the *Annual* as "Just possibly" a book about poor children mentioned in CD's letter to Mrs. Gore on 31 Jan. From other evidence discussed *passim* this identification seems unlikely.
44. CD to Forster and to Maclise, 11 Jan. 1841, PLet 2:183.
45. CD to GCk, 17 Feb. 1841, PLet 2:213.
46. GCk to CD, 10 Apr. 1841, Huntington Library.

47. GCk to CD, 22 Feb. 1841, Huntington Library. See also GCk to CD promising delivery of the plates to Colburn by 21 May, 13 and 19? May 1841, Berg. GCk also contributed an etching to a subscription volume planned in 1840 to benefit Robert Seymour's widow; CD was the only one asked who declined: PLet 5:575 n. 5.

48. GCk to CD, 27 Feb. 1841, Huntington Library.

49. Ellis 2:97.

50. GCk to Ainsworth, 4 Mar. 1841, Princeton; quoted in Ellis 2:97–99.

51. Ainsworth to GCk, n.d. [1? May 1841—"Saturday next" would then be 8 May], Bradburn 5 red.

52. For instance, GCk to Ainsworth, "Waterloo day [18 June]—1841," cited in unidentified dealer's catalogue, Cohn III; all but this part of letter quoted in Harvey, *Victorian Novelists*, pp. 218–219 n. 44, from copy in the Brown, Picton and Hornby Libraries, Liverpool.

53. Ainsworth to Ollier, 22 June 1841, quoted in Ellis 1:404–405.

54. Cruikshank, *Artist and Author*, p. 11.

55. Fanny, Emily, and Anne Blanche Ainsworth to GCk, 30 Dec. 1841, Princeton.

56. Memorandum of Agreement formerly in the Eldridge Johnson Collection, dated Dec. 1841, signed 7 Feb. 1842: Parke–Bernet Johnson sale, Part V, 29 Oct. 1946, lot 53.

57. Cruikshank, *Artist and Author*, p. 11.

58. Ibid., pp. 1–2, quoted from GCk's letter to *The Times*, dated 6 Apr. 1872, published 8 Apr.

59. Thirteen years earlier GCk had requested a copy of a picture of a miser in the Windsor Castle collection: GCk to unidentified person, 6 Nov. 1828, Princeton. The picture, then identified as by Quentin Metsys, has now been ascribed to a follower of Marinus van Reymerswaele: Lorne Campbell, *The Early Flemish Pictures in the Collection of Her Majesty the Queen* (Cambridge and New York: Cambridge University Press, 1985), cat. no. 72.

60. E.D.H. Johnson, *Paintings of the British Social Scene*, pp. 80–81 discusses these pictures and their importance in the rise of popular art.

61. Vauxhall, by the 1840s in perennial difficulties, finally closed for good on 25 July 1859.

62. Quoted in Jerrold 1:262, from the statement prepared by Ainsworth justifying his behavior.

63. Pencil, pen-and-ink, and watercolor sketches, Binyon cat. 1078–1103; 1101 is a reproduction from an old print of "The Floating Hotel on the River Thames." See also pencil and watercolor portraits of characters on verso of an undated "Thursday night" [1842?] letter from Forster to GCk canceling a dinner engagement because of "indisposition," Departments of Prints and Drawings, National Gallery of Art, Washington, D.C., 1944.12.5; pencil drawing autographed "First Sketch for Miser's Daughter," Kenneth W. Rendell cat. 182 (1987), item 23; and pencil and watercolor tracing for "Duel in Tothill," George S. MacManus cat. 249 (1980), item 122.

64. For Ainsworth's suggestion see GCk, *Artist and Author*, p. 12n. An alternative design depicting three men (Barham being the third?) around the table, Berg.

65. *Punch* 2 (1842): 127. The extent to which portraits of GCk were parodied testifies to the widespread circulation of his features, although in person he may have been no more recognizable on the street than in the days of William Clarke.

66. GCk to Ainsworth, 15 July 1842, quoted in Vogler, *Graphic Works*, p. 155 notes to Plate 190; text, AM 2 (Aug. 1842): 128–130. Pencil, pen, and watercolor drawing, Berg.

67. GCk to Ainsworth, 19 July 1842, Princeton.

68. Ainsworth to GCk, n.d. [17? Aug. 1842], Bradburn 47 red.

69. GCk to Ainsworth, 12 Sept. 1842, quoted in Vogler, *Graphic Works*, p. 155 notes to Plate 191, from letter in Vogler Collection, Grunwald Center, UCLA.
70. A comparison to Rowlandson's *The Miser's End* in his *Dance of Death* series reveals the extent to which GCk has shifted from figurative allegory to theatrical narrative, a move that paradoxically diminished the status of the picture as a privileged medium of representation.
71. GCk to Ainsworth, 15 Sept. 1842, Special Collections, University of Missouri-Columbia Libraries.
72. Anthony Burton, *PULC*, p. 113.
73. Joseph Grego, "The Early Genius of George Cruikshank," *Connoisseur* 5 (1903): Part I, 186–193, Part II, 255–260.
74. Grego, "Early Genius," pp. 191, 260.
75. Anthony Burton, *PULC*, p. 113; Grego, "Early Genius," p. 258.
76. Anthony Burton, *PULC*, p. 113.
77. "The 'Miser's Daughter' at the Adelphi," *AM* 2 (Nov. 1842): 474; see Jonathan E. Hill, "Cruikshank, Ainsworth, and Tableau Illustration," pp. 456–459.
78. Ibid., p. 458.
79. Ainsworth to Crossley, 17 Nov. 1841, Ellis 1:430–431.
80. Mrs. Hughes to Mrs. Southey, n.d. [1842], quoted in Ellis 2:55.
81. Ainsworth to W. Alfred Delamotte, n.d. [Autumn 1842], quoted in Ellis 2:107–108.
82. He had tried out this effect in "The Dead Drummer," *BM* 11, no. 62 (Feb. 1842). The lightning zigzagging ominously across a stormy sky ultimately derives from William Wollett's etching of Richard Wilson's painting, *The Destruction of the Children of Niobe* (1761), the most famous landscape print of its time and the one which made Boydell its publisher his first fortune. GCk surely knew it.
83. GCk to Ainsworth: 8 [month illegible] 1844, Princeton; 10 Apr. and 13 May 1844, Berg; 15 Apr. and 14 June 1844, Vogler Collection, Grunwald Center, UCLA.
84. Ainsworth to Thomas Hood, 19 Oct. 1843, Ellis 2:70.
85. Ellis 2:79.
86. Ainsworth to GCk, 9 Mar. 1845, Princeton.
87. Ainsworth to Crossley, 7 June 1845, quoted in Ellis 2:111–112.
88. Cruikshank, *Artist and Author*, p. 12.
89. Ibid., pp. 13–14.
90. Merle to GCk, n.d. [Apr. 1841], Bradburn 20 red. Merle thought the quotation originated with the Scriblerus Club: Merle to GCk, n.d. [Apr. 1841], Princeton.
91. In the 1850s GCk called Grant a "wholesale libeller": see two letters from GCk to Horace Mayhew, 4 Feb. 1856 and 12 June 1867, Berg. In the latter, GCk regrets that "poor Blanchard" rather than Horace had conducted the *Omnibus*.
92. Cuthbert Bede, "Personal Recollections of George Cruikshank," *London Figaro*, 13 Feb. 1878: according to Bede, GCk said that the introduction of Richard Brothers the Prophet was his idea, "and he told me much concerning [*Frank Heartwell's*] eccentric author, and his custom of roaming through the streets during the stillest hours of the night, as he thereby fancied that he could more quietly and effectually turn over in his brain the thoughts that he afterwards committed to paper. [GCk] told me many things concerning 'Bowman Tiller,' which, however, had better not be repeated here."
93. GCk to Blanchard, 25 July 1841, Bradburn 3 red.
94. "Sam Sly" was the pseudonym of William Layton Sammons, a journalist resident in Bath in the 1830s who was friendly with Blanchard, Dickens, and GCk, and who emigrated to Cape Town in 1842, whence he founded and edited a weekly, *Sam Sly's African Journal*, 1843–1851.

95. She is revived briefly in GCk's abortive periodical, *Our Own Times* (C 193, 1846).
96. Ainsworth to GCk, n.d., "Wednesday" [May 1841], Bradburn 5 red; Forster to GCk, 5 May 1841, Princeton; Marryat to GCk, 3 June 1841, Princeton; CD to GCk, 2 May 1841, PLet 2:276–277.
97. GCk to Auldjo, 30 Apr. 1841, Bradburn 13 red.
98. GCk's calculations on verso of a 28 May 1841 bill so torn that sender cannot be identified, and 10 Oct. 1841 account from Tilt and Bogue, both JJ.
99. GCk to CD, 3 Apr. 1841, Berg.
100. Merle to GCk, 4 May 1841, Princeton.
101. Merle to GCk, n.d., "Sunday," continued on Monday [May? 1841], Princeton.
102. GCk to Merle, 1 Feb. 1841, Princeton.
103. K. C. Harrison, Librarian for City of Westminster, to RLP, 11 Jan. 1979.
104. GCk to Morgan, 7 Aug. 1841, Huntington Library.
105. Merle to GCk, 24 Nov. 1841, Princeton; GCk to CD, 1 Dec. 1841, Huntington Library.
106. GCk to "Tom," 25 Aug. 1842, UNC-CH; GCk to Benjamin Lumley, 18 May 1843, Collection Richard F. Kilburne.
107. CD to GCk, 19 Feb. 1841, PLet 2:216.
108. GCk to CD, 27 Feb. 1841, Huntington Library.
109. Forster to GCk, 6 July 1842, UCLA.
110. Thomas Hood to Mrs. Elliot, 11 July 1842, *Letters*, pp. 485–486.
111. CD to Thomas Beard, 11 July 1842, PLet 3:263–264.
112. CD to Cornelius Felton, 31 July 1842, PLet 3:291–293.
113. *DNB.*
114. *Old 'Miscellany' Days* (London: Richard Bentley and Son, 1885), pp. ix–x.
115. GCk to Howard, 2 Sept. 1841, Wilson cat. 50.
116. *DNB.*
117. William Maginn, *Miscellanies: Prose and Verse*, ed. R. W. Montagu, 2 vols. (London: Sampson Low, Marston, Searle, and Rivington, 1885), 1:xviii–xix.
118. Ellis 2:66 and n. 1; *Wellesley Index* 3:8.
119. CD to Forster, 5 Oct. 1842, PLet 3:337–338.
120. Hackwood, pp. 345–346.
121. CD to Felton, 2 Mar. 1843, PLet 3:451–456; see also nn. The allegation that Hone preached at Weigh House Chapel, despite the denials issued at the time of the funeral and subsequently, continued to be repeated: see the notes about 67 Old Bailey, one of Hone's London addresses, printed in the *City Press*, 6 Jan. 1872, inserted in FSB Cohn II.
122. GCk to the Editor of the *Daily Telegraph*, 23 Nov. 1872; draft, Princeton.
123. GCk and CD collaborated to raise money for Mrs. Hone: PLet 3:366–394. CD also lampooned Forster (James Davies, *John Forster*, pp. 174–176), so the exaggerated account may be as much a sign of friendship as of disapproval. Mainly it testifies to the workings of CD's comic imagination.
124. Henry Wadsworth Longfellow to Ferdinand Freiligrath, 6 Jan. 1843, *Letters*, ed. Andrew Hilen, vol. 2 (Cambridge, Mass.: Belknap Press of Harvard University Press, 1966), pp. 495–498; CD to Longfellow, 29 Dec. 1842, PLet 3:407–409.
125. Longfellow to Forster, 29 Apr. 1843, *Letters* 2:530.
126. Draft letter from GCk to Roberts, n.d. [c. 1841], K 71.
127. C 620; advertised in the Dec. 1841 *Omnibus* as in press. Hone's friend Edward Moxhay commissioned GCk to etch these plates, then refused to pay all the publishing costs. O'Neill, an impoverished Irish cobbler, lost money on the Tilt and Bogue edition, despite good reviews; only three hundred copies were sold by 30 June 1842. On 8 June 1843 he applied for relief to the Literary Fund Society

(O'Neill case file, Royal Literary Fund archives, BL Manuscripts Department Loan 96). Ten years after O'Neill's death, *St. Crispin*, a shoe trade magazine edited by J. B. Leno, published in installments O'Neill's *Fifty Years' Experience of an Irish Shoemaker in London* (1868). See John Egan's extramural thesis on O'Neill, University of London, in preparation, and materials forwarded by him to me, 4 Mar. 1993.

31. THE TRIUMPH OF CUPID

1. John Paget, "George Cruikshank," *Blackwood's Edinburgh Magazine* 94, no. 574 (Aug. 1863): 217–224, 219.
2. Robert Bernard Martin, *The Triumph of Wit: A Study of Victorian Comic Theory* (Oxford: Clarendon Press, 1974), p. 5. Otherwise unidentified subsequent quotations are taken from Martin.
3. Ibid., p. 24.
4. Ibid., p. 29; see also Stuart M. Tave, *The Amiable Humorist* (Chicago: University of Chicago Press, 1960), for the shift in the eighteenth century from the aloof superiority of Restoration wit to the sweet philanthropy of Cervantes, Fielding, and Goldsmith.
5. See Roger B. Henkle, *Comedy and Culture: England 1820–1900* (Princeton: Princeton University Press, 1980), and L. Perry Curtis, Jr., *Apes and Angels: The Irishman in Victorian Caricature* (Washington: Smithsonian Institution Press, 1971). The epigraph to Curtis's book quotes Lavater's *Essay on Physiognomy*: "Those who wish to degrade man to beast, caricature him to the rank of the orang outang; and, in idea, raise the orang outang to the rank of man." Thomas Love Peacock did the latter in *Melincourt*, running Sir Oran-Haut-ton for Parliament. GCk did the former in an 1852 *Almanack* plate, "Monster discovered by the Ourang Outangs," etched to accompany "The 'What Is It?'," a mock anthropological account wherein Monkeydom discovers a human being identified as a specimen of a "debased and degenerated breed of some savage Ouran-outan race" that approaches "in some degree, to the verge of a dim and cloudy rationality." This gently Swiftian satire gives the monkeys simian faces such as Tenniel would employ to characterize the Irish in the late 1860s, but GCk applies the satire generally, rather than ethnically or nationally. The force of the famous exchange between Bishop Wilberforce and T. H. Huxley regarding Darwinian descent from apes depends on this background of simian satires.
6. Henkle, p. 13, designates the phases; I have supplied the analogies from GCk's career.
7. Quoted in Martin, p. 44.
8. Paget, "George Cruikshank," p. 220.
9. C 184.
10. Bogue insisted that the format stay the same even when sales drooped; see draft from GCk to unidentified person, 18 July 1852, Princeton.
11. Ibid. Hundreds of pencil, pen-and-ink, sepia, and watercolor sketches, tracings, and proofs for the *Almanack* remain in BM (Binyon cat. 523–602), V&A (9411–9424.A, 9739–9755.I), Princeton, and elsewhere. Edwin Truman's collection of proofs before letters annotated by GCk's widow are in Berg.
12. Paget, "George Cruikshank," p. 220. Donald J. Olsen, *The Growth of Victorian London* (1976; repr. Harmondsworth, Middlesex: Penguin, 1979), maintains that the era democratized aristocratic pleasures (p. 328), but also that by the 1850s Londoners thought that they hated their city, retiring into private spaces from the squalor of the streets (ch. 2). John W. Dodds provides a survey of English culture in

the 1840s in *The Age of Paradox: A Biography of England 1841–1851* (New York: Rinehart, 1952).

13. Harvey, *PULC*, p. 154.

14. Karlheinz Stierle, "Baudelaire and the Tradition of the *Tableau de Paris*," *New Literary History* 11, no. 2 (Winter 1980): 345–361, from which the summaries of the French tableaux, and the translations of Baudelaire, are derived; here, p. 347. Still the best modern treatment of Second Empire street art is Walter Benjamin, *Charles Baudelaire: A Lyric Poet in the Era of High Capitalism*, trans. Harry Zohn (London: NLB, 1973).

15. Kunzle, *PULC*, p. 177; see also Edith Melcher, *The Life and Times of Henry Monnier, 1799–1877* (Cambridge, Mass.: Harvard University Press, 1950), pp. 35–36.

16. This is the first of eight *Almanack* scenes celebrated by Sacheverell Sitwell in his 1937 Northcliffe lecture published in *Trio*.

17. Thackeray to GCk, 30 June [1838], Harry Ransom Humanities Research Center, The University of Texas at Austin, proposing a rambling biography of "Mr. Dodds"; Thackeray to GCk describing the subject for the Apr. 1839 plate, postmarked 28 Aug. 1838, H. Gregory Thomas Collection (ex-Woodin, Cohn), University Club, New York. For an extended discussion of Thackeray's *Almanack* contributions, consult Anthony Burton, "Thackeray's Collaborations with Cruikshank, Doyle, and Walker," *Costerus*, n.s. 2 (1974): 141–184.

18. Seven of GCk's pencil and wash drawings are in Berg.

19. Thackeray to GCk, May? 1839, WMTLet 1:380–381.

20. In 1843 GCk also designed a wood-engraving for Tilt of *The Queen and the Union. No Repeal! No O'Connell!* (C 1882), a declamation against the Irish agitator, who is depicted as a "blustering, foul-mouthed bully"; see Jerrold 2:29 for description and date, absent in Cohn.

21. See Feaver, *PULC*, p. 249.

22. On 29 Sept. 1841 Merle sends GCk a sketch of a quartered man to indicate the date; on 9 Oct. 1843 he closes another letter with "I shall draw on you for a 'Comic Annual' as due to my 1/4 day" (both Princeton).

23. Feaver, *PULC*, p. 252; cf. Jerrold 2:13: "There was some bitterness in this jesting."

24. Quoted in E.D.H. Johnson, *PULC*, p. 22.

25. Feaver, *PULC*, p. 252, makes many of these points. Haydon's suicide and the comparison to Tom Thumb had preoccupied the periodicals throughout the previous summer: see Alethea Hayter, *A Sultry Month: Scenes of London Literary Life in 1846* (London: Faber and Faber, 1965), pp. 137–139.

26. Princeton owns a watercolor of the Father Mathew plate inscribed by GCk on 26 July 1873: "This sketch was made before I became a 'Pump' myself. But I am now happy to say that I have been a 'Total Abstainer' for twenty-six years up to this date" (quoted in E.D.H. Johnson, *PULC*, pp. 27–28).

27. The accompanying introduction, "Election Intelligence," was drafted by James Parry; see Parry to GCk, 2 Aug. 1852, Princeton. For a discussion of three *Almanack* plates about women's issues, see Susan P. Casteras, *The Substance or the Shadow: Images of Victorian Womanhood* (New Haven: Yale Center for British Art, 1982), cat. entries 23–25, pp. 68–71.

28. Statement of account from Tilt to GCk, 21 Sept. 1844, inserted in FSB Cohn II Appendix.

29. GCk's check to Tilt, 4 Nov. 1844, inserted on verso of title page, FSB Cohn I. GCk to Tilt and Bogue, 4 Nov. 1844, offered by Sotheby's in sales of 17 Dec. 1981 and 29–30 June 1982, and thereafter by Paul C. Richards Autographs, the firm which supplied a photocopy of the holograph. A copy in another hand, signed and dated by GCk, is owned by the University of Rochester.

30. PCk "Memoir," pp. 108–110. In a note to this passage Percy instances Tilt's parsimony in putting up for sale in the shop an oil painting by Frederic Calvert (Percy's father-in-law) presented to Tilt by Calvert in appreciation for some business transaction.

31. Bogue to GCk, 23 Nov. [1844], Princeton.

32. GCk draft letter to Bogue, n.d. [c. Dec. 1844], V&A 9997.R.

33. GCk to unidentified person, 11 Mar. 1846, Harvard.

34. GCk to Bogue, 6 Dec. 1846, reproduced in Grant Uden, "Wit and Waffle," *Antiquarian Book Monthly Review* 129 (Jan. 1985): 30; GCk to Bogue, 24 June 1848, Bell and Hyman; GCk to [Bogue], 4 Sept. 1849, Princeton; Bogue to GCk, n.d. [6? Sept. 1849], Princeton. The Bell and Hyman holdings of GCk correspondence, now at Princeton and cited hereafter as Bell and Hyman, concern the publishers David Bogue, Charles Tilt, and George Bell; see also Buchanan-Brown, p. 24.

35. Bogue to GCk, 7 Sept. 1849, Princeton; Bogue asks how the publishers will get twenty thousand copies of the large folding plate about "Breach of Promise" colored in time. Bogue to GCk, n.d., Princeton, says he has decided on a print run of twenty thousand to avoid overprinting and to insure profits.

36. John Ruskin, "The Fireside: John Leech and John Tenniel," *The Art of England: Lectures Given in Oxford*, V (7 and 10 Nov. 1883), *Works*, 33:360.

37. CD to Bradbury and Evans, 8 Jan. 1845, PLet 4:246 and n. 5; M. H. Spielmann, *The History of "Punch"* (New York: Cassell, 1895), p. 497, confirms the imitation.

38. Quoted in Spielmann, p. 495.

39. Anonymous, "Cruikshank's Comic Almanac," *Littel's Living Age* 33 (Apr.–June 1852): 420–421.

40. Jerrold 2:19–20.

41. C 192; pen-and-pencil sketches and proofs, Binyon cat. 1124–1139. Mr. Lambkin was originally called Mr. Chipps.

42. Tilt and Bogue to GCk, 16 Nov. 1841, Princeton.

43. On the flyleaf of the Berg copy a note states that the drawing for the plate was among the items in GCk's estate sold by Sotheby's in 1879; *Oldbuck* not in Cohn. IRCk may have done the translation or the illustration: GCk wrote in the flyleaf of his *Oldbuck*, "copied from a French book by my Brother" (*Lib.* 343). See Kunzle, *PULC*, p. 179 n. 15 and *passim*, and Kunzle, *History of the Comic Strip*, 2:22–25, for the fullest accounts of *Lambkin* and its predecessors, and see Kunzle, *History of the Comic Strip*, 2:28–71, for an extended treatment of Töpffer.

44. C 191, twelve shilling monthly numbers, Jan.–Dec. 1845. Studies and sketches in pencil, pen-and-ink, and sepia, Binyon cat. 1191–1228 and V&A 9997.A–X.

45. Cruikshank, *Artist and Author*, p. 13.

46. See Richard Sieburth, "Same Difference: The French *Physiologies*, 1840–1842," *Notebooks in Cultural Analysis*, ed. Norman F. Cantor (Durham: Duke University Press, 1984), pp. 163–200, p. 173, as well as Benjamin's book on *Baudelaire* cited above.

47. Presumably GCk got some of his information about mesmerism from Dr. Elliotson and here expresses points of tangency between the two practices.

48. For a different but compatible reading of "The Folly of Crime," consult Kelly, "Liberation or Restraint," pp. 23–25. GCk's plate was often discussed in periodicals: see the *Sun*, 31 Dec. 1870 and Frank T. Marziels's review of Reid's *Catalogue* in *London Quarterly Review* 40 (July 1873): 285–310, 301.

49. Colored drawing in H. Gregory Thomas Collection, University Club, New York.

50. C 193, Apr.–July 1846; pencil, pen, and watercolor sketches, Binyon cat. 1231–1272.

51. GCk sketched the plaster model in Wyatt's studio, V&A 9517.

52. C 541, issued in fifteen two-shilling parts as twelve, 1844–1845, and as a volume in green cloth covers with a gilt design, 1845; pencil and gamboge studies and sketches, Binyon cat. 1172–1190; three pencil and tint drawings, with one tracing, H. Gregory Thomas Collection, University Club, New York.
53. Fowles, *PULC*, p. xiv; E.D.H. Johnson, *PULC*, p. 19; Wright, *History of Caricature*, p. 494.
54. Curtis, p. 35.
55. Fowles, *PULC*, p. xv.
56. Letter in the Cohn copy, according to FSB annot. Cohn II.

32. PORTRAITS OF THE ARTIST

1. Mackenzie, "George Cruikshank," p. 178.
2. PCk "Memoir," p. 234.
3. Bell and Hyman; the second poem, "The Wish," speaks of teaching the "rebel heart" to know its duty and of the need to "Restrain the lisence of my tongue."
4. Hilary and Mary Evans identify her portrait in several of GCk's prints (p. 49), but there is no external documentation substantiating any particular likeness.
5. At least, T. J. Thompson invites both Cruikshanks to attend a dinner celebrating a christening, 22 Nov. 1847, Princeton.
6. Henry Pulford to GCk, 14 May 1843, Princeton.
7. G. C. Pulford to GCk, n.d. [1845], 27 Feb. 1845, 4 Dec. 1845, 10 Mar. 1846, 18 Apr. 1846, 24 Sept. 1846, 25 Apr. 1847, 3 May 1847, Princeton.
8. G. C. Pulford to GCk, n.d. [12? Jan. 1848], Princeton, and GCk to Mr. Emberson, n.d., "Monday" [17? Jan. 1848], Berg.
9. 1841 Census Returns, PRO HO 107/659, Book 5, p. 5.
10. GCk draft letter to unidentified person, n.d. [12? Aug. 1845], Princeton.
11. GCk to Mackenzie, 20 Oct. 1847, Princeton; GCk to Mackenzie, 1 Nov. 1847, Historical Society of Pennsylvania, quoted in Vogler thesis, p. 65.
12. Frederick Dickens to GCk, 29 May 1848, UCLA.
13. CD to GCk, 8 July 1848, PLet 5:365; GCk to Bogue, n.d. [2? July 1848], Bell and Hyman.
14. GCk to Alfred Crowquill, 4 Sept. 1848, Huntington Library; GCk to Joseph Gibbs, 12 Jan. 1849, BL Add. MSS 46,172.
15. PCk "Memoir," pp. 224–233, provides this and the following instances of the brothers' exchanges.
16. George Daniel, *Love's Last Labour Not Lost* (London: Basil Montagu Pickering, 1863), p. 175.
17. PCk "Memoir," p. 176.
18. Ibid., p. 226.
19. Ibid., p. 176 insertion.
20. Ibid., pp. 230–233.
21. Ibid., p. 146.
22. PCk to GCk, n.d. [15? Dec. 1842], Princeton.
23. PCk "Memoir," pp. 217, 281–284; GCk to editor of *The Times*, 27 Dec. 1872.
24. PCk "Memoir," p. 158 insertion.
25. Ibid., pp. 158–161.
26. Ibid., pp. 161–164.
27. Ibid., pp. 237–238.
28. Ibid., pp. 116–118.
29. GCk to Barker, 12 Apr. 1845, Princeton.
30. PCk "Memoir," pp. 145–148.

31. Ibid., pp. 238–239.
32. Ibid., p. 278; cf. chapter 1.
33. Ibid., pp. 205–206.
34. Ibid., pp. 206–207.
35. Ibid., p. 238.
36. Ibid., p. 218.
37. Thomas Gunn to GCk, n.d. [2 Mar. 1845?], Princeton. "Doubleyew" in his *Illustrated Sporting and Dramatic News* obituary of GCk, 9 Feb. 1878, p. 518, describes fondly the Amwell Street house and GCk's encouragement of aspiring artists.
38. Sala, p. 568.
39. GCk to Mr. Allen, 25 Nov. 1843, Harry Ransom Humanities Research Center, The University of Texas at Austin; Mr. Oppenheim to GCk, 1 Dec. 1849, K 154.
40. *Art Union* 8 (Mar. 1846): 92. GCk illustrated William Barnes Rhodes's popular burlesque opera for an 1830 edition, C 692.
41. *Art Union* 10 (Apr. 1848): 129.
42. *Art Union* 10 (June 1848): 202.
43. William Lee to GCk, 25 Apr. 1850, Bradburn 26 blue.
44. For the Elton fund, see PLet 3:527–541 *passim* for CD's superintendence and its outcome. See also Jane Seymour to GCk, 29 Oct. 1846, Princeton, and reports on the Glascock Fund, also Princeton.
45. See, for instance, the Reverend D. Laing to GCk, 25 Apr. [1843?], Princeton, asking GCk to pay a £70.1.11 bill; R. Southwood to GCk, 5 July 1843, Princeton, explaining that he cannot pay the money GCk has evidently advanced; and the donation that GCk makes at the end of that month to the Elton fund.
46. John Wight to GCk, 27 Oct. [1843], George Cruikshank Collection (#3833), Manuscripts Division, Special Collections Department, University of Virginia Library.
47. CD to GCk, 13 Aug. 1845, PLet 4:353.
48. CD to Miss Burdett Coutts, 17 Sept. 1845, PLet 4:379–381; CD to GCk, 17 Oct. 1845, PLet 4:404.
49. John Wight to GCk, 30 Oct. 1845, Princeton.
50. John Wight to GCk, 23 Dec. 1845, Princeton. See also letters tracking Bertha Wight's recovery from CD to Miss Burdett Coutts, [24 Sept.], 6 Oct., and 1 Dec. 1845, PLet 4:385, 4:398–399, and 4:442–443.
51. GCk draft letter to CD, 6 Feb. 1846, Clark Library, forwarding to CD via Wills a letter from "Brother Wight"; CD to GCk, 12 Feb. 1846, PLet 4:494.
52. John Wight to GCk, 23 June 1846, Princeton.
53. John Wight to GCk, 6 Sept. 1848, Princeton. See also GCk's aid to other Wights: Thomas Wight to John Wight, 13 Dec. 1848, and G.? Wight to GCk, 16 Dec. 1848, thanking GCk for saving his son and himself, both Princeton.
54. W. Wight to GCk, 26 Sept. 1852, UNC-CH.
55. CD and Douglas Jerrold, among others, tried to help them: see CD to Jerrold, 4 Sept. 1845, PLet 4:369–370. For Ainsworths' obituary notice and publication of Blanchard's correspondence, see *New Monthly Magazine* 73, no. 291 (1845): 428–430 and 76, no. 302 (1846): 131–140.
56. GCk to Robert and John Blackwood, 29 Mar. 1845, National Library of Scotland.
57. R. H. Barham to unidentified person, n.d. [May–June? 1845], unnamed dealer's catalogue in FSB Cohn III.
58. *DNB*.
59. CD to Bradbury and Evans, 29 Sept. 1845, PLet 4:392.
60. Tillotson ed., *Oliver Twist*, p. 393 n. 7.
61. Wrapper design and related drawings, Berg and BM Prints and Drawings.

62. CD's inscription dated 21 Dec. 1845; copy formerly in Jerome Kern Collection, now Berg.

63. CD to GCk, 20 Aug. 1842, PLet 3:309–310; Longfellow to Ferdinand Freiligrath, 6 Jan. 1843, *Letters* 2:495–498; CD to GCk, 22 June 1843, PLet 3:514–515; CD to GCk, 7 Dec. 1843, PLet 3:606; PLet 4:147 n. 1; CD to GCk, 1 Oct. 1845, PLet 4:393–394.

64. PLet 4:466 n. 2.

65. Berg.

66. Frith, p. 149.

67. T. J. Pettigrew to GCk, 8 Dec. [before 1848?], Princeton.

68. CD to GCk, 21 Nov. 1843, PLet 3:601. Ralph Straus says that GCk drew one design (untraced) for the *Carol: Charles Dickens: A Biography from New Sources* (New York: Grosset and Dunlap, 1928), p. 201.

69. CD to Charles Mackay, 7 Mar. 1844, PLet 4:66 and n. 2.

70. CD to Forster, [22 Aug. 1845], PLet 4:363.

71. CD to GCk, [22? Aug. 1845], PLet 4:361–363.

72. PLet 4:379 n. 2.

73. PLet 4:435 n. 3.

74. PLet 4:462 n. 3.

75. CD to GCk, 8 June 1847, PLet 5:80–81.

76. CD to Mark Lemon, 4 July 1847, PLet 5:114–116 and 5:115, nn. 12, 13; CD to GCk, 9 [July] 1847, PLet 5:121.

77. CD to Alexander Ireland, 11 July 1847, PLet 5:124–125.

78. CD to Forster, 9–19? July 1847, PLet 5:131–132 and 5:132 n. 1.

79. GCk to John Watkins, 24 July 1847, Huntington Library.

80. PLet 5:133 n. 2.

81. PLet 5:141 nn. 2, 5. Margaret Cardwell says, "the artists who were to provide the illustrations failed to do so," then notes Leech's sheet of sketches but does not mention GCk's drawing (Charles Dickens, *Martin Chuzzlewit*, ed. Margaret Cardwell [Oxford: Clarendon Press, 1982], pp. 857–858 and nn.).

82. Charles Dickens, "Mrs. Gamp's Account of Her Connexion with This Affair," *Martin Chuzzlewit*, ed. Cardwell, Appendix G, pp. 857–864, 860–862. If Mrs. Gamp derives in any way from Mrs. Toddles, the meeting with her delineator becomes an even more richly layered joke.

33. MASTERPIECES WORTHY OF THE GREATEST PAINTER

1. Quoted in Brian Harrison, *Drink and the Victorians: The Temperance Question in England 1815–1872* (London: Faber and Faber, 1971), p. 158. Hereafter cited as *Drink*; much of the information about the Temperance movement contained in this chapter derives from Harrison's work. See also F.M.L. Thompson, chapter 8.

2. Ben Shahn, *Fine Prints* (New York: International Graphic Arts Society, 1956), p. 2.

3. *Drink*, p. 227.

4. Quoted in Ibid., p. 75.

5. Joseph Livesey, *Life and Teachings* (London: John Heywood, 1886).

6. *Introduction of the Gout*, BMC 13117, 9 Apr. 1818, Fores; many of the caricatures of Richard Brinsley Sheridan, Sir William Curtis, and the Prince Regent; *Tit Bits*, C 2035, an unsigned, undated lithograph Jerrold assigns to 1818 (2:81–82).

7. See the preface to the 1876 reissue of *The Bottle*: E.D.H. Johnson, PULC, p. 28. For the allegation that it influenced GCk, see Tweedie's 4th ed. (1851); Crawford J. Pocock to GCk about a reprint of the O'Neill etchings, 9 May 1876; and GCk's

reply of 23 May saying he scolded O'Neill at the time for the false claim and thought it had been suppressed (both Princeton).

8. Quoted in Jerrold 2:78–79; probably a speech delivered before 1853.

9. CD to Lydia Maria Child, 28 Dec. 1842, PLet 3:403–404; see also similar views conveyed in CD's letter to Theodore Compton, secretary of the National Temperance Society, 26 Jan. 1844, PLet 4:30–31.

10. [Charles Dickens], "Demoralisation and Total Abstinence," repr. from *Examiner*, 27 Oct. 1849, by Alec W. Brice and K. J. Fielding in "A New Article by Dickens: 'Demoralisation and Total Abstinence'," *Dickens Studies Annual* 9 (1981): 1–19, 7. The reference to the "respectable mechanics" was a direct hit at the protagonist of *The Bottle*.

11. Jerrold 2:49–51.

12. Ibid., 2:51.

13. GCk holograph entry, Sunday, 27 Sept. 1846, *Harwood's Diamond Diary; with an almanack for 1846*, private collection.

14. Brian Harrison, "Drunkards and Reformers: Early Victorian Temperance Tracts," *History Today* 13 (Mar. 1963): 178–185.

15. For more on *The British Bee Hive* (published in 1867), see chapter 43 and my article, "George's Hive and the Georgian Hinge."

16. Thomas Hood, *Works*, ed. Thomas Hood [the Younger], 7 vols. (London: Edward Moxon, 1862): 6:311.

17. Joseph Adshead, *Prisons and Prisoners* (London: Longman, Brown, Green, and Longman, 1845), p. iv; C 6. Presentation copy to GCk, *Lib.* 375.

18. Princeton obtained thirty letters, 1846–1848, from GCk to Adshead, and one from PCk to Adshead, in 1988, to add to others in the George Cruikshank Collection; subsequent information about their relations not otherwise referenced is derived from this source.

19. Joseph Adshead to GCk, 7 Aug. 1846, Princeton.

20. Adshead to GCk, 4 Aug. 1846, Princeton; mezzotints (1839) by S. W. Reynolds, original oils (exhibited in 1836) now owned by the Walker Art Gallery, Liverpool.

21. V&A 9601, large paired pencil sketches on one sheet, "Going right, and Going wrong"; Merle to GCk, 3 Oct. 1846 and n.d., Princeton.

22. W. G. Lettsom to GCk, 31 Mar. 1847, Princeton.

23. Bamber Gascoigne, *How to Identify Prints* (London: Thames and Hudson, 1986), 33b; see a less specific description in Wakeman, p. 67. Feaver's catalogue of the 1974 Arts Council GCk exhibition, p. 56, gives a different—unattributed—definition of glyphography: "drawing in ink on packed chalk powder and making a cast of the consequent coagulated lines." The original copper plates, the electros, and the blocks for *The Bottle* and *The Drunkard's Children* were part of GCk's estate, *Lib.* 581–582.

24. GCk to Editor, 1 Nov. 1876, published in *Aesthetic Review* 6 (Dec. 1876–Jan. 1877): 86; draft ACC 534/14a.

25. Quoted in Vogler, *Graphic Works*, p. 159.

26. *DNB* gives 1850 as the start, but July 1848 is cited in Simon Nowell-Smith, *The House of Cassell, 1848–1958* (London: Cassell, 1958), p. 17; Cassell had been publishing the *Teetotal Times* since 1846, but anonymously (p. 15).

27. GCk draft letter to Bogue, n.d. [1847], K 105.

28. Samuel Gurney to GCk, 4 June 1847, Princeton.

29. *DNB Missing Persons* (1993).

30. Louis James, *PULC*, p. 167.

31. Pencil sketches for *The Bottle*, Binyon cat. 1443–1464, and for *The Drunkard's Children*, 1465–1489; colored drawings for *The Bottle*, V&A 9425.A–F, 9426.A–E, and for *The Drunkard's Children*, 9429.A–H.
32. Quoted in Jerrold 2:118–119.
33. For other readings of these plates, and the significance of further details, see especially Jerrold 2:91–94, and Vogler, *Graphic Works*, pp. 159–161, who points out several specific borrowings from Hogarth. Hilary and Mary Evans, pp. 124–132, make much of *The Bottle* and its sequel, but they obscure the cumulative force of GCk's designs by printing the second and fifth images in reverse.
34. Faces in particular seem much more sensitively rendered in preliminary drawings than in the printed plates.
35. Charles Mackay, *The Bottle: A Poem to Illustrate the Etchings of George Cruikshank*, Part the Seventh, stanza 6 (London?: David Bogue?, 1848 or later).
36. Jerrold 2:98–99. George and Edward Dalziel tell essentially the same story, but name Charles Blomfield, Bishop of London, the questioner (*The Brothers Dalziel* [London: Methuen, 1901], pp. 50–51). Conceivably more than one friend asked GCk why he didn't practice what he preached.
37. Charles Mackay to GCk, 25 Nov. 1844, Princeton.
38. Mackay to GCk, 1 June 1848, Princeton. GCk had bragged to an elocution class of his friendship with their hero Mackay: GCk to Mackay, Apr. 1846, Goodspeed's *Flying Quill* cat., Winter 1982, item 37.
39. Bogue to GCk, n.d. [1848?], George Cruikshank Collection (#3833), Manuscripts Division, Special Collections Department, University of Virginia Library; see also JJ and a copy of the two poems bound together, Bodleian Library, Poetry b. 1(4).
40. Matthew Arnold, "To George Cruikshank," *Poems*, ed. Kenneth Allott (London: Longmans, 1965), pp. 59–60.
41. Edmond and Jules de Goncourt, *Gavarni, l'homme et l'oeuvre* (Paris: Henri Plon, 1873), pp. 298–300; this lesson occurred in Aug. 1852, and comprised *The Drunkard's Children* as well. Artists who borrowed motifs from the two glyphographic series include Charles Allston Collins in *Drink* (1850s), Doré in *London* (1872), Augustus Egg in *Past and Present* (1858), Gavarni, and G. F. Watts in *Under a Dry Arch* (c. 1850) and *Found Drowned* (c. 1849/50).
42. CD to Forster, [2 Sept. 1847], PLet 5:156–157. Actually, the garrulous woman seems to be the bonneted middle-aged lady talking *to* the young mother; and despite the Pilgrim editors' note, the baby seems to be, not "quite unperturbed" but rather staring uncomprehendingly at the corpse.
43. Robert Chambers to GCk, 25 Nov. 1847, Princeton.
44. CD to GCk, 15 Feb. 1848, PLet 5:247–248.
45. Moncrieff to GCk, 7 Sept. 1847, Princeton.
46. GCk to Adshead, 4 Nov. 1847, Princeton.
47. Meisel, pp. 124–141, discusses the problems involved in translating *The Bottle* into domestic melodrama. Taylor also asked GCk's permission to adapt *The Drunkard's Children*.
48. O'Neill, *Fifty Years*, chapter 25.
49. Vogler, *Graphic Works*, p. 160.
50. Moore and Co. to GCk, 5 Oct. 1848, Princeton; GCk to Moore and Co., 6 Oct. 1848, Searle 19; G. S. Moore to GCk, 21 Oct. 1848, Princeton.
51. G. S. Moore to GCk, 14 Oct. 1848, JJ.
52. See Wynn Jones, p. 87; the versions of *The Bottle* in G. A. Household, ed., *To Catch a Sunbeam: Victorian Reality through the Magic Lantern* (London: Michael Joseph, 1979): "A Drunkard Yet a Man," pp. 48–51, and "The Drink Fiend," pp. 52–61;

and Norman Longmate, *The Waterdrinkers: A History of Temperance* (London: Hamish Hamilton, 1968), p. 125.

53. Ewing [?] and C. and James [?] to GCk, 24 Oct. 1848, Princeton.
54. J. B. Smithies to GCk, 16 Sept. 1847, UNC-CH.
55. Edward FitzGerald to Marietta Nursery, [Dec. 1866], *Letters*, 2: 615–617; [W.?] Baker to GCk, 29 Sept. 1864, UNC-CH.
56. Mackenzie, "George Cruikshank," pp. 177–182.
57. GCk to Mackenzie, 20 Oct. 1847, Princeton.
58. GCk to Mackenzie, 1 Nov. 1847, Historical Society of Pennsylvania, quoted in Vogler thesis, p. 65, and three letters from Mackenzie to GCk, 2 Nov. 1847, Bradburn 19 blue; 3 Nov. 1847, Princeton; and 11 Nov. 1847, Princeton, where Mackenzie apologizes for the "want of force about the eyes" of the portrait, and explains that he had intended for an elaborate frame inscribed with the names of GCk's principal publications to encircle the bust.
59. GCk draft reply to Charles Peter Pitt's letter of 6 Sept. 1848, n.d., JJ.
60. David Bogue to GCk, 17 Jan. 1848, Bradburn 24 blue.
61. Fred Hopwood to GCk, 8 Dec. 1847, Princeton.
62. J. M. Scollier to GCk, 10 Dec. 1847, George Cruikshank Collection (#3833), Manuscripts Division, Special Collections Department, University of Virginia Library, quoted in Harvey, *Victorian Novelists*, p. 31. Harvey says GCk wrote "interesting" on this letter, but the comment is by FSB.
63. No place of publication, publisher, or date, JJ.
64. GCk draft letter to [editor of *Pictorial News?*], n.d. [1847–1848], protesting the announcement of John Gilbert's? sequel in that journal, K 187.
65. E. J. P[arry] to GCk, 22 Dec. 1847, Bradburn 17 blue.
66. Parry to GCk, 1 Jan. 1848, Bradburn 18 blue; subsequently Parry sent a list of nineteen firms that had received quantities of Billing's imitation, Parry to GCk, n.d. [1848], Princeton.
67. GCk draft letter to [Parry], c. 5 Jan. 1848 [on verso of a bill to be paid by that date], Searle.
68. Parry to GCk, 7 Jan. 1848, Princeton; William Howard to GCk, 20 Jan. 1848, Princeton.
69. William Loaden to GCk, 6 Mar. 1848, Princeton.
70. Watts Phillips to GCk, n.d. [1848], Princeton.
71. Phillips to GCk, n.d. [1848], Princeton.
72. Information supplied by David Kunzle.
73. Quoted in Harrison, *Drink*, p. 225.
74. Cohn, 1:xii; Harvey, *PULC*, p. 150.
75. Harvey, *PULC*, pp. 150–151.
76. Rowlandson's "Suicide" in the *Dance of Death* also has streaming hair and fluttering dress, but the composition and drawing of the figure arrest the action, render it balletic and static.
77. Casteras, p. 68, cat. entry 22. For a full study of this subject, consult Barbara T. Gates, *Victorian Suicide: Mad Crimes and Sad Histories* (Princeton: Princeton University Press, 1988), especially pp. 135–150. In William J. Palmer, *The Detective and Mr. Dickens* (New York: Ballantine Books, 1990), the venue shifts to Chelsea Bridge, where Dickens and Wilkie Collins witness Ellen Ternan's suicide attempt. Palmer, professor of English at Purdue, delights in scrambling fiction with fact and Victorian with modern; in this scene, he unmistakably describes GCk's plate.
78. Thomas Hood, *Works*, 7:45–49. For more about Hood's poem, see Wayne Johnston Pond, "Thomas Hood as a Forerunner of the Victorian Wasteland," M.A. thesis, Brigham Young University, May 1968, pp. 75–80, and Reid, *Thomas Hood*, pp.

215–217; the Thackeray quotation appears without attribution on p. 215. Paget made the connection to the "Bridge of Sighs" in his 1863 *Blackwood's* essay.

79. 8 July 1848, p. 436, misrepresented by Forster, Ley ed., pp. 490–492, as if a letter to him.

80. CD to GCk, 8 July 1848, PLet 5:365; GCk's reply to Alison, 9 July 1848, offered for sale by David Schulson Autographs, cat. 33, item 35.

81. P. W. Bradish of Liverpool to GCk commiserating about this turn of affairs, 6 Aug. 1848, UNC-CH. GCk tells Merle (25 Aug. 1848, Princeton) that the revolutions have "disarranged" all commercial trading, and that he has also lost sales because pirates using the "anastatic process" transferred his images to zinc plates and printed cheaper editions.

82. A lithographic piracy well drawn by D. W. Moody and published by F. Michelin in New York divided the market with Wiley and Putnam's imported original plates; see H. E. K[eyes], " 'The Bottle' and Its American Refills," *Antiques* 19 (May 1931): 386–390. George Gebbie of Philadelphia issued a different set of lithographs printed on tint in 1871, and in 1878 the Happy Hours Company produced an octavo with the plates reduced. So there was continuing demand in the United States for *The Bottle*; it was simply that not all customers bought GCk's version. Reprints of *The Drunkard's Children* are harder to find.

83. GCk to Adshead, 4 Feb. 1848, Princeton.

84. Merle to GCk, after 21 May 1846, Princeton.

85. Daniel Allen to GCk, with a postscript by his son J. Allen, 14 Feb. 1848, Bradburn 15 red. This may be a reply to an undated draft to an unidentified person in which GCk says he cannot pay a bill of £344 until he publishes his sequel, K 40. Out of £416 earned on *The Bottle*, Bogue deducted £166 for other past due accounts, GCk paid back Adshead £75 of those loans, and met another bill for £65. He thus netted £110 for a year's work.

86. GCk to Adshead, 27 Nov. 1847, Princeton.

87. GCk to Bogue, July [1848], Bell and Hyman.

88. GCk draft letter to the Temperance Societies of Great Britain, n.d. [1848], Searle.

34. ENGLAND IS NOT CALIFORNIA

1. Feaver, *PULC*, p. 250.

2. C 385, Binyon cat. 1273–1276, and V&A 9659. A verso. For bibliographic corrections to Cohn's entry, see Stephen H. Cape, "Note 535. A Suppressed Edition of Sir Francis Bond Head's *The Emigrant*," *The Book Collector* 41 (Summer 1992): 258–261.

3. GCk to Robert Cook, 10 Oct. 1846, archives of John Murray.

4. T. H. Sealy to GCk, 3 Sept. 1847, V&A 9895.F; 29 Nov. 1847, Princeton; 18 Jan. 1848, UNC-CH.

5. C 356: *The Snow Storm*, 1845; C 357: *New Year's Day*, 1846 (four colored sketches, V&A 9511.A–D); C 358: *The Inundation; or Pardon and Peace*, 1847.

6. C 128, 1847, T. C. Newby.

7. Quoted from unidentified source by Spielmann, p. 268.

8. Mayhew told GCk he got the idea for a comic magazine from the *Omnibus*: GCk draft reply to John T. Atkinson's letter of 6 Apr. 1865, Princeton.

9. PLet 4:644 n. 2

10. Spielmann, p. 328.

11. Ray, *Thackeray*, 1:211, citing W. E. Church, *William Makepeace Thackeray as Artist and Art Critic* (privately printed), p. x.

12. Henry and Augustus Mayhew, *The Greatest Plague of Life: or The Adventures of a Lady in Search of a Good Servant* (London: David Bogue, 1847), p. 8; C 544. Pencil, pen, and tint sketches, drawings, and mounted tracings, V&A 9957.A–R.

13. Kathleen Tillotson, *Novels of the Eighteen-Forties* (1954; 2d impression, Oxford: Oxford University Press, 1961).

14. Ibid., p. 10.

15. Ibid., p. 13.

16. A comparison of GCk's "expansively good-natured" picture to Leech's "urbane but malicious" adaptation (*Punch*, 31 Aug. 1850) is given by Burton, *PULC*, pp. 117–118.

17. C 543, 1847.

18. Henry Mayhew to GCk, n.d. [1847–1848], included among letters from Merle to GCk but on evidence of handwriting and contents from Henry Mayhew, Princeton.

19. Augustus Mayhew to GCk, n.d. [1847–1848?], Princeton.

20. Spielmann, pp. 141–142.

21. C 545. Pencil studies and tracings, V&A 9895.A–J.

22. GCk draft letter to unidentified person, n.d. [Feb.? 1848], Bradburn 58 blue.

23. GCk to Bogue, 13 Apr. 1848, Bell and Hyman. GCk to Bogue, "Monday Mo[rnin]g" [17 Apr. 1848], Bell and Hyman, promises the finished etching, "The Wedding," by Wednesday.

24. *S. v.* Horace Mayhew.

25. Draft or copy not in GCk's hand on *Punch* stationery to editor of the *Literary Gazette*, n.d. [c. late Dec. 1848/early Jan. 1849], Princeton.

26. Horace Mayhew to GCk, 9 Aug. 1848, Princeton.

27. C 547, 1849, reproduced in the Feaver cat. of the Arts Council of Great Britain 1974 GCk exhibition. Original sketches: Binyon cat. 1315 and 1317, Boston University, and Lilly Library, Indiana University. In a forthcoming essay David Kunzle identifies dentistry as a midcentury pan-European figure for power relations between authority and suffering underclasses and as a displacement of revolutionary anxieties; GCk's strip ends with doctor and patient embracing, an emblem of momentary Victorian social harmony. The strip was so popular, Professor Kunzle informs me, it was crudely copied by Manuel Macedo and published without credit in the 18 May 1866 number of a Portuguese journal, *As Noticias*. Amusingly, a GCk print, *Tugging at a High Eye-Tooth* (BMC 14311, 1 Nov. 1821, Humphrey), which depicts an extraction in a dentist's office, makes the first cartoon reference to Mary Shelley's 1818 *Frankenstein*, the two volumes of which are prominent in the dentist's bookcase (Steven Earl Forry, *Hideous Progenies: Dramatizations of "Frankenstein" from Mary Shelley to the Present* [Philadelphia: University of Pennsylvania Press, 1990], pp. 47–48).

28. GCk to Bogue, 3 Feb. 1849, Bell and Hyman; see also GCk letters to Bogue of 22 Jan. 1849 and "Tuesday Mo[rnin]g" [6? Feb. 1849], Bell and Hyman.

29. Frederick Dickens to GCk, 5 Nov. 1847, UCLA; CD to GCk, 26 Nov. 1847, PLet 5:202.

30. Frederick Dickens to GCk, 20 Dec. 1847, UCLA.

31. Frederick Dickens to GCk, 15 Jan. 1848 [1849], UCLA.

32. Frederick Dickens to GCk, 5 Feb. [misdated "Octr"] 1848, UCLA.

33. CD to G. H. Lewes, 28 Feb. 1848, PLet 5:252–253—the text to GCk is identical, PLet 5:253 n. 1—and CD to G. H. Lewes,. 2 Mar. 1848, PLet 5:258.

34. Rehearsal calls from Frederick Dickens to GCk, 29 Mar. 1848, before 2 May 1848, and 4 May 1848, UCLA.

35. PLet 5:301 n. 1; Charles and Mary Cowden Clarke, *Recollections of Writers* (London: Sampson Low, Marston, Searle, and Rivington, 1878), p. 307.
36. PCk "Memoir," pp. 125–126.
37. GCk draft reply to CD on verso of CD to GCk, 18 May 1848, PLet 5:307–308 and 5:308 n. 1.
38. Frederick Dickens to GCk, 29 May 1848, UCLA, asking whether Mrs. Cruikshank will accompany GCk; Dickens to Francis Robinson, 1 June 1848, reserving a room for Mary Ann, PLet 5:326.
39. Clarke, *Recollections*, p. 314. Mrs. Clarke often adds an "s" to GCk's surname, as if he was too much to be only one person.
40. CD to GCk, 1 July 1848, PLet 5:356.
41. C 143, Grant and Griffith.
42. Mrs. E. M. Ward, *Memories of Ninety Years*, 2d ed. (London: Hutchinson [1924]), p. 85.
43. C 60, 1848, Bogue.
44. C 754, in parts Jan. 1849–Mar. 1850, and as volume, Mar. 1850, A. Hall, Virtue and Co.
45. Berg; see also pencil, pen-and-ink, and watercolor sketches, Binyon cat. 1290–1305.
46. Spielmann, p. 281.
47. C 687, six shilling numbers with two illustrations each, followed by one-volume issue, 1849, Bogue.
48. Reach to GCk, n.d. [late 1848], Princeton.
49. Reach to GCk, n.d., "Saturday" [late 1848], UCLA.
50. Reach to GCk, n.d. [1848–1849], UCLA. These notes may relate to GCk's projected Temperance sequel, "Whiskey after the Goose," a defense of the teetotal family partly inspired by notices in *The Times* and the *Examiner* during the summer of 1849: see V&A 9930.
51. GCk to Reach, 29 Jan. 1849, Princeton.
52. Merle to GCk, 4 Mar. 1842, Princeton.
53. Florence Marryat, *Life and Letters*, 2:186.
54. GCk to Mary Ann Cruikshank, 26 Oct. 1848, Bell and Hyman.
55. Jerrold 1:109.
56. D. Cooksey, annotated bill for Funeral of Mrs. Mary Ann Cruikshank, JJ.
57. Octavian Blewitt to GCk, 30 May [1849], Princeton.
58. W. H. Wills to GCk, 30 May 1849, Princeton.
59. GCk to W. H. Wills, 4 June 1849, UCLA
60. GCk to Forster, 4 June 1849, Special Collections, Tutt Library, The Colorado College.
61. GCk to Merle, 6 Nov. 1849, Princeton.
62. GCk to Edward Lewis, 23 June 1849, Princeton.
63. GCk to Merle, 25 Feb. 1849, Princeton.
64. *Plague*, pp. 14–15.
65. GCk to Mr. Cox in Holborn, 28 Mar. 1849, UCLA.
66. Sir Charles Beaumont Phipps to GCk, 30 June 1849, Princeton. George Pulford refers to his godfather's getting on so well with his picture in a letter of 28 June, Princeton. Watercolor and other sketches, V&A 9446.A–D. See chapters 35 and 39 for further information about this painting, also entitled *The Disturber Detected*.
67. GCk to [Bogue], 4 Sept. 1849, Princeton.
68. Bogue to GCk, 7 Sept. 1849, Princeton.

35. I AM BECOME A NAME

1. Alfred, Lord Tennyson, *Poems*, 3 vols., ed. Christopher Ricks, 2d ed., Longman Annotated English Poets (Harlow, Essex: Longman, 1987), 1:613–620, lines 11–24.
2. G. Linnaeus Banks to GCk, 22 Sept. 1849, Princeton.
3. GCk to Eliza Widdison, 27 and 28 Sept. and 15 Oct. 1849, Vogler Collection, Grunwald Center, UCLA; Eliza Widdison to GCk, n.d. [28? Sept. 1849], Princeton.
4. Eliza Widdison to her uncle and aunt Dalton, n.d. [Jan. 1826], Princeton.
5. GCk draft letter from 11 Scarsdale Terrace, Kensington to unidentified person, n.d. [1849?], Princeton.
6. CD identifies it as Stanfield's former residence in a letter to John Britton, 9 May 1850, PLet 6:96–97. The immediately preceding tenant was William James Sayer, for whom the house had been completely renovated inside and out: see Rate Books and GCk to Thomas Cree, 27 Feb. 1877, Princeton.
7. Robert Brown to GCk, 8 Nov. 1849, UNC-CH; Coutts. GCk did not move in 1848, as is stated in PLet 6:97 n. 4.
8. Thompson, *Rise of Respectable Society*, p. 172, says that the middle class calculated on spending between 10 and 12 percent of income on housing.
9. Register of Marriages, Holy Trinity Church, Islington.
10. Indeed, GCk was uncharacteristically evasive, possibly because the year of mourning was not over. He declined an invitation to a publisher's party on the grounds that he would be "out of town" after the seventh of March (GCk to Mrs. [George] Virtue, 25 Feb. 1850, Berg).
11. PCk "Memoir," pp. 235–236.
12. Mary Cruikshank to ECk, 11 Mar. 1850, Princeton.
13. See letters from ECk to Superintending President of London District P. O. and from GCk forwarding this written authority to redirect all letters for Mrs. Parratt, Mrs. Widdison, and Eliza Widdison, 30 Mar. 1850, John Rylands University Library of Manchester.
14. 1851 Census Return of 48 Mornington Place, St. Pancras, Middlesex, HO 107/1493, folios 5–6. The ages are in most cases approximate, because the records contradict one another. According to John Wardroper, "The secret life of a virtuous artist," *The Independent on Sunday*, 25 Oct. 1992, Home section, p. 5, Adelaide was born in 1831 at Claygate in Surrey; the marriage and baptismal records for Adelaide's parents, William Attree (Altree) and Ann Alum (Allom), for her older sister, Caroline Elizabeth, and for her young siblings Wiliam, Jane, and Henry, all record Cheam. Adelaide was baptised 21 Aug. 1831. For a genealogical table, see p. 523.
15. GCk so endorses a letter of 4 Sept. 1850; after a while ECk became the principal correspondent, often writing out the letters which GCk merely signed, and noting the contents of replies, especially to Temperance invitations ("Accepted" or "Declined").
16. GCk draft letter to unidentified person, n.d. [c. 5 Oct. 1850], V&A 10,046.G.
17. Public Record Office, P.C.C. Wills, Prob 11/2141, folio 810.
18. On the birth certificates of many of her children, the surname is Attree; but according to the Reverend T.J. de L. Surtees, the parish registers in Cheam record the marriage of Adelaide's parents and the baptisms of herself and her siblings under the surname Altree. The 1861 census records Adelaide's mother as "Mrs. Atteree," whereas the will of George Cruikshank spells the name "Altree."
19. Wardroper, "The secret life," quoting Hazel Snaith, a great-granddaughter of Adelaide's sister, and Mrs. Snaith's daughter Jacqueline Owen.

20. From William on, registrations of birth are recorded in the Regent's Park subdistrict of the Pancras District, Middlesex. In the last two cases, the father, George Archibald in one case and Archibold in the other, is identified as a wood-engraver. Prior to them, he is an artist. Arthur's middle name could be Altree but looks more like Attree, which I have therefore preferred here. Annie's birthdate comes from Wardroper, "The secret life."

21. 1861 Census Return of 31 Augustus Street, Public Record Office, RG 9/97, folio 70.

22. James Henry Hardis to GCk, 12 Apr. 1850, Princeton.

23. Augustus N. Dickens to GCk, 13 May 1850, Free Library of Philadelphia.

24. GCk promised Crowquill one of his drawings, but kept putting him off because of other work: see 4 Feb. 1849, Huntington Library. On 14 Mar. 1851 GCk promises that if Forrester is "a good boy" he will make an oil sketch for him: Huntington Library.

25. Thomas Reynolds to GCk, n.d. [1851?], UNC-CH.

26. GCk was invited to the Blewitts for dinner before Mary Ann's death: Octavian Blewitt to GCk, 2 Jan. 1849, Princeton. GCk continued to visit after his marriage: GCk to Blewitt, 24 June 1851, Huntington Library. "Although a stranger to yourself," Charles Kent sent GCk two tickets to a comedy and farce at Miss Kelley's Theatre on 14 Jan. (4 Jan. 1851, UNC-CH), and printed "deserved eulogies" of GCk's work in the 3 June *Sun*: Charles Kent to GCk, 3 June 1851, Princeton.

27. J. Humffreys Parry to GCk, 11 Oct. 1850, Princeton.

28. PLet 1: 483 n. 2.

29. Samuel Carter Hall to GCk asking for six copies of his Temperance plates, 20 Dec. 1850, Princeton.

30. PCk "Memoir," pp. 216–218.

31. GCk to unidentified person, n.d. [c. 1850], V&A Box 86.BB(vi). The oil, 44.8 × 55.9 cm., now entitled *The Disturber Detected*, hangs in the anteroom to the state apartments of Kensington Palace. See chapter 39 for GCk's attempt to sell an engraving from the picture.

32. C 388; facsimile of wrapper in FSB copy.

33. Francis Higginson R. N. to GCk, 14 Oct. 1849, Princeton.

34. Merle to GCk, 5 Aug. 1849, Princeton.

35. GCk to Merle, 11? Aug. 1849, Princeton, day suggested by FSB.

36. Merle to GCk, 28 Oct. 1849, Princeton.

37. W. H. Wills to GCk, 8 May 1850, Princeton.

38. Merle to GCk, 23 Oct. 1850, Princeton.

39. Lemon to GCk, n.d., "Monday" [1850], Princeton.

40. CD to Edward Chapman, 13 Feb. 1850, PLet 6:37.

41. PLet 6:98 n. 4; *Household Words* 1 (8 June 1850): 241–242.

42. Robert Rae to GCk, 30 Oct. 1850, Princeton; GCk to editor of *National Temperance Chronicle*, 10 Dec. 1850, Princeton (a printed letter to the Temperance Societies of the United Kingdom of that date which GCk has emended for the editor).

43. C. P. Pitt to GCk, 23 Nov. 1849, UNC-CH.

44. GCk to Reynoldson, 5 May 1849, Princeton.

36. LOSING BY ALMOST EVERY SPECULATION

1. Spielmann, p. 4.

2. Quoted in C. H. Gibbs-Smith, *The Great Exhibition of 1851*, 2d ed. (London: Her Majesty's Stationery Office, 1981), p. 7.

3. Quoted in Ibid., pp. 12–13.
4. George W. Stocking, Jr., *Victorian Anthropology* (London: Collier Macmillan, 1987), especially the Prologue, pp. 1–6.
5. Henry Mayhew, *1851: or, the Adventures of Mr. and Mrs. Sandboys* (London: David Bogue, 1851), p. 131; C 548, 8 monthly parts, Feb.–Oct., and volume, 1851. Pencil, pen, and in one case watercolor sketches, Binyon cat. 1318–1330 and V&A 9581.A–K. The book was reissued in 1851? as a volume by George Newbold, and a few sets of india proofs were sold separately. GCk's ten copper plates were auctioned by Puttick and Simpson in 1891: Muir, p. 20.
6. Quoted in Gibbs-Smith, p. 10.
7. C 201, 1851, printed and published for the author by Bradbury and Evans.
8. Frith, p. 148. Not all GCk's friends believed this story.
9. J. Phillips to GCk, 12 Apr. 1850, requesting payment on acceptances by Mr. Mills and Mr. Bowles, University of Kentucky; GCk to David Bogue, 4 Nov. 1850, Bell and Hyman (quoted); GCk to David Bogue, 6 Nov. 1850, promising repayment of the advance "out of the first sale of this *new attempt* of mine," Bell and Hyman.
10. 12 Dec. 1850 bill inserted between p. 23 and p. 24 of PCk "Memoir." Although GCk followed his own advice and secured his house according to the robbers' prescriptions, a housebreaker did gain entry in Jan. 1856: GCk to Merle, 24 Jan. 1856, Princeton.
11. W. Baryham? to GCk, 3 Dec. 1850, UNC-CH.
12. James Webb to GCk, 9 Jan. 1851, Princeton.
13. James Parry to GCk, 3 May 1850, Princeton.
14. F. F. LeMaitre to GCk, 22 Nov. 1850, Princeton.
15. L. P. Knowles to GCk, 27 Sept. 1850, William Andrews Clark Memorial Library, UCLA.
16. E. G. Flight to GCk, 21 Dec. 1850, FSB notation opposite C 323, 1851, Bogue. On 29 May 1851 GCk sent Flight proof of one engraving and promised to start another design immediately (London Borough of Camden Libraries and Arts Department).
17. Review of *The True Legend of St. Dunstan, Literary Review*, 20 Dec. 1851, pp. 817–818.
18. Henry Mayhew to GCk, n.d. [Jan.? 1851], Bradburn 25 blue.
19. Bogue to GCk, n.d. [Jan.? 1851], Princeton.
20. BMC 12698, 1 Feb. 1815, Jas. Whittle and Richd. Laurie; C 180, 1832 (pen-and-ink sketch, 1829, Binyon cat. 278); C 190, 1842.
21. The illustrated comic travelogue of part one and the discomforts of London tourism in later installments owe something to the popularity of the French artist Cham (Charles-Henri-Amédée de Noé), who visited London in January 1847 and received a "hurricane welcome" from the Vizetellys, the *Punch* crowd, CD, Thackeray, and GCk, who "wrote affectionate dedications on unpublished drawings he presented to the French artist." Cham contributed *The Foreign Visitor in London* to the *Man in the Moon* (1847), which Henry Mayhew helped produce. Cham's travel satires were a big hit in *Charivari* between 1844 and 1852. For more on the artist and his British connections, see Kunzle, *History of the Comic Strip*, 2:72–99.
22. Harvey, *PULC*, p. 147.
23. There is an undated, virtually illegible note requesting someone to send someone else a rough copy (manuscript? proofs? a pull of the etching?) of "looking for lodgings" at UNC-CH. The University of Rochester owns a letter from GCk to the firm of Dalziel Brothers asking that they return the plate as he had forgotten to etch his initials: "I do not attach any importance to this matter but it may be thought that I have purposely left it out." The name of the month on the hastily written note is ambiguous—probably "Mr. 30," but 30 March was a Sunday in 1851, an improbable

(though not impossible) day for the firm to be at work, especially if the March number was not yet completed.

24. Henry Mayhew to GCk, n.d. [Feb.? 1851], mistakenly filed with Princeton Merle collection.

25. Henry Mayhew, pen-and-ink over pencil drawing of Market Street, Manchester, Jan.? 1851, National Gallery of Art, Washington DC, B.11.210.

26. Quoted in Gibbs-Smith, p. 48, fig. 29. See also the report of the Commissioner of Police, Richard Mayne, to the commissioners for the Great Exhibition, JJ cat. 204.

27. Bogue to GCk, 1 Mar. 1851, Pennsylvania State, University Park.

28. Bogue to GCk, 17 Mar. [1851], Princeton.

29. J. F. Annistead to ECk, 17 Mar. 1851, Princeton; GCk to William Jerdan, 23 Mar. 1851, private collection.

30. C 957, Mar. 1867, published by the artist and sold by W. Tweedie.

31. GCk draft letter to Chairman and Committee for the Royal Fete at Guildhall, n.d. [June 1851], Princeton.

32. Queen Victoria, *Queen Victoria in Her Letters and Journals: A Selection by Christopher Hibbert* (London: John Murray, 1984), p. 84.

33. V&A 9451.1; C 1814 lists, in addition, an india proof state—all three, 29 June 1851, Bogue.

34. GCk to Octavian Blewitt, 24 June 1851, Huntington Library; GCk drafts of letter transmitting items to Prince Albert through Col. C. B. Phipps, verso of an envelope postmarked 4 July 1851, V&A 9734.O; Phipps to GCk, 10 July 1851, UNC-CH.

35. "*Opening of the Great Exhibition.* By George Cruikshank," *Literary Gazette*, 19 July 1851, p. 497. The reviewer's assertion that GCk made no on-site sketches is contradicted by Jerrold 2:174.

36. Jerrold 2:174.

37. V&A 9454.B.

38. Charles Kent to GCk, 3 June 1851, Princeton; final pencil drawing, V&A 9454.A; unfinished etching, V&A 9454.1; proof, *Lib.* 563.

39. PCk "Memoir," pp. 262–263.

40. Anne Humpherys, *Travels into the Poor Man's Country: The Work of Henry Mayhew* (Athens: University of Georgia Press, 1977), pp. 12–14, 12.

41. Harvey, *PULC*, pp. 146–147.

42. GCk to James Cochrane, 13 Oct. 1851, W. Hugh Peal Collection (63M22), Division of Special Collections and Archives, University of Kentucky Libraries.

43. David W. Bartlett, *What I Saw in London; or, Men and Things in The Great Metropolis* (Auburn, NY: Derby and Miller, 1852), pp. 63–67.

37. HITTING RIGHT & LEFT

1. J. W. T. Ley, "Robert Seymour and Mr. Pickwick," *Dickensian* 21, no. 3 (July 1925): 122–127, 126.

2. Bernard Denvir, *The Early Nineteenth Century: Art, Design and Society, 1789–1852* (London: Longman, 1984), p. 9.

3. Longmate, pp. 134–135.

4. Buckingham corresponded with CGk in Jan. 1851 about the artist's letter to the *Temperance Chronicle.* At the same time he ordered three copies each of *The Bottle*, *The Drunkard's Children*, and the proposed subscription series: J. S. Buckingham to GCk, 30 Jan. 1851, Princeton.

5. Quoted in Longmate, p. 135.

6. George Eliot to the Brays (who had missed meeting GCk two years previously), 5 May 1852, *Selections from George Eliot's Letters*, ed. Gordon S. Haight (New Haven: Yale University Press, 1985), pp. 95–96.

7. Autumn 1848, quoted in Jerrold 2:122–123.

8. Jerrold 2:134–135.

9. C. 1850?, quoted in Jerrold 2:124–125.

10. PCk "Memoir," p. 208.

11. Cuthbert Bede, quoted in Jerrold 2:129–133.

12. PCk "Memoir," pp. 176–177.

13. Jerrold 2:102–103.

14. PCk "Memoir," pp. 181–182.

15. Ibid., p. 171. Livesey's *Malt Lecture* and other Temperance tracts did in fact presume to demonstrate scientifically that beer contained unsanitary and unhealthful ingredients. GCk also attempted laboratory demonstrations of the noxious "residuum" of evaporated porter: see Ibid., pp. 271–272.

16. Ibid., p. 172.

17. Ibid., pp. 273–275.

18. Ibid., p. 170. But Mary didn't stop her son from blaming her, even after her death, for his former bibulous habits: "it was she . . . that would have caused him to be a drunkard if any one had" (see "Gravesend and Milton Temperance Society" [a report on GCk's 28 Oct. 1867 speech] in the *Gravesend and Dartford Reports*, 2 Nov. 1867, JJ).

19. PCk "Memoir," pp. 172–174, retold in Jerrold 2:111.

20. John H. Esterbrooke to GCk, 9 Jan. 1852, UNC-CH.

21. J. Shillinghaw to GCk, 2 Feb. 1852, Princeton.

22. John Taylor to GCk, 21 July 1851, UNC-CH; C 1852; see also the Band of Hope Pledge Cards, C 1850 and C 1851.

23. John Jordison to GCk, 8 Nov. 1851, FSB note to C 1850; Jordison to GCk, 24 Nov., 26 Nov., and 3 Dec. 1851, UNC-CH; Jordison to GCk, 20 Dec. 1851, Princeton; Jordison to GCk, 9 Feb. 1852, UNC-CH; GCk draft letter to John Cunliffe, 21 Feb. 1852, Princeton; Cunliffe to GCk, 25 Feb. 1852, UNC-CH.

24. H. Cole to GCk, 5 Mar. 1852, V&A 10,050.B.

25. Banks to GCk, 7 Mar. 1852, V&A 10,050.A.

26. J. L. Mahon to GCk with GCk's draft reply on verso, 12 Mar. 1852, University of Maryland Baltimore County.

27. Program, 15 Mar. 1852, V&A 10,054.6.

28. J. Charles Prebble, Secretary of London Temperance League to GCk, 4 May 1852; [GCk to Robert Rae, 4–11 May 1852, inferred from 11 May letter below]; Prebble to GCk, 8 May 1852; Robert Rae to GCk, 11 May 1852; Prebble to GCk, 15 June 1852: all UNC-CH.

29. GCk draft letters to Moir family, n.d. [c. 9 Apr. 1853], Princeton.

30. John Taylor to GCk, 23 May 1852, UNC-CH.

31. W. Burns to GCk, 6 Sept. 1852, UNC-CH.

32. John Yarnold to GCk, 12 Oct. 1852, Princeton.

33. James Crew to GCk, 25 Oct. 1852, UNC-CH.

34. Evan Lloyd to GCk, 3 Nov. 1852, UNC-CH.

35. W.J.W. Halley to GCk, 11 Nov. 1852, UNC-CH; Morris Oppenheim to GCk with draft reply, 8 Dec. 1852, Searle.

36. James Ritton forwarding a copy of the proceedings for 8 Dec. to GCk, 4 Dec. 1852, Princeton; program, V&A 10,054.11.

37. Charles Kent to GCk, 16 Dec. 1852, Pennsylvania State, University Park.

38. GCk to Kent, 27 Dec. 1852, private collection.

39. Feaver, *PULC*, p. 252.

40. C 788, *The Temperance Offering*, 1852, Tweedie.
41. From the time of its importation from the New World, tobacco and drunkenness had been associated: see Anthony Grafton with April Shelford and Nancy Siraisi, *New Worlds, Ancient Texts: The Power of Tradition and the Shock of Discovery* (Cambridge, MA and London: The Belknap Press of Harvard University Press, 1992), p. 172. C 1850, Band of Hope; and C 1852, Family Pledge Card, 1852. GCk could be quite as hectoring about smoking as about drinking: see PCk "Memoir," pp. 178–181.
42. C 201; see GCk draft captions for sketches, n.d. [1852], Princeton.
43. GCk draft letter to unidentified person, n.d. [1852?], K 236, and GCk to [Cash?], 18 Aug. 1852, George Cruikshank Collection (#3833), Manuscripts Division, Special Collections Department, University of Virginia Library.
44. Unidentified person to GCk, n.d. [1852], Princeton; B. F. Harrison to GCk, fragment referring to "a notice of your 'Betting Book'," n.d. [1852], William Andrews Clark Memorial Library, UCLA; Charles Kent to GCk, 27 Aug. 1852, Princeton; R. Roberts to GCk, sales report, 9 Apr. 1852, Princeton. The Cash brothers were successors to the firm of Charles Gilpin; Roberts is evidently a clerk who stayed on. The *Literary Gazette*, now puffing each of GCk's projects, praised the witty, smart, clever writing "that does exemplary honour to the head and heart of the great caricaturist" (21 Aug. 1852, p. 640).
45. J. Humffreys Parry to GCk, 23 Aug. 1853, UNC-CH.
46. Pasted in opposite C 201, FSB copy.
47. C 413, 1852, Reeve and Co. Pencil sketches, V&A 9656.A–G.
48. Evans, p. 159.
49. Ibid.
50. Reeve to GCk, 3 May 1852, V&A 9656.G.
51. Reeve to GCk, 18 May 1852, Princeton; GCk to Reeve, 20 May 1852, Princeton.
52. Reeve to GCk, 16 June 1852, Princeton.
53. Layard, *Suppressed Plates*, pp. 78–79.
54. Reeve to GCk, 16 Oct. 1852, Princeton.
55. J. W. Green to GCk, 29 Oct. 1852, V&A 10,033.K.
56. GCk drafts of letter to the duke of Norfolk, n.d. [before 6 Nov. 1852], K 60, K 62; Earl Marshal to GCk, 6 Nov. 1852, Princeton.
57. GCk to Mr. Hogarth, 4 Feb. 1853, private collection.
58. Nowell-Smith, *Cassell*, pp. 37–38.
59. Roger Chadwick, "*Uncle Tom's Cabin* in England," unpub. M.A. paper, Rice University, 1987, and Jane Tompkins, "Sentimental Power: *Uncle Tom's Cabin* and the Politics of Literary History," *Sensational Designs* (New York and Oxford: Oxford University Press, 1985), pp. 122–146. Audrey A. Fisch has recently published a study of other aspects of the British "Uncle Tom" craze, "'Exhibiting Uncle Tom in Some Shape or Other': The Commodification and Reception of *Uncle Tom's Cabin* in England," *Nineteenth-century Contexts* 17, no. 2 (1993): 145–158.
60. Nassau William Senior, *American Slavery* (London: Longman, 1856), p. 2.
61. C 777, 23 Oct. 1852–15 Jan. 1853, volume edition by Christmas 1852, Cassell.
62. Pencil, pen-and-ink, and sepia sketches, Binyon cat. 1685–1754 and V&A 9880.A–Z.
63. Chadwick, p. 12.
64. GCk to the brothers Dalziel, 19 Oct. 1852, Special Collections, Tutt Library, The Colorado College.
65. Unidentified person in Cassell's office to GCk, 26 Oct. 1852, FSB annot. at C 777.
66. C 816 [1852].
67. Pencil-and-pen sketches, Binyon cat. 1758–1765, verify that the three interior plates with GCk's signature are by him. FSB annot. at C 816, citing Parke Bernet

26 Feb. 1942 Woodin sale, Part III, item 656; Cassell to GCk, 31 Mar. 1853, Princeton.
68. Nowell-Smith, *Cassell*, p. 39.
69. C 2007, n.d.; pencil sketches, Binyon cat. 1786–1791.
70. Harriet Beecher Stowe, *Sunny Memories of Foreign Lands*, 2 vols. (Boston: Phillips, Sampson, and Co.; New York: J. C. Derby, 1854), 2:10–11.
71. George Cruikshank, "To the Public," *Cinderella and the Glass Slipper* (London: David Bogue, [1854]), pp. 29–30; C 198.
72. PCk "Memoir," p. 204.
73. C 203, 1853, Cassell.
74. PCk "Memoir," pp. 190–191.
75. Merle to GCk, 5 Mar. 1853, Princeton.
76. Merle to GCk, 28 Mar. [1853, not 1854 as FSB? has annotated], Princeton.
77. J. Humffreys Parry to GCk, 6 Mar. 1853, UNC-CH.
78. John Cassell to GCk, 31 Mar. 1853, Princeton.
79. GCk to Samuel Phillips, 25 May 1854, V&A 10,033.R.
80. Samuel Phillips to GCk, 1 Oct. 1854, UNC-CH. See Samuel Phillips, *Portrait Gallery of the Crystal Palace* (London: Crystal Palace Library and Bradbury and Evans, 1854), p. 176. GCk had previously been recognized for his Temperance activities. Edwin Burruss, preparing *Sketches of Eminent and Popular Men* working for Temperance and Mechanics' Institutes, had asked GCk for biographical particulars: Edwin Burruss to GCk, 18 Mar. 1851, Princeton.
81. Funeral invitation to GCk, 17 Oct. 1854, UNC-CH.
82. Gough, *Works*, p. 15.
83. Longmate, pp. 144–150.
84. Quoted in Ibid., p. 146.
85. Jerrold 2:133–134; *Illustrated London News*, 20 May 1854, p. 465.

38. WHOLE HOGISM

1. [Richard Ford], review of *Oliver Twist*, *Quarterly Review* 64 (June 1839): 86.
2. Stone, *PULC*, p. 246.
3. GCk draft letter to CD, n.d. [15–25 Apr. 1851 on verso of 11 Apr. letter from John Sheringham to GCk], Berg.
4. CD to GCk, 25 Apr. 1851, PLet 6:363.
5. George Nalse to GCk, n.d. [1852–1854?], Princeton.
6. Francisca Martins to GCk, 27 Nov. 1851?, Princeton.
7. Georgiana Bennet to GCk, 5 Nov. 1852, UNC-CH.
8. Merle to GCk, 10 Mar. 1853, Princeton.
9. Stone, *PULC*, pp. 213–247, and his *Dickens and the Invisible World* (Bloomington and London: Indiana University Press, 1978), chapter 1: "Dickens, Cruikshank, and the Sanctity of Fairy Tales." An earlier study is by Michael C. Kotzin, *Dickens and the Fairy Tale* (Bowling Green, Ohio: Bowling Green University Popular Press, 1972).
10. CD to Wills, 10 Aug. 1851, PLet 6:457.
11. Brice and Fielding, p. 3. Elihu Burritt's *Peace Papers* were published in Britain by Charles Gilpin, who also republished a series of letters by "Common Sense," *On the Domestic Habits of the People*, for which GCk supplied six designs for wood-engravings cut by Williams, Dalziel, and Percy Cruikshank (C 155, 1852). It may have been this pamphlet, rather than the *Betting Book*, that GCk submitted to *Household Words*; see below. In any case, GCk was in CD's mind connected through friends and allied causes to extremist positions.

12. [Charles Dickens], "Whole Hogs," *Household Words* 3, no. 74 (23 Aug. 1851): 505–507.

13. See Edward Hewett and W. F. Axton, *The Drinks of Dickens and His Times* (Athens: Ohio University Press, 1983), and Cedric Dickens, *Drinking with Dickens* (Goring-on-Thames: Elvendon Press, 1980).

14. GCk to W. Stephenson, 24 Oct. 1853, The Pierpont Morgan Library, New York. MA 4500C Gordon Ray Collection.

15. [Charles Dickens], "Trading in Death," *Household Words* 6, no. 140 (27 Nov. 1852): 241–245.

16. CD to GCk, 23 June 1852, PLet 6:697–698.

17. Stone, *PULC*, p. 217.

18. Bogue to GCk, 16 May [1853], Princeton; C 196, 1853, Bogue. Pencil, sepia, and watercolor sketches for the Fairy Library: Binyon cat. 1353–1366 and V&A 9786.A–G (*Hop*), 9787–9788.A–D (*Jack*), 9789.A–K (*Cinderella*), and 9790 (*Puss*).

19. GCk to Bogue, 13 June and 14 June 1853, Bell and Hyman.

20. The 14 June letter confirms Cohn's hypothesis that the independent leaf is the mark of a genuine first issue; FSB annot. C 196.

21. GCk Coutts account, 24 June 1853.

22. GCk to Bogue, 21 June 1853, Bell and Hyman.

23. Mary Cowden Clarke to GCk, 30 July 1853, V&A 10,048.D.

24. 9 Aug. 1853, Princeton Genl MSS [bd], Block.

25. GCk draft letter to John Ruskin, 10 June 1853, Binyon cat. 1876.e verso. This could be an early instance of GCk's siphoning off money quietly to pay for Adelaide's expenses.

26. GCk to Bogue, 27 July 1853, Bell and Hyman.

27. [John Forster], review of *George Cruikshank's Fairy Library*, *Examiner*, 23 July 1853, p. 469.

28. CD to Wills, 27 July 1853, NLet 2:479.

29. PLet 6:457 n. 6.

30. Barbara Herrnstein Smith challenges the notion that there is any Ur-version of a story (her example is *Cinderella*) in "Narrative Versions, Narrative Theories," *On Narrative*, ed. W. J. T. Mitchell (Chicago and London: University of Chicago Press, 1981), pp. 209–232.

31. [Charles Dickens], "Frauds on the Fairies," *Household Words* 8, no. 184 (1 Oct. 1853): 97–100.

32. Cuthbert Bede, "A Reminiscence of George Cruikshank and His 'Magazine'," *Notes and Queries*, 5th ser., 9 (13 Apr. 1878): 281–283, 281.

33. Quoted in Wynn Jones, p. 96, an undated, uncited letter from GCk to "his godson," presumably George Cruikshank Pulford. Bill for funeral services from the Executrix of the late D. Cooksey, JJ.

34. 23 Dec. 1854, V&A 9768.

35. Quoted in Wynn Jones, p. 102, from an undated, uncited letter by GCk to "his godson."

36. Tombstone inscription, Kenninghall churchyard.

37. *The History of Jack & the Beanstalk*, C 197, 1854; *Cinderella and the Glass Slipper*, C 198, 1854; ech with six steel-etchings (often of more than one subject) and a wood-engraved cover design.

38. Quoted in Bede, "A Reminiscence," p. 283; another version is recounted by Edmund Yates, also working for the *Magazine*, in *Edmund Yates: His Recollections and Experiences*, 2 vols. (London: Richard Bentley and Son, 1884), 1:263–264.

39. On 10 Aug. 1852 Augusta E. Thompson told GCk her father could not engrave his drawing in less than three weeks, V&A 10,048.C; Cuthbert Bede thought the wood-engravings were executed by Thomas Williams.

40. Edward Bradley to GCk, 11 Oct., 23 Nov., and n.d., "Thursday" [25 Nov. 1853], and GCk's draft reply rejecting the first version on the back of Bradley's 25 Nov. letter, H. Gregory Thomas Collection, The University Club Library, New York.

41. Bede, "A Reminiscence," pp. 281–282.

42. Colored sketch, V&A 9448.1; watercolor, V&A 9448.A. The original steel is in the Princeton Cruikshank Collection. It was furnished to the artist by John Sellers of Sheffield: Sellers to GCk, 15 Aug. 1853, K 151.

43. GCk to Bogue, 1 Dec. 1853, V&A 9502.A/P; GCk finished the first number just after midmonth: GCk to J. H. Anderson, 19 Dec. 1853, Berg.

44. An even-handed assessment of the quarrel between GCk and CD was provided in "An Artist of Four Generations" (a review of G. W. Reid's *Descriptive Catalogue of the Works of George Cruikshank*), *London Quarterly Review* 80 (July 1873): 285–310: "Mr. Cruikshank had been wrong altogether when he turned the tales into sermons; and Dickens fell into the same mistake when he forgot his own text for a moment, and professed to value them for gifts which are not theirs" (p. 303).

45. Drawing in the Arents Collection, The New York Public Library, reproduced in Cohen, p. 35, fig. 13.

46. PCk "Memoir," p. 129.

47. See Darton, *passim*.

48. John Taylor to GCk, 14 Feb. 1854, Princeton.

49. *Puss in Boots*, C 199, 1864, F. Arnold, with six etchings each containing two designs and a wood-engraved wrapper design.

50. Quoted in Wynn Jones, p. 100 from K, unnumbered.

51. First and Second Reports of the S.C.H.C. on the Sale of Beer Act, *Parliamentary Papers 1854–1855*, Vol. 4 (microfiche 10:341–542).

52. *The Patriot*, 20 July 1855, reported GCk's testimony.

53. "The Great Baby," *Household Words* 12, no. 280 (4 Aug. 1855): 1–4.

54. See A. E. Dingle, *The Campaign For Prohibition in Victorian England* (New Brunswick, NJ: Rutgers University Press, 1980), especially pp. 22–27.

55. Norris Pope asserts that GCk's testimony was "foolish," as indeed it was, and that CD's distrust of select committees was "perfectly justified" in this instance: *Dickens and Charity* (London and Basingstoke: Macmillan, 1978), pp. 77–78.

56. Yates, 1:294.

57. Samuel Knins to GCk, 18 June 1857, UNC-CH.

39. KNOCK DOWN BLOWS

1. GCk draft letter on verso of draft letter to Lord ?, n.d. [after 24 Feb. 1858], Kohler 44–45.

2. R. P. Bell to GCk, 18 Aug. 1852, Princeton; R. P. Bell to PCk, 4 Oct. 1852, Bradburn 52 blue; PCk "Memoir," pp. 217–218. See also GCk draft letter recommending PCk for employment, on verso of J. Bellows for C[harles] Whiting to GCk, bill for printing *The House That Jack Built*, dated 11 May 1855, UNC-CH.

3. GCk to Cassell, 28 Feb. 1853, John Wilson 1979 and 1982 cats.

4. GCk statement to P. Johnson, 30 May 1852, Princeton; J. Armstrong to ECk, 22 June 1852, Princeton; GCk to ECk, 17 Aug.? 1853, K 67; and Coutts account, Eliza Cruikshank and Isaac Armstrong, executors, 1851–1855.

5. GCk to Jerdan, 23 Mar. 1851, private collection. William Jerdan, *Autobiography*, 4 vols. (London: Arthur Hall, Virtue, and Co., 1852–1853): 4:368–375.

6. William Pulford to GCk, 23 Sept. 1853, Princeton.
7. GCk to George Cruikshank Pulford, 4 Apr. 1854, Huntington Library.
8. William Sylvester Pulford to GCk, 23 Mar. 1875, Princeton.
9. GCk to Thomas Longman, 2 June 1853, Wilson 61; GCk to John Barrow, 6 June 1853, Searle. It is not certain that Barrow is the John Henry Barrow (1796–1858) who was Dickens's maternal uncle and in 1853 leader writer for the *Hampshire Advertiser* (see K. J. Fielding, "John Henry Barrow and the Royal Literary Fund," *Dickensian* 48, part 2 [Mar. 1952]: 61–64). Buchanan-Brown's inference (p. 33) that GCk was recommending Miss Bartholomew for a pension from the Longman firm is wrong.
10. GCk first met Bickerdike in connection with a Temperance soiree: GCk to George Bickerdike, 29 Mar. 1851, Berg. Bickerdike to GCk, 28 Oct., 1, 3, 6, and 8 Nov. 1853, UNC-CH. See also Bickerdike to GCk, 24 Nov., n.d. [26? Nov.], 27 Nov., and 8 Dec. 1853, Princeton, all relating to the difficulty in getting GCk's bill cashed.
11. Bickerdike to GCk, 4, 11, 12, and 14 Jan. 1854, Princeton.
12. Bickerdike to GCk, 7 and 9 Apr. 1854; William Dickens to GCk, 9 Apr. 1854; J. Spokes to [Bickerdike? GCk?], 13 Apr. 1854; W. Dickens to Bickerdike, 15 Apr. 1854; all UNC-CH. GCk Coutts account, deposit of 13 Apr. 1854. Bickerdike to GCk, 16 Apr. 1854, Princeton. Bickerdike to GCk, 27 Apr., 25 June, and 2 July 1854, and Banks to GCk, 20 Oct. 1874, all UNC-CH.
13. C 2012, an uncolored, unpublished etching of a "Suburban Village," and Pearson to GCk, 23 July? 1855, Princeton; H. J. Phillips to GCk, 11 Oct. 1854, UNC-CH. GCk seems to have acted as a representative of the Temperance Permanent Land and Building Society into the 1870s; there is in a private collection an Assignment of Leasehold from GCk and others dated 20 May 1870 for 18 Gladstone Street, Battersea.
14. In 1854 Geary, serving as a steward for the National Temperance League's Quarterly Soiree, invited the Goughs and the Cruikshanks to attend: Geary to GCk, 4 May 1854, Princeton.
15. GCk's design, BM Prints and Drawings, GCk scraps and sketches Box 2.
16. PCk "Memoir," pp. 191–199.
17. Altick, *Shows*, pp. 486–489. PCk reports that after Geary died of cholera, negotiations with a Mr. Coppuck (a Parliamentary agent who actually owned the Gardens but who used Mr. Tyler as front man) came to a standstill; the Temperance party lost interest, and eventually the property was sold to developers. Geary writes to GCk on 24 Aug. 1854: "At the Board of yesterday unexpected occurrences took place which I fear will tend to mar the progress of the Temperance Palace and likely to bring into disrepute our noble cause. The annoyance has made me quite ill" (Princeton).
18. [John?] Davies to GCk, 28 July 1852, Princeton.
19. Benjamin R. Green (Secretary) to GCk, 1 Apr. 1853, K 184.
20. John Sheringham to GCk, 14 Feb. and 31 Aug. 1853, Princeton; Sheringham to GCk, 6 Oct. 1853, UNC-CH; GCk for Sheringham to unidentified person, 23 Apr. 1855, Bradburn 59 red and Searle (draft); Albert Prince to GCk, sending him the patent for the stove along with a bill for costs incurred when one of Sheringham's earlier drafts was refused, 23 June 1855, Bradburn 45 blue; GCk to Charles Kent and Charles Gilpin, offering to show the ventilator to Sidney Herbert at the War Office, 22 Feb. 1858, The Rendells cat. 158 (1982). See also Wynn Jones, p. 105.
21. Flight to GCk, 20 June 1854, Princeton.

22. GCk to Bogue, 4 Oct. 1854, Bell and Hyman; Merle to GCk, 18 Oct. 1854, Princeton.
23. PCk "Memoir," pp. 186–187.
24. Not in Cohn, but tinted sketch (V&A 10,004) and uncolored etching (V&A 10,005) are in the V&A George Cruikshank Collection.
25. PCk "Memoir," p. 223; C 1227, n.d. [Dec.? 1853].
26. Mrs. Annie Merle to GCk, 26? Feb. 1855, and Merle to GCk, 1? Mar. 1855, Princeton.
27. GCk to Phipps, 5 Sept. 1855. RA PP Vic 7201 (1855).
28. C 428, 9 Feb. 1856.
29. Banks to GCk, n.d. [1855] and 26 Mar. 1855, Princeton.
30. GCk to Austen Henry Layard, 14 Feb. 1857; Layard to GCk, 21? Feb. 1857; and GCk to Layard, 4 Mar. 1857; all BL Add. MSS 38,985. GCk had tried to enlist Prince Albert's support for other of Gibbs's schemes for prosecuting the war: see GCk to Phipps, 1 Jan. 1856, RA PP Vic 8538 (1856).
31. Jerrold 1:29n.
32. *Portrait of Robert Cruikshank*, c. 1852, oil, gouache, and watercolor on paper, 16 × 20 inches, with a sketch for *Tam O'Shanter* (1852) on verso, University Club, New York.
33. This character sketch is adapted from the tribute by George Daniel, *Love's Last Labour Not Lost*, pp. 173–176.
34. Registration of Deaths, Clerkenwell District, 19 Mar. 1856.
35. PCk "Memoir," p. 202.
36. GCk retained an interest in the training of graphic artists; in 1850 he allowed his name to be placed in nomination by the Reverend D. Laing for a place on the Committee of Management of the North London School of Drawing and Modelling, but "several circumstances induced [the committee] to decide not to increase the numbers of the Committee *at present*" (J. Neville Warren to GCk, 14 May 1850, Searle).
37. The account of GCk's painting which follows, though compiled from many sources and checked against the originals when possible, is still incomplete and, I suspect, inaccurate because of faulty, ambiguous, or missing records. A thorough study of the subject needs to be undertaken.
38. Jerrold 2:144. The *DNB* suggests that GCk's c. 1830 oil, *Pilot Boats going out of Dover Harbour*, may have been prompted by Stanfield. The same source also lists an 1820 oil sketch, *A Cavalier*. Neither picture has been traced.
39. PCk "Memoir," pp. 210–211 and Jerrold 2:145. GCk painted the picture in Dec. 1832–Jan. 1833, having no other work to do. It did not sell, and afterwards he thought indifferently of it (GCk to Merle, 18 Jan. and 27 Apr. 1833, Princeton).
40. *A Scene from Rob Roy No. 2*, dated "ca. 1850," 39 × 53 cm., glazed, in an elaborate gilt frame, Princeton. The other scene has not been traced. For *The Disturbed Congregation*, see my chapters 34, 35, and below. Princeton owns one version of this painting, oil on panel, 24.4 × 29.5 cm., in gilt frame; it might be the version GCk judged "a dead failure" (PCk "Memoir," p. 218).
41. PCk "Memoir," pp. 212–213; Jerrold 2:146.
42. PCk "Memoir," p. 211; Jerrold 2:145.
43. Quoted in Jerrold 2:139.
44. PCk "Memoir," pp. 215–216. The picture is untraced.
45. V&A 9398.A–D, 9495.B/B and B/J.
46. H.? Horner to GCk, [before 7 Feb.] and 7 Feb. 1852, Princeton; review, *Literary Gazette*, 14 Feb. 1852, p. 162. Horner proposed buying not only the picture but also

the copyright, although he was willing to cede to GCk responsibility for making an engraving of the work should there be a demand for one. The painting, oil on canvas, 55 × 67.5 cm., now belongs to the Victoria and Albert Museum: V&A 721880; see also study in oils V&A 9569.

47. GCk to J. H. Anderson, 27 Mar. 1852, London Borough of Camden Local Studies and Archives Centre.

48. Signed sketch, "Battle of Agincourt," on verso of GCk to Lovell Reeve, 20 May 1852, Princeton. See also pencil drawing, 29 × 41 cm., V&A 9447.A. Painting untraced; Feaver cat. 350 says "presumably destroyed," although another piece, *Christ entering Jerusalem*, discussed below, also said to have been destroyed, is at Princeton.

49. PCk "Memoir," p. 212.

50. GCk draft letter to unidentified person, n.d., on verso of GCk draft letter to Charles Landseer asking for a card of admission to the Royal Academy for 28 July, 24 July 1852, Searle.

51. Sheringham to GCk, 4 Jan. 1853, Princeton.

52. Jerrold 2:146, from PCk "Memoir," p. 214.

53. It is now at Princeton: oil on canvas, 51 × 91 cm., glazed, in a gilt frame. In 1858 GCk failed to secure a commission to finish either biblical picture: GCk to unidentified person, 10 Mar. 1858, Pennsylvania State, University Park.

54. PCk "Memoir," p. 214.

55. GCk draft letter to unidentified person, 9 Apr. 1853, Princeton.

56. Pencil and watercolor sketch in oval, V&A 9495.B/E. Oil on board version, oval approx. 34 × 29 cm. in ornate gilt frame, initialed "GC" within image, Princeton; a label on the verso dates this picture "1845" in what seems like a nineteenth-century hand.

57. Charles Landseer to Blanchard Jerrold, 18 Feb. 1878, Jerrold 2:140.

58. Sala, *Daily Telegraph*, 2 Feb. 1878.

59. GCk draft letter to President and Council of Royal Academy, n.d. [1853], Princeton; see also draft version offered for sale by Jarndyce (Brian Lake and Christopher Johnson) in cat. XIII, summer 1977, item 244.

60. By accident, GCk was identified as "R.A." in *Photographic Groups of Eminent Personages*, c. 1866, where he appears next to his good friend Frith, who was elected R.A. in 1852: Fever, *PULC*, p. 250 n. 2.

61. Robert Dawbarn to GCk, 22 Dec. 1852 and 15 Feb. 1853, Princeton.

62. George [Dawbarn] to GCk, 19 July? 1853, Princeton.

63. Dalziel, p. 46.

64. Unidentified catalogue extract on verso of Princeton copy of *The Disturbed Congregation*. For GCk's correspondence with Phipps about the picture and the print, see 5 Sept. 1855 (RA PP Vic 7201 [1855]) and 19 Feb. 1856 forwarding a proof (RA PP Vic 9177 [1856]).

65. GCk draft letter to [McLean?], 23 Oct. 1855, Princeton.

66. GCk draft letter to unidentified person on verso of GCk draft letter to Merle, [after? 24 Jan. 1856], Princeton.

67. GCk to G. W. Reid, 4 Dec. 1869, Berg.

68. GCk to G. C. Pulford, 4 Apr. 1854, Huntington Library. A fine watercolor drawing of a different version of the fairy godmother and Cinderella in the kitchen, 19.4 × 15.3 cm., framed and glazed, offered for sale by Sotheby's, 2 Dec. 1988, lot 439, is said to be the one exhibited at the Royal Academy in 1859.

69. *Illustrated London News*, 29 July 1854; GCk to President and Council of the Royal Academy, 9 May 1854, John Rylands University Library of Manchester. One version, oil and panel, 43 × 53.5 cm., is V&A 1405 1869.
70. GCk to Alexander M. Crichton, 8 Sept. 1854, John Rylands University Library of Manchester.
71. Henry Miller to GCk, 29 July [1854], Princeton.
72. Miller to GCk, 9 Aug. 1854, Princeton.
73. Jerrold 2:142.
74. PCk "Memoir," p. 221.
75. GCk to the Reverend Thomas Hugo, 11 Apr. 1855, Princeton.
76. GCk draft letter to unidentified person on verso of letter to GCk, n.d. [after 7 May 1855], Harry Ransom Humanities Research Center, The University of Texas at Austin.
77. Miller to GCk, 11 Oct. [1855], and Miller to GCk saying he will pick up the picture at No. 9 Broad Street and is glad to hear that GCk has two commissioned pictures in hand, 28 Nov. 1855, Princeton.
78. Jerrold 2:142; Coutts, 8 Mar. 1855. There is a pencil and watercolor study in the BM, U 563.
79. Watercolor sketch, 22 1/2 × 18 3/4 inches, torn, restored, and mounted, V&A 9450.
80. *Illustrated London News*, 17 Feb. 1855.
81. Wynn Jones, p. 105, cites receipt; Coutts account deposit reads "Josh. Robinson."
82. Possibly the *Midsummer Night's Dream*, oil on board, 34 × 29 cm., in ornate gilt frame, Princeton. See also pencil and watercolor sketch in oval, V&A 9495.B/E.
83. PCk "Memoir," p. 222. In Aug. and Sept. 1856 GCk traveled to Scotland (GCk to Merle, 27 Sept. 1856, Princeton), where he made pencil and watercolor sketches of the countryside: GCk, *Album of Landscapes*, Sotheby's 30 Jan. 1991 sale, item 26 (information courtesy of Marcia Allentuck).
84. Oil on canvas, 36 × 48 inches, now at Yale Center for British Art; reproduced in Altick, *Paintings from Books*, plate 73, p. 113.
85. Altick, *Paintings from Books*, p. 278.
86. Jerrold 2:146. Starting on it in Feb. 1856, GCk finished one version by Apr. and was retouching it a year later: GCk to Tilt, 12 Jan. 1857, Searle 19.
87. Geoffrey Ashton, *Shakespeare and British Art* (New Haven: Yale Center for British Art, 1981), p. 14, says the price was two hundred guineas.
88. GCk to unidentified person [Holdsworth?], n.d., Wynn Jones, p. 105.
89. £270 deposited in Coutts account, 29 Apr. 1857.
90. *On Guard*, untraced, was exhibited at the Royal Academy in 1858. Untitled oil on canvas, 52.3 × 66.3 cm., in flat gilt frame, dated 1859 on frame, Princeton.
91. Collection Ronald Searle; see Feaver cat. 146.
92. Oil, 14 × 17 inches, formerly collection John B. Gough and recorded in his *Works*. Either this, or another version, was exhibited at the British Institution in 1854.
93. Alternate titles: *Grimaldi Shaved*, PCk "Memoir," p. 215; *Grimaldi the Clown Shaved by a Girl*, Jerrold 2:141—dated 1838 by Austin Dobson in *DNB*.
94. *Venus*, oil on canvas, 30.5 × 25 cm., V&A, according to Feaver cat. 383; cf. *Venus rising from the foam of the sea*, study in oils, 9 3/4 × 12 inches, V&A 9570. *Birth*, oil on canvas, 46 × 61 cm., gilt frame, glazed, Princeton.
95. Drawing, 38 × 46.5 cm., V&A 9780.A. Three other known paintings, untraced: *Sir Walter Raleigh Smoking his first Pipe* and *Queen Mab* (both exhibited at the British Institution in 1860), and a black and white "ghost" picture, Sitwell, *Narrative Pictures*, p. 68 and plate 98, said to be in an American collection.

40. WRITE ME DOWN AN ASS

1. Sala, p. 562.
2. GCk draft letter [to Brown and Miller?, publishers in Glasgow], n.d., on verso of Brown and Miller to GCk, 28 June 1858, K 43.
3. Sala, p. 562.
4. Quoted in Richard Ellmann, *Oscar Wilde* (New York: Alfred A. Knopf, 1988), pp. 85–86, undated letter from autumn of 1876. Paula Gillett studies Victorian artists' incomes and expenditures in *Worlds of Art: Painters in Victorian Society* (New Brunswick, New Jersey: Rutgers University Press, 1990); in comparison to the fortunes earned by Frith and his successors in the third quarter of the nineteenth century, GCk's receipts were indeed paltry.
5. GCk draft letter [slightly reconstructed] to unidentified person, n.d. [after 1863], Princeton.
6. C 204, Tweedie.
7. Copy inscribed to Pocock, dated 30 Aug. 1871, Princeton.
8. Tweedie to GCk, 20 Aug. 1856, UNC-CH.
9. 20 June 1857, Coutts.
10. Burns to GCk, 13 Mar. 1856, UNC-CH.
11. Michael Young to GCk, 28 Mar. 1856, Princeton; William Law to GCk, 12 Apr. 1856, Princeton.
12. GCk draft letter to Merle, 24 Jan. 1856, Princeton; Merle to GCk, 28? Jan. 1856, Princeton; Merle to GCk, n.d. [after 28? Jan. 1856], Princeton; 29 Jan. 1856 Coutts deposit from London and Westminster Bank of £60; 1 Oct. 1856, three-months' note for £33, J. C. Bowles to GCk, Wilson 3; 4 Oct. 1856 Coutts deposit of £31.7.0; GCk to Merle, 13 Oct., 22 Oct., 23 Oct. 1856, Princeton; 24 Oct. 1856, four-months' note for £49.15.0, J. C. Bowles to GCk, Wilson 4; 25 Oct. 1856 Coutts deposit of £45. The borrowings from Merle continue in succeeding years.
13. GCk to Tilt, 12 Jan. 1857, Searle; see also GCk to Tilt requesting a meeting with Bogue's executors, 27 June 1857, Bell and Hyman.
14. C 206, 1856, Tweedie.
15. Quoted in George Cruikshank, *J. W. Howell's Bubble, of the General Industry Life and Fire Assurance and Sick-Fund Friendly Society, Burst* (London: Published for the author, 1856), p. 2; C 205; hereafter *Bubble*. Howell may be the same person to whom Mary Cruikshank wrote a cordial invitation in 1852; that Mr. Howell and his sister Miss Howell evidently lived in Finchley, and could therefore have been known to Mary through her uncle Archibald MacNaughton (Mary Cruikshank to Mr. Howell, n.d. [1852], UNC-CH).
16. *Bubble*, pp. 2–3.
17. Ibid., pp. 3–4.
18. Ibid., p. 4.
19. Howell to GCk, 16 Sept. 1856, quoted in ibid., p. 4.
20. Ibid., pp. 4–5.
21. GCk to Howell, 18 Sept. 1856, quoted in ibid., p. 5.
22. Ibid., pp. 5–6.
23. Ibid., pp. 6–7.
24. Ibid., p. 8.
25. J. W. Howell to unidentified person postponing a meeting because the chairman, George Cruikshank, cannot attend, Aug. 1856, Princeton.
26. *Bubble*, p. 7.
27. GCk to William Loaden, 22 Sept. 1856, Princeton.
28. King and George to George Cruikshank via Mr. Howell, 27 Sept. 1856, UNC-CH.

29. Marwood Kelly Braund to GCk, 30 Sept. 1856, UNC-CH.
30. J. Nickoll to GCk, 30 Sept. 1856, UNC-CH.
31. GCk draft letter to Jonathan Smith, editor of the *Daily Telegraph*, 4 Oct. 1856, Princeton; Mrs. Beeton to GCk, 23 Oct. 1856, Princeton.
32. Benjamin Scott to GCk, 7 Oct. 1856, UNC-CH; Sir John V. Shelley, Bart., to GCk, 15 Oct. 1856, Princeton.
33. William Travers to GCk, 16 Jan. 1857, and 19 Jan. reply by GCk in Eliza's hand, UNC-CH.
34. T. G.? Laurence to GCk, 9 Nov. 1856; Thomas Irving White to GCk, 5 Jan. 1857; and Joseph Adshead to GCk, 24 Dec. 1857; all UNC-CH. Edwin Leighton to GCk, 11 Nov. 1856, Princeton.
35. GCk to Flight, 25 Apr. 1857, London Borough of Camden Local Studies and Archives Centre.
36. Proprietors of the *Insurance Gazette* to GCk, 18 Aug. 1859, Princeton.
37. George Cruikshank, *A Slice of Bread and Butter* (London: William Tweedie, n.d. [1857]), p. 9; C 207.
38. Ibid., p. 11.
39. Ibid., p. 15.
40. Ibid., p. 15.
41. Henry M. Barrett to GCk, 20 Dec. 1855, Princeton.
42. Robert Brough, *The Life of Sir John Falstaff* (London: Longman, Brown, Green, Longman, and Roberts, 1858); C 96; 10 monthly parts, Apr. 1857–Jan. 1858, with two full-page etchings per part. Pencil, pen, sepia, and watercolor sketches, Binyon cat. 1377–1425, Huntington Library, and two drawings formerly in the Borowitz Collection, lot 93 of Sotheby's (New York) 2 Dec. 1987 sale.
43. See Brough's "Preface" to *Falstaff*, p. xii.
44. V&A 10,047.G is a printed letter of Oct. 1856 from the Good Samaritan Temperance Society, on which GCk has scribbled notes about Falstaff.
45. GCk to Tilt, 10 Dec. 1856, Searle.
46. Binyon cat. 1387.
47. GCk to the Reverend Samuel Prince, 11 Feb. 1857, Princeton (Rankin Autograph Collection).
48. Harvey, *PULC*, p. 147.
49. John Ruskin to Charles Augustus Howell, 2 Apr. [1866], Ruskin, *Works*, 36: 504–505.
50. Kent to GCk, 13 Apr. [1857], Princeton, in which Kent says he is looking out for the next issue of *Sir John*, the first having been published at the beginning of April, and Kent to GCk, 18 Jan. 1858, Pennsylvania State, University Park, forwarding a copy of the *Sun* with his "brief commendation to your admirable Falstaff."
51. GCk to [Longman or Spottiswoode the printer], 14 Apr. 1857, Searle; an incomplete draft transmitting Brough's additions for Part 2, though GCk fears it is too late.
52. GCk to Tilt, 6 Jan. 1858, with annotations concerning 18 Jan. interview in Tilt's? hand, Bell and Hyman.
53. "Preface," pp. xi–xiii.
54. Probably pirated, seven of the plates, very badly printed, appeared in a nine-part or three-volume illustrated large quarto edition of Shakespeare published by William Mackenzie in 1873, C 738. GCk also painted watercolors from his designs, though probably years after the steels were etched. Two subjects are in the Princeton collection (E.D.H. Johnson, *PULC*, p. 20).

55. Andrew Halliday to GCk, July 1860, UNC-CH; see also Fanny Brough to GCk, 16 July 1860, UNC-CH, thanking GCk for his expression of sympathy on the death of her son.
56. C 739, July 1855–June 1856; C 148, 1858.
57. C 557, 1858.
58. Brown and Miller to GCk, 28 June 1858, K 43.
59. Brown and Miller to GCk, 22 July 1858, Princeton.
60. Alexander Brown to GCk, 24 Sept. 1858, and Thomas Murray and Son to GCk, 10 Nov. 1858, both Princeton.
61. C 496, 1857.
62. C 774, 1858; the three wood-engravings were executed by Thomas Williams. A presentation copy to the lawyer W. Shaen (of Shaen and Roscoe) is inscribed "With the Author's Compliments" in Eliza's hand (offered for sale by L. & T. Respess Books, Durham, North Carolina, February 1988). Henry Southgate, a fine art and book auctioneer who also compiled illustrated anthologies, ferreted out GCk's authorship of *Stenelaus* and in 1862 explored the possibility of commissioning from GCk two plates for an anthology "in the same exquisite manner"; but in the end Southgate's books were illustrated by the rising artists Birket Foster and John Gilbert (Henry Southgate to GCk, 10 Sept. 1862, with GCk's draft reply postponing appointment, Pennsylvania State, University Park).
63. Kent to GCk, 18 Jan. 1858, Pennsylvania State, University Park.
64. GCk to C. R. Leslie, 8 Dec. 1856, Wilson 58; GCk to C. R. Leslie, 19 Jan. 1857, Wilson 57; C. R. Leslie to GCk, 28 Feb. 1857, Princeton. See also the letter book of Evert A. Duyckinck in The New York Public Library.
65. John B. Podeschi, *Dickens and Dickensiana* (New Haven: Yale University Library, 1980), H 1743.
66. There are a substantial number of undated and dated letters of regret in Princeton, as well as J. Humffrey Parry's 14? Mar. 1857 "thank you."
67. GCk to Edward Walford, 2 Feb. 1857, Christie's 22 Oct. 1980 sale, lot 199 (withdrawn).
68. See letters declining to attend party for Gough, Princeton, and GCk to James B. Tomalin, 28 July 1857, Searle.
69. John Cassell to his daughter, n.d. [a few months after Nov. 1857], quoted in Nowell-Smith, *House of Cassell*, p. 55.
70. Ruskin, *Works* 6:471 and n.
71. See accounts in *Praeterita*, Ruskin, *Works* 35:74, and "Notes by Mr. Ruskin. Part II. On his own handiwork illustrative of Turner," *Works* 13:503.
72. Ruskin, *Works* 15:79, 204.
73. GCk, on the other hand, thought Ruskin's eyes "too close together" (autograph note on V&A 9955.G), "in the wrong place—not set properly in his head" (autograph note on V&A 10,031.H).
74. Ruskin, *Works* 15:222–223.
75. Thomas Dixon to GCk, 24 July 1857, Princeton.
76. Eliza could not attend, having gone to Kenninghall to nurse her uncle George Linstead (ECk to GCk, n.d., "Friday afternoon" [3 Apr. 1857], Princeton).
77. Ruskin, *Works* 16:437–438; see also *Building News*, 10 Apr. 1857, pp. 353–355.
78. William Monk to GCk, 8 Oct. 1858, UNC-CH.
79. See also Monk to GCk confirming times of the two meetings, 15 Oct. 1858, UNC-CH.
80. F. M. Redgrave, *Richard Redgrave, C.B., R.A.* (London: Cassell, 1891), p. 205. See also account in the *Literary Gazette*, 11 Dec. 1858, p. 759. GCk's abbreviated remarks recommending—in opposition to Academy training—"the human face as

a fit study" for beginners, and the mastery of painting before etching, are printed in an account of the 1 Nov. 1858 proceedings, Cambridge University Library Cam. d. 858.8.

81. GCk autograph notes for biographical sketch on verso of letter from Tweedie to GCk, 21 Nov. 1856, Princeton.

41. THE VOLUNTEERS

1. GCk autograph draft about the Volunteers, 27 Sept. 1861, V&A 10,047.S.
2. Harrison, *Drink*, p. 307.
3. Longmate, p. 62.
4. Harrison, *Drink*, pp. 307, 192.
5. On 23 June [1860s?] Smith reminds GCk of their forthcoming meeting at the French Hospital (Princeton). *Lib.* 76 is an autographed copy of Smith's 1864 *Practical Dietary for Schools*. In 1873 Smith published two useful books, *Manual for Medical Officers of Health* and *Handbook for Inspectors of Nuisances*. For more on MOH, see Anthony S. Wohl, "Preventive Machinery," chapter 5 of *The Eternal Slum: Housing and Social Policy in Victorian London* (Montreal: McGill-Queen's University Press, 1977).
6. Sir Arthur Salusbury MacNalty, *A Biography of Sir Benjamin Ward Richardson* (London: Harvey and Blythe, 1950). See also, for Richardson's connection to John Snow and the London Epidemiological Society, Abraham M. Lilienfeld and David E. Lilienfeld, *Foundations of Epidemiology* (New York and Oxford: Oxford University Press, 1980), pp. 36–37.
7. Yates, 2:93; Straus, *Sala, passim.*
8. GCk to George Setten, 8 Nov. 1869, Berg.
9. GCk to Catherine Dickens, n.d. [1861], Bradburn 65 red.
10. C. H. Waring to GCk asking if Bradbury and Evans would publish his stories in *Household Words*, 6 Apr. 1859, Princeton.
11. Georgiana Thompson to GCk, 29 Oct. 1860, UNC-CH.
12. E[dwin] Truman to GCk, 26 May 1861, UNC-CH.
13. John Taylor to GCk, 2 Apr. 1859, Pennsylvania State, University Park.
14. [L. D.?] Shearer to GCk, "Artist, London," 5 June 1861, Princeton.
15. Ray, *Illustrator and Book*, p. 139.
16. Receipt, 26 July 1859, Rosenbach Library; C 1909. Though Cohn does not mention it, the plate was sold uncolored and colored; GCk purchased a copy of the latter version for 1s. from his publisher, 22 Aug. 1859, Bradburn 63 red.
17. Jerrold 2:221–222; C 833, 1858–1859.
18. C 1141; FSB annot. in Cohn dates 1850, but it may be later.
19. Reverend Charles Caldwell to GCk, 10 Apr. 1861, Princeton.
20. John S. May to GCk, 15 Sept. 1862, UNC-CH.
21. C 1991, n.d. [Dec. 1862 or Jan. 1863]; no imprint, but Tweedie offered to act as London agent. Sketches, V&A 9548.A–B, and proofs, V&A 9548.1–2. For other instances where GCk portrays outcasts sympathetically, anticipating the social realism of Luke Fildes's *Applicants for Admission to a Casual Ward* (1874), see *Homeless, Destitute, and Starving* (C 1207, n.d.), and its companion piece not listed in Cohn, *Poverty!—Sickness!—Death!* (V&A 9550.A/1 and /2), electro photos (i.e. glass etchings using the Hancock process) depicting the applicants to a South London Night Refuge.
22. Reverend T. Faulkner Lee to GCk, 24 Nov. 1862, Princeton; GCk to Lee, 15 Dec. 1862, Searle.
23. After his death, Hotten's widow sold out to Chatto and Windus.
24. C 516, 1859.

25. C 517, 1859; C 518, 1861. "Hotten purchased the old steel plates of 'The Comic Almanack' and these—with the other two books, he is 'puffing' off I suppose," GCk told John Fremlyn Streatfeild. "As I have a great objection to my name being made a ridiculous use of you will oblige me by letting me know how, and in what manner, he is advertising the name of yours truly" (n.d. [1860?], Special Collections Library, The University of Michigan).

26. Hunnisett, pp. 197–198.

27. B. M. Pickering to GCk, 3 Jan. 1861, Bradburn 33 blue.

28. GCk to George Bell, 6 June 1862, Bell and Hyman; see also GCk to Bell, 2 June 1862, Bell and Hyman, and Bell to GCk, 3 June 1862, Pennsylvania State, University Park. The letter cited by Buchanan-Brown as 6 June 1852 (p. 243 n. 16), is actually a second to Bell dated 6 June 1862 (Bell and Hyman), so GCk had not already known Bell for a decade as Buchanan-Brown infers.

29. GCk to George Bell, 20 Apr. 1861, Bell and Hyman. GCk may still have been clearing his debt to Bogue's estate.

30. GCk to William Loaden, 24 Sept. 1862, Pennsylvania State, University Park.

31. C 199, 1864.

32. C 75; see Vogler, *Graphic Works*, pl. 249 and p. 164.

33. *Fairy Songs* was published without date by D'Almaine and dedicated by the composer, Olivia Dussek, to the Princess Royal, b. 21 Nov. 1840. Vogler places it before 1847 under the impression that Dussek died in that year, but according to Grove's *Dictionary* it was her mother Sophia who died then; Olivia Dussek's dates are "uncertain." FSB annotation at C 256 says publication took place in 1860. Dudley Costello's *Hobgoblins*, C 166, though dated 1861, may have come out in time for the previous winter's holiday trade. Costello wrote GCk on 8 Nov. 1860 promising to call at Mornington Place to see the picture (Pennsylvania State, University Park); as in other instances, so here Hotten also added from earlier GCk publications: three etchings, some woodcuts, and an embossed cover design. *Puck*, 1862, C 633, contained designs by Leech, Phiz, Portch, and Tenniel as well. *Popular Romances*, C 422, was published in two volumes in 1865; for further details see chapter 43.

34. C 329, 1860; GCk to Swain, 6 Feb. 1860, Wilson 77.

35. S. W. Fullom to GCk, 14 Feb. 1860, Pennsylvania State, University Park.

36. Fullom to GCk, 24 Feb. and 6 Mar. 1860, Princeton. The progress of the plate is tracked in an extensive series of letters from Fullom to GCk: 16 Feb., 21 Feb., 27 Feb., 3 Mar., and 6 Mar. with GCk draft reply on verso, Princeton.

37. Fullom to GCk, 20 Mar. 1860, Harry Ransom Humanities Research Center, The University of Texas at Austin.

38. GCk to Hotten, 8 May 1860, The Pierpont Morgan Library, New York. MA 4500C Gordon Ray Collection. Fourteen months previously he had declined an invitation to attend the first anniversary of the Holloway Free School because the chairman was a brewer: "I feel that the Brewer—and the Teetotaler are such opposite characters that it would perhaps be better that I shd. not be present upon this occasion" (GCk to E. Gould replying to Gould's 4 Mar. 1859 invitation, n.d., UNC-CH).

39. C 452; Hotten to GCk, 10 May 1860, Bradburn 29 blue; Hotten to GCk, 18 June 1860, Princeton.

40. [E.?] Phillips to GCk, 6 Jan. 1860, Princeton.

41. Thomas Clegg to GCk, 3 Oct. 1859, Princeton; GCk to Clegg, 17 Oct. [1859], Searle; Gibbs to GCk, 2 June 1860, UNC-CH.

42. Barrett to GCk, 13 Aug. 1859, V&A 10,034.E.

43. George Curtis to GCk, 25 Mar. 1861, Princeton.

44. GCk to unidentified person, 17 Sept. 1859, Princeton.

45. Daniell to GCk, Sept. 1870, ACC 534/14a. Surviving records of GCk's Volunteer service are extensive and will for the most part be summarized rather than quoted. There is correspondence concerning the corps, much of it undated, in most major collections including Princeton's. The largest assemblage, over one thousand folios apparently coming from Cruikshank's files, is in the Letters and Papers of George Cruikshank, Greater London Record Office, Middlesex County, ACC 534 files 1–14. A portion of these records, comprising 246 items, was sold through Howes Bookshop to UNC-CH in 1963.

46. For authorship of the smoking article, see W. S. Austin to GCk, n.d. [Nov.? 1853], Princeton. For Sala's description, see his *Life and Adventures*, 1:431.

47. Austin to GCk, 24, 27, and [29] Oct. 1862, UNC-CH. Three years thereafter when Mrs. Austin was charged with stealing, GCk aided her: Rudolph G. Glover to GCk, 6 Jan. 1865, Princeton.

48. GCk to Joe [Sleap?], 9 Apr. 1859, private collection. Sleap died on 16 Oct. 1859, GCk believed of paternally transmitted insanity that predisposed "one of the best landscape painters of the day—and one of the most extraordinary self-taught Scholars—and mathematicians that ever existed—!!!" to opium addiction (GCk to Merle, 26 Oct. 1859, Princeton). See also chapter 13.

49. Merle to GCk, 21 Apr. 1861, Princeton.

50. Hugh Cunningham, *The Volunteer Force: A Social and Political History 1859–1908* (London: Croom Helm, 1975).

51. George Augustus Sala, *The Grand Volunteer Review. 1860*, 2d ed. with account of the Wimbledon Target Shooting (London: William Tinsley [1860]), p. 15. An equally enthusiastic account was penned by the diarist A. J. Munby: see Derek Hudson, *Munby: Man of Two Worlds* (London: John Murray, 1972), pp. 62–63.

52. *The Times*, 9 Nov. 1859.

53. George Cruikshank, *A Pop-Gun fired off by George Cruikshank, in defence of the British Volunteers of 1803, against the uncivil attack upon that body by General W. Napier; to which are added some observations upon our National Defences, Self-Defence, etc. etc. etc.* (London: Published for the Author by W. Kent [1860]), C 186. Portions of the autograph MS were sold at Sotheby's 24 Apr. 1985, lot 21; one further leaf is in Berg.

54. Ibid., p. 12.

55. Ibid., p. 10.

56. Ibid., p. 19.

57. Ibid., pp. 38–39.

58. PCk "Memoir," pp. 249–261.

59. Merle to GCk, 19? Jan. 1860; Charles Aldis to GCk, 26 Mar. 1860; Isabella Banks to GCk, 5 Mar. 1860; all Princeton.

60. Thomas Brooks to GCk, 24 and 27 Jan. 1860, Princeton.

61. W. Kent to GCk, 24 Jan. 1860, Princeton.

62. GCk to Thomas Brooks, 25 Jan. 1860, Princeton.

63. GCk to Merle, 31 Jan. 1860, offered for sale by Sotheby's c. 1981.

64. ACC 534/2/13a.

65. Malthouse to GCk, 18 Dec. 1860, ACC 534/1/4.

66. Cunningham, p. 42.

67. ACC 534/4/76.

68. GCk to Henry Marshall, 28 Sept. 1861, V&A 10,047.R.

69. ACC 534/1/43a, /43b.

70. All three mottoes are given in GCk's response to Eliza's questions about "Preferences," ACC 534/14a/6b. The first motto is from Horace, *Odes* 1.7.27, and in context might be translated as "nothing to be despaired of [in going into exile]." He

picked the second, "strength is the armor of the brave," for letterhead embossed with a boar's head that he adopted in the 1860s.

42. DIAGRAMS OF DRUNKENNESS

1. GCk, "Preferences," ACC 534/14a/6b.
2. John Stewart, *The Worship of Bacchus*, with a "Descriptive Lecture" by GCk [reproduced from 28 Aug. 1862 *Weekly Record*], 6th ed. (London: William Tweedie, 1865), p. 9; hereafter *WoB*.
3. Altick, *Shows*, p. 412.
4. Merle to GCk, 13 Mar. 1860, Princeton. G. A. Sala, "William Hogarth," *Cornhill Magazine* 1 (Feb. 1860): 185–186.
5. Timetable from GCk's c. 1867 draft notes, K 6.
6. Jerrold 2:149.
7. Copy of proposals from GCk to the committee, 1859, UCLA.
8. GCk's c. 1867 draft notes, K 6.
9. Merle to GCk, 25 Apr. 1860; Taylor to GCk, 7 Apr. 1860; and Fuller to GCk, 15 Sept. 1860, Princeton. See also GCk's acknowledgment of Merle's agreement to serve, 12 May 1860, Norman Fox collection, and a second similar letter of the same date, Princeton.
10. GCk to the 7th earl of Shaftesbury, 31 Mar. 1860, Princeton.
11. Samuel Couling to GCk, 2 May 1860, V&A 10,048.E.
12. Merle to GCk, 28 July and 3 Aug. 1860, Princeton.
13. V&A 71–1880, presented to the museum by ECk.
14. GCk to Mr. and Mrs. Dallas, n.d. [before 25 July 1860], Princeton. Since Dallas and his wife separated shortly after their 1855 marriage, it seems probable that their names appeared on a mailing list and that they were not personal friends of the artist.
15. GCk to T. R. Lamont, 1 Sept. 1860, V&A Library 86 GG Box I.
16. Agreement between Mottram and GCk and Gurney and Owen, 27 Sept. 1860, UCLA.
17. £48 proceeds of a £50 note deposited in Coutts 19 Oct.; see Merle to GCk, 18 and 24 Oct. 1860, Princeton.
18. GCk to Merle, 15 Oct. 1860, Princeton.
19. Jerrold 2:150–151.
20. Merle to GCk, n.d. [before 7 Dec. 1861], Princeton, and GCk's replies, 7 Dec. and 26 Dec., Princeton.
21. GCk to Merle, 26 Feb. 1861, Princeton.
22. *Sunday Times*, extract quoted in *WoB*, p. 24.
23. Merle to GCk, 7 Jan. 1862, Princeton.
24. *WoB*, p. 10.
25. Ibid., p. 6.
26. Charles Kean to GCk, 2 Aug. 1862, Princeton.
27. D. L. Richardson to GCk, 9 Aug. 1862, Princeton; "As there was no written or printed explanation," the reporter postponed a description "to a better opportunity," quoted in *WoB*, p. 23.
28. Jane Ellen [Frith] Panton, *Leaves from a Life* (London: Eveleigh Nash, 1908), pp. 101–102.
29. Ibid., p. 102.
30. Sir Walter Trevelyan to GCk, 27 Sept. 1862, Lilly Library, Indiana University.
31. Quoted in *WoB*.
32. Samuel Fothergill [Trothergill?] to GCk, 14 Aug. 1862, UNC-CH.

33. This event was reviewed by a Trinity man in *Chambers's Journal* 38, no. 462 (8 Nov. 1862): 298–300; he liked every part of the picture except the fulminations against university drunkenness and Trinity ale. But then he forgave the artist because he had been associated with "the most mirth-moving books of the present century." In other words, he accepted *Bacchus* by rejecting its serious intent and celebrating the artist only as a humorist.
34. Taylor to GCk, 15 Aug. 1862, Princeton.
35. Jerrold 2:160–161. Jerrold says this visit was made after Thackeray's 15 May 1863 article but then says that as a result of the initial failure the other works were added, a modification which took place in Nov. 1862.
36. Ibid., 2:164.
37. About a month after the exhibit opened, GCk asked Sir Charles Phipps to return "the sketches relative to a memorial" for the late Prince Albert that had been submitted in May 1862, so that unless Phipps objected they might be incorporated into the show (post 10 May 1862, GCk draft letter to Phipps on verso of GCk draft letter to unidentified person dated 10 May 1862, Searle; GCk draft letter to Phipps on verso of printed letter from Band of Hope Union to GCk dated 6 Dec. 1862, University of Maryland Baltimore County).
38. Thackeray to GCk, 17 Nov. 1862, WMTLet 4:277.
39. Quoted in Exeter Hall exhibition catalogue, p. 23.
40. William Michael Rossetti, "Humouristic Designers. Cruikshank," *Fine Art, Chiefly Contemporary: Notices Re-Printed, With Revisions* (London and Cambridge: Macmillan, 1867), pp. 277–282.
41. Quoted in Jerrold 2:163.
42. MS drafts for first and second editions, K 261. At Merle's suggestion GCk consulted the Brothertons at 14 Woburn Place about spirit rapping (GCk to Merle, 13 Jan., 26 Feb., and 4 Apr. 1861, Princeton).
43. C 208, 1862; 2d ed. with additional cut, "Old Nick under a Table," C 210, 1864.
44. Merle to GCk, 18 Feb. 1861, Princeton, and reproduction of painting in Sitwell, *Narrative Pictures,* plate 98.
45. Draft of announcement about 7 Apr. 1863 lecture, FSB collection.
46. Phipps to GCk, 23 Apr. 1863, Princeton; *Art Journal,* n.s. 2 (1 June 1863): 128.
47. "Cruikshank's Gallery," *The Times,* 15 May 1863.
48. GCk draft letter to Thackeray, 19 May 1863, Berg.
49. F. T. Palgrave, "The Cruikshank Exhibition," pp. 187–194.
50. Palgrave to GCk, 23 July 1863, Princeton; GCk to Palgrave, 25 July 1863, BL Add. MSS 45,741 folio 46.
51. Paget, "George Cruikshank," pp. 217–224.
52. Under the heading of "Modesty," this appeared in *Art Journal* 4 (Mar. 1865): 73–74, and was reprinted in part in *Queen of the Air* (1869); it is from a canceled passage of manuscript that the characterizations of GCk's and Bewick's art are taken; Ruskin, *Works* 19:76–77 and nn.
53. Ruskin, *Works* 17:370 (Letter XII, 20 Mar. 1867), 17:376 (Letter XIII, 21 Mar. 1867).
54. Jerrold 2:165, whose narrative is rather confused at this point, says GCk's "pecuniary reward was exactly £2,053 7s. 6d., as Mr. Tweedie's ledger shows." There are in the Coutts accounts, 1861–1864, a number of deposits identified as from Tweedie, eight amounting to £100 or more each, and many unidentified deposits; in all, GCk deposited a total of £1,417 by Midsummer's Day 1861; £1,050 in 1862; £1,494 in 1863; and £3,606 in 1864. Since GCk was effectively bursar for the corps, however, many of the deposits relate to Volunteer business, and are offset by checks paying 48th Middlesex bills.
55. John Taylor to GCk, 19 Aug. 1863, Princeton.

56. Quoted in Jerrold 2:163–164.
57. Printed subscription flyer, n.d., and 1863 solicitation letter, JJ.
58. Longmate, p. 198.
59. Jerrold 2:164.
60. Reconstruction of c. 1867 drafts, K 6.
61. PCk to Merle, n.d. [1864?], Princeton. This undated draft, extremely difficult to read in places, speaks so vaguely about what was being exhibited that it may not refer to the *Bacchus* tour, about which little information seems to have survived in GCk's papers.
62. GCk to National Temperance League, n.d. [c. 1868], K 8.
63. Extensive correspondence about financing *Bacchus* survives in several collections, notably JJ, Princeton, UCLA, and UNC-CH.
64. See Statement of Account, 18 June 1869, showing that GCk had received £2,547.1.0 and that Tweedie was still owed £1,499.18.0, JJ.
65. GCk's c. 1867 draft notes, K 6; Jerrold 2:166.
66. GCk draft letters to Crossley, n.d. [c. 1867], K 9.
67. True, his deposits (though not his midsummer balances) rise meteorically after 1864; 1865, £5,854 (balance £40); 1866, £7,683 (£17); 1867, £6,087 (£248); 1868, £7,997 (£27); 1869, when corps affairs no longer circulate through his account, £3,214 (£57); 1870, £2,007 (£12).
68. Feaver, *PULC*, p. 256 notes the first and third of these prior images; original pencil sketch, V&A 9498.A, with date of delivery, 8 Apr. 1869.
69. Conway, *Autobiography*, 2:5–6.
70. GCk was never very intimate with Leech, whom he met through Thackeray and taught how to etch (GCk to John Camden Hotten, n.d. [after 8 Nov. 1864], Princeton). He did however join Browne and Marcus Stone at Leech's funeral which Dickens helped the widow to arrange (Marcus Stone, "Reminiscences," unpublished MS at the Dickens House, London).

43. SURELY THERE NEVER WERE SUCH TIMES—!!!

1. John Ruskin, Lecture to the British Institution, 7 Apr. 1867, *Works* 19:199–200.
2. John Ruskin, *Diaries*, ed. Joan Evans and John Howard Whitehouse, 3 vols. (Oxford: Clarendon Press, 1958), 2:610.
3. GCk to Charles Augustus Howell (hereafter CAH), 27 Mar. 1868, Princeton. In 1982 the Jenkins Co., Austin, Texas, offered for sale GCk's personal account ledger, 1868–1874, over 140 leaves "crammed with dated entries of both money collected and spent for a wide variety of [household and professional] purposes" and a list of GCk's works for sale with prices. Untraced.
4. C 51, 1864, Bentley.
5. GCk postscript in letter to Bentley, n.d. [8? Aug. 1863], Princeton.
6. GCk to Bentley, 25 June 1863, Princeton.
7. GCk to Bentley, n.d. [8? Aug. 1863], Princeton.
8. Bentley to GCk, 16 July 1863, unlocated—reference in: GCk to Bentley, 21 July 1863, Princeton; GCk to Bentley, n.d. [8? Aug. 1863], reference above; Dalziel brothers to GCk, 14 Aug. 1863, Bradburn 34 blue; GCk to unidentified [Dalziel or Bentley?], 20 Aug. 1863, Francis Edwards cat. 1023 (1979), item 90; GCk to Bentley, 22 Aug. 1863, Princeton; GCk to Bentley, 5 Sept. 1863, Princeton; Thomas Williams to GCk, 30 Sept. 1863, Princeton.
9. Dalziel, p. 48. GCk thought his *Ingoldsby* designs were spoilt by being "wretchedly cut": annotation by Joseph Gibbs, 6 Oct. 1863, on verso of mount, R 56, BM 1865/2452.
10. GCk postscript in letter to Bentley, 5 Sept. 1863, Princeton.

11. Mrs. C. F. Bond to GCk, 28 Nov. [1863?], Princeton. Though the copyright date on this edition is 1864, Bentley's urgency to get the book published suggests that he wanted to tap the Christmas 1863 market. For the second edition, 1865 (C 51), GCk designed a new vignette for "Patty Morgan the Milkmaid's Story."

12. GCk to Crawford J. Pocock accompanying trial proof of frontispiece, 14 Jan. 1870, Princeton; quoted in E.D.H. Johnson, *PULC*, pp. 30–31.

13. GCk to Bentley, 13 July 1869, Princeton. Bentley's offer had been made the day before. See also GCk to Pocock, 14 Jan. 1870, Princeton.

14. GCk to Bentley, 18 Aug. 1869, Princeton.

15. GCk to Bentley, 20? Sept. 1869, Princeton. Preliminary sketches, the pen-and-ink drawing with a penciled version of the caption, and trial proofs are at Princeton; sketch reinforced with wash, Berg.

16. GCk to Bentley, 19 and 21 Oct. 1869, Princeton. GCk finished a proof by 9 Nov., replied to praise of it by Dalton Barham on 8 Dec. 1869: both Berg.

17. R. H. Dalton Barham, "Preface" to the *Ingoldsby Legends*, 2 vols. (London: Richard Bentley, 1870), 1:ix (C 52).

18. George Routledge to GCk, 10 Jan. 1865, Pennsylvania State, University Park; GCk to Bentley, 21 Jan. 1865, Princeton; GCk to Octavian Blewitt, 10 Mar. 1865, Princeton.

19. GCk draft letter to unidentified person on verso of GCk draft letter to C. B. Cobb of 17 Mar. 1865, Princeton. In 1868 a dispute about bills led Routledge to forego his claim against GCk in exchange for permission to print three hundred sets of *Fairy Library* plates (Routledge to GCk, 12 Oct. 1868, Princeton).

20. Thomas Harrild to GCk, 12 Jan. 1865, Princeton.

21. Routledge to GCk, 2 May 1865, Princeton; Routledge and Sons to GCk, 6 Sept. 1866, and GCk to Routledge and Sons, 7 Sept. 1866, Swann Galleries sale 1339, 14 June 1984, lot 58; John Wrench to GCk, 12 Sept. 1866, Princeton.

22. J. H. Pepper to GCk, 21 May 1866, Princeton.

23. Edward Bell, *George Bell Publisher* (London: Privately Published, 1924).

24. An "Indenture for Articles of Partnership" dated 30 Sept. 1868 confirms a 9 (Bell) to 7 (Daldy) division of assets, income, and liabilities, and extends the arrangement for seven years: Bell and Hyman archives.

25. GCk to Bell and Daldy, 24 Sept. 1868, Bell and Hyman, with annotation by office clerk of terms.

26. Bell and Daldy to Bradbury and Evans, 25 Sept. 1868, Bradburn 23 red.

27. Bell and Daldy to GCk, 15 and 21 Oct. 1868, Princeton; A. Edward Bell to GCk, 2 Nov. 1868, Princeton; GCk to Bradbury and Evans, 23 Dec. 1868, Bradburn 52 red; GCk to Mr. Yates (at Clowes and Sons printers), 22 Nov. 1869, Bell and Hyman.

28. GCk's draft announcement of Bell and Daldy's planned reissues, n.d. [1870], Bell and Hyman. It may have been in connection with these plans that GCk revised *Lord Bateman* (Anne Lyon Haight, pp. [54–55]).

29. Hotten to GCk, 24 Sept. 1864, Princeton.

30. Hotten to GCk, 8 Nov. 1864, Bradburn 30 blue.

31. Robert Hunt to GCk, 21 Feb. 1865, Bradburn 31 blue.

32. Hotten to GCk, 7 Mar. 1865, Princeton.

33. Robert Hunt, *Popular Romances of the West of England*, 2 vols. (London: John Camden Hotten, 1865), 1:n.p., 18 Apr. 1865 (C 422); quoted in part in Jerrold 1:167; drafts of the letter, Princeton. Pencil and watercolor sketches, V&A 9400.A–B; proofs, V&A 9401.1–2.

34. GCk to J. P. Briscoe, n.d. [c. 1873], quoted in Jerrold 1:167–169.

35. GCk to Robert Hunt, 30 Dec. 1869, William H. Allen list 3, item 21.

36. Sir William Fraser to GCk, 31 Jan. [1866?], Princeton.
37. Called "The Maniac Monk" in some copies of the volume, which was never officially published; C 325.
38. GCk to Locker about meeting him and Fraser, 23 May 1868, Huntington Library; Fraser regretting that he is too busy to pay GCk a visit, n.d., Princeton. Fraser to GCk asking how Sotheby's got hold of proof impressions of the plates GCk pulled for him, 17 Dec. [n.y.], Princeton; C 326, C 326A, C 326B, C 326C, C 327.
39. [The firm of] Edward Moxon to GCk, 7? Sept. 1865, Princeton.
40. GCk to Tupper, 18 Sept. 1865, University of Rochester.
41. GCk to Tupper, 28 Sept. 1865, with Tupper's reply abstracted on verso, University of Rochester.
42. Tupper to GCk, 5 Dec. 1865 and 8 Jan. 1866, Princeton.
43. C 579, completed by Nov. 1865 (see V&A 10,055), not Mar. 1866 as Cohn; GCk to [Charles Hancock?], 9 Oct. 1865, Wilson 14, may possibly be related; in GCk to Hancock, 28 Oct. 1865, UCLA, GCk declares that he is "pleased with the block. . . . the first thing that I have done for this Publisher—and I may add of course the first order for any thing in this process." GCk's 19 Dec. 1851 glass-etched portrait of the photographer Peter Wickens Fry is the earliest dated cliché-verre: see Elizabeth Glassman and Marilyn F. Symmes, *Cliché-verre: Hand-Drawn, Light-Printed* (Detroit: Detroit Institute of Arts, 1980), p. 69. From 1853 on, several French artists, including Corot and others of the Barbizon School, made clichés-verre: Helmut Gernsheim, *The Rise of Photography, 1850–1880: The Age of Collodion, The History of Photography*, vol. 2, 3d ed. rev. (London and New York: Thames and Hudson, 1988), p. 58. For the coat of arms, see Payne to GCk, 14 Oct. 1866, UNC-CH.
44. Tupper to GCk, 16 Jan. 1866, Princeton.
45. Kent to GCk, 9 Oct. 1866, UNC-CH; Kent to GCk, 10 Oct. 1866, Princeton; Payne to GCk, 12 Oct. 1866, UNC-CH.
46. Payne to GCk, 31 Dec. 1868, Princeton.
47. GCk to CAH, 15 June 1868, Princeton.
48. Nigel Gosling, *Gustave Doré* (Newton Abbot: David and Charles, 1973), p. 23, citing J. Valmy-Baysse, *Gustave Doré* (1930).
49. Gosling, pp. 23–26. The Doré Gallery, formerly the Black Horse Hotel, is today the exhibition rooms of Sotheby's.
50. For a recent analysis of *London* see Treuherz, pp. 65–70.
51. Wyman H. Herendeen, "The Doré Controversy: Doré, Ruskin, and Victorian Taste," *Victorian Studies* 25, no. 3 (Spring 1982): 304–327; Ruskin, *Works* 25:170.
52. Ruskin, *Works* 15:222–223.
53. Ibid., 7:349–350. In place of this note, the MS praises the "characters" of the Dodger and of Mrs. Gamp; it is not clear whether Ruskin is here thinking about the representation of "vulgarity" by the author or by his artists. If the latter, then Ruskin may have conflated GCk's *Twist* plates with Browne's *Chuzzlewit* plates.
54. Herendeen, p. 312.
55. ACC 534/4/158.
56. Ruskin, *Works* 36:502–521, contain the 1866 letters to CAH concerning GCk.
57. ECk to CAH, 12 Mar. 1866, The John Rylands University Library of Manchester.
58. See Frances Whitehead to GCk, 22 Mar. 1864, with attached letters and receipts concerning Elizabeth's estate, UNC-CH; and GCk to unidentified person, 3 July 1868, Searle. See also documents relating to the estate of George Linstead, JJ.
59. Copy of GCk to A. Robertson regarding the transmission of £50 to Canada from the Baldwyn Trust, 23 Dec. 1868, UNC-CH.
60. Ruskin to CAH, 27 Mar. 1866. CAH's album of materials relating to this project is in the Berg; hereafter Berg-CAH.

61. ECk draft letter to CAH, n.d. [June? 1873], private collection.
62. GCk to CAH, 21 Mar. 1866, Princeton.
63. GCk to CAH, 22 Mar. 1866, Princeton. Printed circular dated July 1866, without reference to purchasing the Exeter Hall collection, JJ.
64. Ruskin to CAH, 2 Apr. 1866.
65. Ruskin to CAH, 4 July 1866. Later Christina Rossetti offered "Hero" for the collection; when Ruskin turned it down, her brother Dante Gabriel got very angry with Ruskin (Berg-CAH).
66. GCk to Charles Kent, 22 June 1866, Wilson 54; ECk to Howell, 2 July 1866, The John Rylands University Library of Manchester; GCk to CAH, 31 July 1866, Princeton.
67. *Diaries*, 6 Aug. 1866.
68. Ruskin to CAH, 2 Sept. 1866.
69. William Sharpe to Hotten, 12 July 1866, Berg-CAH.
70. Ruskin to CAH, 11 Sept. 1866.
71. Ruskin to CAH, Sept. 1866.
72. ECk to CAH, 20 Sept. 1866, Harry Ransom Humanities Research Center, The University of Texas at Austin.
73. Berg-CAH, and two letters from GCk to CAH, both 2 Oct. 1866, Princeton. The "Blue Light" proof may also have been pulled around this time; GCk gave one of the few copies to Crawford J. Pocock 25 July 1873, now in collection of George Watson, Cambridge, England. Pencil and watercolor sketches of "Blue Light," Binyon cat. 1434–1435; slight pencil sketch of "Pied Piper," Binyon cat. 1436.
74. Ruskin to CAH, dated only "1866," but between 3 and 18 Oct. In 1888 Kate Greenaway made thirty-five plates for Edmund Evans's edition of Browning's poem, and these became Ruskin's favorite illustrations by her.
75. Ruskin, *Works* 34:566 (1884).
76. Ruskin to CAH, postcript to letter of [3–18 Oct.] 1866.
77. CAH to GCk, 18 Oct. 1866, UNC-CH.
78. Ruskin to CAH, 3 Nov. 1866.
79. Ruskin to CAH, 9 Nov. 1866.
80. ECk to CAH, 5 Feb. 1867, The John Rylands University Library of Manchester.
81. GCk to Horace Mayhew, 12 June 1867, Berg.
82. Jerrold 2:140.
83. GCk to CAH, 6 Apr. 1868, Princeton.
84. GCk to CAH, 24 Mar. 1867, Princeton; GCk to CAH, 2 Apr. 1867, Wilson 51.
85. References to negotiations with [John?] Phillips in GCk to CAH, 30 May and 3 June 1867, Princeton.
86. GCk to Ruskin, 21 June 1867, Berg.
87. GCk to CAH, 8 Oct. 1867, Princeton; GCk to CAH, 30 Oct. 1867, The John Rylands University Library of Manchester.
88. GCk to CAH, 2 Dec. 1867 and 2 Jan. 1868, Princeton.
89. GCk to CAH, 20 May 1868, Princeton.
90. CAH to Hotten, 9 Nov. 1867, Berg-CAH.
91. Emily Taylor to Hotten, 11 Feb. 1868, Berg-CAH.
92. GCk to CAH, 20 May 1868, Princeton.
93. CAH to GCk, 29 May 1868, Princeton.
94. CAH to GCk, 2 Jan. 1869, UNC-CH; illegible name [Leonard Rowsta—?] to GCk, 1 Feb. 1869, Princeton.
95. Hotten to GCk, 17 Dec. [1868], Buchanan-Brown, p. 243 n. 15.
96. GCk to CAH, 20 Jan. 1869, Princeton.
97. Pocock to ECk, 15 Apr. 1869, Princeton.

98. Numerous pleas for support were published, including one by Clarence Cook, "George Cruikshank," *Galaxy* 5 (Jan. 1868): 126–127.
99. F. W. Cosens to GCk, 4 Mar. 1865, Princeton.
100. GCk to Pocock, 11 Nov. 1865, Princeton.
101. C 496, C 497 with annotations by FSB and cutting from unidentified dealer's cat.
102. C 498, with publication date misprinted "1886."
103. Feaver, *PULC*, p. 250.
104. G. W. Reid to GCk, 13 July 1866, Princeton.
105. G. W. Reid to GCk, 17 June 1868, Princeton.

44. I AM LOOKED UPON AS A *FANATIC*

1. Captain Edwin Horatio Charles Hurley to GCk, 17 Aug. 1868, ACC 534/7. The later folders had in 1988 not been catalogued by item number.
2. *Bee Hive*, C 957, "Published by the Artist, and sold by W. Tweedie." Electrotype block, *Lib.* 585. For further analysis of the imagery GCk incorporates, see ch. 11, my article on "George's Hive," and Guilland Sutherland, "Cruikshank and London," in Nadel and Schwarzbach, esp. pp. 109–112.
3. The eighteenth-century background is provided in William J. Farrell, "The Role of Mandeville's Bee Analogy in 'The Grumbling Hive'," *SEL* 25, no. 3 (Summer 1985): 511–527.
4. BMC 13038, 25 Nov. 1818, Knight.
5. *Boney attacking the English Hives*, by A. M., BMC 10079, Aug.? 1803, [Fores].
6. Cruikshank, *Pop-Gun*, p. 10.
7. Rhoda Broughton, *Cometh Up as a Flower*, rev. ed. (London: Richard Bentley and Son, 1878), ch. 16, p. 172.
8. Charles Dickens, *Our Mutual Friend*, 2 vols. (London: Chapman and Hall, 1865), 1:71.
9. For a discussion of the problems arising from a queen who ruled her nation as a mother and her household as a monarch, see Adrienne Auslander Munich, "Queen Victoria, Empire, and Excess," *Tulsa Studies in Women's Literature* 6, no. 2 (Fall 1987): 265–281.
10. GCk to CAH, 20 Mar. 1867, Princeton.
11. GCk to Major General Sir Thomas M. Biddulph, Bart., 8 Apr. 1867, RA PP Vic 23,667 (1867). GCk knew that the queen did not accept presentation copies, so he asked that a proof plate and pamphlet simply be placed before her, which was done on 12 Apr.
12. The background and rationale for this policy and GCk's pamphlet are considered in Elaine Hadley, "Natives in a Strange Land: The Philanthropic Discourse of Juvenile Emigration in Mid-Nineteenth-Century England," *Victorian Studies* 33, no. 3 (Spring 1990): 411–439.
13. C 211, Aug. 1869, Tweedie.
14. GCk draft letter to Lord —, 11 Sept. 1869, Bradburn 56 red; see also incomplete draft on verso of 4 Aug. 1869 bill from British Stationery Warehouse to ECk, UNC-CH, and 13 Sept. 1869 incomplete draft, Searle.
15. Major General Sir Thomas Biddulph to GCk, 21 Oct. 1869, Princeton.
16. Richard Grenville, duke of Buckingham and Chandos to GCk, 16 Oct. 1869, Bradburn 38 blue.
17. Merle to GCk, 15 Sept. 1869, Princeton.
18. GCk to Merle, 15 Sept. 1869, Princeton.
19. For a general survey of nineteenth-century educational policy, see Gillian Sutherland, *Elementary Education in the Nineteenth Century* (London: The Historical As-

sociation, 1971); for documents concerning the 1870 Act, see J. M. Goldstrom, *Education: Elementary Education 1780–1900* (Newton Abbot: David and Charles, 1972); and for Forster's participation, see T. Wemyss Reid, *Life of the Right Honourable William Edward Forster* (London: Chapman and Hall, 1889).

20. C 207, 1870, Tweedie.
21. G. L. Banks to GCk, 1 July 1863, UNC-CH; Henry Thomas to GCk, 13 July 1863, Frognal cat. 48, item 227.
22. C 1973. Edward Barrett asks GCk where he can obtain a copy, 8 Dec. 1864, Princeton.
23. Isabella Banks to ECk scheduling a rehearsal with GCk for 16 and 21 Mar., 15 Mar. 1864, Princeton; E. Gambart to GCk inviting his participation in the program, 22 and 24 Mar. 1864, Princeton.
24. GCk to Mr. and Mrs. Bowles inviting them to view the watercolor drawing, n.d. [May? 1865], Searle. There were at least three watercolors and one oil on this subject. One pencil and watercolor version, illustrated, is V&A 9781.A. A second, more highly finished, pencil, pen-and-ink, and watercolor version belongs to the Folger Library and may be the picture exhibited in 1867 at the Royal Academy. An oil on canvas, inscribed and dated by GCk 1863–1865, is at the Yale Center for British Art (Geoffrey Ashton, pp. 14–15). See also V&A 9455, sketches V&A 9505.C ("First Sketch") and 9505.D, and the painting said to be Mr. Morson's, V&A 10080 with its color autotype reproduction V&A 10080.A and reduced copy V&A 10081.
25. [I. *or* J.] R. Johnson to GCk, 22 Sept. 1868, Princeton; reviewed in *The Times*, 27 May 1872.
26. Sheridan Muspratt to GCk, 20 Jan. 1864, Princeton.
27. GCk to Dr. Muspratt, 28 Jan. 1867, private collection.
28. Muspratt to GCk, 17 Dec. 1867, Princeton.
29. Muspratt to GCk, 18 and 29 Mar. 1869, Princeton.
30. S. A. Hart to GCk, 26 Apr. 1869, UNC-CH; GCk to CAH, 27 Apr. 1869, Princeton.
31. Muspratt was too ill to see GCk during his 1870 visit to Liverpool (GCk to ECk, 13 and 14 Dec. 1870, Vogler Collection, Grunwald Center, UCLA); Muspratt died of apoplexy on 2 Feb. 1871. The subsequent disputes about GCk's borrowing of the picture in order to autotype it can be traced in the following 1871 letters: Richard Muspratt to GCk, 23 Feb., Princeton; J. R. Hutton (solicitor) to GCk, 3 June, UNC-CH; Anne Muspratt to GCk, 26 Sept., Princeton; Hutton to GCk, 3 Oct., Princeton; GCk to executors of Muspratt estate, 12 Nov., Princeton; GCk to Mrs. S. [Anne] Muspratt promising the return of the painting as soon as he touches up the autotype proof, 25 Nov., Walter Benjamin Autographs, 1987, cat., U–469.
32. GCk to John Noble referring to the "sudden decease of two very old friends" and how overwhelmed he is by "having to attend to their distressed families and their affairs," 11 Jan. 1864, private collection.
33. In succession three daughters, Elizabeth, Margery, and Ellen were appointed testatrix of ECk's will should Dr. Richardson's wife Mary Jolley Richardson not survive (Coutts).
34. Philip Rose (solicitor) to GCk, 25 July 1864, Princeton.
35. GCk draft letter to Mrs. Dudderidge Gibbs on verso of GCk draft letter to [Alfred] Dorsett of 27 July 1864, n.d., Searle; another draft of GCk to Mrs. Gibbs, Searle.
36. GCk draft letter to [administrator of the Civil Engineers' Benevolent Fund], 7 July 1865, Princeton.
37. G. H. Andrews to GCk, 15 Mar. 1866, UNC-CH.

38. William Pulford to GCk, 11 Jan. 1865, Princeton; Russell Pulford to GCk, 26 Feb., 23 Sept., 16 Oct. 1866, UNC-CH; George Pulford to GCk, 28 Feb. 1866, UNC-CH; Joseph Taylor to GCk, 22 Nov. 1866, UNC-CH; George Pulford to GCk, 5 Mar. 1867, Princeton.
39. A. E. Leech to GCk, 30 Apr. 1866, Princeton; Albinus Martin to GCk, 16 Jan. 1866, UNC-CH; W. H. Wills to GCk, Sept. 1866, Princeton; Percy Fitzgerald to GCk, n.d. [c. 1868], Princeton.
40. Joseph J. Elliott to GCk, 27 Apr. 1866, Pennsylvania State, University Park.
41. ACC 534/13; on 26 Aug. 1863 J. E. Mayall sent GCk an idea for a ghost cartoon— cruel and selfish people who never possessed a soul—in acknowledgment of GCk's ghost book, Princeton. The London firm of John and Charles Watkins also produced a strong bust-length carte de visite, James Lowe Autographs, cat. 33, item 161.
42. There is extensive correspondence 1863–1868 with the de Carterets and their agents, Princeton and UNC-CH. Occasionally thereafter members of the family corresponded with GCk on friendly terms. Philip became an active Temperance speaker: see *The Cassell Templars' Watchword*, 14 Feb. 1877, p. 98.
43. In addition to Middlesex records, see GCk draft letter to C. B. Cobb, 14 Mar. 1865, Princeton; Cobb to GCk, 15 Mar. 1865, UNC-CH; copy of letter from GCk to Cobb, 17 Mar. 1865, Princeton; and GCk draft letter to unidentified person, n.d. [c. 7 July 1865], Princeton. Other undated drafts from GCk to Cobb are in Pennsylvania State, University Park and K 58.
44. GCk to editor of the *Sun* [Charles Kent], 3 Jan. 1868, Princeton; teetotalism "was found to be *too* exclusive, and the Regiment has not been a 'Temperance corps' for several years past"; see also the same letter published in *The Times*, 4 Jan.
45. ACC 534/5/78.
46. GCk to editor of *The Times*, 5 Apr. 1866, published 6 Apr.
47. GCk draft letter to editor of *The Times*, n.d. [Jan. 1868], Princeton, and 24 Jan. 1868 copy of final version, ACC 534/11.
48. ACC 534/5/84.
49. ACC 534/5/109.
50. GCk draft letter to editor of the *Observer*, n.d. [Aug. 1868], Princeton. GCk had been assured by an official at the War Office that the dismissed officers would not have their commissions reinstated elsewhere, but that verbal agreement was not kept.
51. GCk draft letter to Wellington, 7 Aug. 1868, Berg, as well as Middlesex records.
52. *The Sun*, 5 Oct. 1868, ACC 534/4/79.
53. Vickers to GCk, 9 Dec. 1869, ACC 534/9.

45. CELTIC STRAINS

1. George Cruikshank, *An Address and Explanation to the Scottish People*, Aug. 1874; hereafter *Address*.
2. For example, Isabella Banks proposed to review the republication of the *Fairy Library* or his new plates for *The Brownies*: Isabella Banks to GCk, 10 and 14 Nov. 1870, UNC-CH.
3. One instance among many: Sidney Smith of Bradford forwarded a copy of the *Bradford Weekly Telegraph* that contained an appreciation of GCk's etchings, adding that although he was not a teetotaler he admired GCk's philanthropic work and believed *The Bottle* should be republished periodically at a cheap rate for the benefit of the working class (Sidney Smith to GCk, 5 Nov. 1870, Princeton).

4. In addition to dozens of queries forwarded to him by publishers regarding the where-abouts of plates and the owners of copyrights, there were letters such as the one from James Gibson of Liverpool, who in preparing a new bibliography of Robert Burns wondered whether GCk had executed a folding plate illustration to the "Jolly Beg-gars" (James Gibson to GCk, 6 Dec. 1870, Princeton).

5. *The Period* 19 (17 Sept. 1870): 201, with accompanying article on "People of the Period. George Cruickshank," p. 203.

6. *The Hornet*, 6 Dec. 1871, reproduced in Evans, p. 174.

7. For instance, the card of the New York bookseller J. W. Bouton, C 950, dated Sept. 1871, and the bookplate for Sir William Augustus Fraser, the Knight of Morar, C 1296, n.d. [c. 1870—see note about sketch of Fraser's Coat of Arms on verso of L. C. Alexander to GCk, 22 July 1869, K 38].

8. C 379, 1872; Longmate, p. 197.

9. C 326A, 1872, F. Harvey.

10. See the Feb. through Apr. 1870 correspondence between Reid and GCk at Prince-ton.

11. C 992, Tweedie; Cohn owned the autograph MS of GCk's poem.

12. C 1312, June 1871, Tweedie.

13. See letters from June to Sept. 1871 to GCk from various correspondents in the collections of Princeton and UNC-CH.

14. Useful accounts of mother and daughter are to be found in Mrs. Ewing's obituary of her mother, first published in *Aunt Judy's Magazine* for Nov. 1873 and reproduced in her *Miscellanea* (London: Society for Promoting Christian Knowledge, 1876); in Mrs. Molesworth's obituary of "Juliana Horatia Ewing," *Contemporary Review* 49 (May 1886): 675–686; in Horatia K. F. Eden, *Juliana Horatia Ewing and Her Books* (London: Society for Promoting Christian Knowledge, 1896; repr. Detroit: Gale Research, 1969); in Marghanita Laski, *Mrs. Ewing, Mrs. Molesworth, and Mrs. Hodgson Burnett* (London: Arthur Barker, 1950); in several books about childhood by Gillian Avery; in Christabel Maxwell, *Mrs. Gatty and Mrs. Ewing* (London: Constable, 1949); and in the account of GCk's relations with Mrs. Ewing provided by Buchanan-Brown, pp. 34–36 (the first publication of her correspondence with George and Edward Bell). Further context is supplied by Darton and by Lance Salway's selection of reprinted essays, *A Peculiar Gift: Nineteenth Century Writings on Books for Children* (Harmondsworth, Middlesex: Penguin-Kestrel Books, 1976), which includes the aforementioned Gatty and Ewing obituaries.

15. *The Brownies, and other Tales*, C 277, published Dec. 1870 but most copies dated 1871.

16. J. H. Ewing to George Bell, n.d., "Saturday Night" [16? Sept. 1865], George Bell archive, Reading University Library. The letters cited subsequently in this chapter to George and Edward Bell are all part of this archive, and will be noted simply "Reading."

17. J. H. Ewing to George Bell, 19 Sept. 1865, Reading.

18. J. H. Ewing to George Bell, 14 Dec. 1869, Reading.

19. J. H. Ewing to George Bell, 22 Dec. 1869, Reading.

20. J. H. Ewing to George Bell, 25 Dec. 1869, Reading.

21. Eden, p. 237.

22. J. H. Ewing to George Bell, 19–20 Jan. 1870, Reading.

23. J. H. Ewing to George Bell, 22 Jan. 1870, Reading.

24. J. H. Ewing to George Bell, n.d., "Wedy." [26? Jan. 1870], Reading—annotated "c. 1878" but probably part of this series.

25. George Bell to GCk, 2 Jan. 1870, Princeton.

26. J. H. Ewing to Edward Bell, 29 Jan. 1870, Reading.

27. J. H. Ewing to George Bell, 19 Feb. 1870, Reading.
28. Eden, p. 43; picture untraced.
29. J. H. Ewing to George Bell, 26 Apr. 1870, Reading. GCk had used enlarged furniture to give a "dreamy" effect to a scene before, in the *Oliver Twist* plate where Monks and Fagin spy Oliver asleep at the Maylies'.
30. Margaret Gatty to George Bell, 4 May 1870; J. H. Ewing to George Bell, 14 May 1870; both Reading.
31. C 346, the one for 1870 being post-dated 1871.
32. J. H. Ewing to George Bell, 14 May 1870, Reading.
33. Quoted in Maxwell, pp. 185–186.
34. C 276, 1874; the one for "Lob" was necessarily new; the two others appeared when the stories, "Timothy's Shoes" and "Benjy in Beastland," were first published.
35. Lady Baden-Powell to Charles Scribner's Sons, 1946, quoted in Maxwell, pp. 145–146.
36. Quoted in Maxwell, p. 146.
37. Quoted in Darton, p. 279, caption to figure 43, juxtaposing the two artists' treatments of "Finding the Baby," and Maxwell, p. 243.
38. L. C. Alexander, Secretary, to GCk, 3 Nov. 1868, Princeton.
39. Colin Rae Brown to GCk, 25 Dec. 1872, UNC-CH. See Brown's follow-ups, 2 Jan. 1873 (UNC-CH) and 6 Jan. 1873 (Princeton).
40. Charles Rogers to GCk, 7 Mar. 1873, Princeton, and draft reply on verso. Although the cousins shared a patronymic, they spelled it differently.
41. Rogers to ECk, Apr. 1873, and Lord Ebury (Robert Grosvenor) to Rogers, 27 Apr. 1873, Princeton.
42. Earl of Shaftesbury to ECk, 30 Apr. 1873, Princeton.
43. BL Add. MSS 44,103, folios 78–80.
44. Rogers to GCk, 14 Apr. 1870, Princeton; Rogers to GCk, 29 Apr. 1870, UNC-CH.
45. Substantial correspondence from Rogers and L. C. Alexander to GCk during 1869 about the Wallace Monument survives; see especially Alexander to GCk thanking him on behalf of the Committee, 17 May 1869, UNC-CH, and Rogers to GCk, 28 May 1869, telling him of the thirteen-year struggle against the opposition of Burns of Glasgow and asking GCk to attend a show-down meeting of the Committee, Princeton. That this endeavor provoked such politicking ought to have warned GCk, though it did not.
46. Even so, his name appears as a member of the committee in a prospectus, *Monument to King Robert the Bruce, on the Field of Bannockburn* (RA PP Vic 9005 [1871], hereafter *Monument*) sent to the queen probably by GCk on 20 June 1870.
47. *Address.*
48. Such are the dimensions given in *National Monument to King Robert the Bruce*; in his letter to Biddulph GCk said the figure was to be ten feet high and the pedestal fourteen feet (GCk to Biddulph, 20 June 1870, RA PP Vic 7082 [1870]).
49. See extensive drafts of GCk's Dec. 1877 letters to *The Times* and other newspapers, Princeton.
50. *Address.*
51. GCk's inscription radically altered the extensive Latin texts composed fifty years earlier by Professor James Gregory of Edinburgh for a previous monument design (reproduced in *Monument*). GCk's text emphasizes the union of kingdoms, Gregory's the triumph over "an exasperated and overwhelming enemy" and the consequent restoration of Scots pride, welfare, and liberty.
52. Rogers to GCk, 23 May 1870, UNC-CH; GCk to Rogers, 23 May 1870, Harry Ransom Humanities Research Center, The University of Texas at Austin.

53. *Address*; Charles Rogers to GCk, 3 June 1870, UNC-CH; Sir William Fraser to GCk, 6 June 1870, Princeton.
54. GCk draft letter to unidentified person, n.d. [July? 1870], Princeton.
55. GCk's 20 June 1870 letter and memorandum of 21 June reply, RA PP Vic 7082 (1870).
56. W. C. Hepburn to GCk, 22 June 1870, and Rogers to GCk, 23 June 1870, both UNC-CH.
57. GCk's 22 June letter and memorandum of 29 June reply, RA PP Vic 7201 (1870); John Longden to GCk, 29 June 1870, UNC-CH.
58. If all transpired according to his 30 June letter to Biddulph, RA PP Vic 7201 (1870).
59. A circular printing excerpts from the *Morning Post, Morning Advertiser, Daily News,* and *Glasgow Star,* JJ.
60. At least twenty-four July letters to GCk relate to the Bruce Monument; all but two are at Princeton or UNC-CH.
61. Rogers to GCk, 12 Nov. 1870, Princeton.
62. RA PP Vic 9005 (1871).
63. *Address.*
64. Graham to Biddulph, 3 Apr. 1871, and copy of reply, RA PP Vic 9005 (1871).
65. Rogers to GCk, 26 Feb. 1872, Princeton.
66. J. S. Muchet to GCk, 5 Feb. 1872, Princeton, and GCk's version of the letter in his drafts of Dec. 1877.
67. Copy in ECk's hand of GCk to Rogers, 11 Mar. 1872, Princeton, with further clarification on 13 Mar. 1872, Harry Ransom Humanities Research Center, The University of Texas at Austin.
68. Rogers to GCk, 17 Apr. 1872, UNC-CH.
69. *Address.*
70. GCk draft letter to William Christie, n.d. [Aug. 1874], Searle.
71. Christie to GCk, 17 and 30 Sept. 1874, UNC-CH; GCk to Alexander, 18 Sept. 1874, J. Stephen Laurence cat. 33, item 195.
72. GCk to Alexander, 28 Sept. 1876, Princeton.
73. See letters to *The Times,* 6 Dec. (reproduced with additions in the *London Scottish Journal,* 15 Dec.) and 19 Dec., and Currie's assertion that his design was made in 1858, 14 Dec.
74. GCk to Christie, n.d. [5 Apr. 1877], Princeton.
75. Rae Brown to GCk, 10 Dec. 1877, Princeton.
76. The Reverend Charles Rogers, ed., *Memoir and Poems of William Glen* (Edinburgh: M'Farlane and Erskine, 1874).
77. Rogers to editor of *London Scottish Journal,* 31 Jan. 1878, published in the *London Scottish Journal,* 2 Feb. 1878.
78. *National Monument to King Robert the Bruce,* 1873, JJ.

46. DISAPPOINTMENT . . . ON DISAPPOINTMENT

1. Harvey, *Victorian Novelists,* p. 34.
2. Quoted in Walter T. Spencer, "'Loving Ballad of Lord Bateman', 1839," *Times Literary Supplement,* 2 May 1935, p. 288.
3. Originally reported in the *New York Tribune* 30 (8 Feb. 1871): 6; reiterated along with an inaccurate transcription of the letter from GCk to W. J. McClellan (see below) by Robert Shelton Mackenzie, Philadelphia *Press,* 19 Dec. 1871. See also William Glyde Wilkins, "Cruikshank versus Dickens," *Dickensian* 16, no. 2 (Apr. 1920): 80–81.

4. GCk to W. J. McClellan, 11 Nov. 1870, Free Library of Philadelphia; another version of this letter was offered in The Rendells's cat. 138, item 25. The history of *Oliver's* inception has generated an enormous bibliography. On GCk's role, the fullest—though differing—modern assessments will be found in Richard Vogler's thesis and articles, Kathleen Tillotson's edition of the novel, and books by John Harvey and Jane Cohen, all cited in chapter 27. Two recent essays have studied Dickens's changes of direction in the course of the novel's serialization: Burton Wheeler's "Text and Plan of *Oliver Twist*" and Robert Tracy's " 'The Old Story' and Inside Stories," also cited in chapter 27. Both substantiate the plausibility of GCk's account.

5. R[obert] S[helton] M[ackenzie], "Philadelphia," *The Round Table*, article dated 6 Nov., published 11 Nov. 1865, pp. 155–156.

6. Forster, Ley ed., p. xvii.

7. Richard Renton, *John Forster and his Friendships* (London: Chapman and Hall, 1912), pp. 247–249.

8. Forster 1:132–134.

9. Mackenzie to the editor of the Philadelphia *Press*, dated 18 Dec., published 19 Dec. 1871.

10. Mackenzie to GCk, 4 Jan. 1872, Arents Collection, The New York Public Library. In his reply of 22 Jan. (Historical Society of Pennsylvania) GCk corrects Mackenzie on one point: what Mackenzie saw were not finished drawings but sketches and a list of proposed illustrations for the "Life of a London Thief," identified by Vogler as V&A 9503.B/B in *PULC*, p. 75.

11. Morgan, pp. 14–15; Dalziel, p. 48; J. Bertrand Payne to GCk, 29 June 1872, Princeton; Frith, pp. 148–149; Merle to GCk, 13 Apr. 1872, Bradburn 53 red; GCk to Merle, 24–25 June 1872, Princeton; Wright, *Life of Charles Dickens*, p. 120.

12. GCk to the Reverend J. B. Deane, 3 Jan. 1872, Free Library of Philadelphia.

13. Dean to GCk, 6 Feb. 1872, Jantzen cat. 14 (July 1959), item 38.

14. *The Graphic*, 6 Jan. 1872, p. 7.

15. GCk to the editor of the *Graphic*, 10 Jan. 1872, The Pierpont Morgan Library, New York. MA 2564.

16. Thackeray, *Fraser's Magazine* 21, no. 124 (Apr. 1840): 400.

17. Q.Q.Q. [Samuel Warren], *Blackwood's Edinburgh Magazine* 52, no. 326 (Dec. 1842): 785.

18. Frith, p. 149.

19. GCk draft letter in ECk's hand to unidentified person, n.d., on verso of May 1872 letter from John Byrne, Secretary of the Newspaper Press Fund, to GCk, Pennsylvania State, University Park.

20. [John Richard Dennett], review of Forster's *Life of Dickens*, vol. 2, in the *Nation* 393 (9 Jan. 1873): 28–29, 29.

21. Review of Forster's *Life of Dickens*, vol. 2, in *Atlantic Monthly* 31, no. 184 (Feb. 1873): 237–239, 239. Notwithstanding this opinion, Forster's biography is one of the two finest on CD and a classic of the genre.

22. Cohen, p. 36.

23. Of CD's biographers, two conceded some of GCk's claims: Thomas Wright, *Life of Charles Dickens*, p. 120, and Jack Lindsay, *Charles Dickens: A Biographical and Critical Study* (London: Andrew Dakers, 1950), pp. 167–172.

24. John Harvey has published the most substantial validation of GCk's statements regarding Ainsworth's novels in *Victorian Novelists*, pp. 34–43; see also Vogler thesis, pp. 162–176. To make certain that he had got the events connected to the *Tower of London* right, GCk read a draft to T. Duffas Hardy, who had been deputy keeper of the Tower since 1819.

25. J. W. T. Ley, *The Dickens Circle* (London: Chapman and Hall, 1918), p. 12.
26. Hamilton, p. 47.
27. K. I. Garrett, *Thomas James Wise and the Guildhall Library* (London: Corporation of London, 1970); see also Nicholas Barker and John Collins, *A Sequel to An Enquiry* (London and Berkeley: Scolar Press, 1983). BM Prints and Drawings owns GCk's autograph drafts of the pamphlet and copies of related correspondence, 1974 U. 1890–1975.
28. Charles Manby had a "notion" that GCk had told him about *Oliver* "a long time ago" (30 Dec. 1871); GCk invited him to see the sketches to which Mackenzie alluded (2 Jan. 1872; both in the Harry Ransom Humanities Research Center, The University of Texas at Austin). Others who communicated support were S. Phillips Day, T. Duffas Hardy, William Bates, Edwin Norbury of Liverpool, F. W. Cosens, Crawford Pocock, and Edwin Truman (three collectors, hence partisan), Howell, the antiquary John Edwin Cussans, E. J. Reed, Charles Ratcliff, Thomas Bowden Green, the surgeon and occultist William White Cooper, and Edward Daper of Westminster, who was "not . . . interested" in the pamphlet because he had been convinced from the beginning that Ainsworth was writing up to the pictures. GCk sent out many presentation copies, including one to the Baroness Burdett Coutts (presentation copy mentioned in draft letter c. 1872 from GCk to unidentified [Mrs. Brown?], Searle). He asked for an appointment to wait on her, presumably with reference to his CD statements (GCk to the Baroness Burdett Coutts, n.d. [Apr. 1872], BM Prints and Drawings 1974 U. 1906). But she was only in town for a day, so she could not manage a meeting. She asked Catherine Dickens to relay this information (Catherine Dickens to GCk, 25 Apr. 1872, Princeton).
29. Phillips to GCk, 16 July [1872], Princeton.
30. Ellis 2:104.
31. H. W. Bruton purchased twenty-nine letters between Ainsworth and GCk and sketches for the illustrations that came onto the market after the author's death; in exchange for proofs he presented these materials to ECk in 1885 (Bruton to ECk, 29 Aug. 1883, 4 July and 7 Oct. 1885, and ECk to Bruton, 15 Aug. 1885, Princeton).
32. Jerrold 1:258–269.
33. J. H. [Lovelock?] to GCk, 4 July 1872, Princeton, docketed "Called upon the gentleman on the 12th inst."
34. Kitton, *Dickens and His Illustrators*, p. 23; GCk's reference was misheard by the transcriber, as other reports of the speech verify.
35. GCk attempted to refute Dickens's story about his behavior at Hone's funeral, which Forster recounted in his second volume, in a 23 Nov. 1872 letter to the editor of the *Daily Telegraph*; he was supported by the Reverend Thomas Binney, the officiating clergyman, and by the Reverend J. C. Harrison (see PLet 3:454 n. 4 and chapter 30).
36. Nicholas Trübner to GCk, 26 Feb. 1873, Princeton.
37. H. E. Wildish to GCk, 20 July 1874, Princeton; GCk to Charles Kent, 22 Sept. 1874, University of Maryland Baltimore County; Joseph Green to GCk, 5 Feb. 1876, UNC-CH; W. I. Jennings to GCk, 22 June 1877, Princeton.
38. Charles A. Howell, *Subscription Testimonial to George Cruikshank*, July 1866, JJ.
39. CAH printed letter rendering a final account of the "Subscription Testimonial," 30 Apr. 1873, Lilly Library, Indiana University.
40. CAH to GCk, 26 Jan. 1870, Princeton.
41. Tweedie to GCk, 11 Dec. 1871, Princeton.
42. See ECk's copy of cash advances due 18 June 1869, UCLA; GCk to Owen, Joseph and John Taylor, and Tweedie, n.d. [Apr. 1870], UCLA; Tweedie to GCk, 8 Dec. 1871, Princeton.

43. GCk to CAH, 31 Jan. 1870, Princeton.
44. John Taylor to GCk, 8 Apr. 1870, UCLA.
45. Joseph Taylor to GCk, 8 Apr. 1870, UCLA. See also Owen to GCk, 8 Apr. 1870, UNC-CH, hoping the others would render GCk the assistance he needed.
46. GCk letters and drafts to Crossley, n.d. [c. 1870], UCLA, Princeton, K 9. GCk to Lofft, 30 Apr. and 2 May 1870, Searle. GCk to Leaf, 3 Aug. 1870, Searle; and various undated drafts to Leaf, UCLA and Berg. Memorandum of loan, 23 Aug. 1870; Leaf and GCk sent the cases to the BM which declined to purchase the collection.
47. GCk to Charles Kent thanking him for his warm praise in the 31 Dec. 1870 *Sun*, n.d. [1 Jan. 1871], drafts in Searle, letter in private collection, and another copy apparently in Gimbel Collection, Podeschi cat. H. 1307.
48. GCk to Tweedie, 25 Feb. 1871, Princeton.
49. E. S. Ellis to GCk, 13 June 1871, UNC-CH, and other June transmissions in collections at UNC-CH and Princeton.
50. John Taylor to GCk, 8 June 1871, UCLA; GCk draft replies to John Taylor, n.d. [16? June 1871], UCLA; Robert Rae to GCk with GCk notes and drafts about the outcome of the League meeting, 29 July 1871, Princeton.
51. GCk to Rae, 28 Aug. 1871, UCLA, copy in ECk's hand.
52. GCk to Tweedie, 18 Oct. 1871, UCLA; copy in ECk's hand, and drafts, Searle.
53. Tweedie to GCk, 20 Oct. 1871, Pennsylvania State, University Park.
54. Gough to GCk, 2 Dec. 1871, Princeton; GCk to Gough, 6 Aug. 1872, Princeton; Gough to GCk, 5 Aug. 1873, Princeton.
55. Louis Huth to GCk, 26 July 1872, Searle.
56. ECk draft letter to CAH, n.d. [June? 1873], private collection.
57. Reproduced in facsimile, Vogler/Borowitz, item 106.
58. GCk draft letters to Sir Richard Wallace, n.d. [June? 1872], Searle; Wallace to GCk, 1 and 20 July 1872, Princeton.
59. CAH to GCk, 31 Oct. 1872, UNC-CH.
60. GCk to CAH, 6 Nov. 1872, Princeton.
61. GCk to CAH, 12 Nov. 1872, Princeton.
62. Watts Phillips, *Collection of the Works of George Cruikshank* ([London?]: Privately Printed [1872?]), JJ.
63. Draft by unidentified person, n.d. [c. July 1873], private collection.
64. ECk to CAH, 2 Apr. 1873, The John Rylands University Library of Manchester.
65. N.d., JJ.
66. GCk to CAH, 31 July 1873, Princeton; GCk to CAH, 3 June 1874, The John Rylands University Library of Manchester.
67. Aug. 1875 codicil to a 27 June 1872 Will, Princeton.
68. GCk to Gough, 12 Feb. 1875, Princeton.
69. Rogers to GCk, 28 May 1875, UNC-CH.
70. Francis Fuller to GCk, 1 July 1875, UNC-CH. Enthusiastically, GCk prepared a print of the collection's proposed setting: pencil sketch, V&A 9497.A, and tracing dated 27 Sept. 1875, V&A 9674 now "written off" (i.e., lost).
71. Merle to GCk, 13 Aug. 1875, Princeton.
72. GCk to Fuller, 16 Aug. [1875], Princeton.
73. ECk to Fuller, 18 Sept. 1875, Princeton.
74. GCk to CAH, 23 Sept. 1875, The John Rylands University Library of Manchester.
75. Fuller to GCk, 30 Sept. and 4 Oct. 1875, UNC-CH, copies in ECk's hand.
76. Fuller to GCk, 8 Nov. 1875, Princeton.
77. GCk to Fuller, 20 Oct. 1875, Princeton.

78. Shaen, Roscoe, and Massey to GCk, 13 Jan. 1876, Princeton.
79. GCk draft letter to unidentified person, n.d. [Oct.? 1875], Searle.
80. J. W. Robertson to [the Cruikshank Art Fund Committee], copy to GCk, 11 Nov. 1875, Princeton; offer confirmed on 9 Dec., according to Rogers to GCk, 10 Dec. 1875, Princeton.
81. Merle to GCk, 4 Aug. 1876, Princeton.
82. GCk to Robertson, 9 May 1877, Princeton. In 1903 the entire collection was dispersed at auction.

47. THE VENERABLE GEORGE

1. [J. Comyns Carr], "George Cruikshank," obituary in the *Saturday Review* 45 (9 Feb. 1878): 170–171, 171; repr. in *Essays on Art* (London: Smith, Elder, 1879), pp. 223–233, 232.
2. Obituary of GCk, *Punch* 74 (9 Feb. 1878): 53.
3. See articles about it in the 9 Mar. *Hour* and the 13 Mar. *Pictorial World*; neither clipping is paginated in JJ.
4. For the furnishings of 263 Hampstead Road see Mr. Dolman's cat. of the 18 Mar. 1880 auction, JJ.
5. GCk attended Halliday's funeral a short time later.
6. The members of Percy's family are not listed among the guests present or sending letters, presumably because they were relations. See printed sheet, *Mr. & Mrs. George Cruikshank's Silver Wedding*, Apr. 1875, Haverford College.
7. Hannah O'Brien, née Fisher, of Birkenhead to GCk, 7 Mar. 1875, Princeton.
8. Brown to ECk, 9 Oct. 1876, Richard E. Cruikshank collection.
9. Jerrold 1:248–249.
10. George C. Gibbs to GCk, 31 Mar. 1877, and Gibbs to ECk, n.d. [Apr.? 1877], Princeton; Barker to GCk, 19 Apr. 1876, Princeton; GCk to Barker, 14 and 25 May and 10 July 1876, University of Maryland Baltimore County; Buchanan-Brown, p. 33; Barker to GCk, 3 July 1876, UNC-CH.
11. H. Macgowen and [T.? W.] Fletcher to GCk, 6 Sept. 1876, K 212; no payment of that size was ever made during GCk's lifetime or after his death from the Coutts accounts; the obligation might have been discharged directly from proceeds of the Westminister Aquarium purchase.
12. Thomas L. Prentice to GCk, 1 Sept. 1874; ECk for GCk to Prentice, 2 Sept.; GCk draft letter to the President and Council of the Artists' General Benevolent Institution, 5 Sept.; Prentice to GCk, 6 Sept.; all JJ.
13. Mrs. Hagan to GCk, 12 July 1875, Princeton.
14. Barbara M. Allen to GCk, 15 Jan. 1877, Princeton, and information from Robert B. Martin.
15. E[mma] Watts Phillips, *Watts Phillips* (London: Cassell, 1891), pp. 146–147.
16. Jerrold 2:233–234.
17. Compare Ellis 2:107 to Jerrold 1:40.
18. John Cordy Jeaffreson, *A Book of Recollections*, 2 vols. (London: Hurst and Blackett, 1894), 2:114–119. See chapter 36 for Frith's version.
19. Ibid., 2:112–113.
20. Frederick Wedmore, "Cruikshank," *Temple Bar* 52 (Apr. 1878): 499–516.
21. Lease between Sarah Wootton and GCk, 23 Feb. 1877, Princeton. This was not an altogether comfortable arrangement. In an undated remonstrance presumably composed after her husband's death, ECk indicates that her housekeeper protested having to run downstairs so often to answer the door for Miss Wootton's callers (private collection).

22. GCk to Thomas Cree, 27 Feb. 1877, and Cree to GCk, 31 Aug. 1877, both Princeton.
23. GCk to Pocock, 26 Aug. 1877, Princeton; see other letters between the two in Aug., Princeton. The Coutts accounts show no substantial single loss; this is probably a ploy to provide Adelaide with cash.
24. Jerrold 2:235.
25. Hamilton to William Bates, 28 Jan. 1881, tipped into Bates's own extra-illustrated copy of his *George Cruikshank*, private collection.
26. 1 Apr. 1828, quoted in Borowitz lot 70.
27. Vogler/Borowitz item 103.
28. GCk to Charles Hancock, 16 Feb. 1872, UCLA; Hancock to GCk saying he has damaged the matrix for the blocks cast from the plates, n.d. [c. 1872], BM Prints and Drawings 1974 U. 1973.
29. GCk to George Bell, 8 Dec. 1872, Bell and Hyman; published by Buchanan-Brown, p. 245 n. 23, where "the cuts" is misread as "the arts." At least informally GCk had arranged with Bell to publish the autobiography a year earlier: see GCk to CAH, 12 Jan. 1871, Princeton.
30. Memorandum of Agreement (1872), Bell and Hyman.
31. Borowitz lot 61.
32. See draft fragment, V&A 10,046.M.
33. ACC 534/14a/6b.
34. GCk to Hancock, 15 May 1874, 3 May 1875, and 28 Sept. 1876, UCLA.
35. Memorandum by ECk, 22 Aug. 1874, B. W. Richardson Papers, George Cruikshank Collection, Princeton.
36. Nottage to GCk, 25 July 1874, V&A 10,048.G; GCk to Hancock, 16 Nov. 1874, UCLA; Chesson, p. 212; *HP* 50. GCk's old friend Charles Wheatstone initiated the science of stereoscopy; Nottage, who founded his company in 1854, became very successful at selling its commercial applications. Within two years of starting, the London Stereoscopic Company had sold 500,000 instruments, and by 1858 it had a stock of 100,000 pictures (Gernsheim, pp. 61–66). Stereoscopic portraits were especially popular.
37. George Walter Thornbury to GCk, n.d. [between 1872 and 11 June 1876], Princeton. Thornbury's article, first published in *Weldon's Register* 1, no. 6 (Jan. 1861), formed part of his *British Artists, from Hogarth to Turner*, 2 vols. (London: Hurst and Blackett, 1861).
38. GCk to Arthur Locker, 3 Mar. 1875, Princeton.
39. *Pro and Con* 4–6 (Mar.–May 1873).
40. Walter Hamilton to GCk, 28 Sept. 1876, Princeton.
41. J. Briscoe to GCk, 19 Oct. 1877, Princeton. Another water drinker offered encouragement in the form of an inscribed copy of his *Worship of Bacchus a Great Delusion* (London: James Clarke; sold at the office of the United Kingdom Band of Hope Union, 1876), UCLA.
42. Hudson, pp. 248–249 (20 Jan. 1868), pp. 305–306 (12 Mar. 1872).
43. C 632, 1875, Simpkin, Marshall.
44. See my "Foreword" to *PULC*, pp. vii–viii.
45. "Cruikshankiana," *The Bookseller*, Christmas 1875 number, pp. 14–18.
46. GCk to Mrs. Blewitt, 18 Nov. 1871, University Club of New York, H. Gregory Thomas collection; draft version, Reverend Michael B. C. Rose collection; GCk to Daldy, 24 Nov. 1871, Bell and Hyman.
47. Mrs. Blewitt to GCk, 31 Oct. 1873, UNC-CH.
48. Mrs. Blewitt to GCk, 29 Jan. 1875, Princeton.
49. GCk to Mrs. Blewitt, 4 Aug. 1875, private collection.

50. Andrew Chatto to Octavian Blewitt, 28 Jan. 1877, Buchanan-Brown, p. 245 n. 19.
51. Mrs. Blewitt to GCk, 23 Sept. [1877], Princeton; C 80, 1877.
52. Hamilton to Bates, 28 Jan. 1881, cited in n. 25.
53. Jane R. Cohen, "'All-of-a-Twist': The Relationship of George Cruikshank and Charles Dickens," *Harvard Library Bulletin* 17 (Apr. 1969): 169–194 and (July 1969): 320–342, repr. in her *Charles Dickens and His Original Illustrators*; see Phillips, reproduction of letter from Watts Phillips to Dr. Ord, 31 Dec. 1873, facing p. 103.
54. William Feaver selects GCk's motto as the title of his *PULC* essay because he argues it characterizes GCk's self-renewal in the later phases of his career.
55. Sitwell, *Trio*, p. 247.
56. Cf. *A Scene in the Farce of "Lofty Projects"*, BMC 14787, 17 July 1825, Humphrey.
57. Maurice Horn, ed., *The World Encyclopedia of Comics* (New York: Chelsea House, 1976), p. 187.
58. The information about Addams comes from an unidentified undated British periodical, possibly the *London Sunday Times Magazine*, in an article by Philip French on "The macabre genius of Charles Addams"; that concerning Roth and Sendak appears in Nick Meglin, *The Art of Humorous Illustration* (London: Pitman; New York: Watson-Guptill, 1973), pp. 131, 149.
59. See the fine caricatures of GCk by Searle and Levine commissioned by *PULC*. Draper Hill's principal interests are Gillray and Thomas Nast, but he is also an *aficionado* of GCk.

48. GEORGE THE 1ST AND LAST

1. Sala, pp. 551–552.
2. The invitations are respectively George Peake to GCk, 19 Dec. 1877; R. Parsons to GCk, 4 Dec. 1877; and T. Alexander Ibbetson to GCk, 27 Dec. 1877; all Princeton.
3. Hamilton to GCk, 24 Dec. 1877, Princeton; review of lecture, "George Cruikshank," in *West Middlesex Advertiser* 1, no. 109 (19 Jan. 1878): 4; J. Jeremiah to GCk, 7 Jan. 1878, Princeton.
4. Austin Dobson to Jerrold, 2 Apr. 1878, Jerrold 1:229–230; see also ibid., 2:233–234 for Locker's recollection of the event and further information from Dobson's letter.
5. Hall to GCk, 31 Dec. 1877, Princeton.
6. Merle to GCk, 3 Jan. 1878, Princeton.
7. Grace Stebbing, *Graphic*, 9 Feb. 1878, p. 147, quoted in Jerrold 2:235–236.
8. *The Publishers' Circular*, 16 Feb. 1878, quoted in Bates, p. 91.
9. In Nov. 1876, when GCk was trying to sell some publisher— any publisher—on a reprint of one of Merle's effusions, he caught a cold and the papers said he was so ill he had to write a denial (GCk to Merle, 17 Dec. 1876, Princeton).
10. See her memorandum, "declined," on invitation from J. Lay of the Kentish Town Band of Hope to GCk, 8 Jan. 1878, UNC-CH.
11. See for example three 1878 letters to GCk: Robert Walker, 16 Jan.; H. Lloyd, 17 Jan.; H. Jeremiah, 25 Jan.; and one to ECk: Colin Rae Brown, 22 Jan.; all UNC-CH. In a fifth letter from the same collection written on 31 Jan., John Mathews tells GCk he is glad to read in the papers that GCk is better. The editor of the *Daily Telegraph* asked ECk on 18 Jan. how her husband was progressing: Borowitz.
12. *The Times*, 21 Jan. 1878.

13. ECk's diary, Borowitz. These pencil scrawls entered in *F. Arnold's Monthly Pocket Diary for January 1878* testify to ECk's distress and supply information about her activities during Feb. Evidently she had had no time while nursing her husband to make any entries in Jan., and no time in Feb. to procure a replacement, so she made do.

14. So attributed by Bates, who lists 40 obituaries, articles, and notes, and three books about the artist, published during 1878. Bates's list is neither accurate nor complete. JJ contains extracts from some of the more obscure notices mentioned hereafter. Within a week, at least twenty-three memorial essays appeared. 2 Feb.: *Birmingham Daily Mail*, and in London the *Daily Chronicle*, *Daily News*, *Daily Telegraph* (by Sala), *Morning Post*, *Pall Mall Gazette*, *Standard*, and *The Times*. On 3 Feb., *Reynolds's Newspaper*. On 6 Feb., the *Christian Herald* adapted Sala's eulogy; on 7 Feb., Bates lists the *Christian Globe* and the *Temperance Record* which I have not seen. On Saturday week, 9 Feb., William Bell Scott published a tribute in the *Academy*, and others appeared in the *Athenaeum*, *Builder*, *Graphic* (by Grace Stebbing), *Illustrated Sporting and Dramatic News*, *Land and Water* (according to Bates, not traced), *London Scottish Journal* which adapted the notices in the *Pall Mall Gazette* and the *Standard*, *Notes and Queries* (by H. S. Ashbee), *Punch* (frequently quoted by subsequent writers), and the *Week*. Berg contains a clipping from the 13 Feb. *Judy*.

15. *Punch* 74 (9 Feb. 1878): 53.

16. The previous year Curtice had published a portrait by PCk of his uncle in top hat and overcoat, Berg.

17. Pierce Egan corrected several statements about his father's collaboration with the Cruikshanks in an unidentified newspaper of 4 Feb., Berg. He insists that his father originated the project and that GCk did not pull out midway through because he disliked Egan's glamorizing London vice.

18. George Du Maurier, "The Illustrating of Books. From the Serious Artist's Point of View," *The Magazine of Art* 13 (Aug., Sept. 1890): 349–353, 371–375: "I confess that in book illustration I think the pretty woman a very important person" (p. 372).

19. Sala's plea appeared in the *Daily Telegraph*, 4 Feb. 1878.

20. ECk draft letter to the editor of the *Daily News*, n.d. [7? Feb. 1878], Borowitz.

21. ECk to the Very Reverend R. W. Church, 19 Feb. 1878, Borowitz.

22. Printed notice from the funeral company to Cosens, Berg.

23. Drafts in ECk's hand, c. 1884, of legend on a cenotaph designed for Kensal Green, Borowitz.

24. The fullest account of this first burial service is given by L. Jewitt in an obituary appearing in the *Reliquary and Illustrated Archaeologist* 18 (Feb. 1878): 231–233; it does not agree in all respects with Jerrold's abbreviated version, 2:237–238. The pallbearer "Mr. Ellis" is not otherwise identified; I have assumed he is one of the Leicester Ellises who attended the silver wedding, though he might also be the Covent Garden bookseller Frederick Startridge Ellis. Merle died 29 Sept. 1878.

25. ECk to R. W. Church, 15 July 1878; R. W. Church to ECk, 16 July 1878; both in Borowitz.

26. Church to ECk, 20 Nov. 1878, Borowitz.

27. A reproduction of the bust and inspection was printed by the *Illustrated London News* on 10 Sept. 1881. Correspondence about the bust, memorial tablet, Kensal Green cenotaph, and receipted bills are in Borowitz and Princeton.

28. ECk draft letter to unidentified "Madam," 29 Sept. 1890, Borowitz.

EPILOGUE

1. Doubleyew, "The Late George Cruikshank," *Illustrated Sporting and Dramatic News*, 9 Feb. 1878, p. 518.
2. Sydney Gedge to B. W. Richardson, 31 May 1878. GCk had written checks to Mr. or "Dr."? Archibold amounting to around £50 in 1876–1877, and totaling £56 from midsummer 1877 to his death. In addition, he apparently paid Adelaide's rent, gave her cash *sub rosa*, and wrote checks to her brother-in-law John Tant. From the proceeds of the Westminster Aquarium sale he invested £500 in 6 percent bonds for her (Coutts, 1 Sept. 1876; Gedge to Richardson, 29 May 1878). On the other side of the ledger, Adelaide lent GCk £14 just a few days before his death. Major sources of information about GCk's estate are the papers of B. Ward Richardson in the George Cruikshank Collection, Princeton, and those from ECk in Borowitz.
3. ECk's diary, Borowitz.
4. Information supplied from documents in the collection of Ronald Searle.
5. Confirmed mid-May: see *The Times*, 22 May 1878, p. 11; also congratulations from Merle, 21 May, and J. C. Roger and Geoffrey Haydon, 22 May, Princeton.
6. Lease dated 12 July 1878, JJ. Subsequently a Mr. Harris sued ECk and Melville for some reason (papers of B. Ward Richardson).
7. Wardroper, "The secret life."
8. If real, he died shortly after GCk, since he is listed as "deceased" in the 19 Aug. 1880 marriage register of Annie Adelaide Archibold, spinster, to George Frederick Carr Vernon, tutor (Islington District, General Register Office, London).
9. Dr. Richardson tried to get out of being executor, but he failed in his plea to Chancery.
10. See Walter Hamilton to William Bates, 15 July 1878 and 28 Jan. 1881, Borowitz, quoted in his "George Cruikshank: Mirror of an Age," p. 89.
11. Lists of material in her hand are in JJ.
12. Reynolds to ECk, 24 July 1878, Princeton.
13. Christie's netted £908, Sotheby's £901. Gillray's worktable and chair sold for nineteen guineas (annotated Christie's cat., reported in *The Times*, 17 May 1878, p. 7).
14. Gedge to Richardson, 13 July 1878.
15. Pocock to ECk, 3? Mar. 1878; ECk to Pocock, 7 Mar. 1878; Pocock to ECk, 12 Mar. 1878; ECk to Pocock, 19 Mar. 1878; all Princeton.
16. Draft by unidentified person on behalf of ECk to PCk, n.d. [1879?], Princeton.
17. Wardroper, "The secret life."
18. ECk to Bates, 7 July 1878, Borowitz. See also Richardson's 21 Mar. 1878 letter declining to supply Jerrold with material on verso of Jerrold's 20 Mar. 1878 request, Princeton.
19. See ECk copies of her replies to Jerrold and Aston, 16 Feb. 1878, Borowitz.
20. On 22 Feb. 1878 *The Times* reprinted a story from the *Academy* to the effect that GCk's "recollections of many literary men, commencing from a date of nearly 80 years ago . . . will appear under the editorship of his widow" (p. 11). *The Bookseller*, 3 Apr., p. 295, confirmed that GCk's "memoranda" were "in course of preparation for the press." ECk assured Cosens on 24 Feb. that she had "found much more Manuscript written than I had expected," and on 11 June that she was going on with the "Recollections" even though they will renew painful feelings (both Berg). Ten years later Harry Thornber regretted that the Autobiography had been so long delayed, and hoped it could soon be issued (*The Later Work of George Cruikshank* [London and Manchester: John Heywood, 1888], pp. 28–29).

21. There were at least twelve sales held by Sotheby's and Christie's: in 1878, 11 Apr., 15 May, 17–18 May, 12 June, 1 July, and 11 Dec.; in 1879, 12 Jan., 25 Mar., 1 May, and 8–9 July; and two later sales, 9 July 1880 and 29–30 July 1881.
22. Jerrold to Richardson, 20 Mar. 1878, Princeton.
23. Bates, p. 74.
24. Hall to Bates, Apr. 1879, quoted in Borowitz, "George Cruikshank: Mirror of an Age," p. 90.
25. Undated clipping in Hone Collection, Berg.
26. George Thompson to Bates, 29 May 1879, tipped into Bates's own copy of his book, Borowitz.
27. Andrew Chatto to Richardson, 29 Mar. 1881, quoted in William Feaver, "Cruikshank for Posterity," p. 271.
28. Richard Altick, "Writing the Life of J. J. Ridley," in *Nineteenth-Century Lives*, ed. Laurence S. Lockridge, John Maynard, and Donald D. Stone (Cambridge: Cambridge University Press, 1989), pp. 26–58.
29. Reviews of Jerrold's biography in the *Critic* 2, no. 35 (6 May 1882): 125–126, and the *Saturday Review* 53 (6 May 1882): 568–569; others appeared in the *Literary World* 13 (20 May 1882): 158, *Academy* 21 (10 June 1882): 421–422, and *Spectator* 55 (5 Aug. 1882): 1026.
30. Draft lease, JJ; see also E.? B. Tussaud to ECk, 5 June 1880, Princeton.
31. Mr. Dolman's cat. for 18 Mar. 1880 sale, JJ. The proceeds netted a little over £700 (Coutts).
32. ECk was through J. T. Sabin an unsuccessful bidder for *Tam O'Shanter* in the Dec. 1878 auction: Sabin to ECk, 19 Dec. 1878, Princeton. The Coutts records show that her annual income steadily diminished from around £500 to under £250.
33. For this and succeeding information, see Registry Papers relating to Cruikshank Collection, Victoria and Albert Museum.
34. Undated memorandum of Board action from Soden Smith to ECk, Borowitz; see also V&A Registry Papers.
35. R. H. Soden Smith to ECk, 20 June 1884, Princeton; H. W. Bruton to ECk, 9 July 1884, V&A 10,048.I; Bruton to ECk, 24 July 1884, Princeton.
36. R. H. Soden Smith to ECk, 18 Feb. 1886, Princeton.
37. Coutts; Thomas Cash to ECk, 20 July and 18 Nov. 1885; ECk to Sidney Colvin, 21 Nov. 1885, and Colvin to ECk, 21 Nov. 1885; all Princeton.
38. John Taylor to ECk, 5 and 10 May 1888; Lofft to ECk, 15 May 1888 and 22 Mar. 1889, Princeton.
39. 9 Aug. 1884 Codicil to ECk's Will.
40. 30 Mar. 1891 Minutes of the Council of the Royal Academy, under the heading "Letters read"; extract courtesy of Sidney C. Hutchison, Hon. Archivist. ECk's Estate totaled £2,357 (papers of B. Ward Richardson).
41. Joseph Pennell, *Modern Illustration* (London: G. Bell, 1895), p. 83.

Bibliography

Many footnote references are not repeated here. This bibliography does not include items cited in the list of abbreviations; publications listed in Cohn; Cruikshank's letters to periodicals; most signed, anonymous, or pseudonymous reviews and obituaries; standard reference books such as Algernon Graves's *The Royal Academy of Arts: A Complete Dictionary of Contributors*; standard editions referenced in a note when quoted; magazines such as *Household Words* and *Punch*; auction house and book dealers' catalogues; general works on theory, history, Victorian art, literature, and culture; or such tangential sources used for background as William Henry Merle's *Melton de Mowbray*. This is primarily a bibliography of identifiably authored secondary materials directly concerning George Cruikshank's life, times, and art.

Abbey, J. R. [From the Library of]. *Life in England in Aquatint and Lithography, 1770–1860: A Bibliographical Cataglogue*. London: Privately Printed at the Curwen Press, 1953.

———. [From the Library of]. *Scenery of Great Britain and Ireland in Aquatint and Lithography, 1770–1860: A Bibliographical Catalogue*. London: Privately Printed at the Curwen Press, 1952.

———. [From the Library of]. *Travel in Aquatint and Lithography, 1770–1860: A Bibliographical Catalogue*. 2 vols. London: Privately Printed at the Curwen Press, 1956.

Adburgham, Alison. *A Punch History of Manners and Modes: 1841–1940*. London: Hutchinson, 1961.

Adrian, Arthur A. *Mark Lemon, First Editor of Punch*. London: Oxford University Press, 1966.

Aldred, Guy A. *Richard Carlile, Agitator: His Life and Times*. London: Pioneer Press, 1923.

Altick, Richard D. *The Cowden Clarkes*. London: Oxford University Press, 1948.

———. *Paintings from Books: Art and Literature in Britain, 1760–1900*. Columbus: Ohio State University Press, 1985.

———. *The Presence of the Present: Topics of the Day in the Victorian Novel*. Columbus: Ohio State University Press, 1991.

———. *The Shows of London*. Cambridge, Mass. and London: Belknap Press of Harvard University Press, 1978.

Antal, Frederick. *Hogarth and His Place in European Art*. New York: Basic Books, 1962.

Arbuthnot, Harriet. *Journal of Mrs. Arbuthnot, 1820–1832*, ed. Francis Bamford and the duke of Wellington. 2 vols. London: Macmillan, 1950.

Arbuthnot, John. *The History of John Bull*, ed. Alan W. Bower and Robert A. Erickson. Oxford: Clarendon Press, 1976.

Ardizzone, Edward. "The Born Illustrator," *Motif* 1 (Nov. 1958): 37–44.

Arnheim, Rudolf. *Visual Thinking*. Berkeley and Los Angeles: University of California Press, 1969.

Ashbee, C. R. *Caricature*. London: Chapman and Hall, 1928.

Ashbee, H. S. "George Cruikshank," *Notes and Queries*, 5th ser., 9 (9 Feb. 1878): 119–120.

Ashton, Geoffrey. *Shakespeare and British Art*. New Haven: Yale Center for British Art, 1981.

Ashton, John. *English Caricature and Satire on Napoleon I*. 2 vols. London: Chatto and Windus, 1884.

Aspinall, A. *Politics and the Press, c. 1780–1850*. London: Home and Van Thal, 1949.

Atherton, Herbert M. "The British Defend Their Constitution in Political Cartoons and Literature," *Studies in Eighteenth-Century Culture* 11, ed. Harry C. Payne. Madison and London: University of Wisconsin Press for the American Society for Eighteenth-Century Studies, 1982, pp. 3–31.

———. *Political Prints in the Age of Hogarth*. Oxford: Clarendon Press, 1974.

Barham, R.H.D. *The Life and Letters of the Rev. Richard Harris Barham*. 2 vols. London: Richard Bentley, 1870.

Bartlett, David W. *What I Saw in London; or, Men and Things in The Great Metropolis*. Auburn, NY: Derby and Miller, 1852.

Bate, Jonathan. *Shakespearean Constitutions: Politics, Theatre, Criticism, 1730–1830*. Oxford: Clarendon Press, 1989.

Bates, William. *George Cruikshank: The Artist, the Humourist, and the Man, with Some Account of his Brother Robert*. London: Houlston and Sons, 1878.

Bathe, Greville and Dorothy Bathe. *Jacob Perkins: His Inventions, His Times, and His Contemporaries*. Philadelphia: Historical Society of Pennsylvania, 1943.

Bathurst, Cynthia Lynne. "Byron's Poetry and Cruikshank's Illustrations: Relationships of the Verbal and the Visual Art." Ph.D. diss. University of Iowa, 1984.

———. "Illustrating Byron's Poetry: Cruikshank's Byron," *Newsletter of the Byron Society* 8 (1982–1984): 4–11.

Beales, Derek. *From Castlereagh to Gladstone, 1815–85*. London: Nelson, 1969.

[Bede, Cuthbert, pseud. Rev. Edward Bradley]. "Parnassian Portrait Gallery," *London Figaro*, 1 Oct. 1873, pp. 3–4.

———. "Personal Recollections of George Cruikshank," *London Figaro*, 13, 20, 27 Feb.; 2, 6, 13 Mar. 1878.

———. "A Reminiscence of George Cruikshank and His 'Magazine'," *Notes and Queries*, 5th ser., 9 (13 Apr. 1878): 281–283.

Beerbohm, Max. "The Spirit of Caricature," *A Variety of Things*, vol. 10 of *Works*. London: William Heinemann, 1928, pp. 205–217.

Belchem, John. *"Orator" Hunt: Henry Hunt and English Working-class Radicalism*. Oxford: Clarendon Press, 1985.

Bell, Alan. "The Journal of Sir Frederic Madden, 1852," *The Library*, 5th ser., 29 (Dec. 1974): 405–421.

Bell, Edward. *George Bell Publisher*. London: Privately Published, 1924.

Benesch, Otto. *Artistic and Intellectual Trends from Rubens to Daumier as Shown in Book Illustration*. New York: Walker and Company with The Department of Printing and Graphic Arts, Harvard College Library, 1943.

Benjamin, Walter. *Charles Baudelaire: A Lyric Poet in the Era of High Capitalism*, trans. Harry Zohn. London: NLB, 1973.

———. *Illuminations*, ed. Hannah Arendt, trans. Harry Zohn. New York: Schocken Books, 1969.

Berkeley, The Hon. [George C.] Grantley F. *My Life and Recollections*. 4 vols. London: Hurst and Blackett, 1865–1866.

Bettelheim, Bruno. *The Uses of Enchantment*. New York: Random House, 1975.

Blakey, Robert. *Old Faces in New Masks*. London: W. Kent and Co. (late D. Bogue), 1859.

Bland, David. *A History of Book Illustration: The Illuminated Manuscript and the Printed Book.* 2d ed., rev. Berkeley and Los Angeles: University of California Press, 1969.
———. *The Illustration of Books.* 3d ed. London: Faber and Faber, 1962.
Bleackley, Horace, ed. *Jack Sheppard.* Epilogue by S. M. Ellis. Notable British Trials Series. Edinburgh and London: William Hodge, 1933.
Bolton, H. Philip. *Dickens Dramatized.* London: Mansell, 1987.
Borowitz, David. "George Cruikshank: Mirror of an Age," *Charles Dickens and George Cruikshank.* Los Angeles: William Andrews Clark Memorial Library, 1971, pp. 73–90.
Bowden, Ann. "William Hone's Political Journalism, 1815–1821." Ph.D. diss. in mass communications. University of Texas at Austin, 1975.
Bowring, Sir John. *Autobiographical Recollections.* London: Henry S. King and Co., 1877.
Brantlinger, Patrick. *Rule of Darkness: British Literature and Imperialism, 1830–1914.* Ithaca, New York and London: Cornell University Press, 1988.
———. *The Spirit of Reform: British Literature and Politics, 1832–1867.* Cambridge, Mass. and London: Harvard University Press, 1977.
Brewer, John. *The Common People and Politics, 1750–1790s (The English Satirical Print, 1600–1832).* Cambridge: Chadwyck-Healey, 1986.
Brice, Alec W. and K. J. Fielding. "A New Article by Dickens: 'Demoralisation and Total Abstinence'," *Dickens Studies Annual* 9 (1981): 1–19.
Briggs, Asa. *The Age of Improvement, 1783–1867.* London: Longman, 1959.
Broadley, A[lexander] M[eyrick]. *Napoleon in Caricature, 1795–1821.* 2 vols. London: John Lane, 1911.
Broderip, Frances Freeling, and Thomas Hood. *Memorials of Thomas Hood.* 2 vols. Boston: Ticknor and Fields, 1860.
Buchanan-Brown, John. *The Book Illustrations of George Cruikshank.* Newton Abbot: David and Charles, 1980.
Buckley, Jerome H. *The Triumph of Time: A Study of the Victorian Concepts of Time, History, Progress, and Decadence.* Cambridge: Belknap Press of Harvard University Press, 1966.
Burton, Anthony. "Thackeray's Collaborations with Cruikshank, Doyle, and Walker," *Costerus* n.s. 2 (1974): 141–184.
Burton, Elizabeth. *The Early Victorians at Home, 1837–1861.* London: Longman, 1972.
Buss, Robert William. *English Graphic Satire.* London: Printed for the Author by Virtue, 1874.
Butler, Marilyn. *Romantics, Rebels and Reactionaries: English Literature and Its Background, 1760–1830.* Oxford: OPUS, Oxford University Press, 1981.
Butt, John, and Kathleen Tillotson. *Dickens at Work.* London: Methuen, 1957.
Byrom, Michael. *Punch and Judy: Its Origin and Evolution.* London: Perpetua Press, 1972.
Calloway, Stephen. *English Prints for the Collector.* Guildford and London: Lutterworth Press, 1980; Woodstock, NY: Overlook Press, 1981.
Carr, J[oseph William] Comyns. *Essays on Art.* London: Smith, Elder, 1879.
Carretta, Vincent. *George III and the Satirists from Hogarth to Byron.* Athens, Ga.: University of Georgia Press, 1989.
———. *The Snarling Muse.* Philadelphia: University of Pennsylvania Press, 1983.
Casteras, Susan P. *The Substance or the Shadow: Images of Victorian Womanhood.* New Haven: Yale Center for British Art, 1982.
Chadwick, Roger. "*Uncle Tom's Cabin* in England," Unpublished M.A. paper, Rice University, 1987.
Chambers, Robert, ed. *The Book of Days.* 2 vols. London and Edinburgh: W. and R. Chambers, [1862–1864].
Chatto, William Andrew, author, and John Jackson, illus. *A Treatise on Wood Engraving Historical and Practical.* London: Charles Knight, 1839; new ed., with an additional chap-

ter [which contains Cruikshank references] by Henry G. Bohn. New York: J. W. Bouton, [1861].

Chesson, W. H. *George Cruikshank*. London: Duckworth; New York: E. P. Dutton, [1906].

Chesterton, G. K. *Appreciations and Criticisms of the Works of Charles Dickens*. London: J. M. Dent and Sons, 1911.

———. *Charles Dickens*. New York: Dodd Mead and Company, 1906.

Chittick, Kathryn. *Dickens and the 1830s*. Cambridge: Cambridge University Press, 1990.

Clarke, Charles and Mary Cowden Clarke. *Recollections of Writers*. London: Sampson Low, Marston, Searle, and Rivington, 1878.

[Clarke, William?]. "Edmund Kean." *The Georgian Era*, ed. William Clarke and Gilbert Abbott à Beckett. 4 vols. London: Vizetelly, Branston, 1832–1834, 4:437–438.

[Clarke, William]. *Every Night Book; or, Life after Dark*. London: T. Richardson, 1827.

———. "George Cruikshank." *The Georgian Era*. 4:226–228.

———. "Life and Genius of George Cruikshank," *Monthly Magazine* 15, no. 86 (Feb. 1833): 131–147.

Clayborough, Arthur. *The Grotesque in English Literature*. Oxford: Clarendon Press, 1965.

Cohen, Jane R. "'All-of-a-Twist': The Relationship of George Cruikshank and Charles Dickens," *Harvard Library Bulletin* 17 (Apr. 1969): 169–194 and (July 1969): 320–342.

———. *Charles Dickens and His Original Illustrators*. Columbus: Ohio State University Press, 1980.

Cohn, Albert M. *A Few Notes upon Some Rare Cruikshankiana*. London: Karslake and Co., 1915.

Cole, G.D.H., and Raymond Postgate. *The Common People, 1746–1946*. 2d ed. London: Methuen, 1946.

Collier, John Payne. *An Old Man's Diary, Forty Years Ago* [1832–1833]. 4 parts. London: Thomas Richards, 1871–1872.

Collins, Philip. *Dickens and Crime* (Volume XVII of Cambridge Studies in Criminology). London: Macmillan, 1962.

Conrad, Peter. "The book as Romantic landscape." *Times Literary Supplement*, 25 March 1977, p. 336.

———. "Wrestling with Demons." *Times Literary Supplement*, 26 July 1974, pp. 798–799.

Conway, Moncure Daniel. *Autobiography: Memories and Experiences*. 2 vols. London: Cassell, 1904.

Cook, Clarence. "George Cruikshank," *Galaxy* 5 (Jan. 1868): 126–127.

Copinger, Walter Arthur. *The Law of Copyright*. London: Stevens and Haynes, 1870.

Cruikshank, George. *The Artist and the Author*. London: Bell and Daldy, 1872.

[Cruikshank, George]. *Drawings by George Cruikshank Prepared by Him to Illustrate an Intended Autobiography*. London: Chatto, 1895.

Cullchickweed, Ebenezer [William Clark]. *The Cigar*. London: T. Richardson, 1826.

Cunningham, Hugh. *The Volunteer Force: A Social and Political History 1859–1908*. London: Croom Helm, 1975.

Cuno, James. "Charles Philipon, La Maison Aubert, and the Business of Caricature in Paris, 1829–41," *Art Journal* 43, no. 4 (Winter 1983): 347–354.

Curtis, L. Perry, Jr. *Apes and Angels: The Irishman in Victorian Caricature*. Washington: Smithsonian Institution Press, 1971.

Dalziel, George and Edward. *The Brothers Dalziel*. London: Methuen, 1901.

Daniel, George. *Love's Last Labour Not Lost*. London: Basil Montagu Pickering, 1863.

Darton, F[rederick] J. Harvey. *Children's Books in England: Five Centuries of Social Life*. 3d ed., rev. Brian Alderson. Cambridge: Cambridge University Press, 1982.

David, Alfred. "An Iconography of Noses: Directions in the History of a Physical Stereotype," in *Mapping the Cosmos*, ed. Jane Chance and R. O. Wells, Jr. Houston: Rice University Press, 1985.

Davies, James A. *John Forster: A Literary Life*. Totowa, N.J.: Barnes and Noble, 1983.

——. "Striving for Honesty: An Approach to Forster's *Life*," *Dickens Studies Annual* 7 (1978): 34–48.

Davis, Frank. *Victorian Patrons of the Arts*. London: Country Life, 1963.

Davis, Paul. "Imaging *Oliver Twist*: Hogarth, Illustration, and the Part of Darkness," *Dickensian* 82, part 3 (Autumn 1986): 158–176.

De Mare, Eric. *The Victorian Woodblock Illustrators*. New York: The Sandstone Press, 1981.

Denvir, Bernard. *The Early Nineteenth Century: Art, Design and Society, 1789–1852*. London: Longman, 1984.

DeVries, Duane. *Dickens's Apprentice Years: The Making of a Novelist*. Hassocks, Sussex: Harvester Press; New York: Barnes and Noble, 1976.

D[exter], W[alter]. "The Reception of Dickens's First Book," *Dickensian* 32, no. 237 (Winter 1935–1936): 43–50.

Dickinson, H[arry] T. *Caricatures and the Constitution, 1760–1832 (The English Satirical Print, 1660–1832)*. Cambridge: Chadwyck-Healey, 1986.

——. "A Good Line in Satire," *Times Higher Education Supplement*, 4 Dec. 1981, pp. 12–13.

Dingle, A. E. *The Campaign for Prohibition in Victorian England*. New Brunswick, N.J.: Rutgers University Press, 1980.

Dodds, John W. *The Age of Paradox: A Biography of England 1841–1851*. New York: Rinehart, 1952.

Duffy, Michael, gen. ed. *The English Satirical Print, 1600–1832*. 7 vols. Cambridge: Chadwyck-Healey, 1986.

Du Maurier, George. "The Illustrating of Books. From the Serious Artist's Point of View," *The Magazine of Art* 13 (Aug., Sept. 1890): 349–353, 371–375.

——. *The Young George Du Maurier: A Selection of His Letters, 1860–67*, ed. Daphne Du Maurier. London: Peter Davis, 1951.

Dyos, H. J. and Michael Wolff, eds. *The Victorian City*. 2 vols. London: Routledge and Kegan Paul, 1973.

Eden, Horatia K. F. *Juliana Horatia Ewing and Her Books*. London: Society for Promoting Christian Knowledge, 1896; reprint Detroit: Gale Research, 1969.

Egan, Pierce. *Life in London* London: Sherwood, Neely, and Jones, 1821; reprint London: John Camden Hotten, [1870].

Eichenberg, Fritz. *The Art of the Print: Masterpieces, History, Techniques*. New York: Harry N. Abrams, 1976.

Eliot, George. *Selections from George Eliot's Letters*, ed. Gordon S. Haight. New Haven: Yale University Press, 1985.

Emsley, Clive. *British Society and the French Wars, 1793–1815*. Totowa, N.J.: Rowman and Littlefield, 1979.

——. "The Impact of War and Military Participation on Britain and France, 1792–1815," *Artisans, Peasants and Proletarians 1760–1860*, ed. Clive Emsley and James Walvin. London: Croom Helm, 1985, pp. 57–80.

Engen, Rodney K. *Victorian Engravings*. London: Academy Editions; New York: St. Martin's Press, 1975.

Epstein, James. "Understanding the Cap of Liberty: Symbolic Practice and Social Conflict in Early Nineteenth-Century England," *Past and Present* 122 (Feb. 1989): 75–118.

Evans, Edmund. *The Reminiscences of Edmund Evans*, ed. Ruari McLean. Oxford: Clarendon Press, 1967.

Evans, Hilary and Mary Evans. *The Man Who Drew the Drunkard's Daughter*. London: Frederick Muller, 1978.

Everitt, Graham. *English Caricaturists and Graphic Humourists of the Nineteenth Century*. London: Swan Sonnenschein, 1886.

Feaver, William. "Cruikshank for Posterity," *Listener*, 2 Mar. 1978, p. 272.

———. *George Cruikshank*. Exhibition catalogue. London: Arts Council of Great Britain, [1974].

———. *Masters of Caricature*. New York: Alfred A. Knopf, 1980.

Fielding, K. J. "John Henry Barrow and the Royal Literary Fund," *Dickensian* 48, part 2 (Mar. 1952): 61–64.

Fielding, T. H. *The Art of Engraving*. London: M. A. Nattali, 1844.

Fildes, L. V. *Luke Fildes, R.A.: A Victorian Painter*. London: Michael Joseph, 1968.

Findlater, Richard. *Grimaldi: King of Clowns*. London: Macgibbon and Kee, 1955.

Fisch, Audrey A. "'Exhibiting Uncle Tom in Some Shape or Other': The Commodification and Reception of *Uncle Tom's Cabin* in England," *Nineteenth-century Contexts* 17, no. 2 (1993): 145–158.

FitzGerald, Edward. *Letters*, ed. Alfred McKinley Terhune and Annabelle Burdick Terhune. 4 vols. Princeton: Princeton University Press, 1980.

Fleuriot de Langle, Vicomte. "English Caricatures of Napoleon Bonaparte," *Connoisseur* 157 (Nov. 1964): 177–181.

Forgues, Emile. "La Caricature en Angleterre." 3 installments. *La Revue Britannique*, 7th ser., 24–25 (Nov. 1854–Jan. 1855): 24:201–216, 321–352; 25:145–202.

Fox, Celina. "The Age of Illustration." *Times Literary Supplement*, 30 Jan. 1981, p. 116.

———. *Graphic Journalism in England during the 1830s and 1840s*. New York and London: Garland Publishing, 1988.

Freud, Sigmund. *Jokes and Their Relation to the Subconscious*. Vol. 8 (1905) of *The Standard Edition of the Complete Psychological Works of Sigmund Freud*, ed. and trans. James Strachey. London: Hogarth Press and Institute of Psychoanalysis, 1960.

Frith, William Powell. *My Autobiography and Reminiscences*. New York: Harper and Brothers, 1888.

Fulkerson, Richard P. "*Oliver Twist* in the Victorian Theatre," *Dickensian* 70, part 2 (May 1974): 83–95.

Gates, Barbara T. *Victorian Suicide: Mad Crimes and Sad Histories*. Princeton: Princeton University Press, 1988.

Gaultier, Bon [Sir Theodore Martin]. "Illustrations of the Thieves' Literature—No. 1. Flowers of Hemp; or, the Newgate Garland," *Tait's Edinburgh Magazine* n.s. 8 (April 1841): 215–223.

Gautier, Maurice-Paul. *Captain Frederick Marryat: l'homme et l'oeuvre*. Paris: Didier, 1973.

Geijer, Erik Gustaf. *Impressions of England, 1809–1810*, trans. Elizabeth Sprigge and Claude Napier. London: Jonathan Cape, 1932.

George, M. Dorothy. *Hogarth to Cruikshank: Social Change in Graphic Satire*. London: Allen Lane, Penguin Press, 1967.

Gettmann, Royal A. *A Victorian Publisher: A Study of the Bentley Papers*. Cambridge: Cambridge University Press, 1960.

Gibbs-Smith, C. H. *The Great Exhibition of 1851*. 2d ed. London: Her Majesty's Stationery Office, 1981.

Gillett, Paula. *Worlds of Art: Painters in Victorian Society*. New Brunswick, N.J.: Rutgers University Press, 1990.

Glassman, Elizabeth and Marilyn F. Symmes, *Cliché-verre: Hand-Drawn, Light-Printed*. Detroit: Detroit Institute of Arts, 1980.

Godfrey, Richard. *English Caricature: 1620 to the Present*. London: Victoria and Albert Museum, 1984.

———. *Printmaking in Britain*. New York: New York University Press, 1978.

Gombrich, E. H. *Art and Illusion*. New York: Pantheon Books, 1960.

Gombrich, E. H. and Ernst Kris. *Caricature*. Harmondsworth: Penguin Books, 1940.

Gordon, Catherine M. *British Paintings of Subjects from the English Novel, 1740–1870*. New York and London: Garland Publishing, 1988.

———. "The Illustration of Sir Walter Scott: Nineteenth-Century Enthusiasm and Adaptation," *Journal of the Warburg and Courtauld Institutes* 34 (1971): 297–317.

———. "Scott's Impact on Art," *Apollo* 98 (July–Sept. 1973): 36–39.

Gosling, Nigel. *Gustave Doré*. Newton Abbot: David and Charles, 1973.

Gough, John B[artholomew]. *Autobiography and Personal Recollections*. Springfield, Mass.: Bill, Nichols, and Co., 1869.

———. *The Works of George Cruikshank*. Boston: The Club of Odd Volumes, 1890.

Grand-Carteret, John. *Napoleon en Images*. Paris: Fermin-Didot, 1895.

Grant, James. *Portraits of Public Characters*. 2 vols. London: Saunders and Otley, 1841.

Gray, Basil. *The English Print*. London: Adam and Charles Black, 1937.

Grego, Joseph. *Cruikshank's Water Colours*. London: A. and C. Black, 1903.

———. "The Early Genius of George Cruikshank," *Connoisseur* 5 (1903): Part I, 186–193; Part II, 255–260.

———. *Rowlandson the Caricaturist*. 2 vols. London: Chatto and Windus, 1880.

Grillo, Virgil. *Charles Dickens' Sketches by Boz*. Boulder: Colorado Associated University Press, 1974.

Grimm, Jacob and Wilhelm. *German Popular Stories*, trans. Edgar Taylor, intro. John Ruskin. London: John Camden Hotten, 1868.

Guratzsch, Herwig. *George Cruikshank, 1792–1878*. Stuttgart: Verlag Gerd Hatje, 1983.

Haden, [Francis] Seymour. *About Etching*. London: Fine Art Society, 1879.

Hadley, Elaine. "Natives in a Strange Land: The Philanthropic Discourse of Juvenile Emigration of Mid-Nineteenth-Century England," *Victorian Studies* 33, no. 3 (Spring 1990): 411–439.

Haight, Anne Lyon. "Charles Dickens tries to remain Anonymous," *Colophon* 1, no. 1 new graphic series (Spring 1939): [39–66].

Haight, Sherman P. "George Cruikshank," *The Publishers' Weekly* 114 (17 November 1928): 2059–2063.

Hall, S. C. *Retrospect of a Long Life: From 1815 to 1883*. 2 vols. London: Richard Bentley and Son, 1883.

Hamerton, Philip Gilbert. *Etching and Etchers*. 2d ed., rev., 1875; reprint, Boston: Little Brown, 1912.

———. *The Graphic Arts*. London: Seeley and Co., 1882.

———. "Modern Etching in France," *Fine Arts Quarterly Review* 2 (Jan.–May 1864): 69–110.

Hamilton, George Heard. "Delacroix, Byron, and the English Illustrators," *Gazette des Beaux-Arts*, 6th ser., 36 (Oct.–Dec. 1949): 261–278.

Hamilton, Walter. *A Memoir of George Cruikshank, Artist and Humourist*. London: Elliot Stock, 1878.

Hamst, Olphar [Ralph Thomas]. "George Cruikshank," *Notes and Queries*, 5th ser., 9 (25 May 1878): 402.

Hanham, H. J. "The Theory of the Constitution," *The Nineteenth-Century Constitution, 1815–1914*, ed. H. J. Hanham. Cambridge: Cambridge University Press, 1969.

Harpham, Geoffrey Galt. *On the Grotesque*. Princeton: Princton University Press, 1982.

Harrison, Brian. *Dictionary of British Temperance Biography*. Aids to Research, No. 1. Coventry and Sheffield: Society for the Study of Labour History, 1973.

———. "Drink and Sobriety in England 1815–1872: a Critical Bibliography," *International Review of Social History* 12 (1967): 204–276.

———. *Drink and the Victorians: The Temperance Question in England 1815–1872*. London: Faber and Faber, 1971.

———. "Drunkards and Reformers: Early Victorian Temperance Tracts," *History Today* 13 (Mar. 1963): 178–185.

Harvey, John. *Victorian Novelists and Their Illustrators*. New York: New York University Press, 1971.

Hatton, Thomas. *Retrospectus and Prospectus: The Nonesuch Dickens*. Bloomsbury: Nonesuch Press, 1937.

Hayter, Alethea. *A Sultry Month: Scenes of London Literary Life in 1846*. London: Faber and Faber, 1965.

Hearn, Michael Patrick. "George Cruikshank: The 'Children's Friend'," *American Book Collector*, n.s. 3 (Jan.–Feb. 1982): 3–13.

Henkle, Roger B. *Comedy and Culture: England 1820–1900*. Princeton: Princeton University Press, 1980.

Herendeen, Wyman H. "The Doré Controversy: Doré, Ruskin, and Victorian Taste," *Victorian Studies* 25, no. 3 (Spring 1982): 304–327.

Hertz, Neil. *The End of the Line: Essays on Psychoanalysis and the Sublime*. New York: Columbia University Press, 1985.

Hill, Draper. *Fashionable Contrasts: Caricatures by James Gillray*. London: Phaidon Press, 1966.

———. *Mr. Gillray, the Caricaturist*. London: Phaidon Press, 1965.

Hill, Jonathan E. "Cruikshank, Ainsworth, and Tableau Illustration," *Victorian Studies* 23, no. 4 (Summer 1980): 429–459.

———. *The Genial Genius of George Cruikshank*. Minneapolis: Wilson Library, University of Minnesota, 1992.

———. *George Cruikshank: A Bicentennial Exhibition*. Philadelphia: Rosenbach Library, 1992.

———. "Serial Humor: George Cruikshank and the Prince Regent," *Humor in Art*, ed. Debra N. Mancoff. Museum of Beloit College Occasional Papers Series, vol. 1, no. 2, pp. 5–13.

Hind, Arthur M[ayger]. *A History of Engraving and Etching from the 15th Century to the Year 1914*. 3d ed. London: Constable, 1923.

———. *An Introduction to a History of Woodcut*. 2 vols. London: Constable, 1935.

Hindley, Charles. *The True History of Tom and Jerry*. London: Charles Hindley, [1888].

Hodder, George. *Memories of My Time*. London: Tinsley Brothers, 1870.

Hodnett, Edward. *Image and Text*. London: Scolar Press, 1982.

Hofmann, Werner. *Caricature from Leonardo to Picasso*. London: John Calder, 1957.

Holbrook, John Pinckney. "Cruikshank's Sketch Book: The 'Gold' Question," *Papers of the Bibliographical Society of America* 40 (3d quarter, 1946): 225–229.

Hollingsworth, Keith. *The Newgate Novel, 1830–1847: Bulwer, Ainsworth, Dickens, & Thackeray*. Detroit: Wayne State University Press, 1963.

Holme, Geoffrey, ed. *British Book Illustration Yesterday and Today*. London: The Studio, 1923.

Hone, J. Ann. *For the Cause of Truth: Radicalism in London, 1796–1821*. Oxford: Clarendon Press, 1982.

Hone, William. *Ancient Mysteries Described*. London: William Hone, 1823.

———. *Aspersions Answered*. London: William Hone, 1924.

———. *The Early Life and Conversion of William Hone*. London: T. Ward and Co., 1841.

———. *The First [Second, Third] Trial of William Hone*. London: William Hone, 1818.

Hood, Thomas. *Letters*, ed. Peter F. Morgan. Toronto: University of Toronto Press, 1973.

————. *Works*, ed. Thomas Hood [the Younger]. 7 vols. London: Edward Moxon, 1862.

Hooker, Kenneth Ward. *The Fortunes of Victor Hugo in England*. New York: Columbia University Press, 1938.

Horne, Richard Hengist, ed. *A New Spirit of the Age*. Reprint, London: Oxford University Press, 1907.

Houfe, Simon. *The Dictionary of British Book Illustrators and Caricaturists 1800–1914*. Rev. ed., Woodbridge, Suffolk: Antique Collectors' Club, 1981.

Howell, Charles A. *Subscription Testimonial to George Cruikshank*. July 1866.

Howitt, Mary. *Mary Howitt: An Autobiography*, ed. Margaret Howitt. 2 vols. Boston and New York: Houghton, Mifflin, 1889.

Hudson, Derek. *Munby: Man of Two Words*. London: John Murray, 1972.

Humpherys, Anne. *Travels into the Poor Man's Country: The Work of Henry Mayhew*. Athens: University of Georgia Press, 1977.

Hunnisett, Basil. *Steel-engraved Book Illustration in England*. Boston: David R. Godine, 1980.

Hunt, John Dixon. *Encounters: Essays on Literature and the Visual Arts*. New York: Norton, 1971.

James, Henry. *A Small Boy and Others*. New York: Charles Scribner's Sons, 1913.

James, Louis. "Cruikshank and Early Victorian Caricature," *History Workshop* 6 (Autumn 1970): 107–120.

————. "'Economic' Literature: The Emergence of Popular Journalism," *Victorian Periodicals Newsletter* 14 (Dec. 1971–Jan. 1972): 13–20.

Jeaffreson, John Cordy. *A Book of Recollections*. 2 vols. London: Hurst and Blackett, 1894.

Jerdan, William. *Autobiography*. 4 vols. London: Arthur Hall, Virtue, and Co., 1852–1853.

Jerrold, Blanchard. *Life of Gustave Doré*. London: W. H. Allen, 1891.

[Jewitt, L.]. "George Cruikshank," *The Reliquary and Illustrated Archaeologist* 18 (Feb. 1878): 231–233.

The John Johnson Collection: Catalogue of an Exhibition. Oxford: Bodleian Library, 1971.

Johnson, Diane L. *Fantastic Illustration and Design in Britain, 1850–1920*. Providence: Rhode Island School of Design Museum of Art; New York: Cooper-Hewitt Museum, 1979.

Johnson, Edgar. *Charles Dickens: His Tragedy and Triumph*. 2 vols. New York: Simon and Schuster, 1952.

————. *Sir Walter Scott: The Great Unknown*. 2 vols. London: Hamish Hamilton, 1970.

Johnson, E.D.H. *Paintings of the British Social Scene from Hogarth to Sickert*. New York: Rizzoli, 1986.

Jones, Howard Mumford. "The Comic Spirit and Victorian Sanity," in *The Reinterpretation of Victorian Literature*, ed. Joseph E. Baker. Princeton: Princeton University Press, 1950, pp. 20–32.

Jouve, Michel. *L'Age d'Or de la caricature Anglaise*. Paris: Presses de la fondation Nationale des sciences politiques, 1983.

Kayser, Wolfgang. *The Grotesque in Art and Literature*, trans. Ulrich Weisstein. 1963, reprint New York: Morningside Edition of Columbia University Press, 1981.

Kelly, Dawn P. "Liberation or Restraint: The Demonic in the Works of George Cruikshank," *CEA Critic* 48, no. 1 (Fall 1985): 23–34.

K[eyes], H. E. "'The Bottle' and Its American Refills," *Antiques* 19 (May 1931): 386–390.

Kitton, Frederic G. *Charles Dickens by Pen and Pencil*. London: Frank T. Sabin and John F. Dexter, 1890.

————. *Dickens and His Illustrators*. London: George Redway, 1899.

————. "Pseudo-Dickens Rarities," *Athenaeum*, 11 Sept. 1897, pp. 355–356.

Klingender, Francis D[onald]. *Art and the Industrial Revolution*, ed. and rev. Arthur Elton. [London]: Evelyn, Adams, and Mackay, [1968].

————, ed. Hogarth and English Caricature. London and New York: Transatlantic Arts Co. and Pilot Press, 1944.

————. Russia—Britain's Ally, 1812–1942. London: George G. Harrap, 1942.

Knight, Charles. Passages of a Working Life during Half a Century. 3 vols. London: Bradbury and Evans, 1864.

Kotzin, Michael C. Dickens and the Fairy Tale. Bowling Green, Ohio: Bowling Green University Popular Press, 1972.

————. "The Fairy Tale in England, 1800–1870," Journal of Popular Culture 4, no. 1 (Summer 1970): 130–154.

Kris, Ernst. "The Psychology of Caricature," International Journal of Psycho-Analysis 17 (1936): 285–303.

Kris, Ernst, and Ernst Gombrich. "The Principles of Caricature," The British Journal of Medical Psychology 17 (1938): 319–342.

Kritter, Ulrich von. The Art of Illustration: Englische illustrierte Bucher des 19. Jahrunderts. Eine Ausstellung im Zeughaus der Herzog August Bibliothek Wolfenbuttel, 1 Dec. 1984–21 Apr. 1985.

Kroeber, Karl. "Constable:Millais/Wordsworth:Tennyson," in Articulate Images: The Sister Arts from Hogarth to Tennyson, ed. Richard Wendorf. Minneapolis: University of Minnesota Press, 1983, pp. 216–242.

Krumbhaar, E[dward] B[ell]. Isaac Cruikshank. Philadelphia: University of Pennsylvania Press, 1966.

Kubiak, Richard. George Cruikshank: Printmaker (1792–1878). [Santa Barbara: no publisher, 1978].

Kunzle, David. "Between Broadsheet Caricature and Punch: Cheap Newspaper Cuts for the Lower Classes in the 1830s," Art Journal 43, no. 4 (Winter 1983): 339–346.

————. The History of the Comic Strip. 2 vols. Berkeley: University of California Press, 1973, 1990.

Lamb, Charles. "Essay on the Genius and Character of Hogarth," in Anecdotes of William Hogarth. London: J. B. Nichols and Son, 1833.

Lang, Andrew. Life and Letters of John Gibson Lockhart. 2 vols. London: John C. Nimmo, 1897.

Langford, Paul. Walpole and the Robinocracy (The English Satirical Print, 1600–1832). Cambridge: Chadwyck-Healey, 1986.

Laqueur, Thomas. "The Queen Caroline Affair: Politics as Art in the Reign of George IV," Journal of Modern History 54 (Sept. 1982): 417–466.

Laski, Marghanita. Mrs. Ewing, Mrs. Molesworth, and Mrs. Hodgson Burnett. London: Arthur Barker, 1950.

Lavater, Johann Caspar. Essays on Physiognomy, trans. Henry Hunter. 4 vols. London: G. G. J. and J. Robinson, 1789.

Laver, James. Taste and Fashion From the French Revolution to the Present Day. Rev. ed., London: George G./D. Harrap, 1945.

Lawley, G. T. "Cruikshank and Hone." Berg Collection, The New York Public Library, Astor, Lenox, and Tilden Foundations.

Layard, George Somes. George Cruikshank's Portraits of Himself. London: W. T. Spencer, 1897.

————. Suppressed Plates. London: Adam and Charles Black, 1907.

————. "Suppressed Plates III," Pall Mall Magazine 17 (Mar. 1899): 341–348.

Ley, J.W.T. The Dickens Circle. London: Chapman and Hall, 1918.

————. "Robert Seymour and Mr. Pickwick," Dickensian 21, no. 3 (July 1925): 122–127.

Lindemann, Gottfried. Prints and Drawings: A Pictorial History, trans. Gerald Onn. New York: Praeger, 1970.

Lindley, Kenneth. The Woodblock Engravers. Newton Abbot: David and Charles, 1970.

Lindsay, Jack. *Charles Dickens: A Biographical and Critical Study*. London: Andrew Dakers, 1950.

Linton, W[illiam] J[ames]. *Some Practical Hints on Wood-Engraving for the Instruction of Reviewers and the Public*. Boston: Lee and Shepard, 1879.

Lister, Raymond. *Great Images of British Printmaking: A Descriptive Catalogue 1789–1939*. London: Robin Garton, 1978.

Lloyd, Christopher. *Captain Marryat and the Old Navy*. London: Longmans, Green, 1939.

Locker-Lampson, Frederick. *My Confidences*. London: Smith, Elder, 1896.

[Lockhart, John Gibson]. "Lectures on the Fine Arts. No. 1. On George Cruikshank," *Blackwood's Edinburgh Magazine* 14 (July 1823): 18–26.

Lockridge, Laurence S., John Maynard, and Donald D. Stone, eds. *Nineteenth-Century Lives: Essays Presented to Jerome Hamilton Buckley*. Cambridge: Cambridge University Press, 1989.

Longfellow, Henry Wadsworth. *Letters*, ed. Andrew Hilen, Vol. 2. Cambridge, Mass.: Belknap Press of Harvard University Press, 1966.

Longmate, Norman. *The Waterdrinkers: A History of Temperance*. London: Hamish Hamilton, 1968.

McCalman, Iain. *Radical Underworld: Prophets, Revolutionaries, and Pornographers in London, 1795–1840*. Cambridge: Cambridge University Press, 1988.

———. "Unrespectable Radicalism: Infidels and Pornography in Early Nineteenth-Century London," *Past and Present* 104 (Aug. 1984): 74–110.

Mackay, Charles. *Forty Years' Recollections of Life, Literature, and Public Affairs*. 2 vols. London: Chapman and Hall, 1877.

———. *Through the Long Day, or, Memorials of a Literary Life During Half A Century*. 2 vols. London: W. H. Allen, 1887.

Mackenzie, R[obert] Shelton. "George Cruikshank," *London Journal* 6 (20 Nov. 1847): 177–182.

———. *Life of Charles Dickens*. Philadelphia: T. B. Peterson and Brothers, 1870.

———. "Philadelphia," *The Round Table*, 11 Nov. 1865, pp. 155–156.

McLean, Ruari. *George Cruikshank: His Life and Work as a Book Illustrator*. English Masters of Black and White Series. London: Art and Technics, 1948.

McMaster, Juliet. *Dickens the Designer*. Totowa, New Jersey: Barnes and Noble, 1987.

MacNalty, Sir Arthur Salusbury. *A Biography of Sir Benjamin Ward Richardson*. London: Harvey and Blythe, 1950.

Macready, William Charles. *Diaries*, ed. William Toynbee. 2 vols. New York: G. P. Putnam's Sons, 1912.

[Maginn, William]. "Gallery of Literary Characters. No. 39. George Cruikshank Esq.," *Fraser's Magazine* 4 (Aug. 1833): 190.

Malcolm, J. P. *An Historical Sketch of the Art of Caricaturing*. London: Longman, Hurst, Rees, Orme, and Brown, 1813.

Mannheim, Karl. *Ideology and Utopia*, trans. Louis Wirth and Edward Stils. New York: Harcourt, Brace, and World, 1936.

Marryat, Florence. *Life and Letters of Captain Marryat*. 2 vols. New York: D. Appleton, 1872.

———. "Memoir of Captain Marryat R.N., C.B., F.R.S.," in *Works of Captain Marryat*, vol. 1. New York: Peter Fenelon Collier, [1900].

Marten, Harry [P.]. "Exaggerated Character: A Study of the Works of Dickens and Hogarth," *Centennial Review* 20 (Summer 1976): 290–308.

———. "The Visual Imaginations of Dickens and Hogarth: Structure and Scene," *Studies in the Novel* 6 (Summer 1974): 145–164.

Martin, Robert Bernard. *The Triumph of Wit: A Study of Victorian Comic Theory*. Oxford: Clarendon Press, 1974.

Maurice, Arthur Bartlett, and Frederic Taber Cooper. *The History of the Nineteenth Century in Caricature*. New York: Dodd, Mead, 1904.

Maxwell, Christabel. *Mrs. Gatty and Mrs. Ewing*. London: Constable, 1949.

Mayoux, Jean-Jacques. *English Painting: From Hogarth to the Pre-Raphaelites*. New York: St. Martin's Press, 1972.

Meglin, Nick. *The Art of Humorous Illustration*. London: Pitman; New York: Watson-Guptill, 1973.

Meisel, Martin. *Realizations: Narrative, Pictorial, and Theatrical Arts in Nineteenth-Century England*. Princeton: Princeton University Press, 1983.

Melcher, Edith. *The Life and Times of Henry Monnier, 1799–1877*. Cambridge, Mass.: Harvard University Press, 1950.

Melville, Lewis. *William Makepeace Thackeray*. 2 vols. London: John Lane, The Bodley Head, 1910.

Michaelis-Jena, Ruth. *The Brothers Grimm*. London: Routledge and Kegan Paul, 1970.

Miller, J. Hillis. "The Fiction of Realism: *Sketches by Boz, Oliver Twist*, and Cruikshank's Illustrations," in *Charles Dickens and George Cruikshank*. Los Angeles: William Andrews Clark Memorial Library, 1971.

Miller, John. *Religion in Popular Prints, 1600–1832 (The English Satirical Print, 1600–1832)*. Cambridge: Chadwyck-Healey, 1986.

Mitchell, Charles. *Hogarth's Peregrination*. Oxford: Clarendon Press, 1952.

Moers, Ellen. *The Dandy: Brummel to Beerbohm*. London: Secker and Warburg, 1960.

Möller, Joachim, ed. *Englische Buchillustration im Europäischen Kontext*. Berlin: Technical University, 1989.

———. *Imagination on a Long Rein*. Marburg, West Germany: Jonas Verlag, 1988.

Morgan, Edward S. "A Brief Retrospect." 4 July 1873. University of Illinois Bentley Papers.

Muir, Percy. *Victorian Illustrated Books*. London: B. T. Batsford, 1971.

Nadel, Ira Bruce and F. S. Schwarzbach, eds. *Victorian Artists and the City*. Oxford and New York: Pergamon Press, 1980.

[North, Christopher, pseud. John Wilson]. "Cruickshank on Time," *Blackwood's Edinburgh Magazine* 21, no. 127 (June 1827): 777–792.

———. "Noctes Ambrosianae. No. XXIX," *Blackwood's Edinburgh Magazine* 20, no. 119 (Nov. 1826): 770–792.

Nowell-Smith, Simon. *The House of Cassell, 1848–1958*. London: Cassell, 1958.

———. *International Copyright Law and the Publisher in the Reign of Queen Victoria*. Oxford: Clarendon Press, 1968.

Oliphant, Margaret. *William Blackwood and His Sons*. 3 vols. Edinburgh and London: William Blackwood and Sons, 1897.

Olsen, Donald J. *The Growth of Victorian London*. 1976; reprint, Harmondsworth, Middlesex: Penguin, 1979.

O'Neill, John. *Fifty Years' Experience of an Irish Shoemaker in London*. *St. Crispin* (1868).

[O'Rourke, Rory, pseud. Michael James Whitty]. "Graphic Humour," *Dublin and London Magazine*, Apr. 1828, pp. 129–134.

Overton, Jacqueline. "Illustrators of the Nineteenth Century in England," *Illustrators of Children's Books, 1744–1945*, compiled by Bertha E. Mahony, Louise Payson Latimer, and Beulah Folmshee. Boston: The Horn Book, 1947.

[Paget, John]. "George Cruikshank," *Blackwood's Edinburgh Magazine* 94, no. 574 (Aug. 1863): 217–224.

Paget, John. *Paradoxes and Puzzles Historical, Judicial, and Literary*. Edinburgh and London: William Blackwood and Sons, 1874.

Palgrave, Francis Turner. *Essays on Art*. New York: Hurd and Houghton, 1867.

Panton, Jane Ellen [Frith]. *Leaves from a Life*. London: Eveleigh Nash, 1908.

Paroissien, David. *Oliver Twist: An Annotated Bibliography*. Garland Dickens Bibliographies. New York and London: Garland, 1986.

Parton, James. *Caricature and Other Comic Art in All Times and Many Lands*. New York: Harper and Brothers, 1877.

Patten, Robert L. "Conventions of Georgian Caricature," *Art Journal* 43, no. 4 (Winter 1983): 331–338.

———. "George Cruikshank's Private 'Day Book,' 1810–1825," *Princeton University Library Chronicle* 51, no. 3 (Spring 1990): 225–244.

———. "George's Hive and the Georgian Hinge," *Browning Institute Studies* 14. New York: Browning Institute and Graduate School and University Center, City University of New York, 1986.

———. "'So Much Pains about One Chalk-faced Kid': The Clarendon *Oliver Twist*," *Dickens Studies* 3 (Oct. 1967): 160–168.

Paulson, Ronald. *Emblem and Expression: Meaning in English Art of the Eighteenth Century*. Cambridge, Mass.: Harvard University Press, 1975.

———. *Hogarth: His Life, Art, and Times*. 2 vols. New Haven and London: Yale University Press, 1971.

———. *Hogarth's Graphic Works*, rev. ed., 2 vols. New Haven and London: Yale University Press, 1970.

———. *Representations of Revolution, 1789–1820*. New Haven and London: Yale University Press, 1983.

———. *Thomas Rowlandson: A New Interpretation*. London: Studio Vista, 1972.

Pellé, M. C. *Landscape-Historical Illustrations of the Waverley Novels*. 2 vols. London and Paris: Fisher, Son and Co., [1841].

Pennell, Joseph. *Modern Illustration*. London: G. Bell, 1895.

Pettigrew, Thomas Joseph. *Medical Portrait Gallery*. 4 vols. London: Fisher, Son and Co., [1838], vols. 1–2; London: Whittaker, 1840, vols. 3–4.

Phillips, E[mma] Watts. *Watts Phillips*. London: Cassell, 1891.

Phillips, Watts. *Collection of the Works of George Cruikshank*. London?: Privately Printed, 1872?

Podeschi, John B. *Dickens and Dickensiana*. New Haven: Yale University Library, 1980.

Pond, Wayne Johnston. "Thomas Hood as a Forerunner of the Victorian Wasteland." M.A. thesis. Brigham Young University, 1968.

Pope, Norris. *Dickens and Charity*. London and Basingstoke: Macmillan, 1978.

Porter, Roy. "Seeing the Past," *Past and Present* 118 (Feb. 1988): 186–205.

Praz, Mario. *The Hero in Eclipse in Victorian Fiction*, trans. Angus Davidson. London: Geoffrey Cumberlege, Oxford University Press, 1956.

Pückler-Muskau, Hermann. *A Regency Visitor*, trans. Sarah Austin (1832); ed. E. M. Butler. London: Collins, 1957.

Raleigh, John Henry. *Time, Place, and Idea: Essays on the Novel*. Carbondale and Edwardsville: Southern Illinois University Press, 1968.

Ray, Gordon N. *The Illustrator and the Book in England from 1790 to 1914*. New York: Pierpont Morgan Library, 1976.

———. *Thackeray*. 2 vols. London: Oxford University Press, 1955–1958.

Redgrave, F. M. *Richard Redgrave, C.B., R.A.* London: Cassell, 1891.

Reid, J. C. *Bucks and Bruisers*. London: Routledge and Kegan Paul, 1971.

———. *Thomas Hood*. London: Routledge and Kegan Paul, 1963.

Renton, Richard. *John Forster and his Friendships*. London: Chapman and Hall, 1912.

Richardson, Sir Benjamin Ward. *Drawings by George Cruikshank Prepared by him to Illustrate an Intended Biography*. London: Chatto and Windus, 1895.

Richardson, Joanna. *George IV: A Portrait*. London: Sidgwick and Jackson, 1966.

Rickword, Edgell, ed. *Radical Squibs and Loyal Ripostes*. Bath: Adams and Dart, 1971.

Ritchie, Anne Thackeray. "Lord Bateman: A Ballad," *Harper's New Monthly Magazine* 86 (Dec. 1892): 124–129.

Robb, Brian. "George Cruikshank's Etchings for 'Oliver Twist'," *Listener* 74 (1965): 130–131.

Roger, J. C[ruikshank]. "Gallery of Comicalities," *Notes and Queries*, 4th ser., 5 (19 Mar. 1870): 301.

[Rolleston, Frances]. *Some Account of the Conversion from Atheism to Christianity of the Late William Hone.* 2d ed., rev. London: Francis and John Rivington; Keswick: James Ivison, 1853.

Rossetti, William Michael. "Humouristic Designers. Cruikshank," *Fine Art, Chiefly Contemporary: Notices Re-Printed, With Revisions.* London and Cambridge: Macmillan, 1867.

Routledge, James. *Chapters in the History of Popular Progress Chiefly in Relation to the Freedom of the Press and Trial by Jury. 1660–1820.* London: Macmillan, 1876.

Rush, Richard. *A Residence at the Court of London.* London: Richard Bentley, 1833.

Ruskin, John. *Diaries,* ed. Joan Evans and John Howard Whitehouse, 3 vols. Oxford: Clarendon Press, 1958.

[Sala, G(eorge) A(ugustus)]. "Engraved on Steel," *All the Year Round* 27 (Oct. 1866): 372–376.

Sala, G[eorge] A[ugustus]. "George Cruikshank in Mexico," *Atlantic Monthly* 15 (Jan. 1865): 54–64.

———. *The Grand Volunteer Review, 1860.* 2d ed. with account of the Wimbledon Target Shooting. London: William Tinsley [1860].

———. *Life and Adventures.* 2 vols. London: Cassell, 1895.

Salway, Lance. *A Peculiar Gift: Nineteenth Century Writings on Books for Children.* Harmondsworth, Middlesex: Penguin—Kestrel Books, 1976.

Sauerberg, Annette Juel. "On the Literariness of Illustrations: A Study of Rowlandson and Cruikshank," *Semiotica* 14, no. 4 (1975): 364–386.

Sharpe, J. A. *Crime and the Law in English Satirical Prints, 1600–1832 (The English Satirical Print, 1600–1832).* Cambridge: Chadwyck-Healey, 1986.

Sherry, James. "Four Modes of Caricature: Reflections upon a Genre," *Bulletin of Research in the Humanities* 87, no. 1 (1986–1987): 29–62.

Shikes, Ralph E. *The Indignant Eye: The Artist as Social Critic in Prints and Drawings from the Fifteenth Century to Picasso.* Boston: Beacon Press, 1969.

Sitwell, Sacheverell. "George Cruikshank," in *Trio: Dissertations on Some Aspects of National Genius* by Osbert, Edith, and Sacheverell Sitwell. London: Macmillan, 1938.

———. *Narrative Pictures.* 1936; reprint, London: B. T. Batsford; New York: Schocken Books, 1969.

Slythe, R. Margaret. *The Art of Illustration: 1750–1900.* London: The Library Association, 1970.

Smith, Olivia. *The Politics of Language, 1791–1819.* Oxford: Clarendon Press, 1984.

Spater, George. *William Cobbett: The Poor Man's Friend.* 2 vols. Cambridge: Cambridge University Press, 1982.

Speaight, George. *The History of the English Toy Theatre.* 1946, rev. ed., Boston: Plays, Inc.; London: Studio Vista, 1969.

———. *Punch and Judy.* Boston: Plays, Inc., 1955.

Spencer, Walter T. "'Loving Ballad of Lord Bateman', 1839," *Times Literary Supplement,* 2 May 1935, p. 288.

Spielmann, M. H. *The History of "Punch".* New York: Cassell, 1895.

Stead, Philip John. *Mr. Punch.* London: Evans Brothers, 1950.

Steig, Michael. "Cruikshank's Peacock Feathers in *Oliver Twist,*" *Ariel* 4 (Apr. 1973): 49–53.

———. "A Chapter of Noses: Cruikshank's Psychonography of the Nose," *Criticism* 17, no. 4 (Fall 1975): 308–325.

———. "Cruikshank's Nancy," *Dickensian* 72, part 2 (May 1976): 87–92.

Stein, Richard L. "The Case for Cruikshank," *Threepenny Review* 1 (Summer 1980): 27–29.

———. *Victoria's Year: English Literature and Culture, 1837–1838.* New York and Oxford: Oxford University Press, 1987.

Steinberg, Norma S. *Monstrosites and Inconveniences.* Worcester, Mass.: Worcester Art Museum, 1986.

Stephens, Frederic G. *A Memoir of George Cruikshank.* London: Sampson Low, Marston, Searle, and Rivington, 1891.

Stephens, J. R. "*Jack Sheppard* and the Licensers: The Case against Newgate Plays," *Nineteenth Century Theatre Research* 1, no. 1 (Spring 1973): 1–13.

Sterrenburg, Lee. "Psychoanalysis and the Iconography of Revolution," *Victorian Studies* 19 (Dec. 1975): 241–264.

Stewart, John. *The Worship of Bacchus.* 6th ed., London: William Tweedie, 1865.

Stierle, Karlheinz. "Baudelaire and the Tradition of the *Tableau de Paris,*" *New Literary History* 11, no. 2 (Winter 1980): 345–361.

Stocking, George W., Jr. *Victorian Anthropology.* London: Collier Macmillan, 1987.

Stone, Harry. *Dickens and the Invisible World.* Bloomington and London: Indiana University Press, 1978.

Stone, Marcus. "Reminiscences." Unpublished MS at the Dickens House, London.

Stowe, Harriet Beecher. *Sunny Memories of Foreign Lands.* 2 vols. Boston: Phillips, Sampson, and Co.; New York: J. C. Derby, 1854.

Straus, Ralph. *Charles Dickens: A Biography from New Sources.* New York: Grosset and Dunlap, 1928.

———. *Sala.* London: Constable, 1942.

[Sturgis, R.]. "George Cruikshank," *Scribner's Monthly* 16, no. 2 (June 1878): 161–177.

Suleiman, Susan R., and Inge Crosman, eds. *The Reader in the Text: Essays on Audience and Interpretation.* Princeton: Princeton University Press, 1980.

Sutherland, John. "John Macrone: Victorian Publisher," *Dickens Studies Annual* 13 (1984): 243–259.

Swinburne, Algernon Charles. *Charles Dickens,* ed. Theodore Watts-Dunton. London: Chatto and Windus, 1913.

Symonds, Arthur. "Oliver Twist," *Essays of the Year (1929–1930).* London: Argonaut Press, 1930.

Szladits, Lola L., annot. *Charles Dickens, 1812–1870: An Anthology.* New York: Arno Press, 1970.

Tave, Stuart M. *The Amiable Humorist.* Chicago: University of Chicago Press, 1960.

Tegg, William. "George Cruikshank," *Notes and Queries,* 5th ser., 9 (15 June 1878): 478.

[Thackeray, William Makepeace]. "Charles Dickens and His Works," *Fraser's Magazine* 21, no. 124 (Apr. 1840): 381–400.

Thackeray, William Makepeace. "De Juventute," *Cornhill Magazine* 2 (Oct. 1860): 501–512.

———. *The Four Georges.* London: Smith, Elder, 1876.

Thomas, Peter D. G. *The American Revolution (The English Satirical Print, 1600–1832).* Cambridge: Chadwyck-Healey, 1986.

Thomas, Ralph. "The Cruikshanks, Artists, and West and Jameson, Publishers," *Notes and Queries,* 12th ser., 7 (9 Oct. 1920): 281–285.

Thompson, Alice. "A Bundle of Rue: Being Memorials of Artists Recently Deceased. I. George Cruikshank," *Magazine of Art* 3 (Mar. 1880): 169–174, 247–251.

Thompson, F.M.L. *The Rise of Respectable Society. A Social History of Victorian Britain, 1830–1900.* Cambridge, Mass.: Harvard University Press, 1988.

Thornber, Harry. *The Early Work of George Cruikshank.* London and Manchester: John Heywood, 1887.

———. *The Later Work of George Cruikshank.* London and Manchester: John Heywood, 1888.

Thornbury, Walter. *British Artists, from Hogarth to Turner.* 2 vols. London: Hurst and Blackett, 1861.

Thrall, Miriam M. H. *Rebellious Fraser's.* New York: Columbia University Press, 1938.

Tillotson, Geoffrey. *A View of Victorian Literature.* Oxford: Clarendon Press, 1978.

Tillotson, Kathleen. *Novels of the Eighteen-Forties.* 1954; 2d impression Oxford: Oxford University Press, 1961.

Tomory, Peter. *The Life and Art of Henry Fuseli.* London: Thames and Hudson, 1972.

Tompkins, Jane. *Sensational Designs.* New York and Oxford: Oxford University Press, 1985.

Tracy, Robert, "'The Old Story' and Inside Stories: Modish Fictions and Fictional Modes in *Oliver Twist,*" *Dickens Studies Annual* 17 (1988): 1–33.

Treuherz, Julian. *Hard Times: Social Realism in Victorian Art.* London: Lund Humphries; Mt. Kisco, NY: Moyer Bell; in association with Manchester City Art Galleries, 1987.

Tucker, Nicholas, ed. *Suitable for Children? Controversies in Children's Literature.* Berkeley and Los Angeles: University of California Press, 1976.

Twyman, Michael. *Lithography, 1800–1850.* London: Oxford University Press, 1970.

Tytler, Graeme. *Physiognomy in the European Novel: Faces and Fortunes.* Princeton: Princeton University Press, 1982.

Uden, Grant, "Wit and Waffle," *Antiquarian Book Monthly Review* 129 (Jan. 1985): 30–31.

Veth, Cornelis. *Comic Art in England,* introduced by James Greig. London: Edward Goldston, 1930.

Viscomi, Joseph. *Playing with the Toy Theatre,* catalogue for exhibition that opened Dec. 1976 at the Neuberger Museum, State University of New York at Purchase.

Vizetelly, Henry. *Glances Back through Seventy Years: Autobiographical and Other Reminiscences.* 2 vols. London: Kegan Paul, Trench, Trubner, 1893.

Vogler, Richard A. *Graphic Works of George Cruikshank.* New York: Dover Publications. 1979.

———. "*Oliver Twist*: Cruikshank's Pictorial Prototypes," *Dickens Studies Annual* 2 (1972): 98–118.

Wakeman, Geoffrey. *Victorian Book Illustration: The Technical Revolution.* Newton Abbot: David and Charles, 1973; Detroit: Gale Research, 1973.

Ward, Mrs. E. M. [Henrietta Mary Ada] *Memories of Ninety Years.* 2d ed. London: Hutchinson, [1924].

Wardroper, John. *The Caricatures of George Cruikshank.* London: Gordon Fraser, 1977.

———. "The secret life of a virtuous artist," *The Independent on Sunday,* 25 Oct. 1992.

Wark, Robert R. *Isaac Cruikshank's Drawings for Drolls.* San Marino, Calif.: Huntington Library, 1968.

Warner, Oliver. *Captain Marryat: A Rediscovery.* London: Constable, 1953.

Wechsler, Judith. *A Human Comedy: Physiognomy and Caricature in Nineteenth-Century Paris.* Chicago: University of Chicago Press, 1982.

Weitenkampf, Frank. *The Illustrated Book.* Cambridge, Mass.: Harvard University Press, 1938.

———. "What the Early Illustrators Did to Dickens," *American Collector* 17 (Sept. 1948): 9–11.

Wendorf, Richard, ed. *Articulate Images: The Sister Arts from Hogarth to Tennyson.* Minneapolis: University of Minnesota Press, 1983.

Wheeler, Burton M. "The Text and Plan of *Oliver Twist*," *Dickens Studies Annual* 12 (1983): 41–61.

Whitley, William T[homas]. *Art in England, 1821–1837.* Cambridge: Cambridge University Press, 1930.

Wickwar, W. H. *The Struggle for the Freedom of the Press, 1819–1832.* London: George Allen and Unwin, 1928.

Wiener, Joel H. *Radicalism and Freethought in Nineteenth-Century Britain: The Life of Richard Carlile.* Contributions in Labor History, no. 13. London and Westport, Conn.: Greenwood Press, 1983.

Wilkins, William Glyde. "Cruikshank versus Dickens," *Dickensian* 16, no. 2 (Apr. 1920): 80–81.

———. "Variations in the Cruikshank Plates to *Oliver Twist*," *Dickensian* 15, no. 2 (Apr. 1919): 71–74.

Williams, Raymond. *The Long Revolution.* New York: Columbia University Press, 1961.

Wohl, Anthony S. *The Eternal Slum: Housing and Social Policy in Victorian London.* Montreal: McGill-Queen's University Press, 1977.

Wolff, Janet. *The Social Production of Art.* New York: New York University Press, 1984.

Wolff, Janet and John Seed, eds. *The Culture of Capital: Art, Power, and the Nineteenth-Century Middle Class.* Manchester: Manchester University Press, 1988.

Wolff, Robert Lee. *Nineteenth-Century Fiction.* 5 vols. New York and London: Garland, 1981.

Worth, George, J. *William Harrison Ainsworth.* New York: Twayne, 1972.

Wright, Beth Segal. "Scott's Historical Novels and French Historical Painting, 1815–1855," *Art Bulletin* 63 (July 1981): 269–287.

Wright, Thomas. *Caricature History of the Georges.* London: Chatto and Windus, 1876.

———. *A History of Caricature and Grotesque in Literature and Art.* 1865; reprint, with introduction and index by Frances K. Barasch, New York: Frederick Ungar, 1968.

———. *The Life of Charles Dickens.* New York: Charles Scribner's Sons, 1936.

Wright, Thomas, and R. H. Evans. *Historical and Descriptive Account of the Caricatures of James Gillray.* London: Henry G. Bohn, 1851.

Wynn Jones, Michael. *George Cruikshank: His Life and London.* London: Macmillan, 1978.

Yarnall, Ellis. *Wordsworth and the Coleridges.* New York and London: Macmillan, 1899.

Yates, Edmund. *Edmund Yates: His Recollections and Experiences.* 2 vols. London: Richard Bentley and Son, 1884.

General Index

à Beckett, Gilbert, 154, 189, 204, 225
Adams Acton, John, 472–475, 493; memorial bust of GCk, 512, 520
Adshead, Joseph, 371; and *The Bottle*, 235–236, 238, 250, 251; and *The Drunkard's Children*, 253; loans to GCk, 238, 262; *Prisons and Prisoners*, 235, 331
Ainsworth, William Harrison: and CD, 10, 19, 69, 103; on CD–GCk collaboration, 54; GCk introduced to, 1, 2, 10; and GCk's illustrations, 425; life and career, 2–6, 7–8; literary circle, 5–6, 64, 349; and Macrone, 33, 71; as *Miscellany* editor, 103, 129, 130, 155, 165; portrait of (fig. 1), 3, 5; in retirement, 483
Ainsworth collaboration with GCk, 220; appreciation for GCk, 99; bad treatment of GCk, 35–36, 161–162, 174–175; early, 23–25, 35–36; exchange of letters and ideas concerning, 138–140; GCk's version of, 136, 138, 483; as partners, 130–132, 139, 143; problems with accounts, 158–160; projects for, 128, 154–155; severe rift and reconciliation, 161–162, 164, 167–168, 174–175; working routine, 111–113, 119, 122, 138, 143–144; termination and later quarrels, 175, 418, 483–484. *See also Artist and the Author, The, in* INDEX OF CRUIKSHANK'S WORKS
—*Crichton*, 28, 33, 34–35, 57
—"Few Words about George Cruikshank, A," 485
—*Guy Fawkes*, 129, 132, 133, 143–144, 147, 165
—*Jack Sheppard*, 64, 71, 72; alterations to, 98; attacks on, 125–127, 149; descriptive style, 98–101, 109; editions, 322;

and Hogarth, 109–111, 115; and *Oliver Twist*, 110–111, 131, 553n11; pressure to finish, 113–114; republication and resonances, 124–125; stage versions, 122–124, 552n91, 553n104
—*Lions of London, The*, project, 35, 57, 71, 72, 97, 481
—*Miser's Daughter, The*, 167–172; GCk taking credit for, 483, 485, 494, 554n21; and Hogarth, 167, 170; stagings of, 172, 483
—*Old St. Paul's*, 161–165
—*Rookwood*, 4, 10, 12, 21, 36, 123; editions of, 23, 27, 68
—*St. James's: or the Court of Queen Anne*, 174
—*Tower of London, The*: exchange of ideas over, 138–140; GCk taking credit for, 132–133, 554n21, 605n24; negotiations for, 130–132; problem with accounts, 158–160; sequel, plans for, 161–165
—*Windsor Castle*: and GCk, 154–155; illustrators for, 173–174
Ainsworth's Magazine: beginnings, 157–158; GCk as illustrator, 158, 166, 185, 263; GCk's attack on Bentley in, 157–158; praise for GCk, 172; purchase of and resignation of Ainsworth, 174
Albert, Prince, 226; art collection, 289; GCk's contacts with, 303, 304, 305; and the Great Exhibition, 293–294, 304; purchase of *The Disturbed Congregation*, 278–279, 289–290, 295, 349; and the Volunteers, 392
Aldis, Charles J., 382, 383, 395
Alexander, Gabriel, 250
Alexander, Sir James E., 473, 474
Alison, Archibald, 261

Index of Cruikshank's Works

About the Author

ROBERT L. PATTEN is a professor of English at Rice University. He is the author of *Charles Dickens and His Publishers* and of many essays on Cruikshank and Dickens. Professor Patten is also editor of *Studies in English Literature 1500–1900* and co-editor of *Literature in the Marketplace* (Cambridge University Press, 1995). This two-volume biography of Cruikshank received support from the Guggenheim Foundation, the National Endowment for the Humanities, the National Humanities Center, the Center for Advanced Study in the Visual Arts at the National Gallery of Art, and the Swann Foundation for Caricature and Cartoon.